The Manual of Photography

formerly The Ilford Manual of Photography

Revised by

Ralph E. Jacobson M.Sc., Ph.D., C.Chem. M.R.I.C.

in cooperation with

Sidney F. Ray M.Sc., F.I.I.P., F.R.P.S.,

G. G. Attridge B.Sc., A.R.P.S. and

N. R. Axford B.Sc.

Focal Press

London & Boston

Focal Press

Is an imprint of the Butterworth Group
which has principal offices in
London, Boston, Durban, Singapore, Sydney, Toronto, Wellington

THE ILFORD MANUAL OF PHOTOGRAPHY
First published 1890
Fifth edition published May 1958
　Reprinted eight times

THE MANUAL OF PHOTOGRAPHY
Sixth edition published April 1971
　Reprinted 1971, 1972, 1973, 1975
Seventh edition 1978
　Reprinted 1978, 1981, 1983

©Butterworth & Co. (Publishers) Ltd, 1978

British Library Cataloguing in Publication Data

The manual of photography. — 7th ed.
　1.　Photography
　1.　Jacobson, Ralph Eric
　770　　　　　Tr 145

ISBN　0　240　51239　1

Text set in 11pt Photon Univers, printed by the Thetford Press Ltd.,
Thetford, Norfolk and bound by Anchor Press Ltd., Tiptree, Essex.

Preface to the Seventh Edition

SINCE publication of the sixth edition a number of significant advances in photographic equipment, materials, and practices have been made. Cameras have become more sophisticated and the 110 format has been introduced. Special cameras for "instant-print" colour materials are becoming increasingly popular and two major manufacturers now produce separate systems for this type of photography. Resin coated papers have become available for black and white as well as colour printing together with appropriate processing equipment. The move to smaller format cameras has necessitated the introduction of a new generation of colour films and the processing and printing of colour materials has become simpler and quicker. These and other developments are included in the present edition.

As editor of the new edition I have followed the example set by previous editors in directing the emphasis towards the principles underlying the practice of photography, although this edition still contains much useful practical information which should be of value to all those involved in photography.

In the previous edition two chapters were devoted to colour photography which appeared at the end of the book. In view of the extensive use of colour materials now made by virtually every photographer, much information on colour has been integrated within the main body of the text in this edition, as well as devoting two chapters exclusively to colour.

Many chapters have been completely re-written to take into account modern developments in the theory and practice of photography but those chapters which still have relevance to present day theory and practice have been retained, with appropriate additions and modifications.

In a book which deals with many diverse aspects of photography it is not possible for any single author to write authoritatively on all aspects.

Like the previous editor, Mr. Alan Horder, I have enlisted the aid of a number of contributors and should like to acknowledge the contributions of my colleagues at The Polytechnic of Central London. Thanks are due to Mr. S. Ray for contributing Chapters 3 to 11 on light sources, lenses, cameras and accessories, and for contributing sections on colour printing in Chapter 22; Mr. G. G. Attridge for Chapters 13–16 and 24 concerned with sensitometry and colour, and for contributing a section on white light and colour mixtures to Chapter 2; Mr. N. R. Axford for Chapter 25 on image evaluation and for contributing on latent image formation to Chapter 12.

London, November 1976 Ralph E. Jacobson

Contents

		Page
Preface		3
1.	**The Photographic Process**	13
	The production of photographs	14
	Characteristic features of the photographic process	15
	Perspective in photographs	16
	Reproduction of colour	16
	Reproduction of tone	17
	Reproduction of detail	18
	Negatives and positives	18
2.	**The Nature of Light**	20
	Optics	20
	Light waves	21
	The electromagnetic spectrum	22
	The visible spectrum	23
	White light and colour mixtures	24
	Use of the word "light" in photography	25
3.	**Light Sources**	27
	Characteristics of light sources	27
	Light output	36
	Constancy of output	37
	Efficiency	37
	Illumination	38
	Economy	41
	Ease of operation and maintenance	42
	Characteristics of some light sources used in photography	42
	Daylight	42
	Tungsten filament lamps	43
	Tungsten halogen lamps	45
	Carbon arc lamps	46
	Mercury vapour discharge lamps	47
	Fluorescent lamps	47
	Sodium vapour discharge lamps	48
	Metal halide lamps	48
	Pulsed xenon lamps	49
	Flashbulbs	49
	Electronic flash	53

4. The Geometry of Image Formation 60

 Interaction of light with matter 60
 Refraction 61
 Image formation 64
 The simple lens 65
 Image formation by a positive lens 66
 Formation of images by compound lens 68
 Graphical construction of images 69
 Relation between object distance, image distance and focal length 71
 Image size 72
 Focal length and angle of view 72
 Covering power of a lens 75
 Geometric distortion 75
 Lens definition 76
 Depth of focus 78
 Depth of field 80
 Perspective 83
 How important is perspective in a photograph? 87
 Viewing prints in practice 88

5. The Photometry of Image Formation 89

 Stops and pupils 89
 Aperture 90
 Vignetting 92
 Illuminance of the image formed by a camera lens 93
 Image illuminance in wide-angle lenses 98
 Exposure compensation for close-up photography 99
 Light losses and lens transmittance 100
 Flare, flare spot, ghost images 100
 T-numbers 101
 Lens coatings 102

6. Lens Aberrations 106

 Chromatic aberration 107
 Lateral colour 109
 Spherical aberration 110
 Coma 111
 Distortion 112
 Astigmatism 114
 Curvature of field 115
 Diffraction 116
 Resolving power of a lens 116
 Stopping down and definition 117

7. The Camera Lens 119

 Compound lenses 119
 Development of the photographic lens 121
 Modern camera lenses 126
 Wide-angle lenses 127
 Long-focus lenses 130
 Zoom lenses 133

8. Types of Camera 135

Introduction 135
Survey of development 135
Camera types 138
Simple cameras 139
Rangefinder cameras 139
Twin-lens reflex cameras 142
Single-lens reflex cameras 144
Technical cameras 147
Special-purpose cameras 148
Automation of camera functions and operations 150

9. The Elements of the Camera 153

The lens 154
The lens hood 156
Filters 156
Supplementary lenses 156
Stereo attachments 158
Diffusion discs 158
Converter lenses 158
Extension tubes and bellows 159
The shutter 160
Between-lens shutters 160
Focal-plane shutters 162
The diaphragm 164
Simple viewfinders 166
Direct-vision optical viewfinders 166
Ground glass screen viewfinders 168
The focusing mechanism 170
Focusing aids 171
Focusing scales 173
The exposure meter 174
Accessory exposure meters 177
Integral exposure meters 177
Integral meters with external cells 177
Through-the-lens exposure measurement 177
Automatic exposure control 181
Flash synchronisation 183

10. Camera Movements 187

Displacement movements 187
Rotational movements 191
Practical considerations and design limitations 195

11. Optical Filters and Attachments 198

General properties and characteristics of filters 198
Commercial forms of colour filters 200
Filter sizes and availability 203
Effect of filters on focusing 203
Colour filters for black-and-white photography 204
Colour filters for colour photography 207
Filters for colour printing 212
Special filters 212
Filters for darkroom use 218
Optical attachments 220

12. The Sensitive Material 222
 Latent image formation 223
 The emulsion binder 225
 Manufacture of photographic materials 226
 The support 227
 Coating the emulsion on the base 230
 Sizes of films and papers 232
 Packing and storage of films and papers 233

13. Spectral Sensitivity of Photographic Materials 235
 Response of photographic materials to shorter than visible radiation 235
 Response of photographic materials to visible radiation 238
 Colour sensitising 238
 Orthochromatic materials 239
 Panchromatic materials 239
 Infra-red materials 240
 Other uses of dye sensitisation 241
 Determination of the colour sensitivity of a material 241
 Wedge-spectrograms 242

14. Principles of Colour Photography 245
 Colour matching 245
 The first colour photograph 247
 Additive colour photography 248
 Subtractive colour photography 250
 Additive processes 254
 Subtractive processes 256
 Integral tripack 257

15. Sensitometry 258
 Subject 258
 Exposure 259
 Blackness of the image 260
 Effect of scatter in negative 262
 Callier coefficient 263
 Density in practice 263
 The characteristic curve 266
 Main regions of the negative characteristic curve 267
 Variation of the characteristic curve with the material 270
 Variation of the characteristic curve with development 270
 Gamma-time curve 272
 Variation of gamma with wavelength 274
 Placing of the subject on the characteristic curve 274
 Average gradient (G) 275
 Contrast index 276
 Effect of variation in development on the negative 277
 Effect of variation in exposure on the negative 278
 Exposure latitude 280
 The response curve of a photographic paper 283
 Maximum black 284
 Exposure range of a paper 285
 Variation of the print curve with the type of emulsion 285
 Variation of the print curve with development 287
 Requirements in a print 288

Paper contrast grades 289
The problem of the subject of high contrast 291
Tone reproduction 291
Reciprocity law failure 295
Intermittency effect 298
Sensitometric practice 298
Sensitometers 300
Densitometers 301
Elementary sensitometry 308

16. The Reproduction of Colour 310

Colours in the spectrum 310
Colours of natural objects 310
Effect of light source on appearance of colours 312
Response of the eye to colours 312
Primary and secondary colours 314
Complementary colours 315
Low light-levels 315
Black-and-white processes 315
Colour processes 318
Formation of subtractive image dyes 320
Colour sensitometry 321
Imperfections of colour processes 329
Corrections of deficiencies of the subtractive system 331
Masking of colour materials 333

17. Developers and Development 336

Composition of a developing solution 337
The developing agent 337
The preservative 340
The alkali (or accelerator) 342
The restrainer 343
Water for developers 344
Miscellaneous additions to developers 345
Monochrome developer formulae in general use 345
Metol-hydroquinone developers 347
Phenidone-hydroquinone developers 348
Fine grain developers 349
High-definition developers 352
Extreme contrast (lithographic) developers 352
Monobaths 353
Colour developers 353
Changes in a developer with use 354
Replenishment 356
Preparing developers 357
Pre-packed developers 359
The technique of development 361
Machine processing 365
The required degree of development 367
Obtaining the required degree of development 368
Development by inspection 369
Development by the time-temperature method 369
The basis of published development times 372
Development at low temperatures 373
Development at high temperatures 373
Obtaining very uniform development 374

Two-bath development 376
Reversal processing 376
Self-developing materials 378
Control of effective emulsion speed in development 378
Adjacency effects 382
Sabattier effect 383
Development of papers 384

18. Processing Following Development 385
Rinse bath 385
Acid stop bath 386
Fixing baths 386
Hardening 389
Making up fixing baths 391
Time required for fixation 392
Changes in a fixing bath with use 393
Useful life of a fixing bath 394
Replenishment of fixing baths 394
Silver recovery 395
Rapid fixing 397
Substitutes for sodium thiosulphate 397
Bleaching of silver images 398
Washing 399
Hypo eliminators and washing aids 400
Tests for permanence 401
Drying 402
Stabilisation processing 403
Uses of wetting agents in photography 403

19. Film Speed 405
Methods of expressing speed 405
Speed systems which are or have been in general use 410
Arithmetic and logarithmic speed systems 415
Conversion between speed systems 415
Speed ratings in tungsten light 415
Speed ratings of commercial films 416
Speed ratings for colour materials 418
Practical value of speed numbers 421

20. Camera Exposure Determination 422
Correct exposure 423
Exposure determination using photographic material 427
Exposure criteria 429
Exposure meters 432
Determination of exposures for flash photography 437

21. Photographic Papers 442
Types of printing papers 442
Type of silver halide employed 443
Paper contrast grades 445
Paper surface 446
Nature of the paper base 447
Colour papers 448
Development of papers 448

	Fixation	453
	Bleach-fixing	454
	Washing	454
	Stabilisation of colour prints	456
	Drying	457
	Glazing	458
	Clearing and reducing prints	460
	Toning prints	460
	Stabilisation papers	460
22.	**Printing and Enlarging**	**462**
	Contact printing	462
	Projection printing	463
	Condenser enlargers	464
	Diffuser enlargers	465
	Practical differences between condenser and diffuser enlargers	466
	Condenser-diffuser enlargers	468
	Light sources for enlarging	469
	Lenses for enlargers	470
	Negative carriers	471
	Heat filters	472
	Easels and paper holders	472
	Determination of exposure times in enlarging	472
	Dodging and shading	478
	Correction – or introduction – of perspective distortion	479
	Minimising graininess	479
	Soft-focus enlargements	480
	Colour printing	480
	Colour filtration	483
	Colour enlarger design	487
	Types of colour enlarger	488
	Methods of evaluating colour negatives for printing	491
	Colour print evaluation	494
23.	**After-treatment of the Developed Image**	**496**
	Reduction	496
	Classification of reducers	496
	Intensification	499
	Classification of intensifiers	499
	After-treatment of prints	499
	Toning	500
24.	**The Chemistry of Colour Image Formation**	**502**
	Chromogenic processes	502
	Silver-dye-bleach process	513
	Dye-releasing processes	516
	Important chemistry	522
25.	**Evaluation of the Photographic Image**	**532**
	Structural aspects	532
	Photographic turbidity	533
	Resolving power	533
	Graininess	536
	Granularity	539

Sharpness and acutance 540
Quality and definition 542
Modern methods of image evaluation 542
Spread function and the modulation transfer function (MTF) 544
Autocorrelation function and power spectrum 547
Detective quantum efficiency (DQE) 548
Information capacity 552
Colour images 553

26. **Faults in Negatives and Prints** 555
Faults in black-and-white negatives 555
Dark bands and patches 562
Index to faults in black-and-white negatives 566
Faults in black-and-white prints 568
Faults in colour materials 570

Appendix 574
Processing formulae for black-and-white materials 574
Developers 575
Stop bath and fixers 582
Reducers 583
Intensifiers 584
Toners 585
Reversal processing of black-and-white films 587
Processing formulae for colour materials 589
Dye reducers (bleaches) 593
Conversion of units 594
Logarithms 595
Trigonometrical ratios 598
The pH scale 599
Some outstanding dates and names in the early history
of photography 601
Bibliography 605

Index 609

11

1 The Photographic Process

ALTHOUGH, today, the photographic process finds many applications, photography is still primarily a method of making pictures. It is a means of making pictures by the agency of light, the word photography having its origin in two Greek words meaning "light" and "writing".

When a photograph is taken with a camera, light is allowed to pass through a lens to form an image on a light-sensitive film. The film records an impression of the image. This impression, which is invisible, is termed a latent ("hidden") image.

Photographs are obtained from an exposed film by *processing*. The processing of a film comprises several chemical operations, the purpose of which is to convert the invisible image on the film into a permanent visible image. The most characteristic operation in processing is development. The essential steps of the whole photographic process in its simplest (black-and-white, negative–positive) form are summarised in Table 1.1.

Exposure	Latent image formed
Processing:	
Development	Visible image formed
Rinsing	Development checked
Fixing	Unused sensitive material converted into soluble chemicals
Washing	Soluble chemicals removed
Drying	

Table 1.1 – The photographic process

The image formed when a film is processed in this way is a negative, and to obtain positive prints the negative is "printed". This involves a repetition of the photographic process using a further light-sensitive material – this time usually in the form of a sheet of paper – on which an image of the negative is formed by passing light through the negative. This paper is processed in a similar manner to the film to produce a black-and-white print of the familiar kind.

The production of photographs

For success in the production of a photograph consideration must be given to each of the following four essential factors.

Composition

By composition we mean the choice and arrangement of the subject matter within the confines of the finished picture. The camera can only record what it sees, and the photographer must control what the camera sees. This can be done, for example, by choice of viewpoint — its angle and distance from the subject, by controlling the placing of the subject within the picture space, and, sometimes, by suitable arrangement of the elements of the picture.

Illumination

Photographs are taken by light travelling from the subject towards the camera lens. Although some objects are self-luminous — e.g. firework displays — most objects are viewed and photographed by diffusely reflected light. The appearance of an object, both visually and photographically, thus depends not only on the object itself but also upon the light that illuminates it.

The main sources of illumination in the day are the sun, the clear sky and clouds. "Control" of the lighting of our pictures in daytime consists largely in selecting (or waiting for) the time of day or season of the year when the natural lighting produces the effect that the photographer desires.

Sources of artificial light are many, but all share, in varying degree, the advantage that, unlike daylight, they can be controlled at will. With artificial light, therefore, a wide variety of effects is possible. It is, however, good practice with most subjects to aim at producing a lighting effect similar to natural lighting on a sunny day, i.e. to use a main light in the role of the sun — casting shadows — and subsidiary lighting to lighten these shadows as required.

Image formation

To produce a photograph, light from the subject must be collected upon a light-sensitive surface, and must illuminate it in a pattern or image which resembles the subject. The faithfulness of the resemblance will depend upon the optical system employed, in particular upon the lens used and the relation of the lens to the sensitive surface.

Image perpetuation

Finally, the image-forming light must produce changes in the light-sensitive material in the camera so that there is implanted in this

material an impression of the image, and this impression must be rendered permanent. This fourth factor is the one generally recognised as most characteristic of photography.

Each of the above factors plays an important role in the production of the finished picture, and the photographer should be familiar with the part played by each, and the rules governing it. The first factor, composition, is much less amenable to rules and regulations than the others, and it is primarily in the control of this — coupled with the second factor, illumination — that the personality of the individual photographer has greatest room for expression. For this reason, the most successful photographer is frequently one whose mastery of camera technique is so complete that he can give his whole attention to the subject that he is photographing.

Characteristic features of the photographic process

Photography is only one of a number of methods of making images. Others include pencil sketching, water-colour painting, oil painting, etching, charcoal drawing, etc. Each method has certain advantages and limitations both as regards its technique and its results.

An outstanding characteristic peculiar to the photographic method of making images is that the photographer usually has to wait for an appreciable period after "taking" the photograph before seeing the result. This has several consequences. On one hand it leads to the remark frequently made by the inexpert camera user — "I will let you have a copy . . . if it comes out!" — whereas, in fact, the performance of photographic materials and equipment has for many decades been such that total failure is most unlikely — unless the camera is handled with a complete lack of understanding of its operation.

The delay between exposure and the production of the actual print also means that great care must be taken in the selection of the subject and in choosing the right moment for exposure. The successful photographer trains himself to work very quickly when necessary, and to form in his mind a mental picture of the subject at the moment of exposure that usually enables him, without seeing the final print, to decide whether he has been successful or whether a retake is required. The ability to do this is indispensable to the professional photographer, for with many of the subjects which he is called upon to photograph there is no opportunity for a retake at a later date. (If, for any reason, he cannot be sure of his results he duplicates his shots.)

Among other features characteristic of the photographic process are the following:

(1) A real subject is necessary.
(2) Perspective is governed by optical laws.
(3) Colour may be recorded in colour, or in black-and-white, according to the type of film used.
(4) Gradation of tone is usually very fully recorded.
(5) Detail is recorded quickly and with comparative ease.

The Photographic Process

Perspective in photographs

The term "perspective" is applied to the apparent relation between the position and size of objects. In a scene examined visually, the perspective depends upon the viewpoint of the observer. The same principle applies when a scene is photographed, the only difference being that the camera lens takes the place of the eye. Control of perspective in photography is therefore achieved by control of viewpoint.

A painter is not limited in this way; he can place objects in his picture anywhere he pleases, and alter their relative sizes at will. If, for example, he is depicting a building and is forced by the presence of other buildings to work close up to it, he can nevertheless produce a picture which − as far as perspective is concerned − appears to have been painted at a distance. The photographer cannot do this. Selection of viewpoint is thus seen to be of great importance to the photographer if a given perspective is to be achieved.

Reproduction of colour

As far as colour is concerned, photographs are of two main types: colour and monochrome (black-and-white). Colour photography did not become a practicable proposition for the average photographer until nearly 100 years after the invention of photography, but in recent years its use has gained rapidly over black-and-white photography, and in many fields now predominates. However, a great deal of photographic work − especially press photography − is still done in monochrome. Colour photography is essentially a development of black-and-white photography, so that a study of the principles of the latter will provide a sound basis for a consideration of colour photography.

Monochrome reproduction is not peculiar to black-and-white photography alone, but is shared by processes such as pencil sketching, charcoal drawing and etching. In all these processes attempts are made to reproduce in two dimensions and one colour, an original subject which is in three dimensions and in many different colours. This is a task to which the photographer must bring all the help provided by the nature of the particular process that is being used. For example, in a photographic print, a fair impression of solidity may be obtained by intelligent use of perspective, differential focusing, haze and receding planes, and, although only shades of grey from white to black in which to reproduce colours are available, by reproducing them as greys similar in tone to the original colours, an acceptable rendering of colours in monochrome may be achieved. Fortunately, in the representation both of solidity and of colour the forces of convention and habit are on our side.

To reproduce an original subject of many different colours in an acceptable manner, colour photographic materials are used, either in the form of prints for viewing by reflected light, or in the form of transparencies for viewing by transmitted light. The observed fact that colours can be reproduced photographically in an acceptable way is surprising when we

consider that the colours of the image are formed by combinations of three "man-made" dyes according to the principles described in Chapters 14 and 16.

No photographic reproduction of colour is absolutely identical with the original and there are certain preferred colour renderings that differ from the original. However, acceptable colour reproduction is achieved if the *consistency principle* is obeyed. This principle may be summarised as follows:

(1) Identical colours in the original must appear identical in the reproduction.

(2) Colours that differ one from another in the original must also differ in the reproduction.

(3) Any differences in colour between the original and the reproduction must be consistent throughout.

The entire area of colour reproduction is very complex and involves considerations of both objective and complex subjective effects. Apart from the reproduction of hues or colours the *saturation* and *luminosity* are important. The saturation of a hue decreases with the addition of white or grey. Luminosity is associated with the amount of light emitted, transmitted or reflected by the sample under consideration. These factors depend very much on the nature of the surface and the viewing conditions. At best, colour reproductions are only representations of the original scene, but as we all know colour photographic materials carry out their task of reproducing colours and tone remarkably well despite differences in colour and totally different viewing conditions between the original scene and the reproduction.

Reproduction of tone

Various ways of achieving gradation of tone are employed in the graphic arts. In etchings and drawings in pen and ink — which consist of lines varying principally in width rather than in density — the effects of light and shade are obtained largely by controlling the width or the spacing of the lines. For example, several lines placed close together, in what is termed "hatching", produce an area of shade. Such pictures are referred to as *line* reproductions. In photographs, on the other hand, the effects of light and shade are obtained by variation of the tone of the print. Thus, a highlight of uniform brightness in the subject appears as a uniform area of very light grey, almost white, in the print. A shadow of uniform depth appears as a uniform area of dark grey, or black, in the print. Between these extremes all shades of grey may be present. Photographs are therefore referred to as *continuous-tone* reproductions. (When, of course, photography is used to record originals which are themselves confined to two tones, as for instance when a line original — e.g. an engineering drawing — is copied, the photographic process is then employed to produce a line, not a continuous-tone copy.)

It should be noted that in black-and-white photography there is only

one variant in the print, that of tone, to reproduce all variations in the subject, whether of luminance or of colour.

Reproduction of detail

For the reproduction of detail the photographic process is without equal. Whereas a detailed drawing demands far more in time and energy from an artist than a simple sketch, the camera can record a wealth of detail just as easily and just as quickly as it can a simple object. Thus it is that the reproduction of texture — essentially fine detail — by the camera is the envy of the artist.

Negatives and positives

Most photographs are produced by exposing a film first, following this by a further exposure to produce a print on paper. This procedure is followed because, with most of the light-sensitive materials that have proved suitable for photography, increasing brightness of the subject produces increasing blackness on the photographic material. The film record therefore has the tones of the subject in reverse — black where the original is light, clear where the original is dark, with the intermediate tones similarly reversed. The original film is therefore referred to as a *negative*, while a print, in which by a further use of the photographic process the tones of the original are re-reversed, is termed a *positive.* Any photographic process by which a negative is made first and employed for the subsequent preparation of prints is referred to as a *negative-positive process.*

It should be noted here that, although the eye accepts a two-dimensional monochrome print as a fair representation of a three-dimensional coloured object, it does not accept a negative as an objective picture. Negative records are thus not acceptable for pictorial purposes — except for deliberate effects — although they are acceptable in certain technical applications of photography.

It is possible to obtain positive photographs directly on the material exposed in the camera, but the procedure for doing this is usually more complex than the preparation of negatives. The first widely used photographic process — that due to Daguerre — did in fact produce positives directly. The first negative-positive process, due to Fox Talbot, although announced at about the same time as that of Daguerre, gained ground rather more slowly, but today negative-positive processes are used for the greater part of black-and-white photography. Although processes giving positive photographs in a single operation appear attractive, in practice, negative-positive processes are useful because two stages are required. In the first place, the negative provides a master which can be stored away for safe keeping. Then, it is easier to make copies from a transparent master than from a positive photograph — which is usually required to be on an opaque paper base. Again, the printing stage of a two-stage process gives an additional and valuable oppor-

tunity for control of the finished picture. However, in professional work, especially colour, it has been the practice to produce *transparencies* from which blocks can be made for subsequent *photomechanical printing*.

Negatives are usually made on a transparent base — film or glass — and positives on paper, though there are important exceptions to this. For example, negatives are sometimes made on paper for reasons of economy, as in document copying and in some forms of commercial portraiture. Positives are sometimes made on film for projection purposes, as in the case of filmstrips and cine films. Such positives are termed *diapositives* or *transparencies*. It should be noted, however, that the action of light in producing an image on negative materials and positive materials is essentially the same in the two cases.

2 The Nature of Light

PHOTOGRAPHY, as far as the photographer is concerned, starts with light. Light radiating from the sun — or whatever other source is employed — travels through space and impinges upon the surface of the subject. According to the way in which it is received or rejected — in whole or in part — a complex pattern of light, shade and colour originates, which, appearing in the visual field, is interpreted by us from past experience in terms of three-dimensional solidity. The picture made by the camera is a more-or-less faithful representation of what a single eye sees, and, from the patches of light and shade in the positive photographic print, the eyes and the mind working together can arrive at a reasonably accurate interpretation of the form and nature of the objects portrayed. Thus, light makes it possible for us to be well-informed about the shapes, sizes, and textures of things — whether we can handle them or not.

The nature of light has been the subject of much speculation. In Newton's view it was corpuscular, i.e. consisted of separate particles, but this theory could not be made to fit all the known facts, and the *wave theory* of Huygens and Young took its place. Later still, Planck found that many facts could be explained only on the assumption that energy is always emitted in discrete amounts, or quanta. Planck's *quantum theory* might appear at first sight to be a revival of Newton's corpuscular theory, but there is only a superficial similarity. Nowadays, physicists make their interpretations in terms of both the wave and quantum theories. The quantum of light is called the *photon*.

Optics

The study of the behaviour of light is termed *optics*. It is customary to group the problems that confront us in this study in three different classes, and to formulate for each a different set of rules as to how light behaves. The science of optics is thus divided into three branches.

Physical optics

This is the study of light on the assumption that it behaves as waves. A stone dropped into a pond of still water causes a train of waves to spread out in all directions on the surface of the water. Such waves are almost completely confined to the surface of the water, the advancing wave-front being *circular* in form. A point source of light, however, is assumed to emit energy in the form of waves which spread out in all directions, and hence, with light, the wave-front forms a *spherical* surface of ever-increasing size. This wave-front may be deviated from its original direction by obstacles situated in its path, the form which the deviation takes depending on the shape and nature of the obstacle.

Geometrical optics

The path of any single point on the wave-front referred to above is a straight line with direction perpendicular to the wave-front. Hence we say that light travels in straight lines. In geometrical optics we postulate the existence of *light rays* represented by such straight lines along which light-energy flows. By means of these lines, change of direction of travel of a wave-front can be shown easily. The concept of light rays is therefore helpful in studying the formation of an image by a lens.

Quantum optics

This branch of modern physics, which assumes that light consists essentially of quanta of energy, is employed when studying in detail the effects that take place when light is absorbed by matter, e.g. on striking an emulsion or other light-sensitive material.

Light waves

As already stated, many of the properties of light are readily explained if we suppose that it takes the form of waves. Unlike sound waves, which require for their propagation air or some other material medium, light waves travel freely in a vacuum. In a vacuum, e.g. in free space, light travels at almost exactly 3×10^8 metres per second (300 000 kilometres per second). In air, its velocity is very nearly as great, but in water it is reduced to three-quarters and in glass to about two-thirds of its value in space.

Many forms of wave besides light travel in space at the same speed as light; they are termed *the family of electromagnetic waves.* All electromagnetic waves are considered to vibrate at right angles to their direction of travel. As such, they are described as *transverse* waves, as opposed to *longitudinal* waves — such as sound waves — in which the direction of vibration is along the line of travel.

The distance in the direction of travel from a point on one wave to the corresponding point on the next is called the *wavelength* of the radiation.

Wavelength is usually denoted by the Greek letter lambda (λ). The number of waves passing any given point per second is termed the *frequency* of vibration. Different kinds of electromagnetic waves are distinguished by their wavelength or frequency. The amount of movement of a light wave in a lateral direction is termed its *amplitude.* Amplitude is a measure of the intensity of the light, but is a term rarely used in photography.

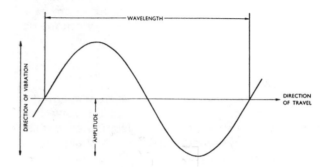

Fig. 2.1 — A light wave shown diagrammatically

Figure 2.1 shows a light wave diagrammatically, and illustrates the terms wavelength and amplitude. In the figure, the ray of light is shown as vibrating in one plane only — the plane of the paper. It should, however, be considered as vibrating in all directions simultaneously, i.e. at right-angles to the paper as well as in its plane.

The product of wavelength and frequency equals the velocity of propagation of the radiation.

The electromagnetic spectrum

Of the other waves besides light travelling in space, some have wavelengths shorter than that of light and others have longer wavelengths. The complete series of waves, arranged in order of wavelengths, is referred to as the *electromagnetic spectrum*. This is illustrated in Figure 2.2. There is no sharp, clear-cut line between one wave and another, or between one type of radiation and another — the series of waves is continuous.

The various types of radiation forming the family of electromagnetic rays differ very widely in what they can do. Waves of very long wavelength such as radio waves, for example, have no effect on the body — they cannot be seen or felt — although they can readily be detected by means of special apparatus. Moving along the spectrum, to shorter wavelengths, we reach waves that we feel as heat, and then come to waves that the eye sees as light. The last-named waves form the *visible spectrum*. Even shorter wavelengths provide radiation such as x-rays, which can penetrate the human body, and gamma-rays, which can

22

penetrate several inches of steel. Both x-rays and gamma-rays, unless properly controlled, are dangerous to human beings.

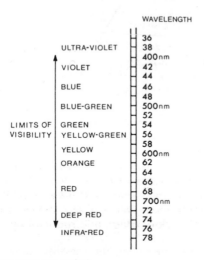

WAVELENGTH (METRES)	FREQUENCY (HERTZ)	PHOTON ENERGY (JOULES)	(ELECTRON VOLTS)

Fig. 2.2 — Electromagnetic spectrum. Relationship between wavelength, frequency and energy.

The visible spectrum

Photography is mainly concerned with visible radiation, although other electromagnetic rays have important applications in specialised branches of photography. The visible spectrum occupies only a minute part of the total range of electromagnetic radiation, comprising wavelengths within

Fig. 2.3 — The visible spectrum expanded

the limits of approximately 400 and 700 nanometres.* Within these limits, the human eye sees change of wavelength as a change of colour. The change from one colour to another is not a sharp one, but the spectrum may be divided up roughly as shown in Figure 2.3. (See also Chapter 16.)

The eye has a very slight sensitivity beyond this region – to 390 nm at the short-wave end and 760 nm at the long-wave end – but for most photographic purposes this can be ignored. Shorter wavelengths than 390 nm, invisible to the eye, are referred to as *ultra-violet* (u.v.), and longer wavelengths than 760 nm, also invisible to the eye, are referred to as *infra-red* (i.r.).

Figure 2.3 shows that the visible spectrum contains the colours of the rainbow in their familiar unvarying order, from violet at the short wavelength end to red at long wavelengths. For many photographic purposes we can usefully consider the visible spectrum to consist of three bands only: blue-violet from 400 to 500 nm, green from 500 to 600 nm and red from 600 to 700 nm. This division is only an approach to the truth, but it is sufficiently accurate to be of help in solving many practical problems and has the virtue that it is readily memorised.

White light and colour mixtures

More than three hundred years ago Newton discovered that sunlight could be made to yield a variety of colours by allowing it to pass through a triangular glass prism. A narrow beam of sunlight was *dispersed* into a band showing the colours of the rainbow. These colours represent the visible spectrum, and the experiment is shown diagrammatically in Figure 2.4. It was later found that recombination of the dispersed light by means of a second prism gave white light once more.

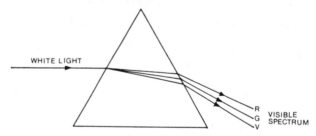

Fig. 2.4 – Dispersion of white light by a prism

Later experiments showed that by masking off parts of the spectrum before recombination a range of colours could be produced. Young in England, and Helmholtz in Germany showed that if small parts of the spectrum were selected in the blue, green and red regions, a mixture of appropriate amounts of blue, green and red light appeared white. Varia-

* 1 nanometre (nm) = 10^{-9} metre (m). The nanometre was formerly known as the millimicron (mμ).

tion of the blue, green and red contents of the mixture resulted in a wide range of colours. Almost any colour could be produced, including *magenta*, or purple, which did not appear in the visible spectrum. The results of mixing blue, green and red light are listed in Table 2.1 and illustrated in Figure 2.5.

Colours of light mixed	Visual appearance
Blue + green	Blue-green, or *cyan*
Blue + red	Red-purple, or *magenta*
Green + red	Yellow
Blue + green + red	White

Table 2.1 – Mixing blue, green and red light

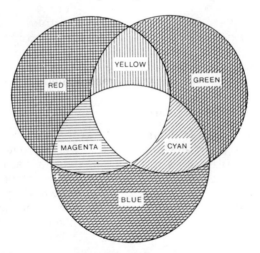

Fig. 2.5 – Mixing blue, green and red light

The results of mixing blue, green and red light suggested that the human eye might possess three types of colour sensitivity, to blue, green and red light respectively. This triple sensitivity theory is called the *Young-Helmholtz theory of colour vision*. It provides a fairly simple explanation for the production of any colour from an appropriate mixture of blue, green and red light.

The colours blue, green and red are called *primary colours* because the other colours can be matched by mixing the appropriate proportions of these primaries.

Use of the word "light" in photography

The various forms of waves comprising the electromagnetic spectrum are referred to generally as *radiation*, or *radiant flux*. Strictly speaking, only radiation capable of stimulating the eye to produce visual sensation should be referred to as light. For the purposes of photography it is,

The Nature of Light

however, frequently convenient to use the term "light" to include both visible radiation and the near-visible radiation — ultra-violet and infra-red — which (as we shall see in Chapter 13) can affect photographic materials.

3 Light Sources

PHOTOGRAPHS are taken by the agency of light travelling from the subject to the camera. This light usually originates at a source outside the picture and is reflected by the subject. Light comes from both natural and artificial sources. Natural sources of importance in photography are the sun, the clear sky and clouds. The many types of artificial light sources used can be classified in terms of the method used to produce the light (see Table 3.1).

Method	Source of light	Examples
Burning	Flame from oil, fat, wax, wood or metals	Candles, oil lamps, matches, magnesium ribbon, flash powder and flash-bulbs
Heating	Carbon or tungsten filament	Incandescent electric lamps, e.g. domestic lamps, studio lamps, tungsten-halogen lamps
Electric spark or arc	Crater or flame of arc	Carbon arcs, spark gaps
Electrical discharge	Gas or metallic vapour Phosphors	Electronic flash, fluorescent lighting, metal halide lamps, sodium and mercury vapour lamps

Table 3.1 – Methods of producing light

Characteristics of light sources

Light sources differ in many ways, and the selection of suitable sources for various purposes is based on the order of importance of a number of characteristics significant from a photographic point of view. A summary of some of the properties of the most common sources used in a range of photographic tasks is given in Table 3.2. Detailed descriptions of these light sources are given later (see page 29).

First, we shall examine in detail each of the factors that characterise a light source. These can be considered later with the properties of individual light sources, although certain of the factors above are applicable only to artificial sources.

Light Sources

For practical purposes, the important characteristics of a light source are:

(1) Spectral quality;
(2) Light output;
(3) Constancy of output;
(4) Efficiency;
(5) Illumination;
(6) Size;
(7) Economy;
(8) Ease of operation and maintenance.

Spectral quality

The radiation from most light sources comprises a mixture of light of various wavelengths. The *colour* of the light from a source, or its *spectral quality* may vary widely, depending on the distribution of energy at each wavelength in the spectrum. Most of the sources used for photographic purposes – with the exception of some discharge lamps – give what is usually described as "white" light. This is a loose term describing light that is not noticeably deficient in any particular colour, but not implying any very definite colour quality. Most white light sources vary considerably among themselves and from daylight. Because of the phenomenon of *colour constancy* of visual perception, these differences matter little in everyday life, but they can be *very* important in photography, especially when using colour materials. It is, therefore, desirable that we should be able to describe light quality in precise terms.

Adopting the approach of physics, light is a particular region of the electromagnetic specturm (see page 22) and is a form of radiant energy. The colour quality may therefore be defined in terms of the energy distribution throughout the spectrum. There are several ways this can be expressed, with varying degrees of precision. Each method has its own advantages, but not all methods are applicable to every light source.

Spectral energy distribution curve

With a suitable instrument it is possible to measure the way in which light energy is distributed through the spectrum, wavelength by wavelength. This information is normally given as a graph of energy against wavelength, termed the *spectral energy distribution curve.* Curves of this type for sunlight, a clear blue sky and a tungsten lamp are given in Figure 3.1. Curves for some other light sources are given in Figure 3.2.

Such graphical presentations show clearly small differences between various forms of light. For example, the light sources in Figure 3.1 seen separately would, owing to colour constancy effects, probably be described as "white", yet the three curves are seen to be quite different. Light from a blue sky has a high blue content, while light from a tungsten lamp has a high red content. While not obvious to the eye, such

Source	Type of spectrum C. continuous L. line B. line plus continuum	Colour temperature (Kelvins) X. correlated value R. range	Efficacy (lumens per watt) R. range T. typical value	Average lamp life (hours) R. range	Light output H. high M. moderate L. low	Constancy output P. poor G. good E. excellent V. variable	Costs L. low M. moderate H. high Initial	Running	Size of unit S. small M. medium L. large	Ease of operation D. difficult M. moderate S. simple
Daylight	C	R 2000–20 000	–	–	H–L	P	L	L	–	S
Tungsten filament lamps:										
General service	C	R 2760–2960	T 13	1000	L	P	L	L	M	S
Photographic	C	3200	T 20	100	L	G	M	M	M	S
Photoflood	C	3400	T 40	R 3–10	M	P	L	M	S	S
Projector	C	3200	T 20	R 25–100	M	G	M	M	S	S
Tungsten halogen lamps	C	R 2700–3400	R 15–35	R 25–200	M	E	M	H	S, M	S
Carbon arc lamps:										
Low intensity	C	R 3800–10 000		R 1–2	H	P	H	L	L	D
High intensity	C	6000		R 1–2	H	P	H	L	L	D
White flame	C	5000		R 1–2	H	P	H	L	L	D
Mercury vapour discharge lamps:										
Low pressure	L	–	6	R 1000–2000	M	G	H	L	M	S
High pressure	L	–	R 35–55	R 7000–8000	H	G	H	L	M	S
Fluorescent lamps	B	X, R 3000–6500	T 62		M	P	M	L	L	M
Sodium vapour discharge lamps:										
Low pressure	L	–	170	R 10–16 000	H	E	M	L	M	M
High pressure	L	–	100		H	E	H	L	M	M
Metal halide lamps	B	R 5600–6000	R 85–100	R 200–1000	H	E, V	H	H	M	M
Pulsed xenon lamps	B	5600	R 25–50	R 300–1000	H	G	H	L	M, S	M
Flash bulbs	C	3800 or 5500	–	used once only	H	E	L	H	S	S
Electronic flash	B	X 6000	40	–	M	G	H, M, L	L	L, M, S	M

Table 3.2 – The properties of some light sources used in photography

differences are clearly shown on any single colour film. Each film type has to be "balanced" for a particular form of lighting.

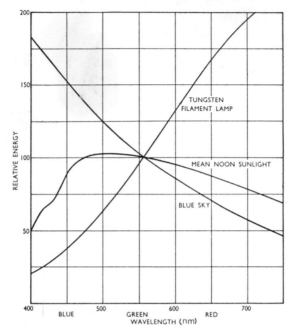

Fig. 3.1 — Spectral energy distribution curves of sunlight, light from a blue sky and light from a tungsten lamp

Spectral energy distribution curves also show that there are three main types of spectra emitted by light sources. The three sources in Figure 3.1 have *continuous* spectra with energy present at all wavelengths in the region measured. Many sources, including all incandescent-filament electric lamps, have spectra of this type. In some sources, however, the energy is confined to a few, very narrow regions of the spectrum. At these wavelengths the energy is intense but virtually nil at all others. This is termed a *discontinuous* or *line* spectrum and is given typically by low pressure discharge lamps such as the sodium or mercury vapour types.

A third type of spectrum, that of broad bands accompanied by a continuous background spectrum of varying prominence, may be obtained from discharge sources in various ways. One method is to increase the pressure inside the discharge tube, as for example, with the high pressure mercury vapour lamp. Another method is to coat the inside of the discharge tube with phosphors which emit light at longer wavelengths than those spectral lines that are used to stimulate them. This technique is used in fluorescent lamps. Yet another method is to use fillings such as xenon or argon gas and metal halides.

A spectral energy distribution curve provides a precise form of expressing the quality of light from any source — continuous or discon-

tinuous. For practical photographic purposes, however, it is not a con-
venient method to apply.

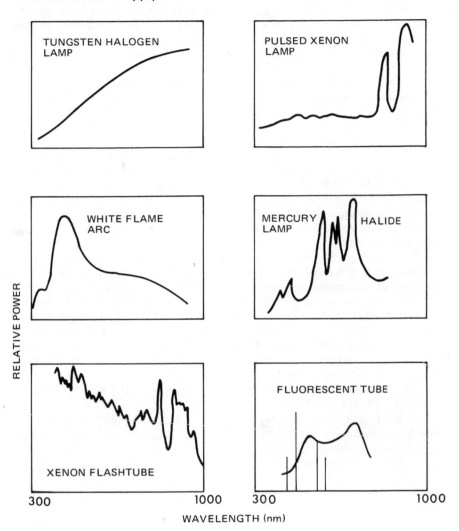

Fig. 3.2 – Spectral energy distribution curves typical of some of the artificial light sources
used in photography

Colour temperature

The most commonly employed method of defining the quality of light
from an incandescent source is by means of its *colour temperature*. This
is defined in terms of a "full radiator" or "black-body" radiator which is a
light source emitting radiation whose spectral distribution depends only
on the temperature and not on the material and nature of the source.

The colour temperature of a light source is the temperature of a full radiator which would emit radiation of substantially the same spectral distribution in the visible region as the radiation from the light source, and which would have the same colour. Colour temperatures are measured on the thermodynamic, or Kelvin, scale, which has a unit of temperature interval identical to that of the Celsius (centigrade) scale, but with its zero at $-273 \cdot 15°C$.

The idea of colour temperature can be appreciated by considering the progressive heating of a piece of metal, which goes from dull black to deep red then bright red to "white" hot. Obviously the quality of light emitted changes with the temperature of the metal and with the predominance of red light at lower temperature.

Luminous sources of low colour temperature are characterised by an energy distribution relatively rich in red radiation, commonly termed "warm" light. With progression up the colour scale the emission of energy is more evenly balanced and the light becomes whiter. At high values the energy distribution is rich in blue radiation and the light is commonly termed "cold". The possibility of confusion in terminology should be noted.

The concept of colour temperature is strictly applicable only to sources acting as full radiators, but in practice may be extended to sources whose spectral energy distributions closely match that from a full radiator, e.g. tungsten filament lamps. The term is often applied for convenience, but incorrectly, to fluorescent lamps whose spectra and hence photographic effects are very different from those of full radiators. An alternative term should be used, that of *correlated colour temperature*, to indicate a similarity to a value on the full radiator scale but with an unpredictable photographic effect.

The approximate colour temperatures of some light sources used in photography are given in Table 3.3.

In black-and-white photography, the colour or quality of light is of limited importance for the practical photographer. In colour photography it is of vital importance because colour materials are balanced to give correct colour rendering with an illuminant of a particular colour temperature. Consequently the measurement and control of colour temperature must be considered for such work.

Colour rendering

In the particular case of fluorescent lamps, of which a large variety of tube types are made, covering a wide range of correlated colour temperatures, the results given by two lamps of nominally the same properties may be quite different, whether used for visual colour matching or colour photography. These effects are due to the different spectral energy distributions. Various objective methods have been devised to give a numerical value to the colour rendering given by such sources as compared with a corresponding full radiator or particular

Light source	Approximate colour temperature	Mired value
Standard candle	1930 K	518
Dawn sunlight	2000 K	500
Vacuum tungsten lamp	2400 K	417
Acetylene lamp (used in early sensitometric work)	2415 K	414
Gas-filled tungsten lamp (general service)	2760 to 2960 K	362 to 338
Warm-white fluorescent lamp	3000 K	333
"Photographic" lamp	3200 K	312
Photoflood lamp	3400 K	294
Clear flashbulb	3800 K	263
Plain carbon arc	3800 K	263
Daylight fluorescent lamp	4500 K	222
White-flame arc	5000 K	200
"Mean noon sunlight"	5400 K	185
Photographic daylight	5500 K	182
Blue flashbulb	6000 K	167
H.I. carbon arc (sun arc)	6000 K	167
Electronic flash tube	6000 K	167
Average daylight (sunlight and skylight combined)	6500 K	154
Colour matching fluorescent lamp	6500 K	154
Enclosed arc	10 000 K	100
Blue sky	12 000 to 18 000 K	83 to 56

Table 3.3 – Colour temperatures of some common light sources

properties of visual perception. Based on the measurement of luminance in some 6 or 8 spectral bands and compared with the total luminance, coupled with weighting factors, a *colour rendering index* or *value* of 100 indicates ideal performance. Typical values vary from 50 for a "warm white" type to greater than 90 for a "colour matching" version.

Percentage content of the primary colours

For many photographic purposes, the spectrum can be considered as consisting of three main bands – blue, green and red. The quality of light from a source having a continuous spectrum can therefore be approximately expressed in terms of the percentages in which light of these three colours is present. This method is not very precise but it is of some interest because it is the basis of some instruments for measuring colour temperature, when the ratios of blue-green and green-red content are compared. The same principles are also used to specify the colour rendering given by a lens, because considerable absorption often takes place in optical glass at the blue end of the spectrum.

Measurement and control of colour temperature

In colour photography, the colour temperature of the light emitted by all the sources used on a subject must agree with that for which the process

being used is balanced. The tolerance permissible depends on the process employed and to some extent on the subject. A departure by all the sources of 100 K from the specified value (which may arise from a 10 per cent variation in supply voltage) is probably the maximum tolerable for colour reversal material balanced for a colour temperature of around 3400 K. Colour negative material may allow a greater departure than this because a certain amount of correction can be applied at the printing stage.

In the final result, a difference between one lamp and another is more noticeable than a difference between all the lamps and the specified colour temperature. A difference of 50 K between lamps, for instance, may be more noticeable than a difference of 100 K between all the lamps and the specified value, the differences being most noticeable in mid-tones.

One of the problems arising on location photography is that of "mixed" lighting where part of the subject may be unavoidably illuminated by a light source of incorrect colour temperature or quality. A localised colour cast may appear in the photograph. Another case is the use of tungsten lamps fitted with a blue dichroic filter used to match daylight for fill-in purposes, when some mismatch may occur. Both flashbulbs and electronic flash may be used successfully as fill-in sources with daylight as the main illuminant.

A visual comparison of the colour temperatures of two light sources may be obtained by viewing the independently illuminated halves of a folded sheet of white paper with its apex pointing towards the observer. Any observable difference in colour will be visible in the photograph and must be corrected (see below). In general, however, instrumental methods are more convenient, using a *colour temperature meter.* The simplest variety relies on the phenomenon of *metamerism* whereby a pair of colour patches will match in one colour temperature of illumination. Most instruments however incorporate a photoelectric cell or cells used in conjunction with colour filters to sample specific regions of the spectrum. Readings of colour temperature may be given directly, or indirectly via calibration charts. A good meter may read to within ± 25 K at 3400 K. Such meters can be used successfully in daylight or tungsten-filament lighting but may be very misleading with sources having marked line spectra.

The colour temperature for which a colour film is balanced and the colour temperature of a lamp are specified by the manufacturers of film and lamp respectively. The colour temperature of a lamp may be affected by the reflector or optics used, and changes with variations in the power supply and with the age of the bulb.

To obtain light of the correct quality, various precautions should be taken. The lamps must be operated at the specified voltage and any reflectors, lenses or diffusers used must be as near to neutral in colour as possible. Voltage control is possible using a constant voltage transformer on the supply or by use of a variable transformer and volt meter. This latter arrangement is also suitable for extending lamp life by arranging

the subject lighting when operating at reduced voltage giving reduced light and heat output and only using correct, full voltage for actual picture taking. Rheostats may also be used in series with individual lamps for trim control. As an alternative to individual rheostats, light-balancing filters may be used over lamps as necessary to raise or lower colour temperature. Pale amber filters lower the colour temperature, pale blue ones raise it.

When tungsten filament lamps age, their envelope darkens from a deposit of tungsten evaporated from the filament. Both light output and colour temperature decrease as a result. Bulb replacement is the only remedy and usually all bulbs of a particular set should be replaced at the same time. Tungsten-halogen lamps employ the tungsten-iodine cycle (see page 45) to maintain constant output throughout their extended life.

To compensate for the wide variations encountered in daylight condition for colour photography, camera filtration is necessary using *light balancing filters* of known *mired shift value* defined below. To use colour film in lighting conditions for which it is not balanced, *colour conversion* filters with large mired shift values are available, see page 210.

The mired scale

Any colour temperature can have assigned to it a value on the *mired scale*, the name of which is an acronym derived from *micro reciprocal degrees*, which itself derives from the fact that the unit now known as the kelvin used to be a degree Kelvin. The relationship between the mired scale and colour temperature is

$$\text{mired value} = \frac{1\ 000\ 000}{\text{colour temperature in kelvins}}$$

Conversion from one scale to the other may be achieved by reference to Figure 3.3. Note that as colour temperature increases, the mired value decreases and vice versa. The main advantage of the mired scale, apart from the smaller numbers involved, is that equal intervals in it correspond to equal variations in colour. Consequently, light balancing filters (page 209) can be given *mired shift values* which indicate at once the change in colour quality that the filter will give, with whatever source it is used. Yellowish filters, for raising the mired value of the light, i.e. lowering the colour temperature in kelvin, are given positive mired shift values; bluish filters for lowering the mired value, i.e. raising the colour temperature in kelvin, are given negative values. For example, a bluish light-balancing filter with a mired shift value of −18, is suitable for converting tungsten light at 3000 K (333 mireds) to 3200 K (312 mireds). It is also suitable for converting daylight at 5000 K (200 mireds) to 5500 K (182 mireds).

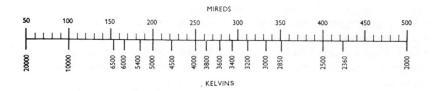

Fig. 3.3 – The mired and kelvin scales

Light output

The output, or power, of a source is one of its more important characteristics. A source can emit energy in a wide spectral band from the ultra-violet to infra-red regions, indeed most of the output of incandescent sources is in the infra-red. For most photographic purposes we are concerned only with the visible regions and three related photometric units are used to define light output. These are *luminous intensity*, *luminance* and *luminous flux*.

Luminous intensity is expressed numerically in relation to the output of a standard light source, in this case a primary standard termed the *candela.* This unit of luminous intensity is by definition the luminous intensity, in the direction of the normal, of a full radiator surface $\frac{1}{600\,000}$ square metre in area at the temperature of solidification of platinum. The candela replaced earlier units based on standard candles and other sources.

The light-radiating capacity of a source in terms of the luminous intensity expressed in candelas is termed its *candle-power.* The candle-power of a source is not necessarily the same in all directions so the *mean spherical candle power* is used as a measure of the average value of candle-power in all directions.

Luminance is defined as luminous intensity per square metre. The unit of luminance is the candela per square metre. The luminance of a source, like its luminous intensity, is not necessarily the same in all directions. The term luminance is applicable equally to light sources and to illuminated surfaces. In photography, we are recording luminances, usually in terms of optical densities of silver or dye deposits.

Luminous flux is a measure of the amount of light emitted into space defined in terms of unit solid angle or steradian, which is the angle subtended at the centre of a sphere of unit radius by a surface of unit area on the sphere. Thus, an area of 1 square metre on the surface of a sphere of 1 metre radius subtends at its centre a solid angle of 1 steradian. The luminous flux emitted into unit solid angle by a point having a uniform luminous intensity of one candela in all directions is termed the *lumen.* Since a sphere subtends 4π steradians at its centre (area of surface of sphere $= 4\pi r^2$), a light source of 1 candle-power radiating uniformly in all directions emits a total of 4π lumens, approximately 12·5. This conver-

sion is only approximately applicable to practical light sources as these do not radiate uniformly in all directions.

The lumen provides a useful measure when considering the output of a source in a reflector or other housing or when considering the amount of light passing through an optical system.

Constancy of output

Constancy of light output and quality are necessary characteristics of any light source to be used in photography and are essential for colour work. Daylight, although an intense and cheap form of lighting, is not constant. Both its intensity and quality vary with the season, time of day and weather. Artificial light sources are much more reliable than daylight, although much effort then goes into arranging lighting set-ups to simulate the desirable directional qualities of sunlight and diffuse daylight.

Electric light sources are more reliable than daylight but even these sources need a constant power supply in order to give constant light output. If the frequency and/or voltage of the mains supply fluctuates, appreciable variation in light intensity and quality may result (see Figure 3.8). For colour work especially, some form of voltage control is desirable to maintain constancy of colour temperature. As bulbs age they may darken, reducing both light output and colour temperature. The advent of incandescent sources employing the tungsten-halogen cycle circumvents these problems (see page 45). Fluorescent lamps have a long life but a gradual decline in light output. Other discharge sources require careful design of ballast and control circuitry to reduce short-term fluctuations in output and colour temperature.

One of the advantages in the use of flashbulbs and electronic flash is the constancy of light output and quality that can be obtained. Flashbulbs in particular have a constant output dependent only on manufacturing tolerances. Electronic flash may also give a constant output provided that adequate recharging time is allowed between successive flashes. The neon ready-light indicators fitted to many units glow when about 80 per cent of the charging voltage is reached which indicates only some two-thirds of full charge. A further time must be allowed to elapse before discharge to ensure full capacity is available, see page 53.

Efficiency

The efficiency of a light source for photographic use is given by consideration of a number of factors which determine its usefulness or economy in particular circumstances. Such factors include control circuitry utilising design techniques to give a low power consumption, e.g. for ballasts, and particular choice of reflector to concentrate light output into a specified region. Electronic flash units are excellent examples of effective reflector design, with very little wasted output.

Light Sources

The photographic effectiveness of a light source relative to a reference source is termed its *actinity* and takes into account the spectral energy distribution of the source and the spectral response of the sensitised material. Obviously it is inefficient to use a source poor in ultra-violet radiation with material whose sensitisation is predominantly in the blue and ultra-violet regions of the spectrum.

A commonly expressed measure of the efficiency of a light source is its *efficacy.* This is the ratio of luminous flux emitted to the power consumed by the source and is expressed in lumens per watt. A theoretically perfect lamp emitting white light of daylight quality would have an efficacy of about 220 lumens per watt. Values obtained in practice for some common light sources are given in Table 3.2. The term "half-watt", now virtually obsolete, was applied to general service lamps presumed to have an efficacy of 1 candle-power per half-watt, corresponding roughly to 25 lumens per watt. This value was rather optimistic.

Illumination

The design of reflector and housing of a light source are important for uniformity and distribution of illumination over the area of coverage of the lamp.

The term *illumination* refers to light falling on a surface and is defined as the ratio of luminous flux falling on a surface to its area. The unit of illumination is the *lux*, an illumination of one lumen per square metre. The relationship between the various photometric units of luminous intensity, luminous flux and illumination is shown in Figure 3.4.

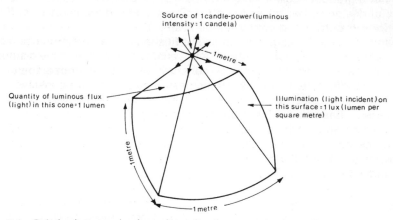

Source of 1 candle-power (luminous intensity : 1 candela)

1 metre

Quantity of luminous flux (light) in this cone = 1 lumen

Illumination (light incident) on this surface = 1 lux (lumen per square metre)

1 metre

1 metre

Fig. 3.4 – Relation between luminous intensity of a source, luminous flux and illumination on a surface

The illumination I on a surface at a distance S from a point light source depends on the output of the source and inversely on the square of the distance S. This relationship between illumination and distance from the source is referred to as *the inverse square law* and is illustrated in Figure 3.5.

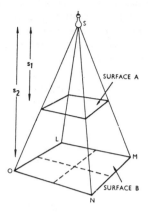

Fig. 3.5 – Demonstration of the inverse square law

Light emitted into the cone to illuminate base area A at distance S_1 with illumination I_1 is dispersed over area B at distance S_2 to give illumination I_2. It is readily shown by geometry that if S_2 is twice S_1 then B is four times A, i.e. illumination is inversely proportional to the square of the distance S.

Expressed mathematically,

$$\frac{I_1}{I_2} = \frac{S_2{}^2}{S_1{}^2}$$

Also, from the definition of the lumen, we can find the illumination in lux (lumens per square metre) produced by a lamp at any distance from it, by dividing the candle-power of the lamp by the square of the distance in metres. Thus, the illumination on a surface 5 metres from a source of 100 candle-power is $100/5^2 = 4$ lux. Recommended values of illumination for different areas range from 100 lux for a domestic lounge to 400 lux for a general office.

The inverse square law applies strictly to point sources only. It is *approximately* true for any source small in proportion to its distance from the subject. The law is generally applicable to lamps used in shallow reflectors, but not when deep reflectors are used. It is not applicable to the illumination provided by spotlight.

Most light sources are used with reflectors, which may be an integral part of the lamp or a separate item. A reflector has a considerable influence on the properties of the lighting unit as regards distribution of illumination, i.e. evenness, and colour of the light.

Reflectors differ widely in size, shape and nature of surface. Some are flat or very shallow, others deeply curved in spherical or paraboloid form. The surface finishes of reflectors vary from highly polished to a smooth matt appearance. Some intermediate arrangement is usually favoured to give a mixture of direct and diffuse illumination.

Light Sources

The effect of the reflector is given in terms of the *reflector factor* which is the ratio of illumination on the subject by a light source in a reflector to that provided by the bare source. A flashgun reflector, depending on design, may have a reflector factor from 2 to 6 approximately.

In many instances flashguns are used with a large reflector of umbrella-like design and construction. A variety of diameters and surface finishes are available, serving to convert the flashgun from a small source giving hard shadows on the subject when used direct, to a large, diffuse source offering softer lighting when used as the sole illuminant, albeit with considerable loss of efficiency.

By way of contrast, the *spotlight* provides a high level of illumination over a relatively small area, and normally gives shadows with hard edges. The illumination at the edges of the illuminated area falls off quite rapidly.

The use of diffusers and "snoots" serves to give softer shadows and well-defined edges respectively. A spotlight consists of a small incandescent light source whose filament is at the centre of curvature of a concave mirror, together with a condenser lens, usually of *Fresnel* construction to reduce weight and heating problems (see Figure 3.6). By altering the distance of the lamp from the condenser the size of the "spot" of light given may be varied at will. For a near parallel beam, the lamp is positioned at the focus of the condenser. With the advent of compact light sources, such as tungsten-halogen lamps, while it has been possible to reduce the physical size of spotlights and floodlights, the optical quality of reflectors and condensers used in such designs needs to be high to ensure even illumination. The housing, reflector and diffuser arrangements of a light fitting for photography are often referred to as a *luminaire.*

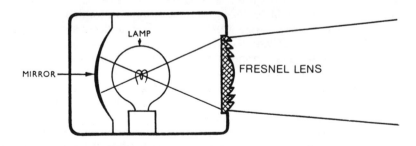

Fig. 3.6 – Principle of the spotlight.

As mentioned earlier, light sources do not radiate uniformly in all directions, due to the shape of the source plus the effects of any reflectors used. An effective way of showing light distribution is to plot the luminous intensity in each direction in a given plane through the source as a curve in polar co-ordinates, termed a *polar distribution curve* (see

Figure 3.7). In this figure the source is at the origin and the length of the radius from the centre to any point on the curve gives the luminous intensity, in candelas, in that particular direction.

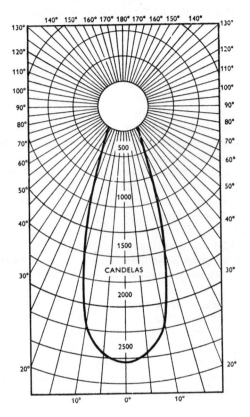

Fig. 3.7 – Polar distribution curve of a reflector spotlight lamp

Economy

The financial aspects of the use of artificial light sources may be divided into two sections – initial capital costs and costs of operation. The initial outlay may be modest, as for a bulb flashgun or portable electronic flash, or considerable, as for comprehensive studio lighting. Other costs may include rewiring or provision of voltage control.

The costs of operation also may vary considerably, from the recharging of an electronic flashgun battery to the power consumption of studio tungsten lighting. Realistic figures may be obtained by evaluating power consumption, necessary maintenance costs for equipment, and lamp life, determining the frequency of lamp replacement.

41

Ease of operation and maintenance

A most desirable attribute of any light source used for photography is its reliability, which covers both constancy of output and certainty of operation. Incandescent sources are often prone to failure when initially switched on, owing to power surges and the sudden physical changes in the filament. Various power control devices, dimmers and series-parallel switching arrangements serve to reduce such occurrences. Extensive switching operations should be avoided. Electronic flash units incorporating solid state circuitry may be very reliable in operation but offer little hope of performing a temporary repair upon failure.

Most light sources are easy to operate in terms of unambiguous control operations for switching on and light output. Safety aspects in view of the use of mains voltage and the high energy storage of capacitors in electronic flashguns should not be ignored however. Heat-resistant operating handles on incandescent lighting units are most desirable.

Modern lighting units of compact dimensions, light weight, ease of portability and incorporating devices such as automatic control of output in electronic flashguns certainly ease the task of operation but the disposition of the lighting arrangements on the subject is still a matter of skill on the part of the operator.

A certain amount of maintenance is necessary for every light source, varying with the particular unit. Operator maintenance may be as simple as ensuring that reflectors are cleaned regularly or that flashgun batteries are replaced or recharged as recommended. Sealed beam units require little attention.

The ability of a light source to operate on a variety of alternative power sources such as batteries, mains or generators may be a decisive factor in its choice. The need for an unusual supply, such as three-phase or very high current is occasionally encountered.

Other convenience factors are those that relate to the comfort of the operator and subject, such as the amount of heat generated by the lamp and the presence of fumes. Undoubtedly, electronic flash lighting is superior in these aspects.

Characteristics of some light sources used in photography

So far, the characteristics of light sources in general have been discussed. In the following pages, the characteristics of some specific sources used in photography — both daylight and artificial sources are described in detail.

Daylight

A great deal of photographic work is done out of doors in ordinary daylight. Daylight includes light from the sun, from the sky and from clouds. It has a continuous spectrum, although it is not exactly represented by any single colour temperature. However, in the visual

region – though not beyond it – colour temperature does give a close approximation to its quality. The quality of daylight varies through the day. Its colour temperature is low at dawn – in the region of 2000 K if the sun is unobscured. It then rises quickly to a maximum and remains fairly constant through the middle part of the day. It tails off slowly through the afternoon, and finally falls rapidly at sunset to a value which is again below that of a tungsten filament lamp. The quality of daylight also varies from place to place and according to whether the sun is shining in a clear sky or is obscured by cloud.

The reddening of daylight at sunrise and at sunset arises from the absorption and scattering of sunlight by the atmosphere (page 2). These are greatest when the sun is low, because the path of the light through the earth's atmosphere is then longest. As the degree of scattering is most marked with the shorter wavelengths, the light which continues to the earth unscattered contains a preponderance of the longer wavelengths and thus appears reddish.

Fluctuations such as have been described prohibit the use of ordinary daylight for the testing of photographic materials in the sensitometric laboratory. Here, it is essential to use light sources of fixed colour quality. For many photographic purposes, especially in sensitometry, the average quality of sunlight at noon at Washington, D.C., is used as the standard. ("Sunlight" in this connection means what it says; i.e. excludes skylight.) This is referred to as *mean noon sunlight* and approximates in quality to light at a colour temperature of 5400 K. Sunlight at Washington was chosen for the standard because the U.S. National Bureau of Standards had made an extensive series of measurements of its quality. "Mean" noon sunlight was obtained by averaging readings taken at the summer and winter solstices (June 21st and December 21st). Light of similar quality with colour temperature of 5500 K is sometimes referred to as "photographic daylight". It is achieved in the laboratory by operating a tungsten lamp under controlled conditions so that it emits light of a given colour temperature, and screening this by a Davis-Gibson liquid filter. Sunlight distribution is of importance in photographic sensitometry, not because it may approximately represent a standard white, but because it represents, perhaps better than any other single energy distribution, the average condition under which the great majority of photographic camera materials are exposed.

The combination of light from sun, sky and clouds usually has, near noon, a colour temperature in the region of 6500 K. An overcast (cloudy) sky has a slightly higher colour temperature, while that of a blue sky may rise to as high as 12 000 to 18 000 K. The colour temperature of the light from the sky and the clouds is of interest independently of that of sunlight, because it is skylight alone which illuminates shadows.

Tungsten filament lamps

A common type of artificial light source is the incandescent lamp, in which light is produced from a filament heated by passing an electric

Light Sources

current through it. The filament is of tungsten, with a melting point 3650 K. By filling the bulb with a mixture of argon and nitrogen gases the operating temperature may be as high as 3400 K. Earlier lamp designs used carbon or tungsten filaments in a vacuum, giving 2080 K and 2400 K respectively and rapid darkening of the bulb with age. Normally, an increase in operating temperature gives increased efficacy but a decrease in life. Photoflood lamps are deliberately overrun to give very high efficacy coupled with a very short life.

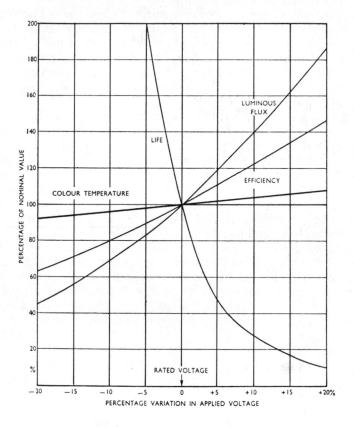

Fig. 3.8 – Variation in the characteristics of a tungsten lamp with applied voltage

A tungsten filament lamp is designed to operate at a specific voltage and its performance is affected by deviation from this condition, either by supply fluctuations or by the use of an incorrect lamp for the supply voltage in use. Figure 3.8 shows how lamp characteristics are affected by a departure from normal voltage. It can be seen that a 1 per cent excess voltage causes a 4 per cent increase in luminous flux, a 2 per cent increase in efficiency, a 12 per cent decrease in life and a 10 K increase in colour temperature (for a nominal value in the range 3200 to 3400 K).

44

Tungsten lamps are supplied with a number of different types of cap. These are described by recognised abbreviations, e.g. BC (bayonet cap), ES (Edison screw) and SCC (small centre contact). Certain types of lamp are designed to operate in one position only, or in a limited range of positions. Reference to manufacturers' catalogues will furnish details as to burning position as well as cap types and wattages available.

Many types of tungsten lamp are made but those used for photographic purposes are of several main types, as follows:

(1) *General service lamps.* These are of the type used for normal domestic purposes and are available in a range of sizes from 15 W to 1500 W and may be supplied with clear, pearl or opal glass envelopes. The colour temperatures of the larger lamps range from about 2760 to 2960 K with a life of about 1000 hours.

(2) *Photographic lamps.* A series of lamps are specially made for photographic purposes, normally for use in reflector spotlights, floodlights and luminaires. The colour temperature is controlled at 3200 K which is obtained at the expense of a life of only about 100 hours. Current versions are designated CP by lamp manufacturers and are rated at 500 W. These are being superseded by the more efficient, smaller, tungsten halogen lamps with greater outputs and longer life.

(3) *Photoflood lamps.* These lamps were developed in an endeavour to obtain a large amount of highly actinic light from household circuits. The lamps operate at 3400 K and have an efficacy of about 2½ times that of general service lamps of the same wattage. Two ratings are available. The smaller No. 1 type is rated at 275 W with a life of 2 to 3 hours. The larger No. 2 type is rated at 500 W with a life of 6 to 10 hours. (Photoflood lamps are also available with internal silvering in a shaped bulb, and thus do not need to be used with an external reflector.)

(4) *Projector lamps.* A bewildering variety of designs of projector lamp have been made, with wide variation in cap design, filament shape and size. They may also include proximity reflectors and lenses in the bulb. Operation is at mains voltage or reduced values by step-down transformer. Wattages from 50 to 1000 are available. Colour temperature is in the region of 3200 K and lamp life is given as 25, 50 or 100 hours. Once again the compact size of the tungsten halogen lamp has great advantages in such applications and operation at low voltages such as 12 or 24 V allows use of a particularly robust filament. Many colour enlargers use projector lamps of either variety as their light source.

Tungsten halogen lamps

The tungsten halogen lamp is a special form of tungsten lamp in which a trace of a halogen is added to the filling gas. During operation a regenerative cycle is set up whereby evaporated tungsten combines with the halogen in the cooler region of the bulb wall and when returned by

convection currents to the much hotter filament region, the compound decomposes, returning tungsten to the filament and freeing the halogen for further reaction. There are various consequences of this cycle. Evaporated tungsten is prevented from depositing on the bulb wall to blacken it with age and thereby reduce output and colour temperature. Filament life is slightly lengthened owing to the returned tungsten but eventually the filament breaks because deposition is uneven. The complex tungsten-halogen cycle functions only when the temperature of the bulb wall exceeds 250°C, achieved by using a bulb of small diameter heated by the proximity of the filament. Normal glass cannot be used, only boro-silicate glass or quartz. The increased mechanical strength of such a construction permits the gas filling to be used at several atmospheres pressure. This pressure inhibits the evaporation of tungsten from the filament and is the major factor in the significantly increased life of such lamps compared with conventional tungsten lamps of equivalent rating. The small size of tungsten halogen lamps has resulted in lighter, more efficient luminaires and lighting units as well as improved performance from protection optics.

In the early lamps of this type, the halogen used was iodine and the lamps were commonly termed "quartz-iodine". Developments in lamp technology now permit materials other than quartz to be used while other halogens and their derivatives have advantages in certain circumstances.

Tungsten halogen lamps are available as small bulbs and in tubular form, supplied in a range of sizes from 50 to 5000 W with colour temperatures ranging from 2700 K to 3400 K. Special designs can replace conventional 500 W photographic tungsten lamps in spotlights and other luminaires with the added advantage of an average life of some 200 hours constant colour temperature and output. Replacement costs are higher, however.

Carbon arc lamps

Carbon arc lamps are still sometimes employed where light sources of very high intensity are required, e.g. in the photomechanical trades for copyboard illumination and in cinematography for projection purposes. They are rapidly being replaced by modern compact sources such as pulsed xenon lamps and metal halide lamps which offer many advantages.

The light from an arc lamp is produced by an electrical discharge between two carbon rods connected to a DC supply. To "strike" the arc, the rods are brought into contact and then rapidly drawn apart, a flame then maintaining itself between the two electrodes which need constant adjustment as they burn away. So-called *low-intensity arcs* using plain carbons emit most of their light from the crater of the positive electrode at a colour temperature of about 3800 K. By enclosing the arc in a glass container a long flame can be maintained with a colour temperature of some 10 000 K.

The *high intensity arc* uses carbons cored with metallic salts to control spectral energy distribution and give a colour temperature of about 6000 K. A current density twice that of the low intensity arc is used, but the light intensity is some six times greater.

The *white-flame arc* or *open arc* also uses cored carbons and gives a colour temperature of about 5000 K. All carbon arcs are especially rich sources of ultra-violet radiation and are still in use for this purpose.

Mercury vapour discharge lamps

A discharge lamp consists essentially of a tube containing two electrodes between which an electric discharge passes. If liquid mercury is used, it vaporises when the lamp is operated and light is emitted from the glowing vapour. The spectrum emitted is discontinuous, a severe disadvantage for most photographic applications, with strong lines in the green, blue and ultra-violet regions. High pressure mercury vapour lamps have broader spectral lines and a low intensity continuum. Other attempts to supply the missing red region of the spectrum include mixing with tungsten filament lamps and incorporation of other metals or phosphorescent coatings in the discharge tube (see below).

The prime advantages of mercury vapour lamps are high efficiency, low current consumption and low heat emission. They were once used in enlargers and some types of printing equipment. One practical problem was that they could not be switched on and off at will.

Fluorescent lamps

A fluorescent lamp consists of a low-pressure mercury vapour lamp with an envelope coated internally with a fluorescent powder or *phosphor.* Fluorescent substances have the property of converting short-wave radiation into radiation of longer wavelength. The phosphors used in lamps absorb ultra-violet radiation and emit visible light, the colour of which depends on the phosphor used. Hence a light quality is attainable much more suited for photographic purposes than ordinary low-pressure mercury vapour lamps.

Fluorescent lamps emit a line spectrum with a strong continuous background so that their quality of light can be approximately expressed in terms of colour temperature – a *correlated colour temperature.* A measure of *colour rendering* may also be given. There are many names for fluorescent lamps such as "daylight", "warm-white", and "natural", but there is little agreement between manufacturers as to the properties of a named variety. It is possible to classify lamps into two groups, either *high efficiency* or *de-luxe.* The former group have approximately twice the light output of the latter, but are deficient in red. They include "daylight" lamps of approximately 4000 K and "warm-white" lamps of approximately 3000 K, an approximation to tungsten lighting. The de-luxe group give good colour rendering by use of rare earth phosphors and include colour matching lamps of 6500 K and 5000 K as well as those

producing light of a colour approximating to 4000 K and 3000 K.

Colour photography with such lamps or if they are unavoidably present as "mixed lighting" generally gives rise to unpleasant green or blue colour casts, necessitating corrective filtration using colour-compensating filters over the camera lens.

The lamps are supplied in the form of tubes of various lengths for use in a variety of domestic and industrial fittings. Domestic lamps operate at mains voltage and use a hot cathode, heated to start the discharge. Cold cathode versions use an emissive cathode at much higher voltages which gives instant-start characteristics. Such lamps in the form of a grid or spiral are widely used for large format enlargers. Such light sources are unsuitable for colour printing purposes (see page 487). Lamp life is in the order of 7 to 8000 hours and they are insensitive to small voltage fluctuations.

Sodium vapour discharge lamps

Low-pressure sodium vapour discharge lamps emit an intense yellow line spectrum, 95 per cent of the energy of which is emitted at a wavelength of 589 nm. The remainder is in the form of weak lines and a weak continuum which must be removed by a yellow filter absorbing wavelengths less than 550 nm when such a source is used to provide safelighting for a black-and-white printing darkroom. Such lamps are very efficient but are being replaced by fluorescent lamps with suitable filter coatings. Lamp life is 10–16 000 hours.

High-pressure sodium vapour discharge lamps use a small sintered alumina envelope and give rather better colour rendering as some red light is emitted, but at a loss in efficiency. Both varieties of lamp are used for street lighting and the illumination of large spaces.

Metal halide lamps

Until quite recently, mercury and sodium were the only metals used in discharge lamps in the form of vapour as the vapour pressures of other metals are too low to give enough working pressure. However, most halides of metals have higher vapour pressures than the pure metals and in particular by using the halides of rare earths in a discharge tube, within the arc they separate into metals and halogens. The hot metal vapours emit light with a multi-line spectrum and strong continuum, virtually a continuous spectrum.

The metals and halides recombine in cooler parts of the envelope. Compounds used include mixtures of the iodines of sodium, thallium and gallium and halides of dysprosium, thulium and holmium in minute amounts.

The discharge lamp is a very small ellipsoidal quartz envelope with tungsten electrodes and molybdenum seals. Oxidation of these seals limits lamp life to about 200 hours but by enclosing the tube in an outer casing and reflector with inert gas filling, life is increased to 1000 hours.

The small size of this lamp has given rise to the term "compact source iodide lamp". Light output is very high with an efficacy of 85–100 lumens per watt. A short warm-up time is needed. When operated on an AC supply the light output fluctuates at twice the supply frequency. Whereas the resulting variation in intensity is about 7 per cent for conventional tungsten lamps it is some 60 to 80 per cent for the metal halide lamps. This can cause problems in respect of exposure duration. Ratings up to 5000 watts are available. Carbon arc lamps are rapidly being replaced by this compact design.

Pulsed xenon lamps

Pulsed xenon lamps are a continuously operating form of electronic flash lamp (see page 53). By suitable circuit design a quartz tube filled with xenon gas at low pressure discharges or flashes at twice the mains frequency, i.e. 100 Hz, so that although pulsed the light output appears continuous. The spectral emission is virtually continuous with a colour temperature of approximately 5600 K and significant amounts of ultra-violet and infra-red radiation. Forced cooling may be needed.

The physical dimensions of such lamps are small and they are another excellent replacement for carbon arc lamps, especially for photo-mechanical applications and film projection. Power ratings up to 8000 watts are available and lamp life is 300–1000 hours depending on type.

Flashbulbs

Most flashbulbs contain shredded foil or fine metal wire in an at-mosphere of oxygen at low pressure, enclosed in a glass envelope with a lacquer coating to prevent shattering when fired. The foil used in the smaller bulbs is of zirconium while the wire used in the larger bulbs is of an aluminium-magnesium alloy. On ignition by the passage of electrical current a bright flash of light is emitted, of a duration ranging from about 0·01 to 0·02 s, the larger bulbs emitting the longer flash. The spectrum of a flashbulb is continuous, with a colour temperature of about 3800 K. Most types of flashbulb are supplied coated with a transparent blue lacquer which has a mired shift value suitable to convert the colour temperature to 5500 K. Originally intended for use with daylight type colour films, they are equally suitable for use with black-and-white materials. In fact, clear flashbulbs are available only in the larger sizes. In the case of flashcubes, four small clear flashbulbs, each with its own reflector, have an outer enclosure of transparent blue plastic which acts as a colour conversion filter.

Flashbulbs, which are available in a range of sizes and types, are in most cases designed to be operated from dry batteries with a voltage range from about 3 to 30 volts. While a circuit which connects a 3 V or 4·5 V battery directly across the bulb will fire the bulb, for greater reliability a battery-capacitor circuit is used. In the preferred form of cir-cuit (see Figure 3.9), a battery is used to charge – through a high

resistance — a capacitor from which the bulb is subsequently fired. A small 15 V or 22·5 V battery is commonly employed in such a circuit, although on their own they cannot be used to fire the flashbulb because of their high internal resistance. In the circuit shown the capacitor is charged only when a bulb is inserted in the socket so that battery life is conserved if the flashgun is stored without a bulb in place. The resistor is of sufficiently high value to ensure that the capacitor charging current is insufficient to fire the flashbulb, but low enough to give a short charging time. A test lamp is used to check on the state of charge.

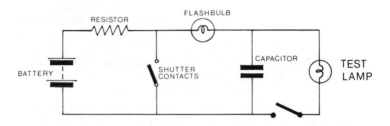

Fig. 3.9 — Preferred battery-capacitor circuit for firing flashbulbs

Such a circuit may also be used to fire several flashbulbs simultaneously in a multiple flash set-up. The limitations to this arrangement are the resistances of the connecting wires, which may be quite lengthy. A preferred arrangement is to use "slave" units connected to the extension heads. One flashbulb is triggered from the camera shutter contacts and the light emitted operates the photocell switches of the slave units. Response is very rapid and no connecting wires are needed. When using a cluster of flashbulbs in a large reflector, by having their envelopes in contact only one bulb need be triggered by a firing circuit, the others fire in sympathy.

Alternative methods of firing flashbulbs are used for flashcubes and other arrays of bulbs in units intended primarily for simple cameras where the user may forget to replace batteries occasionally. The Magicube type uses mechanical firing of a special bulb constructed with a tube containing primer. Each individual bulb also has its own external torsion spring which is released by pressing the shutter release to strike the primer tube and ignite the primer. The characteristics of this arrangement include a very short time to peak, about 7 ms compared with 12 ms for class MF bulbs.

Another system uses a piezo-electric crystal in the camera body to produce the electrical firing pulse when struck by a striker mechanism coupled to the camera release button. Bulbs in an array are fired sequentially by current-steering thermal switches which close circuit paths to the next bulb. Both of these arrangements require cameras with the firing arrangements included in their construction.

Flashbulb characteristics

The performance of a flashbulb is best illustrated by a curve in which the luminous flux emitted by the bulb is plotted against time, as in

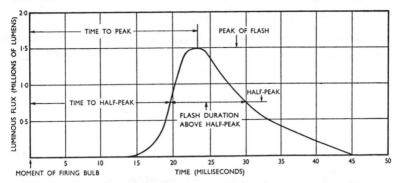

Fig. 3.10 – Flashbulb light output curve

Figure 3.10. The following information can be gained from such a curve:

(1) *Effective flash duration.* This indicates the motion-stopping power of the bulb when the whole flash is used. For most purposes it may be measured from the time when the rising intensity of the bulb reaches a value equal to half its peak value to the time when the intensity falls to "half-peak" again (i.e. "flash duration above half-peak").

(2) *Time to half-peak.* The shutter blades must be fully open at half-peak if use is to be made of the whole flash.

(3) *Time to peak.* The shutter blades must be fully open just before the peak of the flash for synchronisation at high shutter speeds.

(4) *Total light output.* This indicates the power of the bulb as a light source. It is expressed in lumen seconds, or beam candle-power seconds, and is represented on the graph by the total area below the light output curve.

(5) *Maximum luminous flux.* When very fast shutter speeds are employed – using only the peak of the flash – the total light output is not the best guide to the power of a bulb. A more useful figure is the maximum luminous flux, i.e. the luminous flux at the peak of the flash. This is expressed in lumens or beam candle-power.

Calculation of the necessary exposure when using flash illumination is from the "guide numbers" supplied by the manufacturer of the bulb. A guide number G is the product of the f-number N of the camera lens aperture in use and the subject distance d in metres, i.e. $G = Nd$. Guide numbers are quoted for a range of film speeds and shutter speeds. They are of course subject to modification to suit the particular conditions of use, being influenced by the surroundings of the subject and their reflecting properties.

Guide numbers are calculated from a formula as follows:

$$G = \sqrt{0 \cdot 004\ LtRS}$$

51

Light Sources

Where L is the light flux in lumens, t the exposure time in seconds, R is the reflector factor and S is the ASA film speed.

A modification is necessary to this formula for units with built-in reflectors, such as flashcubes, when it becomes

$$G = \sqrt{0 \cdot 05\ EtS}$$

where E is the "effective beam candle-power" of the bulb. This quantity is measured by an integrating light meter across the entire angle of coverage of the reflector and is not therefore influenced by hot spots. It replaces the earlier measure of "beam candle-power" which was measured at the centre of the beam only and thereby could be misleading due to effects from reflectors.

Bulb types

The properties of the several classes of flashbulb are given in Table 3.4 and typical light output curves are shown in Figure 3.11.

The problems of flash synchronisation are discussed on page 163.

CLASS	Time to peak. (ms)	Effective flash duration. (ms)	Notes.
Magicube	7	13	Mechanical ignition. Special camera design.
MF medium-fast	10 − 16	12	Includes Flashcubes.
M medium	15 − 25	15	Clear bulbs available.
S slow	27 − 33	20	Clear bulbs available.
FP focal plane	9 − 21	25	Slow burning bulb with constant light output for use with focal plane shutters whose travel time is 10 to 30 ms.
FP+ focal plane	6 − 14	25	

Table 3.4 − Types of flashbulbs

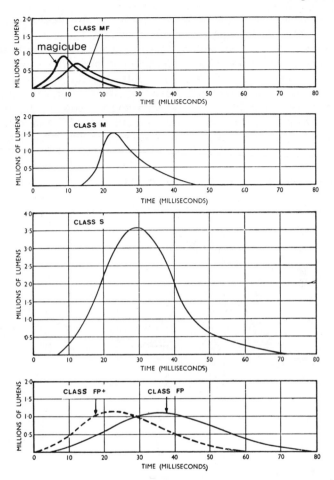

Fig. 3.11 — Typical flash bulb characteristics

Electronic flash

In an electronic flashtube, an electrical discharge takes place in a rare gas — usually xenon, krypton or argon, or a mixture of these gases — with the accompaniment of an intense flash of light. Unlike the contents of expendable flashbulbs, the active components are not consumed by this operation and the tube may be flashed repeatedly, with a life expectancy of many thousands of flashes.

The essentials of an electronic flash circuit are shown in Figure 3.12. A capacitor *C1* is charged from a high voltage DC supply of the order of 350 to 500 V, through a current limiting resistor *R*. This resistor allows a high-power output from a low-current-rated supply with suitably long charging times — in the order of several seconds — and also by limiting

53

the charge current the flashtube can de-ionise and extinguish after the discharge. At the charging voltage the gas pressure and internal resistance of the flash prevent the flow of current from the capacitor, but by applying a triggering voltage — typically a short pulse of about 5 to 15 KV — by means of an external electrode, the gas is ionised and becomes conducting, allowing the capacitor to discharge rapidly through it, giving a brief flash of light. The triggering voltage is obtained from a spark coil arrangement using a triggering capacitor C2 and transformer T and is actuated by a switch — the shutter contacts in the camera. The voltage on C2 is limited to less than 150 V and 500 μA by positioning on the low-voltage side of the spark coil, as this voltage appears on the contacts, so preventing possible accidental injury to the user and damage to the shutter contacts. The trigger electrode is in the form of fine wire around the flashtube or a transparent conductive coating.

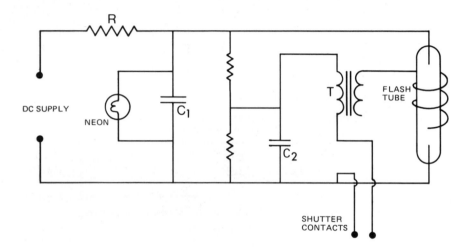

Fig. 3.12 — Essentials of the electrical circuit of an electronic flashgun

Power output may be altered by switching in or out additional capacitors. A low-power setting usually reduces the light output to one quarter of its normal value. Extension heads may be used for multiple flash arrangements and each head may have its own capacitor. If the extension head shares the main capacitor output the connecting lead must be substantial to reduce resistance losses. For greatest efficiency the connection between capacitor and flashtube must be as short and of as low resistance as possible. One-piece studio flash units are good examples of this type. The use of slave units facilitate multiple flash unit operation.

There are various alternatives for the power supply to charge up the capacitor of portable units. The simplest is a high-voltage dry battery but it is heavy and expensive. The preferred alternative is low-voltage

batteries giving 6 to 9 V and suitable circuitry to convert this into high voltage. Usually this consists of a transistorised oscillator to convert DC into AC – accompanied by a characteristic whining noise – the voltage increased by a step-up transformer then rectified into DC once more. Additional circuitry allows for operation directly from the mains supply, which is used for most studio flash units as the sole supply.

The batteries used may be single-use types of the zinc-carbon or alkaline-manganese variety, preferably the latter for improved performance. Alternatively rechargeable nickel-cadmium or lead-acid cells may be used. Additional circuitry is needed for the recharging cycle. A visual state-of-charge indicator in the form of floating balls is possible with lead-acid cells as the specific gravity of the acid varies with discharge. No such indication is possible with nickel-cadmium cells which may hold only enough charge for about 40 exposures, i.e. for a 36-exposure film, in the absence of energy-saving circuitry (see below). Such cells, however, are completely sealed and need no maintenance, unlike the lead-acid varieties.

The energy input J per flash, which is not necessarily always available as output, is given by the formula

$$J = \frac{CV^2}{2}$$

where J is in joules or watt-seconds
C is the capacitance in microfarads
and V is the voltage in kilovolts.

Hand-held units for on-camera use are rated at 20–200 joules. Large studio flash units are available with ratings from 200 to 5000 joules or more.

The state of charge of the capacitor, i.e. readiness for discharge is usually given by a neon light which is usually set to strike at about 80 per cent of maximum voltage, i.e. at about two-thirds full charge. Several seconds must be allowed to elapse after this to ensure full charge. If the tube is not then discharged, various forms of monitoring circuitry may be used to switch on and off the unit to maintain full charge without wasting the power supply.

The characteristics of an electronic flash discharge are shown in Figure 3.13. The *effective flash duration* is generally measured between one-third peak power points and the area under the curve between these points represents approximately 90 per cent of the light emitted, measured in lumen-seconds or effective beam-candle-power-seconds. The flash duration t, as defined above, in a unit whose total tube and circuit resistance is R with a capacitor of capacitance C is given approximately by

$$t = \frac{RC}{2}$$

Consequently for the 1 ms duration most common in flash units, the requirements are for high capacitance, low voltage and a tube of high in-

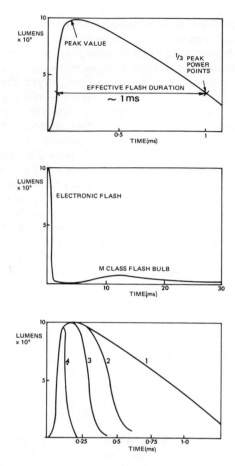

Fig. 3.13 – Some characteristics of electronic flash

ternal resistance. The flash duration is normally in the range 2 ms to 0·02 ms to effect a compromise between motion-stopping ability and avoidance of possible high-intensity reciprocity law failure effects. Units having a variable output either by normal switching in or out of additional capacitors or by automatic operation from the monitoring of scene luminance, have an accompanying alteration in flash duration (see below). For example a studio flash unit on full power may have a flash duration of 2 ms, changing to 1 ms and 0·5 ms when half and quarter power respectively are selected. Some special flash units for scientific applications may have outputs whose duration is of the order of 1 microsecond but with only 1 watt-second or so of energy.

The efficacy E of a flashtube is defined slightly differently from other sources as being

$$E = \frac{Lt}{J}$$

where L is the peak lumen output during effective flash duration t and J is the energy in watt-seconds (Joules).

Subsequently from the above characteristics the guide number G of a flash unit with reflector factor R used with a film of ASA speed rating S is given by

$$G = \sqrt{0 \cdot 005 \ RSJE}$$

The usual practical restrictions apply to such values. The reflectors used with electronic flashguns are highly efficient and direct the emitted light into a well-defined rectangular area with sharp cut-off, approximating to the coverage of a semi-wide-angle lens on a camera.

The use of bounce flash severely reduces the light available on the subject and often needs corrective filtration with colour materials owing to the nature and colour of the reflecting surface. The main attribute of such techniques is to produce soft, even lighting. An umbrella-type reflector of paraboloid shape, made of white or metallic surfaced plastic, is a widely used item. Studio units so equipped have a "modelling lamp" positioned within the usual helix shaped discharge tube used for this purpose. The modelling lamp may be a photoflood and have its output variable with the flash output selected so as to facilitate visual judgement of lighting effects. The calculation of exposure, i.e. necessary lens aperture setting, may be from guide number tables, practical experience, exposure meter readings using modelling light illumination or by means of an integrating flash exposure meter. Often a sheet of Polaroid Land film is exposed for better evaluation of exposure and lighting.

The spectral energy distribution of the flash discharge is basically line, characteristic of xenon, superimposed on a very strong continuous background. The light emitted has a correlated colour temperature of about 6000 K. The characteristic bluish cast given by electronic flash with colour reversal materials may be corrected by a light-balancing filter with positive mired shift value or by a pale yellow compensating filter. Often the flashtube or reflector is tinted yellow as a means of compensation. The flashtube may be of glass or quartz, the former giving a cut-off at 300 nm, the latter at 180 nm. Both give an output up to 1500 nm in the infra-red region. Consequently, an electronic flashgun can be a useful source of ultra-violet and infra-red radiation as well as visible light.

A recent development in flashgun design has been the automation of exposure determination and consequent power saving advantages. This has been possible by advances in electro-optics and use of solid state switching devices called "thyristors".

A fast-acting photosensor such as a phototransistor or a silicon photodiode can monitor the scene luminance when illuminated by the flash discharge and integrate the resultant signal until it reaches a preset level. The discharge can then be abruptly cut off when enough light has fallen on the subject. The switch-off level is determined by the film speed and lens aperture in use. The integrating circuit is a capacitor charging up to a given voltage level, the time taken being a function of the intensity and duration of light reaching the photocell. The discharge is stopped by

Light Sources

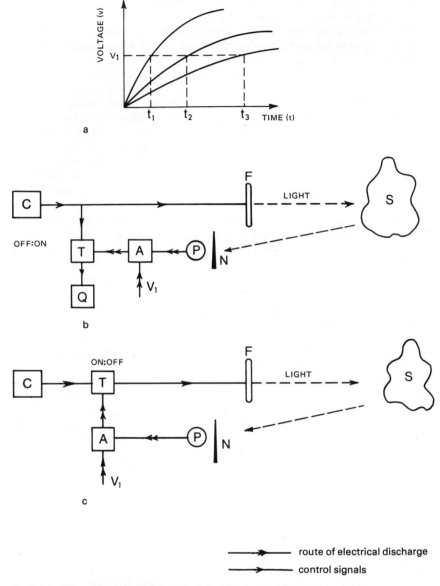

Fig. 3.14 – The operation of automatic electronic flash units.
(a) Charging characteristics of the integrating capacitor shown as voltage against time. Voltage V_1 is the preset triggering level.
(b) Arrangement of the quench tube and thyristor switch.
(c) Preferred-power saving arrangement.
Key: C main capacitor, F flash tube, S subject, P photocell, T thyristor switch, Q quench tube, N neutral density wedge, A integrating amplifier preset to give a pulse to the thyristor at voltage V_1 of the charging curve of the timing capacitor as shown in (a).
t_1, t_2, t_3 are various flash durations determined by the operating conditions.

diverting, by means of a thyristor switch, the discharging capacitor into a "quench" tube, which is a low-resistance flashtube connected in parallel with the main tube. The quench circuit is activated only when the main tube has ignited so as to prevent effects from other flashguns in use. There is no light output from the quench tube and there is a loss of energy. The effective flash duration, dependent on subject distance, reflectance and film speed, may be as short as 0·02 ms, with concomitant motion-stopping ability.

A preferred switching arrangement which saves the residual charge in the discharging capacitor, thereby reducing recharging time per flash and increasing the number of flashes available from a set of batteries or charged accumulator, is to position the thyristor switch between the main capacitor and flashtube. The characteristic of the thyristor is that it may be closed on command, i.e. when the flash is initiated, and then opened almost instantaneously on receiving a pulse from the light monitoring circuit to terminate the flow of current sustaining the flash. Obviously a high current handling capacity is needed of suitable thyristors. An added advantage is that full discharge is possible on manual mode operation simply by taking the photocell out of circuit or covering it over mechanically so the "open" pulse is never given. To allow for the use of different film speeds and lens apertures the photocell may be biased electrically or mechanically. The former method would cause alterations in the firing voltage of the timing capacitor so the latter method is preferred and is also much easier, requiring only a mask or neutral density filter over the photocell. The two types of circuit arrangement are shown in Figure 3.14.

The mounting of the photocell in a small shoe-mounted housing attached to the flash unit by a flying lead allows monitoring of scene luminance irrespective of flash head position.

Synchronisation of electronic flash is via the usual connections to the camera shutter or by "hot-shoe" arrangements whereby connection is made automatically on insertion of the flash unit into the camera accessory shoe. Problems of flash synchronisation are dealt with in Chapter 9.

4 The Geometry of Image Formation

IN PREVIOUS chapters we have considered the nature of light and the characteristics of light sources. In this chapter we shall consider the way in which light forms images.

Interaction of light with matter

When light falls on matter, the incident energy and the material react so that reflection, absorption and transmission may take place. The first two always occur to some extent and often all three occur together. No single effect happens alone.

Absorption

When light is absorbed it disappears as light and reappears in some other form, usually as heat, but other effects, including photochemical and photoelectric effects, may also occur.

Reflection

Depending on the nature of the surface, the reflection of light may be *direct* or *diffuse.* Direct reflection, often called specular reflection, takes place without scatter, as in a mirror, and the physical laws of reflection are obeyed (see Figure 4.1). Diffuse reflection refers to reflection such that light incident upon a surface is reflected from every part of the surface in many directions (see Figure 4.2). The spatial distribution of reflected flux may be such that the luminance is the same in all directions, or shows one or more maxima, termed *uniform* and *preferential diffuse reflection* respectively. Reflection from many subjects combines both direct and diffuse reflection, and is termed *mixed reflection*. Depending on the properties of the incident light, the nature of the material and angle of incidence, the reflected light may be partially or completely polarised (see page 216).

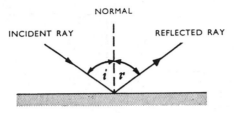

Fig. 4.1 – Light ray reflected by a plane mirror

Fig. 4.2 – Light ray reflected by a matt surface

Objects in the world around us are seen by diffusely reflected light which permits us to perceive detail and texture, qualities which are absent from a highly-reflecting surface, such as a mirror.

Transmission

Some materials allow incident light to pass completely through them, apart from that lost by absorption. Such light is said to be *transmitted*. *Direct transmission* refers to light transmitted without scatter, as, for example, by clear glass. Otherwise, if scattering occurs, light undergoes *diffuse transmission*, which may be uniform or preferential. As in the case of reflection, *mixed transmission* may occur.

Refraction

When a ray of light travelling in (i.e. being transmitted by) one medium passes into another having different optical properties its direction is changed (except in the special case where it enters normally). The ray is bent, termed *refraction*, resulting from a change in the speed of light in passing from one medium into the other. Lenses utilise the refraction of glass to form *images*.

When light passes from a less dense medium of refractive index n_1, into a denser medium of refractive index n_2, the ray is bent toward the normal (see Figure 4.3). The amount of bending is given by Snell's Law, which is $n_1 \sin i = n_2 \sin r$ where i and r are the angles of incidence and refraction respectively. The refractive index of air, n_1, is taken as unity and so the

The Geometry of Image Formation

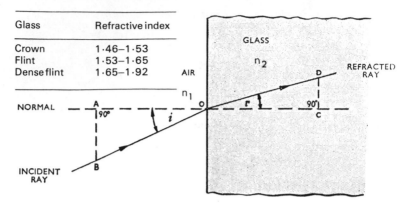

Glass	Refractive index
Crown	1·46–1·53
Flint	1·53–1·65
Dense flint	1·65–1·92

Fig. 4.3 – Light ray passing obliquely from air to glass

refractive power of the other medium, or refractive index is given by

$$n_2 = \frac{\sin i}{\sin r}$$

Refractive index varies from one type of glass to another and it also varies with wavelength, being greater for blue light than for red light, because the speed change of light on entering another medium also varies with wavelength. Thus, any quoted value of refractive index applies only to monochromatic light.

When light is transmitted by clear optical glass solids or prisms, refraction gives rise to other important effects such as deviation, dispersion and total internal reflection.

Deviation refers to the angular change of direction of the emergent ray with respect to the direction of the incident ray. In the case of a parallel sided glass block, the ray is not deviated, but it is *displaced* by its passage (see Figure 4.4a). The displacement d depends on the angle of incidence, the thickness of the block and its refractive index.

In the case of a prism, whose sides are not parallel, the ray is deviated from its original path by two refractions (see Figure 4.4b). The deviation D depends on the refracting angle A of the prism and its refractive index n.

Dispersion. When *white light* passes through a prism it is not only deviated, it is also dispersed (see Figure 4.4c) to form a spectrum by being split up into its component parts. The dispersive power of the prism is not directly related to its refractive index so it is possible to neutralise dispersion by using two types of glass together while retaining a considerable degree of deviation. In the case of lenses (see page 108) this allows rays of different colours to be brought to a common focus.

Total internal reflection. In certain circumstances, light passing through a glass block may suffer *total internal reflection* when the angle of incidence i at the glass-air interface is greater than a certain value, termed the *critical angle C*, which depends on the refractive index of the

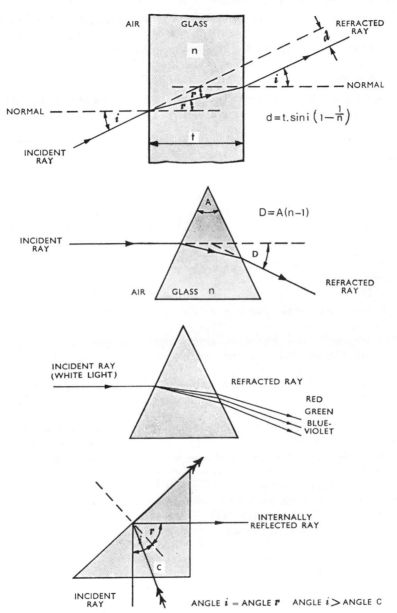

AIR GLASS

n

REFRACTED RAY

d

i — NORMAL

NORMAL

i

r

r

$$d = t.\sin i \left(1 - \frac{1}{n}\right)$$

INCIDENT RAY

t

A

$$D = A(n-1)$$

INCIDENT RAY

D

REFRACTED RAY

AIR GLASS n

INCIDENT RAY (WHITE LIGHT)

REFRACTED RAY

RED
GREEN
BLUE-VIOLET

INTERNALLY REFLECTED RAY

r

c

INCIDENT RAY

ANGLE i = ANGLE r ANGLE $i >$ ANGLE C

Fig. 4.4 – Various consequences of refraction of light by glass prisms.
(a) Light ray passing obliquely through a parallel-sided glass block and resultant displacement.
(b) Refraction of light caused by its passage through a prism and resultant deviation.
(c) Dispersion of white light by a prism.
(d) Total internal reflection in a right-angled prism

glass (see Figure 4.4d). A typical value for C is 42°. A 45° prism can deviate a narrow angular beam through 90° by this means, but for a wider beam the reflecting surface must be silvered.

Image formation

The representation of an object as given after passage of light through an optical system is termed an *image*. An optical system may be exceeding-

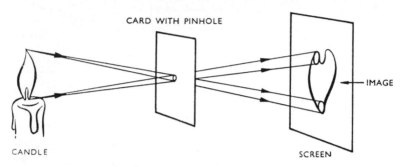

Fig. 4.5 — Formation of an image by a pinhole

ly simple, such as a plane mirror, or highly complex, such as a well-corrected camera lens. Another simple method of image formation, in neither category, is a *pinhole* in an opaque screen. This is illustrated in Figure 4.5 and shows two important properties of such an image. First it is *real*, because it can be caught on a screen as rays from the object actually pass through it. Secondly, as light travels in straight lines, the image must be *inverted* and also *laterally reversed* as viewed from behind the screen. The ground glass screen image of a technical camera is another example of such an image when used with a pinhole or a positive lens.

Many of the properties of images will be considered in detail in this and subsequent chapters. By a knowledge of the geometry of the optical system, the refracting properties of the lens and the distance of the object it is possible to calculate by means of simple formulae and a suitable sign convention most of the properties of the images formed by lenses of small aperture by rays at small angles of incidence. This is an application of geometrical optics in *paraxial* conditions, i.e. relating to rays passing along or close to the optical axis. The position and size of the image may be found, also whether it is real or virtual, erect or inverted and correct or laterally reversed. Simple graphical constructions are also of great assistance.

The same techniques may also be extended to the paraxial imagery given by a compound lens provided the positions of the cardinal points of such a lens are known (see page 68).

A pinhole is limited as a producer of real images, although there is an optimum diameter K for the pinhole in relation to the distance v from

pinhole to screen, for which the image will be sharpest, given by the formula

$$K = \frac{\sqrt{v}}{25}.$$

A larger hole gives a brighter, less sharp image. A smaller hole gives a less bright, less sharp image due to diffraction, see page 116. While a pinhole does not suffer from lens aberrations, its poor resolution and slow speed limit its use to certain applications. Normally, a lens is used in ordinary cameras to form an image.

The simple lens

A *lens* in its general sense is a system of one or more pieces of glass usually bounded by spherical surfaces, all of whose centres are on a common axis – termed the *optical axis*. A *simple lens* consists of a single piece of glass whose axial thickness is small compared with its diameter, whereas a *compound lens* consists of several *components* some of which may comprise several *elements* cemented together. The need for such complexity is discussed in Chapter 6.

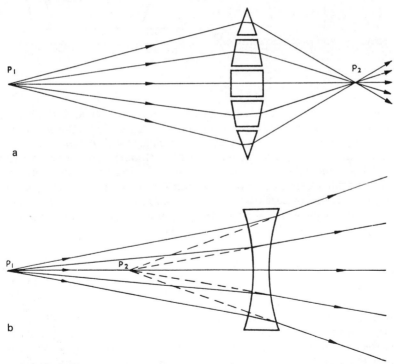

Fig. 4.6 – Negative and positive lenses

a – A simple positive lens considered as a series of prisms

b – Formation of a virtual image of a point object by a negative lens

The Geometry of Image Formation

A simple lens may be considered to be formed from a number of prisms, as shown in cross-section in Figure 4.6a. Light diverging from a point source P_1 and reaching the front surface of the *positive lens* is redirected by suitable refraction to form a real image at point P_2. These rays are said to come to a *focus*.

Alternatively, by using a *negative lens* (Figure 4.6b), the incident rays may be diverged even more by the refractive action of the lens and appear to originate from a virtual focus at point P_3.

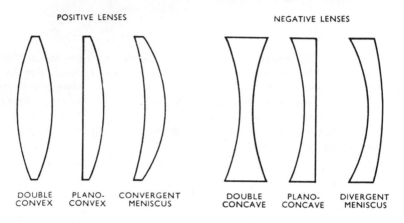

POSITIVE LENSES

NEGATIVE LENSES

| DOUBLE CONVEX | PLANO-CONVEX | CONVERGENT MENISCUS | DOUBLE CONCAVE | PLANO-CONCAVE | DIVERGENT MENISCUS |

Fig. 4.7 – Types of simple lens

The lens front surface may be convex, concave or plane to the incident light. The rear surface may also be curved or plane. Six different types of simple lens are shown in cross section in Figure 4.7. A *meniscus lens* is one in which the centres of curvature of both surfaces are on the same side of the lens. Simple positive meniscus lenses are used as *close-up lenses* for many cameras. While the same power in dioptres is possible with a wide range of curvatures, the *shape factor* of the lens is important in determining its effect on the image given by the prime lens on the camera.

Image formation by a positive lens

Camera lenses, irrespective of their details of construction, are essentially similar to simple positive lenses in their image-forming properties. In particular, they always form a real image. So far, only the formation of images from point objects has been considered. It is of more use to consider the way in which the images of extended objects are formed by a lens. If the object is near, formation of the image by a simple positive lens is shown by considering the refraction of light diverging to the lens from points at opposite ends of the object (Figure 4.8a). The image is found to be inverted, behind the lens and real.

66

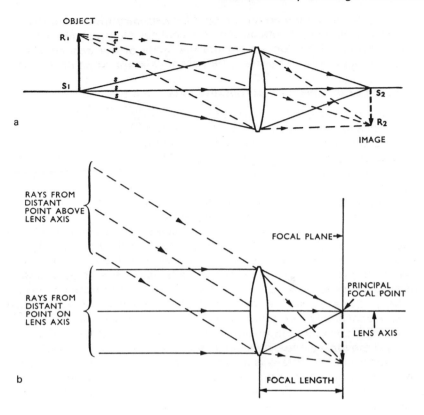

Fig. 4.8 – Image formation by a simple positive lens

a – Image of a near object

b – Image of a distant object

Similarly, for a distant object or one at infinity, all the rays from object points reaching the lens are now effectively parallel and not divergent. The image is formed closer to the lens, behind the lens and inverted as before. The plane in which the image of a distant object is formed is termed the *focal plane.* For a flat distant object and a perfect lens, every point of the image lies in the focal plane. The point of intersection of the focal plane with the optical axis is termed the *principal focus* or *focus* of the lens, and the distance from this point to the lens is termed the *focal length* of the lens (see Figure 4.8b).

Only for an object at infinity does the image distance from the lens, termed *v*, correspond to the focal length, termed *f*. As the object approaches the lens, i.e. object distance *u* decreases, the value of *v* increases (for a positive lens). If the lens is turned round, a second focal point is obtained, but the focal length is the same whichever way the

The Geometry of Image Formation

lens faces. With compound lenses or *thick lenses* the focal lengths are measured to different points on the lens configuration (see below).

The distance of the focus from the rear surface of a lens, measured along the optical axis – is termed the *back focal distance* or *back focus*.

Formation of images by a compound lens

In thin lenses, the axial thickness of the lens is usually small in relation to the object and image distances and to the focal length. Measurement and calculation can be made without need for due regard as to the exact points in or on the lens to which we should measure these distances. With a compound lens whose thickness is a significant fraction of its focal length, the values would differ with the points chosen, whether the front or back of the lens or some point in between.

Fortunately, it was shown by Gauss that thick lenses did not have to be considered element by element in calculations. The lens could be treated as a whole and thin lens formulae used provided that object and image distances are measured from two theoretical planes, fixed with reference to the lens. This treatment of lenses is referred to as *Gaussian optics* and holds for paraxial conditions only. Gaussian optics defines six *cardinal* or *Gauss points* for any lens or system of lenses. These are: two *principal focal points*, two *principal points* and two *nodal points*. The corresponding planes through these points perpendicular to the optical axis are called the *focal planes, principal planes*, and *nodal planes* respectively. The focal length of a lens is defined in Gaussian optics as the distance from the principal point to the corresponding principal focal point. Thus a lens has two focal lengths, an object focal length and an image focal length, as shown in Figure 4.9.

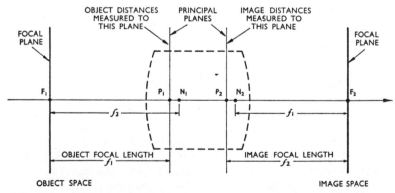

Fig. 4.9 – The cardinal points of a lens

Definitions and properties of the cardinal points of a lens are as follows:

Object principal focal point (F_1). The point whose image is on the axis at infinity in the image space.

Image principal focal point (F_2). The point occupied by the image of an object on the axis at infinity in the object space.

Object principal point (P_1). The point distant the object focal length from F_1. All object distances are measured from this point.

Image principal point (P_2). The point distant the image focal length from F_2. All image distances are measured from this point.

The principal planes through these points are important for we may assume, as shown by Gauss, that the bending of light by the lens takes place here. An additional important property is that they are planes of unit magnification for conjugate rays.

Object nodal point (N_1), *image nodal point* (N_2). These are a pair of points such that rays reaching the lens in the direction of the object nodal point, leave the lens going parallel to their original direction as if they came from the image nodal point. The ray passing through the nodal points of a thick lens is undeviated but displaced.

A lens may be rotated about a vertical axis through its rear nodal point, and the image of a distant object will remain stationary. This property is used to locate the nodal points.

If the refractive index is the same for the object and image spaces of a lens, then the object and image focal lengths are equal, termed the *equivalent focal length*, and also the positions of the principal points and nodal points coincide. This is of great help in calculations and graphical construction. The distance between the nodal points is called the *nodal space.* The great value of Gaussian optics is that provided the cardinal points are known and the object position is given, the image position and magnification may be calculated with no other knowledge of the optical system. Knowledge of the cardinal points and planes can also be used for graphical construction of images.

In some lens designs the nodal points can be "crossed" or both can lie in front of, or behind, the lens as well as within the lens.

Graphical construction of images

The action of a lens is frequently more easily understood if the paths of some of the image-forming rays are traced. For a positive lens a few simple rules can be given, based on definitions of lens properties.

(1) A ray passing through the centre of the lens is undeviated.

(2) A ray travelling parallel to the optical axis, after refraction, passes through the far focal point of the lens.

(3) A ray passing through the near focal point of the lens, after refraction, emerges from the lens parallel to the axis.

These rules are illustrated in Figure 4.10 together with their modification to deal with image formation by negative lenses, concave spherical mirrors and convex spherical mirrors. Also shown is an example of image formation for each optical system using the techniques listed.

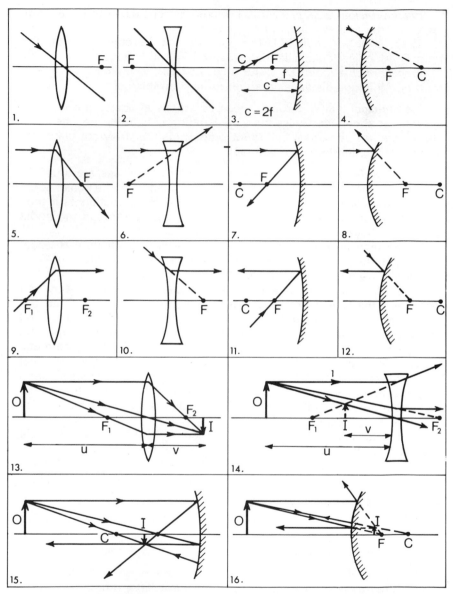

Fig. 4.10 – The graphical construction of images formed by simple lenses and spherical mirrors.

1. A ray passing through the centre of the lens is undeviated.
2. A ray passing through the centre of the lens is undeviated.
3. A ray passing through the centre of curvature is directed back upon itself.
4. A ray directed towards the centre of curvature is directed back upon itself.
5. A ray travelling parallel to the optical axis, after refraction, passes through the far focal point of the lens.

The Geometry of Image Formation

Relation between object distance, image distance and focal length

Using the rules of graphical construction of images by a positive lens we can draw the image of an object at a distance u from a lens of focal length f (see Figure 4.11).

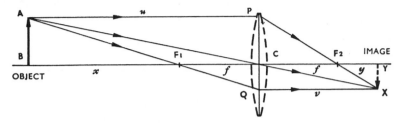

Fig. 4.11 – Derivation of the lens equation

By geometry we can derive a relationship between the image distance from the lens v, u and f, termed the *lens equation*.
From similar triangles ABC and XYC,

$$\frac{AB}{XY} = \frac{BC}{YC} = \frac{u}{v} \tag{1}$$

From the figure

$$BF_1 = u - f \tag{2}$$

Also, from similar triangles ABF and QCF

$$\frac{BF_1}{CF_1} = \frac{AB}{QC} = \frac{AB}{XY} \tag{3}$$

6. A ray travelling parallel to the optical axis, after refraction, appears as if it had originated at the near focal point of the lens.
7. A ray travelling parallel to the optical axis, after reflection, passes through the focus of the mirror.
8. A ray travelling parallel to the optical axis, after reflection, appears as if it had originated from the focus of the lens.
9. A ray passing through the near focal point of the lens, after refraction, emerges from the lens parallel to the optical axis.
10. A ray travelling towards the far focal point, after refraction, emerges from the lens parallel to the optical axis.
11. A ray passing through the focus of the mirror, after reflection, travels parallel to the optical axis.
12. A ray directed towards the focus of the mirror, after reflection, travels parallel to the optical axis.
13. An example of image construction for a positive lens using the three rules illustrated above.
14. An example of image construction for a negative lens using the three rules illustrated above.
15. An example of image construction for a concave mirror using the three rules illustrated above.
16. An example of image construction for a convex mirror using the three rules illustrated above.

The Geometry of Image Formation

Following that by substituting equations 1 and 2 in 3 we obtain:

$$\frac{u-f}{f}=\frac{u}{v}$$

rearranging and dividing by *uf* we have:

$$\frac{1}{u}+\frac{1}{v}=\frac{1}{f} \tag{4}$$

This equation may be applied to thick lenses if *u* and *v* are measured from the appropriate cardinal points.

It is found to be ill suited for practical use as it does not make use of object size *AB* or image size *XY*, one or both of which is usually known.

Defining *magnification* or *ratio of reproduction (m)* as

$$\frac{XY}{AB}=\frac{v}{u}$$

and substituting into the lens equation and solving for *u* and *v* we obtain

$$u=f\left(1+\frac{1}{m}\right) \tag{5}$$

and

$$v=f(1+m) \tag{6}$$

Because of the definite or conjugate relationship between *u* and *v* as given by the lens equation above, they are often called the *object conjugate distance* and *image conjugate distance* respectively. These terms are usually abbreviated to *"conjugates"*.

A summary of useful lens formulae is given in Figure 4.12 including formulae for calculating the combined focal length of two thin lenses in contact or separated by a small distance.

Image size

It is useful to note that when conjugate *u* is very large, as for a distant subject, the corresponding value of conjugate *v* may be taken as *f*, the focal length. Consequently, the image size or magnification *m* is given by

$$m=\frac{f}{u} \tag{7}$$

Thus, ratio of reproduction depends on the focal length of the camera lens and the distance of the object. From a fixed viewpoint, to maintain a constant image size as subject distance varies, a lens with variable focal length is required, i.e. a *zoom* lens (see page 133).

Focal length and angle of view

The focal length of a lens also determines the *angle of view* of the lens as used in conjunction with a given format size. The angle of view of a lens is defined as the angle subtended at the lens by the diagonal of the film

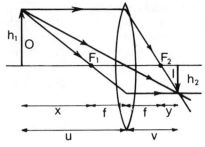

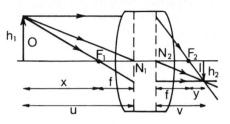

<div style="text-align: center">Simple lens Compound lens</div>

1. $\dfrac{1}{u} + \dfrac{1}{v} = \dfrac{1}{f}$ $\left.\begin{array}{c} \\ \\ \end{array}\right\}$ $u = f\left(1 + \dfrac{1}{m}\right)$

2. $\dfrac{h_2}{h_1} = \dfrac{I}{O} = \dfrac{u}{v} = m$ $v = f(1 + m)$

3. For $u = \infty$, or for $u >> V$, $v = f$ so that $m = \dfrac{f}{u}$

4. $xy = f^2$

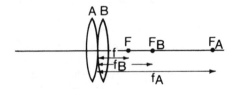

<div style="text-align: center">Thin lenses in contact Thin lenses separated by a small distance</div>

$\dfrac{1}{f} = \dfrac{1}{f_A} + \dfrac{1}{f_B}$ or, $\dfrac{1}{f} = \dfrac{1}{f_A} + \dfrac{1}{f_B} - \dfrac{f_A f_B}{d}$

$\dfrac{1}{f} = P = P_A + P_B$

P is the 'power'

Fig. 4. 12 – Some useful lens formulae.

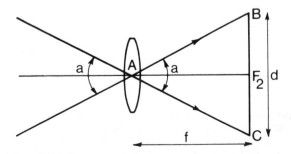

Fig. 4.13 – Angle of View

73

format when the lens is focused on infinity, as shown in Figure 4.13. The angle of view for a particular combination of lens focal length and size of negative may be calculated from Table 4.1. To use this table the diagonal of the negative should be divided by the focal length of the lens, when the angle of view can be read against the quotient obtained.

Diagonal / focal length	Angle of view	Diagonal / focal length	Angle of view
0·35	20°	1·27	65°
0·44	25°	1·40	70°
0·54	30°	1·53	75°
0·63	35°	1·68	80°
0·73	40°	1·83	85°
0·83	45°	2·00	90°
0·93	50°	2·38	100°
1·04	55°	2·86	110°
1·15	60°	3·46	120°

Table 4.1 – Table for deriving angle of view

As the subject approaches closer, the lens is extended to focus on the subject and the angle of view decreases. At unit magnification, for example, the angle of view has half the value obtained when the lens is focused on infinity. One form of classification of lenses is by angle of view. A "standard" lens is one whose focal length is the same as the negative diagonal, giving a value of approximately 52°. Wide-angle lenses may have values up to and in excess of 120°, and long focus lenses have values down to and less than 1°. Table 4.2 gives typical values for some different format sizes in common use.

Negative size	Diagonal of negative	Normal lens Focal length	Angle of view	Wide-angle lens Focal length	Angle of view	Long-focus lens Focal length	Angle of view
mm	mm	mm		mm		mm	
24 × 36	43	50	48°	28	75°	85	28°
				35	66°	135	19°
						200	12°
60 × 60	85	80	56°	50	81°	120	39°
						250	20°
						500	10°
102 × 127	165	150	58°	100	79°	250	36°
						300	30°

Table 4.2 – Typical values of focal length and angle of view for normal-focus, wide-angle and long-focus lenses for three widely used film sizes

Occasionally confusion may arise as to the angle of view of a lens as quoted, because a convention exists in many textbooks on optics to

quote the semi-angle of view, in which cases values given must be doubled.

Covering power of a lens

Every lens projects a circular field of light, the illumination of which falls off toward the edges — at first gradually and then very rapidly. The limit to this *circle of illumination* is set by the rapid fall-off due to vignetting (see page 92).

Also, owing to the presence of residual lens aberrations, the definition of the image deteriorates outward from the centre of the field — at first gradually and then more rapidly. By defining an acceptable standard of image quality, it is possible to locate an outer boundary defining a *circle of good definition* within this circle of illumination. The extent of this field of good definition, which determines the practical performance of a lens as regards *covering power*, is usually expressed as an angle of view which may be the same as or greater than that given by the negative format in use (see Figure 4.14). Extra covering power is essential for a lens fitted to a technical camera when lens displacement movements, such as rising front, are to be used. Covering power is increased by stopping down a lens because vignetting is reduced and residual lens aberrations are decreased by this action.

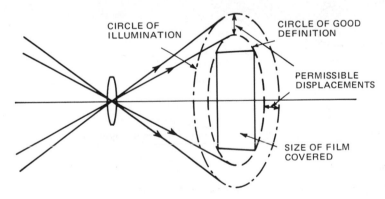

Fig. 4.14 – The covering power of a lens

Geometric distortion

A wide-angle lens, i.e. one whose angle of view is typically about 75°, is invaluable in many instances, such as work under cramped conditions and when use of the steep perspective associated with such lenses is required. The large angle of view and the use of a flat focal surface makes distortion of objects near the edge of the field of view noticeable. The geometry of image formation by such a lens that causes this distortion is shown in Figure 4.15. This form of geometrical distortion must not

be confused with the curvilinear distortion caused by lens aberrations or apparent perspective distortions arising from incorrect viewing conditions.

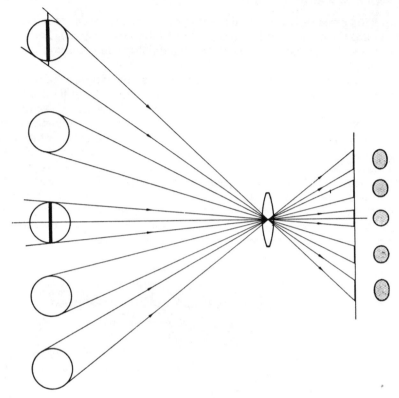

Fig. 4.15 – Distortion of objects at edges of wide-angle photograph

Lens definition

Any scene can be considered as made up of a large number of points. A perfect lens would form a point image of each one of these by refracting and converging the cone of light from the subject point to a focus. By *focusing* the camera, i.e. adjusting the lens to film distance v, the film surface is located at this focus and the conjugate distances thereby satisfy the lens equation (page 72). The image plane, i.e. film surface, is correct for all object points in a conjugate plane but not for an object plane at a different distance. Then, refocusing is required. For an axial point in both planes, each point can be focused in turn, but both cannot be rendered sharp simultaneously. When the image of one is in focus, the other is represented by a disc or *circle of confusion*, and vice versa (Figure 4.16). These circles are cross sections of the cone of light coming to a focus behind or in front the surface of the film.

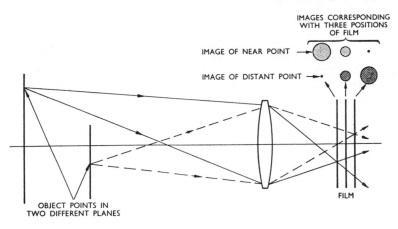

Fig. 4.16 – Object and image points

From this geometric approach it would seem that when photographing an object with depth, only one plane can be in sharp focus. All other planes, whether nearer or further from the camera are out-of-focus. Yet, we know that in practice we do obtain pictures of objects with considerable depth that appear sharp all over. It would seem that the eye is satisfied with something less than pin-point sharpness. The reason is the *resolving power* of the eye.

Resolving power of the eye

By using a test target such as two parallel black lines of equal width separated by a white space of the same width, and viewing from various distances, a point is reached where the two lines cannot be distinguished. This is the limit of resolution of the eye. Eyes vary in their resolving power and the test conditions, especially target contrast and illumination, strongly influence performance. For an average eye, the limit of resolution is reached when the distance of the target is 2500 times the separation of the centres of the two lines. For low-contrast subjects, as is commonly encountered in practice, a more realistic value of 1 part in 1000 is preferred. This corresponds to an angle of about 3 minutes of arc. At the least distance of distinct vision (about 250 mm), this angle corresponds to a circle 0·25 mm in diameter (see Figure 4.17), so that in a print the eye cannot distinguish between a true image point and a circle of confusion of this diameter. Consequently if every image point is equal to or less than this circle of confusion the print will appear sharp all over. The property of the eye of accepting a disc for a point means that in terms of the geometry of image formation a certain latitude is given as regards the plane in which the film is located, i.e. *depth of focus*, and the plane in which the object is located, i.e. *depth of field*, without sacrificing the degree of sharpness of the picture.

77

The Geometry of Image Formation

Circle of confusion

In calculations of depth of field and depth of focus it is necessary, first of all, to decide on a numerical value for the largest diameter of the circle of confusion (*c*) permissible in the circumstances. Such values are usually quoted for the negative but they must be derived from conditions of the degree of enlargement of the print and the viewing distance.

Fig. 4.17 – Circle of confusion

Considerations of perspective suggest that the "correct" viewing distance (*D*) of the final print is the product of focal length of camera lens (*f*) and degree of enlargement (*e*), i.e. $D = fe$ (see page 85). The circle of confusion taken as $D/1000$ gives values of $fe/1000$ for the print and $f/1000$ for the negative respectively.

The print may be viewed under "comfortable" and not "correct" viewing conditions, and unless the two viewing distances coincide the value of $f/1000$ for the circle of confusion is incorrect.

In recent years the validity of the formula $c = f/1000$ has been questioned and some lens manufacturers have adopted different criteria, which accounts for the variation in published data or camera scales for depth of field given by lenses of the same focal length. Instead of the value being dependent upon focal length, a fixed value for *c* of 0·05 mm or even 0·033 mm has been used for a complete range of lenses of various focal lengths. This more stringent criterion gives reduced values for depth of field in general.

The basic assumption is also for imaging by a perfect lens but a lens with residual spherical aberration may not perform as expected, owing to the shape and luminance distribution of its circle of confusion. Variation of effective aperture and astigmatic surfaces towards the edge of the field of view influence results in these regions.

Depth of focus

Depth of focus is the distance through which the film may be moved before the image of a flat object becomes noticeably unsharp. A mathematical expression for depth of focus (*t*) can be obtained from a consideration of Figure 4.18, where *c* is the diameter of the circle of confusion.

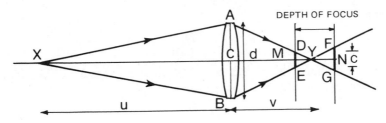

Fig. 4.18 – Derivation of formula for depth of focus

From similar triangles *DEY* and *ABY*,

$$\frac{MY}{CY} = \frac{DE}{AB}$$

Whence:

$$MY = \frac{DE \times CY}{AB} = \frac{cv}{d}$$

Then

$$t = 2MY = \frac{2cv}{d}$$

Since *f/d* equals *N*, the *f*-number of the lens, this equation can be rewritten

$$t = \frac{2cNv}{f}$$

But

$$\frac{v}{f} = (1 + m)$$

$$\therefore t = 2cN(1 + m) \qquad (8)$$

In general, except for extreme close-ups, *m* is small compared with 1 and can be neglected, so equation 8 simplifies to

$$t = 2cN \qquad (9)$$

This is the basic equation for depth of focus and shows that it is directly proportional to the diameter of the circle of confusion and the *f*-number of the lens. So that, the larger the *f*-number, the greater is the depth of focus. Also, with some qualification, this implies that depth of focus increases with focal length as $N = f/d$.

Substituting into equation 9 first a value of *f*/1000 for *c* and then *f/d* for *N* we obtain:

$$t = \frac{2fN}{1000}$$

79

The Geometry of Image Formation

and then

$$t = \frac{2f^2}{1000\,d} \qquad (10)$$

It may be shown (page 82) that $1000d$ is a measure of the hyper-focal distance h so that we can write:

$$t = \frac{2f^2}{h} \qquad (11)$$

Note that equations 9, 10 and 11 above, all assume that u is large. Equations 10 and 11 also assume correct viewing conditions. Only equation 9 is applicable to all viewing conditions.

Depth of focus limits set a tolerance on the necessary flatness and perpendicularity of the film plane. Such tolerances become increasingly smaller with small format cameras using lenses of large maximum apertures and short focal length.

Depth of field

Depth of field is the distance through which the subject may extend when the camera is focused as sharply as possible on one part of it, without the image becoming noticeably unsharp. Outside this *region of sharp focus*, definition falls off progressively. Unlike depth of focus, depth of field is not disposed equally about the plane of sharpest focus. For most subjects it is greater beyond the distance focused on than in front (see Figure 4.19). For many applications we are not concerned with the *total* depth of field but rather with the *limits* of the region of sharp focus as measured from the camera.

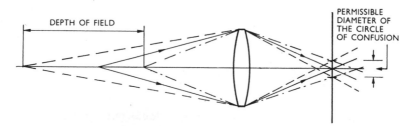

Fig. 4.19 – Depth of field

These distances may be calculated using a quantity called the *hyper-focal distance*, which is defined as the distance from the lens to the nearest object which is just acceptably sharp when the camera is focused on infinity. A formula for h can be derived from consideration of Figure 4.20 which shows a lens focused on infinity. For an object point X

at the hyperfocal distance, a point image Y is given and a circle of confusion diameter DE at the focus F.

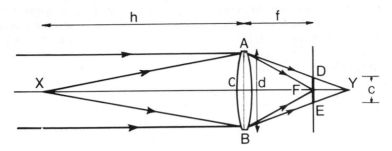

Fig. 4.20 – Derivation of formula for hyperfocal distance

The lens equation

$$\frac{1}{u} + \frac{1}{v} = \frac{1}{f}$$

may be rearranged to give

$$u = \frac{vf}{v - f}$$

For conjugate points X and Y this gives

$$h = \frac{CY.f}{FY}$$

Now, since triangles ABY and DEY are similar,

$$\frac{CY}{FY} = \frac{d}{c}$$

Therefore,

$$h = \frac{df}{c}$$

Since $f/d = N$, the f-number of the lens, this equation can be written

$$h = \frac{f^2}{cN} \qquad (12)$$

Equation 12 shows that hyperfocal distance varies with focal length and f-number of the lens as well as the permissible diameter of the circle of confusion in the negative. For any given lens, the hyperfocal distance must be worked out for each aperture.

Alternative formulae for h are given by taking $c = f/1000$ and $N = f/d$ giving

$$h = \frac{1000f}{N} \qquad (13)$$

and

$$h = 1000d \tag{14}$$

It follows from the definition of hyperfocal distance that the smaller the value of h, the greater the available depth of field, and vice versa.

It may be shown that, for a lens focused on a distance u, the distances from the lens to R and S, the nearest and farthest points in sharp focus, respectively, are given by

$$R = \frac{hu}{h + u} \tag{15}$$

and

$$S = \frac{hu}{h - u} \tag{16}$$

Depth of field, T, is given by $T = S - R$. The values given, while approximate, are adequate for near distances. It is useful to note that for $u = h$, the equations show that the far limit is infinity and the near limit is $h/2$ so that maximum depth of field is given.

This property is made use of in simple cameras with lenses of fixed focus and f-number when the lens is focused on the appropriate hyperfocal distance.

For near objects, the depth of field is small and extends by about the same amount on either side of the distance focused on. In such circumstances a formula for total depth is sometimes useful. This formula is as follows:

$$\text{Total depth} = \frac{2cN(m + 1)}{m^2} \tag{17}$$

The control of depth of field in practice may be exercised in the normal way by stopping down the lens, i.e. increasing the f-number N. If minimum aperture still gives inadequate depth, the lens may be changed for one of shorter focal length if it is important to preserve the perspective of the subject. If perspective may be altered, then the same lens may be used from a more distant viewpoint. In the case of a technical camera fitted with movements, the appropriate movements may be used to make better use of the depth available (see Chapter 10).

The mathematical treatments of depth of field and depth of focus have been on the basis of geometrical optics, assuming a perfect lens and that light travels in straight lines. It is also assumed that the film used is capable of resolving any image, however fine. In practice, some qualification is needed for each of the assumed conditions.

Residential lens aberrations and the fact that light travels in waves, results not in a point image of an object, but in an irregular distribution of luminance around and beyond the plane of best focus, see page 112. Determination of the circle of confusion is then difficult and it may be asymmetric either side of the focus. The distribution of depth about the plane of sharpest focus may vary with the f-number used. Curvature of field, too, may obviously affect depth of field.

Depth of field tables or indicators serve only as a guide and practical experience with a lens is the only guide to its true performance.

The resolving power of an emulsion has its limit (see page 533) and although it is usually lower than that of a highly-corrected lens, it is normally high enough to resolve the permissible circle of confusion. In some circumstances when this is not so, the permissible diameter of the circle of confusion is taken as half the number of lines per millimetre resolved by the film.

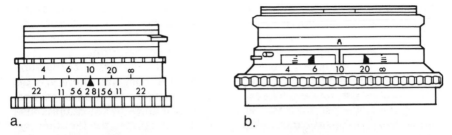

a. b.

Fig. 4.21 – Depth of field indicator scale (a) and coupled indicator (b)

For convenience in use, simplified forms of depth of field tables are fitted to camera lenses as additional scales and indicators linked to the focusing scale (see Figure 4.21). They are often based on a value of $f/1000$ for the circle of confusion.

Perspective

The apparent relation between the shape, size and position of visible objects is termed *perspective, linear perspective* or, sometimes, *drawing*. If two objects of the same size, standing one behind the other, are viewed by an observer, the sizes of the objects will appear to be in inverse ratio to their distances from the observer.

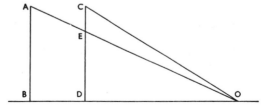

Fig. 4.22 – Dependence of perspective upon viewpoint

Referring to Figure 4.22, if *AB* and *CD* are two objects of equal size viewed by an observer at *O*, then the apparent height of *AB* in relation to *CD* will be *ED*. Since triangles *ABO* and *EDO* are similar:

$$\frac{ED}{AB} = \frac{DO}{BO}$$

Therefore:

$$\frac{ED}{CD} = \frac{DO}{BO}$$

i.e. the apparent heights of the two objects are in inverse ratio to their distances from the observer.

Let us suppose that the distance between the two objects is 10 metres, and that the nearest object is 20 metres from the observer. Then, the relative sizes of the two objects will be $20:30 \times 2:3$. That is, the more distant object will appear to be only two-thirds the size of the nearer object. If we move back until we are, say, 90 metres from the nearer object, the ratio will become $90:100 = 9:10$. That is, the more distant object will appear almost as large as the nearer one.

From these examples, it will be apparent that if the depth of the subject is large in relation to its distance from the observer, there will be considerable difference between the apparent sizes of foreground and background objects, but if the depth is small relative to the subject distance there will be little difference in size. This illustrates the fact that the perspective achieved when viewing a scene depends on the ratio that the depth of the subject bears to its distance from the observer. *The perspective obtained with a given scene therefore depends solely on the viewpoint – whether we are looking at the scene or photographing it.* If the scene be viewed from a short distance, there will be a great disparity between the apparent sizes of foreground and background objects. Foreground objects will have increased prominence and background objects reduced prominence. The perspective in this case is described as *steep.* If the scene be viewed from a great distance, the apparent difference in size between foreground and background objects will be small, and the perspective will be *flat.* Such perspective gives increased prominence to background objects, but the importance of objects in the foreground is not seriously diminished as might be expected. This is probably because the mind, knowing well the sizes of near objects, gives them their usual importance.

Perspective on taking a photograph

As we have already seen, the perspective obtained on *taking* a photograph – sometimes termed the *true perspective* – is governed solely by the viewpoint. If the viewpoint is fixed, there can be no change in perspective, even if we change to a lens of different focal length – although, as we have seen earlier, the image size will alter. If, however, the viewpoint is altered, so will be the perspective, and no change of lens will re-create the perspective obtained at the first viewpoint. *Altering the distance of the viewpoint from the object, without changing the lens, alters both perspective and image size. Altering the focal length of the lens, without changing the viewpoint, alters image size only – leaving perspective unaltered.*

We can, if we wish, by changing viewpoint *and* focal length, keep the

image size of a selected object constant and vary the perspective from flat to steep. This is illustrated again in Figure 4.23, where the size of the front of the house has been kept constant in all three views. We shall consider a little later the factors determining the *best* perspective for a given subject.

Perspective on viewing a photograph

The perspective obtained on viewing a print – sometimes termed the *apparent perspective* – depends, firstly, on the relative sizes of objects in the print – and hence on the perspective obtained in the negative on taking the photograph – and, secondly, on the distance at which the print is viewed.

FLAT PERSPECTIVE: HOUSE 1000 METRES AWAY–LONG-FOCUS LENS

NORMAL PERSPECTIVE : HOUSE 100 METRES AWAY– NORMAL-FOCUS LENS

STEEP PESPECTIVE: HOUSE 10 METRES AWAY–WIDE-ANGLE LENS

Fig. 4.23 – Perspective

Correct perspective is said to be obtained when a print is viewed in such a way that the apparent relation between objects as to their size, position etc., is the same as in the original scene. This is achieved when

the print is viewed at such a distance that it subtends at the eye the same angle as was subtended by the original scene at the lens. The eye will then be at the *centre of perspective* of the print, just as, at the moment of taking, the lens was at the centre of perspective of the scene.

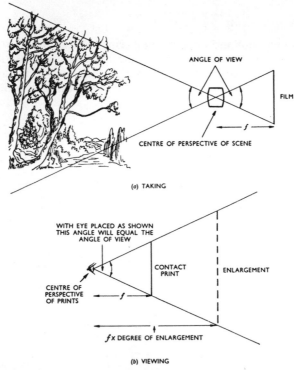

Fig. 4.24 – Perspective on taking and on viewing a photograph

It can be seen from Figure 4.24, that the angle subtended by the scene at the lens is identical with that subtended by the film at the lens, and this angle is governed by the diagonal of the film and the bellows extension, which – for all except close objects – may be taken as equal to the focal length. *For correct perspective, therefore, a contact print should be viewed at a distance equal to the focal length of the taking lens. An enlargement should be viewed at a distance equal to the focal length multiplied by the degree of enlargement.* (This is a simple sum in proportion.) If we view a print at a distance other than the correct one, the perspective achieved will be distorted.

If the perspective achieved on taking a photograph is steep, the perspective achieved on viewing the print "correctly" will also be steep, and vice versa. "Correctness" of perspective on viewing a print does not necessarily imply that the perspective achieved will be pleasing.

How important is perspective in a photograph?

We have considered the factors governing the perspective achieved on taking and on viewing a photograph. We need now to consider how important it is to achieve a particular kind of perspective at each of these two stages.

We have seen that, *on taking a photograph*, we have a choice of perspectives – ranging from flat to steep. Although *unusual* perspective, i.e. too flat or too steep, is normally to be avoided, perspective achieved by standing well back from the subject generally yields a better proportioned view than does steep perspective. In order to fill the frame with the image, while standing well back from the subject to achieve flattish perspective, we require a lens of relatively long focal length. Thus, we associate the use of a lens of long focal length with good "drawing". This must, however, not be pushed to extremes, for, if the focal length is too long, we obtain the excessive flattening of perspective which, when a telephoto lens is used, makes a cricket pitch look only a few metres long.

A long-focus lens is, however, by no means suitable for all types of photography. It gives a narrow angle of view, and, when working in cramped conditions, it is often essential to use a lens of very much shorter focal length – either a "normal" focus or a wide-angle lens – in order to include all the subject in the picture. In this case, the perspective will necessarily be steeper. Frequently, steep perspective cannot be avoided when photographing interiors of buildings, etc., but, provided that the prints are viewed under correct viewing conditions, steep perspective is not usually objectionable with such subjects. Since, however, steep perspective gives disproportionate importance to objects in the foreground, particular care should be taken in the choice and arrangement of objects in the front of the picture.

For most ordinary photography, we require a lens of focal length sufficiently long to give reasonably flat perspective, but not so long that it gives a very small angle of view. For general work, therefore, a compromise is struck at a lens of focal length approximately equal to the diagonal of the film. (We have arrived at this conclusion from considerations of perspective; on page 72 we arrived at the same conclusion from a consideration of angle of view. Obviously, perspective and angle of view are two aspects of the one story.)

On viewing a photograph, the impression of realism is generally enhanced if it is examined under "correct" viewing conditions, as defined on page 78. Correct viewing conditions are, however, by no means always essential, since with many subjects the eye will tolerate considerable distortion of perspective. For example, en-prints in the popular 90 × 90 mm size are invariably viewed at a distance much greater than the "correct" viewing distance; yet this causes no difficulty. Although the perspective is distorted, this is not noticed (see page 88). On the other hand, the perspective of photographs taken with a wide-angle lens and showing steep perspective, does usually appear distorted if these are examined at other than the correct viewing distance. Objects at the *edges* of wide-angle photographs may appear distorted even when the

photographs are viewed at the correct distance.

In general, it would appear that so long as the perspective on taking is average, i.e. neither very steep nor very flat, considerable departure from "correct" viewing can be tolerated. On the other hand, if the perspective on taking is very steep or very flat, the resulting photograph is likely to appear distorted unless viewed at the "correct" distance.

Here, we may note that the perspective of a print viewed from too great a distance tends to appear steep, while that of a print viewed from too short a distance tends to appear flat. This is the reverse of the perspective effects achieved on taking the picture.

Viewing prints in practice

In practice, an observer generally chooses the distance at which he views a print from considerations of personal comfort — i.e. to be such that the eye can comfortably scan the print — rather than with a view to obtaining correct perspective. It is, therefore, usually the *size* of the print and not the focal length of the camera lens — which is more often than not unknown to the viewer — which governs the viewing distance. (The case referred to above, of a photograph taken with a wide-angle lens, reinforces this contention. As was stated there, if a picture of this type is viewed at the "correct" viewing distance its perspective appears correct. Instead, in practice, we normally view it from a comfortable distance and complain that the perspective is distorted!)

Now, the nearest distance from which we can view a print and take it all in without turning the head, is the diagonal of the print. A viewing distance of about equal to or a little longer than the diagonal of the print is, therefore, normally adopted for comfortable viewing. A whole-plate print, with a diagonal of approximately 250 mm, will thus be viewed at a distance of about 250 mm and larger prints at correspondingly longer distances.

Comfortable viewing conditions and *correct* viewing conditions are achieved simultaneously if the diagonal of the print equals the focal length of the camera lens in the case of a contact print, or the focal length of the lens multiplied by the degree of enlargement in the case of an enlargement. *A close approximation to this is achieved in practice when printing from the whole of a negative taken with a lens of normal focal length* (assuming that the print is not smaller than a whole plate).

The nearest comfortable distance for viewing prints with the unaided eye is about 250 mm. This distance is considerably greater than the distance at which en-prints commonly require to be viewed for correct perspective, i.e. about 125 mm. For correct perspective, such prints must therefore be viewed with the aid of an eye-lens of 125 mm focal length, or they should be enlarged by a further two diameters and viewed at 250 mm. When they are viewed with the unaided eye, the perspective of such small prints is too steep from a technical point of view. It is interesting to note, however, that this rarely causes difficulty — the distortion is accepted — although there is probably an unnoticed loss of realism.

5 The Photometry of Image Formation

THE light-transmitting power of a photographic lens, which determines the illuminance of the image on the sensitised material, is usually referred to as the *speed* of the lens. Together with the effective emulsion speed and the subject luminance, it determines the exposure time necessary to give a correctly exposed result. The problem of exposure determination is dealt with in Chapter 20. In the sections below we shall investigate the factors influencing image illuminance, that is, the photometry of image formation, their effects and how they may be controlled.

Stops and pupils

An optical system, such as a camera and lens, normally has two *stops* located within its configuration. The term stop originates from its original construction of a hole in a suitable plate, perpendicular to the optical axis. One of these is the *field stop* which determines the extent of the image in the focal plane and is usually the film gate in the camera.

The *aperture stop* is located within the lens or in close proximity to it, and has the prime function of determining the light-passing ability of the lens. It also possesses two other functions: the control of depth of field (see page 80) and lens performance in terms of the accuracy of the image given together with its resolving power (see page 116).

In the case of a simple lens the aperture stop may be fixed or only have one or two alternative, reduced diameter settings. A compound lens is usually fitted with a variable aperture stop termed an *iris diaphragm* because of its similarity of function to the iris in the human eye. The iris is infinitely adjustable from its maximum aperture value to a minimum value, or may even close completely. The usual construction is of five or more movable blades giving a more or less circular opening. The blade adjustment control, or "aperture ring" may have click-stopped settings at whole and intermediate values. In practical photography the maximum aperture as well as the aperture range is of great importance for picture-making control.

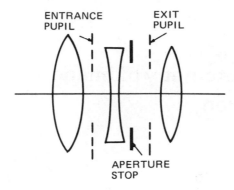

Fig. 5.1 — The entrance and exit pupils of a triplet lens

In a compound lens with an iris diaphragm located within its elements, the image of the iris as given by the elements preceding it when viewed from the object point is called the *entrance pupil*. Similarly from the image point we see the *exit pupil* (Figure 5.1). These pupils are usually virtual images and more important, except in the case of lenses of symmetrical construction, they are not normally of the same diameter.

To measure this difference, if any, the term *pupil factor* or *magnification* is used, defined as the ratio of the diameter of the exit pupil to that of the entrance pupil. While symmetrical lenses have a value of approximately one, telephoto lenses and retrofocus lenses have values less than one and greater than one respectively. The effect of pupil magnification is on image illuminance, as will be seen later.

Aperture

Depending on circumstances and the geometry of image formation, the light-passing power of a lens, usually referred to as *aperture* in deference to the control exercised by the aperture stop, may be defined and calibrated in various ways.

The *effective aperture* of a given setting of the aperture stop for a distant object, is the diameter of a right section of the largest beam of parallel light from an axial object point that is transmitted by the lens. In the case of a thin lens, this may simply be the diameter of the lens itself. If a simple aperture stop is fitted close to or a little way from the lens, it will be the diameter of this aperture (see Figure 5.2b).

In the case of a compound lens, the diameter of the pencil of light that is incident on the lens may be greater than the actual diameter of the aperture. This is due to the converging properties of the front groups of lenses (see Figure 5.2a). The diameter of the incident pencil corresponds to the entrance pupil of the lens.

In general, lenses are fitted with iris diaphragms calibrated in units of *relative aperture*, a number N, which is defined as the equivalent focal length (f) of the lens divided by the diameter (d) of the entrance pupil. Expressed

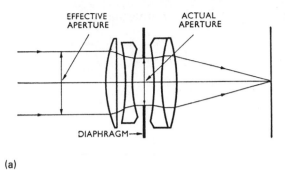

(a)

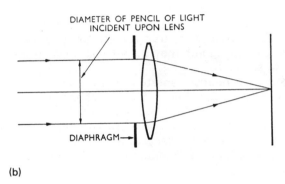

(b)

Fig. 5.2 – The iris diaphragm. (a) Diaphragm between components of a compound lens. (b) Diaphragm in front of a single lens

mathematically $N = f/d$. Thus, a lens with an effective aperture 25 mm in diameter and a focal length of 50 mm has a relative aperture of 50/25, i.e. 2.

The numerical value of relative aperture is usually prefixed by the letter f and an oblique stroke, e.g. $f/2$, which serve as a reminder of its definition. The denominator of the expression used alone is usually referred to as the *f-number* of the lens. However, some lenses express the lens aperture as a ratio without the letter f. Thus aperture of an $f/2$ lens is written as 1 : 2.

The relative aperture of a lens is commonly referred to simply as its "aperture". The maximum aperture of a lens is the relative aperture corresponding with the largest diaphragm that can be used with it.

To simplify exposure calculations, the f-numbers engraved on a lens are usually selected from a standard series of numbers, each of which is related to the next number by a factor of two indicating that the amount of light passed by the lens when set to one number is half that passed by the lens when set to the previous number, as the iris is progressively closed down. Since, as will be shown, the amount of light passed by a lens is inversely proportional to the square of the f-number, the numbers in the series are made to increase by a factor of $\sqrt{2}$, approximately 1·4.

The series of f-numbers currently adopted as standard in most countries is:

$f/1$	$f/8$
$f/1\cdot4$	$f/11$
$f/2$	$f/16$
$f/2\cdot8$	$f/22$
$f/4$	$f/32$
$f/5\cdot6$	$f/45$ etc.

The maximum aperture of a lens may, and frequently does, lie between two of the standard numbers, and in this case will necessarily be marked with a number not in the standard series.

A variety of other series of numbers have been used, notably by European lens manufacturers, using a similar ratio, but with different starting points. Such figures may be encountered on older lenses and exposure meters.

An alteration in relative aperture corresponding to a change in exposure by a factor of 2, is referred to as a change of "one stop" or as a "whole stop". Alteration by "one-third of a stop", "half a stop" and "two stops" refers to exposure factors of $1\cdot26$, $1\cdot4$ and 4 respectively. When the lens opening is made smaller, i.e. the f-number is made larger, the operation is referred to as "stopping down". The converse is called "opening-up".

Vignetting

The effective aperture of a lens is defined in terms of a distant axial object point. Lenses are used to image extended objects however, and depending on the angle of view of the lens, an object point may be considered which is progressively off-axis. If we consider the diameter of a right section of a pencil of rays from an off-axis point passing through a lens we find that a certain amount of obstruction occurs, because of the lens type and design, its axial length and position of the aperture stop, and the mechanical construction of the lens casing (see Figure 5.3). The effect is to reduce the diameter of the pencil of rays that can pass unobstructed through the lens. This is termed *vignetting*. Since, by definition, relative aperture depends on effective aperture, such a reduction means that the image receives progressively less light as the field angle increases. This darkening at the edges of the images is one factor determining image illuminance as a function of field angle and hence the circle of illumination. Vignetting must not be confused with the natural fall-off of light due to the geometry of image formation. Vignetting may be reduced by such measures as oversize front and rear elements for lenses compared with the diameter theoretically necessary in terms of maximum relative aperture.

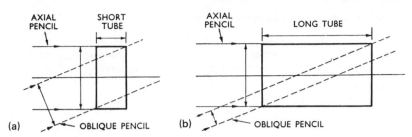

(a) — With a short tube, the area of cross-section of the oblique beam is only a little less than the axial beam

(b) — With a long tube, the area of cross-section of the oblique beam is much smaller than the axial beam.

Fig. 5.3 — Cause of vignetting

Illuminance of the image formed by a camera lens

It is possible to deduce from first principles an expression for the illuminance at any point of an image formed by a camera lens of a distant, extended object. To do this however it is necessary to make use of two other results, the derivations of which are beyond the scope of this book, concerning the light flux emitted by a surface and the luminance of the image given by a lens.

Light flux emitted by a surface

In Figure 5.4, the flux F emitted by a small area s of a uniformly diffusing surface, i.e. one that appears equally bright in all directions, of luminance L into a cone of semi-angle ω, is given by the equation:

$$F = \pi L s \sin^2\omega \tag{1}$$

Note that the flux emitted is independent of the distance of the source. This equation is used to calculate the flux entering a lens.

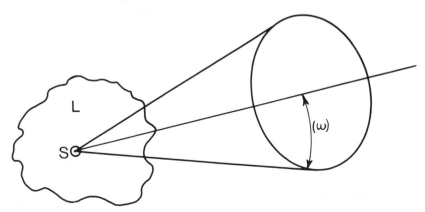

Fig. 5.4 — The light flux F emitted by a small area S of a surface of luminance L into a cone of semi-angle ω is given by $F = \pi L s. \sin \omega$

The Photometry of Image Formation

Luminance of an image formed by a lens

For an object and image that are both uniformly diffuse, whose luminances are L and L' respectively, it may be shown using equation 1 that for a lens of transmittance T that is also aplanatic and free from distortion.
Then,

$$L' = TL \qquad (2)$$

In other words, the image luminance is the same as the object luminance apart from a factor due to the transmittance of the lens, or that the luminance is the same within the cone of semi-angle ω.

Image illuminance

Consider the case as shown in Figure 5.5 where a thin lens of diameter d, cross-sectional area A and transmittance T is forming an image S', distant v from the lens, of a small area S of an extended object distant u from the lens. The object luminance is L and the small area S is displaced from the optical axis such that a principal ray from object to image is inclined at an angle θ to the axis.

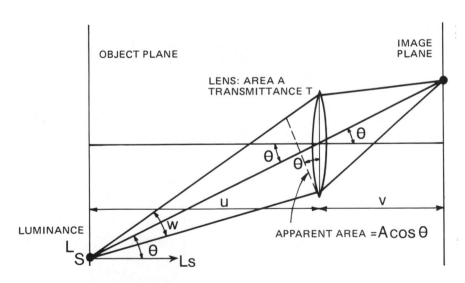

Fig. 5.5 – The factors determining image luminance

The solid angle subtended by the lens at S is ω. The apparent area of the lens seen from S is $A \cos \theta$. The distance between the lens and S is $u/\cos \theta$.

The solid angle of a cone is defined as base area divided by the square of the height.

Consequently,

$$\omega = \frac{A \cos \theta}{\left(\dfrac{u}{\cos \theta}\right)^2} = \frac{A \cos^3 \theta}{u^2}$$

The flux leaving S at the normal is LS, so the flux leaving S at an angle θ into the cone subtended by the lens, is $LS \cos \theta$.

Thus, the flux K entering the lens is given by

$$K = (LS \cos \theta) \left(\frac{A \cos^3 \theta}{u^2}\right) = \frac{LSA \cos^4 \theta}{u^2}$$

Hence from equation 2, the flux K' leaving the lens is given by

$$K' = \frac{TLSA \cos^4 \theta}{u^2}$$

Now, illuminance is defined as flux per unit area, so image illuminance

$$I = \frac{K'}{S'}$$

$$\therefore I = \frac{TLA \cos^4 \theta \, S}{u^2 S'}$$

From geometry, by the ratio of the solid angles involved,

$$\frac{S}{S'} = \frac{u^2}{v^2}$$

$$\therefore I = \frac{TLA \cos^4 \theta}{v^2} \tag{3}$$

The evaluation of equation 3 gives a number of useful results and an insight into the factors influencing image illuminance:

(1) The value of I is independent of u, the object distance although the value of v is related to u by the lens equation.

(2) The axial value of illuminance is given when $\theta = 0$, then $\cos \theta = 1$ and $\cos^4 \theta = 1$.

Hence

$$I = \frac{TLA}{v^2} \tag{4}$$

Now lens area

$$A = \frac{\pi d^2}{4}$$

so that

$$I = \frac{\pi TL d^2}{4v_2} \tag{5}$$

The Photometry of Image Formation

For the object at infinity, $v = f$, that is, the focal length of the lens. By definition, the relative aperture

$$N = \frac{f}{d}$$

By substitution into equation 5 we have

$$I = \frac{\pi TL}{4N^2} \tag{6}$$

This equation gives us the important result that for a distant object, on the optical axis in the focal plane,

$$I \propto \frac{1}{N^2}$$

Hence, image illuminance is inversely proportional to the square of the f-number.

For two different f-numbers N_1 and N_2, the ratio of corresponding image illuminances is given by

$$\frac{I_1}{I_2} = \frac{N_2^2}{N_1^2} \tag{7}$$

Thus, for example it is possible to calculate that the image illuminance at $f/4$ is one quarter the value given at $f/2$.

The *exposure E* received by a film during exposure time t is given by

$$E = It \tag{8}$$

Consequently, for a fixed exposure time, as $E \propto I$, then from equation 7,

$$\frac{E_1}{E_2} = \frac{N_2^2}{N_1^2} \tag{9}$$

Also, from equation 8,

$$I \propto \frac{1}{t}$$

So that the exposure times t_1, and t_2 required to produce equal exposures at apertures N_1 and N_2 respectively, are given by

$$\frac{t_1}{t_2} = \frac{N_1^2}{N_2^2} \tag{10}$$

(3) Also, from equation 7, $I \propto d^2$. In other words, image illuminance is proportional to the square of the lens diameter, or effective aperture of the lens. So, by doubling the value of d, image illuminance is increased fourfold. Values may be calculated from

$$\frac{I_1}{I_2} = \frac{d_1^2}{d_2^2} \tag{11}$$

To give a doubling series of stop numbers, the value of d is altered by a factor of $\sqrt{2}$, giving the standard f-number series.

(4) An interesting result also follows from equation 6. By suitable choice of units, taking I in lux and L in apostilbs (one apostilb $= cd\, m^{-2}/\pi$), then we have

$$I = \frac{TL}{4N^2}$$

So that for a lens with perfect transmittance, i.e. $T = 1$, the maximum value of the relative aperture N is $f/0\cdot5$ so that $I = L$. Values close to $f/0\cdot5$ have been achieved in special lenses.

(5) When the object is not distant, we cannot take $v = f$ in equation 5, but instead use $v = f(1 + m)$ from the lens equation.

Consequently,

$$I = \frac{\pi TL}{4N^2(1 + m)^2} \tag{12}$$

In addition, for non-symmetrical lenses, the pupil magnification P must also be incorporated, since

$$v = f\left(1 + \frac{m}{P}\right).$$

So that

$$I = \frac{\pi TL}{4N^2\left(1 + \dfrac{m}{P}\right)^2} \tag{13}$$

(6) When we consider image illumination off-axis then θ is not equal to 0, and $\cos^4\theta$ then has a value less than one, rapidly tending to zero as θ approaches $90°$.

In addition, we have to introduce a vignetting factor V into the equation to allow for vignetting effects by the lens with increase in field angle.

So our equation, allowing for all factors is now

$$I = \frac{V\pi TL \cos^4\theta}{4N^2\left(1 + \dfrac{m}{P}\right)^2} \tag{14}$$

From equation 14 we see that $I \propto \cos^4\theta$. This is the embodiment of the so-called "$\cos^4\theta$ Law of Illumination" which may be derived from the geometry of the imaging system, the inverse square law of illumination and Lambert's Cosine Law of Illumination. The severe effects of this particular law are shown in Figure 5.6 without the added worsening due to vignetting.

It is seen that even a standard lens whose semi-angle of view is $26°$, has a level of image illuminance at the edge of only two-thirds the axial value. For a wide-angle lens with a corresponding value of $60°$, peripheral illuminance is reduced to $0\cdot06$ of its axial value.

Obviously, for wide-angle lens designs, corrective measures are necessary to try and obtain even illumination over the image area.

The Photometry of Image Formation

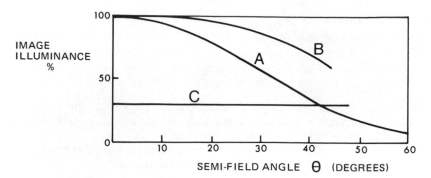

Fig. 5.6 – The effect of cos⁴ θ Law of Illumination.
(a) Natural light losses due to the law.
(b) Improvements possible by utilising the Slussarev effect.
(c) Use of a graded neutral density 'anti-vignetting filter'

Image illuminance in wide-angle lenses

There are many approaches open to lens designers wishing to achieve even illumination in the image plane, these are usually dictated by the particular design of a lens and its applications.

Mechanical methods

An early method was a revolving star-shaped propellor device in front of the lens, as used on the Goerz Hypergon lens. The modern variant is the graduated neutral density filter whose density decreases non-linearly to zero at the rim from a central maximum value. Such filters are widely used with aerial survey lenses.

The advantage of oversize front and rear lens elements has already been mentioned in connection with reduction of vignetting.

Negative outer elements

As the $\cos^4\theta$ effect depends on the angle between a principal ray (one through the centre of the aperture stop) and the optical axis, the use of outer lens elements that are negative reduces this angle of incidence by their property of making a convergent beam of light less convergent. Lens designs such as quasi-symmetrical lenses with short back foci and retrofocus lenses benefit from this technique. The overall effect is to reduce the $\cos^4\theta$ Law to about $\cos^3\theta$.

The Slussarev effect

Named after its discoverer, this approach relies upon deliberately introducing coma into the pencils of rays at the entrance and exit pupils. Their cross-sectional areas are thereby increased, but the coma effects cancel out, so that illuminance is increased at the periphery.

Uncorrected distortion

The theoretical consideration of image illuminance applies only to well corrected, aplanatic lenses free from image distortion. Hence, if distortion correction, which becomes increasingly difficult as field angle increases, is abandoned and the lens design deliberately introduces *barrel distortion* so that the light flux is distributed over increasingly smaller areas towards the periphery, then even illumination is possible even up to angles of view of 180° or more. Fisheye lenses are examples of such lenses.

Exposure compensation for close-up photography

The definition of relative aperture uses a distant object point and assumes that lens or bellows extension is equal to the focal length. When the object approaches closer this is no longer true and instead of f in the equation $N = f/d$ we must use v, the bellows extension. We may then define $N' = v/d$, where N' is the *effective f-number*.

Correction to camera exposure is normally necessary when the object approaches to within about 10 focal lengths from the lens. Various methods are possible depending on whether the values of f and v are known or whether magnification m can be measured. Usually it is easier to use magnification in the correction term for either the effective f-number or the corrected exposure time t'.

The usual equations to give the values of N' and t' are

$$\frac{t'}{t} = \left(\frac{N'}{N}\right)^2 \tag{15}$$

$$t' = t(1 + m)^2 \tag{16}$$

$$N' = N\left(\frac{v}{f}\right) \tag{17}$$

$$N' = N(1 + m) \tag{18}$$

They are easily derived from the lens equation and equation 10 above.

The exposure correction factor increases rapidly as magnification increases. For example, at unit magnification the exposure factor is ×4, so that the original exposure time must be multiplied by four or the lens aperture opened up two whole stops.

For copying, where allowance for bellows extension must always be made, it may be more convenient to calculate correction factors based on an exposure time to give correct exposure at unit magnification.

Table 5.1 gives a list of exposure factors.

The use of cameras with through-the-lens metering systems is often a great convenience in close-up photography, depending on the subject and ambient lighting level, as compensation for bellows extension is taken into account by the light-measuring cells.

(1) Object distance	(2) Bellows extension	(3) Linear scale of reproduction	(4) Marked f-number must be multiplied by:	(5) or Exposure indicated for object at ∞ must be multiplied by:*	(6) or Exposure indicated for same-size reproduction must be multiplied by:*
(u)	(v)	$(m = v/f - 1)$	$(1 + m)$	$(1 + m)^2$	$((1 + m)^2/4)$
∞	f	0	×1	×1	×¼
	$1\frac{1}{8}f$	⅛	×1⅛	×1¼	×⁵⁄₁₆
	$1\frac{1}{4}f$	¼	×1¼	×1½	×⅜
	$1\frac{1}{2}f$	½	×1½	×2¼	×½
	$1\frac{3}{4}f$	¾	×1¾	×3	×¾
$2f$	$2f$	1 (same-size)	×2	×4	×1
	$2\frac{1}{2}f$	1½	×2½	×6	×1½
	$3f$	2	×3	×9	×2¼
	$4f$	3	×4	×16	×4
	$5f$	4	×5	×25	×6

* The exposure factors in columns 5 and 6 are practical approximations.

Table 5.1 — Exposure factors for different scales of reproduction

Light losses and lens transmittance

Part of the light incident on a lens is lost by reflection at the air-glass interfaces and a little lost by absorption. The remainder is transmitted to the image. Thus the value of T in equation 2 and subsequent equations can never be unity, but is always less. The losses in a particular lens depends on the number and composition of glasses employed. An average figure for the loss due to reflection is 5 per cent for each air-glass interface. Consequently, an uncoated, four element lens with eight air-glass interfaces has reflection losses amounting to some 35 per cent of the incident light.

The *transmittance* of the lens in this example would be 0·65, defined as the ratio of the transmitted light to the incident light.

Flare, flare spot, ghost images

Some of the light reflected at the lens surfaces passes out of the front of the lens and causes no further trouble, but a proportion is re-reflected from other surfaces and may ultimately reach the film. Re-reflected "non-image-forming" light which is spread uniformly over the surface of the film is referred to as *lens flare.* The effect of flare is to compress the tones in the shadow areas of the image and to reduce the image luminance range. Not all the re-reflected light may be spread uniformly over the film; some of it may form a more-or-less out-of-focus image of the diaphragm ("flare spot") or of bright objects in the subject ("ghost image"). Lens flare can be minimised: (i) by coating (page 102); (ii) by using an efficient lens hood.

Light reflected from the inside of the camera body, e.g. from the bellows and from the film surface, will also produce flare. Flare from this cause is referred to as *camera flare*. It tends to be especially marked in a technical camera when the field covered by the lens is appreciably greater than the film size, so that considerable light falls on the bellows. Camera flare can be minimised: (i) by using an efficient lens hood; (ii) by using a camera with bellows well clear of the film.

The ratio of subject luminance range to image illumination range is termed *flare factor*. This is a somewhat indeterminate quantity, since it depends not only on the lens and camera but also on the distribution of light within the subject. The flare factor for an average lens and camera considered together, may vary from about 2 to 10 for ordinary scenes, with an average value in the region of 4. Serious flare – i.e. a high flare factor – is characteristic of subjects having high brightness range, such as back-lit subjects.

In the camera, flare affects shadow detail more than highlight detail; in the enlarger, flare affects highlight detail most. In practice, however, provided the negative is properly marked, flare rarely assumes serious proportions in the enlarger. This is partly because the luminance range of the average negative is lower than that of the average scene, and partly because the negative is not surrounded by bright objects, as may be the scene. In colour photography, flare is likely to lead to a desaturation of colours, since flare light consists of a mixture of light from all parts of the scene, which usually approximates to white light. It may also lead to colour casts, sometimes resulting from objects outside the scene photographed.

T-numbers

Because the transmittance of a lens is never unity, or 100 per cent, its relative aperture or *f*-number which is defined by the geometry of the system, does not completely indicate its speed. In practice, two lenses of the same *f*-number may differ widely in transmittance and therefore have different speeds, depending on their particular type of construction, number of components and type of lens coatings.

The use of lens coatings to reduce reflection losses has a marked effect on lens transmittance and the need has arisen in some fields for a more accurate measure of the speed of a lens. The *T*-number was therefore introduced, which is a photometrically determined value taking into account both the geometry of the lens and its transmittance. The *T*-number of any aperture of a lens is defined as the *f*-number of a perfectly transmitting lens which gives the same central image illuminance as the actual lens at this aperture. For a lens with transmittance T and a circular aperture,

$$T\text{-number} = \frac{f\text{-number}}{\sqrt{T}} \qquad (19)$$

Thus a *T*-8 lens is one which passes as much light as a theoretically

perfect $f/8$ lens. The relative aperture of the T-8 lens may be about $f/6\cdot3$.

The concept of T-numbers is of chief interest in cinematography and in colour work, i.e. in fields where exposure latitude is small and the speed of a lens must be known accurately. It is implicit in the T-number system that every lens should be individually calibrated.

If depth of field calculations are made using the T-number instead of the f-number of the lens, the results obtained will, theoretically, be affected. The practical effects may be small, and may usually be ignored since such calculations are based on assumptions that may or may not be true in a particular instance (see page 101).

Lens coatings

A very effective practical method of increasing the transmittance of a lens by reducing reflection losses is by the technique of applying thin coatings of refractive material to the air-glass interfaces. By such means the transmittance at an interface may be increased from about $0\cdot95$ to $0\cdot99$ or more. So that for a lens with 8 such interfaces, the transmittance increases from $(0\cdot95)^8$ to $(0\cdot99)^8$, i.e. an increase from $0\cdot66$ to $0\cdot92$ or approximately one-third of a stop increase in speed at the same f-number. In the case of a zoom lens which may have 20 such surfaces, the transmittance would be increased from $0\cdot36$ to $0\cdot82$, more than doubled. Just as important is the accompanying reduction in lens flare giving an image of useful contrast. Indeed, without the use of such coatings, many lens designs would be impractical owing to light losses and low image contrast.

The surface treatment of a lens in this way, once called "blooming", depends on two principles. First, the dependence of the amount of surface reflectance R on the refractive indices n_1 and n_2 of the two media forming the interface, given by

$$R = \frac{(n_2 - n_1)^2}{(n_2 + n_1)^2}$$

20.

In the case of a lens surface, n_1 would be the refractive index of air and equal to one and n_2 would be the refractive index of the glass.

It can be seen from equation 20 that reflectance increases rapidly with increase in the value of n_2. In modern lenses, using special glasses of high refractive index, typically $1\cdot7$ to $1\cdot9$, such losses would be severe without coating.

The second principle used is that of the destructive interference of light.

In this case we consider the interaction of the two reflected beams R_1 and R_2 from the surface of the lens and from the surface of a thin coating of thickness t and refractive index n_3, applied to the lens surface (see Figure 5.7).

The condition for R_1 and R_2 to interfere destructively is given by

$$2n_3 t \cos r = \lambda/2$$

(21)

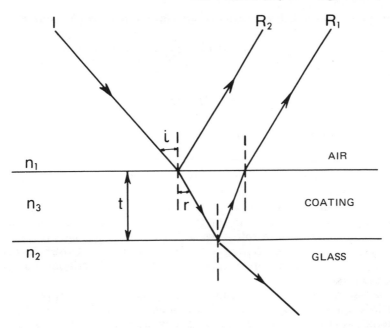

Fig. 5.7 — An anti-reflection coating on glass using the principle of destructive interference of light

which, for normal incidence of light of wavelength λ, simplifies to

$$2n_3t = \lambda/2 \tag{22}$$

From equation 22 we see that to satisfy this condition the "optical thickness" of the coating, the product of refractive index and thickness of that medium, n_3t, must be $\lambda/4$. In other words one quarter the wavelength of the incident light. This type of coating is termed "quarter-wave coating" or "primitive coating". As such a coating thickness can be correct only for one wavelength it is usually optimised for the middle of the spectrum, i.e. green light, and hence looks magenta in appearance. By applying similar coatings for other wavelengths on other lens surfaces giving yellow, blue and green coloured appearances it is possible to balance lens transmittance for the visible spectrum and ensure that a range of lenses for a camera give similar colour renderings on colour transparencies, irrespective of their type of construction.

We have not so far discussed the choice of a material of suitable refractive index for the lens coating. The optimum value is obtained from further consideration of the conditions for reflectances R_1 and R_2 to interfere destructively. The second condition is that the magnitudes of R_1 and R_2, are the same.

From equation 20 we can obtain expressions for R_1 and R_2, i.e.

$$R_1 = \frac{(n_2 - n_3)^2}{(n_2 + n_3)^2}$$

and

$$R_2 = \frac{(n_3 - n_1)^2}{(n_3 + n_1)^2}$$

By equating $R_1 = R_2$ and taking $n_1 = 1$, we find that

$$n_3 = \sqrt{n_2}$$

In other words, the optimum refractive index of the coating should have a value corresponding to the square root of the refractive index of the glass. For glass of refractive index $1 \cdot 51$, the coating ideally should have a value of about $1 \cdot 23$. In practice, the most suitable material is magnesium fluoride with refractive index of $1 \cdot 38$. By such means the average value of transmittance is increased from about $0 \cdot 95$ to about $0 \cdot 98$, for the light energy involved in the destructive interference process is not lost but is transmitted.

The traditional method of applying a coating to a lens is by placing the lens in a vacuum chamber in which is a small container of the coating material. This is electrically heated and evaporates, depositing on the lens surface. The coating thickness is maintained until of the required value and the vacuum released. This evaporation technique is limited to refractive materials which will evaporate at the heating temperatures available. Many other potentially useful substances do not even melt at these temperatures.

A more recent technique is to use an electron beam directed at the coating substance, once again in a vacuum chamber. The high energy, intense beam evaporates materials even with very high melting points and lens surfaces are coated by deposition of the vapour as before. Examples of materials heated in this manner are silicon dioxide ($n = 1 \cdot 46$) and aluminium oxide ($n = 1 \cdot 62$).

Multiple coatings

The technique of controlled surface treatment by coating according to the conditions specified above is now widely applied to a range of optical products, apart from photographic optical systems, including spectacle lenses and aircraft windows.

With the advent of improved coating machinery and a wider range of suitable coating materials together with the aid of digital computers to carry out the necessary complex calculations, it has proved economically feasible to extend coating techniques to use several separate coatings on each air-glass interface. Indeed, a "stack" of as many as 25 or more coatings may be used to give the necessary spectral transmittance of so-called interference filters.

By suitable choice of the number, order and refractive indices of in-

dividual coatings the spectral transmittance of a lens may be selectively enhanced, having a value greater than 0·99 for most of the visible spectrum and very close to unity for part of the spectrum (Figure 5.8).

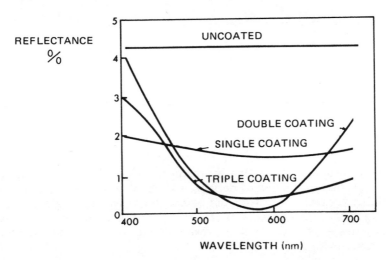

Fig. 5.8 – The effects of various types of anti-reflection coatings compared with uncoated glass for a single lens surface at normal angles of incidence.

The number of coatings per surface may vary in a particular lens design, multiple coatings being used only where necessary, and single coatings otherwise. The use of triple coatings is quite common and numbers between 7 and 11 are claimed. Occasionally, even the interfaces between cemented glass elements may be coated.

Many advanced lens designs would be impracticable without multiple coatings to improve transmittance and reduce flare.

6 Lens Aberrations

SO FAR, in our consideration of image formation, we have dealt with lenses as though they were perfect, and capable of forming absolutely faithful images of any objects set before them. This is an ideal state of affairs which does not exist in practice; with actual lenses – especially simple ones – we get only an approximation to the ideal. There are three main reasons for this:

(1) The refractive index of glass varies with wavelength.
(2) Lens surfaces can only readily be polished if they are spherical – and spherical surfaces do not bring light to a focus.
(3) Light behaves as if it consists of waves.

The ways in which the image departs from the ideal, as a result of the above, are referred to as *lens errors*, or *aberrations*. Errors due to (1) are called *chromatic* errors, errors due to (2) *spherical* errors and errors due to (3) *diffraction* errors.

The chromatic and spherical errors from which an image may suffer are seven in number. Two of them are formed in all parts of the field – including the centre – but the other five affect only rays passing through the lens obliquely, and so do not appear in the centre of the field but only towards the edges, increasing in severity with the distance from the lens axis. The names of the errors are:

Direct errors – affecting all parts of the field
(1) Chromatic aberration.
(2) Spherical aberration.

Oblique errors – not present in centre of field
(3) Lateral colour.
(4) Coma.
(5) Distortion.
(6) Astigmatism.
(7) Curvature of field.

Chromatic aberration and lateral colour are chromatic errors; spherical aberration, coma, distortion, astigmatism and curvature of field are

spherical errors. Each of these is described in detail below. Although, in practice, lens errors are largely interrelated, it will be assumed in considering each error that the lens is free from other aberrations.

Chromatic aberration (axial)

The refractive index of all transparent media varies with the wavelength of the light passing through, shorter wavelengths being refracted most. The focus of a simple lens therefore varies with the wavelength, and hence the colour, of the light employed. The separation of focus along the optical axis for an incident beam of white light, owing to dispersion by a positive lens is shown in Figure 6.1.

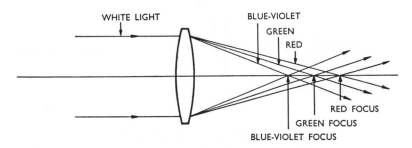

Fig. 6.1 — Chromatic aberration in a simple lens

The focus for blue-violet light is closer to the lens than that for red light. The image suffers from *axial chromatic aberration.* Early photographic lenses were of simple design and a problem was the non-coincidence of the visual (green) focus with the chemical (blue) focus for the blue-sensitive materials then available.

There are various remedies to overcome this form of chromatic aberration. For a simple lens a focus shift allowance may be made after focusing or the lens may be stopped down to increase the depth of focus. The latter technique of using a small stop allows such lenses to be used in inexpensive cameras with a fair degree of success.

Compound lenses use other techniques to give what is termed a chromatic correction. It was shown by Dollond in 1757 that if a lens is made of two elements, the chromatic aberrations in one can be made to cancel out those in the other. Typically, a combination of crown and flint glasses was used. The convergent crown element had a low refractive index and a low dispersive power while the divergent flint element had a higher refractive index and much higher dispersive power. The crown glass element has more refractive power than the other to give a convergent combination. A cemented *achromatic doublet* lens made in this way is illustrated in Figure 6.2.

The chromatic performance of a lens is usually shown by plotting a graph of wavelength against focal length, as shown in Figure 6.3. An un-

107

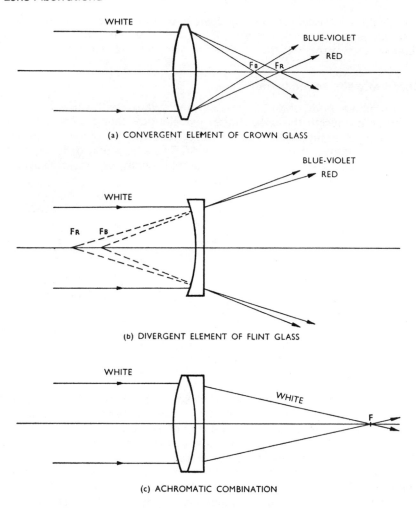

(a) CONVERGENT ELEMENT OF CROWN GLASS

(b) DIVERGENT ELEMENT OF FLINT GLASS

(c) ACHROMATIC COMBINATION

Fig. 6.2 — The principle of an achromatic lens

corrected lens is characterised by a straight line and an achromatic lens by a parabola. The two wavelengths with identical focus positions are usually chosen in the red and blue regions of the spectrum, e.g. the C and F Fraunhofer lines, although other pairs were chosen in early lenses for use with non-panchromatic materials. For some applications, such as colour separation work, a lens is corrected to bring three foci into coincidence to give three images of identical size when red, green and blue filters are used. This higher degree of correction is termed *apochromatic*.

Recently, it has been found possible to obtain an even higher degree of correction and bring four wavelengths to a common focus. Such a lens is termed a *superachromat*. The wavelengths chosen are typically in the

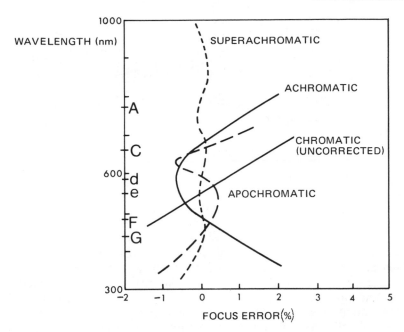

Fig. 6.3 – Types of colour correction for lenses

blue, green, red and infra-red regions so that no focus corrections are required between 400 and 1000 nm.

The use of optical materials other than glass also gives problems of chromatic correction. Plastics are increasingly being used for photographic lenses and it is possible to make an achromatic lens from the varieties available.

The use of reflecting surfaces which do not disperse light, in the form of *mirror lenses* offers another solution for long-focus lens designs only (see page 131).

Lateral colour

Lateral colour, also known as *lateral* or *transverse chromatic aberration* or as *chromatic difference of magnification* is a peculiarly distressing error which appears as the form of colour fringes at the edges of the image, as it is an oblique error (see Figure 6.4). Whereas axial chromatic aberration concerns the *distance* from the lens at which the image is formed, lateral colour concerns the *size* of the image. It is not an easy aberration to correct and its effects rapidly worsen with an increase in focal length and are not reduced by stopping down. It sets a limit to the performance of long-focus lenses of the refracting type, especially for photomechanical colour separation work. Mirror lenses may offer an alternative in some cases but they have their own restrictions and limitations.

Lens Aberrations

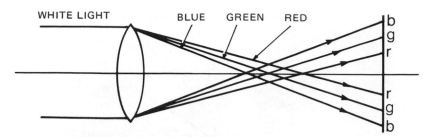

Fig. 6.4 – Lateral colour or transverse chromatic aberration

Lateral colour may be controlled by a symmetrical construction but almost full correction is possible by use of special optical materials. These include optical glass of *extra low dispersion* which may be used in lenses with few additional problems. Another suitable material is *fluorite* or calcium fluoride. This was formerly available as a natural mineral only in small pieces of optical quality, suitable for use in microscope objectives, but it was recently found possible to grow suitable sizes of flawless crystals for use in photographic lenses. Fluorite is, however, attacked by the atmosphere so it must be protected as an inner element in the lens construction. It is also temperature-dependent in that lens focal length varies slightly with ambient temperature. The cost of lenses incorporating fluorite elements is significantly higher than for equivalent conventional designs.

Spherical aberration

The refraction of a ray of light by a lens depends on the angles of incidence made with the lens' surfaces. These surfaces are almost always spherical, because they can be produced economically with the required precision. A consequence of this construction is that a beam of light parallel to the axis incident upon the lens undergoes variable refraction, depending on the *zone* of the lens responsible. A zone is an annular region of the lens, centred on the optical axis. Rays passing through the outer zones come to a focus nearer the lens than the rays through the central zone (see Figure 6.5). Consequently, the image is unsharp and a point image cannot be given from a point source. This error is termed *spherical aberration*.

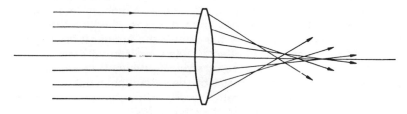

Fig. 6.5 – Spherical aberration in a simple lens

In a simple lens, spherical aberration is reduced on stopping down, accompanied by the *focus shift* characteristic of this aberration. Another form of correction is by the suitable choice of possible radii of curvature of a double convex lens, termed "bending" by optical designers.

Correction in a compound lens is by suitable combination of positive and negative lenses with equal and opposite spherical aberration. This correction may be combined with that necessary for chromatic aberration and coma and such a lens is termed *aplanatic* (as well as achromatic). Spherical aberration, both in its simple and more complex forms, increases as a power function of the diameter of the effective aperture of a lens.

Consequently, a limit is set to the maximum usable aperture of many otherwise excellent lens designs, for example $f/5\cdot6$ for some symmetrical designs. An increase to $f/4$ would require a much more complex construction or even a different design.

The use of Double Gauss designs (see pages 123, 126) with six or more elements allows apertures of $f/2$ and greater with adequate correction. The cost of production is also greater.

The use of an *aspheric* surface in a lens design can give a larger usable aperture or permit a reduction in the number of elements necessary for a given aperture. Modern optical production technology can produce small numbers of such surfaces at high, but not impossible costs.

A preferred alternative is to use modern glasses of very high refractive index which allow more gentle curvatures for the same refracting power in a lens and hence a reduction in spherical aberration.

A novel solution to the problem of increase in spherical aberration as image conjugate increases, i.e. with close focusing, particularly in lenses of large aperture and/or large field angle, has been to have one group of elements move axially for correction purposes as the lens is focused. This arrangement is termed a *floating element* and is a result of experience gained in zoom lens design.

Certain lenses have been designed with a controllable amount of residual uncorrected spherical aberration to give "soft-focus" effects, particularly for portraiture. The degree of softness may be controlled by specially shaped and perforated aperture stops or by progressive separation of two of the lens elements.

Coma

In considering spherical aberration, we saw that in an uncorrected lens different zones of the lens have, in effect, different focal lengths. The effect of this, in the case of oblique rays, is that rays passing through different zones of the lens fall on the film at different distances from the axis, instead of being superimposed. The result is that the image of a point off the axis appears as a comet-shaped fuzz, and is said to suffer from *coma* (Figure 6.6). Coma may thus be regarded as spherical aberration of the oblique rays.

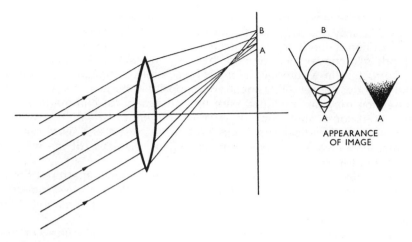

Fig. 6.6 – Coma in a simple lens

Coma may take the form of "outward coma" – with the tail of the comet pointing away from the lens axis (as shown), or "inward coma" – with the tail of the comet pointing towards the lens axis. Coma, like spherical aberration, is reduced on stopping down. Stopping down may, however, cause the image to shift laterally (just as the image shifts axially if spherical aberration is present). Coma can be reduced in a single lens by employing a stop in such a position that it restricts the area of the lens at which oblique rays strike it. This method is adopted to minimise coma in simple box cameras. In compound lenses, coma is reduced by balancing the error in one element by an equal and opposite error in another; in particular, by use of a symmetrical construction.

Distortion

The term *distortion*, or *curvilinear distortion*, is applied to lateral distortion of the image resulting from variation of magnification over the field of the lens. The image of a square object produced by a lens suffering from distortion appears with its sides bowed outwards or inwards, as in Figure 6.7. The two types of distortion shown in this figure are referred to as *barrel distortion* and *pincushion distortion* respectively. Unlike other aberrations, distortion does not affect the sharpness of the image but only its shape.

The reason for distortion is that when a stop is used, e.g. to avoid coma, rays which strike the lens at different angles go through different parts of it (Figure 6.8). As a result, the central ray of an oblique beam of light passed by the lens system, does not pass through the centre of the lens itself. And, since the surfaces of the lens where the oblique central ray does meet it are not parallel, this ray does not go straight on, as is assumed in theory based on thin lenses. This leads to images in which

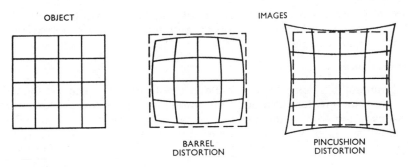

OBJECT

IMAGES

BARREL
DISTORTION

PINCUSHION
DISTORTION

Fig. 6.7 — Distortion

the edges are too small in scale (barrel distortion), or too large in scale (pincushion distortion).

It is apparent that the type of distortion obtained with a particular lens depends upon the *position* of the stop. Distortion shares with lateral colour the property of not being reduced on stopping down, i.e. it is not influenced by the *size* of the stop. Distortion can be corrected in manufacture by making the lens symmetrical, or nearly symmetrical. The first symmetrical lens, the *Rapid Rectilinear* (page 124), took its name from the fact that it gave distortion-free images.

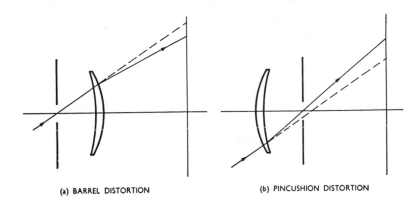

(a) BARREL DISTORTION

(b) PINCUSHION DISTORTION

Fig. 6.8 — Cause of distortion

The first component of this lens — used alone — gives "pincushion" distortion, and the second "barrel" distortion, but when the two components are used together the two defects cancel one another. Use of a symmetrical construction eliminates not only distortion but also coma and lateral colour.

Lenses of asymmetrical construction, e.g. telephoto and retrofocus designs are prone to pincushion and barrel distortion respectively.

Lens Aberrations

General purpose lenses can have about 1 per cent distortion with little effect in practice. Lenses for photogrammetry and aerial survey work must be distortion-free.

Astigmatism

Astigmatism is a defect whereby the image of a point object off the lens axis consists nowhere of a point but varies from a radial to a tangential line according to the position of the focusing screen (see Figure 6.9). Astigmatism is one of the oblique aberrations which affect only the margins of the field. The effect produced on lines in an image by an *astigmatic* lens depends on the relation of these lines to the lens axis, as shown in Figure 6.10.

Astigmatism is reduced to some extent on stopping down. Its complete correction involves the use of a compound lens with glasses having a particular relationship between refractive index and dispersive power. In the early days of photography astigmatic correction was not possible without introducing curvature of field and vice versa. In the 1880's

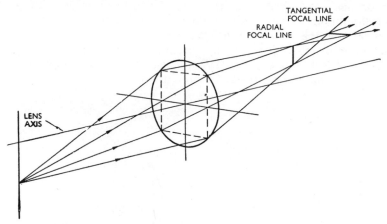

Fig. 6.9 – The production of an astigmatic image

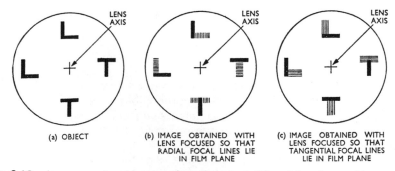

Fig. 6.10 – Images produced by an astigmatic lens at different focusing positions

however, new types of glass were made available by Schott and Abbe which had low refractive index together with high dispersion and vice versa.

Full correction was then possible for astigmatism, as well as the other lens aberrations, at modest apertures. Such lenses were called *anastigmats*. Modern lenses are highly corrected anastigmats.

Curvature of field

Curvature of field is a defect of a lens whereby its place of sharpest focus is not flat, the so-called *Gaussian image plane*, but is saucer shaped, termed the *Petzval surface*. This is often concave to the lens. With a lens suffering from this error it is impossible to obtain a sharp image all over the field; when the centre is sharp the edges are blurred, and vice versa.

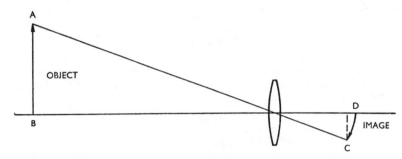

Fig. 6.11 – Curvature of field

By consideration of the geometry of image formation shown in Figure 6.11, we see that curvature of field is to be expected. Because the off-axis object point A is further from the lens than the axial image point B, the image of A, at C, will necessarily be nearer to the lens than the image of B, at D, thus leading automatically to curved field.

Curvature of field is related to astigmatism, as mentioned above and anastigmatic lenses have a substantially flat field.

With a simple positive lens, stopping down to increase the depth of focus and by making the lens of a suitable meniscus shape with suitably positioned aperture stop, can give a reasonably flat field. Otherwise, roll

(b)

Fig. 6.12 – Use of meniscus lenses in simple cameras

film can be bent round a curved film gate (see Figure 6.12).

In some scientific instruments where field curvature is unavoidable, specially thin, bendable glass plates may be used.

Diffraction

Even when all the chromatic and spherical errors in a lens have been reduced to a minimum, errors still remain due to *diffraction*. Diffraction is the name given to phenomena which occur when light passes through a very narrow aperture or close to the edge of an opaque obstacle, and which arise from light deviating from the rectilinear path. Diffraction is explained by the wave theory of light.

Because of this phenomenon, the image of a point source formed by even a theoretically perfect lens is not a point, but a circle of light of finite diameter. The diameter of this circle, or *Airy disc*, can be shown to be:

$$2 \cdot 44 \lambda \frac{v}{d}$$

where λ is the wavelength of the light, v the distance of the image from the lens, and d the effective diameter of the lens aperture. For all except close-ups, this can be written:

$$2 \cdot 44 \lambda N$$

where N is the *f*-number of the lens.

With blue-violet light of wavelength 400 nm, the diameter of the Airy disc becomes $N/1000$ mm, e.g. $0 \cdot 008$ mm for an *f*/8 lens.

The formula for the Airy disc illustrates two things. The first is that the shorter the wavelength of the light the less serious is the diffraction, and, therefore, the higher the resolving power theoretically possible (see below). This is the basis of ultra-violet photomicrography. The second is that diffraction *increases* on stopping down. The practical effects of this are considered below.

Resolving power of a lens

The ability of a lens to resolve fine detail is termed its *resolving power* and is set by the residual aberrations of the lens, by diffraction and by the contrast of the subject.

In practical photography, we are concerned with the resolving power of a photographic system, and this depends on the resolving power of the film as well as upon that of the lens, see pages 533–536.

Various test targets have been devised to obtain an objective measure of resolving power, based on photographing the target at a known magnification and a visual estimation with the aid of a microscope of target details just resolved in the negative.

While such methods have certain merits, and can give useful data on a comparative basis as well as having the advantage of being easily carried

out, a true picture of lens performance is not given. This information is vital for lens design and quality control procedures.

Modern lens evaluation methods make use of the *optical spread function* which is the light-intensity profile of the aberrated image from a point or line source, and of the *optical transfer function* which is a measure of the loss in contrast of a sinusoidal intensity profile test target with increase in spatial frequency of the target, see page 546.

A measure of the unreliability of resolving power tests of a lens is given by considering a common test target consisting of black lines on a white ground, with the lines and spaces of equal width. Consideration of the Airy disc images of these lines suggests that they will be distinctly resolved if the separation between their centres is equal to about one-half of the effective image diameter, according to diffraction theory. Thus, resolving power (*RP*) in lines per millimetre is given by

$$RP = \frac{1}{1 \cdot 22 \lambda N}$$

An Airy disc diameter of 0·008 mm thus corresponds to a resolving power of about 250 lines per millimetre.

The presence of residual lens aberrations giving reduced performance and spurious resolution severely reduces this theoretical value. Of even greater effect is the case when the target optical contrast is reduced from a value of about 1000:1 for the reflectance or luminance of the white to black areas to values typical of those found in practical subjects, which may be as low as 5:1. A series of test targets of differing contrasts would be needed to give useful data.

Stopping down and definition

If the aperture of a lens is stopped down gradually, starting from maximum aperture, the residual aberrations, except lateral colour and distortion, are reduced, but the effect of diffraction becomes greater. At large apertures the effect of diffraction is small but aberrations reduce theoretical performance. The balance between the decreasing aberrations and increasing diffraction on stopping down means that most lenses have an *optimum aperture*, often about 3 stops down from maximum, where best results may be expected. Many lenses do not stop down very far, f/16 or f/22 being usual values, and diffraction effects may not be noticed. Over the 3 or 4 stop range of smaller aperture values the only practical effect may be on depth of field. A variation in performance over the field, especially in the case of wide-angle lenses, is to be expected at any given aperture, owing to the effects of oblique aberrations.

Lens Aberrations

For close-up photography, photomacrography and enlarging the value of v/d is much greater than the f-number of the lens and the diffraction disc is considerably greater than when the same lens is used for ordinary photography. Undue stopping down of the lens in these circumstances should therefore be avoided.

7 The Camera Lens

A LENS consisting of a single piece of glass exhibits all the defects described in the foregoing chapter, to a greater or a lesser extent. In such a lens, chromatic aberration, spherical aberration, lateral colour, coma, astigmatism and curvature of field all combine to give poor definition, while distortion leads to distorted images. We may sum up this state of affairs by saying that the *image quality* of a simple lens is poor.

We have stated that all lens aberrations are present "to a greater or lesser extent", because, in the design of even a simple lens, aberrations can be controlled to a certain degree, in particular by choice of suitable curves for the two surfaces and by careful positioning of a stop of suitable size. Reference was made to this possibility in the previous chapter. If, in addition, the field covered be restricted, it is possible, even with a simple lens, to obtain image quality that is acceptable for some purposes, even if it is still very poor by the highest standards.

The best simple lens that we can produce is, however, limited, not only as regards image quality but also as regards relative aperture, i.e. speed, and field covered. It was early realised that for the photographic process to be exploited to the full, improved performance of the lens in all three of these properties was required, the first need, in view of the slowness of the sensitised materials then available, being of increased speed, to enable portraits to be taken without inconveniently long exposures.

The possible ways of improving the performance of a simple, positive biconvex lens are shown in Figure 7.1. The techniques of *compounding* and *splitting* to allow the use of different glasses and the distribution of power among the elements are powerful tools of lens design.

Compound lenses

The reason that the performance of a lens consisting of a single piece of glass cannot be improved beyond a certain point, is the limited number of variables, or "degrees of freedom", which the designer has at his command. It is, however, apparent that by using two pieces of glass – two

Fig. 7.1 — Methods of making simple derivatives of improved performance from a simple positive biconvex lens.

(a) aspheric front surface
(b) bending to meniscus shape and position of stop.
(c) compounding to an achromatic doublet
(d) splitting to give a symmetrical lens.

elements — instead of one, the number of degrees of freedom available to the lens designer is immediately increased. Not only has he now four surfaces instead of two over which to spread the desired bending of light, but he can employ different types of glass for the two elements and can also vary their spacing. His freedom increases further as he employs more and more elements in the lens, although the introduction of other considerations prevents this being extended too far. Summarising the most important of the factors with which the designer of a compound lens can conjure, we have:

(1) Radii of curvature of lens surfaces.
(2) Maximum aperture — set by stop.
(3) Position of stop.
(4) Number of separate elements.
(5) Spacing of elements.
(6) Thickness of individual elements.
(7) Use of types of glass differing in: (a) refractive index, and/or (b) dispersive power.

Compound lenses were introduced as a means of controlling lens errors in order to provide better image quality, wider apertures and

greater covering power than are given by simple lenses. The way in which each of the chromatic and spherical errors can be corrected in a compound lens by careful design has already been indicated in Chapter 6. The general principle followed is to balance an error in one element by an equal but opposite error in another. It is not, however, usually possible to eliminate any error entirely; it is simply reduced to an acceptable level.

Frequently, the correction of one error affects another and a compromise has to be made. With a lens intended for general use the designer has to steer a middle course. If, however, maximum correction is desired in a lens designed with one particular use in mind − and which will therefore be employed only under a narrow range of conditions, e.g. always at full aperture, or always at one scale of reproduction − the designer can frequently obtain improved performance under these conditions at the expense of the performance under other conditions, e.g. at other apertures or different scales of reproduction. Lenses of the highest correction are, therefore, usually designed to give their best performance at or about one scale of reproduction, at one aperture and with light of a given quality. An apochromatic lens, for example, may be suitable for ratios of reproduction of from $\frac{1}{5}$ to 5. In general, the requirements of high definition, large aperture, and wide covering power are mutually opposed. When the very highest performance in any one of these respects is therefore required, the two other factors must be sacrificed to some degree.

There are only a few basic types of lens from which most practical lenses are derived. The relationships of these types to the basic simple achromatic doublet lens are shown in Figure 7.2. Only the simplest form of each is shown, practical designs having many more elements for the control of lens aberrations.

Development of the photographic lens

In order to meet the continual demands of the photographer for lenses of larger aperture, wider field angle and higher performance, many thousands of lens designs have been produced. These represented current state-of-the-art solutions when introduced, ranging from relatively simple to very complex designs, although the number of elements is not necessarily related to performance.

It is possible to group lenses into several categories, based upon the progress of 19th-century designers, which give a fair indication of the limits to performance parameters. It is of interest to note that by the beginning of the 20th century, lenses were available, albeit of modest aperture and field angle, which were fully corrected for all seven of the primary lens aberrations.

Progress in lens design since that time has largely been through the availability of improved optical materials, lens coating techniques, computer-assisted calculations, advances in lens production methods and objective means of lens testing and evaluation.

Type of lens	Degree of correction of aberrations							Maximum aperture on introduction	Approx. field covered at maximum aperture
	Chromatic aberration	Spherical aberration	Lateral colour	Coma	Distortion	Curvature of field	Astigmatism		
Simple lenses									
Wollaston landscape (stop in front) 1812	Poor	Satisfactory	Very poor	Satisfactory	Poor	Satisfactory	Poor	f/14	53°
Landscape with stop behind	Poor	Satisfactory	Very poor	Satisfactory	Poor	Satisfactory (if film is curved)	Poor	f/14	53°
Chevalier landscape (achromatised) 1828	Good	Good	Poor	Satisfactory	Poor	Satisfactory	Poor	f/12	28°
Petzval lens 1840	Good	Good	Poor	Satisfactory	Poor	Satisfactory	Poor	f/3·7	20°
Doublets									
Steinheil Periskop (not achromatised) 1865	Poor	Good	Very much reduced	Very much reduced	Very much reduced	Satisfactory	Poor	f/10	90°
Rapid Rectilinear ("old" achromat) 1866	Good	Good	Good	Good	Good	Satisfactory	Poor	f/8	44°
Anastigmats (Jena glasses)									
Ross Concentric ("new" achromat) 1888	Good	Satisfactory	Good	Good	Good	Good	Good	f/16	53°
Zeiss Anastigmat (Protar) (= half "old" achromat, half "new" achromat) 1890	Good	Good	Good	Good	Good	Good	Good	f/8	60°
Triplet									
Cooke 1893	Good	Good	Good	Good	Good	Good	Good	f/4·5	53°
Tessar 1902	Good	Good	Good	Good	Good	Good	Good	f/5·5	53°

Table 7.1 – Some outstanding steps in the development of the photographic objective

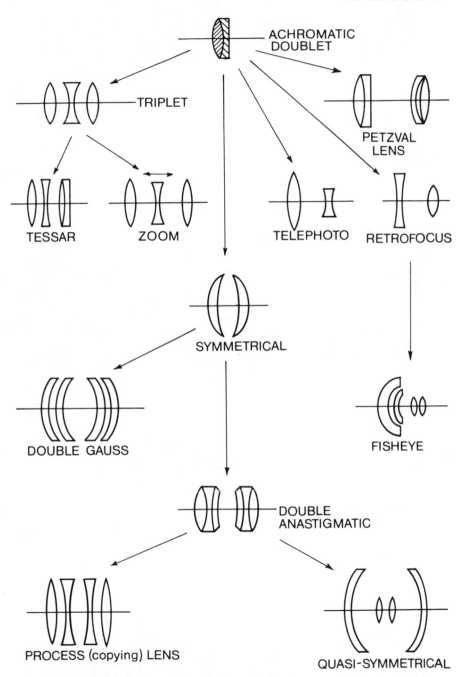

Fig. 7.2 – Relationships of basic lens designs to the simple achromatic doublet

The Camera Lens

It is of interest to relate very briefly the development of the photographic lens, the outstanding early steps of which are shown in Table 7.1. The construction of these lenses is shown in Figure 7.3.

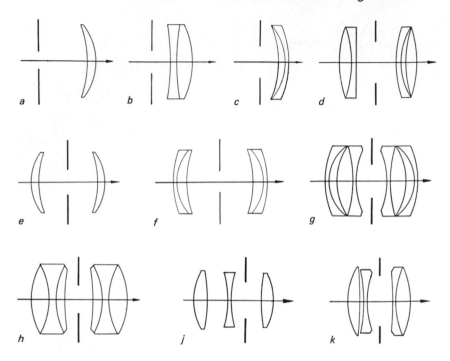

Fig. 7.3 – Construction of early lenses

a – Landscape lens of Wollaston b – Achromatic landscape lens of Chevalier
c – Grubb's landscape lens d – Petzval portrait lens e – Steinheil's Periskop lens
f – Rapid Rectilinear lens g – Zeiss Double Protar lens h – Goerz Dagor lens
j – Cooke triplet lens k – Zeiss Tessar lens

Simple lenses and achromats

The year 1839 is taken as marking the beginning of practical photography. The use of lenses prior to that date had been for spectacles, telescopes, microscopes and the camera obscura. The *landscape* lens as used in the camera obscura was initially adapted for use in cameras, although not of biconvex shape but of meniscus form with a front stop, as Wollaston had shown in 1812 that a flatter field and reduced coma were given by this shape. Such lenses remained in use until comparatively recently in simple cameras.

Dollond in 1757 had produced an achromatic doublet telescope lens and this form was soon used to achromatise landscape lenses for photography. Because of uncorrected oblique errors, such lenses had to be used at small apertures and fields. Maximum aperture seldom exceeded *f*/14.

The Petzval lens

The simple lens was inconveniently slow for portraiture with the insensitive plates of the period and active efforts were made to design a lens of large aperture, for the principles were understood but lack of suitable optical glasses hampered efforts. In 1840 J. Petzval designed a lens of aperture $f/3 \cdot 7$ consisting of two separated, dissimilar achromatic doublets, the first lens computed mathematically specifically for photography. It was faster by a factor of about 15 than contemporary designs.

The residual uncorrected aberrations, particularly astigmatism, gave a poor edge definition that was found particularly pleasing for portraiture, giving a characteristic softness. Its narrow field of good central definition necessitated a longer focal length than standard to cover a given plate format, a factor contributing to improved perspective in portraiture by the necessarily more distant viewpoint.

Symmetrical doublets

There were no significant improvements in landscape lenses until the middle 1860's when lenses of good definition, flat field and moderate aperture became available. The Steinheil Periskop lens of 1865 used two menisci symmetrically about a central stop. The importance of symmetrical, or near symmetrical, construction is that it permits almost complete correction of the oblique errors of coma, lateral colour and distortion. This chromatic lens was superseded in 1866 by the simultaneous introduction yet independent designs of the Rapid Rectilinear by Dallmeyer and the Aplanat of Steinheil. The earlier meniscus lenses were replaced by achromatic combinations. Maximum aperture was $f/8$. Astigmatism was uncorrected.

Anastigmats

Astigmatism and field curvature were uncorrectable simultaneously with the other errors as available optical glasses had dispersion increasing with refractive index. However, after much pioneer work, Abbe and Schott in the 1880's produced alternative, suitable glasses. Use of these led to the first *anastigmatic* lenses.

Early examples of such lenses include the Ross Concentric (1888), Zeiss Protar (1890), Goerz Dagor (1892) and Zeiss Double Protar (1894). These lenses became increasingly complex, using the principle of symmetrical construction but with each component being multiple cemented combinations of old and new glass types. Maximum aperture was about $f/6 \cdot 8$.

Triplets

The increasing complexity of anastigmat lenses led to high manufacturing costs. In 1893 the Cooke Triplet lens was introduced, designed by H. Dennis Taylor and made by Taylor, Taylor and Hobson. This was a

departure from contemporary symmetrical designs, consisting of only three single separated lenses, two of which are convex lenses of crown glass of high refractive index and low dispersion. These are separated by a biconcave lens of light flint glass, serving to flatten the field. The outstanding feature is its simplicity of construction while having enough degrees of freedom for full correction. The original aperture was $f/4 \cdot 5$ but this has been increased to $f/2 \cdot 8$ and intense development work has produced a wide variety of triplet derivatives by the usual techniques of splitting and compounding elements. The Zeiss Tessar lens (1902), while designed independently, is one of the best known forms of triplet design.

Double Gauss lenses

The advantages of symmetrical construction in lens design are considerable, the major disadvantage is the inability to correct higher order spherical aberration in particular, limiting maximum aperture to about $f/5 \cdot 6$. Triplet construction has a limit at about $f/2 \cdot 8$. In order to obtain large, usable apertures such as $f/2$ or greater, it was found that derivatives of a symmetrical design based on a telescope doublet lens design due to Gauss had to be used. This doublet was air-spaced with deeply curved lenses, concave to the subject. Two such doublets, concave to a central stop, are the basis of the Double Gauss form of lens. Derivatives with a minimum of 6 or 7 elements give a useful $f/2$ design.

Modern camera lenses

The highly-corrected camera lenses in use today are usually based on triplet designs for the lower price, moderate aperture varieties and Double Gauss designs for large aperture constructions. Symmetrical design is used for lenses for large format cameras, copying lenses and some types of wide-angle lenses. Highly-asymmetric designs are used for telephoto, retrofocus and fisheye lenses. The complex zoom lens has origins in the triplet design. Completely different in concept, and used only for long-focus lenses, is the mirror lens construction, using reflecting surfaces for its primary means of image formation.

The relationship of these lenses, except for the last type, to the achromatic doublet is shown in Figure 7.2 and Table 7.2 lists some of their features. A selection of typical constructional designs by one manufacturer is shown in Figure 7.4.

The standard lenses for most film formats have reached a high level of development with large, usable apertures and uniform performance over their angle of view. However, the standard lens cannot fulfil all requirements, particularly when photographs of wide coverage in cramped surroundings or of distant, inaccessible objects are required. In such instances, replacement by a wide-angle lens or long-focus lens is necessary. Both types of lens have a long development history and exist in a small number of distinct design types. Developmental work for both types has been intense in recent years.

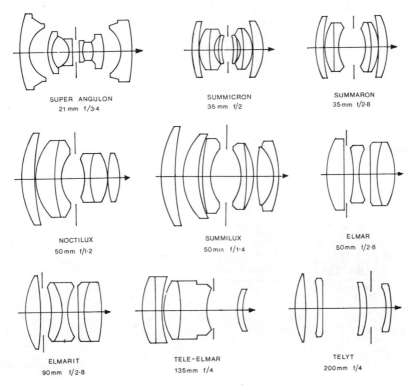

SUPER ANGULON
21mm f/3·4

SUMMICRON
35mm f/2

SUMMARON
35mm f/2·8

NOCTILUX
50mm f/1·2

SUMMILUX
50mm f/1·4

ELMAR
50mm f/2·8

ELMARIT
90mm f/2·8

TELE-ELMAR
135mm f/4

TELYT
200mm f/4

Fig. 7.4 — Construction of some modern camera lenses

Wide-angle lenses

Wide-angle lenses, i.e. referring to a lens whose focal length is less than the diagonal of the film format, have been in use since the earliest symmetrical versions were produced in the middle of the 19th century. Simple meniscus or achromatic doublet versions were used, then more complex designs using the new glasses. Such designs are still in use but with severe limitations on covering power due to the $\cos^4 \theta$ Law, fall-off in image quality at the edges and small usable apertures, typically about $f/22$.

Symmetrical derivative designs

Forms of quasi-symmetrical construction have been found to be advantageous in improving evenness of illumination, image quality and the use of larger apertures up to about $f/2·8$. The correction for distortion is particularly outstanding. These derivatives use very large, negative meniscus lenses either side of the small central positive groups, giving the lens a characteristic wasp-waisted appearance and increasing its relative bulk. Such lenses used on technical cameras even allow limited use of camera

127

The Camera Lens

NAME OR TYPE	BASIC OPTICAL CONSTRUCTION	ABERRATION CORRECTIONS		SPECIAL FEATURES OR ADVANTAGES OF THIS DESIGN OR CONSTRUCTION	USES
		EXCEPTIONAL FOR	POOR FOR		
MENISCUS			A, D, F	CHEAP LOW FLARE	SIMPLE CAMERAS CLOSE-UP LENSES
LANDSCAPE		CA	A, F	ACHROMATIC	SIMPLE CAMERAS CLOSE-UP LENSES
SOFT-FOCUS PORTRAIT			DELIBERATE SPHERICAL ABERRATION	CONTROLLABLE RESIDUAL ABERRATIONS	PORTRAITURE
PETZVAL		S	A, F	LARGE APERTURE GOOD CORRECTION	PORTRAITURE PROJECTION
SYMMETRICAL		D	F	DISTORTION FREE	GENERAL
DOUBLE ANASTIGMAT		D	S	DISTORTION FREE COMPONENTS USABLE SEPARATELY	GENERAL
DOUBLE GAUSS		S, C	D	LARGE APERTURES POSSIBLE	LOW LIGHT LEVEL WORK
TRIPLET				GOOD CORRECTION FOR ALL ABERRATIONS. CHEAP	GENERAL
QUASI-SYMMETRICAL		D		WIDE-ANGLE LENS DISTORTION-FREE	AERIAL SURVEY WORK RANGEFINDER CAMERAS
PROCESS		ALL		HIGHLY CORRECTED	COPYING AND CLOSE-UP WORK
TELEPHOTO			D	SHORT BACK FOCUS COMPACT	LONG-FOCUS LENS
RETROFOCUS			D	LONG BACK FOCUS REFLEX FOCUSING	WIDE-ANGLE LENS FOR SLR CAMERA
FISHEYE			DELIBERATE DISTORTION	FIELD ANGLE EXCEEDING 180° REFLEX FOCUSING	CLOUD STUDIES SPECIAL EFFECTS
ZOOM			D	VARIABLE FOCAL LENGTH WITH CONSTANT f-NUMBER	GENERAL
MIRROR		S, CA, L	A, F	COMPACT CONSTRUCTION LIGHT WEIGHT	LONG-FOCUS LENS

S SPHERICAL ABERRATION
CA CHROMATIC ABERRATION
L LATERAL COLOUR
C COMA
A ASTIGMATISM
D DISTORTION
F FIELD CURVATURE

Table 7.2 – Modern lens types

128

movements such as rising front. Unfortunately, in common with the simpler symmetrical form, they have a very short back focal distance so the rear element is only a short distance from the film plane. Consequently any form of reflex viewing is impossible and lenses of retrofocus construction must then be used.

Retrofocus designs

Departure from the symmetrical form of construction by using a front divergent group with a rear convergent group, gives a lens with a short focal length in relation to its back focal distance (Figure 7.5). This arrangement is the opposite of the telephoto construction (page 130) and is often termed a "reversed telephoto" or "inverted telephoto" lens. The asymmetry can give rise to barrel distortion, found in earlier designs and less well-corrected lenses. The long back focal distance permits devices such as shutters, beam-splitters and reflex mirrors to be inserted between the lens and film. Offsetting this gain are the disadvantages of increased complexity of construction because of the corrections required, its associated cost, bulk and weight.

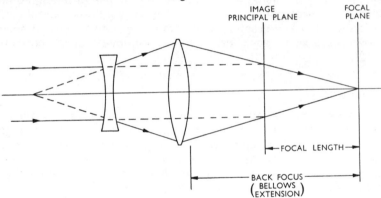

Fig. 7.5 — Arrangement of telephoto lens

Fisheye lenses

As discussed in Chapter 5, the geometry of image formation and illuminance limit the field of view of a lens to about 120°, even making use of various means of reducing the effect of the $\cos^4\theta$ Law, provided that the lens is to be free from distortion. But if the distortion-free requirement is abandoned and barrel distortion introduced, then a lens may be produced covering field angles up to 180° or more. Extreme retrofocus construction is generally used to permit reflex viewing. Such lenses are termed "fisheye" lenses and two varieties are available. The *quasi-fisheye lens* is one which fills the whole format, covering 180° with pronounced barrel distortion, but using central projection for image formation. The true *fisheye lens* gives a circular image on the film format, covers 180° or more and uses an alternative form of projection for the

image. This is usually *equidistant* projection, where image height Y as measured from the principal point of the format or optical axis of a lens of focal length f in terms of the semi-field angle θ is given by $Y = f.\theta$ instead of the usual $Y = f.\tan \theta$ for central projection. Such lenses have many technical applications.

Long-focus lenses

A long-focus lens is one whose focal length is greater than the diagonal of the format in use. The usual design varieties of achromat, Petzval, symmetrical, Double Gauss and triplet have all been used, depending on the maximum aperture required and focal length. Very long-focus lenses of small aperture can be of the simplest construction, i.e. achromatic doublets. However there are problems with the use of such designs. The use of refracting lenses is limited to the diameter of available glasses and by the severe effects of lateral colour as focal length is increased. Also, the great length and weight of such lenses poses design and handling problems. The possibility of flare from the long lens mount is also ever-present. The bulk problem has been offset by the use of telephoto construction and mirror optics, this latter also solving some lateral colour aberration problems. Refracting elements made from fluorite or special extra-low dispersion glass can greatly improve colour correction (page 124).

Telephoto lenses

By placing a suitable negative lens behind an ordinary objective, the pencil of rays is rendered less convergent and comes to a focus as though it had been formed by an objective of much greater focal length; i.e. the principal planes (Chapter 4) are well in front of the lens. The required camera extension, however, is very much less than would normally be needed for a lens of such long focus (Figure 7.6).

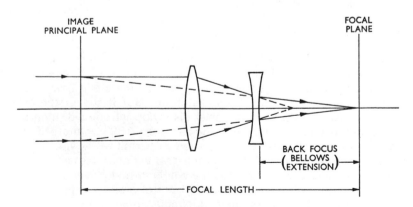

Fig. 7.6 – Arrangement of "reversed" telephoto lens

On this principle, *telephoto attachments* were formerly used in conjunction with ordinary lenses for obtaining a variety of focal lengths with relatively short camera extension. This system, however, yielded focal lengths much too great for general utility and resulted in greatly reduced apertures. Telephoto attachments have, therefore, now been very largely replaced by complete *telephoto lenses*, all the components of which are fully corrected, and which yield more useful values of focal length.

The ratio of the focal length of a telephoto lens to its back focus is termed its *power*. The effect of using a telephoto lens of, say, 2× power is approximately to produce an image twice the size (linear) of that given by a normal lens with the same back focus. A telephoto lens power of less than 2 is not worthwhile from the design point of view, and, conversely, a power much greater than 3 results in too small an aperture. Maximum apertures of modern telephoto lenses approach those of lenses of normal design.

As a class, telephoto lenses have not the highest definition, but they usually have adequate definition for most purposes. They tend to suffer to some extent from pincushion distortion, but provided the angle of view is small this is not usually very serious. Telephoto lenses are very useful for obtaining pictures on a larger scale in the case of distant subjects, and also for semi-close-up work. Assuming that a long-focus lens is needed, the telephoto construction reduces the risk of camera shake, because the camera is better balanced than with an ordinary long-focus lens. Telephoto lenses are less likely to be damaged than ordinary long-focus lenses because they project less; they also have the advantage of being lighter in weight.

So far as their use is concerned, telephoto lenses differ in only one respect from ordinary anastigmats. This difference, which is due to the type of construction, relates to the manipulation of a technical camera when photographing a subject containing vertical lines with the camera in a tilted position. In such circumstances, with an ordinary lens, the camera back needs to be swung so as to bring the film into a vertical plane, otherwise parallel lines in the subject will appear in the photograph to converge upwards (page 190). With a telephoto lens, however, in the same circumstances, the camera back should be swung through only part (approximately one-half) of the angle which would bring the film into the vertical plane.

Mirror (catadioptric) lenses

The advantage of using a mirror reflecting surface instead of a refracting element to form an image is that no chromatic dispersion takes place. Such an approach was used by Newton for a reflecting telescope because achromatic correction was then unknown. Other problems arise, however. For photographic purposes, there must be convenient access to the image, so the Cassegrainian form of mirror objective must be used, requiring a secondary reflector. A specially-figured, aspheric reflector such as a paraboloid is used in astronomical telescopes. This is too

expensive for photographic purposes, which also need larger apertures. If a simple concave spherical mirror is used, the image suffers both from spherical aberration and curvature of field. In addition, strong, off-axis aberrations limit the field of view. The construction is, therefore, suitable only for long-focus objectives.

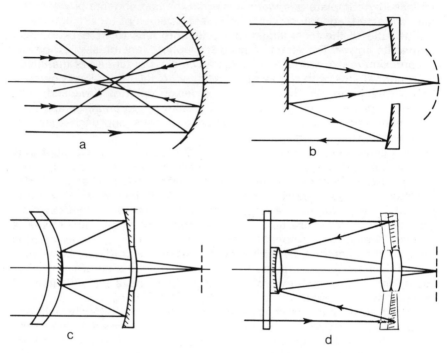

Fig. 7.7 – Mirror lens designs.
(a) Simple spherical mirror with spherical aberration.
(b) Cassegranian construction with secondary reflector.
(c) Bouwers–Maksutov design.
(d) Mangin mirror design

Spherical aberration may be corrected in various ways (see Figure 7.7). An aspheric, Schmidt corrector plate at the centre of curvature is used for large aperture, wide-field cameras of high cost. Cheaper alternatives are to use a Mangin mirror, where the reflecting surface is coated on the rear surface of a refracting element, or to use refracting lenses concentric with the spherical mirror. This latter approach was pioneered independently by Bouwers in Holland and Maksutov in Russia during World War II. The introduction of refracting elements constitutes a *catadioptric* design compared with the pure mirror, *catoptric* version. The refracting elements need to be achromatised but their power may be chosen so as to give a flat field. They may also be conveniently positioned both to seal the mirror lens

barrel and to provide a support for the secondary reflector. In all designs flare is a problem and careful baffling and anti-flare construction is essential.

Because of the central obstruction of the secondary mirror, such a lens cannot be stopped down with an iris diaphragm. Exposure control is by means of neutral density filters or the camera shutter speed. Many mirror lenses are fitted with a filter turret.

Various mirror lenses are available, usually with focal lengths in the range of 300 to 2000 mm and apertures of $f/5 \cdot 6$ to $f/11$. The compact design of short length and wide diameter is advantageous in comparison with equivalent long-focus or telephoto constructions. The use of solid glass construction to reduce optical path length has reduced dimensions even further as well as providing design stability.

Zoom lenses

There are many occasions when a lens of variable focal length, termed a *zoom* lens, can be most helpful. These include use of a fixed camera position, the rapid alteration of image size and tight framing of a picture. A variety of such lenses is now available, development being initially for cinematography and television, but excellent designs predominantly for 35 mm still cameras and a very few for larger formats have been produced.

The principle involved in such lenses is variation in the separation of the positive and negative elements of a lens giving an alteration in focal length. Early forms of zoom lens were the variable separation telephoto lenses which gave, in addition, a variation in aperture with separation as well as various amounts of uncorrected aberrations, particularly distortion.

The modern zoom lens has been developed largely since World War II, especially with the aid of digital computers for the necessary complex calculations and using lens coatings to offset the effects of the large numbers of lens elements. The moving group or groups of elements provide variation in focal length together with a constant f-number and fixed image plane by either *mechanical* or *optical compensation* depending on the individual and independent axial movements of the movable elements. Some lenses are *variable focus* or *varifocal* requiring refocusing after each change in focal length, conferring the advantage of design simplicity.

The *zoom ratio* of a lens is the ratio of maximum to minimum focal lengths available. While 30:1 and 20:1 are common in film and television work, much more modest 2:1 to 5:1 ratios are used in still camera lenses. Usually the focal length range covers medium long focus to long focus or semi-wide angle to medium long focus. Zoom wide-angle lenses are uncommon.

Many zoom lenses also offer a close-focusing facility independent of their normal focusing range. At a particular fixed focal length, the zoom

elements are controlled by a separate focusing ring to give image magnifications of the order of 0·2 to 1·0.

The experience gained in zoom lens design has also permitted the inclusion of a "floating" element in standard and wide-angle lenses of fixed focal length to retain image quality by offsetting spherical aberration when close focusing.

8 Types of Camera

Introduction

A CAMERA is essentially a light-tight box with a lens at one end and a fixture to hold light-sensitive material at the other. In all but the simplest cameras there is provision for variation of the lens to film distance in order to focus upon objects at various distances from the lens. Light is normally prevented from reaching the sensitive material by a shutter, the function of which is to give an exposure time of a required duration. During this exposure time the amount of light reaching the film is controlled by an iris diaphragm, the aperture of which may also be varied as required. The settings of the shutter and iris diaphragm may be determined by an exposure measuring system as part of the camera, possibly measuring through the lens. Finally, the camera must have a viewfinder system by which the amount of subject area included on the film may be determined.

Survey of development

The outstanding feature in the development of the camera since the primitive forms used in the early 19th century is the continuous fluctuation in weight, size and shape with the innovations and improvements in design. Such changes are due to parallel developments in emulsion technology, optical design and manufacturing techniques as well as being directly related to the camera format, materials of construction and versatility of function.

Camera format

For the last decades of the 19th century and continuing well into the 20th, the majority of photographs were taken on glass plates. Contact printing was the normal practice and to obtain large prints plate sizes up to 305 × 381 mm were not uncommon. Indeed, quarter-plate (82 × 108 mm) was regarded as the minimum useful size. Apart from the com-

monly adopted plate sizes there were some unusual ones for specific cameras. Steady improvements in lenses, emulsions and illuminants soon made projection printing a feasibility and started the steady decrease in format size. The advent of roll film hastened this process and brought the 60 × 90 mm format on 120 size material to great popularity just before the start of World War II. By this time the 24 × 36 mm film was beginning to be less of a novelty.

This latter format has stabilised in spite of sporadic efforts to introduce variations such as 24 × 32 mm and 28 × 40 mm. For a few years the "half-frame" format of 18 × 24 mm proved popular on account of film economy and the range of very compact cameras available. The advent of cameras of similar bulk and comprehensive specifications but using the conventional format of 24 × 36 mm soon ousted the smaller format and meant its rapid obsolescence.

The desire for a truly pocketable camera was satisfied with the introduction in the early 1970's of yet another format, 11 × 17 mm on film 16 mm wide in preloaded cartridges, designated 110 size.

Roll films have been manufactured in very many sizes but most are now obsolete or obsolescent. The commonly available sizes are coded 110, 126, 127, 120 and 220 together with film of width 35 mm and 70 mm. The 110 and 126 sizes are in the form of plastic easy-load cartridges with pre-fogged frame rebates. The 126 format is 28 × 28 mm on film 35 mm wide. Both of these are widely used in simple or automatic cameras intended primarily for the amateur photographer or casual user. The 127 size is obsolescent, no new cameras for this size having been introduced for some years. Formats 30 × 40 mm, 40 × 40 mm and 40 × 65 mm were commonly used, giving 16, 12 and 8 exposures respectively per roll. The most commonly used roll film at present is the 120 size and this gives a choice of format sizes: 45 × 60 mm, 60 × 60 mm, 56 × 72 mm and 60 × 90 mm, giving 16, 12, 10 or 8 exposures respectively per roll. These numbers are doubled for the 220 size, of the same width as 120 but twice as long and minus the backing paper. The same formats are used on 70 mm perforated film, but the choice of emulsions is limited. A variety of folding roll film cameras, twin-lens and single-lens reflex cameras as well as technical cameras use the 120, 220 and 70 mm film sizes.

Sheet films were once considered an inferior alternative to plates. The introduction of new plastic base materials such as polyester, with improved dimensional stability, has contributed to the decline in the use of plates for most purposes in recent years. Professional work has tended to become standardised on 102 × 127 mm and 203 × 254 mm sizes, while 60 × 90 mm, quarter-plate, half-plate and whole-plate formats are becoming obsolescent.

A large format size does not always mean bulk as well because ingenious construction methods have been used to reduce the size of the camera for carrying purposes. Technical cameras, even of the monorail type, may be collapsed to moderate dimensions. Cameras using 35 mm film began as very compact pieces of apparatus but have steadily in-

creased in bulk as their versatility has been extended. Cameras using 120 size film began as bulky box cameras which were superseded by compact folding models. These in their turn were replaced by the bulk of the modern twin-lens and single-lens reflex cameras. Many cameras have an adaptation feature to take a smaller format, e.g. roll film backs for technical cameras and 35 mm adapters for 120 size cameras.

The true pocket-size camera has existed in various forms for many years and generally uses perforated 16 mm film with a format size of about 11 × 17 mm. General availability of a standardised loading in the form of the 110 cartridge and improved emulsions have stimulated camera design and developments in this area.

Materials of construction

The materials used are an important feature in determining the weight of a camera. Early plate cameras were constructed of mahogany and brass with leather bellows. These gave low weight and reasonable precision. Ingenious methods of construction were used to reduce the size of the camera for carrying purposes.

Modern technical cameras of die-cast alloys and brass have increased greatly in weight but the bulk remains much the same. Bellows of square, taper or bag construction are still used except for aerial and press cameras.

Small format cameras demanded a precision given only by metal construction and small manufacturing tolerances. The all-metal construction meant a heavy camera, even if of only moderate size. Bellows were used to reduce size but are now obsolete.

Modern requirements of versatility have progressively increased the weight and bulk of these cameras.

Simple cameras have progressed from bulky, cloth-covered plywood boxes to constructions of modern plastics and light alloys. This has led to increased precision with a reduction in bulk but no increase in weight. Even precision cameras now use suitable plastics for components subject to low stress or wear and to enhance visual appeal.

Versatility of function

On early cameras, features such as triple-extension bellows, extensive range of movements, interchangeable lenses and interchangeable backs were taken for granted. As types of cameras developed many of these features were lost. For example, restricted focusing movements often allowed lenses to be focused no closer than one metre; for closer work special attachments were needed. This trend has now reversed and the standard lens on most cameras will focus continuously down to about 500 mm or less without attachments.

Large-aperture lenses require precision-built camera bodies, which entails the loss of camera movements, but the limited circle of sharp definition of such lenses would not permit their use anyway.

137

Types of Camera

Interchangeable lenses became a rarity until the advent of modern small format cameras, especially those of the single-lens reflex type. The facility of interchangeable backs is still limited to a few cameras.

The above comments, of course, do not apply to technical cameras, which have retained all these features and have been much improved by modern innovations such as modular construction, optical bench construction, "international" backs and electronic shutters.

The continuing trend with small-format cameras is to incorporate features to increase versatility, but unfortunately bulk and weight also tend to increase. In accordance with such requirements, 24 × 36 mm, 45 × 60 mm and 60 × 60 mm format cameras are now produced as the basic unit in a "system" of interchangeable lenses, viewfinders and backs, remote control, motor drive, attachments for photomicrography and photomacrography etc. Such a system increases versatility enormously in comparison to haphazardly produced accessories.

Another welcome trend is the consideration of ergonomics in camera design. Cameras are increasingly being designed to be more easily operated when held in the hand. Such improvements include the increased legibility of scales and calibrations, the direction and amount of movement in focusing rings, larger and better-sited controls, large eyepieces in viewfinders, ease of loading and rapid-loading systems.

Another aspect introduced by the versatility of a camera is the increased possibility of faults in the complicated mechanism. Repairs may be more frequent and call for increased skill on the part of the repairer. Modular design of units such as the shutter assembly, greatly facilitates any servicing or maintenance work. The increasing use of electronic components in cameras has certainly not contributed to any significant increase in camera malfunctions as modern solid-state devices have proved to be most reliable. Simple maintenance such as changing batteries that operate electronic shutters and exposure metering systems is the responsibility of the user.

Camera types

There have been many different types of camera manufactured both for general work and for specialised purposes in conjunction with a range of accessories.

It is usually possible to place a particular camera into one of these fairly well-defined types although some designs, of course, are unique and not easily categorised. The following are the main types marketed today (see Figure 8.1):

Simple cameras
Rangefinder cameras
Twin-lens reflex cameras
Single-lens reflex cameras
Technical cameras
Special-purpose cameras

Simple cameras

Evolving from the early primitive box camera, the simple camera has changed little in specification but much use has been made of modern plastics and light alloy stampings. Design and styling have undergone great changes.

Basically the camera has a simple meniscus or doublet lens with an aperture of about $f/11$ with perhaps a facility for stopping down to $f/16$ and $f/22$, as indicated by "weather" symbols on the aperture control. The lens may be fixed-focus, set at the hyperfocal distance to give reasonable sharpness from about 2 metres to infinity. A "portrait" supplementary lens may be available, bringing the nearest distance giving reasonably sharp focus down to about 1 metre. Alternatively, the lens may have an elementary focusing mechanism of the three-point type using symbols to indicate the depth of field obtained; e.g. portrait, 1–2 metres; group, 2–8 metres; landscape, 3 metres to infinity.

The shutter is usually of the simple everset type with two settings, one for "instantaneous", about 1/40th sec., the other a "B" setting. The shutter is normally synchronised for flash work and many cameras have a built-in flashgun for small, capless flashbulbs or a fixture for flashcubes.

The viewfinder is either a bright, optical one or of the brilliant, reflex type for viewing only and with no focusing function.

The formats used have varied greatly, from 8 on 120 film (60 × 90 mm) to 16 on 127 film (30 × 40 mm), but the choice has dwindled to 12 on 120 film (60 × 60 mm), or the 12 or 20 exposures of 126 size cartridges, with 28 × 28 format, and the 20 exposures of 110 size cartridges.

Following the success of the 126 size cartridge which revolutionised simple camera design with its simple drop-in loading, the 110 cartridge allowed even smaller dimensions, with cameras only some 25 mm thick in most cases. Notwithstanding such small volumes and the original concept of the simple camera, many such pocket cameras are available in a range of progressively comprehensive specifications. In particular, exposure automation using an electronic shutter is common, even in models with a lens of modest aperture and fixed focus. The prevalent use of flash with such cameras and the possibility of "red-eye" effects caused by the proximity of the flash reflector to the optical axis, generally necessitates the use of an extender device to increase their separation.

The accompanying improvements in sensitised materials, especially colour negative emulsions, to allow enlargement from the 110 format to enprint size or larger, have also been of great benefit to larger formats.

Rangefinder cameras

This type of camera utilises a coincidence-type rangefinder system (page 171), coupled to the focusing mechanism of the lens to enable the lens to be accurately focused at the subject distance. Some cameras do not have the rangefinder coupled and the indicated distance must be transferred to the lens.

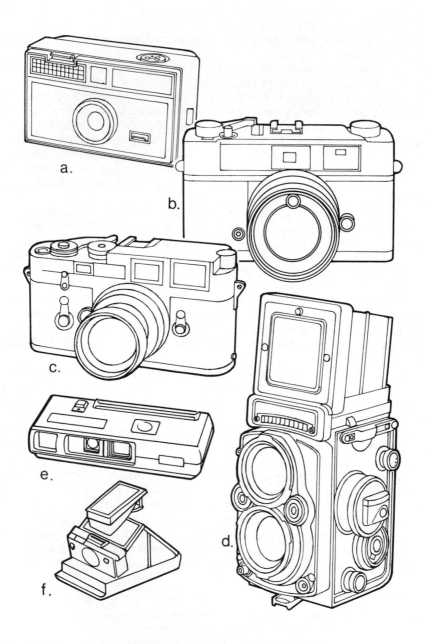

Fig. 8.1 – Camera types: (a) Simple camera using 126 film; (b) Rangefinder camera with fixed lens; (c) Rangefinder camera with interchangeable lens; (d) Twin lens reflex with fixed lenses; (e) Pocket camera for 110 size film; (f) Camera for self-developing film

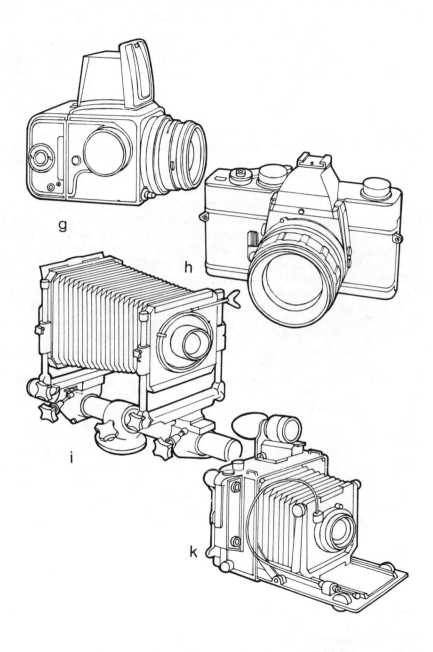

Fig. 8.1 – continued: (g) Single lens reflex for 120 film; (h) Single lens reflex for 35 mm film, (j) Technical camera, monorail; (k) Technical camera, folding baseboard

This method of focusing appeared with the introduction of the early 35 mm cameras, such as the Leica and Contax, being essential for the accurate focusing of large aperture lenses, especially at close range. The method was soon adopted in cameras using other formats, up to and including half-plate technical cameras. Both swinging mirror and rotating optical wedge systems were in common use. Design advanced rapidly in conjunction with improvements in viewfinders and soon combined range-viewfinders with bright line frames were common. Small format roll-film cameras evolved similarly but many ingenious solutions were required to give an accurate rangefinder system when a folding bellows design was used. Press cameras favoured a robust coupled rangefinder, but as a separate item and not as part of the viewfinder. Interchangeable lenses presented a problem as the fixed base-length of the rangefinder meant that focusing accuracy decreased with increase in focal length. Also the limited mirror movement meant that the closest focusing distance was progressively further away from the camera with increase in focal length. In technical cameras, changing lenses also meant changing the focusing cam for the feeler arm coupled to the rangefinder mirror. Each lens had to have an individually calibrated cam. In 35 mm cameras the feeler arm operated on a cam on the lens barrel. Close-focusing devices for rangefinder cameras were clumsy arrangements, in general.

The use of a rangefinder does, however, permit a compact camera design. Rangefinder cameras now fall into distinct categories. Mainly they are 35 mm cameras of moderate specification with a non-interchangeable lens and some form of exposure automation, but there are one or two types of the highest quality, e.g. the Leica M5. A number of medium-format press-type cameras use coupled range-viewfinders as do some large-format technical cameras of the folding baseboard type. The latter also have normal ground-glass screen focusing facilities.

Twin-lens reflex cameras

This type of camera has enjoyed great popularity for many years since the introduction of the earliest version in the form of the first Rolleiflex. Much of this popularity is due to simplicity in use and versatility. Such a camera really consists of two cameras mounted one on top of the other, the upper for viewing and focusing and the lower for exposing the film (Figure 8.2). The two lenses must have the same focal length but the one used for viewing may be of simpler construction and have a larger aperture to facilitate focusing in dim light. The two lenses are mounted on the same panel which is moved bodily to provide continuous viewing and focusing. The reflex mirror gives an upright, laterally reversed image on a ground-glass screen. The screen is shielded for focusing by a collapsible hood with a flip-up magnifier. This hood may be interchangeable with a pentaprism system for eye-level viewing and focusing. The focusing screen may incorporate a fresnel lens, split-image rangefinder or a micro-prism to assist focusing. The viewing lens is always used at full aperture. The operations of film transport and shutter setting are normally done by means of a folding crank device.

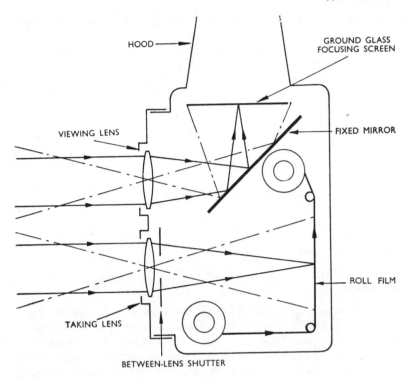

Fig. 8.2 – Principle of the twin-lens reflex camera

This type of camera has been designed for many formats and film sizes, including short-lived 35 mm and 102 × 127 mm types. The most common sizes were 60 × 60 mm and 40 × 40 mm given by 12 exposures on 120 and 127 film respectively. But even the 40 × 40 mm format is obsolete and the use of 120 or 220 film is predominant. The square format was originally chosen so that the camera could always be held vertically for viewing and focusing, the negative being "cropped" during enlargement to give the final composition. Alternative formats on 120 film were obtained by means of adapters and 35 mm film could also be used in some models. Specialised accessories taking plates, 70 mm film and Polaroid film are also available.

Two disadvantages of the twin-lens reflex camera are its bulk and its non-interchangeable lens. To overcome the latter disadvantage some cameras were supplied with lenses of longer or shorter focal lengths than the standard 75 mm or 80 mm usually fitted, but these were short-lived. However, a new lease of life was given to the camera type with the introduction of interchangeable lenses on the early Mamiyaflex model in the late 1950's. This camera has since evolved into a "system" with a range of bodies, viewfinders, focusing screens, backs and lenses. The outstanding feature of the system is the provision of a series of pairs of interchangeable lenses, complete with shutter, mounted on a common

143

lens panel and the ability to focus very close due to the bellows arrangement used.

One of the problems associated with all twin-lens reflex cameras is the field-of-view error in the viewfinder screen due to the separation between viewing and taking lens. Attempts at solving this problem have included the use of a viewing screen of reduced area, a swivelling viewing lens, moving masks and moving pointers to delineate the top of the field of view. The problem becomes more acute with close focusing; use of a wedge-shaped prism over the viewing lens when supplementary lenses are used is a partial answer, but a lifting device to raise the camera bodily on a tripod by the distance between optical axes is needed for accurate work.

The twin-lens reflex camera is usually fairly rapid in its action when provided with crank-lever operation and convenient placement of controls. The disadvantage of earlier models in providing only 12 exposures on 120 film has now been offset by the facility of using 220 film to obtain double that number.

Single-lens reflex cameras

This type of camera has been popular since its introduction in the late 19th century, apart from a temporary slump when the twin-lens reflex design was introduced. Now, after a period of intensive development in the 35 mm and 120 roll sizes, it is perhaps the leading design. Most of the recent innovations in camera design have first appeared in a single-lens reflex camera.

The principle of the camera is illustrated in Figure 8.3. A plane, surface-silvered mirror at 45° to the optical axis is used to form the image from the camera lens on a screen where it may be focused and composed. For exposure the mirror is swung out of the way before the camera shutter opens. The mirror is then returned to the viewing position. These simple operations have evolved to ones of great complexity, involving many sophisticated mechanical operations, details of which are given in Chapter 9.

The great advantages of this design are the ease of viewing and focusing, and the freedom from field-of-view error, especially important for close-up work. The effect of the depth of field at the selected aperture may also be judged.

The earliest designs were for quarter-plate and 102×127 mm formats. A rotating back was an essential part of the design so that upright or horizontal pictures could be composed on the rectangular format. The interchangeable lenses had only an iris diaphragm and were focused using a bellows arrangement on a rack-and-pinion drive. The counterweighted, pivoted mirror was raised by pressure on the release lever which first lifted the mirror out of the way and then released a focal-plane shutter.

After the decline in the use of this type of large-format camera, with the advent of the twin-lens reflex, the design appeared again for 35 mm,

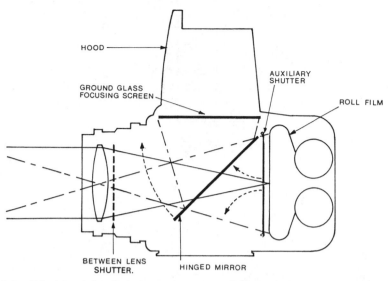

Fig. 8.3 – Principle of the single-lens reflex camera (*Hasselblad*)

127 and 120 size films, an important early model being the Kine-Exakta. Such cameras were popular because of their small size. Innovations included a focal-plane shutter with an extended range of speeds and the mirror was spring-operated, returning to the viewing position upon winding-on the film. The loss of the viewfinder image at the moment of exposure and until the film was wound on to the next frame, was always regarded as a disadvantage of the design. The *instant-return mirror*, now standard on almost all such cameras, permits continuous viewing except while the shutter is open.

The use of the rectangular formats of 24 × 36 mm and 45 × 60 mm was inconvenient when a vertical framing was required for a picture. Usually a direct-vision viewfinder had to be used. The square format of 60 × 60 mm allowed the camera to be held in one position for all photographs and the picture shape determined at the composing or printing stages.

Shortly after World War II, the pentaprism viewfinder was introduced and this boosted the popularity of the single-lens reflex camera enormously. Now eye-level viewing and focusing was possible and the image remained erect and un-reversed for both horizontal and vertical formats. The principle of the pentaprism viewfinder is illustrated in Figure 8.4.

Design innovations and improvements initially were all for the 24 × 36 mm format cameras, but the 60 × 60 mm type was also developing, albeit in much fewer numbers, and is now on a par with the smaller format. Among the improvements were reliable focal-plane shutters with a wide range of shutter speeds. Flash synchronisation of these shutters had always been a problem, but now some for the smaller format are capable of synchronisation with electronic flash at speeds up to 1/125th

145

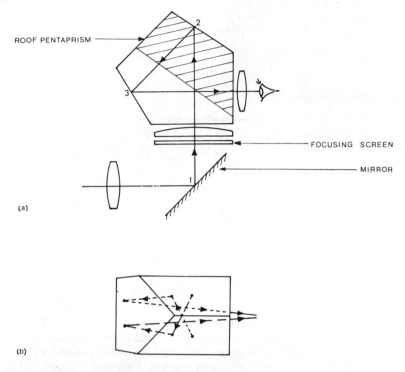

ROOF PENTAPRISM

FOCUSING SCREEN

MIRROR

(a)

(b)

Fig. 8.4 – Action of a pentaprism viewfinder
(a) Side view
(b) top view showing cross-over

sec. Following the introduction of the instant-return mirror the operation of the iris diaphragm, once always manually stopped down just before exposure, evolved into the *fully-automatic diaphragm mechanism (FAD)*.

Improved viewfinder focusing screens with microprisms and optical rangefinders became standard fittings, often with a choice of alternative screens for specialised purposes.

A vast range of lenses, many from independent manufacturers, became available to fit the cameras, ranging from fish-eye to extreme long-focus types. A feature generally confined to the 60 × 60 mm format was the facility of interchangeable magazine backs.

A further great advance in the design of the single-lens reflex camera first became available in mid-1960's. This was *through-the-lens* (TTL) *metering*. The availability of reliable cadmium sulphide (CdS) cells of the required sensitivity and spectral response, coupled with the ease of showing the measurement area in the viewfinder of this type of camera, ensured rapid development of the system. (See page 177).

The great advantages of the single-lens reflex design have meant that it has become probably the most highly-developed system camera and the basic unit for a wide range of accessories. Especially in the case of

the medium format roll-film type, it is increasingly replacing the technical camera for many of those functions which do not specifically call for a large format or use of camera movements. Improvements in optics and emulsions for the smaller camera have ensured high-quality results.

Technical cameras

The term technical camera is used to cover two types of camera. The first is the monorail type, as illustrated in Figure 8.1. This is based on the optical bench principle giving the widest possible range of camera movements. All focusing and composition is done on the ground-glass screen and the camera must therefore be used on a rigid support. The second is the folding baseboard type, as illustrated in Figure 8.1. This camera is of precision manufacture, normally equipped with a coupled rangefinder and optical viewfinder as well as a ground-glass screen, and may therefore be used in the hand as well as on a tripod.

The rationalisation of the technical camera to these two types is another example of continuing improvements in design, manufacture, functional capabilities and automation of operation.

The early wood and brass studio and field cameras were adequate for large format work but very slow in operation. Improvements in lenses and the preference for smaller formats called for greater precision in manufacture. Metal was substituted for wood in the camera body to achieve this, but of course weight was substantially increased. A measure of standardisation was achieved in the sizes of items such as lens panels and backs for darkslides.

Technical cameras have been made in a large number of formats but the number have gradually been reduced. The term "medium format" covers cameras using 56 × 72 mm and 60 × 90 mm negative sizes, but there are few cameras in this category, monorail models being especially rare. The term "large format" covers film sizes of 102 × 127 mm to 203 × 254 mm, but the intermediate sizes of half-plate and whole-plate are rapidly becoming obsolescent. Most cameras in this range feature *reducing backs* as an accessory permitting the use of smaller formats when required for reasons of convenience or economy.

As with other camera types, the modern technical camera is now usually a "system" camera. The basic camera body may be fitted to or adapted with a host of accessories, covering alternatives to almost every component. This is especially true for the monorail camera which is usually designed on modular principles so that rails, front and rear standards, bellows, focusing screens, lenses and shutters are interchangeable to adapt for a range of formats or types of work.

The folding baseboard camera uses a high precision rangefinder normally coupled to three alternative lenses. Viewing is by means of a multiple-frame, bright-line viewfinder. Flat films, roll films, plates and Polaroid materials may all be used. Offsetting its capability of being used in the hand it has a much more limited range of movements than the monorail type. The ground-glass screen must be used for close-up work or camera movements

147

because the rangefinder is then no longer operative. The bellows is usually of the triple-extension type.

Recent developments for technical cameras have included forms of through-the-lens exposure measurement, pre-set mechanisms for shutter speed and aperture settings, electronic shutters, extreme wide-angle lenses of large, usable aperture and binocular viewing and focusing devices.

Special purpose cameras

Many cameras do not fit easily into the classifications given above because they may fulfil limited but specialised functions. Also there are a number of types of camera of which few, if any, examples may currently be in production. Other types are so specialised that production is very limited, possibly to order only. Some cameras are limited to the use of very specific types of film. The following list includes examples of all such categories.

Cameras for self-developing materials

Many cameras are available to take the ranges of self-developing films manufactured by the Polaroid Corporation and Eastman Kodak. These materials are available in roll film, sheet film and film-pack forms and the formats used currently range from 60 × 90 mm to 102 × 127 mm. Both colour and black-and-white materials are available, see page 378. These cameras range from simple plastic types with minimal control of functions to sophisticated, complex models with electronic shutters and full automation of functions, including ejection of the exposed film. The geometry of image formation and the sequence of the layers in the particular film type, may require one or two reflections from mirrors in the camera body in order to obtain a laterally correct image in the print. This requirement can lead to a bulky, inconvenient shape or call for considerable design ingenuity to permit folding to a more compact size for carrying.

Conventional types of film cannot be used in these cameras although adapter backs are available to permit the use of self-developing materials in conventional cameras. A camera designed for one type of self-developing film is incompatible with other varieties.

Such camera and film combinations are often most convenient to use and find a large number of serious applications apart from amateur photography. A wide range of accessories is available to extend their scope.

Subminiature and pocket cameras

Cameras of this type have been popular since the earliest days of photography, appearing in many novel forms, but their common feature was the use of a very small and often unusual format. The term "sub-

miniature" referred to use of a film gauge narrower than 35 mm. Often this was 16 mm film, perforated or unperforated, and loaded in special cassettes to give a moderate number of exposures. The usual problems of incompatibility of cassettes and difficulties in obtaining supplies of film restricted their popularity. The advent of the 110 format using specially perforated 16 mm film in a cartridge of standard dimensions and in a range of types of sensitised materials, revitalised the design of such small cameras. The modest dimensions of such cameras led to the generic title of "pocket" cameras and they found a ready acceptance by the general public not wishing to be burdened by the weight and bulk of most cameras and who appreciated their ease of loading. Many pocket cameras have a comprehensive specification as regards automation of functions such as exposure determination and the use of flash. Features such as zoom lenses and alternative long-focus lenses are available but with an inevitable increase in camera dimensions.

Press cameras

Cameras for press work were once almost exclusively of large format, typically 102 × 127 mm using plates to facilitate rapid processing. Often they were a simplified version of the folding baseboard type of technical camera, usually only retaining camera movements on the front standard carrying the lens. Other simplifications included limited bellows extension or a rigid box construction. The coupled rangefinder was retained and a focal-plane shutter was used in order to obtain high shutter speeds. Flash synchronisation, using Class FP bulbs, was essential. The design emphasis was on speed of operation and sturdiness. Cameras using smaller formats have almost replaced these early press cameras, but several medium-format roll-film cameras retain the basic features with some improvements. Ruggedness and swift operation is combined with lens changing by bayonet fittings, coupled range-viewfinders and rapid film advance by lever wind.

Aerial cameras

Most aerial cameras are rigid, remote-controlled fixtures in an aircraft, but for hand-held oblique aerial photography a few special cameras may be obtained. These are much simplified versions of technical cameras without any movements, rigid bodies and lenses set permanently on infinity focus. A fixture for filters is an important feature and a simple direct-vision metal viewfinder completes the requirements. Ample handgrips with incorporated shutter release are also supplied. If roll film is used, normally 70 mm material, film advance may be by lever wind or electrically driven.

Underwater cameras

Many cameras can be housed in a pressure container with an optically flat window to enable them to be used underwater. This is usually part of

the range of accessories for the camera. Unfortunately these casings are cumbersome. However, a few cameras have been designed as water-tight casings usable to specific depths for underwater work. They are also useful in adverse conditions on land where water, mud or sand would ruin the mechanism of most cameras. The cameras have a simple direct-vision viewfinder and focusing control. The lenses are in-terchangeable. A short-focus lens is fitted as standard to compensate for the optical magnification due to change in apparent distance caused by the refractive index of water. An equivalent field of view to a standard lens on a normal camera is then obtained. Special lenses corrected for underwater use with water in contact with the front element are also available. Such lenses cannot be used in air as aberrations are not then adequately corrected.

Ultra wide-angle cameras

When a large enough angle of view cannot be obtained by the normal range of lenses available for a camera, and when perspective and distor-tion considerations rule out the use of fish-eye lenses, then one of two types of camera embracing a large angle of view may be used.

Firstly, a camera body of shallow depth with a non-interchangeable lens of a large angle of view; e.g. an angle of view of 110° on the diagonal may be obtained on 24 × 36 mm and 102 × 127 mm format by the use of lenses of 15 mm and 65 mm focal length respectively. Focusing of such a lens is usually by scale and the viewfinder may be a simple direct-vision or optical type. A spirit level on the camera body is essential. Other features of the camera are as normal.

Secondly, a panoramic camera may be used. Typically, 140° horizon-tally and 50° vertically may be covered by rotating a normal design lens about its rear nodal point and imaging the scene on a slit which exposes the film sequentially during the exposure time. A high aspect ratio format is employed in such cameras.

Stereo cameras

Stereo cameras have been produced for many years, using a variety of formats on plates, sheet film and roll film. The very few examples in current production produce stereo pairs with formats of about 23 × 24 mm on 35 mm film. Pairs of matched lenses, on an otherwise normal camera body, have their optical axes separated by the average human interocular distance of about 70 mm to give a stereoscopic model of the scene, in an appropriate viewer, with depth extending from about 2 metres to infinity. Beam splitter attachments are available for some cameras to convert them into a form of stereoscopic camera.

Automation of camera functions and operations

Many of the operations of a camera once determined and set by the user are now operated by mechanisms of electrical, mechanical and optical

nature, to which the general title of "automatic" has been applied. Actually, the function should be classed as fully-automatic or semi-automatic, because many rely on manual assistance or pre-setting. The amount of automation in a camera varies enormously from model to model; some of the most advanced examples require only that the shutter release be pressed after selecting the subject. Even the film speed may be set on insertion of a film cartridge and the camera lens focused by a form of focus-seeking opto-electronic device.

Film advance after exposure was one of the first camera functions to be automated and initially, small clockwork motors were built into cameras for this purpose. Modern versions use small electric motors powered by a battery pack. Two varieties are available, the *auto-winder* which simply winds the film on to the next frame when the shutter button is released after exposure, allowing a maximum picture-taking rate of about 2 frames per second. The more sophisticated *motor-drive* allows rates of up to about 5 frames per second depending on the shutter speed selected. An accessory large-load film pack is useful with such a device, allowing up to 250 frames per loading. Motorised rewind is also usual. The bulk and weight of a camera may be increased considerably. The camera may be actuated in various ways when used in motorised mode. An intervalometer or broken light beam may initiate the exposure, for example. In conjunction with automatic exposure determination, such camera set-ups may be left to operate undisturbed and unsupervised for long periods.

The meaning of automatic as applied to most cameras, however, refers to the built-in exposure determination system, see page 422. Usually this is semi-automatic because the shutter speed or aperture controls must be manipulated to bring a moving needle, operated from the meter mechanism, into coincidence with a fixed mark or some other such arrangement. The potential susceptibility of the meter movement to damage plus the visual difficulties of operation in low light levels have been bypassed by use of arrays of light-emitting-diodes (LED's) which light up to display exposure setting information.

The true automatic camera sets the aperture or shutter speed according to a programme when the release is pressed to fire the shutter, the meter cell being actuated and operating the mechanism prior to the moment of exposure. Electronic shutters are widely used for this purpose because they are continuously variable over their exposure time range, which may be from many seconds to less than a millisecond. Pressing the release opens the shutter, the meter cell circuit then closes it when sufficient light for exposure has been recorded. By making use of the almost instantaneous reaction time of silicon photodiodes, the exposure in an SLR camera may be metered from the travelling shutter blind and the film surface itself, even when electronic flash is used with the camera.

Other forms of automation include the appearance of a visual signal if an indicated exposure of longer than 1/30th of a second is necessary, so that a tripod or flash may be used instead.

151

Types of Camera

Exposure automation in SLR cameras with focal plane shutters and automatic iris operation poses certain problems arising from the mechanical functioning of these components. Solid-state devices such as micro-processors and memories are among the methods used to permit automation of exposure by either *aperture-preferred* or *shutter-preferred* systems. The first system allows the aperture to be chosen by the user and the metering system then sets the necessary shutter speed. The second system requires the shutter speed to be selected and the aperture is then set accordingly. Both systems have their advantages and drawbacks, both from the operating and constructional considerations, and a choice of either would be ideal. It is worth noting in passing that increasing automation of camera has placed heavy reliance on battery power. Batteries should be checked or replaced at frequent intervals. Battery failure can sometimes render a camera completely inoperative.

Automatic cameras have generally been of smaller formats, such as 11 × 17 mm, 28 × 28 mm and 24 × 36 mm, but medium format SLR cameras now have equivalent specifications with the added advantage of more room in the camera body to house rechargeable nickel-cadmium cells for greater power and reliability.

9 The Elements of the Camera

AS indicated in Chapter 8, many of the advances in camera design and the emergence of the confirmed popularity of certain types, have been due to developments in design of one or more of the elements of the camera. Owing to the complexity and variations of each of these elements, together with their interdependence, it is worth examining each major design element in detail. The following will be considered in this chapter:

The lens	
Lens accessories:	lens hood
	filters
	supplementary lenses
	stereo attachments
	diffusion discs
	teleconverters
	afocal converters
	extension tubes and bellows
The shutter:	between-lens shutters
	focal-plane shutters
The diaphragm:	conventional diaphragms
	automatic diaphragms
The viewfinder:	simple viewfinders
	direct-vision optical viewfinders
	ground glass screen viewfinders
The focusing mechanism	front cell focusing
	movement of entire lens
	ground glass screen focusing
	coincidence-type rangefinders
	split-image rangefinders
	microprism grids and screens
	focusing scales

The exposure meter: types of meter cell
 accessory exposure meters
 built-in exposure meters with external cell
 through-the-lens exposure measurement
 automatic exposure control

Flash synchronisation synchronisation of between-lens shutters
 synchronisation of focal-plane shutters

The lens

In previous chapters we have already considered the principles of image formation, the properties and aberrations of lenses and the most common types of construction. Progressing from these fundamental concepts, there have been great improvements in design and performance of lenses during the past forty years. These may be ascribed to six interrelated innovations:

(1) *Lens coating* (page 102)

The widespread use of lens elements with single or multiple antireflection layers of various properties, has enabled lens designers to incorporate many more elements than before. The contrast, performance at extremes of aperture and field angle as well as colour balance have all been improved. Increases in maximum aperture and field angle have been possible.

(2) *Optical glass*

New types of optical glass have become available, with higher refractive indices and lower dispersions, as glass manufacturers have extended their ranges of products. Chemical elements such as lanthanum are commonly used in newer glasses, and materials such as fluorite and fused silica are used for some applications.

(3) *Aspheric surfaces*

The use of aspheric surfaces for small production runs of lenses (made possible by advances in manufacturing techniques) allows lenses to be made with very large yet usable maximum apertures in both long-focus and wide-angle designs.

(4) *Floating elements*

Experience with groups of moving elements, as used in zoom lenses, has enabled designers to introduce "floating elements" to correct for residual spherical aberration and retain performance at close object conjugates. Such techniques are particularly applicable to wide-angle lenses of large aperture.

(5) *Use of computers*

The tedious task of calculating ray paths through optical systems, an essential design step, has been greatly speeded by use of digital computers. Often a computer is programmed to optimise a design as far as possible, human judgement then determining further progress.

(6) *Evaluation of results*

The emergence of complex electronic methods for the objective evaluation of lens performance has contributed to improvements in design and to the quality control essential during manufacture.

The direct results of the above have been a considerable increase in the range of focal lengths available for the various formats, larger usable apertures, unusual lens designs for specific functions and an overall improved performance. The range of lenses offered by a manufacturer, for given formats, may nowadays be as follows:

6·5 mm to 2000 mm focal length for 24 × 36 mm format
30 mm to 1000 mm focal length for 60 × 60 mm format
65 mm to 1000 mm focal length for 102 × 127 mm format.

An example of improvements in a class of lens is well illustrated by the case of the wide-angle lens. The old problems of poor covering power, low marginal resolution, small usable apertures and flare have been largely overcome by newer designs. Typically, for the 24 × 36 mm format; 24 mm $f/2$, 35 mm $f/1·4$ and 35 mm $f/2$ lenses are commonly available in symmetrical or retrofocus designs. The 60 × 60 mm format has available lenses of 30 to 50 mm focal length and aperture $f/4$. Large formats also have wide-angle lenses with usable apertures of about $f/5·6$ and sufficient covering power to permit limited use of camera movements.

At the extreme ends of the available range of focal lengths, the "fish-eye" lens and mirror lens designs are now common. The fish-eye design is a wide-angle lens with no correction for linear distortion and commonly has an angle of view of 140° to 180° or more. The mirror lens, on the other hand, uses spherical mirrors as well as refracting surfaces (catadioptric system) to give extremely long focal lengths with a more compact design and larger aperture than would otherwise be possible. The design of mirror lenses is such that they cannot be used with an iris diaphragm; the lens must at all times be used at maximum aperture. Exposure is varied using shutter speeds and neutral density filters.

Another type of lens in a continuing state of development for still cameras, is the variable focal length or "zoom" lens. The so-called "macro" lens, which is designed and corrected for close-up work, incorporating an extended-range focusing mechanism, is also common.

Finally, the "standard" lens for a given format has undergone many changes. Contrast, resolution and freedom from flare have all been im-

proved. Maximum apertures of $f/2$ or $f/1\cdot4$ are normal for lenses used with the 24 × 36 mm format and $f/1\cdot2$ is common. Lenses for the 60 × 60 mm format rarely exceed a maximum aperture of $f/2\cdot8$.

A manufacturer producing a camera as the basis of a system has to ensure that an adequate range of lenses is available. Additionally, other manufacturers produce ranges of lenses with interchangeable or alternative fittings for attachment to various camera bodies. Many manufacturers, of course, still make cameras with their own unique fitting.

As a direct result of improvements in camera design and specifications, the mechanical complexity of lens mountings has greatly increased, to permit incorporation of features such as fully-automatic diaphragms, depth-of-field indicators, exposure-value shutters and close-focusing mechanisms.

The lens hood

The use of a properly designed lens hood with any lens, under most circumstances, will contribute significantly to the quality of results obtained. In particular, it will shield the lens from light extraneous to the subject area and reduce flare, especially in back-lit and side-lit conditions. The most common type of lens hood is conical in shape to enable it to be of maximum depth without causing vignetting. The internal finish is ridged and painted matt black. The front aperture is circular or of the same aspect ratio as the negative format in use. Owing to the danger of vigetting by a lens hood, many wide-angle lenses are not fitted with one, nor would one be of much help, but as the focal length increases the need for an efficient lens hood becomes greater. Many long-focus lenses are now supplied with an integral, telescoping hood to encourage the user to employ it. The bellows type of lens hood is unsurpassed in its efficiency and is adjustable for a wide range of focal lengths. Optimum adjustment is easy with a single-lens reflex camera.

Filters

Camera filters of various categories are fully dealt with in Chapter 11. They are supplied as dyed gelatin, either alone or cemented between glass, as dyed glass or as dyed plastic such as polyester. The optical quality of glass filters is reflected in their price. Filter mounts may be push-on, screw-in or bayonet types. A significant design point, in many manufacturers' favour, is that a range of focal lengths of lenses may be designed to accept the same size of filter, giving considerable economies to the user. Most cameras with a built-in exposure metering system incorporate a setting device to allow for filter factors among other things. In most circumstances, a through-the-lens metering system will compensate automatically for any filter that may be in use.

Supplementary lenses

Supplementary lenses provide a useful means of altering the focal length

of a camera lens. They may be positive or negative, although positive supplementaries are most widely used. Probably the most valuable use of a supplementary lens is for close focusing with cameras having limited focusing movement. We can focus on an object inside the minimum distance for which the camera is scaled, by selecting a positive supplementary lens of focal length equal to the object distance, irrespective of the focal length of the camera lens. The camera lens is then focused for infinity and the path of the rays is as shown in Figure 9.1. This is the basis of "close-up" or "portrait" attachments.

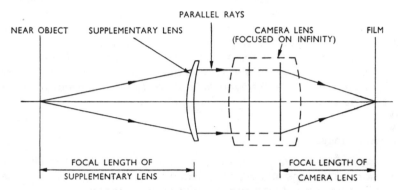

Fig. 9.1 – Use of supplementary lens as a close-up attachment

Supplementary lenses are invariably specified by their power in *diopters*, rather than by their focal length. The relation between the power of a supplementary lens and its focal length is:

$$\text{Focal length in millimetres} = \frac{1000}{\text{power in diopters}}$$

The power of a convergent supplementary lens is said to be positive, and that of a divergent lens negative. The practice of specifying supplementary lenses by their powers is convenient in that powers are additive, i.e. by adding the powers of two supplementaries we obtain the power of the combination. It is possible to purchase supplementary lenses in a range of +¼ to +5 diopters. The weaker ones of ¼ and ½ diopter strength are widely used with long-focus lenses to extend their focusing range without the need for a long focusing movement. They do not usually seriously affect the corrections of the camera lens. For very close-up work, however, where supplementaries of a considerable power would be needed, the use of extension tubes is a preferred alternative (see below). Supplementary lenses are preferably of meniscus form, because this minimises oblique aberrations and affects definition least. For many purposes, ordinary spectacle lenses are suitable for use as supplementary lenses, although a number of supplementary lenses produced for specific lenses are achromats and have antireflection coatings.

Stereo attachments

A stereo attachment is basically a beam-splitter device using surface-silvered mirrors or glass prisms whose optical axes are separated by the interocular distance. There are limitations on the nearest subject distance. One frame of the format in use yields a stereo pair of transparencies which are then used in a stereo viewer or for projection.

Diffusion discs

For some applications, such as portraiture, it is desirable to reduce the resolution available for the lens in use and to obtain a "soft-focus" result. This may be done by using a plain glass disc that has been engraved with concentric depressions, rather like a Fresnel lens. Alternatively, the surface may be treated to give minute, rounded contours. The degree of diffusion obtained from the former type depends upon how large an aperture is used, but the latter type is independent of aperture. Various strengths are available.

Converter lenses

The purpose of a converter lens is to increase or decrease the effective focal length of the lens in use on the camera. There are two types to consider, the teleconverter lens and the afocal converter lens.

Teleconverter lens

This lens unit can be used with interchangeable lenses only, as it is positioned between the camera body and lens. It consists of a short extension tube containing a number of elements forming a negative lens group. This converts the camera lens into one of telephoto construction (Figure 7.6) with the camera lens as the converging group and the converter lens as the diverging group. Converters are generally available in ×2 and ×3 powers, i.e. to double or triple the effective focal length of the camera lens respectively. Acceptable results are obtained with long-focus lenses but their use with standard and especially wide-angle lenses is not recommended, because it may result in a loss of image quality. Concomitant with the increase in focal length is a loss in maximum aperture. Doubling of the effective focal length gives a loss of 2 stops in maximum aperture, i.e. a ×2 teleconverter used with a 100 mm $f/2 \cdot 8$ lens will give a combination of 200 mm $f/5 \cdot 6$, and all other marked aperture numbers are similarly doubled. The teleconverter is a very compact unit of moderate price. Most versions have mechanical linkages to ensure that operation of an automatic diaphragm and meter coupling is retained. The combination will also focus down to the closest distance of the camera lens alone. Teleconverters are primarily designed for use with single-lens reflex cameras of various formats.

Early teleconverters were negative achromatic doublet lenses but

these have evolved to 7 or 8 element multi-coated designs. Some teleconverters are designed for use with specific lenses, when optimum results may be expected.

Afocal converter lens

These multiple-element lens units are generally used with non-interchangeable lenses because they are used in front of the camera lens. The term *afocal* indicates that they have no focal length of their own, i.e. parallel light incident on the unit emerges still parallel. However, when such a converter is used with a camera lens the effective focal length of the combination may be greater or less than that of the camera lens alone, depending upon the construction of the converter. The "wide-angle converter" and the "telephoto converter" decrease and increase the focal length of the camera lens by factors of approximately 0·5 and 1·5 respectively. A common use is with twin-lens reflex cameras, which usually have non-interchangeable lenses. Unless the converters are of high optical quality and cost the results are disappointing. Large apertures give poor resolution and small apertures give vignetting. A medium aperture is best. No change in the marked apertures of the camera lens is necessary. Reflex focusing is essential. With the telephoto converter in use there is a loss of focusing range, in that the nearest distance that can be brought into sharp focus is increased.

Extension tubes and bellows

Like a supplementary lens, extension tubes and bellows provide a means of focusing a camera with limited focusing movement on close objects. Unlike supplementary lenses, however, these are intended for use only on cameras having interchangeable lenses. The extension tube is a tube of similar diameter to the lens mount with suitable fittings for attaching the lens to one end and the camera body to the other. These tubes are usually made in a range of lengths which can be used singly or in combination with one another. For single-lens reflex cameras, automatic extension tubes are made which transmit the operation of the automatic diaphragm mechanism from the camera body to the lens; otherwise, this facility is lost.

Any length of extension tube in conjunction with the focusing movement on the lens mount imparts a limited focusing range. Also, at long extensions, the narrow diameter of the tube may cause vignetting. For these reasons, extension bellows are preferable because they permit an extensive focusing range and allow lenses of very long focal length to be used. Some lenses have the optical part removable from the focusing mount to facilitate their use on extension bellows. Typically, a 135 mm focal length lens for the 24 × 36 mm format with bellows may have a focusing range from infinity down to same-size reproduction. Alternatively, special macro lenses of focal length 65 to 135 mm are available for use with a bellows only.

159

Extension tubes and bellows are of most use with single-lens reflex cameras owing to the ease of focusing, but often reflex attachments may be used with other cameras. The tubes and bellows are normally supplied with data in chart or calibration form giving the necessary information on the increase in exposure required with a range of focal lengths at various magnifications.

The automatic diaphragm operation of a lens may be retained with some designs of bellows, using mechanical linkages to the camera body or a double cable release operating lens diaphragm and camera shutter together. Otherwise, the lens must be stopped down manually. For extreme close-ups, or photomacrography, the optical performance of a lens may be impaired because corrections are normally computed for work at infinity. A lens reversing ring attached to the bellows will often improve results.

Most camera systems offer a macro lens of approximately standard focal length or double this value, which focuses continually from infinity to a magnification of 0·5 with full retention of automatic facilities. A special extension ring then allows the magnification range of 0·5 to 1·0 to be covered likewise. Such a lens is a worthy alternative to bellows or extension tubes.

The shutter

In terms of delicacy, the camera shutter is usually ranked just after any exposure metering system that may be incorporated in the camera. The quality and type of the shutter contribute significantly to the performance of the camera. The function of a shutter is to expose the sensitised material to the action of light for a given time. A perfect shutter should expose each part of the film equally, and preferably at the same time, i.e. it should allow the cone of light passing through the selected aperture to fall upon the film for the entire duration of the exposure, it should be silent in operation, there should be no jarring or vibration and it should require little effort to set it in motion.

The two main types of shutter in use today are the *diaphragm*, or *between-lens, shutter* and the *focal-plane shutter*; both may be purely mechanical in operation or may combine mechanical and electrical features.

Between-lens shutters

The ideal position to intercept the light transmitted by the lens is in the plane of the diaphragm. The beam of light is at its narrowest near the diaphragm and the minimum amount of shutter travel is therefore required if the shutter is in this position. The sensitive material is also evenly exposed at all stages in the opening of the shutter.

Simple cameras often use single-bladed between-lens shutters but the majority of cameras use multi-bladed shutters. The blades, or sectors, open like the leaves of an iris diaphragm. In lower priced cameras

an "everset" or "self-setting" type of multi-bladed shutter is used. In this, a single control is depressed to compress the spring and release the shutter in one movement. Mechanical limitations mean that a speed range of only 1/30th to 1/125th second is obtained.

More expensive mechanical between-lens shutters are of the "preset" type. In these, two movements are required: one for tensioning (cocking) the operating spring and one for releasing the shutter. In many cameras the cocking operation is performed by the film advance mechanism. Preset shutters such as the Compur, Copal and Prontor types commonly provide for exposures ranging from 1 second to 1/500th second, a speed of 1/1000th second being provided by one type. The shutter blades pivot about their ends (or, rarely, centre) and for all but the highest speeds open with constant velocity. An additional spring mechanism causes the blades to open very quickly and close almost immediately at the highest speeds, while the slower speeds are usually controlled by engaging a gear train to retard the blade closing mechanism.

On older shutters, the conventional series of shutter speeds was 1, ½ , 1/5, 1/10, 1/25, 1/50, 1/100, 1/250, 1/500, and 1/1000th second. In current models, it is 1, ½ , ¼, ⅛ , 1/15, 1/30, 1/60, 1/125, 1/250, 1/500, and 1/1000th second, to give a progression of exposures similar to that provided by the standard series of lens aperture numbers, i.e. with each step double or one-half of the next. This has been done primarily to permit the introduction of a mechanical interlock between the aperture and shutter speed controls, in order to keep the two in reciprocal relation. This ensures that as the shutter speed is adjusted, so the iris diaphragm is automatically opened or closed to keep the exposure the same. The advantages of this are obvious.

Shutter speeds are usually set by click stops on the selector ring although the design of the shutter may permit intermediate values to be set. For reasons of economy many shutters do not have speeds below 1/30th second. Large diameter lenses used in large format cameras impose a limit of about 1/200th second as a top speed in their shutters.

In recent years the mechanism of some between-lens shutters (and focal plane shutters) has been made to include electrical as well as mechanical operations. Such shutters are generally called *electronic shutters*. In these, the blades are still opened by a spring mechanism but the closing operation is retarded by an electromagnet, controlled by a timing circuit. A typical capacitor-resistor circuit as used is shown in Figure 9.2. Switch S is closed by the shutter blades opening and battery B begins to charge capacitor C through a variable resistor R. The time taken to reach a critical voltage depends upon the value of R, but when it is reached the capacitor discharges to operate a transistorised trigger circuit T which releases the electromagnet holding the shutter blades open. The alteration of shutter speed normally means switching in a different value of R. A great convenience, however, for automatic cameras, is for R to be the CdS photoresistor or silicon photodiode monitoring the subject luminance and giving a continuously variable speed range from many seconds to about 1/250th second exposure. Even the light reflected from

the subject during the burning of a flashbulb or the duration of an electronic flash may be monitored in this way by some camera exposure systems. A visible signal normally gives a warning when the exposure time is longer than 1/30th second, necessitating the use of a tripod.

As the blades and drive of an electronic shutter are mechanical, it cannot improve on earlier designs in terms of performance at higher speeds or greater efficiency. It does, however, lend itself to automation and remote control. A control box for selecting shutter speeds and apertures may be used on a long cable for linking to electronic shutters in technical camera lenses.

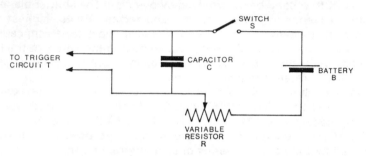

Fig. 9.2 – The timing circuit of an electronic shutter

Returning to the conventional between-lens shutter, we may note some other items usually incorporated in the mounting. In addition to the usual shutter speed and aperture scales, an interlocked shutter bears a third scale of *exposure values* (page 165). The numbers on this scale range from, e.g. 2 to 18, the change from one number to another corresponding to an alteration in the luminance of the scene by a factor of 2. This scale is normally used with a specially scaled exposure meter. A "self-timer" or "delayed-action device is often fitted, by means of which the release of the shutter can be delayed for some 5 to 15 seconds. On many shutters fitted to lenses for technical cameras there is a "press-focus" button which opens the shutter on a time setting irrespective of the shutter speed set. This facilitates focusing and eliminates constant resetting of shutter speeds.

One of the great advantages of between lens shutters is the ease of flash synchronisation of all types and this is discussed fully on page 160.

Focal plane shutters

This type of shutter is located in the camera body and travels as nearly as possible in the focal plane. In earlier forms, the focal plane shutter consisted of an opaque blind with a slit or several slits of varying width; the slit chosen was driven past the front surface of the film and the exposure made as it passed across. The film area was therefore exposed sequentially unlike the single overall exposure given by a between-lens shutter. The speed of travel and width of the slit determined the effective exposure time.

Some shutters, especially those fitted to large format cameras, could give a very wide range of shutter speeds by suitable selection of a combination of slit width and shutter blind tension. Modern versions use two opaque blinds: one starts to uncover the film when the shutter release is pressed and the other follows behind to cover up the film at a greater or smaller distance according to the starting delay set by the shutter speed selected. The separation between the trailing edge of the first blind and the leading edge of the second blind thus constitutes a slit of variable width, allowing a range of exposure times. The speed of movement of the slit across the film gate is constant. Such a shutter is also self-capping in that the slit is closed by overlap of the blinds when the shutter is reset, usually by operation of the film-wind mechanism.

Many focal plane shutters use rubberised cloth blinds, but metals such as titanium are also used, this material having the necessary strength and low mass. The shutter slit may travel from left to right or from right to left or vertically with respect to the film area. This direction of travel, together with the direction of motion of the subject with respect to the slit during the duration of the sequential exposure action of the slit, may give rise to forms of distortion in the image of the subject.

The major problems associated with focal plane shutters have been those of even exposure, shutter bounce and flash synchronisation. The slit width and speed of travel must be maintained accurately to give even exposure over the whole film area, other than the variations due to subject luminance. This problem increases with increase in format size and the mechanical reliability problems associated with exposure durations of one millisecond or less are severe. This, together with flash synchronisation difficulties, caused them to be discontinued in many larger cameras in favour of between-lens shutters. Shutter bounce is shown by a narrow strip of over-exposure at the edge of the film frame where the second blind has recoiled momentarily on retardation of its travel.

The typical exposure time range available is many seconds to 1/2000th second (0·5 ms). But the operating time of the shutter may be about 1/30th second even at this minimum effective exposure time. Flash synchronisation poses problems in that if flashbulbs are used, special bulbs with a long burning time, FP types, are needed with the higher shutter speeds. Electronic flash, with its instant ignition and short duration, poses different problems. The film frame must be fully uncovered at the instant the flash fires, i.e. at the moment the first blind has uncovered the focal plane but before the second blind starts its travel. Depending on the shutter design and the format size, this is usually at a shutter speed of 1/20 to 1/125th second. Shorter exposure durations cannot be used because the frame would be only partly exposed. While subject movement may be effectively arrested by the short flash duration, double images may occur, owing to high ambient light levels. Synchro-sun techniques are therefore severely limited. A between-lens shutter is almost always preferable for flash work.

More recent designs of focal plane shutter do not use the double blind system, instead, elaborate systems of pairs of blades in a guillotine ac-

163

tion, or end-pivoted arrays of fan-shaped blades are used. However, the exposure action is still by a travelling aperture.

The great advantages of a focal plane shutter are that it allows easy interchange of lenses on a camera body, and the lenses do not need individual between-lens shutters. The complexities of an SLR camera with between-lens shutter are thereby avoided. Such cameras also have restrictions on the range of focal lengths available and possible methods of close-up work.

Modular design of shutters allows easy replacement or repair when necessary. For many years, the purely mechanical design of such shutters did not allow for easy automation of exposure, i.e. the user manually altered the shutter speed at a pre-selected aperture in accordance with a separate hand meter or a built-in uncoupled metering system. Redesign of shutters to a combination of mechanical and electronic operation using electromagnets and a transistorised timing circuit to replace the mechanical escapement for release of the shutter blinds, for instance, allowed integration of the shutter mechanism with the light-metering circuitry, as described on page 174. Continuously variable exposure times, typically from many seconds to 0·5 ms, could then be given. Memory lock devices are sometimes incorporated in such cameras to allow compensation for subjects of unusual tone or luminance distributions. However, even mechanical shutters can have continuously variable exposure times between marked settings of about 1/125 to 1/2000th second if the cams used for control are of accurately cut profiles.

The shutter is usually operated by a *body release* on the camera, situated in an ergonomically desirable position to reduce the possibility of camera shake and give convenient fingertip operation. The body-release may also serve to operate a reflex mirror, automatic diaphragm or an exposure metering system before the shutter is actually released. Electronic shutters may be operated by a release which is just an electrical switch. Such devices readily lend themselves to remote control by electrical or radio impulses.

The diaphragm

For a number of reasons, which were discussed in earlier chapters, the beam of light passing through a photographic lens is limited by means of a diaphragm or stop in which is an aperture usually approximately circular in shape. In some simple cameras the aperture is fixed in size. In others the diaphragm consists of a disc bearing several circular apertures and capable of rotation so that any one of the apertures may be brought into position in line with the lens. This arrangement of fixed apertures is often used in fish-eye lenses as well. For some graphic arts purposes the lens aperture must be known very precisely; interchangeable metal plates each with a different aperture are then used. Such fixed apertures are known as *Waterhouse stops*.

Such an arrangement is limited in scope and so the majority of lenses

are fitted with *iris diaphragms*, the leaves of which may be varied, forming an approximately circular aperture of a continuously variable diameter. When the camera shutter is of the between-lens type the diaphragm is normally part of the shutter assembly.

The diaphragm is operated by a rotating ring, usually with click stops at half-stop intervals, calibrated in the standard series of f-numbers (page 91). The interval between marked values will be constant if the diaphragm blades are designed to give such a scale, otherwise, in older lenses with multi-bladed diaphragms the scale is a square-law one with cramping together of calibrations at the small aperture end, $f/11$, $f/16$ etc.

The maximum aperture of a lens is not necessarily a fixed value on the scale but may be an intermediate value, e.g. $f/3·5$. The minimum aperture for lenses on small-format cameras is seldom less than $f/16$ or $f/22$, but for lenses on large-format cameras, minimum values of $f/32$ to $f/64$ are common.

As noted earlier, many cameras have the aperture and shutter speed settings linked together to give a single number scale calibrated in *exposure values*, for use in conjunction with specially calibrated exposure meters.

With the increase in use of the single-lens reflex camera came a demand for automatic selection of the chosen aperture just prior to exposure. This would permit viewing and focusing at full aperture until the shutter was released.

On the earliest forms of these cameras, the lens had to be stopped down by reference to the scale. The introduction of click-stops assisted in this process. Then a pre-setting device was introduced which, by means of a twist on the aperture ring, stopped the lens down to the pre-selected aperture and no further. The next step was to introduce a spring mechanism into this type of diaphragm that was triggered by the shutter release. Operation was easier and the sequence speeded up but the spring had to be reset after each exposure and the diaphragm re-opened to its maximum value. This was known as the *semi-automatic diaphragm*. Finally, with the advent of the instant-return-mirror came the *fully-automatic diaphragm*. An actuating lever or similar device in the camera, when operated by the shutter release, closed the diaphragm down, usually against a spring, during the shutter operation. When the shutter closed the diaphragm was released and re-opened to coincide with the return of the reflex mirror to permit full-aperture viewing again. A manual override is normally fitted for depth-of-field inspection. Certain cameras with through-the-lens (TTL) metering (page 177) necessitate exposure measurement being carried out at the desired working aperture, so this mechanism is essential.

The design of TTL metering systems in many cameras requires that the maximum aperture of the lens in use must be set in the metering system and a variety of complex mechanical or electrical linkages between lens and body have been devised for this purpose. Similar linkages are also necessary for shutter speed preferred automatic

exposure systems when the taking aperture is set at the moment of exposure.

Extension tubes usually transmit the actuation pressure for diaphragm operation but extension bellows may not and manual operation or a double cable release is required.

As the lens focal length increases the problems of fitting a fully-automatic diaphragm increase; the diaphragms of most very long-focus lenses, therefore have to be set manually. A limited number employ electromagnetic diaphragm operation.

In general, the lenses fitted to large-format technical cameras are manually operated, although some pre-setting devices are available. When an electronic shutter is fitted to such a lens, the diaphragm opening may be selected from a remote control box and operated electrically.

Simple viewfinders

The function of the viewfinder is to indicate the limits of the field of view of the camera lens in use and to enable the user to select and compose the picture. Normally, apart from simple cameras, the viewfinder also incorporates a method for focusing the lens by means of a rangefinder or a ground-glass screen. The type of viewfinder used often determines the shape and size of a camera, as with the twin-lens reflex type, and the popularity of a camera may be related to the ease of use of the viewfinder, especially if spectacles are worn.

Increasingly, the viewfinder acts as a "control centre" for exposure measurement systems, with a variety of needles, lights and camera settings being visible around or within the focusing screen area.

The simplest finders, as fitted to early box cameras and as a supplement to the ground-glass screen of a technical camera, employed a positive lens of about 25 mm focal length, a mirror inclined at 45° and a ground glass upon which the image was viewed. This finder was used at waist level and the illumination of the image was poor.

This early type of finder has been superseded by the "brilliant" finder which employs in place of the ground glass a second positive lens, of such a power as to image the first lens in the plane of the viewer's eyes, giving greatly improved illumination. Such finders are still occasionally found on simple cameras.

The need for a simple finder for use at eye level introduced the wire frame finder. A wire or metal open frame, in the same proportions as the negative format, was viewed through a small "peep-sight" to define the subject area. This type of finder is often available as an accessory and is most compact when collapsed. Refinements to the simple design gave exact delineation of the subject area and parallax compensation. Once much favoured for use on press cameras of the large-format type, its use is now mainly confined to technical, aerial and underwater cameras.

Direct-vision optical viewfinders

At one time most small- and medium-format cameras employed a

"direct-vision" finder for use at eye level. In the simplest optical type, a strongly diverging lens is used to form a virtual image which is viewed through a weak positive lens. This type of viewfinder — sometimes termed a Newton finder — is, in effect, a reversed Galilean telescope, the two lenses combining to produce a bright virtual image, erect and the right way round. A great improvement on this viewfinder type — the Albada finder — has a mask bearing a white frame line in front of the positive lens, and the negative lens has a semi-silvered rear surface. As a result, the white line is seen superimposed on the virtual image (Figure 9.3). The view through the finder extends beyond the frame line so that objects outside the scene can be viewed. This is a great aid in composing, especially if the subject is in motion. The eye may be moved laterally without altering the boundary of the scene. This type of finder has been considerably refined in recent years, e.g. in the Leica M series of cameras, where different frames for lenses of various focal lengths may be brought into use in turn. Other refinements are compensation for viewfinder parallax error by movement of the frame with the focusing mechanism and a reduction in the mask area when focusing at closer range. Unfortunately, this finder, while excellent for wide-angle lenses, is unsatisfactory for lenses longer than 135 mm focal length for the 24 × 36 mm format. The subject area covered may, in this case, be indicated by a small frame of an approximate size to the range-finder image in the same viewfinder. The increasing viewfinder error makes this type of finder unsuitable for close-up work.

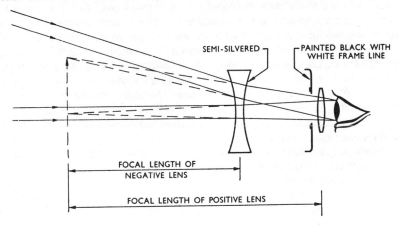

Fig. 9.3 – Albada finder

The image size as seen in such a viewfinder is usually about 0·7× to 0·9× life-size. Simpler cameras with a non-interchangeable lens often have a finder giving a life-size image so that both eyes may remain open, giving the impression of a frame superimposed on the scene.

For technical cameras, the advanced type of range-viewfinder is often used and a zoom-type Albada viewfinder is available for use with a variety of lenses.

Ground-glass screen viewfinders

Many of the earliest types of camera used a plain ground-glass screen upon which the image from the lens was composed and focused, and then replaced by a plate or film holder in order to make the exposure.

This system is still in use on technical cameras, where the inverted and laterally reversed image on the ground-glass screen usually causes no inconvenience. The advantages of exact assessment of subject area covered by the lens, and accurate focusing, offset the disadvantages.

For the majority of small- and medium-format cameras a reflex system is used, where a surface-silvered mirror inclined at 45° to the optical axis gives an image on a ground-glass screen. The image is the same size as it will appear on the negative, and upright, but is still laterally reversed. Viewing and focusing is by a separate lens on the twin-lens reflex camera and by the actual camera taking lens on the single-lens reflex type. Focusing is carried out at waist level using the unaided eye or a flip-up magnifier in the viewfinder hood. Unlike the single-lens reflex type, the twin-lens reflex camera suffers from field-of-view error, and a mask or indicator in the viewfinder, provided to compensate for this defect, may be coupled to the focusing mechanism.

The presence of the mirror in the viewfinder system of a single-lens reflex camera has led to a number of refinements in camera design. The most common requirement is for an instant-return mirror (with an adequate braking system to avoid camera shake). Cameras without this facility have the viewfinder blanked out until the mirror is returned to the viewing position when the film is advanced to the next frame. The mirror may be locked up to enable certain wide-angle lenses to be used. An accessory optical viewfinder is then needed. A common practice in single lens reflex cameras is to introduce a deliberate viewfinder error in that the area as seen on the ground-glass screen may be less, by about 10 per cent per dimension, than the area included on the negative. The reason usually quoted is to overcome differences in aperture size in transparency mounts. One or two cameras, however, do indicate the actual area included on the negative.

While a ground-glass screen gives positive indication of correct focus, a plain screen is not always preferred, because it gives a rather dim image with a rapid fall-off in illumination towards the corners. Evenness of illumination is improved if the screen is etched on the flat base of a plano-convex lens or if a fresnel screen is used, but only at the expense of accurate focusing. Small-format cameras, therefore, usually have a supplementary focusing aid incorporated in the centre of the screen. This may be a clear spot with cross-hairs in order to assist in focusing the aerial image, a split-image range-finder (Figure 9.4), or a microprism screen. Many screens incorporate two or more focusing methods, termed a "mixed screen". Many cameras have interchangeable viewing screens to suit the user. With all these screens, however, if the reflex mirror is of inadequate dimensions, there will be a progressive loss of illumination on the top of the screen with increase in focal length of

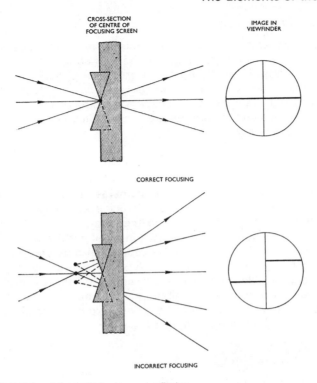

CROSS-SECTION
OF CENTRE OF
FOCUSING SCREEN

IMAGE IN
VIEWFINDER

CORRECT FOCUSING

INCORRECT FOCUSING

Fig. 9.4 – Principle of the split-image rangefinder

camera lens. This cut-off is not obtained on the negative, of course.

With all reflex systems the lateral reversal of the image is most troublesome for certain types of photography, especially when the subject is moving. Direct-vision can often be obtained by pushing down the front flap, but focusing is then not normally possible. Fortunately, the introduction of the pentaprism viewfinder for both 24 × 36 mm and 60 × 60 mm formats has given a method of focusing an upright, right-way-round and magnified image (Figure 8.4) and has been a major cause of the popularity of the single-lens reflex camera. These prism finders are sometimes interchangeable with waist-level finders and many have provision for eyepiece correction lenses to obviate the use of spectacles, if normally worn. The viewfinder prism may also incorporate a through-the-lens exposure metering system for measurements from the ground glass. With the introduction of such exposure measurement systems the viewfinder of many such cameras has acquired more functions. Warning signals may appear to indicate, typically, that an exposure time longer than 1/30th second is needed. The shutter speed or aperture in use may be shown on an adjacent, illuminated scale. The exposure meter needle and matching pointer to give correct exposure may also be visible, see Figure 9.10, or a light-emitting diode array used.

169

The Elements of the Camera

The focusing mechanism

While many lenses can be used satisfactorily as fixed-focus objectives, relying upon depth of field to give adequate sharpness, the situation alters when using lenses of large aperture or long focal length, and for close-up work. To ensure that the subject may be sharply focused at the focal plane of the camera it is then necessary to have a means of altering the lens-to-film distance and to have a visual indication of focus linked to the focusing mechanism.

Front cell focusing

For reasons of economy in simple cameras, and those fitted with between-lens shutters, focusing may be achieved by varying the focal length of the lens and not by varying the lens-to-film distance. This is achieved by mounting the front element in a cell with coarse pitch screw thread. Rotation of the cell alters the separation between the front element and other glasses of the lens. A slight alteration in separation causes an appreciable change in focal length, giving a useful focusing range. Close focusing is not possible because the lens aberrations that would then be introduced would badly affect performance. A distance scale is engraved on the rotating cell.

Movement of entire lens

This is the best method of focusing and is achieved in various ways. Technical cameras of the baseboard type employ a rack-and-pinion or friction device to move the lens panel for focusing by ground-glass screen or rangefinder. Back (as well as front) focusing is common on the monorail type and is most useful in applications such as copying, because back focusing alters the focus only, whereas front focusing alters the size of the image as well as its focus.

Small-format cameras generally use helical focusing, where rotation of an annular ring on the lens barrel moves the lens bodily in an axial direction. Rotation of the lens is undesirable as the various scales would not be fully visible at all times.

The operation of visually focusing the subject is achieved by use of a visual rangefinder system or a ground-glass screen. In the majority of cameras the rangefinder is coupled to the focusing mechanism, but built-in, uncoupled rangefinders are occasionally encountered.

Internal focusing

A recent development has been the introduction of *internal focusing*, whereby rotating the focusing ring moves an internal group or component of the lens along the axis. The lens is not extended in a focusing mount and the whole unit can be sealed against the ingress of dust. This method is often used in zoom lenses.

Focusing aids

Various optical devices can be incorporated into the camera viewfinder to assist rapid, accurate focusing, ideally with a range of lenses over a range of subject distances from infinity to close-up.

Ground-glass screen

Use of the ground-glass screen has been dealt with under the section relating to viewfinders (page 168). It has the great advantages of giving a positive indication of focus and allowing the depth of field to be estimated. No complex linkage between lens and viewfinder is necessary, only a mirror if reflex focusing is used. The screen may be used to focus any lens or optical device that could be fitted to the camera, but focusing accuracy depends, among other things, on eyesight, screen luminance and subject contrast. Supplementary aids such as a screen magnifier and a focusing hood or cloth are essential, especially when trying to focus systems of small effective aperture in poor light.

Coincidence-type rangefinder

Coincidence-type rangefinders usually employ two windows some short distance apart, through each of which an image of the object is obtained. Both images are viewed together, one directly and the other after deviation by an optical system of mirrors or prisms (see Figure 9.5). For a subject at infinity the semi-silvered mirror Y and rotatable mirror Z are

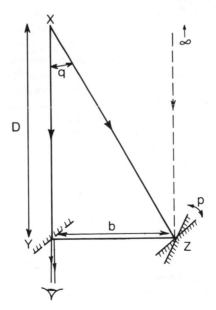

Fig. 9.5 – Principle of the coincidence-type rangefinder

parallel and the two images seem to coincide if superimposed. For a subject X at a finite distance D the two images are non-coincident until mirror Z is rotated through an angle p. This angle p is therefore a measure of D by the geometry of the system and may be calibrated in terms of subject distance.

By coupling the mirror rotation to the focusing mount of the lens in use, the lens is automatically focused on the subject when its two images coincide. The accuracy of such a *coupled rangefinder* system is a function of subject distance D, the base-length b between the two mirrors and the angle q subtended at the subject by b. Mechanical and optical limitations make this system of distance measurement unsuitable for lenses of more than about ×2·5 the standard focal length for the film format, e.g. 135 mm for the 24 × 36 mm format. The method is unsurpassed in accuracy for the focusing of wide-angle lenses however, particularly with a long-base rangefinder and also for use in poor light conditions.

The mirror rotation for a distance range from infinity to about 1 metre is only some 3° so a high degree of mechanical accuracy and manufacturing skill is required for a reliable rangefinder. Alternative systems using two contra-rotating optical wedges or using movable prisms have been devised, permitting more rotational movement or fewer mechanical linkages.

Occasionally a split-field arrangement is used for the two images as well as colouring the two images in complementary, contrasting colours.

Split-image rangefinder

A split-image rangefinder is a passive focusing aid in that, unlike the coincident type rangefinder, it has no moving parts. It is a small device, consisting of two semi-circular glass prisms inserted into the focusing screen itself. As shown in Figure 9.4, any image that is not exactly in focus on the central area of the screen appears split into two displaced halves. These join up as the image is brought into focus, in a similar way to the two halves of the field in a conventional split-field rangefinder.

The image seen is always bright, even in poor light conditions. Because focusing accuracy by the user depends on the vernier acuity of the eye and not the resolving power of the eye, which is of a lower order, the device can be very accurate, especially with wide-angle lenses at suitable apertures. The inherent accuracy of this rangefinder depends on the diameter of the entrance pupil of the lens, so large apertures improve the performance. Unfortunately, the geometry of the system is such that at effective apertures of about f/5·6 or less, location of its exit pupil by the eye is very critical and its diameter is very small so that slight involuntary movements of the user's eye cause one or other half of the split field to black out. Consequently, long-focus lenses or close-up photography can cause a loss of function and an irritating obstruction in the viewfinder image.

Field-splitting arrangements may be vertical, horizontal, at 45° or a

complex arrangement to cope with subjects without definite linear structure. An additional focusing aid such as annual ground-glass ring is often provided around the rangefinder prisms.

Microprism grids and screens

The concept of the split-image rangefinder is used again in the microprism grid array located in the centre of the viewfinder screen. A very large number of small facets in the shape of triangular or square

Fig. 9.6 – The microprism focusing aid.
(a) Typical location in focusing screen
(b) enlarged plan view of prisms with square base of side about 0·05 mm
(c) perspective view of microprisms

base pyramids are embossed into the focusing screen surface (Figure 9.6). An image not exactly in focus on the screen undergoes multiple refraction and deviation by these optical components to break the image up into minute fragmentary areas, imparting a characteristic "shimmering" effect. At correct focus this image snaps back into its correct appearance, giving a very positive indication of the point of focus. The prism shapes used are small enough so as to be below the resolving power of the eye. This system is easy to use and very popular. Once again, no moving parts are involved.

The disadvantages are the same as with the split-image rangefinder, with the microprism array darkening at effective apertures less than $f/5·6$. Interchangeable viewfinder screens are available consisting entirely of microprisms so as to give a very bright image for focusing and also with prisms whose angles are suitable for lenses of a particular focal length. Microprism arrays are generally used in conjunction with one or more of the other focusing aids, e.g. a central split-image rangefinder may be surrounded by annular rings of microprisms and ground glass, with the rest of the screen area a Fresnel lens.

Focusing scales

The majority of lenses are focused without reference to the distance scale engraved in metres (and also, usually, feet) on the focusing knob or ring, when the rangefinder or ground-glass screen is used. It is essential

to retain these figures, however, for two reasons. First, for reference when flash is being used, so that the aperture may be correctly set according to the flash guide number. Certain lenses incorporate a degree of automation in that the flash guide number may be set on a scale on the lens barrel. The aperture is then made to alter automatically in accordance with the focusing and thus gives constant exposure as the distance from the flashgun (on the camera) to the subject is varied. Secondly, the distance figures give the depth-of-field by reference to the appropriate scale. Many cameras have automatic depth-of-field indicators linked to the aperture scale as well as to the focusing mechanism.

As the focal length of a lens determines the amount of extension necessary for focusing upon a nearby subject, the closest marked distance on a focusing scale varies with the lens. The small extension required with wide-angle, short-focus lenses means that many have provision for focusing down to a few centimetres. The standard lenses fitted to 24 × 36 mm format cameras commonly focus down to approximately 0·5 metre without supplementary devices.

Some standard lenses (usually of special design), termed *macro lenses*, are provided with a focusing mount with sufficient extension to permit continuous focusing down to 1:1 reproduction. Such lenses usually also have an additional scale of exposure increase factors on the lens mount. It is interesting to note that in certain lenses which may be focused closer than normal, the focusing mechanism is linked to the iris diaphragm which is opened to compensate for the increase in exposure required. Long-focus lenses fitted to 24 × 36 mm format cameras seldom focus closer than about 2 to 10 metres (depending on focal length) without recourse to extension tubes or bellows. In the case of technical cameras, the long extension of the bellows and the possibility of increasing it by an additional bellows, makes for a very versatile focusing system. Often a "bag" bellows is required with short-focus lenses, because the ridged type will not compress sufficiently to allow focusing to infinity.

Finally, the ease of use of a focusing mechanism on a camera or lens should be considered. Focusing rings, knobs and levers of varying sizes and width are found on lenses and camera bodies. On most of these the amount of friction, ease of gripping and direction of rotation to focus down from infinity are different. This may cause difficulties in changing from one lens or camera to another until the necessary mental adjustment is made. Many lenses have two or three raised rings on the lens barrel to alter aperture or shutter speed, focus and perhaps focal length if the lens is of a zoom type. These lens rings have to be most carefully designed so as not to confuse functions. Zoom lenses often have a "trombone" mechanism where rotation of a broad ring alters focus, and sliding it axially alters focal length. There is room for improvement in all such designs.

The exposure meter

The topic of camera exposure determination is fully dealt with in

Chapter 20. The incorporation of an exposure meter into a camera body is a great convenience but the range of types available, each with advantages and disadvantages, presents a problem of selection for use. With the increased use of colour materials in preference to black-and-white, the need for accurate exposure assumed increasing importance. Separate exposure meters have been in use for many years, but the operation of transfering the indicated values of shutter speed and aperture from meter to camera is felt by many to be disadvantageous. A meter built in to the camera and coupled in some way to the controls would be preferable, giving more rapid operation with one piece of apparatus. Many manufacturers considered inclusion of an exposure meter more important than a focusing device such as a rangefinder. The evolution of the built-in meter has gone through several stages of increasing complexity, but before considering these it is useful to review the salient properties of the types of photoelectric cell in use in exposure meters.

The selenium cell. Light-sensitive selenium is incorporated in a barrier-layer cell. On exposure to light an electric current is generated. A sensitive galvanometer in the circuit gives a deflection according to the amount of light incident on the cell and the necessary camera exposure is derived from a dial-type calculator. Sensitivity of the system is rather limited, depending on the area of the cell exposed to light. A baffling device usually limits the acceptance angle of the cell to approximately that of the camera with normal focus lens.

The cadmium sulphide cell. The action of light upon a cadmium sulphide (CdS) cell is to increase its conductance, i.e. lower its resistance, and hence increase the flow of current from a battery connected across the cell. A sensitive galvanometer in the circuit is calibrated accordingly. A small, long-life battery of constant voltage must be incorporated into the meter circuit. The cadmium sulphide cell may be of very small dimensions yet of greater sensitivity than a selenium cell. The spectral response is adjusted to approximate that of the selenium cell.

The disadvantages of the CdS cell are its temperature dependence, its "memory" and its speed of response. The ambient temperature can affect the response of the cell and upset calibration. The response of a CdS cell also depends on the previous history of illumination so that a reading taken in a low light level after exposure of the cell to a much higher light level, tends to be inaccurate by virtue of an exagerrated response due to the effects and "memory" of the previous light level. A significant time is required before response is back to normal. Finally, the speed of response in low lighting can be quite slow, with several seconds required for a reading while the meter needle "creeps".

Silicon photodiode

Light incident upon a solid-state device known as a silicon photodiode generates a minute current. Thus, it may be regarded as a photovoltaic cell like the selenium cell. But this property is of little use for a practical photocell unless an amplifier is used to produce a useful output. A

175

suitable operational amplifier circuit acts as a current-to-voltage converter and with a suitable feedback resistance gives a high output voltage proportional to the incident light. The response is significant, even at very low light levels, when the photodiode is used in this way and, even more important, is very accurately linear over a wide range of illuminance levels.

The response is almost instantaneous, of the order of microseconds, a most useful property for switching functions. The cell area need only be very small while retaining adequate sensitivity, a necessary function for incorporation into a camera body. The advent of suitable solid-state amplifier modules gave a photocell device with properties superior to those of CdS cells.

Unlike selenium, but more like CdS, the spectral sensitivity of silicon cells extend from about 300 nm to about 1200 nm, with a peak around 900 nm. For photometric use in cameras, filtration of this natural sensitivity is required to give a suitable response. Such filtered varieties for use in the visible spectrum are often termed silicon "blue" cells.

The comparative electrical circuits for the operation of selenium, CdS and silicon photocells are shown in Figure 9.7.

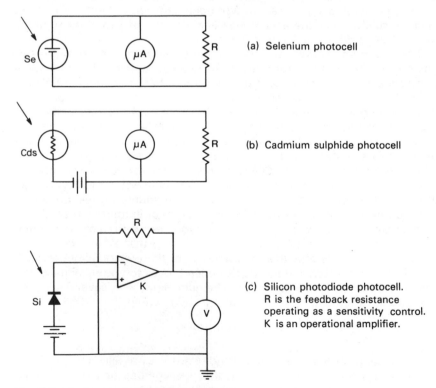

(a) Selenium photocell

(b) Cadmium sulphide photocell

(c) Silicon photodiode photocell.
R is the feedback resistance
operating as a sensitivity control.
K is an operational amplifier.

Fig. 9.7 – Basic electrical circuits for the different types of photocell used for exposure measurement

Accessory exposure meters

These are separate exposure meters but are specially produced for use on a camera.

Clip-on meters. Generally these are selenium cell meters of small dimensions to clip into the camera accessory shoe. They are not coupled to the camera and are of moderate sensitivity.

Coupled clip-on meters. These are also designed to fit into an accessory shoe but have a device to couple with the shutter speed or aperture setting controls. The reading given then indicates directly the other variable once the film speed has been set. They are obtainable as selenium or cadmium sulphide cell types and with a variety of acceptance angles.

Integral exposure meters

These meters are built into the camera body and are not removable. Many camera types are available in two body versions, with or without an integral meter. Cameras with such an exposure meter may be classified into one of two groups:

(a) with the meter cell external to the camera body.

(b) with the meter cell inside the camera body and making light measurements through the lens (TTL metering).

Integral meters with external cells

Both selenium and CdS cells are used in a variety of shapes and sizes, located in various positions on the camera. Owing to the large size of selenium cells, these are generally located in the front plate of the camera or as an annulus around the lens. The acceptance angle of the cell generally matches that of the standard lens. The CdS cell, on the other hand, being smaller, has greater freedom of position, but is generally located behind a small aperture in the front plate or in the lens mount. The acceptance angle is usually smaller than that of the normal focus lens. Provision for a small battery and on-off switch for the meter cell must be made.

Both reflected and incident light readings are possible with these cells. The linking of the meter and camera controls is dealt with in the section on automatic exposure control (page 151).

Through-the-lens exposure measurement

A direct result of the small size and great sensitivity of the CdS and silicon types of cell was the possibility of taking reflected light readings from the subject through the camera lens by a suitable cell in the camera body. In theory, this would automatically compensate for the transmission of the lens in use, for any lens extension for close focusing and for

the use of filters (with limitations). Measurement could be from all or only part of the subject covered by the lens in use. Such a system is most easily incorporated in a single-lens reflex camera. Many cameras of this type are available with a variety of TTL metering systems either fixed in the camera or as an option, by means of an alternative pentaprism housing incorporating the meter system.

Several problems are encountered in the design of a TTL metering system and current camera models reflect the variety of solutions possible.

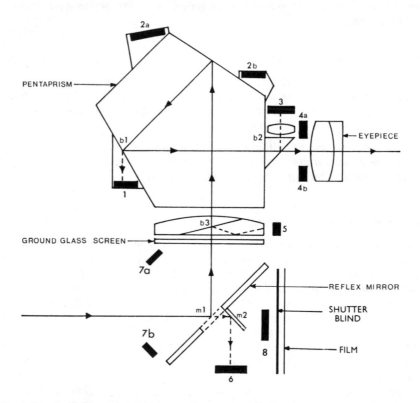

Fig. 9.8 – A selection of through-the-lens metering systems, showing the variations of meter cell position: 1, Cell giving integrated reading from ground-glass screen through pentaprism face via beamsplitter b1. 2a, 2b, Cells in series taking a form of weighted, integrated reading from ground-glass screen. 3, Cell giving reading from ground-glass screen via beamsplitter b2. Depending on design, fully-integrated or centre-weighted readings are used. 4a, 4b, Cells about the eyepiece giving a fully-integrated reading from the ground-glass screen. One cell may be used to correct for light from the eyepiece. 5, Cell reading in an equivalent focal plane via beamsplitter b3. Reading may be fully integrated or from a small area of screen. 6, Cell reading in an equivalent focal plane via partially-transparent mirror m1 and supplementary mirror m2. A small area reading is given. 7a, 7b, Cell monitoring image luminance on film surface or shutter blind. 8, Removable cell on pivoted arm reads close to focal plane.

Position of the meter cell

The cell or cells used can take a variety of shapes and sizes without much effect on sensitivity, allowing great flexibility in their location within the camera body (Figure 9.8). Ideally, the cell should be located as near the film plane as possible, but the presence of the focal-plane shutter hinders this. A cell on a hinged arm to locate it just in front of the shutter is a reasonably satisfactory arrangement, but in general, measurements are best made in an *equivalent focal plane.* This is a plane located at the same distance from the exit pupil of the camera lens as the film plane. One such plane is that of the ground-glass screen used for focusing. Several cameras use a beam-splitter system to divert light from part of the screen to a cell located outside the screen area. The area used for measurement purposes is delineated on the screen and shows clearly the part of the subject being measured. Another equivalent focal plane is located in the base of the dark chamber of the camera body, beneath the reflex mirror. A partially transparent area of the main mirror transmits light from the camera lens via a small subsidiary mirror down into the well of the dark chamber where a cell is located.

A simple solution to cell location is to place the cell behind all or part of the reflex mirror, allowing light to reach it by an arrangement of slits in the mirror or by making the mirror partially transparent.

Such an arrangement is unsatisfactory with interchangeable lenses if there is a change in position of the lens exit pupil. A different lens usually has its exit pupil nearer to or farther away from the mirror along the optical axis. The measurement area of the reflex mirror then intersects the cone of light from the lens exit pupil in a different position and samples a different cross-sectional area of the cone.

Another general solution to cell location is to position cells in the housing of the pentaprism or the eyepiece lens and use them to measure from the image on the ground-glass screen.

Such an arrangement necessitates a minimum amount of redesign of the camera and also permits an interchangeable pentaprism housing with TTL metering to be offered as part of a camera system. This latter alternative is favoured for 60 × 60 mm format cameras both of the twin-lens and single-lens reflex types. The cell or cells used are located either behind a pentaprism face or about the eyepiece lens. A single cell monitoring the whole of the screen area may be used, but generally two cells are employed to give a "weighted" reading favouring the centre of the screen. This is to offset uneven illumination of the screen caused by lenses of a variety of focal lengths.

One ingenious solution is to position a pair of silicon photodiodes to respond to light reflected from the film surface itself, i.e. image luminance, and to terminate the exposure time by controlling the shutter mechanism. Such an arrangement even monitors changes in the subject luminance during the exposure time, when the mirror is raised and when other metering systems would not be operating, and has sufficiently rapid response to monitor the output of an electronic flashgun with

thyristor circuitry (see page 54). To allow for the incomplete uncovering of the film gate by the slit in the focal plane shutter for short exposure times, the first shutter blind is printed with a suitably randomised array of reflecting patches to simulate an "average" subject.

Type of reading

The TTL metering system is based on measurement of the light reflected from the subject as transmitted by the optical system in use. The meter cell does not, however, always measure all the light from the subject area covered by the lens. Several different systems are employed (Figure 9.9). A "fully integrated" reading is a measure of all the light from the subject area and the exposure given is liable to all the usual variations caused by subject tonal distribution and luminance range. A "spot" reading is when a small area of the subject is measured, but, unlike the case when a photometer is used, a midtone must be selected for measurement and not a highlight or shadow only. The "small area" type of reading is an integrated reading of an area of the subject too large to be considered a spot reading but not a fully integrated one. The "weighted" reading is a compromise where the whole subject area is measured but the central portion of the subject as viewed contributes most towards the result given.

Fig. 9.9 – Types of meter readings used in cameras with through-the-lens exposure measurement: (a) Fully integrated from whole of screen area. (b) Small area or narrow angle. Only one-ninth of screen area used. (c) Weighted type. Central area contributes 60 per cent of reading; rest of screen area contributes the remaining 40 per cent.

The multiplicity of methods of reading combined with the different locations possible for the meter cell give rise to the large number of variations in the TTL metering cameras on the market.

Calibration

The variety of designs raises a problem in calibration of the meter system used as there is no generally agreed method. The method used in most cases, however, is based upon "pegging" the selected area as a midtone.

Sensitivity

When a cadmium sulphide cell is used, the sensitivity obtained in a TTL metering system is generally only of the same order as a good selenium cell meter for hand use. This is due to the great absorption of light by the optical and viewing system of the camera. Use of the lens of large maximum aperture naturally improves metering sensitivity unless a stop-down measurement system is being used. The use of a silicon photo-diode with suitable amplification circuitry can increase metering sensitivity by an appreciable factor owing to the greater inherent response of such a circuit.

Operation of the meter

While it is a great convenience to have an exposure metering system in the camera, the method used to set the camera at the indicated exposure varies somewhat between makes of camera. There are a number of steps involved. First, the battery to power the photocell must be switched on. Then the subject must be sharply focused and the appropriate area selected for lens measurement. In semi-automatic models either the shutter speed or lens aperture is first selected and set, and then the other variable set as indicated by the meter. Normally this is done by aligning a pair of needles visible in the viewfinder. One needle is operated by the meter cell and the other is matched to it by adjustment of the lens aperture or shutter speed control. Often another scale is visible in the view-finder indicating the shutter speed or aperture selected. The majority of cameras make full-aperture measurements but a few require that the lens be stopped down to the pre-selected aperture for measurement. The latter system has disadvantages.

In fully automatic cameras the aperture is usually pre-selected and the photocell operates the timing circuit of the electronic shutter for the time required.

Automatic exposure control

The provision of an exposure meter integral with the camera makes possible several methods of exposure control of varying degrees of automation.

Uncoupled. When using an uncoupled exposure meter, the exposure required is read off the meter scales and transferred manually to the shutter speed and aperture setting rings. This meter reading may be simplified as a single number, termed an *exposure value* (page 165) and the shutter speed and aperture rings are linked and calibrated accordingly.

Cross-coupled or follow-pointer. With this type of integral exposure meter the meter needle has a pointer coaxial with it, moving over the same range but connected by a linkage to the shutter speed and aperture

controls. Either may be pre-selected and the other is then set for the indicated exposure by altering the setting control to match the pointer with the meter needle. No calibrations or markings are necessary on the meter scale. The two needles or pointers are often visible in the viewfinder to facilitate operations. This system is much used in TTL metering cameras (Figure 9.10). A manual over-ride is usually provided for atypical subjects and for flash work.

Many cameras use light-emitting-diode (LED) arrays which typically light up in particular sequences to indicate over-, under- or correct exposure, instead of moving needles and their associated delicate movements.

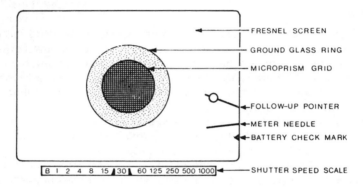

Fig. 9.10 – Typical viewfinder arrangement in a single-lens reflex camera with through-the-lens metering

Programmed shutter. The programmed shutter has a limited range of speeds, usually 1/30th to 1/500th second, and three modes of operation. One is for flash work when the meter connection is uncoupled and the shutter speed set to 1/30th second. Apertures are then set manually as required. The second is for other occasions when manual setting is desired. The third possibility is the automatic mode when both the shutter setting and the lens aperture are linked to the meter needle. The shutter is programmed so that it will remain at a fixed speed while the whole aperture range is used to match the meter needle. If the light is inadequate or excessive at the largest or smallest aperture setting respectively, then the shutter speed will change to a slower or higher speed to enable the correct aperture to be set. This method ensures that the highest possible shutter speed is used in all circumstances. There are variations in this method of programming. A typical shutter is programmed to give exposures ranging from 1/30th second at *f*/2·8 to 1/500th second at *f*/22.

Some cameras have no visible calibrations for shutter speed or aperture when a programmed shutter is used; a single ring only is turned to align two pointers in the metering system.

Automatic control. The meter movement may be used to choose automatically the iris diaphragm in accordance with a pre-selected shutter speed, but this system is not too common in still cameras. The preferred method is to use the photocell in an electronic shutter timing circuit and vary the exposure duration according to a pre-selected aperture. The range may be from 30 seconds to 1/500th second in a typical shutter. A warning is given when an exposure of longer than 1/30th second is needed so that a tripod may be used.

Flash synchronisation

In the early days of flash photography it was customary to set the camera on a tripod, open the shutter, fire the flash and close the shutter. As the manufacture of flashbulbs progressed, bulbs were produced which were sufficiently reliable for them to be synchronised with the camera shutter. This made it possible for flash to be used with the shutter set to give an instantaneous exposure, and the camera could therefore be hand-held. At first, a separate synchroniser was attached to the camera but it is now usual for flash contacts to be incorporated in the shutter itself.

The synchronisation of between-lens and focal-plane shutters presents two different problems. With a between-lens shutter, the aim in synchronising is to arrange for the peak of the flash to coincide with the period that the shutter blades are fully open. In all shutters there is a delay between the moment of release and the time when the blades start to open (approx. 2 to 5 milliseconds), and a further slight delay before the blades are fully open. With flashbulbs also there is a delay after firing, while the igniter wire becomes heated, before combustion occurs and light is produced. Whereas the delay with shutters is fairly constant, the delay with flashbulbs varies widely from one type of bulb to another (see Chapter 3), so that for synchronisation with different types of bulb, several different classes of synchronisation have been introduced. These are as follows:

(1) *Class F*

With this class of synchronisation the shutter is released and electrical contact is made simultaneously. Class F contacts are intended for use with class MF and class M flashbulbs at speeds not faster than 1/40th second. They are *not* suitable for use with electronic flash tubes.

(2) *Class X*

With this class of synchronisation electrical contact is made when the shutter blades are just fully open. Class X contacts are intended for use with electronic flash at all shutter speeds. They are also suitable for use with class MF and class M flashbulbs at speeds up to 1/30th second and with class S flashbulbs at speeds up to 1/15th second.

The Elements of the Camera

(3) *Class M*

With this class of synchronisation it is arranged that the shutter blades are fully open approximately 17 milliseconds after electrical contact is made. This requires a delay mechanism, and one similar to that employed for the slower speeds in preset shutters is commonly employed.

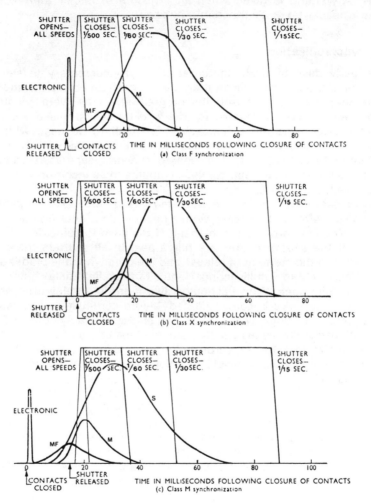

Fig. 9.11 – Flashbulb light output curves shown in relation to shutter performance curves for different types of synchronisation

Class M contacts are intended for use with class M bulbs at all speeds – including the fastest; they are also suitable for use with class S bulbs at speeds not faster than 1/60th second. They are *not* suitable for use with class MF flashbulbs or electronic flash tubes.

Type of synchronisation on camera	Type of flash Class MF bulbs	Class M bulbs	Class S bulbs	Electronic flash
F	Up to 1/40	Up to 1/40	Up to 1/15	–
X	Up to 1/30	Up to 1/30	Up to 1/15	All speeds
M	–	All speeds	Up to 1/60	–

Table 9.1 – Shutter speeds suitable for different types of flash synchronisation with between-lens shutters

The range of shutter speeds suitable for different types of flashbulb and flash synchronisation is illustrated in Figure 9.11 and shown in tabular form in Table 9.1.

It is usual in inexpensive cameras for the flash contacts to be arranged to give class F synchronisation; this permits the use of flashbulbs at relatively slow shutter speeds, but not electronic flash.

Cameras with multispeed shutters usually have two types of synchronisation – X and M. The X setting permits the use of electronic flash and class MF bulbs at slow speeds; the M setting permits the use of class M bulbs at all speeds and class S bulbs at slow speeds. In practice, it is usual to reserve use of the M setting, which involves the operation of the delay mechanism, for exposures with class M bulbs at speeds of 1/60th and over, i.e. for exposures which cannot be made with X synchronisation. A "V" setting on a multispeed shutter with both X and M synchronisation gives delayed-action exposures with X synchronisation. A camera with both X and M contacts is sometimes described as "fully synchronised".

Synchronisation of focal-plane shutters

Synchronisation of focal-plane shutters presents a special problem. Exposures with electronic flash and most ordinary types of expendable flashbulb can be made only at low shutter speeds, when the whole film is uncovered simultaneously. At faster speeds, special slow-burning "focal-plane" (class FP) bulbs are generally necessary. The emission of these bulbs rises to a plateau rather than a peak, giving almost constant output for the whole of the time that it takes the shutter blind to travel across the film.

As focal-plane shutters vary considerably in design and in the speed of travel of the shutter blinds, it is essential to consult the camera instruction book before using flash equipment with a camera fitted with a focal-plane shutter.

Unlike the fully-synchronised between-lens shutter which has only one flash connection and a two-position switch for X or M selection, focal-plane shutters may have one, two or even three flash connections. If only one, unmarked, outlet is fitted to the camera the shutter is X-synchronised only or the camera has a further control to allow the flash delay to be altered. Alternatively, a pair of outlets may be marked X and M,

or, more commonly, X and FP. Use of the appropriate one of these with a suitable shutter speed automatically gives correct synchronisation. Shutter speeds may be colour coded to assist setting a correct speed for the type of flash in use. In general, class MF and M bulbs are used at shutter speeds up to 1/15th second using the X setting or outlet. Use of higher speeds requires a class FP bulb and use of the FP setting or outlet. Electronic flash is widely used with focal-plane shutters. Depending upon the type of shutter, synchronisation may be possible up to a speed of 1/125th second. Shutters with blades travelling vertically generally synchronise at the higher speeds of 1/60th and 1/125th second, but this is restricted to 24 × 36 mm format cameras. Synchronisation of class MF

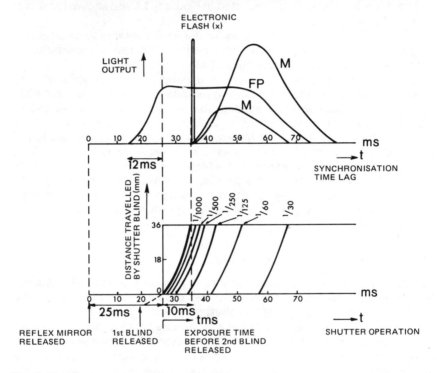

Fig. 9.12 – Flash synchronisation and operation of a focal plane shutter in a SLR camera. Electronic flash can only be used at 1/60 s or slower settings

and class M bulbs is also extended to 1/60th second in such cameras. The relationship between shutter operation, synchronisation and flash output is shown in Figure 9.12.

10 Camera Movements

APART from their use of larger formats, technical cameras, especially of the optical bench or monorail variety offer the facility of movement of the lens axis and film plane relative to each other and to the camera axis. These facilities are also found to a lesser extent on other types of camera and camera accessories.

Such *camera movements* give three forms of control over the image:

(1) Centring of the image with all respect to the film format.

(2) Manipulation of overall and selective image sharpness by focusing techniques.

(3) Retaining or changing image shape or perspective.

The necessary movements are made on the lens panel and on the camera back, usually referred to as "standards" if the camera is of monorail construction.

Figure 10.1 shows an idealised form of monorail camera in a neutral position, i.e. with the optical axis perpendicular to and passing through the centre of the film plane or principal point and coincident with the "camera axis" through the film. Both standards have 6 degrees of freedom of movement with respect to sets of rectangular axes with origins at the rear nodal point N_2 of the lens and principal point P of the film plane respectively. Three of them are translational or displacement movements along the axes, given by sliding the standards in suitably calibrated mountings. The other three movements are rotational about the axes. Most of these different movements have names, such as cross front, rising front, revolving back, swing, tilt and so on. By convention, rotation about a horizontal axis is termed a *tilt*, whereas rotation about a vertical axis is termed a *swing*. A summary of the types and uses of the various movements is given in Table 10.1.

Displacement movements

Focusing. With the camera movements set in their neutral positions the image sharpness may be controlled by movements of the lens or film

Camera Movements

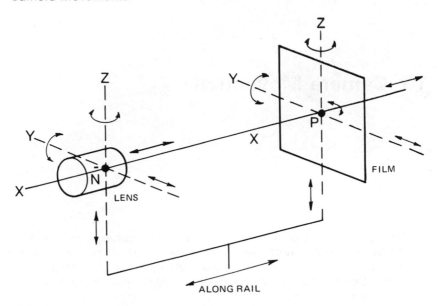

Fig. 10.1 – Monorail camera with its movements in "neutral".
⤸⤸ Rotational movements possible.
↔ Translation or displacement movements possible
The lens optical axis and camera axis are coincident in this neutral position.

Type of movement D displacement R rotational	Axis used L lens C camera	Usual name of movement	Prime function or use
D	X_L	Front focusing	Focusing – with change in magnification
D	Y_L	Cross front	Position image on film
D	Z_L	Rising front Drop front	Position image on film. Correction of verticals
R	Y_L	Front tilt	Depth of field zone
R	Z_L	Front swing	Depth of field zone
D	X_C	Rear focusing	Focusing – no change in magnification
D	Y_C	Cross back	Position image on film
D	Z_C	Rising back Drop back	Position image on film
R	X_C	Rotating back	Alter aspect ratio of image on film
R	Y_C	Tilting back	Depth of field and image shape
R	Z_C	Swing back	Depth of field and image shape

Table 10.1 – A summary of camera movements using the notation of Figure 10.1

standard along the optical axis. This of course is focusing the camera, usually with the aid of a ground-glass screen, and its purpose is to adjust the image conjugate distance or bellows extension in accordance with the distance of the subject from the lens. With most cameras this is accomplished by moving the lens with the film stationary, termed "front focusing". One advantage of a technical camera is that "rear focusing" by moving the film plane may also be used. This does not alter the lens to subject distance, which determines image size or magnification, but only image sharpness whereas front focusing varies both magnification and sharpness (see Figure 10.2). This has practical application when copying to exact size. Additionally a bellows extension may be set to give a fixed magnification and the subject focused by bodily movement of the camera.

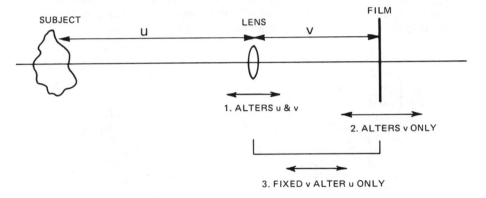

Fig. 10.2 – Possible methods of focusing the technical camera. All 3 methods have advantages in certain circumstances.

This latter technique is often employed in photomacrography and is not confined to technical cameras. Some cameras of the Sinar range have depth-of-field indicators operated from the focusing movement of the rear standard.

Image centration. Apart from focusing, the lens panel and film standard in sliding mounts may be moved in directions at right angles to the camera axis (assuming no rotational movements are used). Vertical displacements above or below the axis are termed *rising* and *falling* front (or back) respectively. Horizontal displacements to the left or right of the axis are simply termed *cross movements.* These movements are very useful in general for centring the image on the film, typically in a copying set-up where it is not possible to get a square-on view of the subject or where constant repositioning of the tripod may be inconvenient. It is important not to exceed the covering power of the lens in such cases (see practical considerations, page 195). Lens manufacturers publish tables of permissible decentrations for their lenses used with various formats and working apertures.

Camera Movements

Of these various movements, perhaps the most generally useful and most widely fitted to cameras perhaps even as the only one, is the "rising front" or vertical displacement of the lens above the camera axis. This is indispensable in architectural photography. When photographing buildings, especially tall ones, with a close viewpoint or lens with inadequate acceptance angle, the camera may have to be tilted up (if it is not provided with movements) to include the whole structure. The result is that vertical lines in the scene converge to the top in the picture, an effect which usually appears unnatural. Such converging verticals can be avoided only by keeping the film plane parallel to the building, when the top of the building may be lost with the inclusion of unwanted foreground, unless a distant viewpoint is chosen. Use of a rising front provides the solution. With the camera held level, the image is moved up the film to include the whole of the buildings as required (Figure 10.3). In studio photography, especially of still-life arrangements, when a high viewpoint is adopted to look down on the subject, the falling-front movement is useful to prevent, in this case, diverging verticals.

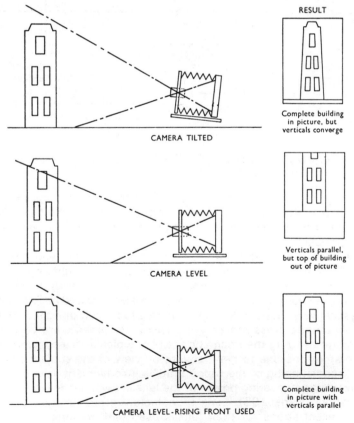

RESULT

CAMERA TILTED

Complete building in picture, but verticals converge

CAMERA LEVEL

Verticals parallel, but top of building out of picture

CAMERA LEVEL-RISING FRONT USED

Complete building in picture with verticals parallel

Fig. 10.3 – Use of rising front in architectural photography

190

The use of cross movements has a particular application in obtaining a square-on view of a reflecting subject such as a mirror or when an obstruction prevents such a view. The film plane is aligned parallel to the subject and the cross front adjusted while also parallel to the film plane to give the image as needed. Tedious minor camera adjustments are avoided and efficient use of the format is obtained.

In some cases where large displacement movements are required, the combined movements on the lens or film standards may be inadequate. In such cases, the use of tilts (or swings) to retain parallel standards may be resorted to in conjunction with the tilted camera.

It is also possible to correct a certain amount of image distortion of the convergent vertical type at the enlarging stage. This is termed *rectification* of the image but requires an enlarger with a range of movements. Consequently, image correction where possible is best carried out at the taking stage and not at the printing stage.

The usefulness of image displacement movements is emphasised by the availability of so-called "perspective control" lenses for 24 × 36 mm format SLR cameras. Such lenses permit a controlled amount of decentration from the camera axis to prevent convergence effects in particular, allowing such cameras to be used for the production of colour transparencies of many architectural subjects. Typical lenses are of 28 mm or 35 mm focal length and of retrofocus construction. The covering power of the 35 mm version is a circle of some 53 mm in diameter, allowing up to 11 mm displacement for a horizontal format. The large apertures and depth of field of these lenses allow even hand-held exposures to be taken of interiors. A ruled viewfinder screen is essential for alignment purposes. One lens also incorporates tilt as well as shift movements.

Extension bellows used in conjunction with a slide copying attachment may also have shift movements, useful to allow cropping or selective copying of the original.

Rotational movements

Revolving back

Many cameras are equipped with a back which rotates about the camera axis to permit pictures to be horizontal or vertical format without turning the camera through 90°, as is the case with a 24 × 36 mm format camera. This arrangement is common on baseboard-type cameras and click stops indicate the two fixed positions although any intermediate position may be selected, useful for instance if the camera cannot be levelled. The reversing back is removed and repositioned on the camera to give only two alternative positions and a more compact design.

Swing and tilt movements

The lens panel and film back may both have these movements: swing

about a vertical axis and tilt about some horizontal axis. Such movements have a dual function:

(1) To control the region of sharp focus, e.g. to enable sharp focus of an object in depth to be retained over the entire negative area.

(2) To permit control of parallel or converging lines in the image, i.e. they control the shape (parallelism) of the image.

There are important practical differences between the use of swing and tilt on the lens panel and on the camera back as will be discussed below.

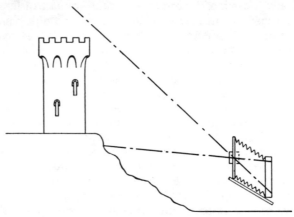

Fig. 10.4 – Tilting back and tilting front used together to give increased rising front

The use of large-format cameras necessitates the use of lenses of long focal length, in accordance with the diagonal of the format, and concomitant shallow depth of field even at small apertures. The use of very small apertures to obtain overall sharp focus is both inconvenient in terms of exposure and lighting requirements and loss of lens performance by diffraction. Fortunately a solution is possible by considering the arrangement of the subject matter and from the geometry of image formation.

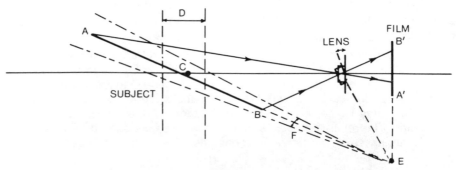

Fig. 10.5 – The use of front tilt to satisfy the Scheimpflug condition and obtain sharp focus over a subject extended in depth

Referring to Figure 10.5, for subject AB extended in depth, with the camera in normal adjustment and focused on point C, use of minimum aperture gives depth of field D extending asymmetrically about C as shown. But if the lens panel is tilted about a horizontal axis as shown, until its plane intersects those of the film and subject AB at E, then both A and B are imaged sharply on the film. Consequently plane AB is sharp and by stopping down the lens a zone of sharpness F is obtained either side to render the subject sharply overall as required.

Similarly the simultaneous use of lens swing movement about a vertical axis can control the extent of subject focus in a horizontal direction. Because of the versatility of this application, an extended irregular 3D subject may be rendered in focus by using the swing and tilt movements for the two larger dimensions and depth of field by lens aperture selection for the third, smallest dimension. The direction of rotation of the panel or standard may be remembered by bearing in mind that the further the subject zone is from the camera, the nearer must the film be to the lens. The condition for this intersection for the planes of focus states that if the object plane and the lens plane intersect in any line, the image of the object will also be sharp in a plane which also intersects the same line. This relationship is also known as *Scheimpflug's Condition*. The use of such movements finds applications in enlarging when rectifying images and in photomacrography when the depth of field is exceptionally shallow.

While swings and tilts are provided on both front and rear standards, the Scheimpflug Condition may be satisfied by adjusting one or the other or both. In practice, other considerations dictate the choice of which standard to rotate, apart from any mechanical problems that may arise.

Swinging and tilting lens panel

These rotational movements of the lens panel affect overall *focus* of the image without altering its shape. This retention of image shape makes such movements very useful when the "shape" or appearance of objects is important and the swing or tilt back cannot therefore be used for this purpose. Another difference between front and rear movements is that when the front movements are applied the image moves to the edge of the field of the lens; with back movements this does not happen. So use of swing front to control focus is quickly limited by the covering power of the lens, and, even within this limit, definition may fall off because the edge of the field is being employed. Thus, for extensive use of movements, a lens with very good covering power is required. This limitation of course also applies to movements such as rising front where the edge of the field is used.

Swinging and tilting camera back

Use of these rotational movements does not seriously affect the centring of the image, unlike use of the front movements. Usually any effect

depends on the location of the particular axis of rotation of the back. The use of a tilting back is often very helpful in conjunction with tilting the camera itself so as to provide additional rising front movement.

It is important to note that when swinging or tilting the camera back, both the shape and focus of the image are affected simultaneously. Sometimes, as for landscapes, this shape distortion does not matter, as indeed for other subjects without manifestly straight lines. It is also worth noting that alteration of the back to give a desired image shape may be in an opposite sense to that required to obtain overall sharp focus, this may well occur, for example, when using tilting back to correct converging verticals.

With the camera in normal adjustment and level the perspective of the subject is determined solely by the viewpoint (see page 84), in this case the centre of the entrance pupil of the camera lens. The image given when the film plane is perpendicular to the optical or projection axis is a correct perspective rendering from this viewpoint. Provided the film plane was vertical, within this image is a *horizon line*, and all parallel lines which appear to converge will continue to do so and finally meet on the horizon line at a *vanishing point*. Lines parallel to the picture plane remain parallel. The height of the horizon line above or below the centre line of the image indicates a low or high viewpoint.

Taking the case of swing back as shown in Figure 10.6(a) with the camera in normal adjustment taking an oblique view of the oblong subject, the positions of the vanishing points V_1 and V_2 are determined by the viewpoint and their separation decreases as the viewpoint approaches, i.e. the camera moves in. If, as in (b), the back is swung so as to be nearly parallel with the left-hand side of the subject this has the effect of reducing the convergence of parallel lines on that side. In addition the convergence of parallel lines on the left-hand side increases. The effect of swinging the back in the opposite direction is just the reverse, as shown in (c).

While such manipulation gives abnormal or untrue perspective from that viewpoint by altering the image shape, for many purposes it may give a more pleasing rendering or even be necessary, as in the case of converging verticals corrected by tilting back with the camera pointed upwards. When either horizontal or vertical perspective is altered in this way the movement that restores the parallelism of the lines also causes an elongation of the subject in the same direction. Rectification during enlargement is possible but seldom applied.

Often swinging and tilting back movements are useful not only for preventing distortion of the image but to introduce distortion for artistic or commercial effect, e.g. to make cars look longer than they really are, to make toys appear massive and realistic, to emphasise vertical lines in clothing or to make a short person appear tall.

It is of interest to note that one medium format SLR, the Rollei SL66, has a tilt movement of up to $\pm8°$, intended to provide additional depth of field in appropriate circumstances. As for all camera movements, visual inspection of the effects on a ground-glass screen is essential.

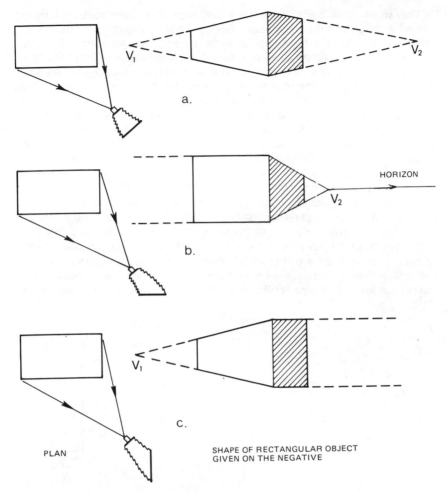

Fig. 10.6 – The use of swingback to control image shape

Practical considerations and design limitations

While the above considerations of the theory of camera movements have assumed ideal movements about the axes specified, in practice there are sometimes severe restrictions in the use of a movement or it may be missing altogether or obtainable only by complex manipulation of other movements, e.g. cross front given by application of rising front with the camera on its side. Manipulation of the movement is also usually a matter of trial and error with successive approximations.

Without doubt the modular construction of the monorail camera permits the widest variety and extent of camera movements. Some displacements cannot be fully utilised, however, because the lenses available have inadequate covering power for the purpose.

195

Camera Movements

The front and back standards usually have identical, calibrated movements with suitable locking devices. Many ingenious mechanical solutions have been found to provide a range of designs. However, several practical problems remain, especially with respect to provision of swing and tilt movements. Ideally the two sets of swing and tilt axes should pass through the rear nodal point of the lens and through the film plane respectively. Considering the lens, its rear nodal point is not indicated on the mount nor is it easy to locate. Additionally, when the lens is mounted on a panel this point is most unlikely to be in the vertical axis of rotation or swing. Indeed, in the case of a telephoto design, the rear nodal point is some distance in front of the front element, which gives unexpected results when camera movements are applied with such lenses. Also the horizontal axis of rotation (tilt) may be located at the base of the lens standard instead of at its centre (see Figure 10.7). This provision of "base" instead of "centre" tilt has mechanical and operating advantages in terms of a simpler, more sturdy construction and the ability to insert or remove lens panels or dark slides irrespective of the amounts of movement in use. However, progressive refocusing is necessary during application of a tilt movement as the conjugate distances are altered. Some refocusing is also usually necessary with centre tilt designs.

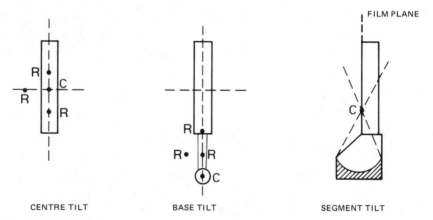

CENTRE TILT BASE TILT SEGMENT TILT

Fig. 10.7 – Tilts and mechanical designs. C is the centre of rotation, which does not usually coincide with the rear nodal point of the lens or the film plane. The segment tilt is the exception. C may be located elsewhere, denoted by R

This is not always necessarily so, the vertical swing axis may be close to ideal but the horizontal tilt axis may be of the centre or base variety. A particularly vexing problem is the simultaneous use of rear swing and tilt movements with a base tilt design when gyration of the image plane occurs. An ingenious solution to these problems is in the "segment" tilt design of the Sinar P cameras when tilting is about a horizontal axis exactly in the image plane. Likewise for swinging about a vertical axis in

the image plane. Both axes of revolution are clearly marked on the focusing screen and any point in focus on one of these axes stays in focus while the corresponding movement is applied to control focus and shape.

The baseboard-type technical camera usually has considerable rising front and a little drop front, but may have only limited or zero cross, tilt and swing movements on the lens standard. Swing front is a less common movement than tilting front as the swing back can safely be used to control overall focus in this direction, i.e. from left to right of the picture, for, although "converging horizontals" are introduced by using the swing back, these are not usually objectionable, certainly by no means as objectionable as converging verticals. Rotational movements rarely exceed 15° or so. Back movements are a combined swing and tilt arrangement by jointed extensible pins from the camera body. Other design features found are a drop baseboard and a hinged top body flap to permit the use of wide-angle lenses and a useful rising front movement respectively.

11 Optical Filters and Attachments

A WIDE range of optical filters and other attachments are available for use with cameras. Filters are used to modify the spectral characteristics of the image-forming light by selective absorption. Other attachments used in front of the lens are spectrally non-selective but alter the image formation by the lens.

There are several types of optical filter employed in photography. These are:

(1) Colour filters for black-and-white photography.
(2) Colour filters for colour photography.
(3) Filters for colour printing.
(4) Special filters.
(5) Polarising filters.
(6) Filters for darkroom use.

General properties and characteristics of filters

Spectral absorption. A colour filter consists of a transparent flat sheet of coloured material that is placed over the lens of the camera (usually) so that the exposure takes place through it. A colour filter acts by selective absorption of part of the light incident upon it, as shown in Figure 11.1. From this figure it will be seen that just as a *yellow* sheet of paper – an *opaque* object – *reflects* green and red light and absorbs blue, so a yellow transparent object *transmits* green and red light and absorbs blue. Other filters behave in a similar manner (except for interference filters see page 202) transmitting the light which, in the case of an opaque object of the same colour, would be reflected.

Colour filters are of use only with materials having full panchromatic sensitivity to permit full control of colour rendering. Colour materials and most general purpose monochrome films are panchromatic. Only yellow filters can usefully be employed with orthochromatic materials. Filtering is not normally possible with blue-sensitive materials.

BLUE ABSORBED BY FILTER

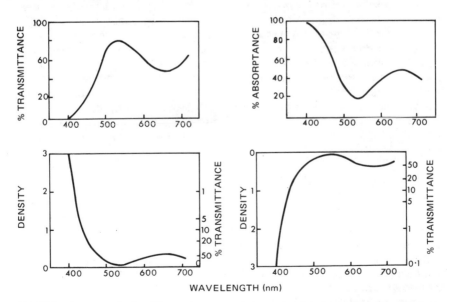

Fig. 11.1 – How a colour filter works

Absorption curves

The spectral transmission characteristics of a filter are expressed most fully by a curve in which transmission throughout the spectral region of interest is plotted against wavelength. Consultation of manufacturer's data shows that a variety of methods and conventions are used. Transmittance (or its reciprocal absorptance) may be normalised or expressed as a percentage. Both arithmetic and logarithmic scales are used. A common and useful method is to plot optical density (see page 305), a function of transmittance, increasing as we go up the vertical axis, giving *spectral absorption curves* (see Figure 11.2). These curves are given by an instrument such as a recording spectrophotometer used to investigate the properties of a filter.

Fig. 11.2 – Some methods of illustrating spectral absorption data for a colour filter. The four graphs show the same data for a pale green filter plotted in different ways to show the variations in curve shape given

Filter factors

To obtain properly exposed results when using a filter, a somewhat greater camera exposure than usual must be given to compensate for the absorption of light by the filter. This increase may be obtained either by increasing the exposure time or by using a larger aperture.

The ratio of the filtered exposure to the corresponding unfiltered exposure is termed the *exposure factor* or *filter factor.* The value of the filter factor for any given filter depends on the spectral absorption of the filter, the spectral quality of the light source used, the spectral sensitivity of the photographic material used and the exposure duration, if reciprocity law failure effects are significant. Often a filter may be described as a "2× yellow" or a "4× orange", implying filter factors of 2 and 4 respectively, irrespective of the particular conditions and photographic material in use. While evidently incorrect for some purposes, such numbers do give an idea of approximate values for pale filters with relatively low filter factors used with pan film. Actual values may range from 1·5 to 2·5 and from 3 to 5 for the examples quoted, but the exposure latitude of most materials can hide such variations.

Filter factors may be determined in a number of ways. One practical method is to photograph a neutral subject such as a black-and-white print with and without the filter under the same conditions of illumination, giving a range of filtered exposures. The ratio of filtered to unfiltered exposure for identical results gives the filter factor. Dense filters (as used in colour separation work) requiring large increases in exposure are best measured in terms of *intensity filter factors*, using a fixed exposure time such as 10 seconds, and altering the lens aperture accordingly.

Cameras incorporating through-the-lens exposure metering may give the correct compensation for certain filters such as neutral density and pale light-balancing types, but with many filters problems may arise owing to the differing spectral sensitivities of the measuring photocell and sensitised material in use. Beam-splitters used in the camera may cause polarising filters to give incorrect exposure indications, depending on the orientation of the polarising axis to the optical axis. In such cases special circular polarising filters must be used instead of the usual linear varieties.

Commercial forms of colour filters

When a filter is required, it is important to use one specially intended for photographic use, and not substitute any convenient coloured piece of glass or film. Apart from its unknown spectral absorption properties, perhaps with unwanted absorptions, the substitute may be of inadequate optical quality and cause image degradation. Photographic filters have suitable absorption characteristics and those for camera use have the necessary optical quality.

Apart from the absence of surface defects, such optical filters should be as thin as possible to minimise image shift (see page 203) and have opposite faces accurately parallel. Departure from parallelism to give a

wedge shape severely degrades the performance of the lens. So important are the possible effects of filters on the image quality that some designs such as fish-eye and mirror lens types are computed to be used with a filter of suitable size and quality permanently in place among the lens elements. Such lenses have a selection of filters in a *filter turret* as an integral part of the lens casing, usually including a colourless filter for normal colour photography and colour filters as required for monochrome photography.

Various forms of filter are supplied by specialist manufacturers, these are gelatin, cellulose acetate, polyester, solid glass, gelatin cemented in glass, gelatin on glass and interference filters. A convenient and permanent form is a sheet of coloured glass, termed "dyed-in-the-mass", as used for many general purpose filters. A restricted range of colours is available. Some special filters, such as heat-absorbing and ultra-violet transmitting filters, are available only in glass form.

When filters of special transmission characteristics are required – as for example in technical, scientific and colour photography – filters in which the absorbing layer is dyed gelatin are usually employed. These filters are made by mixing organic dyes in gelatin and coating this on glass. When dry, the coated film measuring about 0·1 mm thick is stripped from the glass. It is supplied lacquered on both sides for some protection. Occasionally, for some applications such as colour printing where structural strength and heat resistance are required, the dyed gelatin is left on the glass substrate.

Similarly, *light filters* intended for use between a light source and an instrument such as a microscope are of this form where they are not used in the image-forming part of an optical system, so their optical quality and cost may be lower. They should not be confused with cemented filters. Darkroom safelight screens, too, are often of the glass-based type, further protected by a cover glass.

Gelatin filters are of excellent optical quality, exceeding that of the best quality glass filters, and have virtually no effect on image formation. They are available in a very wide range of spectral absorption properties. Because of their susceptibility to surface damage and cockling by handling and heat, for many applications or constant use it is desirable to have the gelatin cemented between suitable pieces of glass.

Normally three types are available to special order as the cement may have to be chosen to match high-intensity light sources.

Instrument filters use ordinary quality glass and are for non-photographic use such as in visual instruments, e.g. a colorimeter.

Camera filters use optically-worked glass and are suitable for most photographic work. A "blank" of the same thickness may be necessary for visual focusing purposes to allow for image shift.

Optical flats use glass worked to optical flatness and are used for high-precision work.

Where constant handling is inevitable, or resistance to heat is necessary or large sizes of filter are required, such as in colour printing, the use of dyed cellulose acetate or butyrate sheet provides a useful

range of filters. Thicker than gelatin filters, their lower optical quality confines their use to the illumination system and not the image-forming parts of optical systems. The combustability of such filters is important: they should melt or char and not catch fire if heated. The low cost of such non-photographic filters and their availability in large sizes and rolls means that filtration of large areas such as windows may be carried out to give safelight conditions or to balance exterior lighting such as daylight to a subject lit by studio lamps.

By using other plastic materials such as methacrylates and polycarbonates which are either dyed in the mass during manufacture or coloured by imbibition of colorant, light-weight and unbreakable filters of optical quality may be made. A thickness of 2 mm is typical.

Interference filters

One of the drawbacks of filters using organic dyes is that they are prone to fading because the dyes are fugitive. Also even a mixture of dyes may not be able to provide the necessary spectral absorption characteristics.

The recent growth of thin-layer coating technology has seen the introduction of *interference filters* into general photographic use, particularly as a substitute for conventional acetate filters in colour enlargers.

Conventional colour filters depend on the selective absorption of light by coloured glass or gelatin. Interference filters make use of the principle of the interference of light to give a selective transmission of any colour in the visible spectrum within narrow limits of wavelength so that spectral transmission characteristics approach very close to ideal with no unwanted losses. The portions of the spectrum that are not transmitted are reflected, not absorbed. Thus, such filters appear one colour, e.g. yellow, by transmitted light and the complementary colour, in this case blue, by reflected light. Hence the alternative name of *dichroic filters.*

Interference filters consist of glass blanks on which are deposited by evaporation or electron bombardment in a high vacuum, a series of very thin layers of metal or dielectric material. As many as 25 individual layers are common. Choice of refractive index and thickness of alternating layers as well as the number of layers are used to restrict transmission to the desired spectral regions.

Constructive and destructive interference of light reflected at successive interfaces give the necessary transmission or reflection of different wavelengths of light. Such filters must be used in a collimated beam of light, because spectral transmission depends on the angle of incidence.

Interference filters are available in small sizes only, owing to the difficulties of coating large filters. Cost, while high, is not unreasonable, bearing in mind the long life with constant performance typical of the product.

Filter sizes and availability

Conventional varieties of colour filters and other optical filters are available in a variety of sizes and forms. Gelatin filters come in sizes from 50 × 50 mm upward. Acetate filters are available from small squares to large rolls, suitable for covering large areas or light fittings. Cemented filters are restricted to a few sizes or circles. Gelatin-on-glass filters vary from large to small depending on the safelight fitting. Glass filters dyed in the mass are available in a range of sizes to fit standard filter holders.

It is desirable to have antireflection coatings on both surfaces of glass filters of all varieties to reduce reflection losses and the possibility of sources of flare. Most filters of reputable manufacture have such single-layer coatings, with multi-layer coatings available at greater cost.

Optical filters may be positioned in front of or behind a lens. The rear fitting allows smaller diameter filters to be used. Lenses with built-in filter turrets have the filters positioned between lens elements.

A variety of push-on, screw and bayonet fittings are used on lenses. Some lens manufacturers use a single filter size common to a wide range of lenses, allowing considerable economies to be made by the user. Special holders are necessary for gelatin filters.

As part of an image-forming system, filters should be treated with care, not handled unduly and kept scrupulously clean. When not in use they should be kept cool and dry, especially gelatin filters. Filter mounts should not strain or distort the filters when in position, otherwise image quality will suffer.

A colourless haze or UV filter is often used as an "optical lens cap" to protect the front element of the lens from damage. It is cheaper to replace even a high-quality filter rather than pay for repair to a lens.

With safelight and lamp filters care must be taken that the filter does not become overheated or become damp and contaminated by chemicals.

Effect of filters on focusing

When using filters in conjunction with a camera, several problems may arise with respect to the accuracy of focusing the filtered image.

Glass filters, especially of the cemented variety, may be thick enough to cause a significant displacement of the image plane of the lens (see page 201). Displacement is approximately one-third of the filter thickness. Visual focusing on a ground-glass screen with the filter in place is essential in this case. If the filter is very dense or perhaps even visually opaque, as in the case of certain ultra-violet and infra-red transmitting filters, then substitution of a clear glass blank of identical thickness is necessary. Correction for the appropriate UV or IR focus is then applied. This problem does not arise with thin gelatin filters.

For infra-red photography when a visually opaque filter is used, focusing through a substitute tri-colour red filter may sometimes be used.

Optical Filters and Attachments

For colour separation work, when exposures through dense tri-colour filters are made, the original is focused using the tri-colour green filter. The wavelength of peak transmission of this filter approximates to the peak sensitivity of the eye in the green region.

With the use of SLR cameras so common, the presence of a colour filter permanently tinting the viewfinder image may be found irksome, especially with the deeper colours such as orange, green or red, causing difficulty in visualisation of the picture or in focusing in dim light conditions.

Colour filters for black-and-white photography

In black-and-white photography, colour filters are employed primarily as a means of controlling the reproduction of colours in terms of greys. A wide range of filter colours and densities are available for this purpose. They may conveniently be divided into two groups in terms of their use, *correction filters* and *contrast filters*.

Correction filters

Sensitised materials for black-and-white photography are available with blue-sensitive, orthochromatic and panchromatic sensitisation (see page 239). The first two are almost exclusively now only available as special-purpose materials, e.g. for copying, and most general-purpose photography is done with panchromatic materials with their higher speeds and capability of recording all spectral colours.

Panchromatic sensitisation however is not uniform throughout the spectrum, most materials being more sensitive to blue than green while some materials have enhanced red sensitivity. Obviously some tonal distortion of subject colours in a monochrome reproduction is inevitable. Correction filters are employed with the aim of recording the colours of the subject in their true luminosities. Full or partial correction is possible but the former necessitates considerable increase in camera exposure.

It is worth noting that although such procedures are technically "correct" the result obtained, especially after full correction may be disappointing from the pictorial point of view, being dull and flat.

A more effective interpretation of the subject is frequently obtained by retaining the colour contrasts existing in the original and modifying them as necessary, using contrast filters to produce the desired effect in each case.

Correction filters are available in various densities of yellow and yellow-green and their use may be summarised in Table 11.1, remembering that for panchromatic films in daylight, blues are rendered too light and greens too dark, while in tungsten illumination reds are too light and blues too dark. Thus white clouds and blue sky may be recorded with similar densities, i.e. no contrast, while the subject of a portrait in tungsten light may appear to have very pale skin and eyes too dark. Typical spectral absorption curves for correction filters are shown in Figure 11.3.

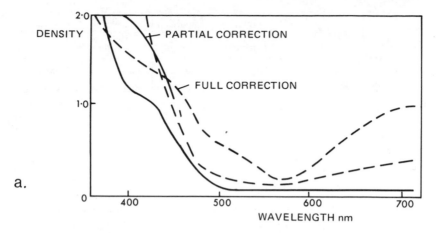

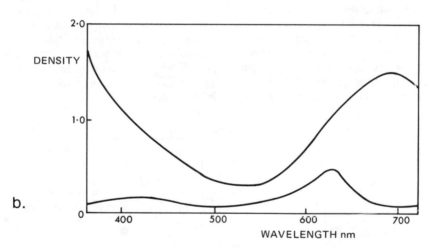

Fig. 11.3 – Spectral absorption curves for correction filters for monochrome films.
(a) Filters for partial or full correction in daylight
(b) Filters for correction in tungsten light

Contrast filters

Differences of colour and luminance in the subject are both represented in the print as differences in tone. Contrast filters are used to control the tone contrast in the print arising from colour contrast in the subject. They may be employed to make a colour appear lighter, to make it appear darker or simultaneously to make one colour darker and another lighter. For example, a subject may have areas of green and orange which, while having considerable colour contrast, may have little difference in

| Light source | Film sensitisation | Rendering of colours | | Correction filter needed | |
		Too dark	Too light	Partial correction	Full correction
Daylight	pan	green	blue	pale yellow	yellow-green
Daylight	ortho	red	blue	pale yellow	not possible
Tungsten	pan	blue	red	pale greenish blue	blue-green
Electronic flash	pan	–	blue	–	pale yellow

Table 11.1 – Correction filters for monochrome photography

luminance. A "correct" rendering would show both as similar shades of grey with little or no contrast. A contrast filter is required to produce the necessary tone separation that is essential if the photograph is to be an objective reproduction.

The fundamental property of a colour filter of the absorption type is that it transmits light of its own colour and absorbs all other wavelengths comprising the complementary colour. Depending on filter density, various amounts of the nominal wavelength transmission band may also be absorbed. Hence the basic rules for the selection of contrast filters are that to lighten a colour use a filter which transmits that particular spectral region and conversely to darken a colour use a filter which transmits poorly or not at all in that region.

Filter	Colour	Absorbs	Lightens	Typical uses
tricolour blue	blue	red, green	blue	copying, emphasis of haze
tricolour green	green	blue, red	green	landscape photography
tricolour red	red	blue, green	red	cloud photography, haze penetration
narrow-cut blue	deep blue	red, green some blue	blue	copying and colour separation
narrow-cut green	deep green	blue, red some green	green	copying and colour separation
narrow-cut red	deep red	blue, green some red	red	
minus blue	yellow	blue	yellow	cloud photography
minus green	magenta	green	magenta	copying
minus red (complementary filters)	cyan	red	cyan	copying
orange ("furniture red")	deep orange	blue, some green	red	emphasis wood grain

Table 11.2 – Contrast filters for monochrome work

Some colours such as reds and yellows are easily controlled in this way but greens and browns prove more difficult, usually because of low saturation, i.e. containing a significant proportion of white light.

A contrast filter of the same colour as a self-coloured object is often termed a *detail filter*, because it lowers the contrast between the object and its surroundings so that contrast in the object itself can be increased by photographic means. Uses range from photomicrography to rendering of texture.

A summary of the more important contrast filters for photography is given in Table 11.2 and typical spectral absorption properties in Figures 11.4, 11.5 and 11.6. Narrow-cut filters are those whose spectral transmission band is narrower than that of conventional tri-colour filters.

Haze penetration

Distant objects frequently exhibit low contrast because the light reaching the observer has been scattered by molecules of the gases composing the air and by suspended droplets of water. The scattering produced by particles small compared with the wavelength of light, such as gas molecules, is not the same for all wavelengths. In fact, it is inversely proportional to the fourth power of the wavelength.

Consequently it is a maximum for ultra-violet radiation and decreases steadily through the visible spectrum to reach a minimum in the infra-red. Thus, the direct light tends to have a relative higher red content than the original radiation, while the scattered light has a correspondingly higher blue content.

In photography, we sometimes wish to retain the effect of haze, as in pictorial work, and sometimes to eliminate it, as in telephotography. All photographic materials have pronounced sensitivity to the blue and ultra-violet regions of the spectrum so that panchromatic films exposed without a filter give an impression of more haze than the eye. To prevent the scattered radiation from recording and hence reduce the impression of haze, thereby increasing subject contrast, a filter is required which absorbs in the blue end and transmits in the red end of the spectrum. A pale-yellow filter allows panchromatic film to approximate closely to the visual impression of haze. Greater penetration is achieved by using an orange or red filter. Maximum penetration is given using infra-red sensitive materials.

Even infra-red photography, however, cannot penetrate haze caused by large droplets, such as fog or sea mist, because scattering by such particles is almost independent of wavelength.

To absorb ultra-violet radiation only without affecting the visible spectrum, an ultra-violet absorbing filter may be used. This is especially valuable in colour photography. It requires no increase in exposure.

Colour filters for colour photography

Colour materials have more severe restraints upon their use so as to produce an acceptable colour reproduction than is the case with

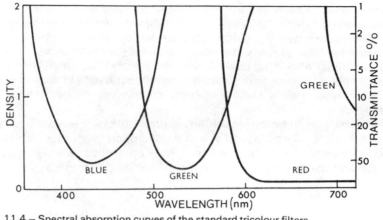

Fig. 11.4 – Spectral absorption curves of the standard tricolour filters

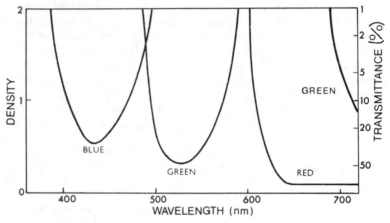

Fig. 11.5 – Spectral absorption curves of the narrow-cut tricolour filters

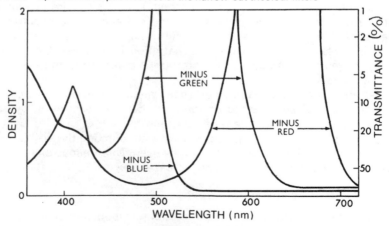

Fig. 11.6 – Spectral absorption curves of the complementary filters

monochrome materials. Principal among these are the colour temperature of the source, for colour film is balanced for use with a particular value, usually 3200 K, 3400 K or 5500 K, and the exposure duration restricted to a specified range to avoid any unwanted reciprocity law failure effects. Accordingly, there are many pale filters in various colours to assist with lighting problems at the exposure stage and to prevent or reduce otherwise unavoidable colour casts in the result. In addition, colour negatives are printed with the aid of colour filters to obtain correct colour balance in the print (see page 483).

Light-balancing filters

These are a form of photometric filter intended for use to raise or lower by small increments the colour temperature of the light reaching the film. They may be used over the camera lens or over individual light sources so as to bring these to a common value suitable for the colour film in use.

Two series of filters are available, one bluish in colour and intended to raise the colour temperature, the other brownish to lower colour temperature. They are suitable only for use with incandescent sources that have a continuous spectral energy distribution. Their effect and calibration is best described using the mired scale (see page 35) because equal intervals correspond to equal variations in colour of the source. The *mired shift value, S,* of the filter required is given by the formula

$$S = \left(\frac{1}{T_2} - \frac{1}{T_1} \right) \times 10^6$$

Filter colour	Mired shift value	Exposure increase in stops	Typical use
pale blue	−81	1	Type D film with aluminium flashbulbs
	−56	2/3	Type D film with zirconium flashbulbs
	−45	2/3	Type B film with G.S. lamps
	−32	1/3	Type B film with G.S. lamps
	−18	1/3	Type A film with 3200 K lighting
	−10	1/3	
pale amber	+10	1/3	With electronic flash
	+18	1/3	Type B film with photofloods
	+27	1/3	
	+35	1/3	Type A or B film with clear flashbulbs
	+53	2/3	
orange	+112	2/3	Type A films in daylight
	+130	2/3	Type B films in daylight
blue	−130	2	Type D films in 3200 lighting

Table 11.3 – Light-balancing and colour-conversion filters for use with colour films. Type A is balanced for artificial light of 3400 K (photoflood); Type B is balanced for artificial light of 3200 K (studio lamp); Type D is balanced for daylight of 5500 K.

where T_1 is the measured colour temperature of the light source and T_2 is the colour temperature balance of the material in use. The value of the shift may be positive or negative. The pale-blue filter series have a negative value, giving an increase in colour temperature and vice versa for the pale-brown series. Such filters have small filter factors. In practice their effect is most marked on colour rendering. An 18-mired shift, for example, removes the strong blue cast due to skylight when photographing subjects in open shade.

Table 11.3 gives a summary of the properties and availability of colour filters, while Figure 11.7 illustrates their spectral properties.

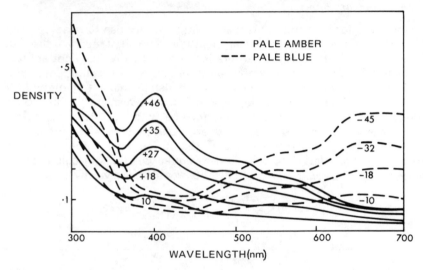

Fig. 11.7 – Spectral absorption curves for light-balancing filters. The number adjacent to each curve refers to its mired shift value

Colour conversion filters

Occasions often arise when it is unavoidable to expose colour film balanced for a particular colour temperature, in conditions where the illuminant has a colour temperature suitable for another type of film, e.g. daylight-type film intended for 5500 K exposed in artificial light of 3200 K. To reduce or prevent the deep colour cast such mismatching would cause, colour conversion filters are available in two series, deep blue and orange in colour respectively. The mired shift value of such filters is high, typically 130, being the difference between 3200 K and 5500 K. The blue series for exposing daylight-type film in artificial light, have large filter factors, give incomplete correction and can be regarded as for emergency use only. On the other hand, the orange series for using artificial-light film in daylight, have small filter factors and can give complete correction. Indeed many movie films are balanced only for artificial light and the camera has a colour conversion filter permanently installed.

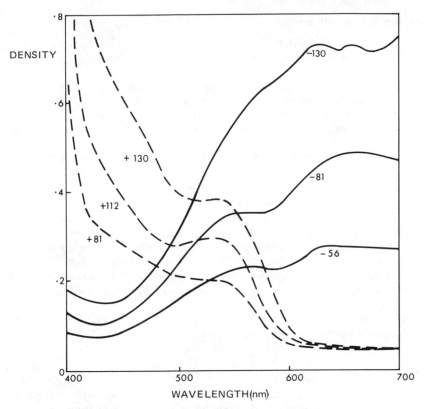

Fig. 11.8 – Spectral absorption curves for colour conversion filters.
The numbers adjacent to the curves refer to their mired shift values

Insertion of movie lights on a bar or a different type of film cartridge automatically removes the filter from the optical system.

Colour compensating filters

These filters are used to influence the overall colour balance of results obtained from colour films. Without such action various colour casts could be encountered. Common causes include deficiencies in the spectral quality of the light source used, bounce light coloured by reflection from a coloured surface, film batch variations, reciprocity law failure effects, light absorption in underwater photography and so on.

They can, of course, also be used to introduce deliberate colour casts for mood or effect. It is possible to use them to remove colour casts in colour printing (see page 485). CC filters, to give them their common abbreviation, are available in six colours – red, green, blue, yellow, magenta and cyan. A designation such as CC 20R indicates a pale red filter whose optical density at its peak absorption is 0·2. A range of densities is available and even the higher values have moderate filter factors.

211

Filters for colour printing

Various types of colour filter are used to obtain satisfactory colour balance in the final print, depending on the printing technique in use (see page 198).

A tri-colour set comprising red, green and blue filters is used for the triple-exposure printing method. Alternatively, colour-compensating filters can be used in front of the lens with a single exposure, but the calculations necessary to keep the necessary number of filters to a minimum and the need to avoid damage through handling are disadvantages. The preferred method for single-exposure "white light" or "subtractive" colour printing is to use sturdy acetate filters above the condenser lens where their optical quality is unimportant. CP filters, as they are commonly termed, are available in yellow, magenta, cyan and red in a number of densities. The designation CP 40M denotes a magenta filter of density 0·40 in its region of maximum spectral absorption.

Latterly introduced, interference filters with a single density and yellow, magenta or cyan in colour are now widely used. They are calibrated in arbitrary numbers or actual optical densities related to their effect when inserted to a greater or lesser extent into a collimated beam of light.

Ultra-violet absorbing and infra-red (heat) absorbing filters are also needed in a colour enlarger (see page 488).

Special filters

In addition to the ranges of colour filters described above there are others that have special or distinct functions. Some of them may even have no colour or be visually opaque because their filtering action may be outside or entirely within the visible spectrum.

Ultra-violet absorbing filters

The eye is insensitive to ultra-violet radiation, but all photographic materials possess considerable sensitivity in this region. UV radiation is strongly scattered by haze and in such conditions monochrome photographs lose contrast while colour photographs show a strong blue cast. Typically, distant views show increasing haze or blueness with increasing subject distance.

In addition, the spectral transmission of different lenses may vary for the ultra-violet region and different colour balances in terms of "warmth" of image will result from a range of lenses for a camera. Consequently, it is desirable to use an ultra-violet absorbing or *haze* filter. Another name is a *skylight* filter because an additional use is to reduce the effect of excessive scattered light as found in a blue sky. Most such filters are colourless or very pale pink or yellow in colour depending on their cut-off wavelength (see Figure 11.9). Often the digits in a filter code number indicate this point, e.g. 39 denotes 390 nm. Glass, gelatin and acetate

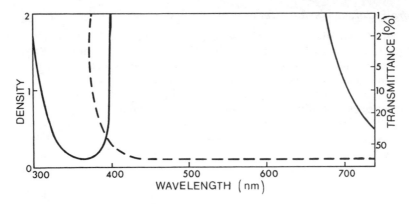

Fig. 11.9 – Absorption curve of an ultra-violet transmitting filter, and of an ultra-violet absorbing filter – – – –

varieties are all available. A haze filter is often used as protection for the lens and left permanently in place. It is equally effective with monochrome or colour film.

Ultra-violet transmission filters

For some applications of photography, pictures are taken using only ultra-violet radiation. Suitable sources also emit visible light. Special opaque glass filters are used which do not transmit the visible spectrum, only the near ultraviolet region (see Figure 11.9). A focus correction is essential.

Infra-red absorbing filters

As well as emitting visible light, all thermal light sources emit most of their energy in the form of infra-red radiation or heat. In an enclosed optical system such as an enlarger or slide projector, the negative or transparency in the gate must be protected from this unwanted heat. Also colour print materials are sensitive to infra-red and its elimination from the image-forming light is essential to facilitate correct colour reproduction.

Various colourless glass filters, absorbing infra-red but transmitting light are available (see Figure 11.10). They need not be of optical quality if they are mounted adjacent to the light source in an enlarger or projector. A loose mounting is needed to avoid cracking due to heat expansion.

Interference-type filters may also be used. Usually such a filter transmits infra-red and reflects visible light. Termed a *cold mirror*, the filter may usefully form an integral reflector for a tungsten-halogen light source.

Infra-red transmission filters

Infra-red sensitive materials are generally specially sensitised pan-chromatic materials with sensitivity extended to about 900 nm. Consequently, their use demands a special filter opaque to ultra-violet radiation and visible light but transmitting in the required infra-red region (see Figure 11.10). Such filters have a high filter factor when used for this purpose. Gelatin or glass versions are available.

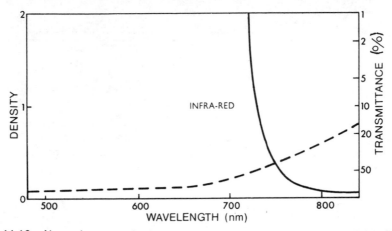

Fig. 11.10 – Absorption curve of an infra-red transmitting filter and of an infra-red absorbing filter or heat filter– – – –

Neutral density filters

neutral density filters are filters that absorb all wavelengths almost equally, and thus appear grey in colour. Depending on the type of filter it can have scattering or non-scattering properties. A filter for use in front of the camera lens must be non-scattering but for other applications in non-image-forming situations, such as the attenuation of a beam of light, the scattering variety may be used.

Optical quality ND filters are made by dispersing colloidal carbon in gelatin. The addition of dyes with the necessary spectral absorption properties, combined with the brown colour due to the carbon, give the necessary neutral characteristics, selective only for the visible spectrum (see Figure 11.11). The use of carbon particles of a size approximating to the wavelength of light gives improved non-selective neutral density filters, but the concomitant scattering makes them unsuitable for camera use.

Photographic silver can produce a good non-selective neutral for the visible and infra-red regions but the scattering properties may limit its use to non-image-forming beams.

The alloy inconel, evaporated in thin layers on glass, gives an excellent non-selective, non-scattering, neutral filter. But as the attenuation is

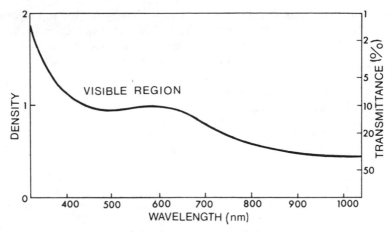

Fig. 11.11 – Absorption curve of a neutral density filter (non-scattering type, density 1.0)

both by absorption and reflection, the specular reflection may be a nuisance.

Perforated metal discs or wire mesh serve as excellent non-selective light attenuators, used for example in colour enlargers where they have no effect on the colour temperature of the light source. Their scattering properties do not allow their use in front of a camera lens unless it is to give a star-burst effect (see page 221).

Neutral density filters are also available in graduated form to give continuous light control or to give attenuation to part of the scene only, e.g. the sky region but not the foreground.

Another method of continuous variation in attenuation is by a pair of contra-rotating polarising filters, which give almost complete cut-off when in the crossed position (see page 216). Combination filters are also available when a neutral density filter is combined with a colour filter, e.g. a yellow filter. Neutral density filters for camera use are calibrated in terms of their optical density. They can of course be used with both monochrome and colour films, having no effect on colour balance.

Their uses are varied, ranging from a means to avoid over-exposure with a fast film in very bright conditions to a way of using large apertures for selective focus in well-lit conditions. They may also be used as viewing filters. Mirror lenses have to use ND filters in lieu of aperture stops (see page 214). Filters of specific value allow direct exposure relationships to be established between Polaroid Land film and conventional colour film when the former is used for test exposures.

Viewing filters

Viewing filters are intended for observation purposes only and not for use over the camera lens. They are used to assist the photographer to visualise the scene when recorded. Neutral density filters lower the general scene brightness to make viewing more comfortable.

Optical Filters and Attachments

A *monochromatic vision filter* is a dark yellow in colour typically transmitting the spectral band from 555 to 630 nm (see Figure 11.12). It thereby removes all colour differences in the scene, leaving only differences in brightness. This can assist the lighting of studio sets.

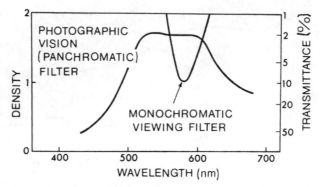

Fig. 11.12 – Absorption curves of two viewing filters

The *photographic vision (panchromatic) filter* is purple in colour and serves to convert the sensitivity of the eye to that of a panchromatic emulsion. It can then be used to judge the effect of contrast filters simply by using the two filters combined.

Fluorescent light filters

Colour photography using fluorescent lighting as the sole illuminant results in colour casts in the photographs due to spectral quality of such light sources. In particular a green cast is caused by the strong emission line at 546 nm in the mercury spectrum. However, by using a variety of colour-compensating filters such effects can be reduced. Two varieties are available, one for use with daylight-type colour film, the other with artificial light colour film.

Polarising filters

As we saw in Chapter 2, light can be considered as a transverse wave motion or vibration, with vibrations normally occurring in all possible directions at right angles to a ray of light. Thus, looking down a ray, the vibrations can be represented by arrows, as in Figure 11.13a.

Under certain conditions, however, light vibrates in one particular plane only (Figure 11.13b). This is known as the plane of polarisation, and the light is said to be *plane polarised* or, simply, *polarised.* Such light can be controlled by means of a special type of filter termed a *polarising filter*.

216

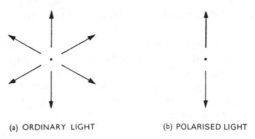

(a) ORDINARY LIGHT (b) POLARISED LIGHT

Fig. 11.13 – Vibration of ordinary and polarised light

A polarising filter for use over the camera lens is a sheet of plastic consisting of transparent polymer molecules which have all had their axes aligned in one direction during manufacture. By a straining technique they are made dichroic so that the resulting sheet selectively absorbs light vibrating in one direction but transmits light vibrating at right angles to this direction. Light vibrating in intermediate directions is partially transmitted and partially absorbed. A polarising filter may therefore be used to select light for transmission if some of it is polarised.

The main applications of polarising filters are:

(1) *To control the rendering of the sky.* Light from a clear, blue sky at right angles to the line of sight to the sun is partially polarised. The sky in this region can thus be made darker by placing a polarising filter over the camera lens. When used for this purpose, a polarising filter has the advantage over a normal filter that it does not distort colour rendering and may therefore be used in colour photography.

(2) *To reduce unwanted reflections.* Light that is directly reflected from the surface of a non-metal at a certain angle (about 55° from the normal for many substances)* is almost totally polarised, and light reflected from a reasonably wide range of angles about this angle is partially polarised. Polarising filters may, therefore, be used for the control of reflections from, for example, glass, wood, paint, oil, french polish, varnish, paper and any wet surface. Their practical applications include the photography of swimming pools and the interiors of rooms – where glare spots on painted walls, wood panelling and furniture, and reflections from glass-fronted furniture may be objectionable.

(3) *To increase colour saturation in colour photography.* In colour photography, reflections reduce colour saturation, thus degrading the picture quality. Use of a polarising filter to eliminate reflections increases colour saturation and improves picture quality.

When using a polarising filter the photographer can observe the effect produced, either on the focusing screen or by looking through the filter itself at the subject. The filter should be rotated slowly until the best effect is obtained. The position of marks on the edge of the filter should

* More precisely, the angle of incidence whose tangent is equal to the refractive index of the material.

then be noted, and the photograph taken with these marks in the same position as when viewing.

For subjects that show reflection at only one surface or group of similarly placed surfaces, it is usually possible to select a camera position from which the polarising filter will subdue the reflection to any desired extent. On the other hand, when the reflections come from very different angles it is not possible, merely by placing a polarising filter over the lens, to suppress them all at once.

A polarising filter on the lens offers little control of reflections in copying, because the unwanted light is not usually reflected at the appropriate angle. Only in the case of oil paintings — when individual brush marks may cause reflections at the appropriate angle — is any control achieved, and this is very limited. Control of reflections in copying can be obtained, however, by using filters both over the lens and over the lamps. When this method is employed, the diffusely reflected light is depolarised and forms the required image, whereas the unwanted directly reflected light is still polarised, and can be cut out by the filter over the lens. In the same way, reflections from metal objects can be controlled to some extent by placing polarising filters over the light sources as well as over the camera lens. The use of filters on both lamps and lens is not, however, without difficulties, unless special lamps are available. In particular especial care must be taken that a polarising filter placed in front of a light source does not become overheated.

The ideal polarising filter works equally well for all wavelengths, and therefore has no effect on colour. In practice, polarising filters are not always neutral in their effect, particularly if old, and care should be taken in selecting a filter for colour photography. A perfect polarising filter would stop one-half of the light passing through it and have an exposure factor of $\times 2$. In practice, some light is absorbed by the bonding material between the crystals, and a factor of nearer $\times 4$ should be used, although the filter factor appears to vary somewhat from one individual filter to another. The filter factor of a polarising filter, unlike that of a colour filter, is independent of the sensitive material and light source employed.

A particular problem arises with the use of a beam-splitter in the optical system of a camera to sample the incoming light for exposure determination. The beam-splitter analyses incident light into two beams plane-polarised at right angles to each other. Consequently, when a plane-polarising filter is rotated over the camera lens, the beam-splitter does not then divide this partially plane-polarised beam into the correct proportions for viewing and light measurement. In fact the result depends on the orientation of the filter. If, however, a circular polarising filter is used with such cameras the beam-splitter properties are unaffected and light measurement errors avoided.

Filters for darkroom use

The filters used in darkroom safelights are a special application of colour filters. Their function is to filter the light from a tungsten or other lamp so

as to pass light of a restricted range of wavelengths so that darkrooms may have as high a level of illumination as is consistent with the safe handling of photographic materials. Specific recommendations are usually given as to the wattage of the lamp to be used and the minimum

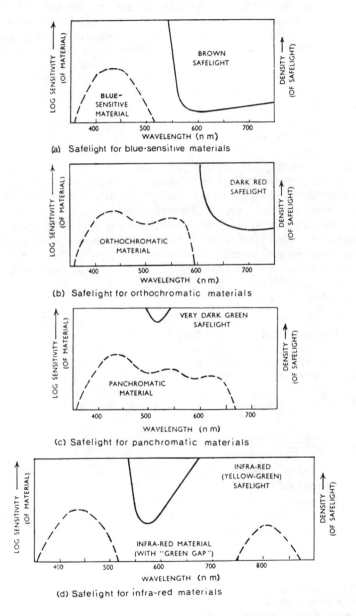

(a) Safelight for blue-sensitive materials

(b) Safelight for orthochromatic materials

(c) Safelight for panchromatic materials

(d) Safelight for infra-red materials

Fig. 11.14 – Absorption curves of the principal types of safelight shown in relation to the spectral sensitivity curves of the materials with which they are employed

safe distance of the lamp but the user is always recommended to carry out his own tests.

For blue-sensitive and orthochromatic materials the filter transmission range is chosen to fall outside the range of wavelengths to which the material is sensitive. Thus a yellow, orange or brown safelight may be used with blue-sensitive materials, and red safelights with ortho-chromatic materials. With panchromatic materials the problem is different because these materials are sensitive to light of all colours. Thus, processing is carried out either in complete darkness or in a very low level of illumination of a colour to which the eye has near maximum and the material has minimum sensitivity. For example, blue-green for panchromatic films and deep amber for colour print materials and pan-chromatic bromide paper (see Figure 11.14). Several minutes of dark adaptation must be allowed before visual perception is possible in such circumstances.

Infra-red materials may be produced without green sensitivity so that they can be handled by a special green safelight passing only wave-lengths in the "green gap" of the spectral sensitivity of the material.

Other forms of light source may be used in a darkroom. A sodium vapour discharge lamp gives a high intensity of yellow illumination but an additional yellow filter is needed to absorb wavelengths below about 550 nm. Fluorescent lamps are also in use, fitted with suitable filters. Electroluminescent panels also find application in darkroom safelighting.

Optical attachments

A wide range of optical attachments and gadgetry is available for use in front of the camera lens. Like filters they are produced in a range of fit-tings and sizes and are attached in a similar manner. Materials used range from high-quality optical glass, suitably coated, to moulded plastics. Depending on its function, the device may be transparent and non-selective or selectively absorb some wavelengths.

A brief description of some of the more common attachments is as follows:

Soft focus attachments

A recurrent vogue in certain types of photography, such as portraiture, is for a soft-focus effect given by the spreading of the highlights of a sub-ject into adjacent areas, causing a lowering of image contrast. Special portrait lenses using controllable residual spherical aberration to give this effect are available but are expensive and limited in application. A soft focus attachment is a cheap alternative for use with any conventional lens.

Two basic types of attachment are available, one having concentric grooves in plain glass and the other having small irregular deposits about one micrometre thick of refractive material randomly scattered over a flat glass disc. The former type gives diffusion effects that depend on the aperture in use: the larger the aperture, the greater the diffusion. The

latter type operates independently of lens aperture. The softening of the image results from the effects of scattering, refraction and diffraction due to the presence of the attachment. Various "strengths" are also available.

The use of soft-focus attachments at the negative printing stage gives different results from those given at the camera exposure stage. Also available are similar devices termed "haze" filters and "fog" filters which find particular application in cinematography. This type of haze filter is not to be confused with the ultra-violet absorbing variety.

Multiple-image prisms

A special moulded glass or plastic prismatic attachment can give an array of repeated images of a single subject. These additional images typically may be in parallel, echelon or symmetrical arrangements, such as a central image with some three to seven repeat images distributed around it. The central image is generally of poor quality and the others are severely degraded.

Split-field close-up lens

By using half of a close-up lens in a semi-circular shape in front of the camera lens it is possible to have simultaneous focus on both near and far objects with an indistinct region between them.

Centre-focus lens

An attachment consisting of a glass disc with a clear central region and the outer annular region lightly ground gives an image with normal central definition and otherwise blurred peripheral detail.

Star-burst and twinkle devices

Closely-spaced engraved lines on plane glass can, by diffraction, cause elongation of small, intense highlights to give a "star" effect to these regions without seriously affecting overall definition. Occasionally, plastic replica diffraction gratings are used alone or in tandem to produce small spectra from every small highlight or light source in the picture area.

Graduated filters

A filter with colour over about half its area and clear otherwise with a gradual transition between the two areas, gives selective filtration of parts of the subject. For example, a graduated yellow filter may be used to filter the sky in a landscape picture but not the foreground while the horizon coincides with the transition zone. Graduated neutral density filters are also available.

12 The Sensitive Material

MANY light-sensitive substances are known, widely varying in their sensitivity. In the manufacture of conventional photographic materials, reliance is placed almost entirely upon the light sensitivity of the *silver halides*, the salts formed by the combination of silver with members of the group of elements known as the halogens – bromine, chlorine and iodine.

Photographic materials are coated with suspensions of minute crystals (with diameters from $0\cdot03$ μm for high resolution film to $2\cdot5$ μm for a fast medical x-ray film) of silver halide in a binding agent – nowadays almost invariably gelatin. These photographic suspensions are called *emulsions*, although they are not emulsions in the true sense of the word. The crystals are commonly referred to as *grains*. In materials designed for the production of negatives, the halide employed is usually silver bromide, in which small quantities of iodide are also normally present. With papers and other positive materials the halide used may be silver bromide, silver chloride or a mixture of the two. The use of two silver halides in one emulsion results not in two kinds of grains but in grains in which both halides are present, although not necessarily in the same proportion in all grains. Photographic materials containing both silver bromide and silver iodide are referred to as iodobromide materials, and materials containing both silver chloride and silver bromide as chlorobromide materials.

A property making the use of the silver halides particularly attractive in photography is that they are *developable* which means that the effect of light in producing an image can be amplified by using a developing solution. The gain in sensitivity achieved in this way is of the order of a thousand million times. The image produced when photographic materials are exposed to light is normally invisible, the visible image not being produced until development. The invisible image is termed a *latent* ("hidden") *image*. Photographic materials in which the image is produced in this way are sometimes termed *development*, or *developing-out, materials*.

For special purposes, silver halide emulsions are sometimes produced

in which the action of light alone is relied upon to produce the visible image. These are referred to as *printing-out materials*. They are necessarily very much slower than development materials, and their use is nowadays confined to the preparation of certain types of contact printing and chart recording papers.

Latent image formation

The latent image is any exposure-induced change occurring within a silver halide grain that increases the probability of development from a very low figure to a very high figure. Although all grains will eventually be reduced to metallic silver if developed for a sufficient time, the rate of reduction is very much greater for those grains containing a latent image.

It is generally believed that this change is the addition at a site or sites on or within the crystal of an aggregate of silver atoms. The latent image sites are probably imperfections and impurities (e.g. silver sulphide specks) existing on the surface and within the bulk of the silver halide crystal. Light quanta are absorbed, releasing photoelectrons which combine with interstitial silver ions to produce the atoms of silver. Interstitial silver ions are mobile ions displaced from their normal positions in the silver halide lattice and are present in silver halide grains of an emulsion prior to exposure. The general reaction can be represented by the equations

$$\mathrm{Br}^- \xrightarrow{h\nu} \mathrm{Br} + e^- \quad \text{and} \quad \mathrm{Ag}^+ + e^- \longrightarrow \mathrm{Ag}$$

where $h\nu$ is a light quantum and e^- is an electron.

The energy levels relevant to latent image formation are shown schematically for a silver bromide crystal in Figure 12.1. Discounting thermal fluctuations, absorption of a quantum of energy greater than 2·5 eV is necessary in order that an electron may be raised from the valence to the conduction band. In this state it may contribute to the formation and growth of the latent image. An energy of 2·5 eV is equivalent to a wavelength of approximately 495 nm and corresponds to the longest wavelength of the spectral sensitivity band of ordinary silver bromide. Also indicated in Figure 12.1 are the relevant energy levels of an adsorbed dye molecule suitable for sensitising silver bromide to longer wavelengths. It can be seen that a photon of energy much less than 2·5 eV may, upon absorption by the dye, promote the molecule from its ground energy state to its first excited state. If the excited electron can pass from the dye to the crystal, latent image formation may proceed. In this way it is possible to sensitise silver halides to green and red light and even infra-red radiation, although it should be noted that in the latter case electron transitions arising from thermal effects may cause grains to become developable without exposure. Excessive fogging can result and careful storage and utilisation of such materials is necessary.

Although a number of different mechanisms have been suggested to account for the details of latent image formation, there is considerable

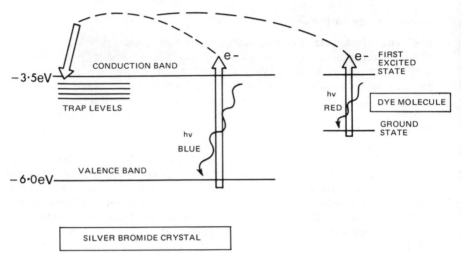

Fig. 12.1 – Schematic representation of the energy levels relevant in latent image formation.

experimental evidence supporting the basic principle suggested by Gurney and Mott in 1938. The essential feature of this treatment is that the latent image is formed as a result of the alternate arrival of photoelectrons and interstitial silver ions at particular sites in the crystal. Figure 12.2 shows the important steps. Here the process is considered as occurring in two stages:

(1) The nucleation of stable but subdevelopable specks.
(2) Their subsequent growth to just-developable size and greater.

The broken arrows indicate the decay of unstable species, an important characteristic of the process. The first stable species in the chain is the two-atom centre, although it is generally believed that the size of a just developable speck is 3 to 4 atoms. This implies that a grain must absorb at least 3 to 4 quanta in order to become developable, but throughout the sequence there are various opportunities for inefficiency and normally far more than this number will be required.

During most of the nucleation stage the species are able to decay, and liberated electrons can recombine with halogen atoms formed during exposure. If this occurs, the photographic effect is lost. The halogen atoms may also attack the photolytically formed silver atoms and reform halide ions and silver ions. Although gelatin is a halogen acceptor and as

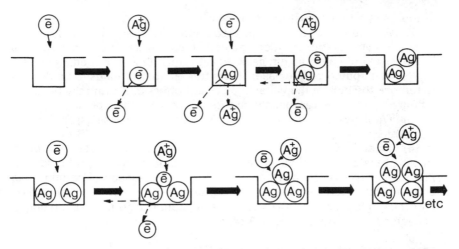

Fig. 12.2 – Latent image nucleation (top), initial growth (bottom row)

such should remove the species before such reactions can occur, its capacity is limited and its efficiency drops with increasing exposure.

These considerations lead to possible explanations for low-intensity and high-intensity reciprocity law failure. During low-intensity exposures, photoelectrons are produced at a low rate and the nucleation stage is prolonged. As a result the probability of decay and recombination is relatively high. During high-intensity exposures large numbers of electrons and bromine atoms are simultaneously present in the crystals. Such conditions can be expected to yield high recombination losses. Also, nucleation may occur at many sites in the grain, producing large numbers of very small silver specks.

The emulsion binder

For the proper working of a photographic material, the silver halide grains must be evenly distributed and each crystal should preferably be kept from touching its neighbour, the sensitive layer must be moderately robust so that it may be able to resist abrasion and slight rubbing, and the grains in the layer must be accessible to processing solutions. There are few emulsion binders which meet all these requirements.

One of the first binding agents to be used was collodion, a syrupy, transparent fluid prepared by dissolving pyroxyline (gun-cotton) in a mixture of ether and alcohol. However collodion, although of historical interest as an emulsion binder, was replaced by gelatin over 100 years ago.

Gelatin has remarkable properties as a binding agent:

(1) Dispersed with water, it forms a convenient medium in which solutions of silver nitrate and alkali halides can be brought together to form crystals of insoluble silver halides. These crystals remain suspended

in the gelatin in a fine state of division.

(2) Warmed in water it forms a solution which will flow, and further, by cooling an aqueous solution of gelatin it can be set to a firm jelly. Thus it is possible to cause an emulsion to set firmly almost immediately after it has been coated on the base. Thereafter, all that remains to be done is to remove the bulk of the water in a current of warm air, and the resulting emulsion surface is reasonably strong and resistant to abrasion.

(3) When wetted, gelatin swells and allows processing solutions to penetrate.

(4) Gelatin is an active binding agent, containing traces of sodium thiosulphate and nucleic acid degradation products which profoundly influence the speed of emulsions made from it. By reason of certain of its constituents, such as sodium thiosulphate, gelatin acts as a sensitiser and thus influences the speed of an emulsion. It also acts as a halogen acceptor, as described on page 224.

Manufacture of photographic materials

Over the years, great progress has been made in the production of emulsions – a result of the policy adopted by all the leading photographic manufacturers of maintaining their own research establishments which work in close association with the production units. Each firm has developed its own particular methods, many of which are naturally regarded as confidential, but the general principles on which emulsion-making rests are well established, and these will at least serve to illustrate the complexity of the whole process.

The principal materials used in the preparation of the emulsion are silver nitrate, alkali-metal halides and gelatin, and all these must satisfy stringent tests. The gelatin must be carefully chosen, since it is not a simple chemical but a complex mixture of substances obtained from the hides and tendons of animals, and, although silver salts form the actual sensitive material, gelatin plays a very important part both physically and chemically, as already explained. Gelatins vary greatly in their photographic properties. The "blending" of gelatins originating from different sources helps in producing a binder with the required properties and in obtaining consistency. The general way to test a blend of gelatin for performance is to use some of it to make an emulsion and to test this to see whether it possesses the desired photographic properties.

Nowadays "inert" gelatin is generally used, i.e. containing less than five parts per million of sulphur sensitisers and nucleic acid type restrainers. A recent development by gelatin manufacturers is to provide gelatins which are substantially free of all sensitisers and restrainers ("empty" gelatin). These gelatins may then be "doped" to the required degree by the addition of very small amounts of the appropriate chemicals by the emulsion manufacturer.

The emulsion-making process, reduced to its essentials, consists of the following stages:

(1) Solutions of silver nitrate and soluble halides are added to gelatin

under carefully controlled conditions, where they react to form silver halide and a soluble nitrate. This stage is called *emulsification* or precipitation.

(2) The emulsion thus formed is subjected to heat treatment in the presence of the gelatin in a solution in which the silver halide is slightly soluble. During this treatment the crystals of silver halide grow to the size and distribution which will determine the characteristics – in particular speed, contrast and graininess – of the final material. This stage is known as the *first* (or *Ostwald*) *ripening*.

(3) The emulsion is then *washed* to remove the by-products of emulsification. In the earliest method of doing this the emulsion was cooled (chilled) and thereby caused to set to a jelly, shredded or cut to a small size and then washed in water. In modern practice, washing is achieved by causing the emulsion to settle to the bottom of the vessel, by the addition of a suitable coagulant to the warm solution. The liquid can then be removed by decanting or some other means.

(4) The emulsion is subjected to a second heat treatment in the presence of a sulphur sensitiser. No grain growth occurs (or should occur) during this stage, but sensitivity nuclei of silver sulphide are formed on the grain surface and maximum sensitivity (speed) is reached. This stage is known as the *second ripening*, *digestion* or *chemical sensitisation*.

(5) Sensitising dyes (see Chapter 13), stabilising reagents, hardeners, wetting agents, etc. are now added.

All these operations are capable of almost infinite variation, and it is in the modification of these steps that much progress has been made in recent years, and emulsions of extremely diverse characteristics produced.

The support

The finished emulsion is coated on to a support, usually referred to as the "base". The commonly used supports are film, glass and paper. Negative emulsions are normally coated either upon film or upon glass (plates); paper base is usually reserved for positive emulsions. There are, however, important exceptions to this.

Film base

The base used in the manufacture of films is usually a cellulose ester – commonly triacetate or acetate-butyrate. Cellulose nitrate (celluloid) also was at one time widely used, but its use has now been almost entirely discontinued on account of its flammability. Cellulose triacetate and acetate-butyrate are not, strictly speaking, non-flammable, but they are slow-burning. These "safety" bases have the additional advantage that they keep well, whereas nitrate base disintegrates on prolonged storage. Early acetate film bases would not stand up to wear and tear or the effect of processing solutions so well as nitrate base, but triacetate and acetate-butyrate bases do not suffer from these disadvantages.

Until World War II, film bases were made almost exclusively from

cellulose derivatives. Since then, and particularly in the past decade, new synthetic polymers have appeared which offer important advantages in film properties, particularly dimensional stability; this makes them of especial value in the fields of graphic arts and aerial survey.

The first of these new materials used at all widely was polystyrene, but the most outstanding dimensionally stable base material to date is polyethylene terephthalate, a polyester, and the raw material of Terylene fabric. As a film, polyethylene terephthalate has exceptionally high strength, much less sensitivity to moisture than cellulose derivative films and an unusually small change of size with change of temperature (see Table 12.1). Being insoluble in all common solvents, it cannot be fabricated by the traditional method of "casting", i.e. spreading a thick solution of the film-former on a moving polished band or drum, evaporating off the solvent, and stripping off the dry skin. Instead, the melted resin is extruded, i.e. forced through a die, to form a ribbon which is then stretched, while heated, to several times its initial length and width. A heat-setting treatment locks the structure in the stretched condition, and the film is then stable to heat throughout the range of temperatures encountered by photographic film. Polystyrene is extruded in a somewhat similar manner.

Bisphenol—A polycarbonate, another polyester, is of interest in that while it compares with polyethylene terephthalate in several of its physical properties, it is soluble in some solvents and can be made by the same casting technique as cellulose derivative films. However neither polystyrene nor polycarbonate are in current use other than for a few specialised purposes.

Film base is of different thickness according to the particular product and type of base, most bases in general use coming within the range of 0·08 mm to 0·25 mm. Roll films are generally coated on 0·08 mm base, miniature and cine films on 0·13 mm base and flat films on 0·10 mm to 0·25 mm base. Polythylene terephthalate base can usually be somewhat thinner than the corresonding cellulosic base because of its better strength characteristics.

	Glass	Paper	Cellulose triacetate	Polyethylene terephthalate
Thermal coefficient of expansion per °C	0·001%	–	0·0055%	<0·002%
Humidity coefficient of expansion per % RH	0·000	0·003 to 0·014%	0·005 to 0·010%	0·002 to 0·004%
Water absorbed at 50% RH, 21°C	0·0%	7·0%	1·5%	0·5%
Processing size change	0·00%	−0·2 to −0·8%	<−0·1%	±0·03%
Tensile strength at break in kg cm^{-2}	1400	70	1085	1750

Table 12.1 — Properties of supports

Glass plates

Plates came before films, and, although they have now to a large extent been replaced by films, they are still used in some specialised branches of photography, because of inherent advantages. The first thing that characterises the glass plate is its rigidity. During processing, glass plates undergo no significant changes in dimensions, a feature that is particularly valuable in scientific work when accurate evaluation of image size is important. Similar conditions apply in photogrammetry and in many graphic arts processes, although the dimensional stability of modern safety film bases is such that the use of plates is now rarely *essential* in these fields. A further advantage of using plates is that no pains need be taken to ensure that the sensitive material lies flat in the camera; there is not the possibility of cockling which is frequently present with film. Plates are, of course, at a disadvantage as regards the possibility of breakage, weight, space taken up for storage and the fact that each must be loaded in the darkroom in a special dark-slide.

Paper base

The paper used for the base of photographic papers must be exceptionally pure. Photographic base paper is, therefore, manufactured at special mills where the greatest care is taken to ensure its purity. Before it is coated with emulsion, the base is usually coated with a paste of gelatin and a white pigment known as baryta (barium sulphate), the purpose of which is to provide a pure white foundation for the emulsion, giving maximum reflection. Baryta is chosen because it is a pure white pigment which is highly insoluble and is without any harmful action on the emulsion.

Some modern paper bases are not coated with baryta but are coated on both sides with a layer of polyethylene and are known as PE or RC (polyethylene or resin-coated) papers (Figure 12.3). The polyethylene backing is generally matt so that it has the appearance of traditional paper and can be written on. The polyethylene coating is impermeable to water which prevents the paper base from absorbing water and processing chemicals. This results in substantially shorter washing and drying times than are required by the traditional baryta coated papers.

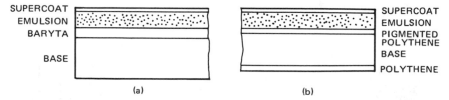

Fig. 12.3. — Construction of photographic papers. (a) baryta paper, (b) polythene or resin-coated paper.

The Sensitive Material

Coating the emulsion on the base

Before coating, the base must be suitably prepared to ensure good adhesion of the emulsion. Glass for photographic plates is prepared by coating it with a very thin *substratum* of strongly hardened gelatin; film base is similarly coated with a substratum. Film base is also usually coated with an anticurl and antihalation backing layer before being coated with emulsion (Figure 12.4). Plates are usually backed after the emulsion has been coated.

The coating of modern materials is a complex task and the coating methods in current use are the subject of commercial secrecy. One of the earliest forms of coating flexible supports was dip or trough coating (see Figure 12.5) but this method has almost certainly been replaced by one or other of the coating techniques outlined below. Dip coating is a slow method because the faster coating is carried out the greater is the amount of emulsion picked up by the support. Attempts at increasing coating speed result in thick emulsion layers which are difficult to dry and in any case would have undesirable photographic properties (see page 231). In order to increase the coating speed this method has been modified by the use of an "air-knife". The air-knife is an accurately machined slot which directs a flow of air downwards onto the coated layer and increases the amount of emulsion running back into the coating trough. Thus coating by this method results in the use of more concentrated emulsions, a faster coating speed and thinner coated layers.

Other coating methods employ accurately machined slots through which emulsion is pumped directly onto the support (slot applicator or extrusion coating) or after flowing down a slab or over a weir onto the support (cascade coating). Such coating methods allow coating speeds to be far higher than were possible with the more traditional methods. It is thought that coating speeds approaching 60 metres a minute are now being used to coat base material approximately 1·4 metres wide. Modern monochrome materials have more than one layer coated and colour materials may have as many as fourteen layers whilst the instant

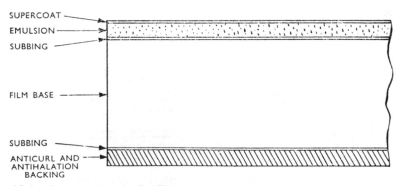

Fig. 12.4 — Cross-section of a flat film

"self-developing" colour print films have an even more complex structure (see page 378). In modern coating technology many layers are coated in a single pass of the base through the coating machine either by using multiple slots, or by using a number of coating stations, or by a combination of both.

The coated material is chilled to set the emulsion, after which, with films and papers, a protective layer – termed a *nonstress supercoat* – is applied to reduce the effects of abrasion, and drying is then carried out. With papers, the supercoat also serves to give added sheen or "lustre" and, in the case of glossy papers, assists in glazing.

Plates are coated on glass of various sizes, but not usually smaller in size than about 150 × 150 mm. Small plates are prepared by coating larger sheets of glass and cutting them.

Film base is coated as large rolls, commonly a little over 1 metre wide by approximately 300 metres long, and when dry is "slit" and "chopped" into the required sizes. Papers, too, are coated as large "parent" rolls. These may be up to 1000 metres long for single-weight papers and 500 metres long for double-weight.

"Festoon" drying was one of the methods adopted for the drying of films and papers, the coated material being passed through a drying tunnel in a series of festoons supported on crossbars travelling on an endless chain.

"Flat-bed" dryers are now in common use in which air at the appropriate temperature and relative humidity is blown onto the surface of the coated material as it passes horizontally through a long drying tunnel (Figure 12.5). The coated material passes through graded zones of temperature and "chilling" may not be required provided that the first zone is sufficiently low in temperature and relative humidity to set the emulsion.

With fast negative materials it is usually impossible to obtain the desired properties in any *single* emulsion. Two emulsions may then be prepared which together exhibit the desired characteristics. These may be mixed and coated in the same way as a single emulsion, or they may

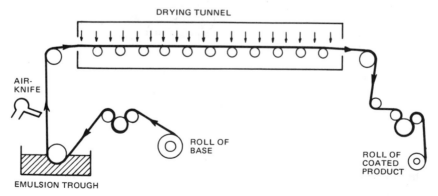

Fig. 12.5 – Schematic diagram of a coating machine.

be applied as two separate layers, an "undercoat" and a "topcoat". For the highest speeds the top-coat consists of the fastest component emulsion while the undercoat comprises a slower layer. This arrangement gives the required combination of speed, contrast and latitude.

Sizes of films and papers

Flat films and papers are supplied in a great number of sizes. The nominal sizes in most common use and the names by which certain of them are known are as follows:

5.7×8.3 cm ($2\frac{1}{4} \times 3\frac{1}{4}$ in)
6.4×8.9 cm ($2\frac{1}{2} \times 3\frac{1}{2}$ in)*
8.3×10.8 cm ($3\frac{1}{4} \times 4\frac{3}{4}$ in, quarter plate)*
8.9×14.0 cm ($3\frac{1}{2} \times 5\frac{1}{2}$ in, postcard)
9.0×12.0 cm
10.2×12.7 cm (4×5 in)†
10.5×14.8 cm (A6)
12.1×16.5 cm ($4\frac{3}{4} \times 6\frac{1}{2}$ in, half-plate)*
14.8×21.0 cm (A5)
16.5×21.6 cm ($6\frac{1}{2} \times 8\frac{1}{2}$ in, whole-plate)*
20.3×25.4 cm (8×10 in)
21.0×29.7 cm (A4)

* Obsolescent sizes.
† Although non-standard is likely to be used for many years.

Roll and miniature films are made in several sizes, identified by code numbers. The most popular sizes are given in Table 12.2:

Size coding	Film width	Nominal image size	Number of images	Notes
110	16 mm	13 × 17 mm	12/20	Single perforations, cartridge loaded
120	62 mm	45 × 60 mm	16/15	Unperforated, rolled in backing paper
		60 × 60 mm	12	,,
		60 × 70 mm	10	,,
		60 × 90 mm	8	,,
126	35 mm	26 × 26 mm	12/20	Single perforations, cartridge loaded
127*	45 mm	30 × 40 mm	16	As for 120
		40 × 40 mm	12	,,
		40 × 65 mm	8	,,
135	35 mm	18 × 24 mm	40/72	Double perforations, cassette loaded
		24 × 36 mm	20/36	,,
220	62 mm	As for 120 but double number of images		Unperforated film with leader and trailer
70 mm	70 mm			Double perforations, casette loaded

* Obsolescent sizes.

Table 12.2 — Film sizes

Where more than one picture size is given in the list above, the picture size achieved in any given instance depends upon the design of the camera used.

Films 35 mm wide, perforated at each edge, are normally employed to yield images measuring 24 × 36 mm, a 1·64 metre length of film yielding 36 exposures and a 1·03 metre length, 20 exposures. Cameras are also available yielding 18 × 24 mm images on perforated 35 mm film. These are usually referred to as "half-frame" cameras.

Roll films 16 mm wide with perforations along one edge loaded in cartridges are now being used extensively by amateurs in the modern generation of "Pocket cameras" (see page 148).

Papers are supplied in packets for amateur use, in boxes for professionals and in continuous rolls for photofinishers. As with films, a wide range of sizes is available.

Packing and storage of films and papers

Flat films are normally packed facing one way, interleaved with paper to minimise the risk of abrasion of films in contact, and to prevent possible interaction of the backing of one film with the emulsion of the next. Most types of flat film are notched in manufacture to facilitate identification of the emulsion side in the darkroom. When such films are held with the notch at the right-hand end of the top (short) side the emulsion is facing the user.

Sheets of paper are usually packed with the emulsion surfaces of all sheets — except the top one — facing the same way. The top sheet faces the rest.

Roll films are normally packed in sealed foil wrappers in boxes and 35 mm cassettes are usually sealed in rigid metal or plastic containers.

If films are badly stored the quality of the results eventually obtained with them will be inferior. Bad storage causes a loss in speed and contrast accompanied by high fog levels. Generally multilayer materials suffer more than single layer materials. In multilayer colour materials the rates of deterioration of the individual layers differ, resulting in speed and contrast imbalances between the layers and hence poor colour reproduction. Also the faster the material the more rapidly it deteriorates. Exposed film suffers more than unexposed film; so film should be removed from the camera and processed as soon after it has been exposed as possible. As many amateurs leave colour films in their cameras for long periods of time some allowance is made for this in their manufacture.

It is generally recommended that photographic materials should be stored in a refrigerator or a freezer in order to prolong their life, provided that they are contained in sealed packets or containers to protect them from humidity. Unprocessed material requires protection from: (a) high temperature, (b) high relative humidity, (c) harmful gases and vapours, (d) ionising or penetrating radiation such as x-rays or those emanating from radioactive materials, and finally (e) physical damage. The bulk of these conditions are met if photographic materials are stored in sealed

packets in a refrigerator at a temperature below about 10°C. The shelf-life of colour materials can be prolonged by storage in a freezer at temperatures down to −18°C. When removing films from cold storage they must be allowed to warm to ambient temperature *before* opening the sealed packet. If this is not done, warm moist air may condense on the film and form moisture or even water droplets. At least one hour should be allowed for warming a 35 mm cassette in its sealed container after removal from cold storage.

For storage after exposure and before processing, if there is likely to be an appreciable delay and ambient temperatures are high, storage in a refrigerator is also to be recommended. However *before* placing in the refrigerator the films must be dried by sealing in a container with a desiccant such as silica gel. This is especially important in conditions of high relative humidity.

13 Spectral Sensitivity of Photographic Materials

THE inherent sensitivity to light of the silver halides is confined to a limited range of wavelengths. This range includes the blue and violet regions of the visible spectrum, the ultra-violet region and shorter wavelengths extending to the limit of the known spectrum – including x-rays and gamma-rays (see Figure 2.2). This applies, in general terms, to all types of emulsion – chloride, bromide, iodobromide, etc. – although the position of the long-wave cut-off of sensitivity varies with the type of emulsion, as shown in Figure 13.1.

Response of photographic materials to shorter than visible radiation

Despite the fact that the silver halides have an inherent sensitivity to all radiation of shorter wavelengths than the visible, the recording of such radiation involves special problems. In the first place, the emulsion *grains* significantly absorb radiation of wavelength shorter than about 400 nm. The result is that images produced by ultra-violet radiation lie near the surface of the emulsion, because the radiation is unable to penetrate very far. Then, at wavelengths shorter than about 330 nm, the radiation is absorbed by *glass.* To record beyond this region, quartz, or fluorite, transmission optics have to be employed.

At about 230 nm, absorption of radiation by the *gelatin* of the emulsion becomes serious. To record beyond this region, Schumann emulsions or Ilford Q emulsions have been employed. Schumann emulsions have an extremely low gelatin content, and in Q emulsions, by the adoption of a particular manufacturing technique, the concentration of the silver halide grains is made much higher at the surface than in the depth of the emulsion layer. Particular care must be taken that the surface of both types of emulsion is not abraded, or stress marks will result. As an alternative to the use of such special emulsions, fluorescence can be employed to obtain records in this region. Ordinary photographic films are used and the emulsion is coated with petroleum jelly, or other mineral oil, which fluoresces during the exposure to form a visible image

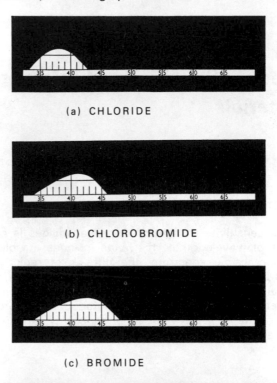

(a) CHLORIDE

(b) CHLOROBROMIDE

(c) BROMIDE

(d) IODOBROMIDE

Fig. 13.1 – Wedge spectrograms of unsensitised chloride, chlorobromide, bromide and iodobromide emulsions (to tungsten light at 2850 K)

to which the emulsion is sensitive. The jelly is removed before processing, by bathing the film in a suitable solvent.

The region 230 to 360 nm, sometimes referred to as the "quartz U.V. region", is of particular importance in spectrography because many elements display characteristic lines here. By a fortunate coincidence, the gamma of many emulsions which, in general, varies considerably with wavelength, is comparatively constant throughout this region. This is illustrated in Figure 13.2.

Beyond about 180 nm, radiation is absorbed by air, and recording has to be carried out in a vacuum. At about the same wavelength, absorption

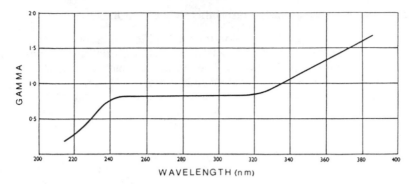

Fig. 13.2 — Relationship between gamma and wavelength in the ultra-violet for a typical emulsion

of radiation by quartz becomes serious, and fluorite optics or reflection gratings have to be employed. Beyond 120 nm, fluorite absorbs the radiation and reflection gratings only can be employed. Using Schumann or Q emulsions in vacuum with a reflection grating, records may be made down to wavelengths of a few nanometres, where the ultra-violet region merges with the soft x-ray (Grenz ray) region. This technique is known as *vacuum spectrography*.

No problem of absorption by gelatin or by the equipment arises in the x-ray or gamma-ray regions. In fact, the problem here is that the radiation is absorbed very little by anything — including the emulsion — and it is therefore necessary to employ a very thick emulsion layer to obtain an image. For manufacturing reasons, this is normally applied in two layers — one on each side of the film base. Another way of getting round the difficulty which arises from the transparency of emulsions to x-rays is to make use of fluorescent salt intensifying screens. Such screens, placed in contact with the x-ray film — one on either side — emit under x-ray excitation blue or green light to which the film is very sensitive and thus greatly increase the effective film speed. Salt intensifying screens are very important in reducing the radiation dosage to patients receiving diagnostic x-ray exposures. For very short-wave x-rays and gamma-rays, such as are used in industrial radiography, metal screens can similarly be used. When exposed to x-rays or gamma-rays these screens eject electrons which are absorbed by the photographic material. The metal employed for such screens is usually lead.

Although invisible to the eye, ultra-violet radiation is present in daylight, and — to a much lesser extent — in tungsten light. Ultraviolet radiation from about 330 to 400 nm, sometimes referred to as the "near U.V. region", therefore affects the results obtained in ordinary photographs giving increased haze in distant landscapes and blue results in colour photographs of distant, high altitude or sea scenes. Shorter wavelengths than about 330 nm are absorbed by the lens.

Spectral Sensitivity of Photographic Materials

Response of photographic materials to visible radiation

Photographic materials that rely on the unmodified sensitivity of the silver halides are referred to variously as *blue-sensitive, non-colour-sensitive, ordinary* or *colour-blind* materials. The materials used by the early photographers were of this type. Because such materials lack sensitivity to the green and red regions of the spectrum, they are incapable of recording colours correctly; in particular, reds and greens appear too dark – even black – and blues too light, the effect being most marked with saturated colours (see Chapter 16).

For some types of work this is of no consequence. Thus, blue-sensitive materials are still in general use today for printing papers, and for negative materials used with black-and-white subjects. Even coloured subjects such as landscapes, architectural subjects and portraits can be recorded with a fair degree of success on blue-sensitive materials – witness the many acceptable photographs that have survived from the days when there were the only materials available. One of the reasons for success in these cases is that the colours of many natural objects are not saturated, but are in fact whites and greys that are merely tinged with one colour or group of colours (page 311). Photographs on blue-sensitive materials are thus records of the blue content of the colours, and, as the blue content is often not very far from being proportional to the total luminosity of the various parts of the objects, a reasonably good picture is obtained.

Nevertheless, when the colours are not subdued or diluted, blue-sensitive materials show their deficiencies very markedly, and photographs in which many objects appear far darker than the observer sees them cannot be regarded as entirely satisfactory.* It is, therefore, desirable to find some means of conferring on emulsions a sensitivity to the green and red regions of the spectrum while leaving the blue sensitivity substantially unchanged.

Colour sensitising

It was discovered by Vogel in 1873 that a silver halide emulsion can be rendered sensitive to green light as well as to blue by adding a suitable dye to the emulsion. Later, dyes capable of extending the sensitivity into the red and even the infra-red region of the spectrum were discovered. This use of dyes is termed *dye sensitising, colour sensitising* or *spectral sensitising*. The dyes, termed *colour sensitisers*, may be added to the emulsion at the time of manufacture, or the coated film may be bathed in a solution of the dye. In all commercial emulsions today the former procedure is adopted, although when *colour-sensitive materials* were first introduced it was not uncommon for the user to bathe his own

* That such photographs were regarded as satisfactory for so long was because photographers were so accustomed to an incorrect rendering that a sort of photographic convention was set up in their minds. They regarded the reproduction of blue sky as white and bright red as black as normal.

materials. In either case sensitisation follows from the dye becoming "stuck to" the emulsion grain surfaces — a phenomenon called *adsorption*. Dye that is not adsorbed does not confer any spectral sensitisation. The amount of dye required is extremely small, usually sufficient to provide a layer 1 molecule thick over only part of the surface of the crystals of the emulsion.

The sensitivity conferred by dyes is always additional to the sensitivity of the undyed emulsion, and is always added on the long wavelength side. The extent to which an emulsion has been dye-sensitised necessarily makes a very considerable difference to the amount and quality of light which is permissible during manufacture and in processing (page 219).

For practical purposes, colour-sensitive materials may be divided into three main classes. These are:

(1) Orthochromatic.
(2) Panchromatic.
(3) Infra-red-sensitive.

Orthochromatic materials

In the first colour-sensitive materials, the sensitivity was extended from the blue region of the spectrum into the green. The sensitivity of the resulting materials thus included ultra-violet, violet, blue and green. In the first commercial plates of this type, introduced in 1882, the dye eosin was used and the plates were described as *isochromatic*, denoting equal response to all colours. This claim was of course exaggerated, because the plates were not sensitive to red at all, and the response to the remaining colours was by no means equal.

In 1884, dry plates employing erythrosin as the sensitising dye were introduced. In these, the relation between the rendering of blue and green was improved and the plates were termed *orthochromatic* = "correct colour". Again, the description was an exaggeration. The term orthochromatic is now applied generally to all green-sensitive materials. Most modern green-sensitive materials have the improved type of sensitising of which erythrosin was the first example. Although orthochromatic materials do not give correct colour-rendering, they give results that are acceptable for many purposes, provided the dominant colours of the subject to not contain much red.

Spectral sensitisation of the orthochromatic type is used in a few special-purpose monochrome materials and in all modern colour materials (see Chapter 24).

Panchromatic materials

Materials sensitised to the red region of the spectrum as well as to green, and thus sensitive to the whole of the visible spectrum, are termed *panchromatic*, i.e. sensitive to "all colours". Although red sensitising dyes were discovered within a few years of Vogel's original discovery, the sen-

sitivity conferred by the red sensitising dyes at first available was quite small, and it was not until 1906 that the first commercial panchromatic plates were marketed.

There are many different types of panchromatic sensitisation, but the differences between some of them are quite slight. The main variations lie in the position of the long-wave cut-off of the red sensitivity, and in the ratio of the red sensitivity to the total sensitivity. Usually, the red sensitivity is made to extend up to 660 to 670 nm. The sensitivity of the human eye is extremely low beyond 670 nm and an emulsion with considerable sensitivity beyond this region gives an infra-red effect, that is subjects which appear visually quite dark may reflect far red radiation that is barely visible but which leads to a fairly light reproduction when recorded by such a film.

Panchromatic materials have two main advantages over earlier types of material. In the first place, they yield improved rendering of coloured objects, skies, etc. without the use of filters. In the second place, they make possible the control of the redering of colours by means of filters (Chapter 11). Where the production of a negative is concerned, and the aim is the production of a correct representation in monochrome of a coloured subject, panchromatic emulsions must be used. Again, when it is necessary to modify the tone relationships between differently coloured parts of the subject, fullest control can be obtained only by the use of panchromatic materials in conjunction with filters.

Infra-red materials

The classes of colour-sensitised materials so far described meet all the requirements of ordinary photography. For special purposes, however, emulsions sensitive to yet longer wavelengths can be made; these are termed *infra-red materials*. Infra-red sensitising dyes were discovered early in this century, but infra-red materials were not widely used until the nineteen-thirties. As the result of successive discoveries, the sensitivity given by infra-red sensitising dyes has been extended in stages to the region of 1200 nm. The absorption of radiation around 1400 nm by water would make recording at longer wavelengths difficult, even if dyes sensitising in the region were available. Infra-red monochrome materials are invariably used with a filter over the camera lens or light source, to prevent visible or ultra-violet radiation entering the camera.

Infra-red materials find use in aerial photography for the penetration of haze and for distinguishing between healthy and unhealthy vegetation, in medicine for the penetration of tissue, in scientific and technical photography for the differentiation of inks, fabrics etc. which appear identical to the eye, and in general photography for the pictorial effects they produce. The first of these applications — the penetration of haze — depends on the reduced scattering exhibited by radiation of long wavelength (see page 207). The other applications depend on the different reflecting powers and transparencies of objects to infra-red and visible radiation.

Lenses are not usually corrected for the infra-red, so that when focusing with infra-red emulsions it is necessary to increase the camera extension very slightly. This is because the focal length of an ordinary lens for infra-red is greater than the focal length for visible radiation.* Some modern cameras have a special infra-red focusing index for this purpose. With others, the increase necessary must be found by trial. It is usually of the order of 0·3 to 0·4 per cent of the focal length.

Other uses of dye sensitisation

Sensitising dyes have other uses besides the improvement of the colour response of an emulsion. In particular, when a material is to be exposed to a light source that is rich in green or red and deficient in blue, its speed may be increased by colour sensitising. Thus, some photographic papers are colour-sensitised to obtain increased speed without affecting other characteristics of the material.

The most critical use of dye sensitisation occurs in tripack colour materials (see Chapter 24) in which distinct green and red spectral sensitivity bands are required in addition to the blue band. This has required quite narrow sensitisation peaks, precisely positioned in the spectrum. Spectral sensitivities of a typical modern colour film are shown in Figure 13.5.

Determination of the colour sensitivity of a material

The colour sensitivity of a material can be most readily determined in the studio by photographing a colour chart consisting of coloured patches with a reference scale of greys. In one such chart it has been arranged that the different steps of the neutral half have the same luminosities as the corresponding parts of the coloured half when viewed in daylight. If a photograph is taken of the chart, the colour sensitivity of the emulsion being tested, relative to that of the eye, is readily determined by comparing the densities of the image of the coloured half with the densities of the image of the neutral half. The value of the test is increased if a second exposure be made on a material of known colour sensitivity, to serve as a basis for comparison.

A more precise, yet still quite practical, method of measuring the colour sensitivity of a material is to determine the exposure factors of a selection of filters (page 200). With panchromatic materials, three filters – tricolour blue, green and red – are preferably used. With orthochromatic materials, measurement of the minus blue filter factor alone provides all the information that is usually required.

* This applies even when an achromatic or an apochromatic lens is used. In an achromat the foci for green and blue-violet (usually) are made to coincide, and the other rays in the visible spectrum then come to a focus very near to the common focus of green and blue-violet (page 108). Similar considerations apply to an apochromatic lens. Infra-red rays, however, are of appreciably longer wavelength than any part of the visible spectrum and do not come to the same focus as the visible rays. Lenses can be especially corrected for infra-red but such lenses are not generally available.

Spectral Sensitivity of Photographic Materials

In the laboratory, the colour sensitivity of a material is usually expressed in terms of filter factors or illustrated by means of a wedge spectrogram.

Wedge spectrograms

The spectral response of a photographic material is most completely illustrated by means of a curve known as a *wedge spectrogram*, and manufacturers usually supply such curves for their various materials. A wedge spectrogram, which indicates the relative sensitivity of an emulsion at different wavelengths through the spectrum, is obtained by exposing the material behind a photographic wedge in an instrument known as a *wedge spectrograph*. The spectrograph produces an image in the form of a spectrum on the material, the wedge being placed between the light source and the emulsion. A typical optical arrangement is shown in Figure 13.3.

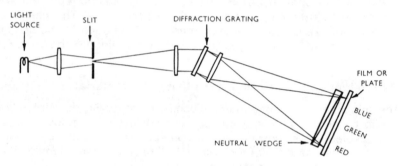

Fig. 13.3 – Optical arrangement of wedge spectrograph

Examples of the results obtained in a wedge spectrograph are shown in Figure 13.4, which comprises wedge spectrograms of typical materials of each of the principal classes of colour sensitivity. We have already seen other examples of wedge spectrograms in Figure 13.1. The outline of a wedge spectrogram forms a curve showing the relative sensitivity of the material at any wavelength. Sensitivity is indicated on a logarithmic scale, the magnitude of which depends on the gradient of the wedge employed. All the spectrograms illustrated here were made using a continuous wedge, but step wedges are sometimes used.

The shapes of the curves in Figure 13.4 are of interest. In the first place, the short wave cut-off at the left of each curve is characteristic, not of the material, but of the apparatus in which the spectrograms were produced, and arises because of the ultra-violet absorption by glass, to which reference was made earlier. Secondly, the curves of the colour-sensitised materials are seen to consist of a number of peaks; these correspond to the absorption bands of the dyes employed.

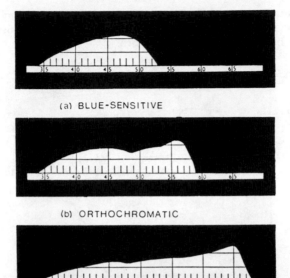

(a) BLUE-SENSITIVE

(b) ORTHOCHROMATIC

(c) PANCHROMATIC

(d) INFRA-RED

Fig. 13.4 – Wedge spectrograms of typical materials of each of the principal classes of colour sensitivity (to tungsten light at 2850 K)

The shape of each curve depends not only on the sensitivity of the material but on the quality of the light employed. All the curves shown in Figure 13.4 were made to a tungsten light source, with a colour temperature of approximately 2850 K. Wedge spectrograms of the same materials, made to daylight, would show higher peaks in the blue region and lower peaks in the red.

The wedge spectrogram of the infra-red material in Figure 13.4 shows a gap in the green region of the spectrum. This permits the handling of the material by a green safelight (page 219). It should be noted, however, that infra-red-sensitive materials do not necessarily have this "green gap".

The colour material whose spectral sensitivity is shown in Figure 13.5 was designed for daylight exposure and was therefore exposed using a tungsten source of 2850 K and a suitable filter to convert the illumina-

tion to the quality of daylight. The omission of the conversion filter would have resulted in a relatively higher red sensitivity peak, at about 640 nm, and a lower blue peak, at about 450 nm.

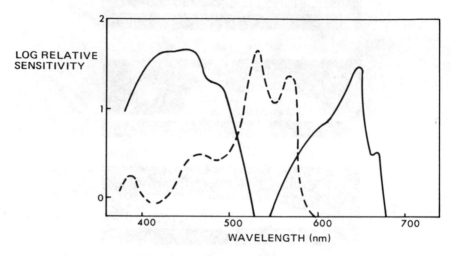

Fig. 13.5 – Spectral sensitivities of a typical modern colour film

Uses of wedge spectrograms

Although they are not suitable for accurate measurements, wedge spectrograms do provide a ready way of presenting information. They are commonly used:

(1) *To show the way in which the response of an emulsion is distributed through the spectrum.*

(2) *To compare different emulsions.* In this case, the same light source must be used for the two exposures. It is normal practice to employ as a source a filtered tungsten lamp giving light equivalent in quality to daylight (approx. 5500 K) or an unfiltered tungsten lamp operating at 2850 K, whichever is the more appropriate.

(3) *To compare the quality of light emitted by different sources.* For this type of test, all exposures must be made on the same emulsion.

(4) *To determine the spectral absorption of colour filters* (Chapter 11). For this, all exposures must be made to the same light source and on the same emulsion.

14 Principles of Colour Photography

MATERIALS that reflect light uniformly through the visible spectrum appear *neutral*, that is white, grey or black depending on the *reflection factor*. A reflection factor of unity indicates total reflection of incident light and the object appears perfectly white. Conversely, a zero reflection factor indicates a perfect black. A reflection factor of 0·20 corresponds to a mid grey reflecting 20 per cent of the incident light. Equal visual steps between black and white are not represented by equal steps in reflection factor.

The sensation of colour arises from the selective absorption of certain wavelengths of light. Thus a coloured object reflects or transmits light unequally at different wavelengths. The reflection factor varies with wavelength and the object, illuminated with white light, appears coloured. Colour may be described objectively by a graph of reflection factor against wavelength and typical coloured surfaces described in this way are shown in Figure 14.1. It is similarly possible to describe the appearance of materials viewed by transmission, such as stained glass or photographic filters. In such cases a *transmission factor* is analogous to the reflection factor already described. An alternative is to describe a colour in terms of the variation of reflection or transmission *density* with wavelength (see pages 261, 283). Equal density differences are found to be visually approximately equal so that in some instances the use of reflection or transmission density is advantageous.

Colour matching

The colours of most objects around us are due to a multitude of dyes and pigments. No photographic process exists that can form an image from these original colorants, but colour photography can produce an acceptable *reproduction* of colours in the original scene. Such a reproduction reflects or transmits mixtures of light that appear to match the original colours although in general they do not have the same spectral energy distributions. Different spectral energy distributions that give rise to an identical visual sensation are termed *metamers*, or *metameric pairs*. A

245

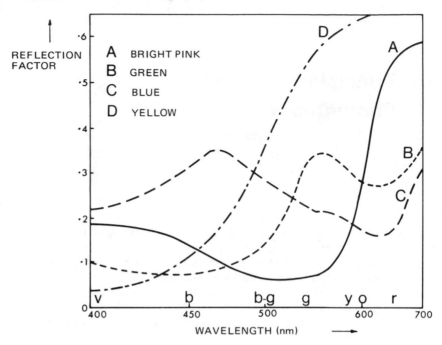

REFLECTION FACTOR

A BRIGHT PINK
B GREEN
C BLUE
D YELLOW

WAVELENGTH (nm)

Fig. 14.1 — Spectral absorptions of typical colourants.

typical metameric match is shown in Figure 14.2.

Because of this phenomenon of metamerism it is only required that a colour photograph shall be capable of giving appropriate mixtures of the three primary colours. We shall now consider the methods by which blue, green and red spectral bands are selected and controlled by colour photographs.

A convenient way of slecting blue, green and red light from the spectrum for photography is to use suitable colour filters. We may thus select bands in the blue, green and red regions of the spectrum, and this selective use of colour filters is illustrated in Figure 14.3 which shows the action of ideal primary colour filters, and their spectral density distributions.

The spectral density distributions of primary colour filters available in practice differ from the ideal, and the curves of a typical set of such filters are illustrated in Figure 14.4. It will be noticed that the filters shown transmit less light than the ideal filters, although the spectral bands transmitted correspond quite well with the ideal filters previously illustrated.

The blue, green and red filters available for photography are thus able to give three separate records of the original scene, and such filters were in fact used in making the first colour photograph.

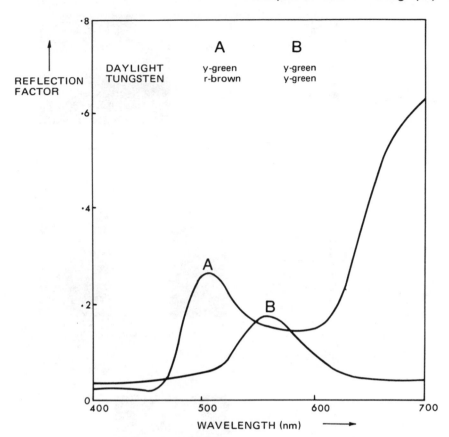

Fig. 14.2 – Spectral absorptions of a metameric match

The first colour photograph

Clerk Maxwell in 1861 prepared the first three-colour photograph as an illustration to support the three-colour theory of colour vision. He took photographs of some tartan ribbon through a blue, a green and a red filter in turn, and then developed the three separate negatives. Positive lantern slides were then produced by printing the negatives, and the slides were projected in register. Provided the positive corresponding to a particular taking filter was projected through a filter of similar colour, the three registered images together formed a successful colour reproduction and a wide range of colours was perceived. Maxwell's process is shown diagrammatically in Figure 14.5.

Methods of colour photography that involve the use of primary colour filters at the viewing stage, in similar fashion to Maxwell's process, are called *additive* methods. In the context of colour photography the colours blue, green and red are sometimes referred to as the *additive primaries*.

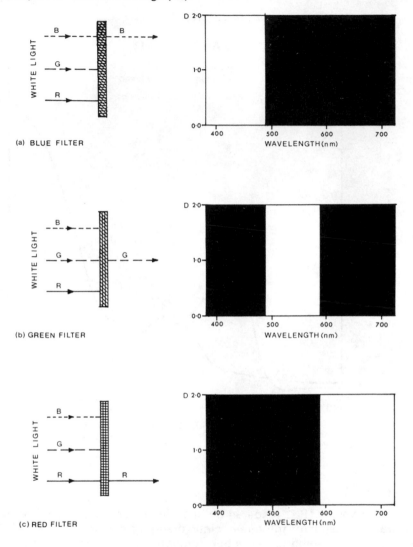

Fig. 14.3 – The action of ideal blue, green and red filters, and the corresponding spectral density distributions

Additive colour photography

In Maxwell's process the selection of spectral bands at the viewing stage was made by the use of saturated primary colour filters. The control of the amount of each primary colour projected onto the screen was achieved by means of the silver image developed in the positive slide.

(a) BLUE FILTER

(b) GREEN FILTER

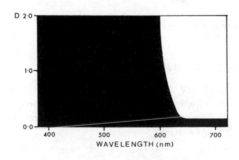

(c) RED FILTER

Fig. 14.4 – The spectral density distributions of primary colour filters used in practice

An alternative approach to the selection of spectral bands for colour reproduction is to utilise the complementary colours yellow, magenta and cyan to absorb independently light of the three primary colours – blue, green and red. The action of ideal complementary filters listed in Table 14.1 is shown in Figure 14.6.

249

Principles of Colour Photography

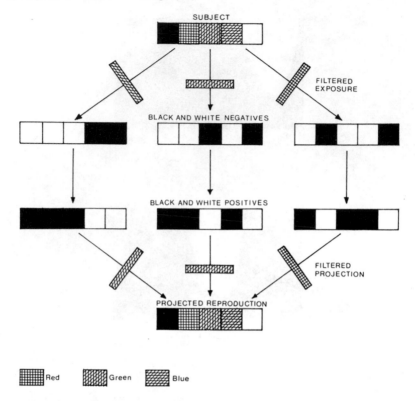

Fig. 14.5 – Maxwell's method of colour photography

Subtractive colour photography

Whereas the ideal primary colour filters illustrated in Figure 14.3 may transmit up to one-third of the visible spectrum, complementary colour filters transmit up to two-thirds of the visible spectrum – they *subtract* only one-third of the spectrum.

Primary (or *additive* primary) colour	Complementary (or *subtractive* primary) colour
Red	Cyan (blue-green)
Green	Magenta (red-purple)
Blue	Yellow

Table 14.1 – Primary and complementary colours

As with primary colour filters, the complementary colour filters available in practice do not possess ideal spectral density distributions, and examples of such filters are shown in Figure 14.7.

Combinations of primary colour filters appear black because they have

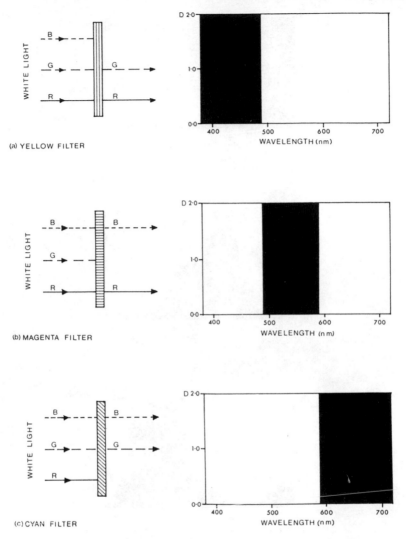

Fig. 14.6 – Ideal yellow, magenta and cyan filters

no common bands of transmission, so such combinations cannot be used together to control the colour of transmitted light. With the complementary colour filters the situation is quite different. Despite the imperfections of practical complementary filters it remains substantially true that each absorbs only about one-third of the visible spectrum. Consequently such filters may be used in combination to control the colour of transmitted light. The effect of combining complementary colour filters is shown in Figure 14.8.

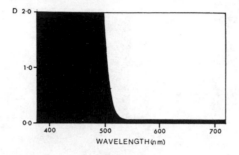

(a) YELLOW FILTER

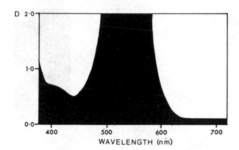

(b) MAGENTA FILTER

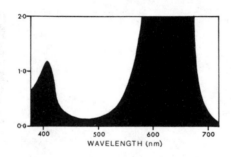

(c) CYAN FILTER

Fig. 14.7 — Typical yellow, magenta and cyan filters

In principle, the positive lantern slides used in Maxwell's additive method of colour photography can be made as positive dye images. If we make the colour of each positive complementary to that of the taking filter — the positive record derived from the negative made using a blue filter being formed by a yellow dye and so on — then the three positives can be superimposed in register and projected using only one projector. Such methods, which involve the use at the viewing stage of dyes which

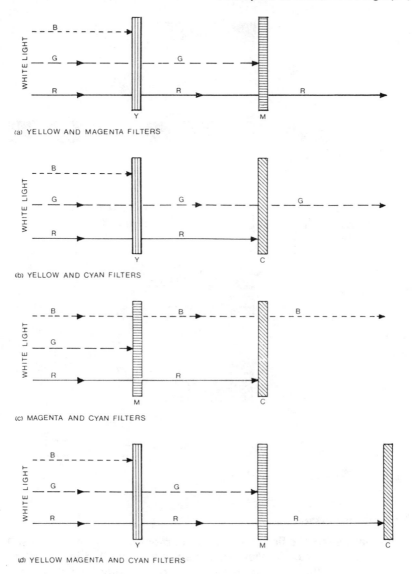

(a) YELLOW AND MAGENTA FILTERS

(b) YELLOW AND CYAN FILTERS

(c) MAGENTA AND CYAN FILTERS

(d) YELLOW MAGENTA AND CYAN FILTERS

Fig. 14.8 – Combinations of complementary colour filters

subtract blue, green and red light from the spectrum, are called *subtractive* processes. The preparation of a subtractive colour reproduction from blue, green and red light records is illustrated in Figure 14.9.

We have examined the principles of operation of the *additive* and the *subtractive* methods of colour photography, and will now consider the operation of some practical examples of each type of process.

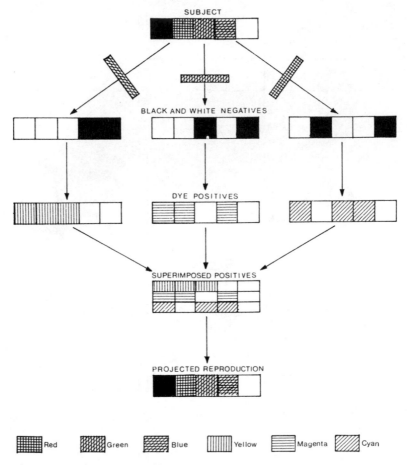

SUBJECT

BLACK AND WHITE NEGATIVES

DYE POSITIVES

SUPERIMPOSED POSITIVES

PROJECTED REPRODUCTION

Red Green Blue Yellow Magenta Cyan

Fig. 14.9 – A subtractive colour photograph

Additive processes

As we have seen, the first three-colour photograph was made in 1861 by an additive process. The viewing system alone required the use of three projectors and the entire process was too unwieldy for general photography.

By the first decade of the twentieth century, however, an ingenious application of the additive system made possible the production of plates yielding colour photographs by a single exposure in a conventional camera.

In order to achieve analysis of the camera image in terms of blue, green and red light, the exposure was made through a mosaic, or *reseau*, comprising very many blue, green and red filter elements. Depending on the manufacturer, the reseau was either integral with the photographic

material, or, in some cases, was placed in contact with it. Materials which employed an integral reseau were then reversal processed, while those using a separate reseau could be negative processed and then printed to yield a positive which was subsequently registered with a colour reseau screen.

In each case, projection yielded a colour reproduction of the original scene, the method being exemplified by the Dufaycolor process in which the reseau was integral with the film. The system is shown in Figure 14.10.

Exposure was made through the film base, the reseau being coated on the base beneath the emulsion. After first development the silver image

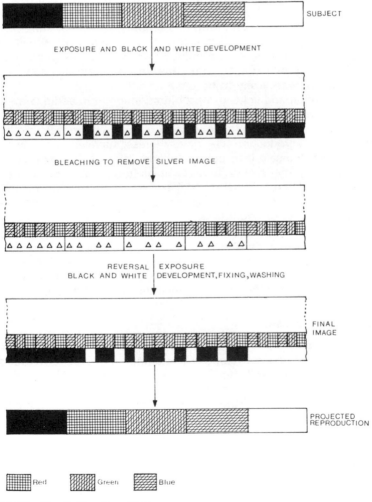

Fig. 14.10 – The Dufaycolor system

was completely removed using a potassium permanganate bleach solution, and the residual silver halide was fogged and developed to metallic silver. After fixing, washing and drying, the reproduction could be viewed.

In such additive processes, whether employing an integral or separate reseau, the colour mosaic was present at the viewing as well as the taking stage. This meant that the brightness of reproduction of white was limited by the light absorption of the reseau. Only about one-third of the light striking the film could be transmitted. Such methods therefore wasted about 70 per cent of the available light and generally gave a dim picture.

Additive methods employing three separate analysis negatives and the corresponding positives can give very good colour reproduction and a bright image owing to the use of three separate light sources. Such methods are cumbersome in operation and suffer from registration difficulties. The more convenient methods employing reseaux suffered from the loss of light at the projection stage, and definition difficulties due to the reseaux. Even if the reseau employed were so fine as to be unobjectionable in the reproduction, further generations of reproduction, such as reflection prints, were likely to be unsatisfactory.

The registration and light-loss problems inherent in additive methods of colour photography led to the adoption of methods based on the subtractive system for practical colour photography. The mosaic method of additive colour reproduction has, nevertheless, survived in colour television tubes. The mosaic incorporated in the face of the television tube consists of red, green and blue light-emitting substances that are stimulated by electron impact. Registration of images is ensured by careful manufacture and setting-up procedures, and there is no filtering action to cause loss of brightness.

An instant motion-picture film, Polavision, introduced by the Polaroid Corporation uses an integral reseau for additive colour reproduction and represents a resurrection of such systems. The material is however designed for rather a small degree of projection magnification and light loss and reseau visibility are correspondingly reduced in importance.

Subtractive processes

Subtractive systems use yellow, magenta and cyan image dyes in appropriate concentrations to control the amounts of blue, green and red light transmitted or reflected by the reproduction. Thus white is reproduced by the virtual absence of image dyes, grey by carefully balanced quantities of the three dyes, and black requires a high concentration of each dye. Colours are reproduced by superimposed dye images of various concentrations. The effects of superimposing pairs of subtractive dyes are identical to the combination of filters of the same colours and have been illustrated in Figure 14.8.

The possibility of preparing subtractive dye positives from blue, green and red separation negatives has already been referred to. If such dye positives are used then it is possible to superimpose the yellow, magenta

and cyan images to obtain a reproduction that may be projected using one projector only.

Although such a separation system suffers from registration difficulties when the positives are superimposed, two important commercial processes have operated in this manner. In each case separation positives are made which are able to absorb dye in an amount depending upon the amount of image. Each positive then carries the dye and is made to deposit it on a receiving material which retains the transferred dye. The three dye images are laid down in sequence to build up the required combination. The positive transmission or reflection prints made in this way can be of very high quality provided accurate image registration is maintained. The two processes which operate by this method are the Kodak Dye Transfer method of making reflection colour prints, and the Technicolor method of preparing motion-picture release colour prints.

Integral tripack

While, as we have seen, it is possible to produce subtractive dye images separately, and to superimpose them to form a colour reproduction, this method finds limited application. Most colour photographs are made using a type of material which makes blue, green and red records in discrete emulsion layers within one assembly. This specially designed emulsion assembly is called an *integral tripack.*

The latent-image records within the three emulsion layers are then processed in such a way that the appropriate dye images are generated in register within the emulsion layers by colour development. The processing chemistry is such that the blue, green and red records are made to generate yellow, magenta and cyan images respectively. We shall look further at this type of process in Chapter 24.

15 Sensitometry

THE objective study of the response, or sensitivity, of photographic materials to light is termed *sensitometry*. It is concerned with the measurement of the exposure that a material has received and with the measurement of the resultant blackening.

It is perfectly possible to produce photographs without any knowledge of sensitometry, but to obtain the *best* performance out of photographic materials, under all conditions – abnormal as well as normal – an understanding of the principles governing the response of materials is invaluable. A knowledge of at least an outline of sensitometry is therefore highly desirable for anyone wishing to make use of any of the specialised applications of photography in science and industry.

As sensitometry is concerned with the measurement of the "performance" of photographic materials, it involves the necessity for the correct use of terminology in defining the quantities that are measured. The impression that a photograph makes on us depends on physiological and psychological factors as well as on physical factors, and for this reason the success or otherwise of a photograph cannot be determined from any single measurement or even a series of measurements. This does not mean, however, that we can learn nothing from a study of the factors that *are* amenable to measurement; it simply means that we must not forget that there are limitations to the help that sensitometry can give us.

Subject

As far as the camera is concerned, a subject consists of a number of areas of varying luminance and colour. This holds good whether the subject is a portrait or a landscape, a pictorial or a record shot. In the same way, a photographic print consists of areas of varying luminance and sometimes colour. Luminance is measured in candelas per square metre (see page 36).

The variations in luminance in a subject are due to the different reflection characteristics exhibited by different areas of it, to the different

angles at which they are viewed,* and to variation in the illumination that they receive. The ratio of the maximum to the minimum luminance in a subject is defined as its *luminance range*.

It may surprise us at first to realise that an effect such as a sunset, or the rippling of wind over water, can be successfully reduced to "areas of varying luminance". Yet, so it is in the camera, and so it is in the eye viewing a black-and-white print, with the difference that the mind draws not only on the eyes for its impression but, most important of all, on past experience. (Thus, when we look at a picture of an apple, for example, we see more than just light and shade. Our past experience of apples — their size, their weight, their taste — all comes to the aid of the eyes in presenting to the mind a picture of an apple.)

Our final goal in sensitometry is to relate the luminances of the subject with the luminances of the print. This involves the study first of the response of the negative material, then of the response of the positive material and finally of the relation between the two. We shall consider each of these in turn, beginning with the negative material.

It is customary to refer to the bright areas of a scene as the "highlights" and the dark areas as the "shadows". To avoid confusion, it is desirable that the same terms should be applied to corresponding areas both in the negative and in the print, even though in the negative the "highlights" are dense and the "shadows" clear.

Exposure

When a photograph is taken, light from the various areas of the subject falls on corresponding areas of the film for a certain time. The effect produced on the film is, within limits, proportional to the product of the illumination I and the exposure time t. We express this by the equation:

$$E = I \cdot t$$

where E is the *exposure.*

More recently the symbol H has been adopted to express exposure and the symbol E to express illuminance (lux) received by the film. Accordingly the exposure may be expressed by the equation:

$$H = E \cdot t$$

However because the symbol E has been used for many years to express exposure it will be retained throughout this text.

As the luminance of the subject varies from area to area, it follows that the illumination on the film varies similarly, so that the film receives not one exposure over the entire surface but an infinite number of different amounts of light energy, i.e. a range of exposures. In ordinary photography, the exposure time is constant for all areas of the film,

* A surface that diffuses light fairly completely, such as blotting paper, looks equally bright no matter from which direction it is viewed, but a surface that reflects light in mirror fashion may look very bright or very dark, according to the angular relationship between source, surface and eye.

variation in exposure over the film being due solely to variation in the illumination that it receives.

Illumination is measured in lux (lumens per square metre, page 38), and time in seconds, so that exposure is expressed in lux seconds. The use of the word "exposure" in the sense in which we are using it here is quite different from its everyday use in such phrases as, "I gave an Exposure of 1/60th sec. at f/8". We can avoid confusion by distinguishing the latter as *camera exposure* (page 422).

Blackness of the image

When a film has been processed, areas of the image that have received different values of illumination, are seen to have differing degrees of blackening. The blackness of a negative, i.e. its light-stopping power, can be expressed numerically in several different ways. The following three ways are of interest in photography:

(1) *Transmission*
The transmission, T, of an area of a negative is defined as the ratio of the light transmitted, I_t, to the light incident upon the negative, I_i. Expressed mathematically:

$$T = \frac{I_t}{I_i}$$

Transmission is always less than 1 and is normally expressed as a percentage. Thus, if 10 units of light fall on a negative and 5 are transmitted, the negative is said to have a transmission of $5/10 = 0 \cdot 5$, or 50 per cent. Although transmission is a useful concept in certain fields, in sensitometry it is not the most expressive of units because it *decreases* as blackness *increases* and equal changes in transmission do *not* appear as equal changes in blackness.

(2) *Opacity*
Opacity, O, is defined as the ratio of the light incident on the negative, I_i, to the light transmitted, I_t. That is:

$$O = \frac{I_i}{I_t}$$

It is apparent, therefore, that opacity is the reciprocal of transmission, i.e.:

$$O = \frac{1}{T}$$

Opacity is always greater than 1 and *increases* with *increasing* blackness. From this point of view, it is a more logical unit to use in sensitometry than transmission but still does not simply reflect equal changes in blackness.

(3) Density

Density, D, is defined as the logarithm* of the opacity, O. That is:

$$D = \log O = \log \frac{1}{T} = \log \frac{I_i}{I_t}$$

Density is the unit of blackening employed almost exclusively in sensitometry. It shares with opacity the property of increasing with increasing blackness, and has the following practical advantages over opacity:

(a) The numerical value of density bears a simple relation to the amount of silver present. For example, if the amount of silver present in a negative of density 1·0 is doubled, the density is increased to 2·0, i.e. it is also doubled. The opacity, however, increases from 10 to 100, i.e. tenfold.

(b) The final aim in sensitometry is to relate the print to the subject. Blackness in the print depends on the way the eye assesses it, and is therefore essentially physiological. The law governing the effect produced in the eye when stimulated is not a simple one, but over a wide range of viewing conditions the response of the eye is approximately logarithmic. Thus, if we examine a number of patches of a print in which the density increases by equal steps, the eye accepts the steps as of equal blackness increase. From this point of view, therefore, a logarithmic unit is the most satisfactory measure of blackening.

Density	Opacity	Transmission (per cent)	Density	Opacity	Transmission (per cent)
0·0	1	100	1·6	40	2·5
0·1	1·3	79	1·7	50	2
0·2	1·6	63	1·8	63	1·6
0·3	2	50	1·9	79	1·25
0·4	2·5	40	2·0	100	1
0·5	3·2	32	2·1	126	0·8
0·6	4	25	2·2	158	0·6
0·7	5	20	2·3	200	0·5
0·8	6·3	16	2·4	251	0·4
0·9	8	12·5	2·5	316	0·3
1·0	10	10	2·6	398	0·25
1·1	13	7·9	2·7	501	0·2
1·2	16	6·3	2·8	631	0·16
1·3	20	5	2·9	794	0·12
1·4	25	4	3·0	1000	0·1
1·5	32	3·2	4·0	10 000	0·01

Table 15.1 – Density, opacity and transmission

Table 15.1 gives a conversion between density, opacity and transmission.

When it is desired to distinguish between densities of images on a transparent base and those of images on an opaque base, the former are

* An explanation of logarithms is given in the Appendix

referred to as *transmission densities* and the latter as *reflection densities* (page 283).

Effect of scatter in negative

When light passes through a negative it is partially scattered (see Chapter 25). One result of this is that the numerical value of density depends on the spatial distribution of the incident light, and on the method adopted for the measurement of both this and the transmitted light. Three types of density have been defined; these are illustrated in Figure 15.1.

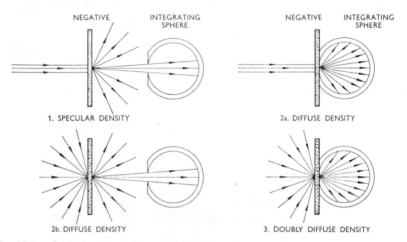

Fig. 15.1 – Optical systems for measuring different types of density

(1) *Specular density*
This is determined by using *parallel* illumination and measuring only *normal* emergence.

(2) *Diffuse density*
This is sometimes termed *totally diffuse* density. It may be determined in either of two ways:

(a) By using *parallel* illumination and measuring *total* emergence (whether normal or scattered), or
(b) By using *diffuse* illumination and measuring only *normal* emergence.

The numerical value of diffuse density is the same whichever method of measurement is employed.

(3) *Doubly diffuse density*
This is determined by using *diffuse* illumination and measuring *total* emergence.

Practical measurements of any of these types of density are based on the ratio of a photometer reading when the sample is not in place (taken as I_i), to the reading on the same photometer when the sample is in place (I_t).

The difference between diffuse density and doubly diffuse density is usually quite small, but specular density is always greater than either.

Callier coefficient

The ratio of specular density to diffuse density is termed the *Callier coefficient*, or *Callier Q factor*, and can be expressed as:

$$Q = \frac{\text{specular density}}{\text{diffuse density}}$$

This ratio, which is never less than 1·0, varies with grain size, the form of the developed silver and the amount of the deposit. As far as the grain is concerned, the finer it is – and therefore the lower is the scattering – the nearer to unity is the Callier coefficient.

The factors listed above, which influence the value of Q, vary quite markedly with the degree and type of development used. Consequently a complex variation of Callier coefficient with density and contrast is found, even when a combination of only one film and one developer is investigated. A typical example of such behaviour is illustrated in Figure 15.2 where the value of γ for each curve indicates the degree of development received by the film. At low degrees of development the value of Q is shown to be approximately constant at densities above about 0·3; for more complete development, however, there is no single value of Q that can be adopted and consequently no simple correction for specularity can be applied to densitometer readings.

One result of the variation of the Callier coefficient with density is that the tone distribution in the shadow areas of a print produced with a condenser enlarger is likely to be different from that in a print produced using a diffuser enlarger (Chapter 22). Colour photographic images, however, are essentially non-scattering, that is they possess Callier coefficients close to 1·0, and consequently may be measured by a variety of optical arrangements. In practice, however, diffuse densities are usually measured. In printing colour negatives there is little difference between the results from diffuse or condenser enlargers.

Density in practice

The types of density encountered in photographic practice are mainly as follows:

Type of work	Effective density
Contact printing	
(a) In a box, with diffused source	Doubly diffuse
(b) In a frame, using clear bulb	Diffuse (parallel illumination, total emergence)

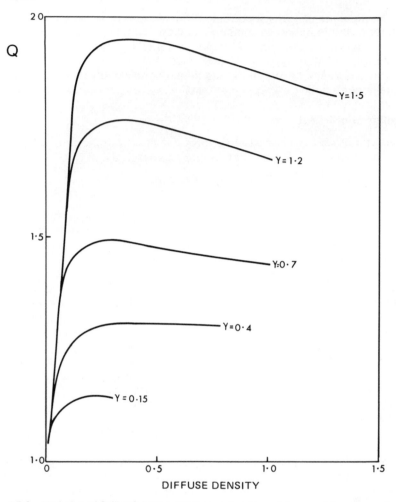

Fig. 15.2 – Variation of Callier Q factor with image density and degree of development

Type of work	Effective density
Enlarging	
(a) Condenser enlarger (point source, no diffuser)	Specular
(b) Diffuser enlarger (particularly *cold cathode* types)	Diffuse (diffuse illumination, normal emergence)
Still or Motion-Picture Projection	
All types	Specular

Some kinds of work represent a mixture of different types of density, as, for example, when an opal bulb or a diffusing screen is used in a condenser enlarger.

Apart from the true condenser enlarger and projectors, the effective density in all the examples quoted is either diffuse or doubly diffuse. As already stated, the difference between the latter two forms of density is slight. For normal photographic purposes, therefore, densities of negatives are expressed as diffuse densities.

If the image in a negative or print is not neutral in tone, its measured density will depend not only on the optics employed to measure it, but also on the *colour* of the light employed and the response to colour of the device employed to measure it. According to these last two factors we may consider density as being of four main kinds, as follows:

(1) *Density at any wavelength, spectral density*
Determined by illuminating the specimen with monochromatic radiation.

(2) *Visual density*
Determined by measuring the illuminated specimen with a receiver having a spectral response similar to that of the normal photopic eye.

(3) *Printing density*
Determined by illuminating the specimen with tungsten light and employing a receiver with a spectral response similar to that of photographic papers.

(4) *Arbitrary density*
Determined by illuminating the specimen with tungsten light and employing an unfiltered commercial photo-electric cell of arbitrary sensitivity as the receiver.

This classification applies equally to all three main types of density: specular, diffuse and doubly diffuse. For most photographic purposes *diffuse visual density* is employed.

Colour densities are usually measured in diffuse densitometers. The colour images (see Chapter 14) are composed of three dyes, each controlling one of the primary colours red, green and blue. In practice therefore colour images are described in terms of their densities to red, green and blue light — the densitometer being equipped with filters to select each primary colour in turn.

The colour filters chosen for a densitometer may simply and arbitrarily select red, green and blue spectral bands and measure the integrated effects of all three dye absorptions within those bands. The densities measured are called *arbitrary integral densities* and are commonly used in quality control measurements. For more useful results the densitometer filters and cell sensitivity are carefully chosen so that the densities measured reflect either the effect of the image on the eye or on a printing paper. Such measurements parallel density categories 2 and 3 for black-and-white images and are referred to as *colorimetric* and *printing densities* respectively. In practice, colorimetric densities are seldom measured because suitably measured arbitrary densities can usefully

describe the eye's response to visual neutrals and near neutrals – all that is usually required. Printing densities are, however, widely applied in the assessment of colour negatives for printing purposes (see Chapter 22).

The characteristic curve

If density as ordinate is plotted against exposure as abscissa, a response curve for a film or plate of the general shape shown in Figure 15.3 is obtained.

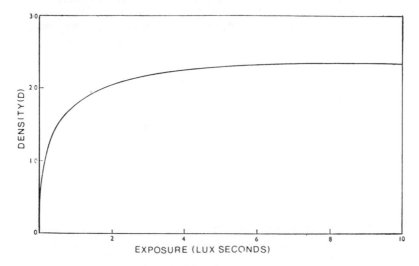

Fig. 15.3 – Response curve of an emulsion obtained by plotting density against exposure

Although a curve of this type is occasionally of value, a far more useful curve for most purposes is obtained by plotting density against *log* exposure. A curve of the shape shown in Figure 15.4 is then obtained. This is the type of response curve employed in ordinary photography. It is referred to as a *characteristic curve, D log E curve* or *H and D curve* – the latter after Hurter and Driffield, who were the first to publish curves of this type. The characteristic curve is simply a diagram which shows the effect on the emulsion of every degree of exposure from under-exposure to over-exposure – for any one development time and any particular developer.

The use of log E instead of E as the unit for the horizontal axis of the response curve of a photographic material offers several advantages:

(1) In practice, we consider changes in camera exposure in terms of the factor by which it is altered; i.e. the natural progression of exposure is geometrical, not arithmetical. (When increasing an exposure time from 1/60th to 1/30th second, for example, we speak of doubling the

exposure, not of increasing it by 1/60th second.) A logarithmic curve therefore gives the most reasonable representation of the way in which density increases when exposure is changed. The series of camera exposure times 1/500, 1/250, 1/125 second etc. is, in fact, a logarithmic series, as is that of printing exposures, 2, 4, 8, 16 . . . seconds.

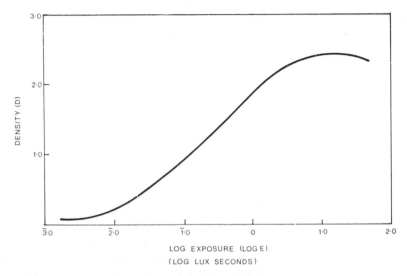

LOG EXPOSURE (LOG E)
(LOG LUX SECONDS)

Fig. 15.4 – A characteristic curve – the response curve obtained by plotting density against log exposure

(2) A *D* log *E* curve shows on a far larger scale than a density-exposure curve, the portion of the curve corresponding with just perceptible blackening, i.e. with small values of exposure. As the speed of a film is usually judged in terms of the exposure needed to produce quite small values of density (Chapter 19), the increased clarity in this region of the curve is very valuable (see page 597).

(3) The use of a logarithmic unit of both horizontal and vertical axes, enables values of negative density to be transferred readily to the log exposure axis of the characteristic curve of the print. This facilitates the overall task of relating the brightnesses of the original scene, the transmission densities of the negative and the reflection densities of the print.

Main regions of the negative characteristic curve

For convenience, the characteristic curve of a negative material may be divided into four main regions: the toe, an approximately straight-line portion, the shoulder and the region of solarization, as shown in Figure 15.5.

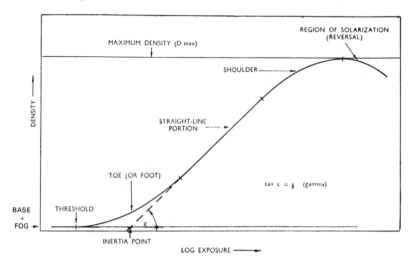

Fig. 15.5 — The "geography" of the characteristic curve of a negative material

It is only on the straight-line portion of the curve that density differences in the negative correspond proportionally to visual differences in the original scene. For this reason, the straight line was at one time referred to as the region of correct exposure, the toe as the region of under-exposure and the shoulder as the region of over-exposure. As we shall see later, however, such descriptions are apt to be misleading (see, e.g. page 275). The value of density reached at the top of the shoulder of the curve is referred to as the D_{max}, the maximum density obtainable under the given conditions of exposure and development.

Provided the density and log E axes are equally scaled the numerical value of the tangent of the angle, c, which the straight-line portion of the curve makes with the log E axis is termed *gamma*, γ. A gamma of 1 is obtained when the angle has a value of 45°.

Gamma may also, and less ambiguously, be defined in terms of the values of density and log exposure corresponding to any two points lying on the straight-line portion of the curve. Referring to Figure 15.6:

$$\gamma = \tan c = \frac{BC}{AC} = \frac{D_2 - D_1}{\log E_2 - \log E_1}$$

It is thus seen that gamma serves to measure *contrast* — i.e. the rate at which density grows as log exposure increases — in the straight-line portion of the curve. It should be noted, however, that gamma gives information about only the straight-line portion of the curve; it tells us nothing about the other portions. Further, as will be seen later, the contrast of a negative is not determined by gamma alone — other factors play an important part and, with modern emulsions, straight-line portions may not be obvious.

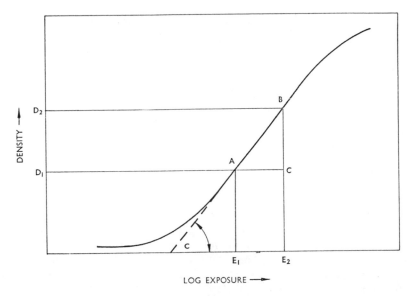

Fig. 15.6 — Gamma in terms of density and log exposure

The region of solarization, or reversal, although not employed in ordinary photography, is of interest in that here an increase in exposure actually results in a *decrease* in density. The exposure necessary to produce solarization is commonly of the order of one-thousand times greater than normal exposures and is seldom encountered. However, it should be noted that materials vary widely in the degree of solarization which they show. In general, the more efficient a material is at using light for forming an image, the less likely is solarization to be encountered.

Below the toe, the curve becomes parallel to the log E axis, a little way above the axis. The value of density in this region, usually quite small, is termed *base + fog* or the D_{min}, being the minimum density obtainable with the process employed. *Base* refers to the density of the support. Fog results from the development of unexposed grains (page 337). The point on the curve corresponding to the first perceptible density above fog is called the *threshold*.

The intersection of the extrapolated straight-line portion of the curve with the D_{min} produced is referred to as the *inertia point*, and the value of exposure at this point as the *inertia.*

On published characteristic curves the log exposure axis may be marked "Relative log exposure", often abbreviated to "Rel. log E", or "Log relative exposure", similarly abbreviated to "Log rel. E". Use of a relative instead of an absolute scale of exposures does not affect the shape of the curve in any way, and occasions little loss to the user, although it does mean that absolute values of speed cannot be determined from the curve.

Variation of the characteristic curve with the material

The characteristic curves of individual materials differ from one another in their shapes and in their positions relative to the log E axis. The *position* of the curve in relation to the log E axis depends upon the sensitivity or *speed* of the material. The faster the material, the further to the left of the scale is the curve situated. Film speed is dealt with in detail in Chapter 19. The main variations in the *shape* of the curve are:

(1) Slope of straight line (gamma).
(2) Length of straight line.

The length of the straight line is usually expressed in terms of the density at which the toe merges with the straight line, and the density at which the straight line merges with the shoulder.

Photographic materials differ both in the maximum slope that can be reached and in the rate at which a given slope is achieved. Modern negative materials are usually made to yield a gamma of 0·7 to 0·8 at normal development times. They commonly have a long toe, which may extend up to a density of as high as 0·7, and the straight line may be quite short. Some modern ultra-fast materials have a so-called "bent-leg" curve, which has in effect two straight-line portions. The lower part of the curve is fairly steep, but at a density of about 1·2 the slope changes to a much lower value. A curve of this shape may have certain advantages in the photography of subjects which contain relatively very bright highlights, e.g. night scenes.

Materials intended for copying are usually designed to have a short toe (i.e. one which merges into the straight line at a low density), and a long straight line, the slope of which will be governed by the nature of the work for which the material is intended. Materials for copying are available capable of yielding gammas, or contrasts, ranging from below 1 up to 10 or more.

Characteristic curves for specific materials are published by film manufacturers.

Variation of the characteristic curve with development

A characteristic curve is not a unique function of an emulsion, but alters in shape with the conditions of exposure (e.g., the colour (page 274) and intensity (page 295) of the light source) and with the conditions of processing; in particular, the curve is markedly affected by the degree of development (Chapter 16).

On varying development time, and keeping other conditions constant, a series of characteristic curves is obtained, which, in the absence of soluble bromide (or other anti-foggant) in the emulsion or developer, is of the type shown in Figure 15.7 in which density *above fog* is plotted against log exposure.

It will be seen from this figure that, whereas a single characteristic curve tells us a certain amount about the behaviour of a material, a "family" of curves made with increasing development time gives a much

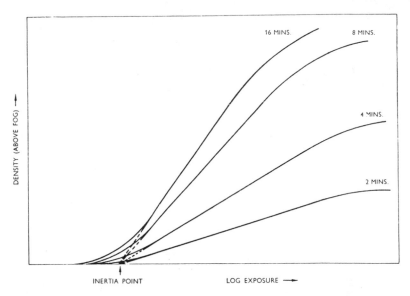

Fig. 15.7 – Effect of development time on characteristic curve of older sensitive materials

more complete picture. The most obvious change in the curve with increasing development is the increase in the slope of the straight-line portion, i.e. gamma. For any given emulsion, then, gamma is a measure of the degree of development, and has for this reason sometimes been termed the *development factor.* Another point that may be noted is that the straight-line portions of all the four curves shown in the figure meet, when produced, at a common inertia point.

In the early days of sensitometry, a series of characteristic curves of the type shown in Figure 15.7 could fairly readily be obtainable with the sensitive materials of the time by using a developer free from bromide ion. This Figure is not typical of materials used today. These commonly contain anti-foggants and most modern developers now contain bromide ion in solution, and the curves obtained are usually of the general pattern shown in Figure 15.8.

The straight lines are seen still to meet at a point (although this is not invariably the case), but this point is depressed, i.e. is now below the log E axis. As a result, not only does the slope increase but the curve as a whole moves to the left as development time is increased, the inertia shifting towards a limiting value. This shift is termed *regression of the inertia.* This corresponds to an increase in speed with increased development (page 367).

It is important to notice that throughout any consideration of the inertia and confluence points all densities must be recorded as values *above* D_{min} for each sample of film. (D_{min} itself, as well as speed and contrast, varies with development time.)

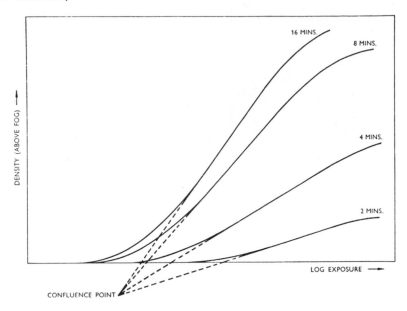

Fig. 15.8 — Effect of development time on characteristic curve of current sensitive materials

Gamma-time curve

By plotting gamma as ordinate against development time as abscissa we obtain a curve, the general shape of which is illustrated in Figure 15.9.

Gamma is seen to increase very rapidly as development begins, and then to increase at a more gradual rate until, finally, a point is reached where increased development produces no further increase in gamma. The value of gamma at this point is termed *gamma infinity* ($\delta\infty$). Gamma infinity varies from emulsion to emulsion and depends to some extent on the developing solution used. A material capable of yielding a high gamma infinity is said to be of *high contrast.* With most materials it is rarely desirable to develop to gamma infinity, since prolonged development is accompanied by an increase in fog and graininess, either or both of which may reach an objectionable level before gamma infinity is attained. Owing to fog, gamma will actually fall off on very prolonged development, as the effect of the additional density due to fog is greater on low densities than on high. This fall-off is illustrated by the broken portion of the curve shown in Figure 15.9.

A gamma-time curve shows at a glance the gamma infinity obtainable with a given material and developer. It also shows the development time required to reach this or any lower value of gamma. We have seen that it is rarely desirable to employ the very top part of the gamma-time curve owing to the growth of fog and graininess. It is also usually unwise to employ the very bottom part – where a small increase in development time gives a

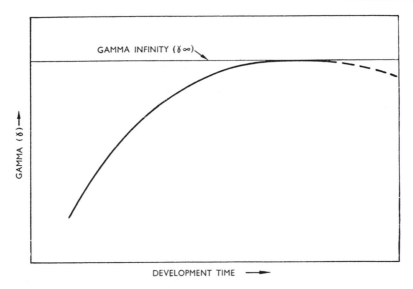

Fig. 15.9 – Gamma-time curve

big increase in gamma – because in this region any slight inequalities in the degree of development across the film will be accentuated, with the likelihood of uneven density, or mottle.

Figure 15.10 contains gamma-time curves for a film in two differing developer formulae. Curve A was produced in an M.Q. developer of normal composition; curve B in an M.Q. borax developer. Comparison of such curves assists in the choice of a suitable developer when the desired gamma is known. For example, if a gamma of 0·5 is desired, the M.Q. borax developer would normally be preferable to the M.Q. developer, since, with the latter, contrast is changing too rapidly with development time at the gamma required. On the other hand, to achieve a gamma of 1·1 the M.Q. developer would be the more suitable, the M.Q. borax developer requiring an excessively long development time to reach this value.

Gamma-time curves for individual materials under stated conditions of development are published by film manufacturers. Such curves give a good indication of the general behaviour of a material, and can be of considerable assistance in the selection of a material and developer for a given task. However, because working conditions may vary from those specified and because of variations in materials in manufacture and during storage, to be of greatest value gamma-time curves for any given material should be determined by the user under his own working conditions.

When plotting sensitometric results such as fog, emulsion speed or contrast against development time it is often useful to adopt a logarithmic scale of times. This effectively compresses the less useful,

273

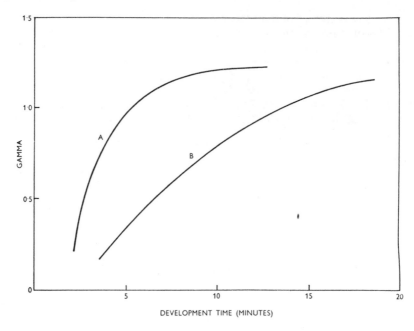

Fig. 15.10 – Gamma-time curves for the same material in two different developers

long development, region and enables the more interesting results to approximate a straight-line graph. This is easier to draw, and hence use, than a curve.

Variation of gamma with wavelength

Besides being dependent on development, gamma also depends to some extent on the colour of the exposing light used. The variation within the visible spectrum is not great, but it becomes considerable in the ultra-violet region. The general tendency is for gamma to become less as wavelength decreases. This variation of gamma can be ignored in ordinary photography, but must be taken into account in three-colour work and, most important, in spectrography (page 237).

In the visible region the gamma of an emulsion can be controlled in manufacture by the addition of suitable dyes. It has therefore been possible for three-colour work to make available special emulsions in which the gammas achieved in the three main regions of the spectrum – blue, green and red – are very nearly equal.

Placing of the subject on the characteristic curve

As we have already noted, a characteristic curve shows the response of a material under a wide range of exposures. Only a part of this curve is

used by any single negative. The *extent* of the portion used depends on the subject luminance range;* its *position* depends on the actual luminances in the scene and on the exposure time and lens aperture employed.

We have already stated that the characteristic curves of most modern negative materials are characterised by a long toe. The part of the curve used by a "correctly exposed" negative includes part of this toe and the lower part of the straight-line portion. This is illustrated in Figure 15.12.

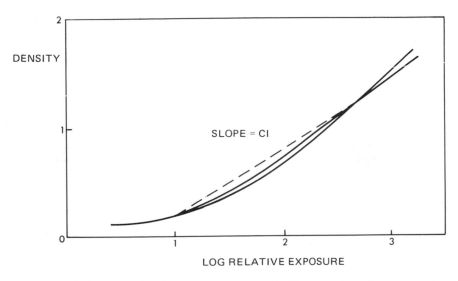

Fig. 15.11 – Two negative characteristic curves with different values of gamma (γ) but identical contrast index (C.I.)

Average gradient and (\bar{G})

If follows from the fact that a negative usually occupies part of the toe of the curve as well as part of the straight line, that gamma alone gives an incomplete picture of the contrast of an emulsion. Frequently, a better measure of contrast is obtained by taking the slope of the line joining the two limiting points of the portion of the characteristic curve employed (Figure 15.13). This is referred to as the *average gradient*. It is obviously always lower than gamma.

Several limiting points on the curve are specified in standards concerning special photographic materials. For normal negative films the quantity \bar{G} is defined by Ilford as the slope of a line joining the point at a density of 0·1 above D_{min} with a second point on the characteristic curve 1·5 log rel. E in the direction of greater exposure.

* Strictly, it is the illumination range of the image on the film with which we are concerned here, and, if flare is present, this will be less than the subject luminance range (page 100). However, in the present context we shall assume that flare is absent.

275

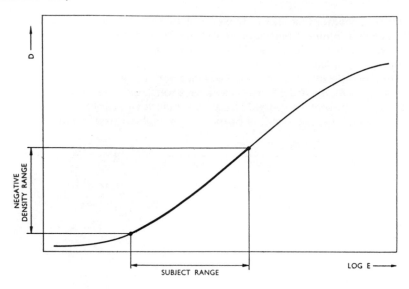

Fig. 15.12 – Portion of the characteristic curve employed by a "normally exposed" negative

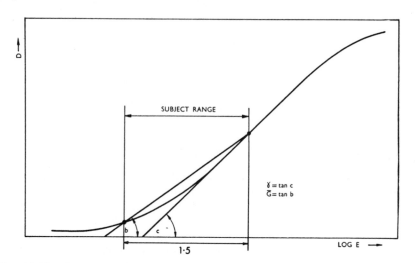

Fig. 15.13 – Average gradient

Contrast index

A measure of contrast used by Kodak Ltd. is the *contrast index* which, like \bar{G}, takes into account the toe of the negative characteristic. The method of determination involves the use of a rather complicated transparent scale overlaid on the characteristic curve, although an approximate method is to draw an arc of 2·0 units cutting the characteristic

276

curve and centred on a point 0·1 units above D_{min}. The slope of the straight line joining these two points is the contrast index.

A more full and rigorous description of contrast index determination is to be found in Kodak Data Booklet SE-1.

Two curves of different gammas but identical contrast index are illustrated in Figure 15.11. Negatives of identical contrast index produce acceptable prints using the same grade of printing paper. Gamma is clearly a poor guide to the density scale of the processed negative.

Effect of variation in development on the negative

Let us assume that the negative represented by the curve in Figure 15.12 was given "normal" development. If we make two other identical exposures of the same subject, and give more development to one and less development to the other, we shall obtain two further curves such as those which are shown, together with the "normally developed" curve, in Figure 15.14. Because the camera exposure is the same in all three cases, the limiting points of the parts of the curves used, measured against the log E axis, are the same for all three curves.

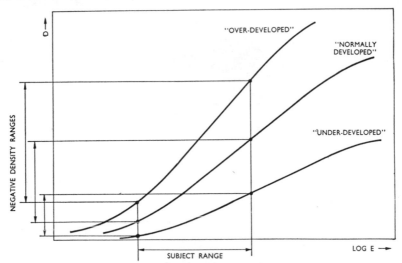

Fig. 15.14 – Effect on negative of variations in development

A study of these curves shows that over-development increases the density of the negative in the shadows to a small extent and in the highlights to a large extent. As a result, the negative as a whole is denser and, more important, its *density range* – the difference between the maximum and minimum densities – is increased. Under-development does just the reverse. It decreases density in both shadows and highlights – in the highlights to a far greater extent than in the shadows – and thus the negative as a whole is thinner and its density range is reduced.

277

The *major* effect of variation in the degree of development is on the density range — sometimes termed the *overall contrast* of the negative.

Effect of variation in exposure on the negative

Let us suppose that we are photographing the cube shown in Figure 15.15 and that S_1 is the darkest area in the subject, S_2 the next darkest, H_1 the highest highlight and H_2 the next highest. Then on a "normally-exposed, normally-developed" negative the exposures and densities corresponding to these areas will be approximately as shown in Figure 15.16.

In an *under-exposed* negative of the same subject, given the same development, the location of these points will be as shown in Figure 15.17.

Compared with the normally exposed negative, the density range of

Fig. 15.15 — Subject tones

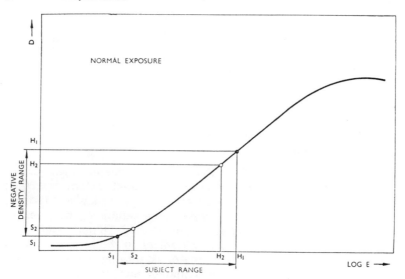

Fig. 15.16 — Densities on normal exposure and normal development

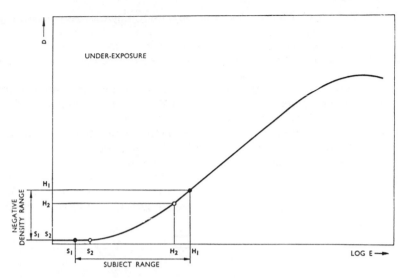

Fig. 15.17 – Densities on under-exposure and normal development

the under-exposed negative is greatly compressed. More important, the two shadow areas S_1 and S_2, although having different luminances and thus yielding different exposures on the film, yield the same density on the negative; they are thus no longer separated in any print. Some shadow detail is therefore completely lost, and the shadow detail that remains will be degraded. This is a case of *considerable* under-exposure.

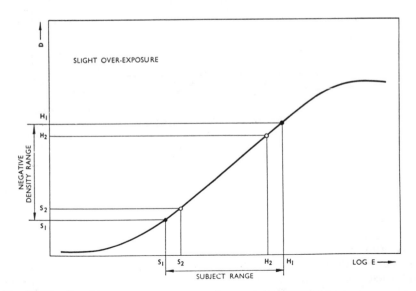

Fig. 15.18 – Densities on over exposure and normal development

Slight under-exposure would result in shadow detail being degraded, but not completely lost.

In a *slightly over-exposed* negative, given the same development, the four selected areas of the subject will be placed on the curve as shown in Figure 15.18.

The average density of the negative is now greater than that of the normally exposed negative, and the density range is expanded. Tone separation in the shadows, in particular, is increased.

In the case, however, of a *heavily over-exposed* negative, the shoulder of the curve may be reached (Figure 15.19). In these circumstances, the density range of the negative will be compressed and highlight detail degraded, if not completely lost. With modern negative films over-exposure sufficient to degrade highlight detail is fairly unusual; it is far more common to encounter under-exposure, which, of course, degrades or compresses shadow detail.

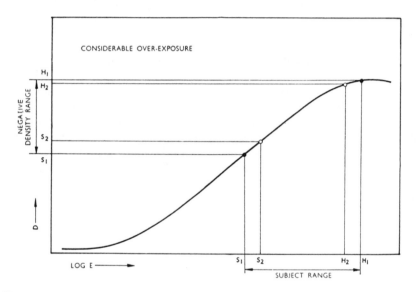

Fig. 15.19 – Densities on heavily over-exposed negative

Exposure latitude

We define *latitude* as the factor by which the minimum camera exposure required to give a negative with adequate shadow detail may be multiplied without loss of highlight detail. Latitude is illustrated in Figure 15.20.

We may call the distance along the log *E* axis between the lowest and highest usable points on the curve the *useful exposure range*. Useful exposure range depends principally upon the emulsion and the degree of development. These two factors also govern latitude, but in ad-

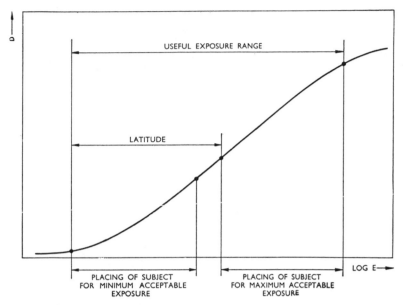

Fig. 15.20 – Exposure latitude

dition the latter is dependent upon the subject contrast, i.e. the subject luminance range. This is illustrated in Figure 15.21.

In practice, loss of highlight detail – which sets the upper limit to exposure – often results from loss of resolution due to graininess and irradiation (see page 536), *before the shoulder of the curve is reached.* As the required level of resolution usually depends upon the negative size employed and the consequent degree of enlargement necessary in making the final print, we may add "size of negative" to the factors given above as governing useful exposure range and latitude. Thus, in general, there is less exposure latitude with a miniature camera than with a large-format camera.

The luminance range of the average subject is less than the useful exposure range of the film, and there is usually considerable latitude in exposure. If, however, we have a subject with luminance range equal to the useful exposure range of the film there is no latitude – only one exposure is permissible. With the exceptional subject having a luminance range *greater* than the useful exposure range of the film, no exposure will yield a perfect result; we must either lose shadow detail or highlight detail or both. All that we can do is to decide which end of the tone range we can best sacrifice.

If the subject range is below average we have more latitude than usual. In practice, however, this is limited on the under-exposure side by the fact that an exposure too near the minimum will be located entirely on the toe and may result in an unprintably soft negative. It is usually preferable to locate the subject on the characteristic curve in such a posi-

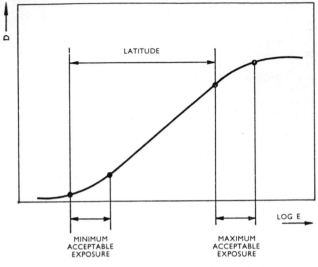

(a) SUBJECT OF LOW CONTRAST—GREAT LATITUDE

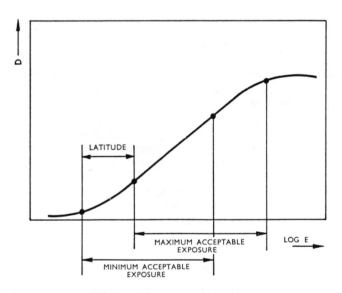

(b) SUBJECT OF HIGH CONTRAST—LITTLE LATITUDE

Fig. 15.21 — Effect of subject contrast (luminance range) on latitude

tion that part at least of it is on the straight-line portion. In this way, better negative contrast is achieved.

The response curve of a photographic paper

The characteristic curve of a paper is obtained in the same way as that of a film or plate, by plotting density against log exposure. Density in this case is *reflection density* (not transmission density) and is defined by the equation:

$$D = \log \frac{1}{R}$$

where *R,* the *reflection factor,* is the ratio of the light reflected by the image to the light reflected by the base or some other more absolute white. This definition of reflection density is analogous to that of transmission density (page 261).

Figure 15.22 illustrates the general shape of the characteristic curve of a paper. This curve, like that of a negative material, can be divided into four main regions: toe, straight line, shoulder and region of solarisation.

The main differences between the curve of a paper and that of a film or plate are:

(1) The shoulder is reached at a relatively low density and turns over sharply, the curve becoming parallel to the log *E* axis at a D_{max} which rarely exceeds a value of 2·1.

(2) The toe extends to a fairly high density, i.e. is long.

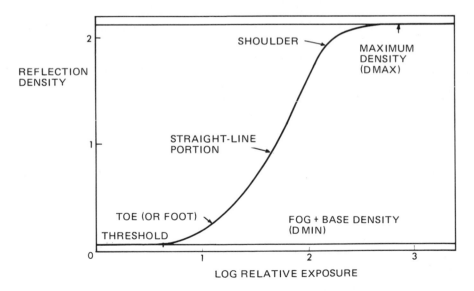

Fig. 15.22 – The "geography" of the characteristic curve of a paper

(3) The straight-line portion is short — in some papers, non-existent, the toe running into the shoulder.

(4) The slope of the straight line is generally quite steep compared with the same emulsion on film or glass.

(5) Fog — with normal development in correct safe-light conditions — is absent, although the minimum density may slightly exceed the density of the paper base material alone due to stain acquired in processing.

Differences (2) and (4) arise from the fact that when a silver image on an opaque base is viewed by reflected (as opposed to transmitted) light its effective density is increased, because light must pass twice through the image.

Maximum black

The practical consequence of (1) above is that the maximum density obtainable on any paper is limited, however long the exposure or the development. The highest value of density which can be obtained for a particular paper with full exposure and development is called the *maximum black* of the paper.

The maximum density obtained on any given paper depends principally on its surface. It can be seen from Figure 15.23 that light striking the surface of a print undergoes three types of reflection:

(1) Part is reflected by the surface of the gelatin layer in which the silver grains are embedded.

(2) Part is reflected by the silver grains themselves.

(3) The remainder is reflected by the surface of the paper base itself (or the baryta coating on the base).

It is the sum of these three reflections that determines the reflection factor and hence the density of the print.

By increasing the exposure received by a paper, and thus the amount of silver in the image, we can eliminate entirely the reflection from the paper base, but reflections from the gelatin surface of the emulsion and from the individual grains themselves cannot be reduced in this way. It is

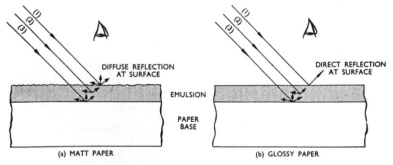

Fig. 15.23 — Diagrammatic representation of the reflection of light striking two papers of differing surface characteristics

these reflections, therefore, that set a limit to the maximum black available.

The value of the reflection from the surface of the emulsion depends upon the nature of this surface. A print will normally be viewed in such a way that direct reflection from its surface does not enter the eye. We are, therefore, concerned only with the diffuse reflection. Now, the reflection from the surface of a glossy paper is almost entirely direct, so that the amount of light reflected from the surface of such a paper which enters the eye when viewing a print is very small indeed. In these circumstances, the limit to the maximum density of the print is governed principally by the light reflected by the silver image itself. This is usually a little less than 1 per cent, corresponding to a maximum black of just over 2·0.

The reflection from the surface of a matt paper, on the other hand, is almost completely diffuse, so that an appreciable amount of light (e.g. 4 per cent) from the surface of the paper reaches the eye, in addition to the light from the silver image. (There may also be present light reflected from starch which is usually included in the emulsion of matt papers.) The maximum black of matt papers is therefore relatively low. Semi-matt and stipple papers have maximum blacks intermediate between matt and glossy papers. The following figures are typical of the values of maximum black obtainable on papers of the three main types of surface.

Surface	Reflection density
Glossy – glazed	2·10
Glossy – unglazed	1·85
Semi-matt	1·65
Matt	1·30

Modern resin-coated printing papers are not glazed after processing but possess a high natural gloss and thus may achieve a D_{max} of over 2·0 without glazing.

The effect of variation in maximum black on the characteristic curve is confined largely to the shoulder of the curve, as shown in Figure 15.24.

Exposure range of a paper

The ratio of the exposures corresponding to the highest and lowest points on the curve employed in a normal print is termed the *exposure range* of the paper (Figure 15.25). This may be expressed either in exposure units or in log exposure units.

Variation of the print curve with the type of emulsion

Photographic papers are of three main types: contact (chloride) papers, chlorobromide papers and bromide papers (See Chapter 21). The characteristic curves of these papers differ somewhat in shape. To il-

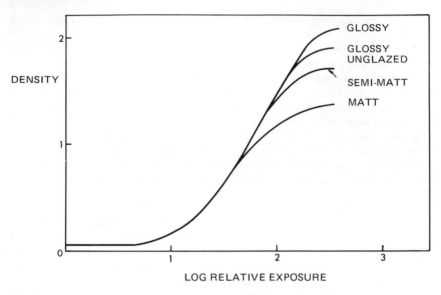

Fig. 15.24 – Characteristics of papers of different surfaces

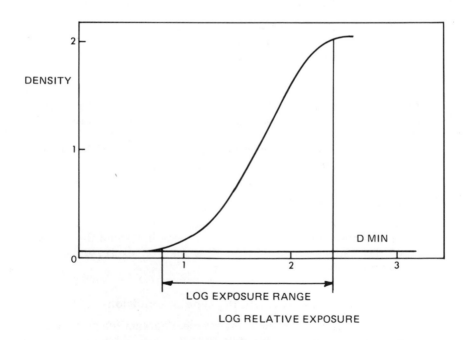

Fig. 15.25 – Exposure range of a printing paper

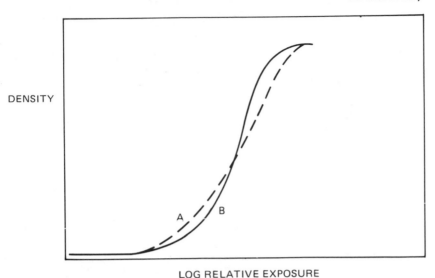

Fig. 15.26 – Characteristic curves of two different papers

lustrate these differences, characteristic curves of two widely differing papers of the same grade are shown in Figure 15.26.

It will be seen that although in the examples selected both papers give the same range of tones, i.e. have the same density range, and both have the same exposure range, the growth of density with exposure is not the same in the two cases. With paper A the density grows evenly with the increase in exposure, but with paper B the growth in density is at first slow, then grows more and more rapidly and finally grows less and less rapidly. In practice, paper A would be expected to give better tone separation in the shadows and highlights than paper B. Curve A is typical of chloride papers and curve B of bromide papers; a chloro-bromide paper curve would be intermediate between the two.

Variation of the print curve with development

With papers the characteristic curve varies with development, but rather differently from that of negative film.

Figure 15.27 shows a family of curves for a bromide paper. The normally recommended development time for this paper, in the developer employed, is 2 minutes at 20°C.

With bromide papers, development normally requires a minimum of about 1½ minutes. At longer development times the curve moves bodily to the left, but, unlike the curve of a chloride paper, the slope may increase slightly. In other words, both speed and contrast of a bromide paper increase on prolonged development. The increase in contrast is not great, but it is sometimes sufficient to be of practical value. The *major*

287

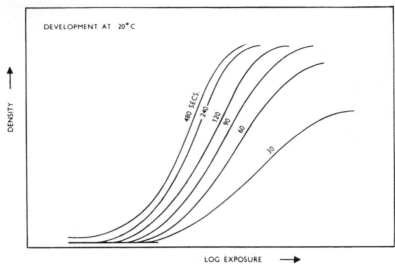

Fig. 15.27 — Characteristic curves of a typical bromide paper for different development times

effect of variation of development time on papers of all types is, however, on the speed of the paper, i.e. for a given exposure, on the density of the print. The situation may be complicated by the doubtful composition of "bromide" paper, which may contain significant amounts of silver chloride. This modifies the development behaviour, effectively ruling out any contrast increase with development time once maximum black has been reached.

With papers of all types, there is *development latitude* between the two extremes of under- and over-development. With the bromide paper shown in Figure 15.27, this extends from about 1½ minutes to 4 minutes. Between these times the maximum black is achieved but with no increase in fog. The ratio of the exposure times required at the shortest and longest acceptable times of development is referred to as the *printing exposure latitude*. It will be apparent that development latitude and exposure latitude are interrelated; both cannot be used at the same time. Thus, when once an exposure has been made there is only one development time that will give a print of the desired density.

Requirements in a print

It is normally desirable in printing that:

(a) All the important negative tones should appear in the print.

(b) The print should show the full range of tones between black and white that is capable of being produced on the paper used. (Even in high-key and low-key photographs it is usually desirable that the print should show *some* white and *some* black, however small these areas may be.)

288

In printing, the exposure of the paper is governed by the densities of the negative; the greater the density of any negative area, the less the exposure, and vice versa. In order, then, to meet both requirements (a) and (b) above, the exposure through the highlight areas of the negative must correspond with the toe of the curve of the printing paper, and the exposure through the shadow areas of the negative must correspond with the shoulder of this curve. Expressed sensitometrically this means that the log exposure range of the paper must equal the density range of the negative. This correspondence is illustrated in Figure 15.28 showing the negative characteristic together with that of an appropriate printing paper and one that is too contrasty.

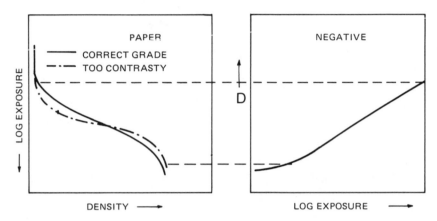

Fig. 15.28 – Negative and paper characteristics

Now, not all negatives have the same density range; this varies with the luminance range of the subject, the emulsion used, the exposure and the degree of development. Obviously, therefore, no single paper will suit all negatives, because, as we have seen, the log exposure range of a paper is a more-or-less fixed characteristic, affected only slightly, if at all, by development. A single paper with a sufficiently long exposure range would enable requirement (a) to be met in all cases, but not requirement (b). Printing papers are therefore produced in a series of *contrast grades*, or *gradations*, each of the papers in the series having a different log exposure range. Figure 15.28 shows two such grades and relates them to the negative density range.

Paper contrast grades

In Figure 15.29 are shown the characteristic curves of a series of bromide papers. These papers all have the same surface and differ only in their contrast grades, which are described as soft, normal and hard respectively. All three papers have been developed for the same time. It

will be noted that the three curves show the same maximum black, but the steepness of the curve *increases* and the exposure range *decreases* as we proceed from the soft grade to the hard. From this we see that the descriptions "soft", "normal" and "hard" apply to the inherent contrasts of the papers themselves, and not to the negatives with which they are to be used. The soft paper – with long exposure range – is, in fact, intended for use with *hard* negatives, with high density range. Conversely, the hard paper – with short exposure range – is intended for use with *soft* negatives, with low density range.

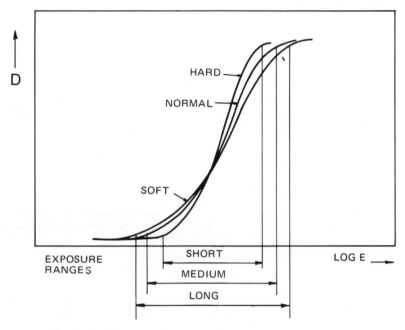

Fig. 15.29 – Paper contrast grades

If negatives of the same subject, differing only in contrast, are each printed on papers of the appropriate exposure range, the prints will be practically identical. If, however, an attempt is made to print a negative on a paper with too short an exposure range (i.e. too hard a paper), and exposure is adjusted to give correct density in, say, the highlights, then the shadows will be over-exposed and the result will appear too hard. If, on the other hand, a paper of too long an exposure range is used (i.e. too soft a grade) and exposure is again adjusted for the highlights, the shadow areas of the print will be under-exposed and the result will appear flat.

The softer the grade of paper, i.e., the longer its exposure range, the greater is the exposure latitude (as defined earlier) in printing. It is,

however, generally unwise to aim at producing negatives suited to the very softest paper because one then has no grade to fall back upon if for some reason a negative proves to be exceptionally hard. It is, therefore, generally best to aim at negatives suitable for printing on a middle grade of paper.

A simple, if only approximate, check on the exposure range of a paper can be made by giving to a strip of it a series of progressively increasing exposures. The exposure range is the ratio of the exposure required to yield the deepest black that the paper will give, to the time required to produce a just perceptible density. (See also page 309).

The problem of the subject of high contrast

Meeting the "formal" requirements (a) and (b) on page 288 does not necessarily imply that the resulting print will be aesthetically pleasing. In practice, the print will usually be satisfactory if the subject luminance range is not high, but with a subject of high contrast the result will often appear flat, even though both the formal requirements have been met. This is because the luminance range of a high contrast subject is far greater than the maximum range that can be obtained on a paper.

Two remedies are possible. The simplest is to print the negative on a harder grade of paper and to sacrifice detail at either the shadow or the highlight end of the scale. This, in effect, means abandoning requirement (a) but is often satisfactory. A preferred remedy is to use a harder grade of paper but to isolate the various tone-bands within the picture, and treat them individually by "printing-in" or by use of masks. In this way we can obtain the contrast we desire within the various tone-bands of the picture without sacrificing detail at either end of the scale.

Tone reproduction

The relation of the reflection factors of the various areas of a print — or luminances when the print is suitably illuminated — to the corresponding luminances of the subject is referred to as *tone reproduction*. Our object in photography is normally to obtain an acceptable reproduction of the various luminances of the original scene, thus keeping each tone in approximately the same relative position in the tone scale. We cannot always do this, but the very least we should strive for is to retain *tone separation* throughout the whole range of tones.

Theoretical perfection aims at obtaining *proportionality* between print luminances and subject luminances throughout the whole range of the subject; *equality* can rarely be hoped for, because the range of luminances possible on a paper is less than the luminance range of the average subject.

Hurter and Driffield were the first to study the problem of tone reproduction from the sensitometric point of view. Their work extended over the period 1874–1915, their classic paper being published in 1890. At this time, the popular negative and printing materials all yielded

characteristic curves with a long straight line. Hurter and Driffield took the view that perfect tone rendering in the print could only be achieved by first obtaining a *negative* in which all the opacities were proportional to the luminances of the subject. They stated that, for correct reproduction, exposure should be judged so that all the tones of the subject are recorded on the straight-line portion of the characteristic curve, and the negative should be developed to a gamma of 1·0. This state of affairs is illustrated in Figure 15.30, where it is apparent that if the log exposure differences, A_1, A_2 and A_3 are all equal, then the corresponding density differences B_1, B_2 and B_3 will also be equal to one another and to A_1, A_2 and A_3.

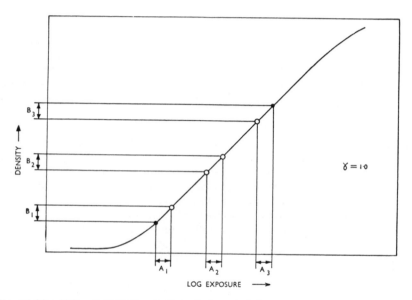

Fig. 15.30 – Using straight-line portion of characteristic curve

From their "correct" negative, Hurter and Driffield made prints on carbon, platinum or gold-toned printing-out-papers (or P.O.P.), using only the straight-line portion of the paper curve. All these papers had characteristic curves with a short toe and short shoulder, so that, assuming the papers to be capable of yielding a gamma of 1·0, it was quite a simple matter to obtain technically correct reproduction of many types of subjects. If the gamma of the paper selected was not 1·0 (it was usually greater), correct reproduction could be obtained by developing the negative to a gamma equal to the reciprocal of the print gamma, so that the product of the gammas of negative and positive remained unity. Hurter and Driffield's approach, although not generally applicable to modern materials, is the basis of the methods still used for the preparation of duplicate negatives.

The introduction of chloride and bromide papers early in the present century altered the situation described above, because these papers have no very long straight-line portion, but a long toe. It is quite impracticable when printing on these materials to use only the straight-line portion of the curve, and, therefore, with such papers, a negative made to Hurter and Driffield's specification does not give correct tone reproduction. Some distortion is in fact inevitable at the printing operation; our aim must be to introduce the appropriate distortion in the negative to counteract this.

Now, fast modern negative materials also have a long toe, use of which does in fact introduce some distortion in the right direction. If, therefore, as is usual, we place our shadow tones on the toe of the curve of such a negative material and the highlights on the straight line (page 274), the contrast in the shadows of the negative is lower than in the highlights. In printing, however, the contrast of the paper curve in the shadows — located on the upper half of the curve — is greater than the contrast in the highlights, which are on the toe. The overall effect, therefore, in the final print, is to yield roughly proportional contrast through the whole tone range. This is illustrated in Figure 15.31.

The quadrant diagram

It has been found valuable to employ graphical methods to study the problems of tone reproduction, one very useful method being the so-called *quadrant diagram* originated by L. A. Jones. This enables practical problems in tone reproduction to be studied from a scientific point of view. The simplest form of quadrant diagram is illustrated in Figure 15.32. This employs four quadrants, representing the negative, the print and the overall reproduction, the remaining quadrant being merely a transfer quadrant. For a more complete solution of the problem, other quadrants may be added as desired, to illustrate the effects of flare, viewing conditions, intensification or reduction, etc.

In quadrant 1 of Figure 15.32, the densities of the negative have been plotted against the log luminances of the original scene. If the camera is free from flare, this curve will be identical with the characteristic curve of the material, in which density is plotted against the log exposure received by the film. In quadrant 2 is shown the characteristic curve of the printing paper. This is turned through 90° in a clockwise direction from its normal position, as in Figure 15.28, to enable density values on the negative to be transferred directly to the log exposure scale of the positive, since it is the negative densities which modulate the exposure on the print.

To relate print densities and scene luminances we draw lines parallel to the axes to link corresponding points on the negative and positive curves, turning the lines proceeding from the positive curve through 90° in the transfer quadrant to intersect the lines from the negative curve in quadrant 4. By linking corresponding points, such as x, y and z, for every part of the negative and positive curves we obtain an *overall reproduction curve* as shown. For exact reproduction this curve should take the

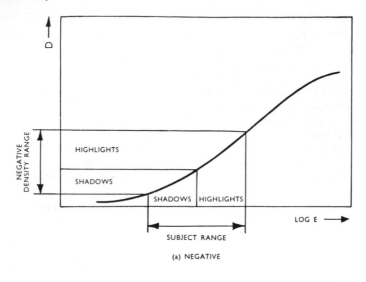

(a) NEGATIVE

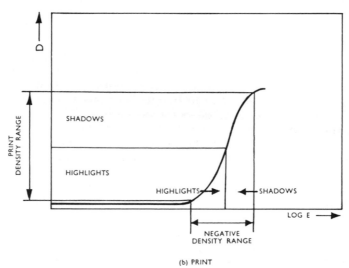

(b) PRINT

Fig. 15.31 – Obtaining proportional contrast in prints

form of a straight line at 45° to the axes. In practice, it is always more-or-less S-shaped, owing to the negative and positive characteristics. Flattening at the top of the reproduction curve indicates tone compression in the shadows, arising from the toe of the negative characteristic. Flattening at the bottom of the curve indicates tone compression in the highlights arising from the toe of the print characteristic.

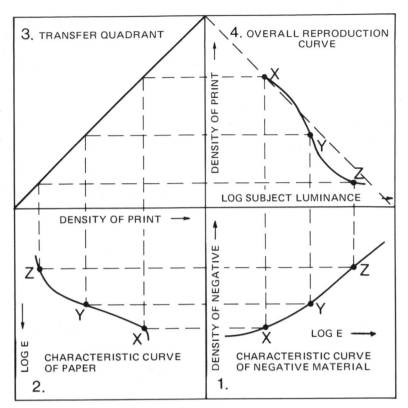

Fig. 15.32 – A quadrant diagram

Reciprocity law failure

The reciprocity law, enunciated by Bunsen and Roscoe in 1862, states that the photographic effect is dependent simply upon the total light energy employed, i.e. upon the product of the exposure time, t, and the illumination on the film, I, time being a reciprocal of illumination, and vice versa. Assuming that the reciprocity law holds, then if either illumination or time is varied to suit practical conditions, the same density will be obtained, provided that the other factor is varied in such a way as to keep the product E (in the equation $E = I.\,t$, page 259) constant.

Abney first drew attention to the fact that the photographic effect depends on the actual values of I and t, and not solely on their product. This failure of the reciprocity law is often termed *reciprocity failure*. Reciprocity failure arises because the effect of exposure on a photographic material depends on the rate at which the energy is supplied (see page 225).

All emulsions exhibit reciprocity failure to some extent, but it is usually serious only at very high or very low levels of illumination, and for much

Sensitometry

ordinary photography the reciprocity law can be considered to hold. For this reason, we have assumed that it holds in this book so far. In the sensitometric laboratory, however, the effects of reciprocity failure cannot be ignored, nor can they in certain practical applications of photography.

Practical effects of reciprocity failure

Reciprocity failure is encountered in practice as a falling off in speed at extremely high and extremely low levels of illumination, as a falling off in contrast at high levels of illumination, and as an increase in contrast at low levels of illumination. The degree of the falling off in speed and the region at which maximum speed is obtained varies from material to material. The effects of reciprocity failure are illustrated in Figures 15.33–15.35.

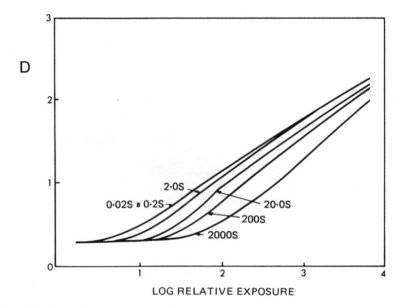

Fig. 15.33 – Characteristic curves of a fast negative film for different exposure times

Figure 15.34 shows that the variation in speed with exposure time – and therefore illumination level – is quite different for two types of emulsion. In manufacture, emulsions are designed so that the optimum intensity is close to the intensity normally employed. Thus, the fast negative film illustrated is intended for use at high intensities, with exposures of a fraction of a second, and the astronomical plate for use at low intensities, with exposures running into minutes or hours.

The fall-off in contrast at short exposure times assumes practical importance with high-voltage electronic flash lamps, which may give

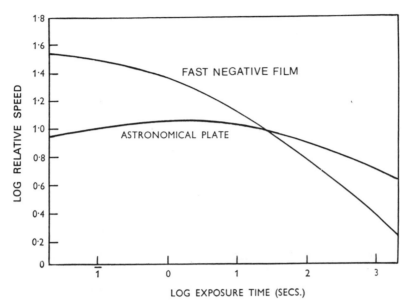

Fig. 15.34 – Reciprocity Law failure—effect on speed

exposures of the order of 1/5000th second or less. Then, the fall-off in contrast is such that it is normally desirable to increase development times by about 50 per cent to compensate for it.

As the result of reciprocity failure, a series of graded exposures made on a time scale (page 301) yields a result different from an intensity scale of exposures. Consequently, in sensitometry, a scale appropriate to the conditions in use must be chosen if the resulting curves are to bear a true relation to practice.

For the same reason, filter factors (page 200) depend to a very marked degree on whether the increase in exposure of the filtered negative is obtained by increasing the intensity of exposure (e.g., by varying the camera stop), or by prolonging the exposure time. In the former case the filter factor is independent of the time of exposure, but in the latter case it depends largely on the exposure time required by the unfiltered negative. Two types of filter factor are therefore quoted for some types of work: "intensity-scale" factors and "time-scale" factors. (An explanation of the terms intensity-scale and time-scale is given on page 301.)

Because of reciprocity failure, exposure times for the making of "giant" enlargements are sometimes unexpectedly long (page 475).

The variation of speed and contrast with exposure time is usually different for each of the three emulsion layers present in colour materials (Chapter 24). Consequently, departures from recommended exposing conditions may lead to unacceptable changes in colour reproduction for which no compensation may be possible.

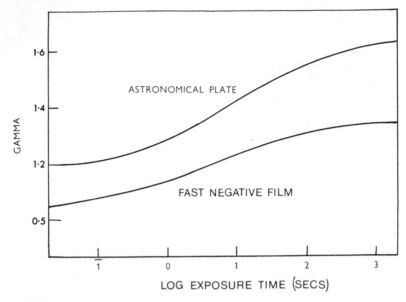

Fig. 15.35 – Reciprocity failure—effect on contrast

Intermittency effect

An exposure given in a series of instalments does not usually lead to the same result as a continuous exposure of the same total duration. This variation is known as the *intermittency effect*. It is associated with reciprocity failure, and its magnitude therefore varies with the material.

In practical photography, the intermittency effect is not of importance. In sensitometry, however, the effect cannot be ignored because some sensitometers give intermittent exposures. It is found, however, that a continuous exposure and an intermittent exposure of the same *average* intensity produce similar effects when the frequency of the flash exceeds a certain critical value, which varies with the intensity level. It is normally important, therefore, that intermittent exposures given in a sensitometer should be made at a rate above a critical frequency, which has to be determined by experiment for each emulsion studied.

Sensitometric practice

It would be possible to construct the characteristic curve of an emulsion – or at least part of the curve – from a picture negative, by measuring the luminances of the various parts of the subject and plotting against them the densities of the corresponding areas of the negative. This is illustrated in Figure 15.36.

This would, however, be an exceedingly laborious method if many curves were required, and it is not normally adopted. Usually, a standard

"negative" is produced by giving a known range of exposures to the material under test. The production of characteristic curves by this method involves:

(1) Exposure of a strip of the material in a graded series of exposures; this is carried out in a *sensitometer.*

(2) Processing of the exposed material under controlled conditions.

(3) Measurement of the densities obtained; this is carried out using a *densitometer.*

(4) Plotting of the results.

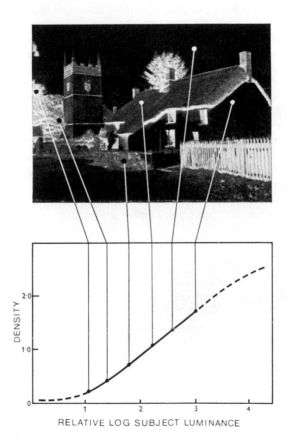

Fig. 15.36 – Characteristic curve derived from a negative

Sensitometry requires careful work and – to be of fullest value – the use of special apparatus. In manufacturers' laboratories, where the production of characteristic curves is a routine, elaborate apparatus, usually designed by the manufacturer's own research staff, is employed.

Sensitometers

A *sensitometer* is an instrument for exposing a photographic material in a graded series of steps, the values of which are accurately known. The essentials of a sensitometer are:

(1) *A light source of standard intensity and colour quality.* Many sources have been proposed and used at various times. The light source adopted as standard in recent years has been a gas-filled tungsten lamp operating at a colour temperature of 2850 K. The lamp is used with a selectively absorbing filter to yield the spectral distribution that corresponds to daylight of 5500 K modified by a typical camera lens. The filter used may be made of a suitable glass or employ specified solutions made up by the user. The colour temperature of 5500 K corresponds to daylight with the sun at a height typical of temperate zones during the hours recommended for colour photography and is therefore suitable for the exposure of colour and monochrome films designed for daylight use.

Any sensitometric light source, particularly when used for colour materials, must be stabilised both in terms of candle power and colour temperature. Mains voltage fluctuations can alter both quantities and are generally compensated by elaborate and sophisticated voltage stabilisers. Alternatively battery operation may sometimes be used to avoid power variations. In most cases a DC supply to the lamp is used to avoid AC modulation of the exposure, which is potentially significant at short exposure times.

(2) *A means of modulating the light intensity.* To produce the graded series of exposures, it is possible to alter either the intensity of illumina-

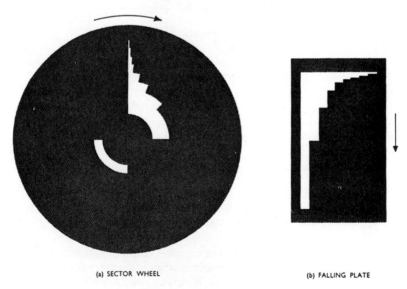

(a) SECTOR WHEEL (b) FALLING PLATE

Fig. 15.37 – Two types of time-scale sensitometer shutter

tion or the time for which the exposure lasts. As already stated, because of reciprocity failure the two methods will not necessarily give the same results, and, to obtain sensitometric data which will correctly indicate the behaviour of the material under the conditions of use, the exposure times and intensities should be comparable with those which the material is designed to receive in practice.

A series of exposures in which the scale is obtained by varying the intensity — referred to as an *intensity scale* — can conveniently be achieved by use of a neutral step wedge. A series of exposures in which the scale is obtained by varying the time — referred to as a *time scale* — may be achieved by use of a rotating sector wheel (Figure 15.37a), a falling plate (Figure 15.37b), or, in some cases a sectored cylindrical drum.

Whichever system of modulation is chosen, a sensitometer is designed so that the exposures increase logarithmically along the length of the strip. The steps selected are usually ×2, ×$\sqrt{2}$ or × $\sqrt[3]{2}$, i.e. the log exposure steps are 0·3, 0·15 or 0·1. If, for any reason, it is desired to interrupt the exposure, this must be done in such a way that the intermittency effect (page 298) does not affect the results. Figure 15.38 shows a typical sensitometric strip. This particular example was produced in an intensity-scale sensitometer, being exposed behind a step wedge.

Fig. 15.38 — A sensitometric strip

As the state of affairs obtaining in the camera is best represented by an intensity scale of exposures, sensitometers used for process control are preferably of the intensity-scale type. Early commercial sensitometers were usually time-scale intruments, because the design problems with such a means of exposure modulation are easier, but this was not a serious drawback. On occasion, however, it did cause confusion, and modern commercial sensitometers are nearly always intensity-scale instruments.

Densitometers

The name *densitometer* is given to special forms of photometer designed to measure photographic densities. Instruments designed to measure the densities of films and plates are described as *transmission densitometers*, while those designed to measure papers are termed *reflection densitometers*. Some densitometers are designed to enable both transmission and reflection densities to be measured on the one instrument.

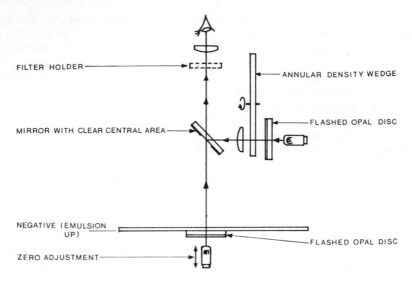

(a) TRANSMISSION MODE

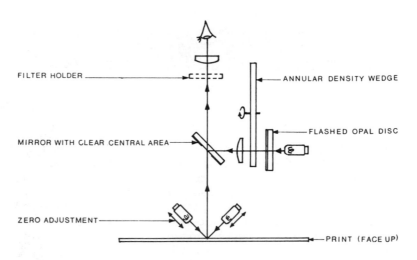

(b) REFLECTION MODE

Fig. 15.39 – Arrangement of the Kodak RT Colour Densitometer

Densitometers can be broadly classified into the two types; visual densitometers and photo-electric densitometers. The earliest densitometers were visual instruments and, although density measurements in quantity are nowadays invariably carried out on photo-electric instruments, visual instruments are still of value when only a few readings are required, and eye-strain is unlikely to be a problem. They have the advantages of simplicity and

relative inexpensiveness. The Kodak RT Colour Densitometer is a modern visual instrument designed to enable both transmission and reflection densities to be measured. The principle of this instrument is shown diagrammatically in Figure 17.39.

Photo-electric densitometers, sometimes termed physical, or electronic, densitometers are of many different types, ranging from simple direct-reading instruments to instruments with highly sophisticated circuits employing a null system, with, in some instances, automatic plotting of the results.

Single-beam instruments, direct reading

The commonest type of densitometer uses a photo-electric cell illuminated by a beam of light in which the sample to be measured is placed. The response of the photo-electric cell is displayed on a meter calibrated in units of density. The design is illustrated in Figure 15.40a – a single-beam direct-reading densitometer. Such instruments are usually set up for measurement by adjusting the density reading to zero when no sample is present in the beam. This operation may be followed by a high density setting using some calibration standard or even an opaque shutter for zero illumination of the photo-cell. Once set up the instrument is used for direct measurements of the density of samples placed in the beam.

Constancy of light output, the stability of any electronics used (not shown in Figure 15.40) and of performance by the photo-cell, all over a period of time, are required for accurate density determination using instruments of this type. In practice fairly frequent checks of the instrument zero are required to eliminate drifts of measured density with time. A further requirement of the direct-reading instrument is that of linearity of cell response to changes of illumination.

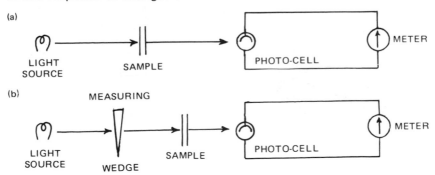

Fig. 15.40 – Single-beam instruments (a) direct-reading; (b) substitution or null-reading

Single-beam instruments, null reading

In order to avoid difficulties due to non-linearity of cell response it is possible to arrange that the illumination of the photo-cell remains constant no matter what density is to be measured. The design of the instru-

ment is shown in Figure 15.40b. In this, a *substitution* method is used.

The *measuring wedge* inserted into the measuring beam is a con-
tinuous neutral wedge calibrated so that its density is known at any point
inserted in the beam. The instrument zero is established by moving the
wedge so that its maximum density lies in the beam and arranging that
the meter needle is at a single calibration position. The sample to be
measured is placed in the beam and the meter restored to its null posi-
tion by withdrawal of the measuring wedge. The density of the sample is
given by the extent of withdrawal.

The consistency of density measurement thus depends on the same
factors as for direct-reading instruments with the exception that cell non-
linearity is eliminated as a source of error. On the other hand the
measuring wedge calibration is introduced but is a less serious source of
potential error.

Twin-beam instruments

Many of the sources of error inherent in single-beam instruments can be
eliminated if two beams are taken from the same source as shown in
Figure 15.41. One beam, A in the diagram, has a path identical to that of
a null-reading single-beam instrument, while the other beam, B, passes
through an *uncalibrated* compensating wedge before illuminating a se-
cond photo-cell. The outputs of the two cells are compared electronically
and the *difference* between them is indicated on the meter. Normally
only one gradation is shown on the meter, all reading being of the null
type.

To zero the instrument the measuring wedge is inserted into the
measuring beam, A, to its maximum density. In general the meter will

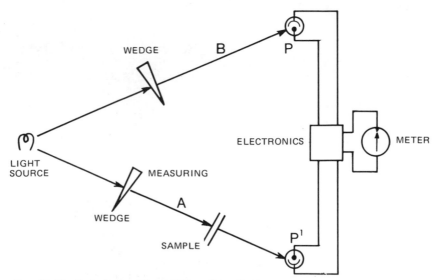

Fig. 15.41 – Twin-beam differential or null-reading instrument

not then be at its null position. The uncalibrated wedge is then inserted in the *compensating beam* so that the meter registers no deflection from the null position. Measurements are then made by placing samples in the measuring beam and withdrawing the measuring wedge until the null reading is restored, the extent of withdrawal indicating the density of the sample.

Fluctuations in lamp output affect both beams equally and are thus entirely compensated in instruments of this type. The photo-cells are maintained under constant conditions of illumination and no assumptions of linearity of response are required. The accuracy of the instrument depends on the calibration of the measuring wedge, sources of short-term errors in density being eliminated by this design.

All visual densitometers are differential twin-beam instruments. While quite unreliable as an absolute judge of density, the human eye is very sensitive to small differences between two compared densities. Figure 15.39 shows that visual densitometers compare the unknown density with a calibrated wedge displayed side-by-side in the visual field. The illumination is not maintained constant in the illustrated instrument.

Automatic plotting

Densitometers used for the measurement of large numbers of sensitometric strips are often arranged so that the characteristic curve is automatically plotted by the instrument.

To achieve this a pen is moved across appropriately scaled graph-paper at a rate corresponding to the movement of a sensitometric strip past the measuring aperture. This requires that the strip was exposed through a *continuous* sensitometric wedge, the density of which varied directly with the distance along it. The density detected by the instrument is revealed as a signal which makes a *servo-motor* drive the plotting pen to an appropriate position relative to the density scale on the graph paper. Usually the servo-motor automatically drives the measuring wedge to a null position using a mechanical link to which the pen is attached.

One type of automatic-plotting densitometer is illustrated in Figure 15.42. It is referred to as being a *twin-beam split and chopped* instrument. The desirable features of twin-beam operation are retained but the two beams are used to illuminate a single photo-cell. The *chopper* is a rotating shutter which allows the beams to reach the cell alternately. Any difference between the beam intensities appears as a variation of the output current from the photo-cell. The variation can be amplified electronically and used to drive the servo-motor and measuring wedge to the null position.

Microdensitometers

These instruments are used to examine density changes over very small areas of the image. These microstructural details are measured for the

assessment of *granularity, acutance* and *modulation transfer function* as described in Chapter 25.

To measure the density of a very small area it is usual to adopt a typical microscope system, replacing the human eye by a photomultiplier tube. The sample is driven slowly across the microscope stage

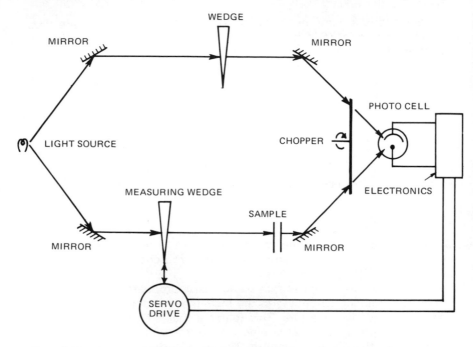

Fig. 15.42 – Automatic plotting densitometer (twin-beam split and chopped)

in synchronism with graph paper moving past a pen which registers density as with the automatic plotting densitometers already considered. Such microdensitometers are commonly twin-beam instruments and the ratio of graph-paper movement to sample movement may be of the order of 1000:1.

Colour densitometers

In addition to monochrome silver images it is often necessary to make sensitometric measurements of colour images. These colour images (see Chapter 14) are composed of just three dyes absorbing red, green and blue light respectively. It is therefore possible to assess colour images by making density measurements in those three spectral regions. Colour densitometers are thus similar to monochrome instruments but are equipped with three primary colour filters — red, green and blue.

The best idea of the behaviour of a dye image is achieved when the densitometer measures only within the spectral absorption band of the

dye. So colour densitometers are usually equipped with quite narrow-cutting filters, a typical set being shown in Figure 15.43. In view of the unwanted spectral absorptions of images dyes (see Chapter 11) it will be appreciated that a colour density measurement (red, green or blue), represents the sum of contributions from *all the dyes present.* Such measured densities are described as *integral densities.* For most purposes no further information is required but sometimes a single image dye is to be measured in the presence of the other two. In such cases *analytical densities*, which reflect the individual dye concentrations, have

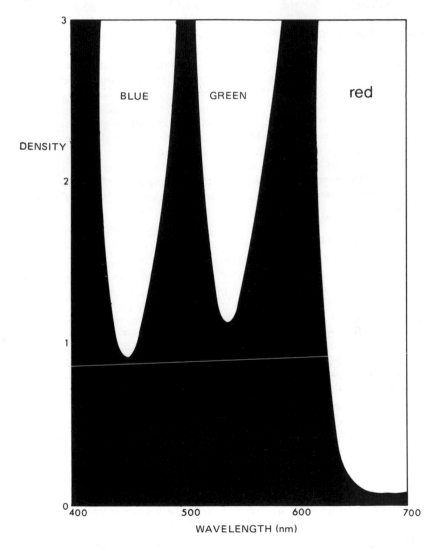

Fig. 15.43 – Blue, green and red filters for colour densitometry

to be calculated from the measured integral densities. Procedures for doing this are beyond the scope of this work; it is sufficient to note that, outside a research laboratory, there are no simple methods of measuring analytical densities.

An important choice of densitometer filters arises when the response of the instrument is to be matched to that of a colour printing paper. The purpose of this exercise is to use a densitometer to assess colour negatives and hence to predict the printing conditions required to yield a good colour print. Instruments set up according to recommendations from Kodak Ltd. for the measurement of Kodak masked negatives are said to give *Status M* densitometry. When set up so that visual neutrals formed of the three image dyes of a reversal film give red, green and blue densities which are identical and equal to those of a matching non-selective neutral (such as silver), the system is described as *Status A* densitometry. These designated types of density have become internationally recognised ISO standards.

The spectral responses of instruments for Status densitometry are tightly specified. It may not, however, be necessary to establish a system meeting such specifications because *arbitrary* integral densities are often quite satisfactory for such purposes as quality control.

As with black-and-white densitometers the commonest type is the direct-reading single-beam instrument. Instruments of this type include Gretag transmission and MacBeth transmission and reflection densitometers.

Elementary sensitometry

An elementary form of sensitometry, which, although not of a high degree of precision, can be of real practical value in testing the performance of sensitised materials or photographic solutions, can be carried out with nothing more elaborate than a step wedge and a simple visual densitometer. If a commercial step wedge is not available, a suitable wedge can be made by giving a stepped series of exposures to an ordinary film or plate. Useful step increases in a wedge used for this purpose are density values of 0·15 for the testing of films and plates and 0·1 for testing papers.

A strip of the material under test is exposed through the wedge by contact, or the wedge may be illuminated from the rear and photographed with a camera. If the latter procedure is adopted, care must be taken to eliminate possible causes of flare. The densities obtained on the strip are then plotted against the densities of the wedge — which govern the exposure. The wedge densities are plotted to increase from right to left, this corresponding with log exposure of the strip increasing from left to right in the usual way.

Simple sensitometry of this type may be used for various purposes, e.g.:

(1) To study the effect of increasing development on the speed and contrast of an emulsion.

(2) To compare the emulsion speeds and contrasts yielded by two developers.

(3) To compare the speeds of two emulsions.

(4) To compare the contrasts of two emulsions.

(5) To determine filter factors.

(6) To measure the exposure range of a printing paper.

The candle-power, distance, etc., of the lamp used are needed only if we wish to find the *absolute* speed of a material. All the characteristics listed above can be studied without this information, provided only that the candle-power, distance and colour temperature of the lamp remain constant and identical exposure times are given.

16 The Reproduction of Colour

IN photography, two alternative approaches to the reproduction of colour are open to us. All objects of whatever colour can be reproduced as shades of grey varying from black to white, or means may be employed to reproduce the subject in colours that are acceptably close to those of the original.

Black-and-white photography existed for nearly a century before colour photography became common and it was found very early on that the eye would accept a monochrome picture as a true record of coloured objects provided that the greys of the reproduction related to the brightnesses of the original colours. To understand how this is achieved we need to know something about the responses to different colours of the eye and of photographic emulsions.

We shall then go on to consider the reproduction of colour by colour films, a rather more complicated story.

Colours in the spectrum

We saw in Chapters 2 and 4 that white light can be separated by means of a prism into light of different colours – notably violet, blue, green, yellow, orange and red. We also saw that these colours correspond to different wavelengths. White light is thus seen to be a *mixture* of light of different wavelengths. Light consisting of a *single* wavelength, or narrow band of wavelengths, is invariably strongly coloured, colours of this type being referred to as *spectral*, or *spectrum*, *colours*.

Colours of natural objects

The pure colours of the spectrum are rarely to be found in the objects which we see around us; instead we see many colours not to be found in the spectrum. This does not mean that light of a different nature is emitted by these objects, but simply arises from their power of selective absorption or subtraction. Objects are visible because of the light which they pass on to our eyes, most objects deriving this light from some out-

side source of illumination. Coloured objects appear so because they absorb some wavelengths and reflect others; typical examples are shown in Figure 14.1.

Suppose we examine a number of pieces of coloured paper. Now, although we can discern six or more colours in the spectrum of white light, for many purposes we may consider it as a mixture of three main colours – blue, green and red (see page 24). Suppose the first piece of paper reflects only the blue part of the light falling on it, the green and red portions being absorbed. Then, when illuminated by white light, it will look blue, and we say that it is a "blue" piece of paper. Similarly a "green" paper will reflect green and absorb blue and red, and a red paper will reflect red and absorb blue and green. Sometimes, an object reflects more than one of the three groups. For example, one of the papers may reflect green and red, absorbing only the blue; this paper will look yellow. In the same way, a paper reflecting blue and red will look purple or "magenta", while a paper reflecting blue and green will have the blue-green colour which we call "cyan". In general, any common object assumes a colour which is a mixture of the spectral colours present in the illuminant and not absorbed by the object.

The colours described in the above example were all produced as a result of the complete absorption of one or more of the main colour groupings of white light. Such colours are termed *pure*, or *saturated*, colours. The pigments of most commonly occurring objects, however, absorb generally and reflect generally – no part of the spectrum being reflected completely and no part absorbed completely. The colours of natural objects – sometimes referred to as *pigmentary* colours – therefore contain all wavelengths to some extent, with certain wavelengths predominating. They are of much lower purity (saturation) than the colours of the papers supposed in our example. Thus, a red rose, for example, appears red not because it reflects red light only, but because it reflects red light better than it reflects blue and green. The spectral properties of some commonly-found surface colours are shown in Figure 14.1.

Colours occurring in natural objects	Degree of reflection in indicated region of spectrum		
	Blue-violet	Green	Red
Red	Badly (5%)	Badly (5%)	Very well (45%)
Orange	Badly (6%)	Fairly well (15%)	Very well (50%)
Yellow	Badly (7%)	Very well (50%)	Extremely well (70%)
Brown	Very badly (4%)	Badly (8%)	Less badly (12%)
Flesh	Well (25%)	Well (30%)	Very well (40%)
Blue	Well (30%)	Rather badly (15%)	Badly (5%)
Green	Badly (6%)	Rather badly (10%)	Badly (7%)

Table 16.1 – Typical reflectances of natural objects in the three main regions of the spectrum

The Reproduction of Colour

Table 16.1 shows the degree of reflection in the three principal regions of the spectrum, of some of the main colours in the world around us. It will be seen that the general rules connecting the kind of absorption with the resulting impression are the same as with the pure colours of the papers considered in the example above. The figures quoted in the table, which are approximate only, are percentages of the amount of incident light in the region concerned, not of the total incident light.

We see from Figure 14.1 that the spectral absorption bands of commonly encountered coloured objects are broad. We do not usually find absorption spectra consisting of a series of spectral lines.

Effect of light source on appearance of colours

We noted above that the colour assumed by an object depends both upon the object itself and on the illuminant. This is strikingly illustrated by a red bus, which by the light of sodium street lamps appears brown. We are accustomed to viewing most objects by daylight, and therefore take this as our reference. Thus, although, by the light of sodium lamps, the bus appears brown, we still regard it as a red bus.

The change from daylight to light from a sodium lamp represents an extreme change in the quality of the illuminant, viz., from a continuous to a line spectrum. The change from daylight to tungsten light — i.e. from one continuous source to another of different energy distribution — has much less effect on the visual appearance of colours. In fact, over a wide range of energy distributions the change in colour is not perceived by the eye. This is because of its property of *chromatic adaptation*, as a result of which the eye continues to visualise the objects as though they were in daylight.

If we are to obtain a faithful record of the appearance of coloured objects, our aim in photography must be to reproduce them as the eye sees them in daylight. Unlike the eye, however, photographic materials do not adapt themselves to changes in the light source, but faithfully record the effects of any such changes. If, therefore, a photograph is not being taken by daylight, the difference in colour quality between daylight and the source employed must be taken into account if technically correct colour rendering is to be obtained. Colour filters find application in this connection. (See Chapter 11.)

In practice, a technically correct rendering is rarely required in black-and-white photography, and changes in the colour quality of the illuminant can for much work be ignored. In colour photography, however, very small changes in the colour quality of the illuminant may produce significant changes in the result and accurate control of the quality of the lighting is therefore required if good results are to be obtained.

Response of the eye to colours

Our sensation of colour is due to a mechanism of vision which is complicated, and which operates in a different way at high and low levels of

illumination. In considering the reproduction of colours in a photograph we are concerned with the normal mechanism, i.e. of the one operating at fairly high light-levels. For the purposes of photographic theory, it is convenient to consider this as using three types of receptor. A consideration of the way in which these receptors work is known as the *trichromatic theory of colour vision.*

This theory, associated with the names of Young and Helmholtz, postulates receptors which differ in their sensitivity and in the regions of the spectrum to which they respond. The first set of receptors is considered to respond to light in the region of 400 to 500 nm, the second to light in the region of 450 to 630 nm and the third to light in the region of 500 to 700 nm. The behaviour of the eye, considered on this basis, is probably best grasped from a study of curves in which the response of the receptors is plotted against wavelength, as in Figure 16.1. From this figure it is seen that the three sets of receptors overlap in sensitivity and that the green set of receptors is far more sensitive than the other two.

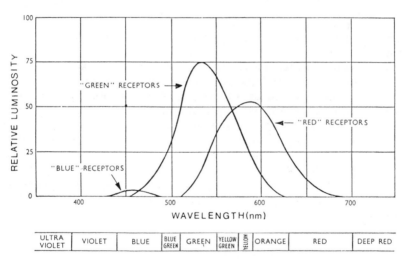

Fig. 16.1 – The three fundamental sensation curves of the trichromatic theory of colour vision

The validity of the three-colour theory was for a long time a subject of controversy, but it is now supported by a firm basis of experimental evidence indicating three types of colour-sensitive receptor in the eye. The justification of the use of the theory for our purposes is that a person with normal colour vision can match almost any given colour by mixing appropriate amounts of blue-violet, green and red light. Colour photography itself relies on this phenomenon.

By adding together the ordinates of the three curves shown in Figure 16.1, we obtain a curve showing the sensitivity to different wavelengths of the eye as a whole. Such a curve is shown in Figure 16.2. This *visual*

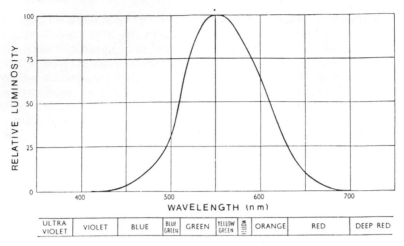

Fig. 16.2 — Visual luminosity curve

luminosity curve shows the relative luminous efficiency of radiant energy.

It is a commonly recognised fact that the normal human eye does not see all colours as of equal lightness. Most blues, for example, when compared with medium shades of orange or green appear dark, while yellows, including even the deepest shades, are light. The visual luminosity curve illustrates this diagrammatically. It shows exactly how the human eye responds to the series of spectral colours obtained by splitting up a beam of pure white light — sometimes referred to as an *equal energy spectrum* — to which sunlight approximates roughly. It is important to notice by how many times the luminosity of the brightest colour, yellow-green, exceeds that of colours nearer the ends of the spectrum.

Primary and secondary colours

When any one of the three sets of receptors of the eye is stimulated by itself the eye sees blue-violet, green, or red light respectively. These three colours are known to the photographer as the *primary colours*, already mentioned in Chapters 2 and 14. The sensations obtained by mixing the primary colours, as illustrated in Figure 2.5, are called *secondary* or *complementary colours* and are obtained when two sets of receptors are stimulated leaving only one set inactive. If all three sets of receptors are stimulated in suitable proportions the colour perceived is white.

Some care is needed when speaking of primary and secondary colours because a painter is accustomed to refer to the photographer's secondary colours as blue, yellow and red and to call them primary colours, since by mixing *pigments* of these three colours he can, if he wishes, obtain almost all the colours he needs.

Complementary colours

Any two colours (i.e., coloured lights, not pigments), which when added together produce white, are said to be *complementary*. Thus, the secondary colours are complementary to the primary colours. These secondary colours, cyan, yellow and magenta – sometimes given the names minus red, minus blue, and minus green – are known as the *complementary colours*.

Primary Colour	Secondary or Complementary Colour	Colour Mixture
Red	Cyan	Blue + green
Green	Magenta	Blue + red
Blue	Yellow	Green + red

Table 16.2 – Primary and Complementary Colours

Low light-levels

At low light-levels, when the eye becomes *dark-adapted* a different and much more sensitive mechanism of vision operates. The dark-adapted, or *scotopic*, eye has a spectral sensitivity differing from the normal, or *photopic*, eye. The maximum sensitivity, which, in the normal eye, is in the yellow-green at about 555 nm, moves to about 510 nm – near the blue-green region. This change in sensitivity is referred to as the *Purkinje shift* (Figure 16.3). It is because of this shift that the most efficient dark-green safelight for panchromatic materials has a peak transmission at about 515 nm rather than at 555 nm (page 219).

It is also found that the eye, which can distinguish a large number of colours under bright lighting conditions, becomes decreasingly colour sensitive at lower levels of illumination. Under really dim conditions only monochrome vision is possible. This property is not shared by colour films so that, despite dull conditions, the correct exposure will reveal the colours of the subject and often surprises the photographer whose recollection may be of a far more drab original.

Black and White Processes

As already stated, a photographic emulsion reproduces colours in monochrome, and is considered to do so faithfully when the relative luminosities of the greys produced are in agreement with those of the colours as seen by the eye. So far as a response to light and shade is concerned – and this, of course, has a very large part to play in the photographic rendering of the form and structure of a subject – it is clear that a light-sensitive material of almost any spectral sensitivity will answer the purpose. If, however, our photograph is to reproduce at the same time the colours of the subject in a scale of tones corresponding with their true luminosities, then it is essential that the film employed shall have a spectral response corresponding closely to that of the human eye.

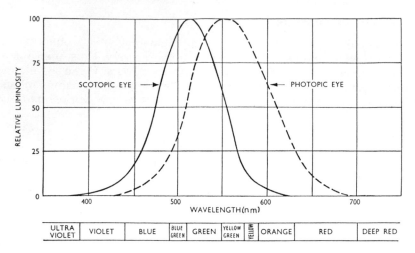

Fig. 16.3 — The Purkinje shift

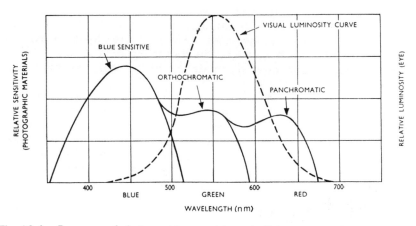

Fig. 16.4 — Response of photographic materials to daylight

We saw in Chapter 13, that, although the ordinary silver halide emulsion is sensitive only to ultra-violet and blue, it is possible by dye-sensitising to render an emulsion sensitive to all colours of the visible spectrum. To assist us in evaluating the performance of the various materials in common use, there are reproduced in Figure 16.4 curves showing the sensitivity of the eye and the sensitivity to daylight of typical examples of the three main classes of photographic materials. Figure 16.5 contains curves for the same materials when exposed to tungsten light, the visual response curve being repeated.

316

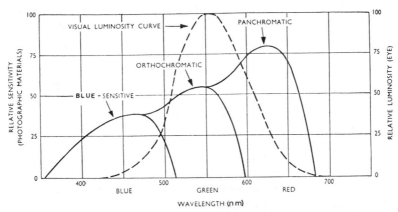

Fig. 16.5 – Response of photographic materials to tungsten light

Table 16.3, which lists the primary and secondary colours and indicates how each is recorded in monochrome by the three main classes of emulsion, illustrates the practical effects of the differences shown between the visual luminosity curve and the emulsion spectral sensitivity curves in the foregoing figures. The descriptions given in the table are relative to the visual appearance of the colours.

Colours	Blue-sensitive Daylight	Ortho-chromatic Daylight	Panchromatic	
			Daylight	Tungsten
Primaries				
Blue-violet	Very light	Light	Rather light	Correct
Green	Dark	Rather dark	Slightly dark	Slightly dark
Red	Very dark	Very dark	Slightly light	Light
Secondaries				
Yellow	Very dark	Slightly dark	Correct	Rather light
Cyan	Light	Very light	Slightly light	Slightly dark
Magenta	Slightly light	Correct	Rather light	Rather light

Table 16.3 – Recording of the primary and secondary colours by the main types of photographic emulsion

Less saturated colours than the primaries and secondaries follow the general pattern shown in the table but to a lesser extent. Thus, brown can be regarded as a degraded yellow, and pink as a desaturated magenta.

It is clear from the curves in Figures 16.4 and 16.5 and from Table 16.3 that:

(1) No class of monochrome material has exactly the same sensitivity as the human eye, either to daylight or to tungsten light. In the first place, the characteristic peak of visibility in the yellow-green coincides with a region of comparatively low photographic response – even with panchromatic materials. On the other hand, the relative sensitivity of pan-

317

chromatic materials to violet, blue and red greatly exceeds that of the human eye.

(2) The closest approximation to the eye is given by panchromatic materials.

(3) Of the three groups of light-sensitive materials listed, only panchromatic materials can be employed with complete success for the photography of multi-coloured objects, since they are the only ones which respond to the whole of the visible spectrum.

(4) Even with panchromatic materials, control of the reproduction of colours may be needed when a faithful rendering is required, since no type of panchromatic material responds to the different colours of the emulsion in *exactly* the same manner as the eye. Control of colour rendering is also sometimes needed to achieve special effects.

The control referred to under (4) above, is achieved by means of *colour filters*. These are sheets of coloured material having the power to absorb certain colours either partially or completely, while transmitting others freely. By the correct choice of a filter, it becomes possible to reduce the intensity of colours to which the response of the emulsion is too strong. The use of colour filters is considered in detail in Chapter 11.

Colour processes

The principles of the two major types of photographic colour reproduction, namely additive and subtractive, have been described in Chapter 14. The processes considered in that chapter illustrate the ways in which additive and subtractive colour synthesis can be carried out following an initial analysis by means of blue, green and red separation filters. It was, however, stated that most colour photographs are made using the emulsion assembly known as the *integral tripack* and the procedure of *colour development* in which are formed yellow, magenta and cyan image dyes to control the transmission of blue, green and red light respectively by the final colour reproduction. As shown in Figure 16.6, three emulsions are coated as separate layers on a suitable film or paper base and these emulsions are used independently to record the blue, green and red components of light from the subject. The analysis is carried out, not by the

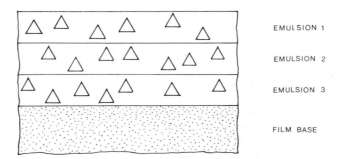

Fig. 16.6 – Cross-section of an elementary integral tripack film

use of separation filters, but by limiting the emulsion layer sensitivities to the spectral bands required.

The sensitivities of typical emulsions used in camera-speed films are illustrated in Figure 16.7, from which it will be clear that all three layers possess blue sensitivity and that no independent record of blue light can be achieved without special steps being taken.

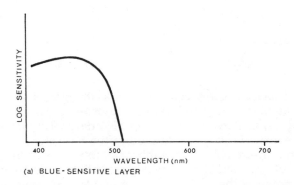

(a) BLUE-SENSITIVE LAYER

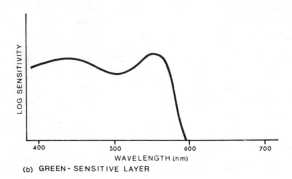

(b) GREEN-SENSITIVE LAYER

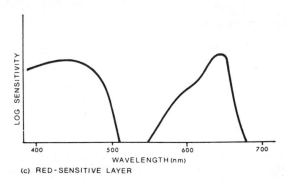

(c) RED-SENSITIVE LAYER

Fig. 16.7 – Layer sensitivities of an elementary tripack film

319

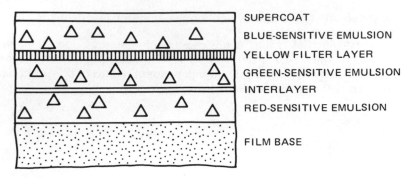

SUPERCOAT

BLUE-SENSITIVE EMULSION

YELLOW FILTER LAYER

GREEN-SENSITIVE EMULSION

INTERLAYER

RED-SENSITIVE EMULSION

FILM BASE

Fig. 16.8 – Cross-section of integral tripack film of camera speed

What is usually done in practice is to coat the film as shown in Figure 16.8, with the blue-recording layer on top of the other two, and with a yellow filter layer between the blue-recording and green-recording layers. The supercoat is added to protect the emulsions from damage. The filter layer absorbs blue light sufficiently to suppress the natural blue sensitivities of the underlying emulsions and an interlayer is usually positioned between the lower emulsion layers. The resulting effective layer sensitivities are illustrated in Figure 16.9.

Formation of subtractive image dyes

Having analysed the camera image into blue, green and red components by means of the tripack film construction it is then necessary to form the appropriate image dye in each layer. Conventionally this is achieved by the reaction of the by-products of silver development with special chemicals called *colour couplers* or *colour formers*, the process being detailed in Chapter 24. Developing agents of the p-phenylene diamine type yield oxidation products:

Exposed silver bromide + developing agent⟶ silver metal +

oxidised developer + bromide ions

which then react with a colour coupler to give a dye:

oxidised developer + coupler⟶ dye.

Thus to form a dye image alongside the developed silver image a special type of developer is required and a suitable colour coupler must be provided — either by coating it in the emulsion or by including it in the developer.

The dyes formed in subtractive processes would ideally possess spectral absorptions similar to those illustrated in Figure 14.6 but are not, in reality, ideal and possess spectral deficiencies similar to, but often worse than, those shown in Figure 14.7. The consequences of these dye imperfections become obvious when the sensitometric performance of colour films is studied.

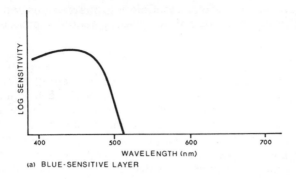

(a) BLUE-SENSITIVE LAYER

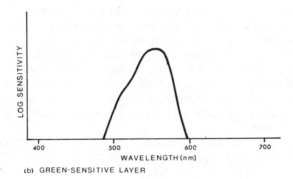

(b) GREEN-SENSITIVE LAYER

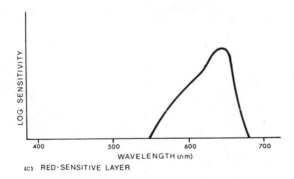

(c) RED-SENSITIVE LAYER

Fig. 16.9 – Effective layer sensitivities of a typical tripack film

Colour sensitometry

Using the sensitometric methods already examined in Chapter 15, it is possible to illustrate important features of colour films, in terms of both tone and colour reproduction. Tone reproduction properties are shown by neutral exposure, that is exposure to light of the colour quality for which the film is designed, typically 5500 K or 3200 K. This exposure is probably the most important since it also gives information about the

overall colour appearance of pictures. Colour exposures are used to show colour reproduction properties not revealed by neutral exposure.

Negative-positive colour

Colour negative films and printing papers have tone reproduction properties not unlike those of black and white materials (see Figure 24.7) except that the colour negative is designed for exposure on the straight-line portion of the characteristic curve. The materials are integral tripacks (see Chapters 14 and 24) and generate a dye image of the complementary colour in each of the three emulsion layers: yellow in the blue-sensitive, magenta in the green-sensitive and cyan in the red-sensitive layer.

The densities of colour images are measured (Chapter 15) using a densitometer equipped with blue, green and red filters and all three colour characteristic curves are drawn on one set of axes. Typical simple negative characteristics following neutral exposure are shown in Figure 16.10, which shows that the three curves are of similar contrast although of slightly different speeds and density levels. The unequal negative densities have no adverse effect on the colour balance of the final print because colour correction is carried out at the printing stage as described in Chapter 22.

Neutral-exposure characteristic curves are rather uninformative about colour reproduction, but colour characteristics are better. Saturated

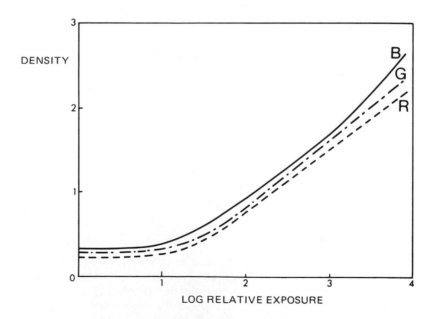

Fig. 16.10 – Neutral exposure of a simple colour negative film

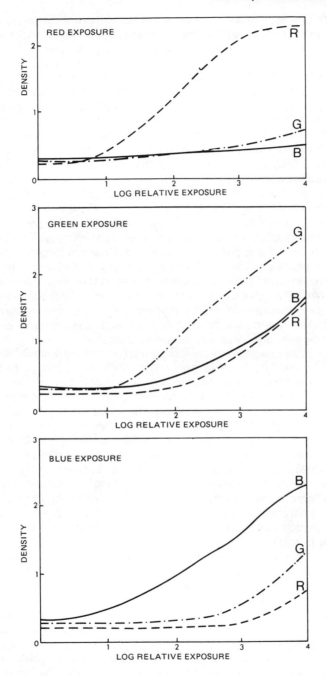

Fig. 16.11 – Colour exposures of a simple colour negative film

primary-colour exposures could be expected to reveal the characteristics of individual emulsion layers. The results of such exposures of a simple negative film are shown in Figure 16.11. The characteristic curves show a number of departures from the ideal in which only one colour density would change with colour exposure. Two main effects are seen to accompany the expected increase of one density with log exposure: the first is the low contrast increase of an unwanted density with similar threshold to the expected curve; the second is a high contrast (similar to that of the neutral curves) increase of an unwanted density with a threshold at a considerably higher log exposure than the expected curve. The former effect is due to *secondary*, unwanted, density of the image dye — thus the cyan image formed on red exposure shows low contrast blue and green secondary absorptions. The second effect is due to the exposing primary colour filter passing a significant amount of radiation to which one or both of the other two layers are sensitive — the blue exposure clearly affected both green and red sensitive layers. In this case of blue exposure the separation of layer responses is largely determined by the blue density of the yellow filter layer in the tripack *at exposure* as all emulsion layers of the negative are blue-sensitive. The results of green exposure show a combination of the two effects, revealing secondary blue and red absorptions of the magenta dye and the overlap of the green radiation band passed by the filter with the spectral sensitivity bands of the red- and blue-sensitive emulsions.

Modern colour negative films yield different characteristics from those shown in Figure 16.11 owing to various methods adopted to improve colour reproduction. Sensitometrically the most obvious of these is *colour masking* which is designed to eliminate the printing effect of unwanted dye absorptions by making them constant throughout the exposure range of the negative. Important characteristics of a masked colour negative film are shown in Figure 16.12. The most obvious visual difference between masked and unmasked colour negatives is the overall orange appearance of the former and this is revealed as the high blue and green minimum densities. The mechanism of colour masking is described later but its results can be clearly seen in the case of the red exposure illustrated. The unwanted blue and green absorptions of the cyan image due are subject to correction by masking. Ideal masking would result in blue and green characteristic curves of zero gradient, indicating completely constant blue and green densities at all exposure levels. In practice it is clear that the blue absorption is overcorrected so that the blue density actually *falls* with increased exposure, while the green secondary absorption is not fully compensated by the mask.

A second method of colour correction is to make image development in one layer inhibit development in the other emulsion layers. If an emulsion has an appreciable developed density this may drop with development of another layer giving a corrective effect similar to that of colour masking. Such *inter-image effects* are not always simply detected by measuring integral colour densities but they are sometimes obvious. Inter-image effects, for example, would appear to operate in the negative film illustrated in

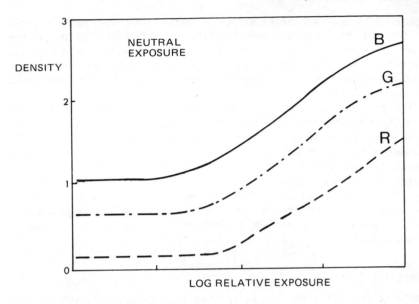

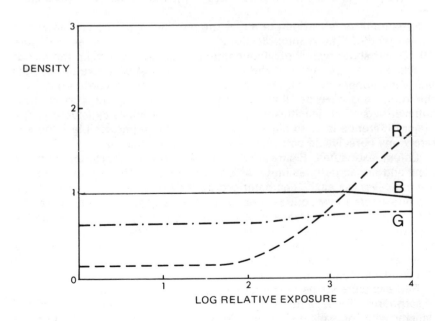

Fig. 16.12 – Neutral and red exposures of a masked negative film

Figure 16.11. Blue exposure results in development of the yellow image in the top layer of the tripack and this, in turn, inhibits development of the green- and red-sensitive layers so that the green and red fog levels fall while the blue density increases. Such unexpectedly low image densities are usually the only clue to the existence of interimage effects to be found using integral densitometry.

The most recent colour negative films use a combination of colour masking with inter-image effects that allows excellent colour correction with much lower mask densities than were previously used (or are shown in Figure 16.12). The mask density and its colour, however, remain far too high for such colour correction methods to be used in materials, such as reversal films, designed for viewing rather than printing. The consequences of dye deficiencies in such systems are, however, less important than in negative-positive systems where two reproduction stages are involved with a consequent "doubling-up" of colour degradation.

Reversal colour

Colour reversal films are constructed similarly to integral tripack negative films. The positive nature of the image springs from a major difference in the processing carried out, not the emulsions used in the film. As in the negative, the dye image generated in each layer is complementary to the sensitivity of the emulsion: a yellow dye in the blue-sensitive layer and so on.

Sensitometry is carried out as for the negative film and characteristic curves plotted. The results of neutral exposure are illustrated in Figure 16.13 and show typical positive characteristic curves. Unlike the colour negative it is important that the results of a neutral exposure on reversal film shall appear neutral; no simple correction can be carried out once the image has been developed. In the case illustrated the curves show sufficiently similar densities for the result to be visually satisfactory. The major difference is at so high a density as to be imperceptible — there is rarely any perceivable colour in regions of deep shadow.

Colour exposures, Figure 16.14, show various departures from the ideal and are sometimes quite difficult to interpret. The two main effects are, however, as easily characterised as they were for colour negatives; the unexpected low contrast decrease of density with log exposure and the high contrast decrease in a colour density other than that of the exposure. The former effect is generally caused by the secondary absorption of an image dye while the latter shows the overlap between the spectral region passed by the exposing filter and the sensitivity band of the emulsion concerned.

Red exposure yields characteristics showing the effects of secondary absorptions. The expected result of red exposure is the decrease of red density with increasing exposure. This is seen in Figure 16.14 but unwanted results are also seen: the large decrease in the cyan dye image with increased exposure is accompanied by small decreases in the blue

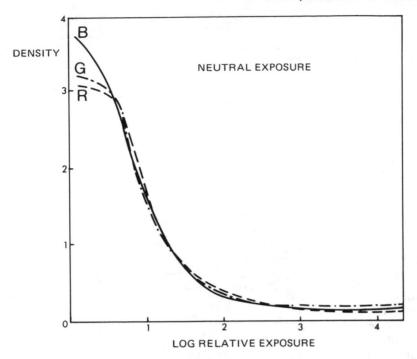

Fig. 16.13 – Neutral exposure of reversal colour film

and green densities showing that the cyan image possesses blue and green absorptions. The apparently high red fog level in the case of red exposure is due to unwanted red absorptions of the yellow and magenta image dyes present in maximum concentration. No decrease in these image dyes is seen because only the red-sensitive layer is significantly affected by the red exposure.

In the case of blue exposure all three layers show the effects of actinic exposure, the speed separation of the emulsions being mostly due to the yellow filter layer present at exposure. As with colour negative all the emulsion layers possess blue sensitivity. The low contrast shoulder of the green characteristic shows the reduced green absorption associated with decreasing yellow dye concentration. The yellow image clearly absorbs some green light – it has a green secondary absorption. The long low-contrast foot of the blue characteristic is due, not to the yellow image dye which is probably present at minimum concentration, but to the blue secondary densities of the magenta and cyan dyes which are decreasing in concentration with increased exposure.

A possible inter-image effect is seen in the low contrast *increase* in red density seen over the lower range of green exposures. This is in contradistinction to the blue curve which shows no similar rise over the same log exposure range but, in fact, falls owing to the decreasing blue

The Reproduction of Colour

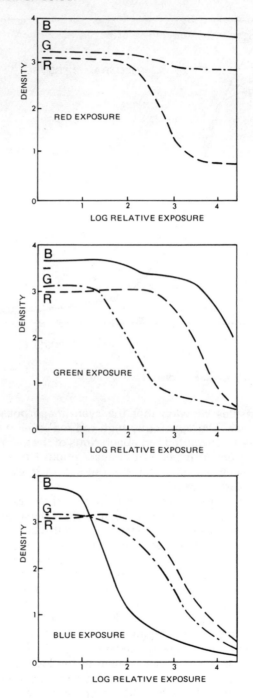

Fig. 16.14 – Colour exposures of a reversal colour film

secondary density of the magenta image dye which is decreasing in concentration. A second inter-image effect is evident in the blue-exposed case.

In essence, each of the colour-exposed results may be analysed in terms of three main regions. The first, at low exposure levels, shows one dye decreasing in concentration and its secondary densities are revealed by low contrast decreases in the other two densities. The second region, at intermediate exposure, shows no change in any of the three curves but the level of the lowest is well above the minimum found on neutral exposure, owing to the unwanted absorptions of the two image dyes present. This is exemplified by the red exposure (Figure 16.14) at a log relative exposure of 4·0. Lastly we find, at high exposures, the region where sufficient actinic exposure of the remaining two emulsions leads to a decrease in the concentration of the corresponding image dyes. The secondary absorptions of these two dyes are shown by a low-contrast decrease in the third curve – for example the blue density at log relative exposures of 3·0 or more. Departures from this scheme for reversal film are caused by inter-image effects which appear as unexpected increases in density with increased exposure, or by overlap of filter pass bands with sensitivity bands of the emulsions. This last departure from the ideal results in a compression of the three regions with the possible loss of the middle one and overlap of the other two. In the examples shown, the middle region is not evident on green or blue exposure owing to the speed separations of the three emulsions being only as much as is needed for adequate colour reproduction. Only the red exposure has speed separation to spare. Indeed the existence of an extensive range of exposures over which no change is seen in the image may result in poor reproduction of form and texture of vivid red subjects. Red tulips or roses, for example, may simply appear as red blobs with no visible structure.

Interimage effects are extremely common in colour processes, being present either by design or accident. They are, however, not usually detectable by integral densitometry, although we have seen a number illustrated in Figures 16.11 and 16.14.

Imperfections of colour processes

Additive system

Typical spectral sensitivity curves of the eye are shown in Figure 16.15 and it is clear that the sensitivities of the three colour receptors overlap considerably. While the red receptor alone can be stimulated by light of a wavelength of 650 nm or greater, there are no wavelengths at which unique stimulation of the blue or green receptors is possible. A good approximation to the ideal can be achieved by using a wavelength of about 450 nm for the blue stimulus, but the best that can be done for the green is to select light of a wavelength of about 510 nm. Even at this wavelength there is still considerable red and blue sensitivity in addition to the green.

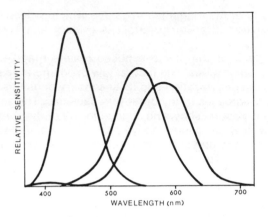

Fig. 16.15 — Spectral sensitivities of the human eye

In practical systems of additive colour photography shortage of light usually dictates the use of fairly wide spectral bands. The green record will thus elicit a significant response from the blue and red sensitive receptors as well as from the green receptor. The green light then appears to be mixed with some blue and red light, and in consequence appears a *paler* green. Reproductions of greens thus appear paler than the originals. Similar, but less severe, *desaturation* of blues and reds is also encountered owing to the broad spectral bands used in practice. The overall effect is to make colours less vivid, to desaturate them, effectively, by the addition of white light.

The impossibility of achieving separate blue, green and red stimulation of the retina is in fact common to all three-colour systems of colour reproduction, whether additive or subtractive.

Subtractive system

The subtractive system not only shares the limitations of the additive process in the reproduction of colours, but also suffers from defects introduced by the use of subtractive image dyes.

Ideally, each subtractive dye controls one-third, and only one-third, of the visible spectrum. If the regions controlled were made narrower than this, it would not be possible to reproduce black, or saturated colours, owing to uncontrolled transmission in one or two bands of the spectrum.

The subtractive system thus uses blue, green and red spectral bands that are broader than those used in the additive system and the reproductions of vivid colours are accordingly more desaturated. This would result in reproduced colours appearing markedly paler than the originals, if certain steps, detailed later, were not taken to improve matters.

In addition to the inherent inferiority of the subtractive system when compared with the additive, a further difficulty arises from the imperfec-

tions of the image dyes. It is found in practice that magenta and cyan image dyes especially, have additional absorptions in regions of the spectrum other than those required.

The blue secondary absorption of the magenta dye results in dark blues, bluish greens, poorly saturated yellows and reddish magentas being found in reproductions. The blue and green secondary absorptions of the cyan dye cause dark blues, dark greens, poorly saturated reds, yellows and magentas, and dark cyans of poor saturation. It is clearly advantageous to correct such deficiencies where possible.

Correction of deficiencies of the subtractive system

Various means are adopted to minimise the deficiencies of the subtractive system. One common procedure is to construct the photographic emulsions so that the blue, green and red sensitivities have steeper peaks which are more widely separated than those of the eye. A comparison between typical colour film sensitivities and those of the eye is shown in Figure 16.16. This expedient improves the saturation of many colours but may introduce marked errors, either through the emulsion sensitivities extending beyond those of the eye, or through a gap in the film sensitivities such as that shown at a wavelength of about 580 nm in the illustration.

The extension of emulsion sensitivity further into the ultra-violet than that of the eye may result in blue skies being reproduced at too high a saturation, and distant views appearing pale and blue. If these faults are encountered, the remedy is usually to employ an ultra-violet absorbing filter over the camera lens. At the long wavelength end of the spectrum, the extended sensitivity of the colour film compared with that of the eye may lead to an interesting effect. Flowers which reflect blue light often also possess a high reflectance close to the long wavelength limit of retinal sensitivity. The result is that in colour photographs it is frequently found that these flowers appear pink or pale magenta instead of blue. The light reflected by the flowers records in both the blue- and the red-sensitive emulsion layers. There is no simple remedy for this fault because filters which cut off the extended sensitivity region adversely affect colour reproduction within the visible region.

It is found that the desaturation of colour reproductions described above is reduced by adopting a higher emulsion contrast than would be objectively ideal. The reproduction then possesses a higher contrast than the original and this results in an increase in saturation of vivid colours together with a decrease in saturation of pastel colours and a departure from objectively correct tone reproduction. In most cases faults due to the increased tone contrast are outweighed by the superior colour saturation. It is, however, often advisable to keep the lighting ratio of the subject low in colour photography, if the increased tone contrast of the reproduction is not to be objectionable.

In the processing of colour materials it is often found that development of the record of one colour inhibits the development of an adjacent

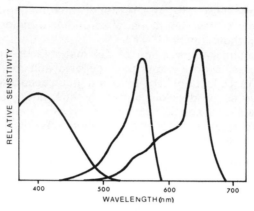

(a) A TYPICAL COLOUR FILM

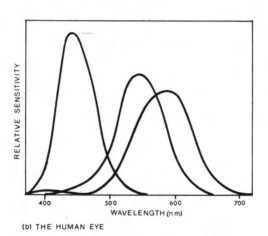

(b) THE HUMAN EYE

Fig. 16.16 – Spectral sensitivities of a typical colour film, and the human eye

emulsion layer. This *inter-image effect* is in many ways similar to the Eberhard effect encountered in black-and-white processing (page 383); the products of development of the colour record diffuse into adjacent emulsion layers and inhibit development. An important difference lies in the fact that the action of the Eberhard effect extends parallel to the film base whereas useful colour inter-image effects are perpendicular to the film base in action.

The inter-image effects found in colour processes may be promoted by design of the system and harnessed to improve colour reproduction. The development of the record of any colour is made to inhibit the development of other colour records. Thus the neutral scale reproduction may possess a contrast which is much exceeded by the contrast of the reproduction of

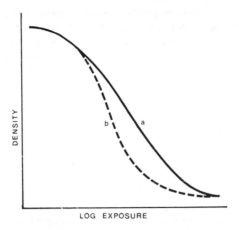

Fig. 16.17 – The characteristic curve of the red-sensitive layer of a colour reversal film:
(*a*) in the case of a neutral exposure
(*b*) in the case of a red exposure

colours, such a situation being illustrated in Figure 16. 17. Successful use of inter-image effects gives increased colour saturation with little distortion of tone reproduction, and can lead to very acceptable results.

Compensation for deficiencies of the subtractive system achieved by these means may be successful in a first generation reproduction. This category embraces colour transparencies produced by reversal processing of the original camera film. In many cases further generations of reproduction are required. Such further reproductions include reflection prints made from colour negatives or reversal transparencies, and also duplicate positive transparencies.

It is generally true that further reproduction stages accentuate the departures from ideality of the first generation. Saturated colours become darker and may change hue, pale colours become paler and lose saturation, and tone contrast increases so that highlight detail is lost while the shadow areas become totally black. From the point of view of colour reproduction, therefore, it is usually preferable to make the camera record on negative film which can be made relatively free from deficiencies of colour and tone reproduction. The method used to achieve this freedom from deficiencies of colour reproduction is called *colour masking.*

Masking of colour materials

The spectral density distribution of a typical magenta image dye is shown in Figure 16.18. The characteristic curve of the green-sensitive emulsion which generates the dye is shown alongside and represents the green, blue and red densities of the dye image. It will be seen that the

333

The Reproduction of Colour

density to green light increases with exposure as would be expected, and that the unwanted blue and red absorptions of the dye are shown by the increase in blue and red densities over the same exposure range.

At the printing stage an unmasked negative record employing this dye will convey spurious information to the printing paper about the distribu-

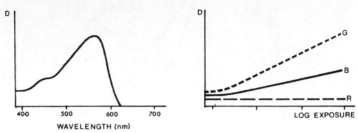

(a) SPECTRAL DENSITY DISTRIBUTION AND CHARACTERISTIC CURVE OF THE MAGENTA DYE IMAGE

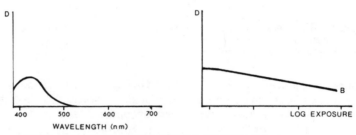

(b) SPECTRAL DENSITY DISTRIBUTION AND CHARACTERISTIC CURVE OF THE YELLOW MASK

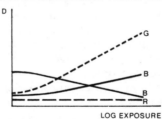

(c) THE IMAGE AND MASK CHARACTERISTIC CURVES

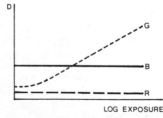

(d) THE COMBINED CHARACTERISTIC CURVES OF THE MASKED GREEN-SENSITIVE LAYER

Fig. 16.18 – Elements of masking the blue absorption of a magenta dye: (a) spectral density distribution, and characteristic curves of the magenta dye image; (b) spectral density distribution, and characteristic curve of the yellow mask; (c) image and mask characteristic curves; (d) combined characteristic curve of the masked green-sensitive layer

334

tion of blue and red light in the camera image. This is undesirable and results, for instance, in bluish greens in the print reproduction among other short-comings mentioned on page 331.

In order to compensate for the variation of blue density with the magenta dye content of the negative, it is merely necessary to prepare a corresponding positive yellow dye record as shown in Figure 16.18b. The yellow positive is then superimposed in register with the negative as shown in (c). Provided the blue density characteristic curve of the positive is of the same contrast as that of the negative, the combined effect of the mask and the unwanted secondary density of the image dye is as shown in (d). The printing effect of the unwanted absorption of the magenta image dye has been entirely compensated at the expense of an overall increase in blue density.

Making separate coloured masks is usually inconvenient and the most useful masking systems rely on the formation of masks within the negative colour film. This is called *integral masking*, and is widely used in colour negative films. The overall orange-brown appearance of such negative films results from the yellow mask of the magenta dye together with the reddish mask required by the cyan image dye. The yellow image dye is usually sufficiently free from unwanted absorptions that masking is unnecessary.

It should be noted that the overall coloration due to integral masking precludes the use of this process in reproductions which are to be viewed. The eye does not adapt to the overall orange appearance, and consequently masked images are unacceptable for viewing and can only be used as intermediates in the production of final prints.

In Chapter 24 we shall examine the methods by which subtractive dye images are produced in a variety of practical processes.

17 Developers and Development

THE PURPOSE of development is to blacken those parts of the light-sensitive material which have been influenced by light, i.e. to produce a visible image corresponding to the invisible latent image. Development may be carried out in two ways. In ordinary photographic practice the process of *chemical development* is employed. This involves the reduction of the individual silver halide grains to metallic silver.

Silver halide + Reducing agent → Silver metal +
Oxidised reducing agent + Halide ion

In this process each grain of the emulsion acts as a unit, in the sense that a grain is either developable as a whole or is not developable. There is a second type of development in which the silver forming the developed image is derived from a soluble silver salt contained in the developing solution itself. This is termed *physical development*. It is described later in this Chapter (page 351).

On exposure to light photographic emulsions form latent images mainly on the surfaces of the grains as was shown in Chapter 12. With sufficient exposure latent images of a developable size are formed. These are termed *development centres.* When a photographic emulsion is immersed in a developing solution the grains are attacked at these points by a *developing agent*, and, in chemical development, each grain which has received more than a minimum exposure is rapidly reduced to metallic silver. The degree of blackening over the surface depends principally upon the number of grains which have been attacked, although it is also influenced to some extent by the fact that some grains which start to develop may not develop to completion in the time for which the developer is allowed to act.

Developing agents are members of the class of chemical compounds termed *reducing agents*. Not all reducing agents may be used as developing agents; only a few are able to distinguish between grains which have been light-struck and grains which have not. With reducing agents that have been found suitable for photographic use, the action of the agent on exposed and unexposed (or insufficiently exposed) grains is

distinguished by its *rate*. It is not that unexposed grains do not develop at all, but that exposed grains develop very much more quickly than unexposed grains. The latent image is essentially a catalyst that can accelerate the rate of development but cannot initiate a reaction that would not occur in its absence. Under normal conditions, the proportion of unexposed grains developed is quite small, but with very prolonged development practically all the grains in an emulsion – exposed and unexposed – will develop. Density resulting from the development of unexposed grains is termed *fog.*

Composition of a developing solution

Developing agents are not used alone; a developing solution – usually referred to simply as a *developer* – always contains certain other constituents whose presence is essential for the proper functioning of the solution. A developing solution therefore usually comprises:

(1) *A developing agent* (*or agents*) – to convert the silver halide grains in the emulsion to metallic silver.

(2) *A preservative* – to prevent (a) wasteful oxidation of the developing agent, (b) discoloration of the used developing solution with consequent risk of staining of negatives and prints and (c) to act as a silver halide solvent in some fine grain developer formulae.

(3) *An alkali* (sometimes termed the *accelerator*) – to make the developing agent sufficiently active, and to act as a buffer to maintain the pH or alkalinity at a constant value.

(4) *A restrainer* to increase the selectivity of the development reaction, i.e. to minimise fog formation by decreasing the rate of development of unexposed grains to a greater extent than that of exposed grains.

(5) *Miscellaneous additions* – these include wetting agents, water softening agents, solvents for silver halides, anti-swelling agents for tropical processing, development accelerators etc.

In addition, there must be a *solvent* for these ingredients; this is nearly always water.

We shall consider each of these constituents in turn, in detail.

The developing agent

A large number of different substances have been used from time to time as photographic developing agents. Almost all of those in use today are organic compounds. Not all developing agents behave in exactly the same way, and for certain purposes one agent may be preferred to another. Consequently, a number of different agents are in use for one purpose or another, the characteristics of the more important ones being described below.

Metol

Metol (N-methyl-4-aminophenol sulphate), introduced by Hauff in 1891, is a white crystalline powder readily soluble in water. Metol developers

are characterised by high emulsion speed (foot speed), low contrast and fine grain. They are valuable when maximum shadow detail is required. Useful soft-working developers may be made up, using metol, sulphite and sodium carbonate, or simply metol and sulphite alone. In general, however, metol is used in conjunction with a second developing agent — hydroquinone (see below) as a superadditive combination, developers containing the mixture having certain advantages over developers based on either developing agent alone. (See page 347.) Metol-hydroquinone developers are usually referred to simply as "M.Q." developers, the letter Q being derived from the word "quinol", a synonym for hydroquinone.

Phenidone

Phenidone (1-phenyl-3-pyrazolidone), the developing properties of which were discovered in the Ilford laboratories in 1940, possesses most of the photographic properties of metol together with some quite unique advantages of its own. A property which it shares with metol is that of activating hydroquinone so that a Phenidone-hydroquinone (P.Q.) mixture forms a useful and very active developer. Used alone, Phenidone gives high emulsion speed but low contrast, and has a tendency to fog. It is not, therefore, normally recommended for use by itself. Mixed with hydroquinone, however, and with varying concentrations of alkali, Phenidone produces a very wide range of developers of differing types. The activation of hydroquinone requires a much lower concentration of Phenidone than of metol which also possesses this activating property. A detailed comparison of the relative merits of P.Q. and M.Q. developers is given on pages 348, 349.

More stable derivatives of Phenidone have been proposed especially for use in concentrated liquid developers (see page 360). These include Phenidone Z (1-phenyl-4-methyl-3-pyrazolidone) and Dimezone (1-phenyl-4,4-dimethyl-3-pyrazolidone).

Hydroquinone

Hydroquinone (quinol, 1,4-dihydroxybenzene), whose developing properties were discovered by Abney in 1880, takes the form of fine white crystals, fairly soluble in water. The dry substance should be kept well-stoppered, as there is a slight tendency for it to become discoloured. Hydroquinone requires a strong alkali, e.g. caustic soda, to activate it. Hydroquinone developers are characterized by high contrast. Hydroquinone-caustic developers are mainly used for the development of high-contrast films and plates in graphic arts work. They are not usually suitable for use with fast materials on account of the resulting high fog. Hydroquinone-caustic developers are suitable for low temperature processing (page 373). Hydroquinone is used mainly in combination with metol or Phenidone with which it forms superadditive mixtures (see page 349).

Amidol

Amidol (2,4-diaminophenol hydrochloride) is a fine white or bluish-white crystalline powder, readily soluble in water. An amidol developer can be made simply by dissolving amidol in a solution of sodium sulphite, without other alkali. Amidol developer should be made up when required, as it has poor keeping qualities. The solution of amidol and sulphite, while not becoming discoloured to any extent, loses much of its developing power within two or three days. Amidol developing solutions, although not themselves coloured, produce heavy bluish-black stains on fingers and nails. In the dry state, amidol is slowly affected by air and light; it should therefore be kept in well-stoppered bottles. Amidol developers develop rapidly. They were at one time widely used with papers but are rarely used at the present time other than for the developing of nuclear track emulsions.

Glycin

Glycin (4-hydroxyphenylamino-acetic acid) is a white crystalline powder, only slightly soluble in water but freely soluble in alkaline solutions. Glycin developers are non-staining and have exceptionally good keeping properties, but, unfortunately, they are too slow in action for general use. To obtain as much activity as possible, potassium carbonate is to be preferred as the alkali for glycin developers because it can be used at a greater concentration than sodium carbonate (page 342). Glycin is used in certain warm-tone developers for papers. It is also used, in conjunction with other developing agents, in some fine grain developer formulae of low energy. (See Paraphenylenediamine, below.) The action of glycin is greatly restrained by bromide. The non-staining properties of glycin and its very slow oxidation by air make it very suitable for any process in which the sensitive material is exposed to the air during development. It is thus useful when it is desired to develop a print while still on the enlarger easel, as in some pictorial control processes.

Paraminophenol

Paraminophenol (4-aminophenol) is a developing substance which has been widely used for compounding highly concentrated developers. The active agent in these is an alkali salt of 4-aminophenol, produced by the action of caustic alkali. The solution contains a certain excess of caustic alkali and is diluted with from 10 to 30 times its bulk of water to form the working developer.

Paraphenylenediamines

At one time, many popular fine grain developers were based on paraphenylenediamine (p-phenylenediamine, 4-aminoaniline, 1,4-diaminobenzene) as the developing agent (page 351). Paraphenylenediamine itself is poisonous, and used alone requires very long development times. To ob-

tain convenient developing times, most paraphenylenediamine developers contain another developing agent, e.g. glycin or metol. In such developers, the paraphenylenediamine probably acts primarily as a silver halide solvent, favouring a physical type of development.

Pyrogallol

Pyrogallol (pyro, pyrogallic acid, 1,2,3-trihydroxybenzene) is very poisonous and is very soluble in water. The image formed by a pyrogallol developer consists not only of silver but also of brownish developer oxidation products which stain and tan the gelatin. This stain, the degree of which depends upon the sulphite content of the developer, has an important effect on the printing quality of the image. If the formula contains a large amount of sulphite the amount of staining is small, but with reduced sulphite the stain becomes appreciable and markedly increases the printing contrast of the negative. Pyrogallol was sometimes used in combination with metol and sometimes with both metol and hydroquinone. Pyrogallol developers were once used almost universally but are rarely used today, the preference being for developers with colourless, soluble oxidation products.

Catechol

Catechol (pyrocatechin, pyrocatechol, 1,2-dihydroxybenzene) is sometimes used to provide tanning developers and warm-tone developers for certain papers. With caustic alkalis it gives rapid development with high contrast, in a similar manner to hydroquinone.

Of all the developing agents described above only Phenidone, metol and hydroquinone are in widespread use today for the development of monochrome materials, while analogues of p-phenylenediamine (4-aminoaniline) are being used for the development of colour materials (see Table 17.1).

The preservative

Sodium sulphite is commonly used as the preservative in developing solutions, although potassium metabisulphite is sometimes used as an alternative, either by itself or in addition to sulphite. Sodium sulphite is sold both in crystalline and in anhydrous (desiccated) forms, one part of the latter being equal in two parts of the former. Sulphite crystals dissolve most freely in water at about 40°C, giving a weakly alkaline solution (approx. pH 8·5). Dry, or anhydrous, sulphite is obtained as a powder which dissolves readily in water. Supplies of both crystalline and anhydrous sulphite should be kept in well-closed containers.

Potassium metabisulphite takes the form of transparent crystals, which usually have a slight opaque incrustation. This, however, does not denote deterioration to any appreciable extent. In the dry state, metabisulphite keeps very much better than sulphite. It dissolves fairly

	Chemical name	Trade name
I	Diethyl-p-phenylenediamine sulphite, or 4-Amino-N,N-diethylaniline sulphite	Genochrome (May & Baker)
II	Names as above but hydrochloride	CD 1 (Kodak)
III	Ethylhydroxyethyl-p-phenylenediamine sulphate,	S-5, Dicolamine (Ansco)
	or 4-Amino-N-ethyl-N-(β-hydroxyethyl)aniline sulphate	Droxychrome (May & Baker)
IV	N,N-Dietyl-3-methyl-p-phenylenediamine hydrochloride,	Tolochrome (May & Baker)
	or 4-Amino-N,N-diethyl-3-methylaniline hydrochloride	CD 2 (Kodak)
V	N-Ethyl-3-methyl-N-(β-methylsulphoamidoethyl(-p-phenylenediamine sesquisulphate,	Mydochrome (May & Baker)
	or 4-Amino-N-ethyl-3-methyl-N-(β-methylsulphonamido-ethyl)aniline sesquisulphate	CD 3 (Kodak)
VI	N-Ethyl-N-(β-hydroxyethyl)-3-methyl-p-phenylenediamine sulphate,	
	or 4-Amino-3-methyl-N-ethyl-N-(β-hydroxyethyl) aniline sulphate	CD 4 (Kodak)

Table 17.1 – Colour developing agents. Colour developing agents are generally specific to a particular colour material and the formulation used. Thus compounds I or II are used for the development of *Agfa* reversal films, III was used in the development of *GAF* reversal films, V is used in the *Ektaprint 2* process, and VI is used for *Kodacolor II* films. All the compounds listed are potentially hazardous by skin absorption and rubber gloves should always be worn when preparing or using colour developing solutions.

readily in tepid water, forming an acid solution smelling of sulphurous acid. One advantage in using metabisulphite in preference to sulphite is that it forms a slightly acidic solution (pH 4–5)* which helps to decrease the rate of aerial oxidation in concentrated two-solution developers, i.e. one solution containing the developing agent and preservative and the other containing the alkali.

As stated earlier, one of the main functions of the "preservative" is to prevent wasteful oxidation of the developing agent(s) by air. It is convenient to think of the sulphite as removing the oxygen from the air dissolved in the solution or at the surface of the solution, before it has time to oxidise the developing agent. This, however, represents only a simplification of the real state of affairs. The action of the preservative is not simply a matter of preferential reaction between sulphite and oxygen; the rate of uptake of oxygen by a solution of sulphite and hydroquinone, for example, is many times smaller than the rate of uptake by either the sulphite or hydroquinone alone.

Sulphite also reacts with developer oxidation products and prevents

* An explanation of the pH scale is given in the Appendix.

staining of the image by forming soluble and often colourless sulphonates:

Silver halide + Developing agent →
Oxidised developing agent + Silver metal + Halide ion
+ Hydrogen ion (acid)

Oxidised developing agent + Sulphite ion + Sulphite ion + water →
Developing agent sulphonate + Hydroxyl ion (alkali)

In addition to its function as a preservative and prevention from staining sulphite has a third function. It acts as a solvent for silver halides and so promotes some solution physical development which leads to finer grained images provided that its concentration is sufficiently high.

The alkali (or accelerator)

In practically all developing solutions an alkali is required to activate the developing agent. By suitable choice of alkali, the pH* of a developing solution can be adjusted to almost any required level, and in this way a range of developers can be prepared of varying activity. One alkali commonly used is sodium carbonate, of which there are three forms available commercially: crystalline or decahydrate, containing 37 per cent of the salt itself; monohydrate, containing 85 per cent of the salt; and dry, anhydrous or desiccated, containing practically 100 per cent of the salt. The monohydrate has the advantages of being more stable and more easily dissolved than the other forms. One part of the anhydrous may be replaced in formulae by 2·7 parts of the crystalline form or by 1·17 parts of the monohydrate. Ordinary washing soda is only an impure form of crystalline sodium carbonate, and should *not* be used for photographic purposes. (The "carbonate of soda" sold as a white powder is a different substance altogether (sodium bicarbonate) and is useless as the alkali of a developer.)

In some developer formulae, *potassium* carbonate is used as the alkali. This is supplied as "potassium carbonate, dried". It should be kept tightly sealed, if left exposed to the air, it rapidly becomes damp or even semi-liquid, in which state its strength is greatly reduced. Potassium salts offer no advantage over sodium salts as the alkali in developers, apart from increased solubility, which permits them to be used, if required, at a higher concentration.

For highest contrast it is usual to employ hydroquinone as the developing agent with caustic soda (sodium hydroxide) or caustic potash (potassium hydroxide). These substances are very strong alkalis and have a corrosive action. If caustic alkali gets upon fingers or clothes, therefore, the affected parts must be washed immediately in cold water. Bottles containing solid caustic alkali or a solution of it should not have glass stoppers, since these tend to stick.

In the high sulphite, low energy class of fine grain developers, borax is the common alkali. The use of sodium metaborate as alkali has been ad-

* An explanation of the pH scale is given in the Appendix.

Buffer	pH range
Sodium or potassium hydroxide	above 12·5
Trisodiumphosphate/sodium hydroxide	12·0–13·0
Trisodiumphosphate/disodiumhydrogenphosphate	9·5–12·6
Sodium carbonate/sodium hydroxide Potassium carbonate/potassium hydroxide	10·5–12·0
Sodium carbonate/sodium bicarbonate Potassium carbonate/potassium bicarbonate	9·0–11·0
Borax/boric acid	8·0–9·2
Sodium sulphite/sodium metabisulphite Potassium sulphite/potassium metabisulphite	6·5–8·0

Table 17.2 – Some buffering agents and their useful pH ranges.

vocated in certain formulae. Identical results are obtained by employing equal parts of sodium hydroxide and borax.

Alkalis in developers also act as *buffers* to maintain the pH value constant during the development reaction and on storage or standing of the developer in a tank line or processing machine.

A solution is said to be buffered when it shows little or no change in pH on addition to acid or alkali. Water is unbuffered and its pH is greatly and quickly affected when only a little acid or alkali is added. Buffering of photographic solutions is commonly achieved by the use of relatively large amounts of a weak acid, e.g. boric acid, and the sodium salt of that acid, e.g. borax (see Table 17.2).

The relative amounts of the buffer components determine the pH value of the solution and their concentrations determine the buffering capacity. For example 21.2 g/l of anhydrous sodium carbonate has a pH value of 11·6. So has a solution containing 0·13 g/l of sodium hydroxide but the latter would rapidly become neutralised.

The restrainer

Two main types of restrainer are employed, inorganic and organic. The function of a restrainer is to check the development of unexposed grains, i.e., to prevent fog; restrainers also affect the exposed grains to a greater or lesser extent and so affect film speed. The effectiveness of a restrainer in minimizing fog, and its effect on film speed, varies from one developing agent to another and depends on the emulsion. It is also influenced by the pH of the developing solution.

Potassium bromide, an inorganic substance, is the most widely used restrainer. Soluble bromide is produced as a by-product of the development process and affects the activity of the developer. Inclusion of bromide in the original developing solution therefore helps to minimise the effect of this release of bromide. For this reason most developer formulae employ bromide as a restrainer, including those formulae which also contain organic restrainers. Among the few developers that do not

343

include bromide are the soft-working M.Q. borax formulae. Developers for papers always include bromide, because with papers any trace of fog is objectionable. High-contrast developers of the hydroquinone-caustic type contain comparatively large amounts of potassium bromide. The purpose of this is to reduce the foot speed in order to obtain a characteristic curve with very short foot, which leads to higher contrast. Phenidone is much less influenced by bromide than is metol, especially at a low pH.

Of the several organic substances that have been found suitable for use as restrainers, benzotriazole is widely employed. Organic restrainers are especially valuable in Phenidone developers, the activity of most Phenidone formulae being such that to prevent fog with high-speed materials the amount of bromide required as restrainer would be so great that there would be a risk of stain, because bromide when present in excess is a mild silver halide solvent. Use of an organic restrainer avoids this risk. A certain amount of bromide is, however, usually included in Phenidone formulae to help to keep the activity of the solution constant with use, for the reason already explained. Benzotriazole has been found to be very suitable for use as an organic restrainer in Phenidone developers. With contact papers, it combines a blue-black toning action with its restraining action, making it very suitable for use in P.Q. formulae intended for the development of contact prints.

Organic restrainers appear to be capable of restraining fog, without affecting film speed, to a greater extent than inorganic restrainers. For this reason they have come to be widely used as *anti-fogging agents* (anti-foggants), for addition to standard developer formulae whenever there is particular danger of chemical fog or staining. In this rôle, organic restrainers are commonly used:

(1) To minimise the risk of fog and staining on material subjected to prolonged development or to development at high temperatures.

(2) To help to prevent fog or veiling on materials which have been stored under unfavourable conditions or which are of doubtful age.

The use of anti-foggants is particularly valuable with prints, because fog is more objectionable with these than with negatives. Organic anti-foggants are very potent and must be used with care. Their use in excess may lead to a loss of effective emulsion speed, a slowing of development, and, with prints, to poor blacks.

Water for developers

While distilled water, on account of its purity, is usually the best for the purpose, its degree of superiority is not usually sufficient to justify its extra cost; tap water is normally a perfectly satisfactory alternative. The mineral salts in tap water are usually without photographic effect. If they give rise to calcium sludge, a calcium sequestering agent (see below) may be added to the water before making up the developer.

Miscellaneous additions to developers

Besides the usual four main ingredients (developing agent(s), alkali, preservative, restrainer) a developing solution sometimes contains other ingredients for specific purposes. These may include wetting agents (page 403), silver halide solvents (page 377) anti-swelling agents for tropical processing (page 390), calcium sequestering agents, i.e. water softening agents and true development accelerators.

The presence of calcium salts in most ordinary waters often causes a calcium sludge to be precipitated by the sulphite and carbonate in the developer. This may cause a chalky deposit to appear on films and plates on drying. This scum is most likely with developers with a high sulphite content and low pH, e.g., M.Q. borax formulae, especially if hard water is used. (In developers containing caustic alkali, the calcium salts do not generally precipitate.) Calcium scum may be removed by bathing negatives in a 2 per cent acetic acid solution after washing, and then briefly rinsing them.

The function of a *calcium sequestering agent* in a developer is to prevent scum from forming on negatives, by transforming the calcium salts into soluble complexes which cannot be precipitated by the sulphite and carbonate in the developer. Sodium hexametaphosphate (Calgon) is commonly used for this purpose. A suitable concentration in most circumstances is about 3 grammes per litre. This should be added to the water *before* the other developer constituents.

EDTA (ethylenediaminetetraacetic acid) is used also as a sequestering agent in developers but suffers from some disadvantages although it is an efficient sequestering or complexing agent for calcium ions. In the presence of trace amounts of copper or iron ions it catalyses or speeds up the rate of aerial oxidation of developing agents. Also EDTA is able to form complexes with silver ions that may cause dichroic fog, owing to physical development. This effect is especially noticeable with chloride emulsions because of their higher solubility.

Some developers also contain true *development accelerators* which increase the rate of development independently of the alkali which is also termed an accelerator. Examples of these compounds include cationic (positively charged) wetting agents such as cetyl pyridinium bromide, organic amines, e.g. ethylenediamine, non-ionic polymers, e.g. polyethylene glycols, and urea in extremely small amount.

Monochrome developer formulae in general use

Many thousands of different developer formulae have been published through the years and a great number of different formulae are still in general use. Nevertheless, the number of basic types of formula employed today is relatively small. Hence those used of negative development, excluding those used in specialized applications of photography, are mainly of the following types:

(1) General purpose developers of the M.Q. or P.Q. carbonate types.

With appropriate dilution, they are suitable for developing a wide range of different negative emulsions and, depending upon the relative amounts of developing agents and carbonate in the particular formulation, can yield "normal", "low" or "high" contrast.

(2) Fine grain developers of the M.Q. or P.Q. borax types. These are the most widely used developers and were originally formulated many years ago for developing 35 mm films.

(3) High contrast developers of the hydroquinone-caustic type. These developers are formulated for giving maximum contrast with slow, high-contrast materials.

The function of each of the constituents of these developers is shown in Table 17.3. Specific formulae of each of the three types are given in Appendix 1, together with other developer formulae.

In the "general purpose" developer the developing agents are either metol and hydroquinone or Phenidone and hydroquinone. (The differences between these two pairs of agents are described on pages 337, 338). The alkali is carbonate and the restrainer bromide, although P.Q. formulae also require the inclusion of an anti-foggant.

In the fine grain formula the developing agents are again metol and hydroquinone or Phenidone and hydroquinone, but the alkali is borax, giving a low pH. This produces a soft-working developer, an advantage when fine grain is required. The relatively long development time necessitated by the low activity of this developer permits the sulphite, which is present in high concentration, to have an appreciable solvent action on the undeveloped grains. This further contributes to the fine grain action of the solution. (See also page 349.)

Constituents	General purpose	Fine grain developer	High-contrast developer
Developing agent(s)	Metol and hydroquinone or Phenidone and hydroquinone	Metol and hydroquinone or Phenidone and hydroquinone	Hydroquinone
Preservative	Sodium sulphite	Sodium sulphite	Potassium meta-bisulphite
Alkali	Sodium carbonate	Borax	Potassium hydroxide
Restrainer	Potassium bromide and (P.Q. formulae only) organic restrainer	M.Q. formulae: Nil P.Q. formulae: Potassium bromide	Potassium bromide
Approximate pH	10–10·5	8·5–9·0	11

Table 17.3 – Constituents of three common types of negative developer

In the third type of developer, the high-contrast formula, use is made of the density-giving powers of hydroquinone at high pH; caustic alkali is therefore employed. Hydroquinone-caustic developers oxidise rapidly and for prolonged storage are best made up in two-solution form, with the alkali in one solution, and the remaining constituents in the other. An acidic preservative, metabisulphite, can then be used in preference to sulphite with greater preservative effect. The hydroquinone-caustic formula contains a high bromide concentration, which further assists in obtaining high contrast (page 349).

The two most widely-used types of developer – the "general purpose" and the fine-grain formulae – are based on mixtures of metol and hydroquinone, or Phenidone and hydroquinone. Although, for special purposes, other developing agents have found favour from time to time, for general photography nothing has been found to equal M.Q. and P.Q. mixtures in all-round efficiency and flexibility.

Metol-hydroquinone developers

Until the introduction of Phenidone, the general-purpose developers used in practical photography were with very few exceptions compounded with mixtures of metol and hydroquinone. The success of these mixtures depends on the fact that their photographic properties are superior to those of the components taken separately and are not just equal to their sum or arithmetical mean. This phenomenon is called superadditivity or synergesis.

The following simple experiments illustrate the phenomenon of superadditivity (see Figure 17.1). If a film is developed in an M.Q. carbonate developer for the recommended time image of normal contrast showing both highlight and shadow detail is obtained. If, however, the film is developed in the same basic developer formulation for the same time but *omitting metol* only a trace of the brightest highlights are recorded. If the film is developed for the same time in the developer *omitting hydroquinone* a low contrast image is obtained that contains both highlight and shadow detail.

It is clear from these experiments that a developer containing both metol and hydroquinone produces a photographic effect that is greater than would be expected from a mere addition of the effects of metol and hydroquinone. Thus metol and hydroquinone in combination are said to form a *superadditive* or *synergistic* system.

Superadditivity of development rates for two developing agents, A and B, is shown if:

$$\text{Rate } (A + B) > \text{Rate } A + \text{Rate } B$$

In the case of M.Q. developers and other similar superadditive developers the mechanism of superadditivity may be explained as follows: Metol or the *primary* developing agent is adsorbed to the grain surface where it reduces a silver ion to metallic silver. In doing so it becomes oxidized and the oxidation product remains adsorbed to the

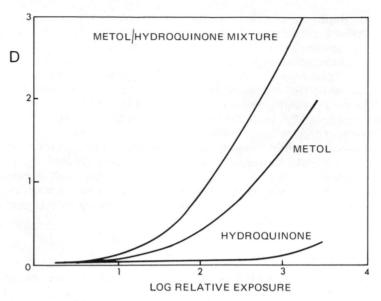

Fig. 17.1 – Superadditivity in a metol-Hydroquinone developer

grain. Hydroquinone or the *secondary* developing agent then reduces the primary developing agent oxidation product and so *regenerates* the primary developing agent at the grain surface. The secondary developing agent is oxidized and its oxidation product is removed by reaction with sulphite. This cycle repeats itself until that grain is fully developed. Thus superadditivity involves a regeneration mechanism in which a constant supply of active primary developing agent is maintained at the surface of the developing grain. The efficiency of the development reaction is far greater in superadditive developers than in developers containing single developing agents where fresh developing agent has to diffuse to the grain surface, the oxidation product diffuse away, react with sulphite and be replaced by the diffusion of more developing agent.

Phenidone-hydroquinone developers

Phenidone forms a superadditive system with hydroquinone just as metol does, but it is much more efficient than metol in this capacity. Whereas a given wieght of hydroquinone requires about one quarter of its weight of metol to activate it, it needs only a fortieth part of its weight of Phenidone. This means that a P.Q. developer is cheaper than its M.Q. equivalent, and highly concentrated liquids can be produced with a P.Q. system without so much danger of the developing agents salting out. The latter feature has led in recent years to a considerable increase in the use of ready-compounded developers in liquid form.

At the same pH, a P.Q. developer is slightly more active than its M.Q. equivalent. Therefore, to attain the same activity as its M.Q. counterpart,

a P.Q. developer can work at a slightly lower pH, giving better keeping properties in use and a longer "shelf life". In some formulae, use of a P.Q. mixture in place of an M.Q. mixture avoids the need for the use of obnoxious caustic alkali otherwise required.

In any hydroquinone developer containing sulphite, the oxidation product of hydroquinone is hydroquinone monosulphonate. With metol, this forms an almost inert system, but with Phenidone it forms a superadditive system of appreciable developing power. This means that a P.Q. developer will last longer in use than its M.Q. counterpart, since, with the latter, development virtually stops when the hydroquinone has been converted to its monosulphonate.

As stated earlier, with the M.Q. system the hydroquinone tends to regenerate the metol. This process, however, has a low efficiency and some of the metol is lost by conversion to an inactive monosulphonate. In P.Q. developers, the regeneration of hydroquinone of the primary oxidation product of phenidone appears to be much more efficient and is not accompanied by any Phenidone sulphonation. This results in a longer working life. It also simplifies the control of replenished P.Q. developers, since only a small fixed allowance need be made for the loss of Phenidone.

Bromide ion has less of a restraining action on P.Q. developers than on M.Q. ones, especially at a low pH. A very marked difference is apparent in borax-buffered developers. This means that replenisher systems operating on a "topping-up" basis can be worked for longer periods when Phenidone is used (page 343). Further, the P.Q. borax type of negative developer is less likely than an M.Q. borax developer to give the marks known as "streamers" (page 383).

In general, Phenidone is less likely than metol to produce dermatitis on hands which have been immersed in the respective developers. Because the ultimate oxidation product of Phenidone is colourless, P.Q. developers are less liable to cause staining on fingers and clothes than M.Q. developers. Such staining cannot, however, be completely avoided since it partly results from the oxidation products of hydroquinone.

Metol, particularly at high pH, tends to become hydrolysed to form methylamine, thus giving rise to an unpleasant fishy odour. Phenidone is not open to this objection.

P.Q. developers tend to give a later start to the image formation and subsequently to build up the image rather more quickly than their M.Q. counterparts. This effect is especially noticeable in paper developers.

At the pH levels associated with carbonate buffering, P.Q. developers tend to give fog with high-speed materials. For this reason, it is necessary in most P.Q. developers to include an organic antifoggant such as benzotriazole (page 344). P.Q. borax formulae do not require this.

Fine grain developers

All photographic images have a grainy structure (see Chapter 25). Although this structure is not normally visible to the naked eye it

becomes so on enlarging, especially if high magnifications are employed. The tendency to use smaller negative sizes and make all prints by enlargement aroused interest in the possibility of obtaining a less grainy image than is normally yielded by conventional developers. As a result, special *fine grain* and *extra fine grain* developers have been evolved.

These developers achieve the desired result in several ways. First of all, they are usually soft-working – because this minimises *clumping* of the silver grains. Whereas with active development silver filaments formed from an exposed grain may come into contact with neighbouring grains and to make them developable. This is termed *clumping*. Some formulae actually produce smaller individual grains – although this tends to result in reduced emulsion speed.

Most fine grain developers yield negatives of comparatively low contrast due in part to a *compensating effect* in which developer in the highlight areas of the negative becomes exhausted and effectively gives less development in the more dense areas of the negative than would be obtained in the absence of any compensating effect (see Figure 17.2). Although a reduction in contrast serves to minimise the graininess of the negative, it is doubtful whether it contributes significantly to a reduction in the graininess of the final print. Any reduction in graininess achieved by lowering the contrast of the negative is likely to be offset by the increased contrast of the harder paper required to print it.

Fine grain developers may be divided into four main types:

(1) *M.Q. borax and P.Q. borax developers.* We have already referred to these developers (pages 345–346). They are characterised by low

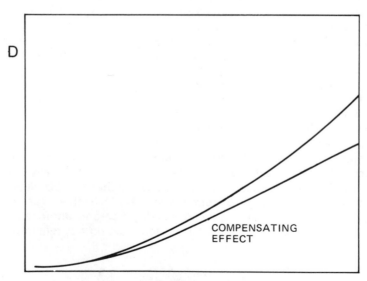

LOG RELATIVE EXPOSURE

Fig. 17.2 – Hypothetical example of compensation in development

alkalinity and high concentration of sodium sulphite, the suphite acting as a mild silver halide solvent. One advantage of developers of this type is that no increase in exposure is necessary; another is that development times are not inconveniently long. The scope of M.Q. borax and P.Q. borax developers is not limited to miniature camera work; they are very suitable for use as general negative developers and are quite cheap to make up. This is an important point, and it is probably for this reason more than any other that these are the only types of fine grain developers which have achieved popularity for commercial finishing and for general use.

(2) *Paraphenylenediamine developers*. These consist of para-phenylenediamine and sodium sulphite with varying amounts of another developing agent, usually metol or glycin. They produce brownish images which show a very considerable reduction in graininess, but require that exposures be increased by a factor of from $1\frac{1}{4}$ to 4, according to the type of developer and negative material. In general, those formulae which give the most striking improvement in graininess require the greatest increase in exposure. The maximum contrast obtainable with these developers is rather low and development times tend to be long.

(3) *Solvent developers.* Certain fine grain developer formulae contain silver halide solvents, such as hypo, potassium thiocyanate, etc. With these formulae, development is partly chemical and partly physical (see below), but, whereas in true physical developers the silver for the image comes from the developer, in solvent developers it comes from the emulsion. Solvent developers depend for their success largely upon the fact that the silver redeposited from the solution is in very fine form. They necessarily cause some loss in emulsion speed.

(4) *Physical developers.* Physical developers differ from ordinary (chemical) developers in that they contain silver in solution. An image which has been formed by physical development consists of finely divided metallic silver deposited on the latent image from the silver in solution, instead of being derived from the silver bromide of the emulsion. These give extremely fine-grained images that are finer than those yielded by chemical development and much less dependent on the type of negative material used. Physical fine grain developers have found only a limited practical application because they are rather difficult to use; in particular, there is a tendency for silver to be deposited where it is not wanted. Vessels used for physical development must therefore be chemically clean.

A number of proprietary fine grain developers are on the market. The formulae of these are not published, but most of them are variants of one or other of the types of fine grain developer described above.

It should be noted here that the influence of the developer on graininess has been much exaggerated. The most important condition for obtaining negatives of low grannularity is the choice of a fine-grained emulsion (page 540). A table indicating very approximately the degree of enlargement permissible with various combinations of film and developer is given on page 480.

High-definition developers

High-definition, or *high-acutance*, *developers* are solutions which give increased sharpness to photographic images by enhancing the contrast of edges and fine detail in the negative, although the resolving power of the emulsion may not be any higher than ordinarily. This is achieved by use of formulae of high pH and low concentration of developing agents. This promotes the production of adjacency effects (page 382). High definition developers may increase emulsion speed by a factor of one stop or more, but they also increase graininess. They are, therefore, generally recommended for use only with fine grain (i.e. slow or medium-speed) emulsions. Because of their low concentration of developing agents, most high-definition developers should be made up only when required for use and used once only.

Enhanced adjacency effects may be obtained in M.Q. borax and other soft-working fine grain developers by using them at greater dilutions, e.g. by diluting the stock solution 1 + 1 or 1 + 3 and increasing the developing time by the appropriate amount.

Extreme contrast (lithographic) developers

Lithographic development is characterised by a D-log E curve showing very low fog, very high contrast and a very sharp toe (see Figure 17.3). It

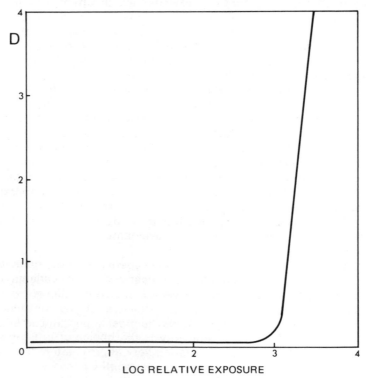

Fig. 17.3 – Lithographic development

results from a combination of special lithographic emulsions and developers. The *lith effect* (Figure 17.3) is not given by developing normal negative emulsions in a lithographic developer nor is it given by developing a lithographic emulsion in a high contrast developer of the type described on page 346.

Lithographic developers contain hydroquinone as the developing agent in the presence of very little sulphite preservative and depend for their effect on *infectious development*, i.e. the acceleration of the development of low densities (lightly exposed areas) adjacent to high densities (more heavily exposed areas). Although these developers give extreme contrast with the appropriate emulsions they are usually much less alkaline (lower pH) than developers that we normally associate with high contrast (page 346). A very low concentration of sulphite is maintained in the developer, either by the addition of sulphite as an aldehyde-bisulphite compound, or by the addition of paraformaldehyde which forms formaldehyde-bisulphite in the developer on reaction with sulphite. The aldehyde-bisulphite compound dissociates slightly into its component chemicals thus supplying a constant and small amount of sulphite, sufficient to protect the developer from aerial oxidation but not enough to interfere with infectious development. The pH value for infectious development is critical and must be maintained within very small tolerances by the inclusion of an appropriate quantity of a suitable buffering compound.

Monobaths

The term *monobath* is applied to a single solution which combines the actions of development and fixation. Solutions of this type have attracted interest for many years but it is only recently that the problems associated with their formulation have been solved. The main problem was the loss of emulsion speed which results if the exposed silver halide is dissolved away by the fixation process before development can take place. To prevent this, developing agents of high activity and short induction period are required. Modern monobaths usually contain Phenidone and hydroquinone as developing agents, and sodium thiosulphate as fixing agent.

Monobaths have the advantages of simplifying and speeding up processing, but it is usually necessary to provide a specially balanced monobath formula for each emulsion or group of similar emulsions. For these reasons, monobaths have found their main application in fields in which rapid access to photographic records is important, as in data and trace recording, etc., and where the inflexibility of the system is not a disadvantage.

Colour developers

Colour developer solutions have many similarities with monochrome developers. They contain the same types of constituents with some

modifications, i.e. a developing agent based on p-phenylenediamine (see Table 17.1), a preservative such as sodium sulphite, an alkali (see Table 17.2) and a restrainer or antifoggant such as potassium bromide or potassium iodide in a very small amount. Apart from the developing agent a major difference between a colour developer and a typical monochrome developer is that in a colour developer sulphite is present at a much lower level (generally less than 2 g/l). The reason for this is that in the colour development reaction the developer oxidation products are required to form the dye image by reaction with a colour coupler (see also Chapter 24). As developer oxidation products also react with sulphite a significant amount of sulphite in the developer would compete with the colour coupler and the yield of dye image would be reduced:

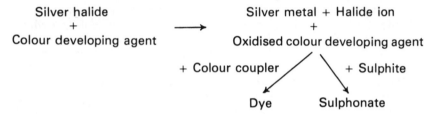

Colour developer solutions may also contain an *antioxidant* or anti-stain agent such as hydroxylamine or ascorbic acid which provides some protection from the effects of aerial oxidation that promotes colour coupling and hence dye formation or staining in unexposed areas. Other constituents of colour developing solutions include competing couplers, e.g. citrazinic acid or a competing black and white developing agent to control colour contrast, benzyl alcohol to aid the diffusion of the oxidised developing agent to the colour coupler which in some materials in incorporated in the emulsion in solution in oil droplets. With materials processed at higher temperatures, however, using active colour developing solutions and conditions, benzyl alcohol appears to be no longer necessary. In colour reversal processing the colour developer often contains a chemical fogging agent to avoid the inconvenience of the reversal exposure.

Colour developers also contain some of the additional developer constituents mentioned on page 358.

Changes in a developer with use

As the function of a developer is to effect a chemical change in the sensitised materials passed through it, it is apparent that the composition of the developing solution itself must change with use. As a developer is often used more than once, in particular when tank development is employed, it is important to know what changes to expect, how these changes affect the function of the solution and what can be done to prevent them or to compensate for them.

The main changes are as follows:

(1) Some developer solution is carried out of the tank with the film, both on its surfaces and absorbed in the emulsion. This removes from the solution some of each ingredient. The amount removed depends upon the size of the negative, the type of clip or hanger employed and the time during which developer is allowed to drain back from the film into the tank.

(2) The developing agents are used up: (i) by reducing the silver halide in the negative to silver, and (ii) by aerial oxidation. When the developing agents are used up by reducing silver halide, the products of the reaction tend to cause a *fall* in pH; when, however, the developer is used up by aerial oxidation, the pH tends to *rise*. The reactions involved, expressed in simple form, are as follows:

Exhaustion through use
Developing agents + Silver bromide → Oxidised developing agents
+ Silver + Bromide ions
+ Hydrogen ions (acid).

Exhaustion on standing
Developing agents + Oxygen →Oxidised developing agents
+ Hydroxyl ions (alkali).

With the less alkaline developers, e.g., M.Q. borax and P.Q. borax developers, changes in pH have a very marked effect on the activity of the solution. These changes may be countered by incorporating in the developer a so-called "buffer" system in place of the normal alkali (page 343).

(3) The sulphite is used up.

(4) The bromide content of the developer is *increased*, as bromide is liberated from the emulsion itself (see under (2) above).

The main effects of these changes on the working of the developer are:

(1) The development time required to reach a given contrast increases, due to exhaustion of the developing agents and increase in the bromide content. If, therefore, it is desired to use a developer repeatedly, the development time must be increased as more and more material is put through the bath, or the developer replenished.

(2) The effective emulsion speed produced in the developer decreases owing to the increase in bromide. This speed loss may be partially offset by the increased development time required to maintain contrast.

Complete exhaustion of the solution occurs when the developing agents are entirely used up. Exhaustion of the developing agents is bound up with exhaustion of the sulphite, since, if the sulphite is completely oxidised before the developing agents are used up, the developing agents being then without a preservative will rapidly oxidise too. (The "shelf life" of a developer is usually determined by the sulphite content; its "working life" may be governed either by exhaustion of the

developing agents or by exhaustion of the sulphite.) With many developers, the approach of exhaustion is characterised by a brown colour. Since the solution in this condition can stain sensitised materials, developers should not be overworked.

For the amateur, it is a good rule to discard a developer after it has been used once, or, with expensive fine grain developers, after the amount of material recommended by the author of the formula has been passed through it. For the professional who handles large quantities of material, a more economical use of solutions can be achieved by use of a replenishment technique, as described below.

Replenishment

Replenishment, ideally, involves a continuous replacement of part of the used developer by a solution which has been formulated so that the mixture maintains a constancy of photographic characteristics in the material developed. The aim is not to keep the *composition* of the bath constant but its *activity*.

Two methods of replenishment are commonly employed. The first is known as the "topping-up" method and the second as the "bleed" system. In the former, which is used extensively in tank processing in the larger photofinishing establishments, the developing solution is maintained at a constant level either by periodical addition of the replenisher or by a feed system, so that the volume added is equal to the volume of developer carried over by absorption in the gelatin and on the surface of the material being developed. With M.Q. formulae, and P.Q. formulae of high pH, owing to a gradual rise in the bromide content of the mixed solutions, even with no bromide in the replenisher, it is possible to maintain reasonable constancy of characteristics only for a certain period of replenishment. After a given volume of replenisher has been used, therefore, the mixture is discarded and the procedure repeated with fresh developer. P.Q. formulae of low pH, however, are not greatly affected by bromide, so that, with these, replenishment by the "topping-up" method may be continuted almost indefinitely.

In the "bleed" system, which is commonly employed for the machine processing of film with a circulating developer system, used developer is run off and replenisher fed in continuously, so that the level of the developer and its characteristics remain constant. The bled-off developer, after modifications, is often used for other purposes. The "bleed" system of replenishment is the only one in which it is possible to maintain absolute constancy in the bromide concentration. In certain circumstances, this offers practical advantages.

Formulation of replenishers

The formulation of a satisfactory replenisher for any developer depends largely upon the processing conditions employed and the photographic material being developed. Storage conditions, and the frequency with

which the developer is used and its surface agitated during passage of the photographic material, affect the allowance which must be made for aerial oxidation. The coating weight and the average amount of developable silver per unit area of material developed — determined by the exposure and the degree of development — are also factors which must be considered. The carry-over, which depends largely on the type of hanger employed and the draining time, has a very considerable bearing on the formulation of a replenisher. Only for standard conditions of work, therefore, is it possible to recommend a single replenisher, which can be formulated from the data obtained by quantitative study of the chemical changes in the developer solution under working conditions. This procedure is normally followed by the manufacturers of packed developers in devising replenishers for use under standard conditions of processing.

In the absence of a specially formulated replenisher, the developer itself, omitting bromide, may be used as a replenisher solution, but the performance of a bath replenished in this way cannot be expected to maintain constancy of performance over a very long period.

If facilities for analysis of a developer bath are available, addition of individual ingredients may be made to it as required, even under varying conditions of work, and the life of the solution maintained indefinitely. This procedure is adopted in cine processing laboratories where very large volumes of solution are employed and constant performance of the bath is of utmost importance.

Preparing developers

In general, developers should be made up in warm water to speed up the dissolving of the chemicals. With developers containing metol it is recommended that this water should not be at a temperature above 50°C, otherwise, under certain circumstances, the metol may be affected. Developers containing Phenidone can, however, be made up with advantage in *hot* water, at about 50°C, without danger. When making up a developer, only about three-quarters of the required final volume should be employed to start with, so that by adding the remainder after the various chemicals are dissolved, the volume can be made up exactly to the required quantity. This final addition should be of cold water, to help bring the solution down to room temperature again.

The order in which the constituents of a developing solution are dissolved is important. In general, the best order is:

(1) Preservative
(2) Developing agent(s)
(3) Alkali
(4) Other components (restrainers, solvents, etc.).

This order is governed principally by the need to guard the developing agents from wasteful oxidation. Addition of the preservative first, prevents oxidation of the developing agents while the solution is being

made up. The rate of oxidation of the developing agents is very much accelerated by the presence of alkali. It is, therefore, usually best for addition of the alkali to be left until both preservative and developing agents are in solution. The other components have little influence on the rate of oxidation of the developing agents and can be left to last.

There are important exceptions to the above general rules:

(1) *Developers containing metol*

Metol is relatively insoluble in strong solutions of sodium sulphite, so that with metol developers and M.Q. developers only a small quantity of sulphite should be added first as a preservative, then the developing agent and then the balance of the sulphite.

(2) *Developers containing Phenidone*

Phenidone is not as readily soluble as some developing agents, but its solubility is assisted by the presence of alkali. It is, therefore, best added after both sulphite and alkali. (Phenidone does not share with metol the difficulty of dissolving in strong solutions of sulphite.)

(3) *Developers containing glycin*

Glycin is almost insoluble in neutral solution. Hence, it is even more desirable with glycin than with Phenidone to add the developing agent *after* the alkali has been dissolved.

(4) *Colour developers*

To prolong the life of a colour developer prepared from the individual chemicals all the ingredients, except the developing agents, should be dissolved in the order given in the formula and the colour developing agent added immediately before use.

Take note of the warning that *all* processing chemicals should be regarded as being potentially hazardous by contact or ingestion and should be treated with caution. Rubber gloves should be worn when preparing processing solutions and neither the chemicals nor the solutions should be allowed to come into contact with skin or food. For example borax, boric acid, metol, hydroquinone and pyrogallol are all known irritants and sodium hydroxide is corrosive. Stirring greatly facilitates solution but must not be too vigorous or air drawn into the solution will cause oxidation of the developing agents.

To keep its bulk to a minimum, a developing solution is often made up in a more concentrated form than is required for use. The solution made up in this way is referred to as a *stock solution*. For use, this is diluted by adding a specified quantity of water to make a *working solution*. The working strength for tank use is usually more dilute than the strength recommended for dish use, being commonly half the dish strength. The reason for this is that the development times required using a developer at dish strength are usually too short for uniform development to be obtained under the slight degree of agitation employed in tank work. An exception to the general rule arises with certain soft-working developers, e.g., M.Q. borax and P.Q. borax formulae, which are used at full strength (stock solution strength) in both dish and tank. This is because even

when these developers are made up to be as concentrated as the solubility of the chemicals will permit, the required development times are more than long enough to permit uniform development under tank conditions of agitation.

Pre-packed developers

To avoid the inconvenience of preparing developers and replenishers from their constituent chemicals, many compounded developers and replenishers are available for processing virtually all black-and-white and colour materials. The two main types are *powdered chemicals* and *liquid concentrates*. For ease of use liquid concentrates are often preferred because they require only dilution before use which is much simpler to carry out than the more lengthy procedure involved in dissolving powders. The modern trend is toward the use of liquid concentrates and many developers are available only in this form. However liquid concentrates are more bulky, more expensive and have a more limited shelf-life than powdered chemicals.

From time to time other forms of packaging achieve a certain measure of popularity. These include the packaging of developers in tablet form, in pastes in tubes, or in aerosols but their usage is insignificant in comparison with that of the two main types of packaging mentioned above.

Powdered chemicals

Powdered chemicals are usually dissolved in warm water (approx. 40°C) to make up the working strength solution directly but in some cases are used to prepare a stock solution which is then diluted as required. The main problems encountered in packaging developers in a powdered form are the stability of the mixture and the selection of appropriate chemicals such that the powders dissolve rapidly.

Generally dry, anhydrous, finely-ground chemicals are used. They must not absorb moisure to any great extent or they may form a hard cake that is difficult to dissolve. To increase the stability of the powdered chemicals it is usual to pack the developing agent and alkali separately. The packet that contains the developing agent also contains some sodium metabisulphite as a preservative. The remainder of the developer components, preservative, restrainer and alkali are packed in the second packet or container. In some cases a third packet is included. This contains a sequestering agent and should be dissolved first.

For dissolving powdered chemicals the following sequence is followed:

(1) Dissolve the contents of the first packet containing the developing agent and some preservative by stirring it into approximately two-thirds of the final solution volume of warm water.

(2) When the contents of this packet have dissolved add the contents of the second packet slowly and continue stirring until all the chemicals are fully dissolved.

(3) Make up the solution to the required volume with cold water.

The recommended temperature for dissolving the chemicals must not be exceeded and stirring must be moderate. It has to be sufficient to agitate the solution but must not be so vigorous that air is drawn into the solution to oxidise the developer.

Powdered chemical packs should not be divided into smaller quantities for making up less than the recommended solution volume. The chemicals are not perfectly mixed in their packets and taking less than the complete packet may result in the preparation of developers with totally wrong proportions of the various constituents.

Liquid concentrates

Liquid concentrates are widely available for processing most types of photographic material. However, single-solution liquid concentrates are inherently less stable than their powder counterparts and therefore may have a more limited shelf-life. They have the advantage, however, that large quantities can be purchased and divided for storage into smaller airtight containers, before diluting to the required volume. Unlike powdered chemicals, liquid concentrates are perfectly homogeneous.

For economic considerations liquid concentrates are made as concentrated as possible. Some liquid concentrates for one-shot processing may be diluted by as much as one hundred times but more usually the required dilution to prepare the working strength solution is within the range of 1 + 3 to 1 + 50. In compounding liquid concentrates one of the major problems is that of the limited solubilities of the chemicals and the tendency of some to crystallise from solution, especially when subjected to storage or transport at low temperatures. Normally potassium salts are used in preference to sodium salts because of their greater solubility. In addition to the usual developer chemicals, liquid concentrates may contain a water-miscible solvent such as ethylene glycol or methylcellosolve to keep the developing agents in solution. In general, Phenidone-hydroquinone systems are used in preference to metol-hydroquinone systems because they enable more concentrated developers to be prepared (see page 338). In some liquid concentrates, 4-aminophenol is used as the developing agent because of its high solubility in alkaline solution.

Because of the high pH of the concentrate an additional problem is that of stability of the developing agents. For example Phenidone hydrolyses, especially at high temperatures. Accordingly more stable derivatives of Phenidone such as Phenidone Z or Dimezone (see page 338) may be used in liquid concentrates. To increase the stability and shelf-life of liquid concentrates some are packed in the form of two solutions, one containing the developing agent and preservative, the other containing the remainder of the developer chemicals. This is especially important for colour developers and various special-purpose developers such as lithographic and high-contrast developers.

For simplicity and versatility in packaging developers and replenishers

for large-scale processing a *"starter"* solution is included in a separate and smaller bottle from the "developer". The starter solution contains mainly the restrainer together with possibily a small amount of developing agent oxidation product which when added to the "developer" at the appropriate dilutions forms the actual developer solution. The "developer" when diluted appropriately forms the replenisher.

The technique of development

The manipulation of the sensitive material during development depends largely upon the nature of the material — flat films, plates, and roll films each requiring different methods of handling. Details of the procedures recommended with each of these classes of materials are given in the following pages.

Development of flat films

Flat films may be developed in a dish, lying flat — emulsion upwards — or in a tank, suspended vertically in hangers of special design. For dish development, the best practice is to place the film in the empty dish and swiftly but carefully to flood it with developer. The surface must be wetted quickly and evenly, otherwise developing marks will result. During dish development, the dish must be rocked continuously to provide agitation. Care must be taken to ensure that the rocking is not too rapid and that it is varied at intervals — e.g., first to and fro, then from side to side — to avoid patterns of uneven density caused by regular ("standing") waves. In tank development, the agitation provided should be intermittent, and achieved by lifting the films (in their hangers) from the tank, allowing them to drain to one corner, and replacing them in the bath — every two minutes. At the beginning of development, films should be agitated vigorously for about 30 seconds to dislodge any airbells and ensure even wetting. Vigorous agitation throughout the whole of the development process is, however, to be avoided, as it may lead to uneven development owing to the inevitable variation in the degree of agitation at the edges of films.

Roll films

Roll films (including 135 and 110 size films) may be developed in an open dish, in specially designed roll films tanks, or — in photofinishing establishments — in deep tanks.

Dish development of roll films. Dish development has the advantages that it requires no special apparatus and is relatively quick. Its disadvantages are that the whole operation must be carried out in a dark-room, and great care is needed to ensure that the film is uniformly developed and that solutions are not splashed about the room. Although tank development is now almost universal, dish development is still useful in an emergency. The following procedure is recommended:

Developers and Development

Unroll the exposed film and attach a non-corroding (e.g., stainless steel) clip to the near end of the sensitive film. Continue unrolling the spool until the far end of the film is reached. Detach this end from the backing paper and attach to it a second clip. (This operation is simplified if the first clip – with the film attached – is fastened to a hook on the wall while the remainder of the film is unrolled.)

Dry film is springy, and to make it more manageable in development it is recommended that it should first be thoroughly wetted to make it limp before development starts. To do this, hold the clips – one in each hand – so that the film hangs in a U-shape, and pass the film through a dish of clean water two or three times, lowering the left hand while the right hand is raised, and vice-versa, "see-saw" fashion. This preliminary wetting is more easily managed if the film is held with the emulsion side *down*, although in all subsequent operations the emulsion side must be *up*. When the film is sufficiently limp, drain it for a moment and transfer it to the developer. This may be in an ordinary photographic dish – although a 1 litre jug from a local store makes an excellent alternative. Continue the "see-saw" movement, taking care that the film is evenly and completely covered by the solution from one end to the other.

When the required development time has elapsed, the film should be rinsed in plain water and fixed in a suitable fixing bath, the "see-saw" movement being continued throughout. After fixation, the complete film should be placed in a sufficiently large dish or bowl to wash, the clips being left on the ends of the film to prevent it from curling up on itself. Finally, the film should be hung to dry (page 402).

Tank development of roll films. It is the general practice today, except in photofinishing establishments, to develop roll films in individual tanks. Many different types of tank have been designed for this purpose. Some permit daylight loading, although the majority involve darkroom loading. All are suitably light-trapped to make it possible to carry out the actual developing process in the light. Most tanks accommodate the film in the form of a spiral coil and many devices have been employed to keep the various coils separate. One of the earliest of these took the form of a celluloid apron which was wound up with the film inside. Projections along the edges of the apron held the picture area of the film away from the apron. Nowadays, it is more common to wind the film into a special holder comprising a spool having wide flanges, the inner surfaces of which bear spiral grooves. In some tanks of this type, the distance between the flanges can be adjusted to accommodate various widths.

There are two basic types of spiral available for developing tanks, these are *self-loading* and *centre-loading* types. In self-loading spirals the film is loaded from the outside of the spiral flanges towards the central core. The flanges of the spirals are free to rotate a limited amount and the outermost grooves of the flanges have gripping devices which allow the film to pass in one direction only. Loading the film on the spiral is accomplished by pushing the film into the grooves just past the gripping mechanisms and then rotating the flanges backward and forward by small amounts so causing the film to be drawn into the spiral.

Centre-loading spirals have fixed flanges and loading is accomplished by clipping the film to the central core and then rotating the entire spiral in one direction whilst holding the film in a curved position such that it clears the outermost grooves and is loaded from the centre towards the outside. These spirals are sometimes provided with device which maintains the film in a curved position and aids the loading operation. Centre-loading spirals are also available in stainless steel whereas the self-loading spirals are usually constructed of a plastic material. The former have advantages of being robust, and are able to be dried rapidly by heating to higher temperatures than are possible with the latter which is useful if a number of films are to be processed one after the other.

A darkroom-loading roll film tank is essentially a miniature dark-room. Once the film has been loaded into the tank, all processing operations and the removal of the film may be carried out in full daylight, only the actual loading need be done in the dark. It is best to practise loading — using a length of old film — until one becomes so familiar with the operation that it is easy to repeat it in total darkness. The atmosphere of the room in which loading is done must, of course, be free from dust.

The actual loading procedure for the various types of tank varies in detail, and full instructions for loading usually accompany each tank. After loading, the tank may be brought into the light. Developer is usually introduced into the tank through a central light-tight opening in the lid. During development, agitation is obtained by movement of the film through the solution. If the tank is spill-proof this may be achieved by periodic inversion of the complete tank. Alternatively, the holder carrying the film may be rotated in the tank. Rotary action is usually achieved by means of a "twirling rod", which is inserted through the central opening to engage the film-holder spindle; it is usually recommended that the film should be agitated for 30 seconds at the start of development, followed by five seconds agitation every thirty seconds. This agitation should be "to-and-fro", since continuous rotation of the film holder in one direction may cause the film partially to leave the spiral.

After development is complete, the solution should be poured from the tank by the spout provided. Thereafter, the tank should be filled with a stop bath. After the tank has been emptied it should be filled with fixing solution. About ten minutes should be allowed for fixation (in a fresh fixing bath) and during this time the film holder should be rotated once or twice by means of the twirling rod. After this period has elapsed, the fixing solution should be poured from the tank, which should then be placed under a running tap, so that the water enters the central hole via a piece of flexible tubing. The jet should not be too fierce and washing should be continued for at least thirty minutes. Alternatively, if running water is not available, the tank should be filled and emptied with clean water at least six times, allowing five minutes to elapse between each filling and emptying.

After washing, the tank should be opened, a drop of wetting agent added and the film removed as carefully as possible. The film should then have a clip attached to each end and be hung by one of these clips in a

Fig. 17.4 – Developing tanks and spirals. (a) Developing tank, which may be used with 1, self-loading spiral, 2 centre-loading spiral or 3, automatic loading spiral. (b), (c) Two models of daylight-loading tanks.

warm, clean atmosphere and allowed to dry (page 402). The tank should be thoroughly washed, wiped, and placed to dry. It is important that this drying should be thorough and that the wiping should not leave traces of fibrous material in the spiral grooves. Only moderate heat should be used to speed up the drying of a plastic tank otherwise warping may occur.

Machine processing

For processing large quantities of film or print materials simple tank processing of films or dish processing of papers are not appropriate. There are available a number of processing machines with various capacities suitable for all scales of operation from the amateur photographer to the large-scale photofinishing laboratory. Table 17.4 gives approximate capacities of various types of processing device.

Processor	Approximate capacity
Multispiral developing tank (manual)	Up to 5 135–36 exposure films
Tank line (13·5 l) using spirals loaded in processing racks (manual)	Up to 30 135–36 exposure films, 30 8 × 10″ prints/batch
Tube or drum (machine)	Up to 50 135–36 exposure films/batch, 60 A4 prints/batch
Self-threading roller (machine)	6 m/min 450 A4 prints/hour (B & W) 25 A4 prints/hour (colour)
Continuous, roller (machine)	Up to 20 m/min (film) 10 m/min (prints)
Dunking (machine)	400 films/hour

Table 17.4 – Approximate capacities of processors

The various approaches to machine processing of photographic materials are shown in Figure 17.5. These include a variety of *tube or drum processor*, (a) to (d) which are relatively small-scale batch processors and have the advantage of versatility. One such processor may be used for processing almost any photographic material provided that the appropriate roll-film, sheet film or paper holders are available. Many tube or drum processors use *one-shot processing* in which fresh processing chemicals are used for each batch of material being processed and are discarded after their use, although the more sophisticated types re-use the solutions and require replenishment.

The simpler versions are non-automatic and require the operator to pour in the processing chemicals and to drain the drum at the end of each processing cycle. However, once loaded these machines may be operated in the light as the tube or drum is itself light-tight or is contained in a light-tight box. These processors have the disadvantage of an intricate loading procedure. For higher throughput of films or papers and ease of loading *self-threading roller processors* (Figure 17.5e) are commonly used especially for RC black-and-white and colour papers, X-ray films and graphic arts materials provided that the scale of operation justifies their use. As the name implies, the material – film lengths, sheet films or papers – is fed in at one end of the machine and is guided in and out of the processing tanks by a number of closely spaced rollers and emerge from the machine dry. These machines are fully automatic and use replenishment systems to maintain solution activity. Another exam-

Fig. 17.5 – Machine processors

(a)–(d)	types of drum processor.
(e)	self threading roller processor.
(f)	'Transflo' processor.
(g)	continuous roller processor.
(h)	dunking machine.

ple of this type of processing machine is shown in Figure 17.5f. This is an *in-line* or *straight-through* processing machine in which the material travels horizontally through the machine, guided by rollers, through applicators into which solutions are pumped from reservoirs contained in the machine.

For very large-scale processing in photofinishing laboratories, either *continuous roller processors* (Figure 17.5g) or *dunking* machines (Figure 17.5h) are used.

These machines have a high throughput and employ replenishment to maintain the activity of processing chemicals. Continuous roller processors contain relatively few rollers compared with self-threading roller processors but require a leader to be used for attaching the roll of material to be processed. Both types of processor lack the versatility of tube or drum processors, in that a machine is normally designed for one product, either a specific film or paper material. Dunking machines are used for processing films in individual lengths, which obviates the need for splicing films together before processing. A typical dunking processing machine is shown in Figure 17.6. Films are placed in clips and hung on bars or frames that are automatically raised and lowered into the processing tanks by a chain-driven hoist mechanism. The bars or frames are moved forward in each tank by serrated tracks along the sides of the processing tanks. To move the film forward the outer tracks move upward past the inner stationary tracks and move the ends of the rods supporting the films over and into the next serration. When the bars reach the last serration in the tank the hooks on the lifting mechanism pick them up and transfer them to the next tank.

The required degree of development

When an exposed film is immersed in a developer, the highlights – the most heavily exposed parts of the negative – appear almost at once; then the middle tones appear, and finally the shadow details. If the film be taken out of the developer as soon as the shadows appear, a thin negative of soft gradation will be obtained. If, however, development be continued further, every tone will gain in density, but the highlights and middle tones will gain more rapidly than the shadows. This means that the negative will increase in contrast as well as in density. If neither the emulsion nor the developer contained soluble bromide, no sensible increase in shadow detail would be noticeable on continuing development, but in practice all modern emulsions and most developers do contain bromide, and the result is that on increasing development, shadow detail not apparent on short development appears. Lengthening the time of development can, therefore, be said to increase both the contrast and speed of the emulsion, where, by speed, we mean ability to record shadow detail. There is a limit to which this can be carried. After a certain time in the developer, no further detail appears, the emulsion having reached the maximum speed attainable in the particular developer used. Similarly, after a certain time, contrast reaches its highest value, referred to as gamma infinity. Frequently, speed and contrast increase together, but this relationship varies with different emulsions. Fog and graininess also increase with increasing time of development. (See pages 536–539.)

The point at which development is stopped in practice depends upon the nature of the work being undertaken.

Thus:

(1) In the making of ordinary (continuous-tone) negatives, develop-

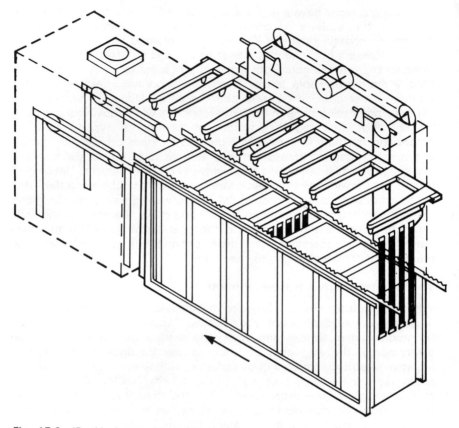

Fig. 17.6 – 'Dunking' processing machine

ment is continued until a degree of contrast is achieved which will give negatives of suitable printing quality. (Occasionally, this criterion is abandoned in favour of continuing development until maximum emulsion speed is obtained. This, however, is a specialised technique. See page 370.)

(2) When copying line originals, development is continued until maximum contrast is achieved.

(3) In processing colour materials the degree of development is defined by the fixed times and temperatures recommended by the manufacturers. With few exceptions departures from these recommendations are likely to lead to inferior results.

Obtaining the required degree of development

There are two ways by which it may be ensured that a negative is given the required degree of development. The first is *development by inspection*; the second, *development by the time-temperature method.*

Development by inspection

In development by inspection, the film is viewed by light from a suitable safelight and the appearance and growth of the image is watched. Development is stopped when the negative is judged to have suitable densities. This calls for skill and experience. In the early days of photography, development was always by inspection. Adoption of this method was in fact almost essential because, at first, printing papers were available in one contrast only, and it was necesary for all negatives to be of a uniform density range to suit the paper. Development by the time-temperature method does not generally achieve this.

When developing by inspection, use may be made of the fact that, with a normally exposed film, the development time necessary to produce a given degree of development in a specified developer can be expressed as a multiple of the time taken for the first appearance of the image. Suitable factors for different developers were worked out by Alfred Watkins in 1893. Development by inspection with the aid of the appropriate Watkins factor is called the *factorial method of development.* The advantage of the factorial method lies in the fact that it is easier to judge the first appearance of the image than to decide when a certain degree of contrast has been achieved.

The ease with which development by inspection may be carried out depends largely on the type of safelighting permissible, and thus upon the colour sensitivity and speed of the materials being handled. With blue-sensitive materials the method presents no difficulty. With ortho-chromatic materials, however, where only a dark red light is permissible, judgement of negative quality is less easy. With panchromatic materials any attempt at development by inspection is attended by a risk of fogging. Use of a transparent developing dish, beneath which a safelight is placed, greatly facilitates dish development by inspection.

The development of continuous-tone negatives by inspection is rarely carried out today but finds application in the development of negatives on slow blue-sensitive materials – both line and continuous-tone – as, for example, in copying and has considerable application in the development of papers (Chapter 21) and in lithographic development.

Development by the time-temperature method

Development of negatives today is normally performed almost entirely by the *time-temperature method.* The basis of this method is that a standard developer formula is used and a development time is given which it is known will produce a given degree of contrast. The time given is based either on the recommendations of the manufacturer for the emulsion employed, or on the user's experience. This method of development does not allow compensation for variation in subject range or for errors in exposure, but, provided reasonable care is taken in determining exposure, the latitude of the photographic process is such that satisfactory results are usually achieved. Development by the time-temperature

method may be carried out in total darkness, and is thus well suited to the development of modern negative materials, which are almost invariably panchromatic.

The development time required to obtain a given contrast (e.g., gamma, contrast index or average gradient) with a given material depends principally on:

(1) The particular film used.
(2) The developer used, its dilution and its state of exhaustion.
(3) The temperature of the developer.
(4) The degree of agitation employed.

The effect of each of these factors is discussed below.

Film used. Materials differ appreciably in the rate at which they develop. This was referred to in Chapter 15 (page 270).

Developer. The effects of variations in the composition of a developer on the development time required to reach a given contrast have been referred to earlier in this Chapter.

The temperature of the developer. Rate of development is profoundly affected by the temperature of the developing solution, the activity of the solution increasing with temperature. For photographic processing it is usually best to work at a temperature in the region of 18 to 21°C. This represents a compromise between low temperatures which lead to inconveniently long development times, and high temperatures which lead to uncontrollably short development times, an undesirable amount of fog or stain, and undue swelling of the emulsion with its attendant difficulties such as frilling, reticulation, etc. Published development times are usually related to a standard temperature of 20°C, a temperature selected as easily maintainable (in temperate climates) all the year round. However with modern colour materials and some special purpose hardened monochrome emulsions far higher temperatures are being used. For example processing temperatures of 38°C are used for many colour materials. It is recommended that where possible the temperature of the developing solution should be maintained at this figure. Where conditions are such that working at 20°C, or even within the range 18 to 21°C, is not practicable, development of most materials may be carried out satisfactorily at any temperature from 13 to 24°C, provided that the development time is adjusted accordingly. At temperatures below 13°C, development in the usual solutions is inconveniently slow, and above 24°C special precautions have to be taken because of the risk of softening the emulsion.

Within the range 13 to 24°C, the development time required may be ascertained approximately by multiplying the published time – related to 20°C – by an appropriate factor.

The factor to be used in any given circumstances will depend upon the *temperature coefficient* of the developing agent employed. This is defined as the ratio of the development times required to give the same

contrast at two temperatures 10°C apart. With many M.Q. and P.Q. developers the temperature coefficient is between 2·5 and 3·0 Development-time factors corresponding to a temperature coefficient of 2·75 are given in Table 17.5.

Calculation of development times for the time-temperature method is facilitated by use of curves in which temperature is plotted against time of development for a given gamma. Such curves, referred to as *time-temperature curves*, are usually plotted with a linear temperature scale and a logarithmic development-time scale, because the "curves" then take the form of straight lines. A *time-temperature chart* usually comprises a series of such curves, each related to different value of gamma. Such a chart is shown in Figure 17.7. This chart, like the development factors given in Table 17.5, is based on a temperature coefficient of 2·75. It will be noted that in the chart the slopes of all the curves shown are the same. The slope, which depends directly on the temperature coefficient, is, in fact, more-or-less constant for all emulsions in any one developing agent, although it varies from agent to agent. Use of a time-temperature chart avoids the calculation required with development-time factors.

Temperature of developer	Factor
13°C	2·02
14°C	1·83
15°C	1·66
16°C	1·50
17°C	1·35
18°C	1·22
19°C	1·11
20°C	1·00
21°C	0·90
22°C	0·82
23°C	0·74
24°C	0·67

Table 17.5 – Development-time factors for use when development time is known at 20°C

To use a time-temperature chart one has first to find the development time required at the published temperature – usually 20°C – and then follow the diagonal line corresponding to this time until it cuts the horizontal line representing the temperature to be used. The point on the horizontal axis immediately below the intersection gives the development time required.

Colour processing requires very accurate control of the temperature to within ±0·25°C in order to maintain contrast and speed balance between the layers. The times and temperatures are fixed and should not be varied from those recommended unless the speed rating of the film is being increased (see page 378).

Degree of agitation. The degree of agitation employed in the develop-

371

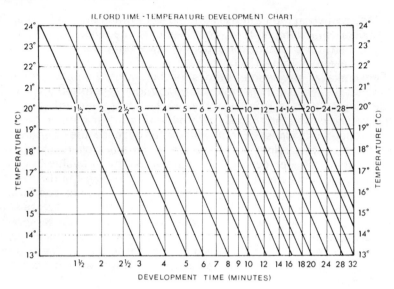

Fig. 17.7 – Time-temperature development chart for M.Q. and P.Q. developers of normal composition

ment of a film or plate affects the development time required; the more vigorous the agitation, within limits, the shorter the development time required. Thus, the continuous form of agitation recommended in dish development permits the use of development times about 20 per cent shorter than those required when developing in a tank with intermittent agitation.

The basis of published development times

For a given material and developer, the degree of development required by an ordinary (continuous-tone) negative depends principally upon the nature and lighting of the subject (subject luminance range) and, to a lesser extent, on the printing conditions to be employed (type of enlarger, etc.; see page 467).

Published development times assume a subject of average brightness range and are designed to give, with such subjects, negatives suitable for printing (in a condenser-diffuser enlarger) on a middle grade of paper. This usually corresponds to a gamma of 0·65 to 0·80 or an average gradient (\bar{G}) of 0·55 to 0·70. (The times published for general-purpose developers usually yield a level of contrast at the upper limit of the range quoted; those quoted for fine grain developers usually yield a level of contrast at the lower limit.) With subjects of below-average or above-average luminance range, published development times will usually yield negatives which require to be printed on harder and softer grades of paper respectively.

For sheet films separate development times are usually published for

dish and tank use. The difference between the two sets of times takes into account the differing forms of agitation employed in the two cases. If the recommended tank dilution of the developer differs from the dish dilution, the change in dilution is also allowed for. Development times for roll and 35 mm films are usually given only for tank development (with intermittent agitation). In the event of it being desired to develop a roll film in a dish (with continuous agitation), the published time should be reduced by 20 per cent.

Published development times for high-contrast materials used for the photography of line subjects are designed to be sufficient to produce the maximum contrast that the material is capable of yielding.

Where a specific value of gamma is required, the published gamma-time curve (page 273) for the material and developer concerned will give an indication of the required development time, provided that the user's working conditions are similar to the conditions under which the curve was determined.

Development at low temperatures

The activity of all developers slows down at low temperatures and development times must be increased accordingly, the increase required depending on the temperature coefficient of the developer used.

With M.Q. and P.Q. developers, however, development at temperatures below 13°C is slowed down to an extent greater than would be expected from the temperature coefficient. This is because the superadditivity of these mixtures is markedly reduced at low temperatures, an M.Q. developer, for example, behaving in these circumstances as if it contained metol only. In practice, therefore, M.Q. and P.Q. mixtures should not normally be employed at temperatures below about 13°C.

It should be noted, however, that although metol and Phenidone fail to activate hydroquinone at low temperatures, the developing action of hydroquinone itself, in, for example, a hydroquinone-caustic solution, is not impaired, although development times have to be increased to allow for the temperature coefficient. Hydroquinone-caustic solutions are in fact recommended for low temperature work in preference to other formulae, and have been used with success at temperatures below 0°C, an anti-freezing compound being added to prevent solidification of the solution.

Development at high temperatures

Although many modern processes operate at relatively high temperatures (up to 38°C), processing may be required under tropical conditions in which the ambient temperature exceeds that recommended and where it is not possible to cool the solutions to the required temperature. For colour materials, processing under these conditions is not possible and temperatures have to be maintained very accurately within the manufac-

turer's specifications. However for black-and-white materials some modifications are possible in order to reduce the adverse effects of processing at high temperatures. Apart from reducing the time of development it is also necessary to minimise the softening and swelling of the gelatin of the emulsion that may cause problems of possible mechanical damage or removal of the emulsion from the film base.

In general the more alkaline the developer the more the gelatin swells and the more rapidly development takes place. When processing at high temperatures either a low pH developer based on amidol (see page 339) or a mildly alkaline borax buffered developer are recommended. Alternatively a pre-hardening bath may be used or a specially formulated tropical developer. Tropical developers are characterised by a mild alkalinity, the inclusion of sodium sulphate to minimise swelling of the gelatin and the addition of extra anti-foggant. Whatever the procedure adopted it is best to consult the film manufacturer to obtain recommendations for processing under these conditions.

Obtaining very uniform development

Uniform development is always desirable, and the normally recommended methods of development are designed to give a good degree of uniformity. Some slight unevenness is commonly obtained using these methods, but in normal photography this is not detectable. For certain types of work, however, a much higher degree of uniformity than usual is desirable, as in the processing of colour separation negatives, spectrographic plates, sensitometric strips etc. The following points should then be noted:

(1) Use of a considerable amount of developer in a large dish, e.g. a size larger than the negative to be processed, helps to minimise the risk of uneven development at the edges, which arises if a dish of the same size as the film or plate is used.

(2) Since the degree of agitation affects the degree of development, variation in the degree of agitation received by different areas of the negative will tend to yield unevenness in development. This problem can be overcome in dish development by employing a degree of agitation so great that further increase does not affect the degree of development.* In sensitometric work, the required degree of agitation is therefore commonly obtained by "brush development" (in which a felt or camel hair brush is used to brush the sensitive surface in all directions during the whole of the development period), or by use of a wiper which moves rapidly to and fro about 1 mm above the negative.

(3) When more normal methods of agitation are employed, i.e., rocking in a dish or intermittent agitation in a tank, uniform development is assisted if the dilution of the developer is so arranged that the develop-

* This principle cannot be applied in tank development because in a tank a high degree of agitation leads to uneven development, because of interruption in the flow of developer by hangers, racks etc.

ment time required is not less than 5 minutes in a dish or 10 minutes in a tank.

(4) Employment of a material whose contrast is such that it is possible to work near gamma infinity will help to ensure uniformity, because near gamma infinity small changes in the degree of development affect density least. Further, variation of emulsion speed due to variation in the amount of bromide in the developer – which may arise from ageing of the developer (especially if in a tank) – is smallest near gamma infinity.

(5) If a developer of low pH is to be employed, use of a P.Q. formula is to be preferred to an M.Q. formula (page 348).

Quality control

To ensure consistency of processing from day to day or batch to batch, adequate quality control procedures are essential, especially in large-scale processing involving replenishment systems. This is commonly

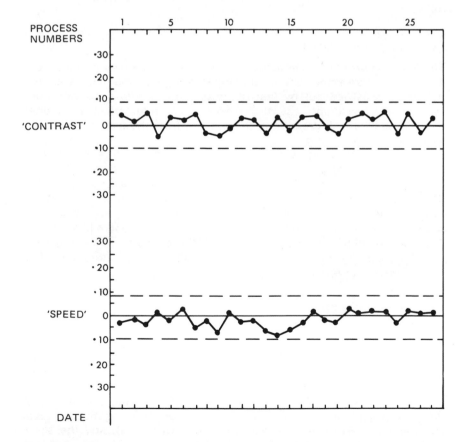

Fig. 17.8 – Typical process control chart for a black and white process

carried out sensitometrically, using pre-exposed control strips processed with the batch of films or at regular intervals in a continuous processor. Control strips comprise a step wedge or series of patches of certain densities pre-exposed under strictly controlled conditions by the film or paper manufacturer. After processing, the patches or steps of the wedge are read in a densitometer together with a master strip, which is a processed control strip provided by the manufacturer along with the pre-exposed but unprocessed strips. From the density readings, parameters of fog, speed and contrast are derived and the differences between these values for the user-processed strip and the master control strip are plotted on a quality control chart against the date or process number. Control limits are specified which appear on the chart as horizontal lines above and below the central line (see Figure 17.8). The process must be maintained within these limits and the intelligent use of control charts enables this to be done and consistent results to be obtained. Thus if the control limits are exceeded action has to be taken to bring the process back into control. This may involve an adjustment in the replenishment rate after checking that processing times, temperatures and agitation are correct for the process.

Two-bath development

The aim of two-bath development is to limit the density range of the negative. It is an extreme form of compensating development (see page 350) and is carried out by first immersing the film in a solution containing the developing agent, preservative and restrainer then after careful and thorough draining of the solution from the film, immersing it in a solution containing the alkali. This technique allows full use to be made of the film speed while restricting contrast due to exhaustion of developer in the more heavily exposed areas. It does find some application in recording scenes of high subject luminance range such as those encountered in architectural photography although low contrast developers are available (see appendix). A similar technique known as *water-bath development* has also been used. This technique involves immersing the film alternately in developer and water according to a planned schedule. It was of greatest value when it was common practice to develop by inspection but is rarely used today.

Reversal processing

As we have seen, normal methods of processing involve the production of a negative from which a positive is produced on another material by a separate printing operation. It is, however, possible to carry out these two operations on the one material, producing the positive image by what is called the *reversal method.*

In reversal processing, a negative image is first obtained in the usual way by development of the original latent image. This negative image is then dissolved away in a bleach bath (see page 398), and the silver halide remaining is exposed and developed to provide the required

positive image. The second exposure may or may not be controlled. The second development is usually followed by fixing in a hypo bath, although, if the second exposure has been sufficiently great, little un-developed silver halide usually remains to be fixed out. The first developer normally contains a silver halide solvent which may be sodium thiosulphate or ammonium thiocyanate. Inclusion of a solvent is necessary to dissolve some of the excess silver halide which would otherwise be developed to metallic silver in the second developer. This reduces the density of the positive image and helps to give clear highlights. Figure 17.9 shows a typical negative characteristic curve

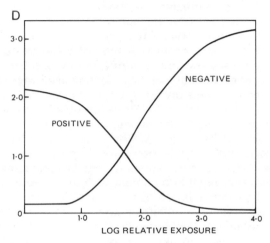

Fig. 17.9 – Characteristic curves for reversal processing

together with the corresponding positive curve. The positive curve is not quite the mirror image of the negative curve because of the presence of the silver halide solvent in the first developer. For the final developer, any normal formula may be used. In some methods of reversal processing, the second exposure before final development is replaced by a chemical fogging treatment.

Films especially designed to be processed by reversal methods are supplied by some manufacturers. Many, although not all, monochrome negative materials may also be reversal processed, but the procedures to be followed for best results will vary from one material to another. Manufacturers should be consulted for details of materials suitable for reversal processing and for appropriate processing procedures.

Colour reversal processing (see Chapter 24) differs slightly from monochrome reversal processing in the way in which the negative and positive images are differentiated from each other and in the means by which the unwanted silver images are removed. In colour reversal processing the negative image is obtained using a black-and-white

negative developer similar to the one described above. The positive colour image is then obtained together with its associated silver image by development in a colour developer after re-exposure or a fogging treatment. Both the negative and positive silver images are then removed by bleaching and fixing.

Self-developing materials

Self-developing or instant-print materials are finding increasing application in both black-and-white and colour image formation. Special cameras (see page 148) or camera backs are required for these materials. As the name implies the material contains not only the light-sensitive emulsion but also the chemicals necessary to bring about development to form a stable image, in the form of a reflection print, within seconds of exposure. In one type of self-developing material a negative is also obtained with the print and can be subsequently printed on paper by conventional printing techniques after removing the processing chemicals and drying. Colour self-developing materials are described in detail in Chapter 24. These materials were invented by Dr. Edwin Land and are sold under the name *Polaroid*.

The black-and-white materials comprise a negative light-sensitive layer, processing chemicals incorporated in pods in a viscous solution and a receptor layer that is not light sensitive. After exposure of the negative layer it is brought into contact with the receptor layer by pulling the film from the camera. In removing the film from the camera the pods containing the processing chemicals are ruptured and the viscous processing solution is spread between the negative layer and the receptor layer. After the required time the two layers are separated to yield a negative in the light-sensitive layers and a positive image in the receptor layer.

There are some similarities between the processing solutions used for self-developing materials and monobaths (see page 353). Like monobaths the processing solution for self-developing materials contains an active combination of developing agents in an alkaline solution, together with a fixing agent but a thickening agent such as carboxymethyl cellulose is also present to keep the solution between the two layers during processing. During processing the fixing agent dissolves the unexposed silver halide from the negative layer and the soluble silver complexes diffuse into the receptor layer which contains *catalytic nuclei*. On reaching the receptor layer the soluble silver complexes react with the developing agent and are reduced to metallic silver in the presence of the catalytic nuclei to form a positive image (see Figure 17.10).

Control of effective emulsion speed in development

With all the aids to exposure assessment available today (see Chapter 20), the photographer who concerns himself only with normal subjects

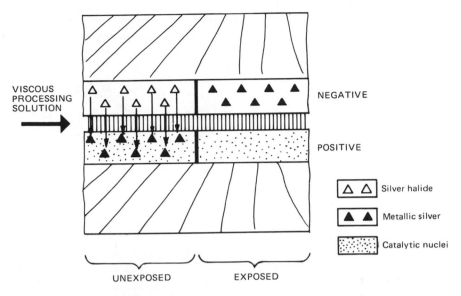

VISCOUS PROCESSING SOLUTION

NEGATIVE

POSITIVE

△ △ Silver halide

▲ ▲ Metallic silver

Catalytic nuclei

UNEXPOSED EXPOSED

Fig. 17.10 — Black and White self-developing material during 'processing'

should not obtain seriously incorrectly-exposed results. There are, however, occasions when mistakes happen, or when under-exposure is inevitable and it is desired to correct for the error, as far as possible, in development. In such cases, some control is possible in the following ways:

(1) Variation of development time

Although the main effect of alteration of development time is on contrast, with modern emulsions there is also a moderate effect on speed. Shortened development decreases the effective speed; lengthened development increases it (see Figure 17.11). The limit to the control of speed possible by varying development time is set largely by the accompanying variation in contrast; development must not be such that negatives are too soft or too hard to be printed on the available papers. The maximum development time may also be limited by granularity and fog, both of which rise with increasing development. The practice of continuing development to obtain maximum speed is sometimes referred to as *"forced" development*. Because this technique yields a high contrast, it is generally suitable only for negatives of subjects of short luminance range.

Figure 17.11 shows the effect of changes in development time on speed, where speed has been defined as the log relative exposure required to reach a density of 0·1 above base plus fog (see page 407). It can be seen that changes in effective speed have been obtained at the expense of contrast. However dilution of the developer and extending the development time gives a compensating effect (see page 350) that

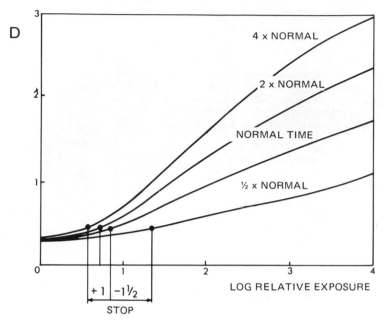

Fig. 17.11 – Effect of development time on speed

slows down the rate of increase in contrast while giving a small speed increase.

(2) *Choice of developer*

Certain active developers give the maximum speed that the material is capable of, normally at the expense of high contrast and increased granularity, for example by using an active M.Q. carbonate developer. However many manufacturers supply specially formulated developers that yield optimum negatives with respect to speed gain, contrast and granularity. The gains in speed with such developers are of the order of one-third to two thirds of a stop.

It must be stressed that film speed is fixed by the development of the film under standard conditions defined in the appropriate American, British or other national or international standard (see Chapter 19) and as such cannot be varied. Film speeds for general photography are based on a camera exposure slightly greater than the minimum required to yield a negative that will give an "excellent" print. A safety factor of one-third of a stop is included in their determination. Thus by extending development a very little extra shadow detail may be recorded.

The majority of claims for vast speed increases are based to a very great extent on the exposure latitude of the film when used for recording scenes of low contrast or low subject luminance range (see page 281) that contain virtually no shadow detail or in fact do not record it. In such

cases the film is effectively being underexposed and the scene is recorded further down the characteristic curve (see pages 423–425).

In practice it is possible to "up-rate" certain films by as much as two to three stops depending on the scene contrast and the individuals' criteria for acceptability of prints that contain little if any shadow detail. Techniques of forced development or "push-processing" give only marginal improvements in image quality for underexposed negatives of low contrast scenes.

Real and significant speed increases are possible with reversal films. These are achieved by increasing the time in the first developer. Speed increases of two to three stops are common for certain colour reversal materials. In reversal processing the situation is quite different from that for negative materials. Shadow detail *is* recorded even if the film is underexposed but remains unrevealed in the dense areas of the transparency when subjected to standard conditions of processing. Increasing the time in the first developer leads to less silver halide being available for the second development and hence a less dense positive image which reveals underexposed shadow detail (see Figure 17.12).

Figure 17.12 shows the effect of increasing the time in the first developer for a typical colour reversal film. Speed changes have been

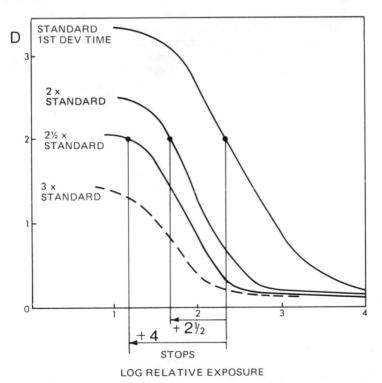

Fig. 17.12 – Effect of first development time on speed for a reversal process

arbitrarily defined as relative log exposures required to give a density of 2·0. However there is a limit to speed increases with reversal films. For example the lowest curve in Figure 17.12 shows that the maximum density is far too low for acceptibility and that the curve is too short to record both highlight and shadow detail even for scenes of moderate subject luminance range. Another limitation that is not shown by the plotting of visual densities from a material that has been exposed to a neutral light source is that the three sensitive layers may be affected differently by modifying the processes – and that affects the colour reproduction as well as the tone reproduction.

Increasing the speed rating of colour reversal films by increasing the time of the first development also reduces image quality to some extent. Maximum density is reduced, graininess and contrast increase whilst there is some change in colour rendering and a reduction in the films ability to record scenes of moderate-to-high contrast. However "up-rating" reversal films is a very useful and much practised undertaking for recording poorly lit scenes or for recording fast action where short exposure times are essential.

Adjacency effects

The action of development results in the production of soluble bromide, which is liberated in proportion to the amount of silver developed. Since bromide restrains development, local concentrations resulting from still development would render the whole process very uneven. Agitation during development is designed to prevent such local concentrations of exhausted developer. If, however, insufficient agitation is given, a number of *adjacency effects* may arise. These are sometimes all given

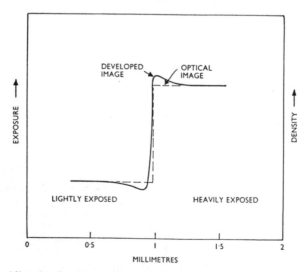

Fig. 17.13 – Microdensitometer trace across boundary between lightly exposed and heavily exposed areas of a negative

the general title of *Eberhard effects*, although this term is properly applied to one particular manifestation of these effects, described below.

Adjacency effects may take the following forms:

(1) *Streamers*

Insufficient agitation of films developed in a vertical plane, leads to light *bromide streamers* from heavily exposed areas and dark *developer streamers* from lightly exposed areas. If a film is developed in a horizontal plane the effect may take the form of "mottle", a peculiarly distressing form of uneven development.

(2) *Mackie lines*

This effect is sometimes seen where there is a sharp boundary between two areas having a large difference in density. The passage of relatively fresh developer from a lightly exposed area to a heavily exposed area accelerates the growth of density at the edge of the heavily exposed region, while the diffusion of bromide in the reverse direction retards development at the edge of the lightly exposed area. The result is a dark line just within the edge of the heavily exposed area and a light line just within the lightly exposed area, the two being called *Mackie lines*. The effect is illustrated in Figure 17.13, which shows a micro-densitometer trace across a boundary between a lightly exposed area and a heavily exposed area.

(3) *Eberhard effect*

The density of a developed image of small area is influenced by the actual size of the area and upon the density of adjacent image areas. Further, the density of an image area may vary from point to point, even though exposure has been constant all over the area. This is known as the *Eberhard effect*. It is due to the same causes as the Mackie lines.

(4) *Kostinsky effect*

Not only the density but the actual *size* of a small image area may be reduced by the presence of an adjacent image area. The effective separation between the two areas is therefore increased (Figure 17.14). This is known as the *Kostinsky effect*, after the astronomer who first noticed it.

Sabattier effect

If an exposed film or plate be developed and washed (but not fixed), and then given a second overall exposure and redeveloped, certain parts of

OPTICAL IMAGE

DEVELOPED IMAGE

Fig. 17.14 – Kostinsky effect

the original image may be found to be reversed. This is known as the *Sabattier effect*. The effect is often observed when films or plates are developed in an unsafe light. It is believed to result partly from optical shielding by the image produced by the first exposure and development, and partly from a desensitising effect resulting from the first exposure and development.

The Sabattier effect is sometimes used to obtain special effects in pictorial photography, where it is commonly — but incorrectly — termed "solarisation". (Reversal due to the Sabattier effect should not be confused with true solarisation, i.e. reversal due to use of the region of reversal of the characteristic curve.)

Development of papers

See Chapter 21.

18 Processing Following Development

AS soon as a film has been developed it bears a visible silver image and in the case of colour materials also a dye image, but it is not yet in a condition to be brought into the daylight or be used in the further operation of making positive prints. In the first place, the silver halide grains which were not affected by exposure — and which have not undergone reduction by the developer — still remain in the emulsion, making it difficult to print from the negative. Further, these silver halide grains are still light-sensitive and will gradually print out, changing colour and masking the image to a greater and greater extent as time goes on. Also, the gelatin is in a swollen condition and has absorbed a considerable amount of the development. The fixing operation also may be used to harden the quickly stopped.

The purpose of *fixation* is to remove the unwanted silver halide without damaging the silver image, and, at the same time, to stop development. The fixing operation also may be used to harden the gelatin, to prevent further swelling.

Rinse bath

A *plain rinse bath* is very commonly employed between development and fixation to *slow* the progress of development, by removing all the developing solution which is merely clinging to the surface of the film. A rinse bath does not completely *stop* development — because it leaves more-or-less unchanged the developer actually in the swollen emulsion layer — but it does remove much of the gross contamination of the film by the developing solution. Rinsing is carried out by quickly immersing the material in clean plain water. To ensure that it does not become loaded with developer, a rinse bath should be changed frequently — or running water should be employed.

Rinsing in plain water must be followed by fixation in an acid fixing bath to *stop* development. The rinse bath then serves not only to slow development, but also to lessen the work that has to be done by the acid in such a fixing bath. Rinsing thus "protects" the fixing bath.

Processing Following Development

Acid stop bath

Although a plain rinse bath is all that is commonly used between development and fixation, a better technique is to use an *acid stop bath*, the function of which is not only to remove the developer clinging to the surface of the film, but also to neutralise developer carried over in the emulsion layer, and thus to stop — not merely slow — development. It does this by virtue of the fact that developing agents fail to act in acid solution. An acid stop bath is of particular value when a highly alkaline developer such as a hydroquinone-caustic formula is used.

In selecting an acid to acidify a stop bath it must be remembered that some of the bath will be carried into the fixer as films pass through it. This rules out use of the stronger acids (e.g., sulphuric acid), since these would cause precipitation of sulphur in the fixing bath. Solutions of potassium metabisulphite ($2\frac{1}{2}$ per cent) or acetic acid (1 per cent) are commonly used. Acetic acid, the acid present in vinegar, is available in pure form as "glacial" acetic acid. This is a colourless liquid which freezes at a temperature of about 16°C. It is this freezing propensity which gives it the description of "glacial". Impure or dilute samples of acetic acid freeze at a lower temperature. Acetic acid crystals expand on melting, so that if a bottle of the substance has frozen hard, warmth should be applied first near the *top* — to avoid a burst bottle. It should be noted that in its concentrated, or glacial, form acetic acid is an exceedingly strong irritant to the skin.

Fixing baths

Although, as stated earlier, a *fixing bath* may perform several functions, its characteristic action is the removal of unexposed silver halide from the emulsion.

Silver halide + fixing agent →

silver-fixing agent complex (soluble) + halide ion.

Fixing baths, therefore, always contain a solvent for silver halides — whatever else they may contain. For use in photographic processing, the solvent must be one which forms a complex with silver which can be washed out, it must not damage the gelatin of the emulsion and must not attack the silver image to any great extent. Of the possible solvents for the silver halides, only the thiosulphates are in general use — all the others have disadvantages of one kind or another. The alkali cyanides and thiocyanates, for example, although more rapid in action than the thiosulphates, exert a softening action on the gelatin and have a fairly considerable solvent action on the silver image. Also cyanides have the additional disadvantage of being highly poisonous.

By far the most widely used silver halide solvents are ammonium and sodium thiosulphate. Besides being a solvent for silver halides, sodium thiosulphate (or hypo) has a weak solvent action on the silver image itself — more so in acid solution than in neutral solution — and while this action

is negligible during the time required for fixation, prolonged immersion in the fixing bath may reduce the density of the image, the effect being most marked with fine grain negative emulsions and printing papers. In the latter case, image colour may be affected as well as image density (page 351).

The fixing bath removes the residual silver halide by transforming it into complex sodium argentothiosulphates. These substances are not particularly stable and, after fixation, must be removed from the emulsion by washing. If left in the emulsion, they will in time break down to form an all-over yellowish-brown stain of silver sulphide.

In the presence of a high concentration of soluble silver, or low concentration of free thiosulphate, as when the fixing bath is nearing exhaustion, there is a tendency for the complex sodium argentothiosulphates to be "adsorbed", or "mordanted", to the emulsion, in which condition they are difficult to remove by washing. Fixation in an exhausted bath is therefore attended by risk of subsequent staining, as a result of the breakdown of the silver complexes remaining in the emulsion, however efficient the washing process.

To avoid the danger of such staining, the best practice is to use two fixing baths in succession, according to the following procedure. Initially, two fresh baths are prepared and materials are left in the first bath until they are just clear, being then transferred to the second bath for an equal period. In the course of time, the clearing time in the first bath – which is doing practically all the work of fixation – will become inconveniently long. When clearing requires, say, double the time required in a fresh bath, the first bath should be discarded and replaced by the second, which, in turn, should be replaced by a completely fresh bath. This process is repeated as required, with the result that the second bath is always relatively fresh. Adoption of this procedure ensures that all films leave the second fixing bath in good condition from the point of view of subsequent permanence; as good in fact as if they had been fixed throughout in a fresh bath. The method is also economical, in that it enables all the fixer in turn to be worked to a point far beyond that at which a single bath would have to be discarded.

A fixing bath for negatives is usually made to contain between 20 and 40 per cent of crystalline sodium thiosulphate. A bath intended for papers is not usually made stronger than 20 per cent; a stronger bath will be attended by the risk of bleaching the image on prolonged fixation, and will also aggravate the problem of removing sodium thiosulphate from the paper on washing, a problem which with papers is more serious than with films, owing to the absorbent nature of the base, although this problem has been overcome with the use of resin-coated papers (see page 447). As the average coating weight of papers is only about one-quarter of that of negative materials, fixing times for papers are shorter than those required by negative materials, and the times required in the weaker bath are not excessive. (For the fixing of papers see also Chapter 21.)

Ammonium thiosulphate is now commonly used as a fixing agent at

concentrations of around 10–20 per cent. The presence of the ammonium ion has been shown to greatly increase the rate of fixation when compared with sodium thiosulphate. For example the rate of fixation of ammonium thiosulphate is between two and four times that for an equivalent concentration of sodium thiosulphate. However ammonium thiosulphate does have some limitations as a fixing agent. It is less stable than the sodium compound and attacks the silver image more readily. Exhausted ammonium thiosulphate fixing baths readily cause staining, owing to the more rapid breakdown of the silver complexes. Despite these limitations, ammonium thiosulphate is the basis of most rapid fixers now on the market.

Plain fixing bath

A solution containing sodium thiosulphate alone is termed a *plain fixing bath*. If such a bath be used immediately following development, or with only a plain rinse between development and fixation, there is a very considerable danger of staining resulting from the carry-over of developer in the emulsion layer. This staining may be of two kinds. Organic stains may result from oxidation of the developer, since the concentration of the preservative is now lowered by dilution. More serious, silver stains may result from the fact that any development which takes place in the fixing bath does so in the presence of an excess of a silver halide solvent.

If, therefore, it is desired to use a plain fixing bath, it must be preceded by an acid stop bath. In practice, it is more common to combine the stop bath with the fixing bath to form an *acid fixing bath* (see below).

A plain fixing bath, without a previous stop bath, is used when it is desired to get the maximum amount of staining with a pyro developer, which for this purpose is made with a low concentration of sulphite (page 340). When a plain hypo bath is used, white light must not be switched on until fixation is complete.

Acid fixing bath

For the reasons stated above, the addition of a suitable acid to the sodium thiosulphate solution provides a more satisfactory bath than a plain fixing bath. An additional convenience when an acid fixing bath is used is that white light may be switched on shortly after the sensitive material has been placed in the bath, provided that the material is completely immersed and agitated for the first few seconds after being placed in the bath.

The stronger acids cause thiosulphate to decompose with the formation of colloidal sulphur which cause the solution to become milky in appearance. This reaction is enhanced by the presence of sulphur, with the result that once sulphur has appeared in it the solution deteriorates rapidly. The presence of sulphite in the solution, however, tends to prevent this decomposition of the thiosulphate. Acid fixing baths are therefore usually made up either:

(1) By the addition of potassium metabisulphite to the solution of sodium thiosulphate or

(2) By the addition to the sodium thiosulphate solution of a weak acid such as acetic acid, together with sodium sulphite. (A stronger acid than acetic – for example, hydrochloric acid or sulphuric acid – would decompose the thiosulphate even in the presence of sulphite.)

When amidol is used as the developing agent, it is more than usually important that the fixing bath should be acidic, since amidol continues to develop even in neutral solution.

Hardening

When, for any reason, it is necessary to process in warm solutions or to carry out rapid drying by the application of heat, it is an advantage – sometimes essential – to harden photographic materials. Even at ordinary temperatures hardening has important advantages:

(1) It checks swelling and consequent softening of the emulsion layer. A hardened film is thus less easily damaged in subsequent processing operations. Further, since less water is taken up by a hardened emulsion, there is less to be removed on drying – which in consequence is more rapid.

(2) Hardening raises the melting point of the emulsion. It thus allows a slightly higher temperature to be used for drying. For this reason, and because there is less water to be removed, hardening makes possible a considerable speeding up of the drying operation.

The extent to which an emulsion swells, i.e., takes up water, is limited if it is in a solution containing a high salt concentration. In normal processing, therefore, only a limited amount of swelling takes place in the developer and fixer, and this is not usually serious. There is a tendency for further swelling to take place in the rinse between developer and fixer, but provided the rinse is brief this swelling is not serious. On finally washing in plain water, however, an unhardened gelatin layer will swell considerably and it is then that the film is in its weakest state. This is illustrated in Figure 18.1. The use of extremely soft water aggravates this swelling, because of its low salt concentration. From this it is seen that for hardening to be of value it must take place before washing begins.

In practice, it is usually most convenient to combine the hardening process with fixation, and this is done by the addition of a *hardening agent* to the fixing bath, to form a *hardening-fixing bath*. This avoids the need for an additional processing operation.

The degree of swelling of an emulsion increases with temperature. In tropical climates, therefore, even the partial swelling which takes place in the developer may assume significant proportions. It is then common practice to harden the film *before* development.

Typical hardening agents are ordinary alum – sometimes called white alum or potash alum – and chrome alum. These are respectively aluminium potassium sulphate and chromic potassium sulphate.

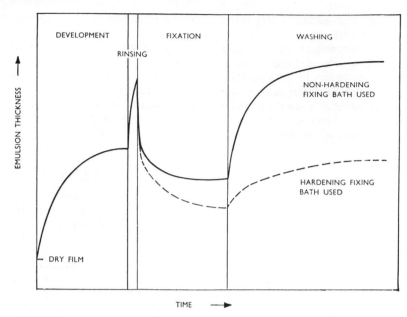

Fig. 18.1 — Swelling of an emulsion layer during processing

Hardening by means of these agents is a chemical process in which aluminium or chromium ions combine with the gelatin to form cross-links and make it more resistant to water, to heat and to abrasion.

Both chrome alum and potash alum are widely used in hardening-fixing baths. Chrome alum acid hardening-fixing baths can be made up with a higher concentration of sodium thiosulphate (up to 40 per cent) than potassium alum baths (maximum of 30 per cent). This does not, however, make it possible to process more quickly in the former, because, for efficient hardening with chrome alum, the film must be in the bath for about 10 minutes at 20°C, as opposed to the 5 minutes required in a potassium alum bath. It is stated that chrome alum is capable of yielding a greater degree of hardening than potash alum. However, the hardening properties of a chrome alum hardening-fixing bath diminish with age, becoming negligible after two or three days, whether the bath is used or not. For these reasons, chrome alum is most useful when a hardening-fixing bath is required for use over a short period only, soon after mixing; when a hardening bath is required for continuous use, potassium alum is to be preferred. Potassium alum is always to be preferred when it is required to harden prints, because with chrome alum some papers have a tendency to acquire a slight greenish tint which will not wash out. Chrome alum is commonly used when a hardening rinse bath is required between development and fixation, as when processing is carried out at high temperatures. A chrome alum bath containing no fixer retains its hardening powers indefinitely unused, although hardening falls off in a few days once the bath is used.

A fairly careful adjustment of the acid activity of the solution is required in both chrome alum and potash alum hardening-fixing baths. If the pH is too low there is a danger of sulphurization; if too high of sludging. A safe range is 4 to 6·5. For optimum hardening, the pH should be at about the middle of this range. Hardening-fixing baths are therefore made to contain ingredients which ensure good buffering properties (page 389); this prevents carry-over of developer from affecting the pH too much.

Formalin or other organic hardening agents are sometimes used to harden photographic materials when a hardening rinse bath is required, as, for example, when processing under tropical conditions. To obtain maximum hardening with formalin, the solution must be alkaline. A formalin bath is generally employed either before development or after fixation, depending upon circumstances. It should not be employed immediately after development, since developer carried over in the emulsion layer may combine with the formaline to soften, rather than harden, the emulsion layer. Formalin is not suitable for use in combined hardening-fixing baths.

Making up fixing baths

The principal ingredient of most fixing baths is sodium thiosulphate (hypo). This is available in two forms: crystalline (sodium thiosulphate pentahydrate) and anhydrous. The crystals are fairly clear and hexagonal, about the size of a pea. Anhydrous sodium thiosulphate is a white powder. Crystals of sodium thiosulphate contain 36 per cent of water and only 64 per cent of the salt, whereas anyhydrous hypo contains practically 100 per cent of the salt. It is common practice to specify the concentration of fixing baths in terms of crystalline sodium thiosulphate. Thus, a 40 per cent sodium thiosulphate bath contains 40 grammes of crystalline sodium thiosulphate per 100 ml of solution, or 25 grammes of anhydrous sodium thiosulphate.

The making up of fixing baths is effected most rapidly if the sodium thiosulphate is first dissoved in *hot* water. This is especially advantageous when crystalline sodium thiosulphate is employed, since solution of this form is accompanied by a fall in temperature. (Anhydrous sodium thiosulphate gets slightly warm on dissolving.)

When an acid fixing bath is required, the metabisulphite should be added to the *cool* hypo solution. If metabisulphite is added to hypo in a hot solution the hypo may decompose.

The formulae of acid-hardening fixing baths are more complicated than those of ordinary acid fixing baths, and greater care is therefore needed in making them up. The procedure to be followed in making up a hardening-fixing bath will depend on the particular formula employed; detailed instructions are given with each formula and packing. Provided that these instructions are carefully followed no difficulty should be experienced. One general rule that may be noted in making up potassium alum hardening

fixers supplied as single-powder mixtures is that the water used should not be above 27°C; if hot water is used the fixer may decompose.

Time required for fixation

Rate of fixation depends principally upon the following factors:

(1) *Type of emulsion and thickness of coating*
Other things being equal, fine grain emulsions fix more rapidly than coarse ones, and thin emulsions more rapidly than thick ones. Silver chloride fixes more rapidly than the bromide.

(2) *Type and degree of exhaustion of the fixing bath*
The rate of fixation depends on the concentration of the fixing agent up to about 15 per cent for both sodium and ammonium thiosulphate but increasing the concentration above 15 per cent hardly alters the rate. As stated earlier, the concentration of sodium thiosulphate usually employed in practice is between 20 and 40 per cent. A partially exhausted bath fixes more slowly than a fresh bath, not only on account of reduction in concentration of thiosulphate, but also, if used for fixing negatives, because of the accumulation of soluble silver and of iodide (page 393). For special work, fixing agents which clear more rapidly than hypo may be employed (page 397).

(3) *Temperature of the bath*
Increase in temperature gives increased rate of fixation.

(4) *Degree of agitation*
The rate of fixation is controlled by a diffusion process, so that agitation materially reduces the time required.

(5) *Degree of exposure*
The heavier the exposure, the less the amount of unused silver halide to be removed in the fixing bath, and hence the more rapid the rate of fixation.

As a general rule, a material may be considered to be fixed after approximately twice the time required for *clearing*. In a fresh acid fixing bath of normal composition, fixation of films and plates may be regarded as complete in about 10 minutes at 20°C. Fixation is complete when all visible traces of the silver halide have disappeared, but as the exact moment of clearing is not easily determined it is good practice to give double the apparent clearing time. With papers, clearing of the image is even less readily observed, but fixation may be regarded as complete in about 5 minutes in a fresh bath. Hardening takes place slowly and usually requires longer than clearing. To be efficient, hardening is therefore assisted by allowing materials to remain in the fixing bath for twice as long as they take to clear.

The temperature of the fixing bath is by no means as critical as that of the developing solution, but it should normally lie within a few degrees of the temperature of the developer, to avoid the danger of reticulation of the gelatin.

Changes in a fixing bath with use

The composition of a fixing bath, like that of a developer, changes with use. We can best understand the reasons for these changes by considering the sequence of events following development, assuming that an acid-hardening fixing bath is used, preceded by a plain rinse.

(1) The rinse bath removes much of the gross contamination of the film by the developing solution, and thus slows development.

(2) The film is transferred to the fixing bath where the acid neutralises the alkali of the developing solution in the emulsion layer and stops development.

(3) The thiosulphate converts the silver halide in the emulsion to soluble complex sodium argentothiosulphates and halide ions. Thus the concentration of silver complexes and halid ions increases.

(4) The hardening agent soaks into the gelatin and begins its hardening action.

As the bath is used, more and more of the alkaline developer is carried over and the acid will become exhausted. A good guide to the degree of acid exhaustion is provided by an indicator paper. The pH of the bath should preferably not be allowed to rise above about 6·0. If the bath becomes definitely alkaline, it will not stop development quickly enough, and consequently there will be risk of staining. If the bath is a hardening one, there will also be a serious reduction of hardening power. If a hardening-fixing bath becomes very alkaline, sludge may be formed from the interaction of the hardening agent and the alkali. This will tend to deposit itself on negatives in the form of scum, which may be difficult to remove. (The white scum from potash alum will usually wash off while the negative is wet, but not when dry. The bright green scum from chrome alum will frequently not wash off at all.) (See also page 345.)

Not only does the acidity of the bath fall off as the bath is used, but the clearing action itself becomes slower. This is partly due to exhaustion of the thiosulphate, but, with negative materials at least, is also due to a concentration of iodide — derived from the emulsion — which builds up in the bath. Silver iodide, present in small amount in many negative emulsions, is extremely difficult to dissolve in a solution of sodium thiosulphate, and has the effect of depressing the solubility of silver bromide and so retarding the clearing process as a whole. We thus have a symptom of apparent "exhaustion" which is brought about by the piling up and resisting action of an end-product. Among other products which build up in the bath with important results are the complex sodium argentothiosulphates. These retard clearing, too, but their most important effect is upon the permanence of the negatives and prints (page 453). Silver indicator test papers are available which change colour on immersion in a fixer containing silver. These papers are calibrated so that the intensity of the colouration may be read from a chart which relates the colour to the silver content.

A further cause of exhaustion of a hardening-fixing bath could be exhaustion of sulphite, but the quantity employed is usually sufficiently

large to ensure that the occurrence of trouble from this source is rare.

Lastly, since a small volume of water from the rinse bath is carried into the bath on each film, while a small volume of the fixing solution is carried out, the fixing bath becomes progressively diluted on use. This, also, leads to an increase in the clearing time required.

Useful life of a fixing bath

A fixing bath is usually discarded when its useful life is considered ended. This life depends upon several factors, of which the number of films passing through is but one. For this reason, it is not possible to state with any high degree of precision the number of films or plates which may safely be fixed in a given bath. The following figures may, however, be taken as a rough guide:

Material	No./litre of 24 per cent sodium thiosulphate solution
20·3 × 25·4 cm sheets	26
10·2 × 12·7 cm sheets	104
120 film	26
135–20 film	42
135–36 film	26

Table 18.1 — Approximate capacity of fixer

We have just noted that as a bath approaches exhaustion, the time it takes to clear a film increases for a variety of reasons. It is common practice to discard a bath when the clearing time has risen to double the time required by the bath when fresh. When a bath is used solely for papers this rule is not readily applicable, since it is not easy to tell when a paper is cleared. In this case, the bath should be discarded when a known area of paper has been passed through. This, of course, necessitates the keeping of some sort of record.

Replenishment of fixing baths

Although, at one time, a fixing bath was invariably discarded when exhausted, it has increasingly come to be recognised that this is unnecessarily wasteful of both the fixing agent and silver, and the possibility of replenishing a fixing bath has therefore been studied. The first property of a fixing bath to fall off with use is its acidity; then, usually, its hardening properties. The life of a bath may, therefore, be usefully increased by the addition of a suitable acid mixture. If this is made to contain a hardener, both acidity and hardening power can be restored to a certain extent. This process cannot, however, be continued indefinitely because of the accumulation of iodide (usually) and silver in the bath. It is not, therefore, worth while to attempt to replenish a fixing bath by the addition of hypo, unless some means of removing the silver is available, as, for example, by electrolytic silver recovery (see below).

Where silver recovery *is* being practised a bath may be replenished by adding fresh sodium thiosulphate and hardener (say, 10 per cent of the amount used initially) when the initial clearing time is exceeded by about 50 per cent. Following this, the acidity of the bath should be restored by adding, with stirring, 50 per cent acetic acid solution until a pH of about 5·0 is achieved. This may be checked with an indicator paper. It is desirable, before replenishing, to draw off a quantity of the solution to ensure that the bath does not overflow on replenishment.

Silver recovery

The recovery of silver from a fixing bath is attractive because of the high value of silver, quite apart from the possibility of replenishing the fixing bath.

In black-and-white materials only a relatively small amount of the silver halides are reduced to silver by the developer to form the image. The remainder is dissolved from the sensitive layer and ends up as silver complexes in the fixer solution. In colour materials *all* the silver halides are removed from the material by the bleach or bleach-fixing solution. Thus if sufficient material is processed recovery of silver becomes worthwhile. Table 18.2 gives the approximate recoverable silver from various types of photographic materials.

Photographic material	Recoverable silver g/100 units processed
B & W negative (1–120, 1–135–36, roll)	10–16
B & W print (20·3 × 25·4 cm)	3–6
Colour negative (1–120, 1–135–36, roll	24–28
Colour print (20·3 × 25·4 cm)	1–2
"Lith" film (20·3 × 25·4 cm)	10–17
Industrial x-ray (35 × 43 cm)	155–249
Medical x-ray (35 × 43 cm)	46–93

Table 18.2 – Amounts of potentially recoverable silver in photographic materials

The various methods of silver recovery commonly practised at the present time may be divided into 3 main groups:

(1) Electrolytic,
(2) Metallic replacement, and
(3) Chemical (sludging).

Electrolytic silver recovery units operate by passing a direct current through the silver-laden fixer by means of two electrodes – usually a carbon anode and a stainless steel cathode – on to which almost pure silver is deposited (by cathodic reduction of silver ions). The silver is stripped from the cathode periodically and sent to a silver refiner. There are many electrolytic units commercially available. Some types employ a high current density, which requires efficient agitation by re-circulation of the fixer solution, and use rotating cathodes to prevent "sulphiding". Low

current density units make use of a large area cathode and do not need agitation.

Whatever the type of the electrolytic silver recovery unit, careful control of the current density is required. If it is too low silver recovery is slow and inefficient and if too high silver sulphide is formed. Fixer solutions that have been electrolytically de-silvered may be re-used after replenishment. During electrolysis both sulphite and thiosulphate ions are oxidised at the anode. Thus before re-use thiosulphate and sulphite must be added. During the recovery of silver by electrolysis the pH must be maintained below 5, there must be sufficient sulphite present and also a small amount of gelatin is desirable as an aid to the even plating of silver.

Electrolytic methods may be used for recovering silver from fixers based on sodium and ammonium thiosulphates and from bleach-fix solutions used in some colour processes. This method of silver recovery has advantages that the solution may be re-used and that the silver is recovered in a pure form (92–99 per cent). The main limitations of this method are the expense of the units, the consumption of electricity and the degree of control that has to be exercised by the operator.

Metallic replacement methods, although simplere, give a fixer solution that is contaminated by other metal ions after recovery of silver. The fixer solution cannot be re-used and the recovered silver is in a less pure form than that from the electrolytic methods described above. Metallic replacement depends on the principle that if a metal less noble than silver is added to a solution containing silver ions, the less noble metal (e.g. copper, zinc, iron) will dissolve in the solution and metalic silver will be deposited from solution.

Zinc dust was once used in this method but now steel wool is more common because it is cheap, readily available, and easy to handle. Also iron salts present in the discarded fixer are more acceptable to the water treatment authorities than are zinc salts.

The modern application of this method is to pass the silver-laden fixer through a cartridge of steel wool in which the metallic replacement takes place. When silver is detected in the effluent from the cartridge, the cartridge is replaced by a fresh one and the exhausted cartridge is sent away for silver refining. For efficient recovery the pH of the fixer should be between 4·5 and 6·5. Below 4·5 the steel wool dissolves and above 6·5 the replacement is slow. This is a simple, efficient, inexpensive and non-electrical method but has the limitation that the fixer solution cannot be re-used. Bleach-fix solutions so treated can, however, be re-used after the appropriate replenishment and adjustment of concentration. A number of firms supply cartridges and on return of the exhausted cartridge pay the processing laboratory for the silver recovered less a charge for refining, etc.

Chemical methods (sludging) involve the addition of certain compounds to the silver-laden fixer which precipitate an insoluble silver compound or metallic silver. For example when a solution of sodium sulphide is added to

an exhausted fixer silver sulphide is precipitated. The solution must be *alkaline* or toxic hydrogen sulphide is produced. Alternatively, sodium dithionite (hydrosulphite) precipitates metallic silver from a used fixer solution.

Although these methods are efficient they are potentially hazardous to the user and the chemicals can contaminate photographic materials and solutions. The de-silvered solution is not re-usable and this is not a recommended method for use in or near a processing laboratory.

Rapid fixing

We have seen earlier (page 392) that rate of fixation is influenced by a number of factors. Rapid fixing is normally achieved in three ways: by using hypo at its optimum concentration, by using fixing agents such as ammonium thiosulphate which clear more rapidly than sodium thiosulphate, and by raising the temperature of the bath. If it is desired to raise the temperature above about 24°C, special precautions must be taken to prevent the emulsion layer from swelling unduly.

The concentration normally employed in practice is 20 to 40 per cent, but the reduction in fixing time that can be achieved by working hypo at a higher concentration is not very great. As already noted, however, ammonium thiosulphate clears many materials much more rapidly than sodium thiosulphate. If a shorter fixing time still is essential, ammonium thiocyanate may be employed. This solvent, like ammonium thiosulphate, is particularly effective with emulsions containing silver iodide. For ultra-rapid processing, thiocyanate is sometimes employed at high temperatures with specially hardened films, under which conditions it clears in a few seconds. Some of the products of fixation with thiocyanate are, however, insoluble in water and darken rapidly on exposure to light. If, therefore, permanent records are required, fixation with thiocyanate must be followed by immersion in a solution of sodium thiosulphate.

Substitutes for sodium thiosulphate

In times of scarcity, interest has been aroused in substitutes for sodium thiosulphate. The most successful method appears to be to replace part of the sodium thiosulphate by ammonium sulphate. Instead of using 400 g sodium thiosulphate crystals per litre, for example, we may use 100 g of ammonium sulphate and 250 g of sodium thiosulphate. The ammonium sulphate converts some of the sodium thiosulphate into ammonium thiosulphate, which clears film more rapidly than sodium thiosulphate. The clearing time of this bath is similar to a 40 per cent solution of sodium thiosulphate crystals – the increase in clearing time that would be expected from the decrease in the amount of sodium thiosulphate being balanced by the acceleration of clearing due to the presence of the ammonium salt.

Bleaching of silver images

The removal of silver images by bleaching is necessary in a number of processes. For example in black-and-white reversal processes the negative silver image is removed after the first development stage, leaving the originally unexposed silver halide unaffected. In chromogenic processes (see page 522) it is necessary to remove the unwanted silver image that is formed together with the dye image; in various methods of after-treatment such as intensification and reduction (see Chapter 23) bleaching of silver is also involved.

Bleaching of silver images involves the oxidation of metallic silver to silver ions which combine with other ions to form either soluble or insoluble silver compounds. In black-and-white reversal processing the negative silver image is removed by immersing the material in an acidic solution of an oxidising agent such as potassium dichromate or permanganate:

Metallic silver + Oxidising agent + Sulphuric acid →
Silver sulphate (soluble) + Reduced oxidising agent

With the exception of silver sulphate the products of the reaction tend to remain in the emulsion and may cause staining. The bleaching reaction is therefore followed by a clearing solution of sodium metabisulphite which removes these products.

Different bleach solutions are used in chromogenic processes. To remove metallic silver in these processes two basic methods are used:

(1) Conversion of metallic silver to silver bromide by the use of potassium ferricyanide as the oxidising agent in the presence of bromide ions (*rehalogenising bleach*):

Metallic silver + Oxidising agent + Bromide ions →
Silver bromide + Reduced oxidising agent

The silver bromide so formed may then be removed in a conventional fixing solution. Potassium ferricyanide is now being replaced by iron sequestrene as the oxidising agent because the latter is not harmful when discharged into streams, whereas ferricyanide decomposes under the influence of air and sunlight to give low concentrations of cyanide ion which is toxic.

(2) In some chromogenic processes (see Chapter 24) a combined bleaching and fixing solution is used (*bleach-fix* or *blix*):

Metallic silver + Oxidising agent + Thiosulphate →
Silver-thiosulphate complexes (soluble) + Reduced oxidising agent

The choice of the particular oxidising agent for use in combination with thiosulphate in a bleach-fix solution is critical. Strong oxidising agents such as potassium permanganate, dichromate or ferricyanide cannot be used because they would oxidise thiosulphate. The most commonly used oxidising agent is iron sequestrene (iron (III) ethylenediaminetetra-acetic

acid). This oxidising agent is strong enough to convert metallic silver to silver ions but does not decompose thiosulphate.

The earliest bleach fix solution to be used was *Farmer's reducer* (see page 498) which is an unstable solution based on ferricyanide and thiosulphate and is normally prepared immediately before use and then discarded. It did find use in some colour processes in which the material was first immersed in a solution of ferricyanide and then transferred to a second solution of fixer without an intermediate rinse. The ferricyanide carried over in to the fixer formed an unstable bleach-fix but this approach could only be used in one-shot processing methods. Farmer's reducer is used in after-treatment of negatives (see Chapter 23).

Washing

The purpose of the washing operation is to remove all the soluble salts left in the emulsion layer after fixing. The important salts to be removed are sodium thiosulphate and the complex silver salts. If sodium thiosulphate is allowed to remain, it can cause the silver image to discolour and fade, the sulphur in the residual thiosulphate combining with the silver image to form yellowish-brown silver sulphide. If the complex silver salts are allowed to remain they also may decompose to form silver sulphide, which will be especially noticeable in the highlights and in unexposed areas.

Flat films are best kept in their hangers and washed in a tank with a siphon. Films which have been developed in roll film tanks may usually be washed in the same tanks, as described in Chapter 17.

For efficient washing of films, plates or papers, running water is best, the reason being that this ensures that fresh water is continuously brought to the gelatin surface. In practice, this method is very wasteful, and satisfactory washing can be obtained by using several changes of water. The removal of thiosulphate from an emulsion layer is a simple process of diffusion of soluble salt from the layer to the water, the rate increasing with the difference between the concentrations of salt in the layer and in the adjacent water. If the concentration of salt in the water becomes equal to that in the emulsion layer no further diffusion of salt from the emulsion can be expected. From this, the advantage to be gained by frequent changes is easily seen. Agitation during washing is very advantageous, because it displaces water heavily loaded with soluble salt from the emulsion surface and replaces it with fresh water. For quick and efficient washing of films, six changes, each lasting for two minutes with agitation, will usually prove satisfactory. (With *extreme* agitation, three changes of half-a-minute will provide adequate washing for many purposes.) Without agitation, six changes of five minutes each may be given. The "number-of-changes" system is, in effect, employed in tanks fitted with siphon devices to give periodic emptying.

Washing is even more important with prints than with negatives, because paper emulsions are of finer grain than negative emulsions and consequently fade much more readily in the presence of thiosulphate.

Processing Following Development

Whereas in the fixation of films and plates only the gelatin layer becomes impregnated with sodium thiosulphate, with prints sodium thiosulphate permeates the base and becomes held in the paper fibres and baryta coating, from which it is very difficult to wash out. For normal purposes, washing times of 30 minutes for single-weight papers and 1 hour for double-weight papers are adequate. However, even with these times of washing, traces of sodium thiosulphate are retained in prints which are sufficient in time to cause fading under certain storage conditions, in particular high temperature and high humidity. If the highest degree of permanence of prints ("archival permanence") is required, use of a hypo eliminator is necessary (see below). However modern resin coated papers (see page 447) do not suffer from these problems and a washing time of only two minutes is used.

Since the ill-effects of faulty washing (and faulty fixation) appear only after the image has been stored for some considerable time, there is a tendency for the dangers inherent in such faulty processing to be overlooked. It is, however, most important that these stages of processing should be treated seriously; all the work that goes into the making of a photograph rests upon them.

Hypo eliminators and washing aids

Water-washing, properly carried out, is, with negative materials at least, all that is usually required for permanence. Good washing removes practically all the hypo, and, provided the negative has been properly fixed, the unwanted silver compounds too. With papers, however, a small trace of hypo may be detected in a print even after 60 minutes good washing.

When permanence is more than usually important, the last trace of hypo may be destroyed by a *hypo eliminator,* essentially an oxidising agent which converts the thiosulphate to sulphate, which is inert and soluble in water. Various hypo eliminators have been suggested, such as potassium permanganate, sodium hypochlorite, persulphate, iodine and potassium perborate, but probably the best method is to immerse the well-washed material in an ammoniacal solution of hydrogen peroxide for five minutes, following this with ten minutes further washing.

As already stated, the use of a hypo eliminator appears to be justified only when it is impossible to remove the hypo by washing, a situation which normally arises only with prints. Hypo elimination is not intended as a short cut to do away with washing.

There are, however, occasions when it is desired to shorten the washing time, and this can be achieved by the use of washing aids, sometimes referred to as "assists". These are based on an observation that the constitution of processing solutions can greatly influence the rate of removal of hypo from a photographic material during the final wash. One recommended technique is to rinse the material being processed briefly after fixation and then immerse it for two minutes in a 2 per cent solution of anhydrous sodium sulphite. By the use of this

technique, the subsequent washing time can be reduced to one-sixth of that normally required.

Tests for permanence

It is sometimes desirable to test the completeness of the fixing and washing of negatives and prints. Two tests are required: one for the presence of unwanted silver salts, the other for the presence of thiosulphate. If either of these is present the permanence of the negative or print cannot be assured.

Test for residual silver

A simple test for the presence of injurious residual silver compounds is to apply a drop of 0·2 per cent sodium sulphide solution to the clear margin of the negative or print after washing and drying (or squeegeeing). After two or three minutes the spot should be carefully blotted. If silver salts are present, silver sulphide will be formed. Any colouration in excess of a just-visible cream indicates the presence of unwanted silver salts. For careful control, a comparison standard may be made by processing an unexposed sheet of material through two fixing baths and making a spot test on this sheet. The presence of unwanted silver salts may be due to too short an immersion in the fixing bath, use of an exhausted fixing bath, or to insufficient washing.

Test for residual sodium thiosulphate

Tests for residual thiosulphate are of many kinds; some are intended to be applied to the wash water, others to the photographic material itself. A test applied to the wash water gives an indication of the readily diffusible thiosulphate in the emulsion layer, but no indication of the amount of thiosulphate held by paper fibres or baryta coating. Such tests may therefore be useful with films but are of no value with papers. With all materials, a test of the residual thiosulphate in the photographic material itself is to be preferred.

One of the usual solutions for detecting the presence of thiosulphate in the wash water is an alkaline permanganate solution. The procedure for the use of this is as follows: Dissolve 1 gramme of potassium permanganate and 1 gramme of sodium carbonate (anhydrous) in 1 litre of distilled water. Add one drop of this solution to each of two vessels, one containing drops of water from the washed film or plate and the other an equal quantity of water straight from the tap. If the colour persists for the same time in both, then washing has been satisfactory. If, however, the colour of the water drained from the washed material clears first, washing is incomplete. (The tap water control is required because tap water itself may contain substances which decolorise permanganate.)

The detection of thiosulphate in the processed photographic material may be carried out quite simply by applying one spot of a 1 per cent

silver nitrate solution to the clear margin of the negative or print after washing and drying (or squeegeeing). After 2 or 3 minutes the negative must be thoroughly rinsed to remove excess reagent, which if not removed will darken on exposure to light. If thiosulphate is present, silver sulphide will be formed where the spot was applied. Any colouration in excess of a pale cream indicates the presence of an unsafe amount of hypo. This test is suitable for use with films, plates and papers.

Drying

After washing, the film should preferably be given a final rinse for a minute or two in a bath containing a few drops of wetting agent (page 403). This will improve draining and so help to prevent the formation of tear marks on drying. The material should then be taken straight from this bath and placed to dry. Surplus moisture from the surface of the material may be wiped off with a clean, soft chamois leather or a viscose sponge dipped in water and wrung dry.

For satisfactory drying, care should be taken to avoid placing films or plates too close together, as this will prevent effective access and circulation of air, with the result that negatives will dry slowly from the edges, the centre being the last to dry which results in variation in density. This effect is probably due to variation with drying rate of the packing, or orientation, of the silver particles in the emulsion layer. Flat films and roll films are best dried by clipping them on a line in such a manner that they cannot touch one another if blown about by a draught.

Rapid drying by heat is not recommended except in properly designed drying cabinets; even if the films have been hardened, quick drying involves risk. Good circulation of clean air is much more expeditious than drying by heat. The air stream must not, however, be too violent – a steady current is all that is required. Under normal conditions, a roll film hung to dry about five feet from an electric fan will dry in about 20 to 30 minutes. Care must be taken to maintain the flow of air until drying is complete, for the reason explained above. A fan must not, of course, be used in a room where it is likely to raise dust. If there is a risk of this, it is a good plan to leave negatives to dry naturally overnight, when there is least likelihood of trouble from dust.

Where rapid drying of a large number of films is required, the use of heated drying cabinets is essential. When such cabinets are employed, it is desirable that ducting be used to lead to the outside of the building the heated moisture-laden air that emerges from the cabinet.

Films may be quickly dried by immersion for 2 or 3 minutes in a bath of industrial alcohol and water, containing not more than 80 per cent alcohol. Such a bath should be used in ample quantity and frequently renewed, as it takes up water from each film. These films can then be dried in a few minutes in a brisk current of air. Although it should be noted that, if immersion of the film in the alcohol is unduly prolonged, there may be a risk of obtaining streaky negatives, owing to action of the alcohol on plasticiser in the film base.

In large-scale processing drying is normally carried out within the processing machine. For high out-put and more rapid processing more efficient drying techniques are required. *Jet-impingement dryers* are one such example which direct air onto the film surface by slots or holes perpendicular to the surface. Other drying techniques include drying by infrared and microwave radiation.

Stabilisation processing

A method of processing in which an exposed material is developed, "fixed" without intermediate rinsing, and then dried without washing has been evolved in recent years. In this process, known as *stabilisation*, the silver halide remaining in the sensitive layer is converted into compounds which are relatively stable to light. It can be shown, in fact, that the image on an unwashed print is more stable than an incompletely washed print — although by no means as stable as a completely washed print. The fixing — or, rather, stabilising — agent employed may be ordinary sodium thiosulphate, although many other compounds have also been suggested.

Stabilisation processing has come to be widely used with the introduction of materials — in particular, papers (page 456) — in which a developing agent is incorporated in the emulsion. Such materials develop in a few seconds in alkaline solution and, by combining this rapid development with the use of a rapid-acting stabilising agent, such as ammonium thiocyanate, semi-dry prints can be produced in as little as 10 seconds. The two solutions are applied to the material by immersion or surface application, in a machine through which the material is transported by rollers.

The life of stabilised prints is not as great as that of conventionally processed prints, but they will not normally show significant fading for some months and can, in any event, be fixed by normal methods at any time after stabilisation. However modern resin-coated papers may be processed in a short time in the appropriate processing machine (see page 450) to yield stable dry prints and are gradually replacing stabilisation materials.

Uses of wetting agents in photography

Wetting agents are compounds which, when added in small amounts to liquids, enable them to spread more easily. Their use is of value whenever a dry photographic surface has to be wetted or a wet surface has to be dried. Special wetting agents are available for photographic purposes. They are particularly useful:

(1) *For minimising water marks when drying films or plates*
The washed films or plates should be immersed for about 1 minute in a bath containing wetting agent, and then placed to dry in the usual way.

(2) *For improving the glazing of prints*
The washed prints should be immersed for about 1 minute in a bath containing wetting agent, and then glazed in the usual way.

(3) *For promoting the flow of developers*
A few drops of wetting agent, added to the developer, will help to prevent the formation of airbells.

(4) *For facilitating the application of water colours, opaques, etc.*
A few drops of wetting agent should be added to the water used to make up the water colour, etc.

Photographic wetting agents are usually supplied as concentrated liquids, a few drops of which should be added to the solution concerned. Wetting agents are not usually suitable for addition to fixing baths.

19 Film Speed

TWO films are said to differ in *speed* if the exposure required to produce a negative on one differs from the exposure required to produce a negative of similar quality on the other, the material requiring the lesser exposure being said to have the higher speed. The speed of a material is thus seen to vary inversely with the exposure required, and we can therefore express speed numerically by selecting a number related to exposure.

The response of the photographic emulsion is, however, complex and speed varies with many factors, of which the following are the most important:

(1) *Exposure*

(a) The colour of the exposing light, e.g. whether daylight or tungsten light.

(b) The intensity of the exposing light. This is because of reciprocity law failure (page 295).

(2) *Development* (see Chapter 17)

(a) The composition of the developing solution – especially as regards the developing agent used and the amount of bromide or other restrainer present.

(b) The degree of development – e.g. as measured by the contrast achieved. This depends principally upon the development time, the temperature and the degree of agitation.

We must, therefore, disabuse our minds once and for all of the idea that the speed of a material can be completely expressed by any one number. Nevertheless, a speed number can provide a useful guide to the performance that may be expected from a material.

Methods of expressing speed

The problem of expressing the speed of a material numerically is one that exercised the minds of photographers and scientists almost from the beginnings of photography, but only comparatively recently has there

been produced a *speed system* which has gained anything approaching universal approval. From some points of view, the problem of allotting a speed number appears simple. It would seem, for instance, that if we wish to compare the speeds of two materials, all we have to do is to make exposures on each to yield comparable negatives, and the ratio of the exposures will give us the ratio of the speeds. It is true that we can usefully *compare* speeds in this way, but the comparison may not be typical of the relation of the two materials under other conditions, and in any case will tell us nothing about the *absolute* speed of the materials. It is in trying to obtain absolute speed numbers of general application that difficulties arise.

The problem of allotting speed numbers arose first in connection with the use of black-and-white negative materials and it is with such materials that we shall be principally concerned in this Chapter. The evolution of speed systems for colour materials followed on similar lines and is also explained in this chapter.

One of the first problems in allotting speed numbers is connected with the variation in the speed of photographic materials with the conditions of use. This problem is generally overcome by agreeing upon standard conditions of exposure and processing for the speed determination. A further problem is concerned with the *criterion* of exposure to be used as the basis for the measurement of speed, i.e. the particular conception of speed which is to be adopted. This problem arises from the fact that a negative consists not of a single density but of a range of densities. Consequently, it is not immediately apparent which density or other negative quality should be adopted as the basis for comparison. The characteristic curve is a help here, and several different points related to this curve have from time to time been suggested as speed criteria. Most of these points are related to the toe of the curve, i.e. to the shadow areas of the negative.

These criteria can be divided into five main types, as follows:

(1) Threshold.
(2) Fixed density.
(3) Inertia.
(4) Minimum useful gradient.
(5) Fractional gradient.

The underlying principles of these various criteria are outlined below. Later in the Chapter, specific speed systems which are or have been in general use — employing one or other of these criteria — are described.

Threshold systems

The threshold is the point on the characteristic curve corresponding to just perceptible density above fog — i.e. the point where the toe begins (page 268). Under the heading "threshold systems", we group those systems in which speed is based on the exposure needed to give such a density (Figure 19.1).

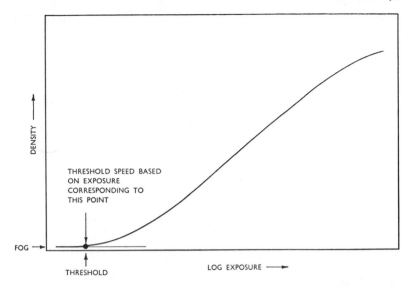

Fig. 19.1 – Threshold criterion of speed

The earliest method of expressing the speed of a silver bromide-gelatin emulsion was a threshold system evolved by Warnerke. Warnerke exposed plates through a sensitometric tablet, i.e. a step wedge, the steps being numbered with opaque figures. A candle or phosphorescent tablet was used as light source, and the last number which could be read on the developed plate was taken as indicating the speed of that plate. The Scheiner system, described later, was another threshold system.

The disadvantages of the threshold as a criterion of speed are that it is difficult to locate exactly and that it is not closely related to the part of the characteristic curve used in practice.

Fixed density

Another method of comparing film speeds is in terms of the exposure required to produce a given density above fog. For general-purpose films, a (diffuse visual) density of 0·1 or 0·2 above fog is frequently selected, to correspond roughly with the density in the shadows of an average negative. With high-contrast materials in which a dense background is required, a density of from 1 to 2 is a more useful basis for speed determination, while for materials used in astronomy, a density of 0·6 has been suggested. It will be apparent that the exposure corresponding to a specified density can be more precisely located than the threshold.

A fixed density criterion (of D = 0·1 + fog) was adopted in the first National Standard speed system, the DIN system, in 1934 (page 411), and is now employed in American, British and German Standard speed systems (pages 413–414).

407

Film Speed

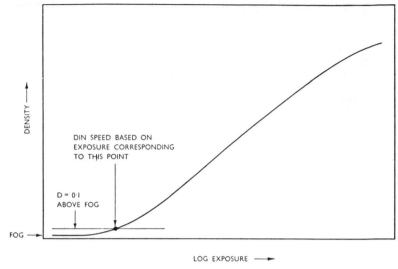

Fig. 19.2 — DIN speed criterion (fixed density)

Inertia

The inertia point was the basis selected by Hurter and Driffield for their pioneer work. Where inertia is the exposure at the point where an extension of the straight line portion crosses the extended line at the base + fog level (see page 269). Under certain conditions which were prevalent in Hurter and Driffield's day, inertia is independent of development and so offers a fixed point of reference. Further, the inertia point is related to the straight-line portion of the characteristic curve, i.e. the part of the curve in which objectively correct reproduction in the negative is obtained. With short-toe materials, as used by Hurter and Driffield, this would appear to be an advantage. With modern long-toe materials, the straight-line portion of the curve assumes less importance (page 270).

Minimum useful gradient

Threshold speed systems work at the very bottom of the toe of the characteristic curve, while systems based on inertia ignore the toe completely. Neither system approximates very closely to actual practice today, where a part — but only a part — of the toe is used. It was at one time suggested that a criterion more closely related to practice could be obtained from that point on the toe of the characteristic curve at which a certain minimum gradient is reached. A value for tan a in Fig. 19.3 of 0·2 was proposed.

The *minimum useful gradient criterion* was based on the idea that loss of tone separation in the shadows (shadow detail) is the first sign of under-exposure, and that this in turn is due to unacceptably low contrast in the portion of the characteristic curve occupied by the shadows. The

408

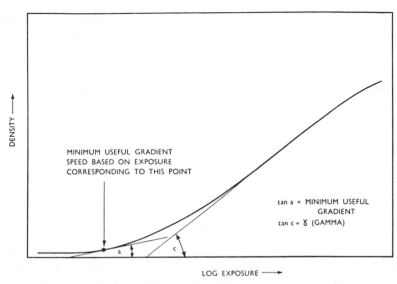

Fig. 19.3 – Minimum useful gradient criterion

minimum useful gradient criterion did not come into general use, but is of interest because it led to the more fundamental fractional gradient criterion.

Fractional gradient

Consideration of the minimum useful gradient criterion reveals that the minimum value of contrast acceptable in the shadows is not a constant, but depends upon the contrast grade of the paper on which the negative is to be printed. If the overall contrast of the negative is such that it needs a hard paper, the contrast of the negative in the shadows can be lower than with a negative requiring a soft paper. In other words, the minimum contrast acceptable in the toe depends upon the contrast of the negative as a whole. Realisation of this fact led to the conception of the *fractional gradient criterion.*

The point chosen for this criterion is the point *A* in Figure 19.4, where the slope of the tangent to the curve at *A* equals a given fraction of the slope of *AB*, the line joining the points marking the ends of the portion of the curve employed. This is usually expressed by the equation:

$$G_{min} = K \times \overline{G}$$

where $G_{min} = \tan a$
\overline{G} $= \tan b$ (provided that the Density and log exposure axes are equally scaled)
and K is a constant to be determined empirically.

Practical tests by L. A. Jones showed that a value for K of 0·3 gave results corresponding very well with the minimum exposure required to

409

Film Speed

give a negative from which an "excellent" (as opposed to a merely "acceptable") print could be made. In Jones's work, the *fractional gradient point A* was located by the equation:

$$G_{min} = 0.3 \times \overline{G} \ (1.5)$$

where \overline{G} (1·5) means the average gradient over a log exposure range of 1·5, a value which has been shown to be fairly typical for exterior scenes in daylight. When located in this way, point A is sometimes referred to as the "Jones point".

This criterion was employed first by the Eastman Kodak Company in 1939, and later adopted by the American Standards Association (in 1943) and the British Standards Institution (in 1947) as the basis for national standards.

Speed systems which are or have been in general use

So far we have described speed *criteria* only. We shall now describe the more important of the speed *systems* which are or have been in general use. The essentials of the systems described are given in Table 19.1. Through the years many systems have been evolved and discarded in turn. Some were discarded because the criterion employed was felt to be insufficiently related to practice; others because exposure and development conditions were not sufficiently well defined. The preferred systems today are those based on the American, British and German national standards. These standards have been laid down after much study of the

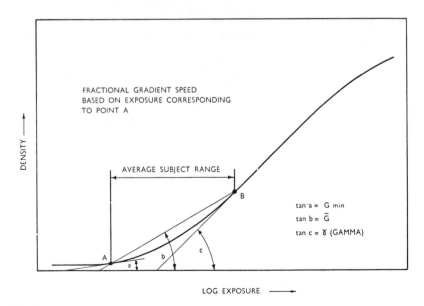

Fig. 19.4 – Fractional gradient criterion

System	Date of intro- duction	Type of unit	Speed criterion	Development
H and D	1890	Arithmetical	Inertia	Developer to be bromide free; development time not important.
Scheiner	1894	Logarith- mic	Threshold	Not specified.
DIN	1934	Logarith- mic	Fixed density (0·1 + fog)	To be continued until maximum speed is obtained (optimal development).
BS	1941	Logarith- mic	Fixed density (0·1 + fog)	To be under carefully controlled conditions giving a degree of development comparable with average photofinishing.
ASA*	1943	Arithmetical	Fractional gradient	To be under carefully controlled conditions giving a degree of development comparable with average photofinishing.
BS and ASA	1947	Arithmetical and logarithmic	Fractional gradient	To be under carefully controlled conditions giving a degree of development comparable with average photofinishing.
DIN	1957	Logarith- mic	Fixed density (0·1 + fog)	To be under carefully controlled conditions giving a degree of development comparable with average photofinishing.
ASA DIN BS ISO	1960, 1972 1961 1962, 1973 1956, 1962	Arithmetical Logarithmic Arithmetical	Fixed density (0·1 + fog)	To be under carefully controlled conditions giving a degree of development comparable with average photofinishing (see Fig. 19.5 and accompanying text).

Table 19.1 — The principal methods of expressing film speed of negative monochrome materials

various factors involved, and in compiling them experience with earlier systems has been put to good use.

DIN

In the original DIN† system (which has since been modified) the light source was a 40-watt lamp, filtered so that it approximated closely to the colour quality of daylight, and the range of exposures was given through an optical wedge of thirty steps, the exposure time being constant and

* American Standards Association (ASA) is now known as the American National Standards Institute (ANSI). However speed ratings on film packs still use the designation ASA.

† DIN = Deutsche Industrie Norm (German Industrial Standard).

equal to one-twentieth of a second. Development was continued to give maximum speed ("optimal development"), and after processing the material was examined to determine the highest wedge density which had produced a density of 0·1 above fog. The speed number allotted depended upon the density of this step. DIN speed numbers, which are logarithmic, were originally specified in fractional form (e.g. 14/10°) to distinguish them from Scheiner numbers.

Development to give maximum speed is open to the objection that such development is nearly always greater than is employed in practice, and that materials which go on gaining speed after a desirable degree of contrast is reached are given undue credit for speed in relation to other materials. This form of development was adopted because it was claimed by the Germans that precise and reproducible results could not be ensured with limited times of development without the use of elaborate apparatus for the control of temperature and agitation of the solution.

In a revision of the DIN Standard published in 1957, "optimal development" was replaced by "time-temperature" development, as in the BS and ASA methods, and the fractional form of the numbers was abandoned. Further revision in 1960–2 resulted in the DIN, BS and ASA methods all being brought into line (see below).

BS, ASA and ISO

The British and American Standard speed systems have been developed upon parallel, but not identical, lines. The original British Standard (published in 1941) employed the same fixed density speed criterion as the DIN system; the original American Standard (1943) employed the fractional gradient criterion. In 1947, the use of a fixed density criterion in the British Standard was abandoned, in the interests of international standardisation, in favour of the fractional gradient criterion.

The original British Standard specified logarithmic speed numbers, following the example of the Scheiner and DIN systems, and a formula for deriving speed was adopted which gave numbers that were interchangeable for practical purposes with Scheiner ratings. The original American Standard specified arithmetical speed numbers, to give ratings suitable for use with existing American exposure meters (Weston and GE). Following a joint revision of the two Standards in 1947, both for a number of years specified two types of rating, logarithmic and arithmetical, although the logarithmic ratings were not intended to be used in America. In the current versions of the two standards, logarithmic (to base 10) ratings have been discontinued.

The British and American Standards are designed to yield speed ratings suitable for "snapshot" work in daylight. Exposure and processing conditions, which are closely laid down, are therefore related to pictorial photography with roll films developed by the average photofinishing establishment. An intensity scale of exposures is given. The Standards both incorporate a very simple method of "time-temperature" development –

devised by S. O. Rawling – for which the necessary apparatus consists only of a vacuum flask and a thermometer.

In 1960–2, the American, British and German Standard speed systems were brought into line in all respects except for the type of speed rating employed, the American and British Standards specifying arithmetical numbers and the German Standard logarithmic ones. This agreement was made possible by work which showed that good correlation exists between speeds based on a fixed density of 0·1 above fog and the fractional gradient criterion, for a wide variety of materials when developed to normal contrast. Speed in all three systems is therefore now determined with reference to the exposure required to produce a density of 0·1 above fog density, this criterion being much simpler to use in practice than the fractional gradient criterion.

The American and British standards were further modified in 1972 and 1973 respectively. Both use the same speed criterion mentioned below but the developer solution and the illuminant specified are slightly different from those specified in the earlier standards.

The common method adopted for determining speed in the three Standards is illustrated in Figure 19.5. In this, the characteristic curve of a photographic material is plotted for specified developing conditions. Two points are shown on the curve at M and N. Point N lies 1·3 log exposure units from point M in the direction of increasing exposure. The developing time of the negative material is so chosen that point N has a density 0·80 ± 0·05 greater than the density at point M. When this condition is satisfied, the exposure corresponding to point M represents the criterion from which speed is calculated. It is for the degree of development thus obtained that the correlation between the fixed density criterion and the fraction gradient criterion that was referred to above holds good.

In the American and British Standards, speed (arithmetical) is computed by use of the formula:

$$\text{Speed} = \frac{0 \cdot 8}{E_M}$$

where E_M is the exposure in lux seconds corresponding to the point M.

In the German Standard, speed (logarithmic) is computed by use of the formula:

$$\text{Speed} = 10 \log \frac{1}{E_M}$$

where E_M is the exposure in lux seconds corresponding to the point M.

In practice the recommended values of speed in DIN are allotted to range of values in log E_M (generally within 0·09).

The International Organisation for Standardisation (ISO) also issues standards and ISO recommendations are intended to be used as a basis for national standards of the various member countries of ISO. Many of the BS and ASA standards mentioned in the chapter are in agreement, or at least in partial agreement, with ISO standards. For example ANSI

Film Speed

PH2.5–1972 for determining the speed of monochrome negative materials is in agreement with ISO 6-1974 and the British standard BS 1380: Part 1:1973 also agrees with the international standard (ISO 6-1974) provided that the ISO developer formulation specified in the standard is used for the determination of film speed. Thus there is more general agreement between the national standards and many standards for the determination of film speed are becoming more unified and accepted on an international basis.

The additive system of photographic exposure (APEX)

When a camera exposure is made, the illumination at the surface of the sensitive material is dependent primarily on the luminance of the subject and the relative aperature of the lens (Chapter 5). The effect of the exposure can, therefore, be predicted from a knowledge of these two variables, the exposure time and the speed of the sensitive material. This can be stated in the form of a camera exposure equation which takes the basic form:

$$\frac{\text{Subject}}{\text{luminance}} \times \frac{\text{Lens}}{\text{aperture}} \times \frac{\text{Exposure}}{\text{time}} \times \frac{\text{Film}}{\text{speed}} = \text{Constant}$$

The *additive system of photographic exposure (APEX)*, was a simplified method of expressing the camera exposure equation. In this system, each of the parameters was expressed in terms of the logarithm

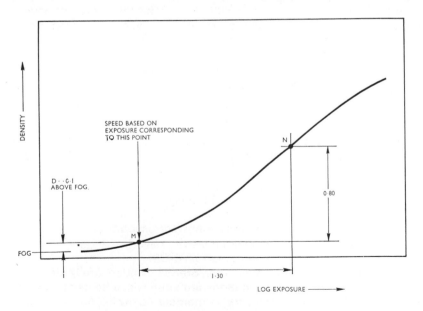

Fig. 19.5 – Method adopted for determining speed in current ASA, BS, ISO and DIN systems

414

to base 2 of that parameter. The values were assigned in such a way that the form of the equation becomes:

$$E_v = A_v + T_v = L_v + S_v$$

where E_v = exposure value
 A_v = lens aperture value
 T_v = exposure time value
 L_v = subject luminance value
 S_v = film speed (logarithmic, to base 2)

The advantage claimed for this system was that the relationships between the various parameters are expressed in a way in which they could be handled by simple addition, a set of numbers being obtained for each parameter in which a change of unity represents a doubling or halving of the corresponding quantity.

The APEX system was not generally accepted and is obsolete.

Arithmetical and logarithmic speed systems

In Table 19.1 and elsewhere in the text reference has been made to arithmetical and logarithmic speed ratings. With the former type the progression of numbers is *arithmetical,* i.e. a doubling of film speed is represented by a doubling of speed number. With the latter type of numbers − formerly distinguished by a degree sign − the progression is *logarithmic*. With the exception of the speeds used in the APEX system, logarithmic speeds are expressed on a logarithm to base 10 scale. The logarithm to base 10 of 2 is almost exactly 0·3 and logarithmic film speeds are scaled so that a doubling of film speed is represented by an increase of 3 in the speed number.

Conversion between speed systems

Because the methods of defining and determining speeds differed there was not necessarily any parallelism between the results obtained using the early speed systems, and any conversions between the various systems could therefore only be approximate.

Now, however, that a common basis is adopted in the determination of America, British and German standard film speeds direct conversion between the systems is possible as indicated in Table 19.2.

Speed ratings in tungsten light

Because the quality of tungsten light differs from that of daylight, different speed ratings may have to be used when an exposure meter is employed in tungsten light. As compared with daylight, artificial light is marked by an increase in red content and an approximately equal decrease in blue content. As all photographic materials derive a large proportion of their speed from their sensitivity to blue light (Chapter 13), some drop in speed is to be expected in tungsten light. With fully colour-sensitive (panchromatic) materials this drop in speed is quite small, and

Film Speed

may normally be ignored, but with orthochromatic materials – and even more with blue-sensitive materials – the loss is considerable. Speed ratings for use in tungsten light, for all except panchromatic materials, are therefore lower than daylight ratings.

Speed ratings of commercial films

The speed ratings printed on the boxes of films are daylight ratings of two types – ASA, ISO, BS (arithmetical) and DIN (logarithmic). The

Relative speed	American standard speed (arithmetical) (ASA speed)	British standard arithmetical speed	DIN speed
	3200	3200	36
2048	2500	2500	35
	2000	2000	34
	1600	1600	33
1024	1250	1250	32
	1000	1000	31
	800	800	30
512	650	650	29
	500	500	28
	400	400	27
256	320	320	26
	250	250	25
	200	200	24
128	160	160	23
	125	125	22
	100	100	21
64	80	80	20
	64	64	19
	50	50	18
32	40	40	17
	32	32	16
	25	25	15
16	20	20	14
	16	16	13
	12	12	12
8	10	10	11
	8	8	10
	6	6	9
4	5	5	8
	4	4	7
	3	3	6
2	2·5	2·5	5
	2·0	2·0	4
	1·6	1·6	3
1	1·2	1·2	2
	1·0	1·0	1

Table 19.2 – Conversion table between speed systems

ratings are determined on the basis of sensitometric tests confirmed by practical tests in the camera.

Speed ratings are not published for high-contrast materials such as those used in the graphic arts or for microcopying, nor for special materials such as astronomical plates and recording films. As we have already seen, any system for expressing the speed of a photographic material must take into account exposure and development conditions, and must be related to some particular criterion of correct exposure. The systems in general use for ordinary photographic materials cannot be applied to high-contrast or special materials since the conditions of exposure and development are quite different.

The prefix ASA, BS, DIN or ISO implies that the photographic material has been exposed, processed and measured and evaluated exactly in agreement with the appropriate standard. Some manufacturers quote an "exposure index" for materials for which there is no standard such as those mentioned in the preceding paragraph. An exposure index value is a suggested value for use with exposure meters calibrated for ASA, BS, ISO or DIN speeds. Exposure index values are those suggested by the manufacturer's testing procedures and conditions which are useful guides for determining camera settings.

Speed ratings for specialised applications

Various criteria have been adopted for certain more specialised uses of photographic materials such as copying, aerial photography, printing, cathode ray tube recording etc. These are included in Table 19.3 together with the criteria on which they are based:

Name and application	Speed point	Formula
Copying index. Copying of line and continuous tones where bright objects must record at high density	Fixed density 1·2–1·7 above gross fog	$S = \dfrac{1}{E}$
Aerial film speed. Air to ground photography with aerial films	Fixed density 0·3 above gross fog	$S = \dfrac{1 \cdot 5}{E}$
Printing index. Comparison of sensitivities of printing papers and for estimating exposures when printing onto different papers	Fixed density 0·6	$S = \dfrac{1000}{E}$
CRT exposure index. Comparison of sensitivities of films for CRT recording	Fixed densities, 0·1, 1·0 and 2·0 above gross fog	$S = \dfrac{3}{2E}$
Photorecording sensitivity. Comparison of sensitivity of photorecording emulsions	Fixed density 0·1 above gross fog	$S = \dfrac{45}{E}$

Table 19.3 – Speed systems for some specialised applications (E = exposure in lux-seconds)

Film Speed

Speed ratings for colour materials

Colour negative film

The principles of speed determination for colour negative films follow those previously described for monochrome materials. However, speed determination is complicated by the fact that colour materials contain layers sensitive to blue, green and red light and the standards involve averaging the speeds of the three sensors. The British standard (BS 1380: Part 3: 1975) adopts fixed density criteria for locating the speed points of the three layers, exposed in a defined manner and processed according to the manufacturer's recommendations after storage at $20 \pm 5°C$ for no more than between 1 and 10 days. Blue, green and red densities are measured (see Chapter 15) and the characteristic curves shown in Figure 19.6 are plotted.

On these characteristic curves the points B, G and R are located at densities of 0·15 above the minimum densities for the blue, green and red sensitive layers. The log exposure values corresponding to these points are log E_B, log E_G and log E_R respectively. The mean exposure, E_M is then calculated from two of these values (E_G and the slowest layer, normally the red sensitive layer E_R) according to the following formula:

$$\log E_M = \frac{\log E_G + \log E_R}{2}$$

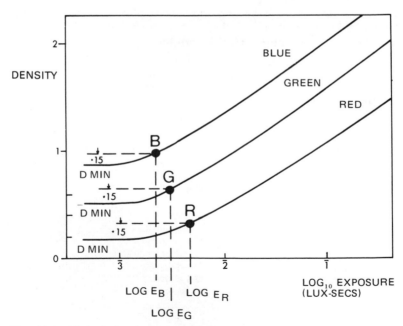

Fig. 19.6 – Methods for determining speed of colour negative films (BS 1380: Part 3: 1975)

The arithmetical speed is then calculated from the value of E_M by the formula:

$$\text{Speed} = \frac{\sqrt{2}}{E_M}$$

where all exposure values are in lux-seconds.

The corresponding American standard for determining the speed of colour negative films (ANSI, PH2.27-1965) adopts slightly different criteria. On the characteristic curve for the green sensitive layer shown in Figure 19.7 the point A is located at a density of 0·10 above the minimum density. Point P is located on the curve at 1·3 log exposure units from point A in the direction of greater exposure. The density difference between points A and P is evaluated ΔD_G. The speed points B, G and R are located on their respective curves such that they are $0·2\Delta D_G$ above the minimum density (D_{min}) for the appropriate curve. The log exposure values corresponding to these points are respectively log E_B, log E_G, and log E_R, from which the average value (log E_M) is calculated by the following formula:

$$\log E_M = \frac{(\log E_B + \log E_G + \log E_R)}{3}$$

The speed is derived from the above mean exposure value (E_M) as:

$$\text{Speed} = \frac{1}{E_M}$$

where exposures are in lux-seconds.

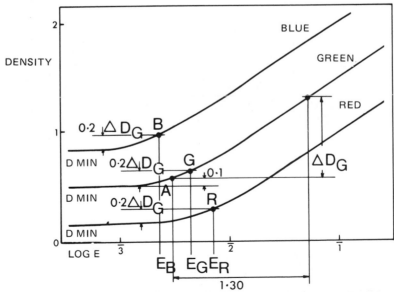

Fig. 19.7 – Method for determining the speed of colour negative films (ANSI, PH2.27–1965)

Film Speed

Colour reversal film

For colour reversal films both American and British Standards adopt the same criteria for the determination of speed (ANSI, PH2.21-1972 and BS 1380: Part 2: 1974). However unlike the previously described standard for colour negative films that for colour reversal films involves measurement of *diffuse visual density* (see page 265) and the plotting of a *single* characteristic curve shown in Figure 19.8. Films are exposed in a defined manner and processed according to manufacturer's recommendations. For the determination of speed two points (*H* and *S*) are located on the characteristic curve of Figure 19.8. Point *H* is 0·20 above the minimum density. From point *H* a straight line is drawn such that it is a tangent to the shoulder of the curve at point *S*. However if it happens that the shape of the curve is such that point *S* is at a density greater than 2·0 above the minimum density then point *S* shall be taken as that point on the curve at which the density is 2·0 above the minimum density.

The log exposure values (log E_S and log E_H) corresponding to points *S* and *H* are read from the curve and their mean value (E_M) calculated:

$$\log E_M = \frac{\log E_S = \log E_H}{2}$$

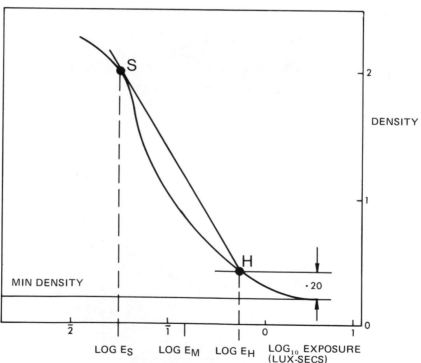

Fig. 19.8 – Method for determining the speed of colour reversal films (ANSI, PH2.21–1972, BS1380: Part 2: 1974)

420

from which the speed may be calculated:

$$\text{Speed} = \frac{10}{E_M}$$

All exposure values are in lux-seconds.

This method of speed determination for colour reversal films for still photography is also in agreement with the international standard ISO 2240-1972.

Practical value of speed numbers

The only useful speed number in practice is one which adequately represents the speed of a material under the conditions in which it is likely to be used. Published speed numbers aim at providing exposures which will secure a printable negative under a wide range of conditions. The published number for a given material cannot therefore be the best to use under *every* condition.

It follows that the serious photographer should determine for himself speed numbers for each type of material he uses, to suit his own equipment, developing conditions and desired image quality. Published speed numbers provide a valuable starting point for such a determination. But, when the photographer has selected the number that suits his needs, he should remember that this number is no more "correct" than the published one — except for his own conditions of working.

The effect of development conditions on speed for negative and reversal materials has been discussed on page 378.

20 Camera Exposure Determination

IN EARLIER Chapters we have considered the part played by the camera lens in forming an image, and have also studied the response to light of photographic materials. When we "make an exposure" we are permitting light to pass through the lens to form an image on the film, which the latter records. In any given circumstances (subject, lighting, film etc.), the densities produced upon the film – which govern the quality of the prints which are subsequently made from it, and the ease with which these are made – depend upon the intensity of the light which is permitted to pass through the lens to the film and on the time for which this light is allowed to act. These two factors are controlled by the *camera exposure*, i.e., the combination of lens aperture and shutter speed employed. Determination of a suitable camera exposure is therefore important whenever any photograph is taken.

Let us look at this in more detail. We saw in Chapter 15 that any subject comprises a range of varying luminances, so that when a photograph is taken the film actually receives a range of exposures – using the word "exposure" in the sense of illumination × time. The range of densities produced by these exposures depends first on the characteristic curve of the film, which is governed by the particular film used and the development conditions employed, and secondly on the placing of the range of exposures on this curve. The placing is determined principally by the following factors:

(1) Luminance of the different parts of the subject.
(2) Lens aperture (*f*-number).
(3) Ratio of reproduction.
(4) Filter factor (if any) under the particular working conditions.
(5) Shutter speed.

The first four of these factors together determine the illumination falling on the film; the last factor determines the time for which this light is permitted to act. Other, usually less important, factors affecting the illumination on the film are lens transmission, flare and off-axis losses due to \cos^4 law and vignetting (Chapter 5).

The basic need in the determination of camera exposure (by any method except practical trial) is a knowledge of the luminance of the different parts of the subject. This, in turn, depends upon the illumination on the subject and its reflection characteristics. If the luminance of the subject is known we can readily make allowance for the other factors determining camera exposure (type of film, development, lens aperture, ratio of reproduction, filter factor, shutter speed), since these are known quantities.

Here, we may note that for a given camera exposure there is usually a range of combinations of lens aperture and shutter speed which may be used. Sometimes, the nature of the subject is such that achieving a suitable exposure time is the most important factor, after which the aperture is adjusted so that the correct amount of light reaches the film during the time that the shutter is open. This applies particularly with moving subjects, where it is often desirable for the shutter speed to be sufficiently fast to freeze any movement of the subject. On other occasions the aperture may be the most important factor, e.g., to obtain suitable depth of field, and the exposure time must then be chosen to fit in with the particular aperture selected. Sometimes we are able to vary the illumination on the subject in order to obtain a suitable aperture and exposure time. This applies especially to work by artificial light.

Correct exposure

The greater part of the Chapter will be taken up with a consideration of ways by which we may obtain a knowledge of the luminance of the subject, and from this find the required camera exposure. Before proceeding to this we need to remind ourselves that whichever method of exposure determination we adopt, the criterion of the correctness of exposure rests finally upon the printing quality of the resulting negative. A *correctly exposed negative* may be defined as the one that will yield an excellent print with the least difficulty. Judging negative quality requires considerable experience, because the values of density required in any given circumstances depend on the printing material to be employed and on the printing conditions; they are also to some extent influenced by personal preference. As a guide it may be said that a correctly exposed (continuous-tone) negative will generally have some – but not excessive – detail in the shadows, with highlights which just permit print to be read through them when the negative is laid on a newspaper in good light.

We saw in Chapter 15, that, provided the luminance range of the subject is not excessive, there are usually several exposures capable of giving good results, the ratio of the longest to the shortest being termed the *exposure latitude.* If we give an exposure outside the permissible latitude, negative quality will suffer. Thus, if the exposure is too short, shadow detail will be lost; we term this *under-exposure.* If the exposure is too long, highlight detail will be lost and the negative may suffer from excessive graininess and poor resolution; we term this *over-exposure.*

Although, by definition, all the exposures within the latitude of the film

423

will yield good negatives, they will not yield identical negatives. For example, with the minimum acceptable exposure, a subject of average range is generally located almost entirely on the toe of the characteristic curve. The negative is low density and of low contrast. Being thin, has the advantages that it requires a short printing time and enables the printer to see clearly what he is doing when enlarging. But, being of low contrast, it almost certainly requires a hard grade of paper for printing, and while this may not be a disadvantage in itself it means that if for any reason we give insufficient development the negative may be too low in contrast to be printed. Further, if we miscalculate in exposure, we run the risk of under-exposure, with consequent loss of shadow detail.

If we given the maximum acceptable exposure, a subject of average range is generally located almost entirely on the "straight-line" portion of the characteristic curve. This negative is of high density and may be of high contrast. Being dense, it requires a long printing exposure and may prove trying to enlarge. If it is high in contrast, it requires a soft grade of paper for printing, and, while this may not be a disadvantage in itself, it means that, if for any reason we over-develop, the negative may be un-printably contrasty. On the other hand, if we aim at this denser type of negative we can be more sure of a picture of some sort, even if we mis-calculate, than if we aim at a very short exposure – and miss. In practice, we have to strike a mean between the minimum and maximum accep-table exposures.

Such an exposure normally places an average subject partly on the toe and partly on the straight-line portion of the characteristic curve (Figure

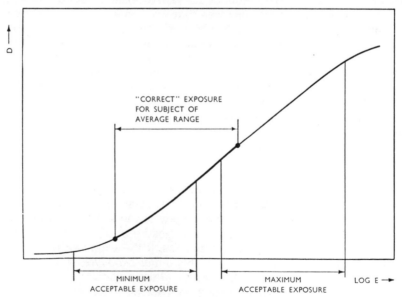

Fig. 20.1 – "Correct" exposure for an average subject

20.1) and corresponds closely with our earlier definition of a correctly exposed negative.

With a subject of exceptionally short luminance range the best placing is usually as shown in Figure 20.2. This results in the shadows having rather more density than in the negative of the average subject, but the highlights have less density. If the negative of a short-range subject is exposed so as to produce similar shadow density to the negative of the average subject, it will be located entirely on the toe of the curve and will normally be undesirably low in density range.

With a subject of exceptionally long luminance range the best placing is usually as shown in Figure 20.2. This results in the shadows having less density than in the negative of the average subject, but the highlights have greater density. If the negative of a long-range subject is exposed so as to produce similar shadow density to the negative of an average subject it is likely to have too great a density range, and detail in the highlights may suffer.

Exposing for the shadows

In the early days of photography, the rule of exposure in negative making was "expose for the shadows and develop for the highlights". This rule applied when negatives were treated individually and developed by inspection. Also it was essential to produce negatives from subjects of widely different luminance ranges that would print satisfactorily on the single grade of paper then available.

However this rule is much less applicable today than formerly. Development nowadays is carried out by the time-temperature method. Also one negative material is normally used for a wide range of subjects, in particular when using roll film cameras. Consequently, the characteristic curve of the negative material is usually fixed. Fortunately, today a wide range of paper grades are available that cater for negatives of varying density range, but, nevertheless, for various reasons, the aim is usually to produce negatives that print on a "normal grade" of paper.

In many cases we can adopt the rule, "expose for the shadows and let the highlights take care of themselves". With subjects of normal luminance range this usually leads to negatives of suitable quality. Negatives of subjects of very short range, exposed in this way, are however, usually on the soft side. Better contrast with such subjects is achieved by giving two to three times the exposure based on the shadows. On the other hand, with subjects of extremely high luminance range with important highlight detail, better results are usually achieved by giving one-half to one-third of the exposure based on the shadows (see Figure 20.2).

"Expose for the shadows and develop for the highlights" is still, to some extent, applicable today when negatives are developed individually, but if this rule is adopted it must not be overlooked that with most modern materials shadow density as well as highlight density is influenced by the degree of development.

For correct exposure of colour negatives similar criteria apply together with certain extra considerations. Colour negatives should receive a minimum exposure to locate the shadows on the straight-line portions of the characteristic curves so that both tone and colour are correctly reproduced. The highlights can be reproduced at any points on the characteristic curves provided that they are still on the straight-line portions of the curves. However, the tone range that a colour print is able to reproduce is more limited than that of a black-and-white print because tone distortions that appear acceptable in black-and-white prints are unacceptable in colour. This is due in part to the fact that in the colour negative-positive system two separate stages occur in which errors in colour balance can accumulate and, in part, to a psychological effect that colour distortions are more apparent than tone distortions. For example if the shadow colour is distorted relative to mid-tone colour in the colour negative, these distortions tend to be exaggerated in the colour print and may appear unacceptable. Such distortions cannot be corrected at the printing stage by the use of filters because filters can correct only for overall colour casts (see page 483).

Colour negatives are almost always developed for a fixed time at a specified temperature to yield negatives of a fixed contrast and different grades of colour printing paper are not available. Thus modification in processing or selection of a "suitable" grade of colour paper to accommoderate scenes of especially short or long luminance ranges is not possible.

Exposure of reversal materials

In this Chapter so far we have been concerned solely with the camera exposure for negative materials. The methods used for the determination of exposure for reversal-processed materials (page 376), whether black-and-white or colour, are generally similar to those used for negative materials, and the "fundamental" method (see page 429) of determining exposure, that of measuring the luminance of both shadows and highlights and placing these on the curve in the most suitable positions, remains unaltered.

There is, however, one important difference between reversal and negative materials. With a transparency, the one fixed factor is the highlight end of the tone range, which is set by the clear film. When, therefore, a simpler method of exposure determination is required than the "fundamental" method (see page 429), the best part of the subject on which to base exposure is the highlights. If the exposure is such that there is just perceptible density in the highlight areas of the resulting transparency, the shadows will "take care of themselves". This procedure produces satisfactorily exposed transparencies of most subjects. With light subjects, with no important dark areas, some improvement is usually obtained by reducing the indicated exposure by one-half to one stop. On the other hand, when dealing with dark subjects, with no important light areas, the exposure should be increased by one-half to

one stop. Subjects falling in these two classes however, are usually few.

When using an exposure meter it is not usually convenient to measure the luminance of the highlights of a subject directly. However, a close approximation to this can be obtained by using the meter by the incident-light method (see page 432). As the highlights of most subjects are white or near-white in tone, it is apparent that a measurement of the illumination on the subject provides in effect a measurement of the luminance of the highlights. The incident-light method of using a meter is therefore of particular value in reversal work.

Exposure determination using photographic material

One reliable way of determining exposure is to make a series of trial exposures, e.g. in the form of a "test strip", and then assess the results. This method has the advantage that it automatically takes into account variations in the performance of equipment, materials etc. It is of especial value for studio work, in particular for copying, but is usually impracticable for work away from the studio.

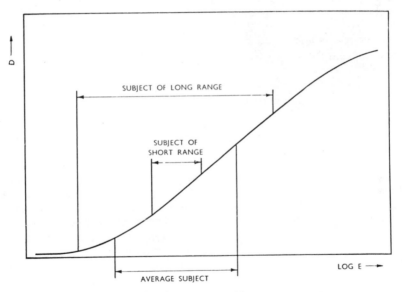

Fig. 20.2 – "Correct" exposure for short-range and longe-range subjects

The principle of the "test strip" method when using large-format cameras is that the dark-slide cover is used as a shield by means of which progressively increasing exposures are given across the film. A suitable series of exposures is 2, 4, 8 and 16 seconds, or 5, 10, 20 and 40 seconds. The "2, 4, 8, 16" series is obtained by exposing the whole film for 2 seconds, then closing the shutter and pushing in the dark-slide cover to obscure one-quarter of the film. A further 2 seconds exposure is

given, the shutter closed, and the dark-slide cover pushed in to cover one-half of the film. A further 4 seconds exposure is given, the shutter again closed, the dark-slide cover moved to cover three-quarters of the film and a final 8 seconds exposure is given (Figure 20.3). Care must be taken to allow the camera to become perfectly stationary before each exposure. A "5, 10, 20, 40" series is obtained in a similar way, the four exposures in this case being 5, 5, 10 and 20 seconds.

For 35 mm cameras the same principle can be adopted by exposing successive frames for 2, 4, 8 and 16 seconds or other appropriate series of exposure times.

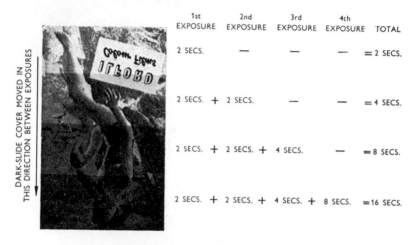

	1st EXPOSURE	2nd EXPOSURE	3rd EXPOSURE	4th EXPOSURE	TOTAL
	2 SECS.	—	—	—	= 2 SECS.
	2 SECS. +	2 SECS.	—	—	= 4 SECS.
	2 SECS. +	2 SECS. +	4 SECS.	—	= 8 SECS.
	2 SECS. +	2 SECS. +	4 SECS. +	8 SECS.	= 16 SECS.

DARK-SLIDE COVER MOVED IN THIS DIRECTION BETWEEN EXPOSURES

Fig. 20.3 – A processed test strip for determining camera exposure

Another important method that also involves exposing photographic material is by the use of a "self-developing" material (see page 378) such as Polaroid–Land film of known speed rating as a means of determining or verifying the correct exposure. This method finds application when large format colour film is to be exposed in a studio or on location where mistakes are expensive in terms of model fees, travel expenses, material consumed etc. The correct exposure can be found by exposing the self-developing material in an appropriate film holder and examining the image – or images if a series of exposures are made – immediately after exposure. Differences in speed between the self-developing material and the colour film can either be taken into account by simple calculation or an appropriate neutral density filter may be used when carrying out the test exposure that enables the self-developing film to be rated at the same speed as the colour film.

This method has the additional advantage that lighting, reflections, positioning of the subject etc., can be checked in a photographic record in which any faults may be more obvious than when looking at an image on the ground glass screen.

Exposures are, however, more generally determined by measurement with an exposure meter, although some photographers are able to base exposure on experience. Also many amateur photographers rely exclusively on exposure tables that are provided in the instructions with the film or in the form of a simple calculator on the camera itself. Exposure tables or calculators also find application in flash photography (see page 438) and in photography by artificial light where many tables and calculators have been devised for specific purposes and different types of lighting. They vary in detail, but follow the same general pattern, making allowance for type and power of lamps (depending on wattage and efficiency), reflector efficiency, distance and direction of lamps.

Even with these aids, there are occasions when we are unable to be absolutely sure of the best exposure to give. If the photograph is important we must then resort to "bracketing", i.e. the making of a series of exposures. For this purpose it is useful to make three exposures, one at the most likely value and the other two a stop or so on either side of this.

Exposure criteria

The basic principle behind the design and use of exposure tables and exposure meters is that of measuring the luminance of part or parts of the subject and using this information to locate the subject in a suitable position on the characteristic curve.

To locate subjects of all types in the best position on the curve, we require fundamentally to know the luminance of the darkest part of the subject in which detail is required and the luminance of the brightest part of the subject in which detail is required. A double exercise of judgement is thus required of the photographer. In the first place, he must decide on the darkest and brightest areas in which he requires detail; this choice is governed to some extent by aesthetic considerations. Secondly, the photographer must decide where these areas can be most favourably located on the characteristic curve. This choice is determined principally by the requirements of the printing process. In view of the many "links" in the chain, the best location of the shadows and highlights on the curve is usually found more readily by practical trial under the photographer's own conditions, than from sensitometric considerations.

This "fundamental", or "luminance range", method of exposure determination is somewhat complicated and is not very suitable for use under everyday working conditions. Other exposure criteria which, if less exact, are simpler to apply are therefore usually adopted in ordinary photographic practice. These criteria include:

(1) Luminance of darkest object.
(2) Luminance of brightest object.
(3) Luminance of selected object intermediate between shadows and highlights ("key" tone or "spot" measurement).
(4) Integrated effect.
(5) Incident light.

Descriptions of each of these criteria are given below. They all represent attempts to obtain a simpler method than the "fundamental" one, while still retaining a useful degree of precision, and each method has its own advantages. Because, however, these methods are necessarily compromises, it is important that when we adopt any of them we should be quite sure of both (a) what we are measuring, and (b) what we must allow for.

Measurement of luminance of darkest object

In this method the darkest object in the subject is located at a fixed point on the toe of the characteristic curve. This ensures that there is a little, though not excessive, density in the shadows, and that all the other tones of the subject are recorded as progressively increasing densities. The method has the advantage that it appears simple, but it suffers from serious drawbacks. In the first place, measurement of the luminance of the darkest object in a scene is usually a difficult one to make because most measuring devices are limited in their sensitivity at low luminances. Secondly, when making the measurement it is not always easy to prevent stray light from the brighter parts of the subject from bring included. Thirdly, the method tells us nothing about what happens to the highlights, and, as will be apparent from our earlier discussion, with subjects of long luminance range it may lead to loss of highlight detail and with subjects of short luminance range to too low contrast.

Measurement of luminance of brightest object

In this method the brightest object in the subject is located at a fixed point on the characteristic curve. This enables the density in the highlights to be controlled at a suitable level, and the other tones in the subject are recorded as progressively decreasing densities. The method tells us nothing about what happens to the shadows, but by placing the highlights well up on the curve it is possible to ensure that detail is obtained in the shadows of all but the most contrasty subjects. This usually means, however, that the average subject receives more exposure than is readlly desirable.

Measurement of luminance of selected object intermediate between shadows and highlights ("key" tone or "spot" measurement)

In this method a selected object, or "key" tone, is placed at a fixed point on the characteristic curve. The method ensures a favourable rendering of an important tone. In much work where the method is adopted the "key" tone selected is a flesh tone. The key-tone method is of greatest applicaion where lighting is under the control of the photographer, so that both highlights and shadows can be lit in such a way that they too are suitably recorded. The method may be employed, after suitable prac-

tical trial, in any class of work in which it is desired to record a selected tone at a given level.

Measurement of total amount of light coming from the subject ("integration" method)

This method is the one most widely used in everyday photographic practice and is adopted in many SLR cameras although spot or "key" tone measurements may also be used in some models. It consists in taking a reading by directing a meter at the subject as a whole. Despite its popularity, this method is open to serious objection on theoretical grounds, because the reading obtained bears no direct relationship to the luminance of either the shadows or the highlights of the subject, or to any selected tone. With subjects having identical luminances at the two ends of the scale, but different luminance distributions, the readings obtained using the meter by the "integration" method may differ widely, although both subjects require the same exposure. Nevertheless, the simplicity of this method makes it attractive, and, as we have stated, it is widely used. Its fair degree of success is due partly to the statistical relationship between the total amount of light reflected from a subject and the amounts reflected from the deepest shadows and highest highlights, and partly to the fact that the useful exposure range of modern negative materials is generally much greater than the luminance range of the average subject. Nevertheless, it we use this method we should be alive to its limitations, and to the fact that it is liable to let us down from time to time.

For example when taking a photograph against the light an integrated reading indicates a short exposure. The subject is underexposed and appears in silhouette unless allowance is made for the "false" meter reading. Similar errors in exposure determination occur in photographing scenes that depart appreciably from the "normal" which is taken as 18 per cent reflectance (a mid-grey or mid-tone). Examples of such scenes include those with large areas of shadows and small highlight areas and vice versa. The former have less than 18 per cent reflectance and the latter more than 18 per cent reflectance. Depending on which area of the scene is of the greater interest an adjustment of the indicated exposure is required.

The substitution method

In the substitution method the reading is not taken from the scene but from a suitable object which has the same reflectance as that inaccessible part of the scene in which the photographer is most interested. Most suitable objects are papers or cards of tones ranging from white to black, one of which will almost certainly match the area of interest of the scene. The matching tone is used as the subject and the meter reading taken with the meter sufficiently close to the card so that the card completely occupies the field of view of the meter cell. The meter reading is taken

from the same position that the eyes occupied when the match was made. This method may be regarded as a cheap alternative to spot or key tone measurements or to measurements of the luminances of shadows and highlights because a normal photographic exposure meter is used rather than a meter with a narrow acceptance angle.

Measurement of light incident upon the subject

In the "incident-light" method, the light falling on the subject is measured, instead of the reflected light; i.e. we are measuring illumination rather than luminance. With a suitably designed meter the measurement is an easy one to make. This method results in the placing at fixed points on the characteristic curve of all surfaces in the subject that are directly illuminated by the major light source. Like measurement of the luminance of the brightest object (see above), measurement of the light incident upon the subject tells us nothing about the shadows.

Where reference is made to the incident-light method today it is implicit that the illumination measured is the maximum illumination. This method of exposure determination was first suggested by P. C. Smethurst in 1936.

Exposure meters

Nowadays, many photographers like to get as much assistance as possible in determining exposures. Measuring devices that are available to assist the photographer in the determination of correct exposure fall into two main categories:

(1) Exposure meters
(2) Exposure photometers.

Each of these types of meter is described in detail below. No meter entirely eliminates the need for personal judgement; to get the best out of any instrument it is necessary to understand what it is doing and how to make allowance for factors with which it may be unable to deal unaided.

Exposure meters

An exposure meter consists essentially of a light-sensor, a device to limit the acceptance angle, a galvanometer and a calculator from which the necessary exposure can be derived from the scale reading in terms of exposure time and lens aperture for a given film speed.

Modern exposure meters for use in professional and technical photography are available as a system with various attachments for making different types of measurements for specific purposes. Typically these may include attachments for taking spot readings of selected small areas of the subject, a diffuser for taking incident light readings and a fibre optic probe for taking measurements from small areas of the image on the ground-glass screen of a technical camera.

Exposure meters use two main types of sensor: those that generate electrical current and those acting as variable resistances in response to light falling on them. Meters using the photo-resistor types of sensor need a battery and are the most common type today although a new type of self-generator – silicon blue – is becoming increasingly important. The earlier types, generally using selenium as the sensor, are self generating, i.e. when light falls on the light-sensitive surface a potential difference is set up between two layers in a barrier layer cell. As a result, the needle of the galvanometer – which is connected in series with the cell – is deflected, the deflection giving an indication of the total amount of light falling on the cell. A baffle is needed to limit the acceptance angle, because the cell reacts to all the light that falls on it, from whatever direction. For a meter that is to be used from the camera position, the acceptance angle should preferably not exceed the angle of view of the camera; otherwise, light coming from outside the area being photographed may influence the meter reading.

A limitation of the selenium meter is that its sensitivity is limited. Increased sensitivity can be obtained by using a larger cell and/or a galvanometer that is more sensitive than those normally employed, but the instrument is then more costly and probably more delicate. Alternatively, the angle of acceptance of the meter may be increased, but then the readings of the meter are less useful – in particular, the sky will affect them. As a compromise, the baffle is sometimes made oblong in shape, i.e. wider in the horizontal direction. In the Weston meter, the angle of acceptance for normal used (high light-levels) is 50°, i.e. close to the average camera angle. When the low-light-level scale is used, the angle of acceptance is increased to 70°, to assist in obtaining the desired increase in sensitivity.

The sensitivity of some meters using selenium may be increased by means of a special "booster" element containing an additional cell. This is attached to the meter when it is required to take readings at very low light levels. In one such meter an increase in sensitivity of about four times is obtained by use of a booster.

The most widely used photo-resistor in exposure meters is cadmium sulphide (CdS). Strictly, this is a photo-conductor, i.e. when light falls on the sensor its electrical resistance drops. If, therefore, the sensor is connected in series with a small battery and a galvanometer, the deflection of the needle gives an indication of the amount of light falling on the light-sensitive surface.

In some cases the needle is replaced by a luminous readout supplied by light-emitting diodes (LEDs) or similar devices.

The main advantage of cadmium sulphide over selenium is that the cadmium sulphide cell has a much higher sensitivity. It has the disadvantage of needing a battery. The later silicon-type meters suffer from the same disadvantage but for a different reason. The cell is self-generating but the current generated is so small that a battery-powered amplifier has to be used. The advantage of silicon is that it reacts almost immediately to changes in light, whereas cadmium sulphide needs time to

give a settled reading, particularly in low light. Cadmium sulphide is also affected by strong light to such an extent that it may not be able to give a correct reading in lower light for a period of a few minutes or more. It is said to have a "memory". Silicon blue photodiodes are superior to CdS cells in terms of their immediate and linear response, and high sensitivity. In silicon blue photodiodes the natural spectral sensitivity of silicon is restricted to the visible spectrum by the use of filters. Typical circuitry for selenium, cadmium sulphide and silicon sensors are given in Figure 9.7 (page 176). There are several methods by which an exposure meter may be used. The one adopted in any given circumstances depends on the type of material being used, the degree of sensitivity required, or simply, on convenience. The following are the three most commonly used methods:

(1) *Measurement of total flux (integration method)*. This is the general method for which the scales of practically all exposure meters are calibrated. It consists of taking a reading, from the camera position, of the total amount of light coming from the subject, the calibration of the meter being based on an assumed average subject. As we have already stated (page 431), this method, while theoretically unsound, gives usable results, although it may fail on difficult subjects. When taking readings on outdoor scenes by this method the meter should preferably be held with its axis pointing slightly below the horizontal, to prevent the sky from exerting an undue effect on the readings. If the angle of acceptance of the meter is larger than the camera angle, readings should preferably be taken, not from the camera position, but from a point nearer the subject – to ensure that it fills the angle of acceptance of the meter.

A slight variant of the integration method, which aims at avoiding the most gross errors to which it is prone, is to take close-up meter readings of the brightest and the darkest parts of the subject in turn, and base the exposure on the point lying in the middle of the two readings.

(2) *Measurement of light incident on the subject.* This measurement may be made in two different ways:

(a) By directing a suitable meter at the camera position.
(b) By taking a reading of the light reflected from a white (or grey) card placed to receive the maximum incident light, and making allowance for the reflection factor of the card.

Method (a) requires the use of special "incident-light" attachment, i.e. a diffusing medium over the sensor. Method (b) can be adopted with an ordinary reflected-light meter; a piece of white blotting paper makes a very suitable white card. This method is sometimes called the "artificial highlight" method or "substitution method". Both methods are particularly suitable for work where the placing of the highlights is the principal factor governing exposure, as, for example, in reversal work (page 381).

(3) *Measurement of luminance of most important area of subject*

("key" tone or "spot" reading). This method may be used where one particular tone, e.g. a flesh tone, constitutes the most important part of the subject. Where the method is used in portraiture, the procedure is to take a reading on the highlight side of the face. The key-tone method can be applied in most branches of photography by choosing the most important area and deciding on the grey in which it is to be recorded. For this method to be of maximum value, the lighting of the subject must be carefully controlled, so that both shadows and highlights are suitably recorded.

It is not usually convenient to measure the luminance of either the shadows or the highlights with an exposure meter. To do so, the subject must be approached until the shadow or highlight area fills the angle of acceptance, and the meter is then usually so close to the subject that it obstructs the incident light unless the meter is provided with a "tele" attachment for taking spot readings. In addition, at the shadow end, the luminance of the subject is usually so low that it may be difficult to obtain a significant reading.

The simplest exposure meters are calibrated for the integration method only. More elaborate meters are provided with a diffuser so that the meter may be used in addition as an incident-light meter. With some meters, such as the Weston, the diffuser is supplied separately from the meter. The Weston meter is calibrated for all of the methods described above.

The first exposure meters were completely separate from the camera. Later, smaller meters were designed to fit the accessory shoe of a camera and then, inside the camera and coupled to the lens diaphragm or shutter speed controls so that the camera exposure is set automatically (or semi-automatically) as the camera is pointed toward the subject. Finally, as smaller sensors became available the meters were able to read the light transmitted by the lens and, again, set aperture and/or shutter speed automatically (see Chapter 9). Notwithstanding these developments, separate exposure meters are still widely used and offer a greater flexibility in use which is of value in many types of photography.

Exposure photometers

A *photometer* is an instrument that enables the luminance of an object to be measured by comparison with a surface of known luminance. With a photometer, the luminance of any area of the subject may be measured even at quite low values. A *telephotometer* is a photometer incorporationg a telescope to enable reading to be taken from the camera position, however far away the subject may be. In practical photography, a telephotometer is much more useful than an ordinary photometer.

The idea of the telephotometer is not new, but for a long time the standardisation of the luminance of the reference surface presented a difficulty. In the S.E.I. (Salford Electrical Instruments Ltd.) Exposure Photometer the problem is overcome by the use of a photo-electric cell in a circuit which enables the light output of the standard lamp to be

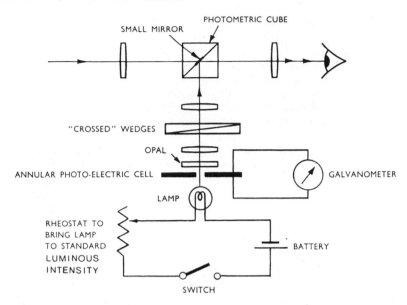

Fig. 20.4 — Simplified arrangement of the S.E.I. Exposure Photometer

measured, and, if not at the required level, brought back to standard by a rheostat in the lamp supply circuit. The S.E.I. Exposure Photometer is illustrated diagrammatically in Figure 20.4.

Although a telephotometer can be used to measure the luminance of any part of a subject, when employed for exposure determination it is generally used to measure one of the following:

(a) Luminance of the darkest shadow.
(b) Luminance of the brightest highlight.
(c) Luminance of a selected "key" tone, e.g. a flesh tone.

The S.E.I. exposure photometer is specially calibrated for the "darkest shadow" and "brightest highlight" methods. It may also be used to measure the luminance range of a subject. The telephotometer is the only type of meter permitting exposures to be determined by the fundamental "luminance range" method (page 281).

The S.E.I. photometer is a visual instrument and suffers from the limitation that it is somewhat slow to use although it is very accurate. Electronic photometers are more rapid in their use and rely on a CdS or similar sensor and a meter so that visual matching does not have to be carried out. In principle electronic photometers are rudimentary single lens reflex cameras that have a lens, a mirror and an eye-piece or pentaprism viewing arrangement for sighting the instrument on the area to be measured (see Figure 20.5). The light sensor measures a small field of about 1° which is indicated as a circle in the viewfinder. A scale and meter needle are also visible in the viewfinder to indicate the luminance

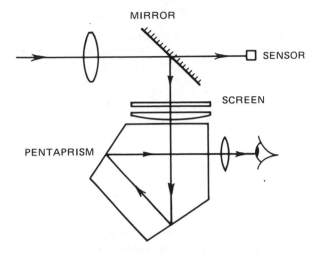

Fig. 20.5 – Simplified arrangement of an electrical spot photometer

of the small selected area. Scales or calculators are normally provided with or on the instrument so that exposures can be based on shadows, mid-tones, or highlights.

Such instruments are not intended for use in general photography where integrated meter readings or incident light readings are normally perfectly adequate and are far quicker and easier to carry out. However exposure photometers find application in certain more specialised applications of photography, such as in scientific and industrial photography, because spot metering of this type allows scene contrast to be accurately monitored and decisions to be taken as to whether they are within the exposure range of the film being used, or if not what sacrifices in shadow or highlight detail have to be made.

Determination of exposures for flash photography

Exposures required for flash may be determined in a variety of ways which may be listed as follows:

(1) By the use of guide numbers, tables or calculators.
(2) By variation of the duration of the flash in an automatic flash unit.
(3) By the use of a flash meter.
(4) By the use of meter readings taken with the aid of modelling lights in a studio flash unit.
(5) By the use of polaroid film.

With the exception of fill-in flash, exposures for flash photography are determined by varying the lens aperture only because the exposure time is fixed by the duration of the flash and the shutter is set to the speed that enables the particular flash source to be synchronised with the shutter (see page 186).

437

Guide numbers, tables and calculators

The exposure required with an electronic flash tube (or flash bulb) is conveniently expressed in the form of an *exposure guide number*, or *flash factor* which is calculated using the equations shown on pages 51 and 57. A guide number represents the product of the lens aperture (*f*-number) and the flash-to-subject distance required for correct exposure with a particular film and flash tube or bulb. Given the appropriate guide number, the lens aperture required can be obtained by dividing the guide number by the flash-to-subject distance, and vice-versa.

Guide numbers, of course, vary with the measurement unit — commonly either feet or metres — and are also governed by the film speed and, for flash bulbs by the shutter speed.

Example. The meter guide number for a certain combination of film and flash is 20. Then:

(a) If the flash is to be used at a distance of say 2 metres from the subject, the aperture required for correct exposure is $20/2 = f/10$ ($f/11$ in practice). With the flash 5 metres from the subject, the required aperture is $20/5 = f/4$.

(b) If it is desired to work at a given aperture, say $f/8$, then the flash must be $20/8 = 2\cdot5$ metres from the subject. At $f/2\cdot8$ the flash must be $20/2\cdot8 = 7$ metres from the subject.

To avoid having to do the above mental arithmetic most flash units are fitted with a simple table or calculator as shown in Figure 20.6, from which the required aperture or distance can be read from a scale once the calculator has been set to the appropriate film speed.

Because a guide number takes into account only the power of the light source and its distance from the subject, separate allowance must be made for reflector, type of surrounding and type of subject, if these

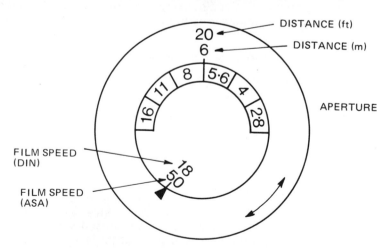

Fig. 20.6 – A typical flash exposure calculator

differ from the conditions under which the guide numers were determined. Unless otherwise specified, when guide numbers are published the assumption is made that the whole of the flash will be employed. Such guide numbers are applicable to flash bulb exposures by open flash and to synchronised exposures at slow shutter speeds. Guide numbers specially determined for the higher shutter speeds are lower than those quoted for slow speeds, because at high speeds only a part of the flash is employed. Electronic flash is generally of shorter duration than the fastest recommended shutter speed so the guide number does not vary.

We saw earlier (page 89) that the apertures of the f/number series were obtained by multiplying the preceding f/number by $\sqrt{2}$ (or approximately 1.4) and that increasing the aperture by 1 stop doubles the exposure. Thus if practical photographic tests indicate that the film is being over-exposed consistently by 1 stop the guide number should be *multiplied* by 1·4. (In practice it may be simpler to use 1·5.) This can be shown by the following simple calculation. The guide number (G) is given by the expression:

$$G = f\text{/number} \times \text{distance}$$

However the guide number that is required in practice (G') is calculated from an expression that uses the next higher f/number to decrease the exposure by 1 stop, i.e. $G' = f\text{/number} \times 1\cdot4 \times \text{distance}$. Thus $G' = G \times 1\cdot4$. Conversely, if the film is consistently being under-exposed by 1 stop the guide number should be *divided* by 1·4.

Similar considerations apply when the film is changed for one of a different speed. Thus if the film speed is halved the guide number must be *divided* by 1·4 and if doubled the guide number must be *multiplied* by 1·4. Calculations of exposure become more difficult when two or more flash sources are used to light the subject because they are normally placed in different positions at different distances or differ in output. However, if the second source is used only as a fill-in to light the shadows, the required exposure may be based entirely on the guide number for the key light alone. Similarly exposure may be based on the key light when more than two sources of flash are used, provided that the additional sources are placed significantly further from the subject than the key source, or are diffused, or are of lower intensity. In such situations it is better to determine the exposure by means of a flashmeter or photographic test.

Automatic flash units

Developments in photosensors and solid state switching devices have made possible the introduction of automatic or "computer" flashguns (see page 53). Automatic flashguns are provided with a rapid-response sensor and feedback circuitry that monitors the light reflected from the subject and integrates the signal, which is then used to alter the duration of the flash so that the film is correctly exposed. Normally the film speed is set on a simple calculator dial on the flashgun from which an ap-

propriate aperture is selected from the scale. There may be one, two, or three apertures depending on the power of the flashgun, and the flash-to-subject distance. Once the indicated aperture has been set on the camera the exposure is automatically controlled by variation in the duration of the flash. However, in certain situations an incorrect exposure may be given as is often the situation when exposure is based on measurements of the integrated light reflected from the subject. For example when photographing a child against a dark background or at a distance in front of the wall of a room. In this situation the exposure is controlled to a large extent by the light reflected from the background and the auto automatic control of the flash duration leads to too long an exposure with the result that the subject is over-exposed. With negative materials their exposure latitude may be such that over-exposure, of say the child's face, may not affect the final print but it may be significant when using reversal film where there is no printing stage in which corrections can be made.

Flashmeters

A normal photographic exposure meter cannot measure the exposure required for flash photography because it responds only to intensity, whereas exposures for flash require the measurement of intensity and duration. Developments in rapid-response photosensors, such as the silicon blue cell with a response time of 10 micro-seconds, and integrating circuitry have enabled meters to be made that measure the intensity and duration of the light emitted from flashguns.

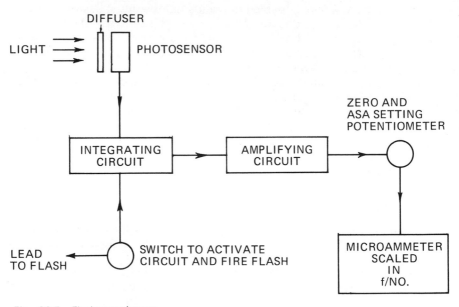

Fig. 20.7 – Flashmeter layout

440

A diagram showing the main components of a typical flashmeter is given in Figure 20.7.

The flashmeter is normally placed at the subject pointing towards the camera. It is provided with a switch and lead to fire the flash unit(s) and the required aperture is read from the metre scale or LED display. They may also be used for measuring reflected light.

Flashmeters are especially useful in studios where a number of flash sources may be used and they avoid difficult calculations based on guide numbers.

Measurements from modelling lights

Many studio flash units have a tungsten light source incorporated in the flash head called a modelling light. The modelling light gives the photographer an indication of the nature of the lighting that the subject will receive when the flash is fired. They may also be used to assess the exposure for the flash by taking meter readings with an exposure meter. In many flash units the intensity of the flash bears a direct relationship to the intensity of the modelling light, so taking this factor into account it is simple to convert the meter reading taken with the aid of the modelling light to the exposure required when the flash is used.

The following procedure may be used for flash units of the same output and modelling lights of the same intensity.

(1) Set up the flash units to light the subject.

(2) Take an incident light reading with an exposure meter set to the speed rating of the film being used.

(3) Set the calculator dial on the meter to the reading.

(4) Make a series of flash exposures using different apertures and record the apertures used.

(5) Process the film, examine the negatives and select the one that is correctly exposed to find the required aperture.

(6) Note the *shutter speed* on the dial of the exposure meter opposite the required aperture.

(7) The modelling light-flash light relationship has now been found and when the equipment is used on another occasion with a different lighting set up the aperture required for the flash exposure is found from (2) and (3) above by reading the *f*/number from the dial of the exposure meter opposite the noted shutter speed in (6).

Use of Polaroid–Land film

This method of exposure determination has been described earlier (page 428) and is of great value for flash because lighting effects, unwanted reflections etc., are difficult to predict.

21 Photographic Papers

WE HAVE confined our attention in this book so far largely to the preparation of negatives. The negative, although important, represents only the first stage in the preparation of a photograph. We have now to deal with the second stage — the preparation of the positive from the negative. In this chapter we shall consider the papers used for printing, and in the next chapter the printing operation itself.

Types of printing paper

As far as the method of image production is concerned, printing papers behave in exactly the same way as negative materials, using a similar light-sensitive material, i.e. a suspension of silver halides in gelatin. It is coated on paper base which must be entirely free from substances that would have a harmful effect on the emulsion (Chapter 12).

Many different types of printing paper are made, they may be classified into two overall types — monochrome papers and colour papers. Within each of these types there exist many different papers for various purposes but we will restrict our discussion in this chapter to those that are used in photographic printing. For convenience we may classify the characteristics of monochrome papers under the following headings:

(1) Type of silver halide employed in the emulsion,
(2) Contrast of the emulsion,
(3) Nature of the paper surface,
(4) Nature of the paper base.

Colour papers may be classified under the following headings, although items (3) and (4) above are also relevant to colour papers:

(1) Papers for printing from colour negatives,
(2) Reversal papers for printing from colour positives or transparencies.
(3) Direct positive print materials also for printing from colour

transparencies (strictly speaking these materials are not papers but are coated on pigmented film base).

We shall consider each of these in turn.

Type of silver halide employed

Monochrome papers can be divided into three main classes in terms of the type of silver halide employed in the sensitive layer. These are *chloride papers*, *bromide papers* and *chlorobromide papers*, the sensitive material in the latter being a mixture of silver chloride and silver bromide in which the individual grains comprise silver, bromide and chloride ions. Bromide and chlorobromide emulsions may also contain a small percentage of silver iodide. Chloride papers are intended for contact printing but are now rarely used. The nature of the silver halide employed in a paper emulsion largely determines its speed, image colour and tone reproduction qualities. These three will be considered in further detail.

Speed. Papers differ widely in their speed, chloride papers being the slowest and bromide the fastest with chlorobromide papers in between. Generally speaking chlorobromide papers are of greater speed and softer in contrast as their bromide content increases. The fastest of them are in the same speed range as bromide papers.

Also, as the bromide content increases the spectral sensitivity extends to longer wavelengths.

Whereas monochrome negative materials are spectrally sensitised to enable the reproduction of colours to be controlled, printing papers that are employed only to print from monochrome negatives have no need of spectral sensitisation other than as a means of increasing their sensitivity to tungsten light or as means of obtaining differing spectral sensitivities for *multigrade papers.*

However some monochrome papers are spectrally sensitised so that they can be used for producing black-and-white prints with correct tones from colour negatives. Such papers are therefore sensitive to light of all wave-lengths and require handling in total darkness or using a dark amber safelight.

Image colour. The colour of the image on a photographic paper (untoned) depends primarily on the state of division of the developed image, i.e. on its grain size, although it is also affected by the tint of the base. The grain size of the image depends in turn on the nature and size of the grains in the original emulsion, on any special additions which may be made to the emulsion and on development.

The grain size of paper emulsions is very small, so that no question of visible grainess due to the paper ever arises, even with the fastest papers. In fact, with many paper emulsions, the individual grains of silver in the developed image are so small that their size is comparable with that of light waves; the image then appears no longer black but coloured. As grains become progressively smaller, the image, which with large grains is black, becomes first brown, then reddish and then yellow, finally

becoming practically colourless. When a paper is developed, the grains are small at first but grow as development proceeds; it is, therefore, only on full development that the image gets its full colour. The finer the original grains of the emulsion, the greater the possibility of controlling the image colour, both in manufacture, and by control during development.

Bromide papers have relatively corse grains, and, when developed normally, yield images of a neutral-black image colour. Contact (chloride) emulsions are of finer grain. Some papers are designed to yield blue-black images by direct development, others to yield warm-black images by direct development — the colour depending on the treatment the emulsion has received in manufacture. For example some paper emulsions contain *toning* agents that change the image colour on development probably by modifying the structure of the developed silver image so that it appears colder or bluer in colour. Chlorobromide emulsions are intermediate in grain size — as in many other properties — between contact papers and bromide papers. Some chlorobromide papers are designed to give only a single warm-black image colour; others can be made to yield a range of tones — from warm-black and warm-brown to sepia.

Tone reproduction qualities. Most monochrome printing papers are available in a range of *contrast grades*, or *gradations*, to suit negatives of different density ranges. We saw the need for this in Chapter 15. With any given negative, therefore, it is usually possible to make a good print on any type of paper, provided that the appropriate contrast grade is chosen. There will, however, be certain differences in tone reproduction between prints on different types of paper. The differences arise because the characteristic curves of different papers vary somewhat in shape (see page 283).

So far we have been dealing with the characteristics of the three main types of paper emulsion. We will now consider their uses.

Contact papers

Papers employing silver chloride as the sensitive material are used almost exclusively for contact printing, on account of their slow speed, and as we have already noted are usually referred to not as chloride papers but as *contact papers.*

Because of their low speed, contact papers have the advantage that they can be worked by a bright yellow or orange light.

Bromide papers

Bromide papers are the fastest type of printing papers. Their high speed makes them very suitable for enlarging and also for the rapid production of prints by contact. Bromide papers must be handled and processed by orange or greenish-yellow light.

Bromide papers give prints of a neutral-black colour by direct develop-

ment, which normally requires from $1\frac{1}{2}$ to 2 minites at 20°C. Because of the popularity of bromide papers for professional and commercial work, many processes have been worked out for subsequent toning of the finished print, so as to facilitate the production of warm-black, sepia and other toned images. Details of some of these processes are given in Chapter 23.

Chlorobromide papers

The third important group of papers comprises the chlorobromides. These papers are of many different kinds. In all of them, silver bromide and silver chloride mixed crystals are present, but the proportion of the two may vary widely from paper to paper. In many respects, the properties of chlorobromide papers may be regarded as intermediate between those of chloride and bromide papers, the balance struck between the characteristics of the two depending very largely on the proportions in which the two halides are present.

Some chlorobromide papers are in the same speed class as bromide papers; others are much slower. They may be used for both contact printing and enlarging, although the slower papers require a high-intensity light source for enlarging. Chlorobromide papers have, in general, a characteristic curve which results in good tone separation throughout the whole range of tones, and most of the papers are designed to give warm-toned images. They also tend to have good development latitude.

Chlorobromide papers, like bromide papers, must be handled and processed in a darkroom with an orange or greenish-yellow safelight. Many chlorobromide papers are spectrally-sensitised – to increase their speed – so that especial care must be taken to use only the recommended safelights. Some safelights that are suitable for use with bromide papers may, with chlorobromide papers, cause fogging.

If a mercury vapour light source (page 469) is employed when printing with a colour-sensitised chlorobromide paper, the contrast obtained tends to be low and a harder grade of paper than usual may be required. The speed of the paper, in relation to that of bromide paper, may also be reduced.

Paper contrast grades

The contrast of a paper, unlike that of a negative, can be varied only within narrow limits by altering development (see page 287). To print satisfactorily from negatives of different density ranges, papers are required in a range of contrast grades.

At one time, printing papers were manufactured in one contrast grade only, and it was standard practice to control the contrast of each negative by individual development, in order to produce a satisfactory print on the paper available. The introduction of the roll film, however, made this method of working impossible, and it was probably this, as

much as anything, that made necessary the manufacture of papers in several contrast grades.

Most papers are therefore made today in several grades. Glossy-surfaced papers – the most widely used variety – are usually made in five grades, although some other surfaces are available only in two or three grades.

The selection of a suitable grade of paper for a given negative is a matter for personal judgement based on experience, or for practical trial. If a trial is considered necessary, it is important that, during this, development should be standardised at the recommended time and temperature (see page 449). If the correct grade of paper has been selected, and exposure adjusted so that the middle tones of the picture have the required density, then the highest highlights in the picture will be almost white – though with just a trace of detail – and the deepest shadows black. If the highlights show appreciable greying, and the shadows are nowhere black, the paper selected is of *too soft* a contrast grade for the negative; a harder paper should be tried. If the highlights are completely white with no detail at all, and not only the shadows but the darker middle tones are black, the paper selected is of *too hard* a contrast grade for the negative; a softer paper should be tried.

In addition to the conventional printing papers so far described, special types of paper are manufactured in which the effective contrast can be changed at will by varying the colour of the printing light. With such *variable-contrast papers* it is possible to produce good prints from negatives of any degree of contrast on one paper – which thus does the work of the entire range of grades in which other printing papers are supplied, and so makes it unnecessary to keep stocks in a variety of grades.

Paper surface

The surface finish of a paper depends on two factors: (1) the texture, or mechanical finish of the paper, and (2) its sheen.

The texture of a paper depends on the treatment that the paper base receives in manufacture. Glossy papers, for example, are calendered, to produce a very smooth surface, while grained papers are usually embossed by an embossing roller. Rough papers receive their finish from the felt on the paper-making machine. Surface texture governs the amount of detail in the print. Where maximum detail is required, a smooth surface is desirable, whereas a rough surface may be employed to hide graininess or slight lack of definition. A smooth surface is desirable also for prints that are required for reproduction and have to be copied using a camera. Various textures are available for special effects.

Surface finish arises largely from the thin layer of gelatin – the super-coating – that is applied over the emulsion of many papers in manufacture, to provide protection against abrasion (page 229). This layer gives added brilliance to the print, by increasing the direct (specular) reflecting power of the paper surface. Glossy papers are smooth with a high sheen;

a higher maximum black is obtainable on glossy papers than on others. Matt papers are smooth but have no sheen; starch is usually included in the emulsion to subdue direct reflection.

Between the two extremes of surface and texture there have been many other surfaces, but they are gradually being reduced to a fine regular or irregular pattern, variously known as silk, lustre, stipple, etc., and a semi-matt.

Nature of the paper base

The colour, or tint, of the base paper used for photographic papers may be white or one of a variety of shades of cream or blue. In general, cream papers tend to give an impression of warmth and friendliness; they are very suitable for prints of warm image colour. A white base may be used to simulate coldness and delicacy.

Two thicknesses of base are commonly available, designated *single-weight* and *double-weight* respectively. Both double-weight and single-weight papers are used for enlargements; single-weight is often sufficient if the print is to be mounted on card but in the larger sizes double-weight paper is to be preferred because there is a danger, with the thinner papers, of creasing in a wet state. Various thinner papers are available to special order.

Resin coated papers

Many printing papers consist of a paper base coated or laminated on both sides with an impervious layer of a synthetic organic polymer such as polyethylene (polythene). Such papers are termed RC (resin-coated) or PE (polythene) papers. Although more expensive than their baryta-coated-paper equivalents they offer a number of advantages for the user. Because the base on which the emulsion is coated is impervious to water and most processing chemicals, washing and drying times are considerably shorter than with conventional papers. For example, washing times are reduced from 30–45 minutes to about 4 minutes which not only saves time but also saves water. RC or PE papers cannot be heat-glazed but the glossy surface variety dries to a gloss finish and they lend themselves very readily to rapid machine processing. They also resist curling and dry almost completely flat. Processing can be considerably quicker than with conventional baryta-coated papers if the chemistry devised specifically for RC papers is used. However they also have their limitations, processing a number of sheets at one time in a processing dish may lead to damage of the emulsion surface by the "sharp" edges, different retouching techniques and materials are required, and some papers "frill" or de-laminate at the edges especially if dried too rapidly. Dry mounting of RC type papers generally requires the use of low-melting-point mountants.

RC papers are available in a limited number of surfaces. These include glossy, silk and "pearl". Only one weight of RC paper, intermediate between "single" and "double", is currently available.

Colour papers

Colour papers are available for both negative-positive and positive-positive printing (see Chapter 22). The majority of papers for colour printing are polythene coated and are available only in one contrast grade that is matched to the contrast of the negative or transparency which has been developed under standard conditions. However the Cibachrome process does not use a paper base because paper could not withstand the high acidity of the bleach solution used in this process (see page 527). The base is a white pigmented film base material that has a similar appearance to paper.

All colour papers are based on the subtractive principle of colour reproduction and are integral tripacks (see page 257) having individual layers sensitive to red, green and blue light. The emulsion layers also contain the appropriate colour couplers but direct-positive print materials (Cibachrome) contain cyan, magenta and yellow dyes that are bleached in an image-wise manner (see page 513). The emulsions for colour materials are manufactured so that they have the required contrast (the same for all three layers), spectral sensitivity and speed for the printing and processing procedures for which they are intended.

Unfortunately because of variations between different manufacturers' materials and processing solutions there are no universal colour print processing formulae or procedures. Each manufacturer's colour paper has to be processed in the recommended solutions, or substitute solutions provided by an independent and reputable manufacturer, by the recommended processing procedure. The characteristics of colour print materials together with their processing chemistry are described in detail in Chapter 24 but Table 21.1 summarises the processing sequences for the three common types of colour print materials.

Papers for printing from colour negatives	Reversal papers	Direct positive print materials
1. Develop	1. B & W develop	1. B & W develop
2. Bleach-fix	2. Stop	2. Bleach (dye and silver)
3. Wash	3. Wash	3. Fix
4. Stabilise	4. Colour develop	4. Wash
	5. Wash	
	6. Bleach-fix	
	7. Wash	
	8. Stabilise	
	9. Rinse	

Table 21.1 – Summary of processing sequences for colour print materials

Development of papers (*see also Chapter 17*)

The developers used today for paper of all types are commonly M.Q. or P.Q. formulae. Formulae for typical monochrome paper developers are given in the Appendix (page 581). We saw earlier that the image colour

or tone is influenced by development. The three most important components of the developer that influence image colour are the developing agent, bromide restrainer and organic antifoggant. For example developing agents such as glycin or chlorohydroquinone give a warm image tone in the absence of organic antifoggants but are little used now in print developers. Organic antifoggants such as benzotriazole tend to give a cold or bluish image. Thus P.Q. developers will give a bluish image because they usually contain an organic antifoggant. As the bromide content is increased the image becomes warmer in tone. Thus M.Q. developers tend to give warmer images than P.Q. developers. Colour papers should be developed only in the recommended developer and there are no truly universal developers for all types of colour paper. Chromogenic colour development depends upon colour couplers in the paper reacting with oxidised developing agent to form the image dyes (see page 354). The colour of an image dye depends on the structure of the coupler and the developing agent and either one or both of these almost certainly will be different with different manufacturers' papers and developers. Using other than the recommended colour developer with a colour paper is likely to lead to inferior colour and tone reproduction.

Development time and temperature

The timing of the development of monochrome papers usually done on the basis of a combination of the time-temperature and inspection methods of development. Initially, the exposure time is adjusted so that a correctly exposed print is obtained in the development time recommended by the paper manufacturer at the recommended temperature (normally 20°C). This means that any trial exposures must be developed strictly by the time-temperature method.

We saw, however, in Chapter 15 that there is a range of development times within which a paper will yield good prints, provided that the exposure time is adjusted accordingly. The development time recommended by the manufacturer lies within this range. A print that has been given slightly more exposure than normal, may usually be removed from the developer after a little less than the recommended time, without loss of quality. Similarly, a slightly under-exposed print can usually be brought to the required density by a little longer development than recommended. This latitude between exposure time and development time, permitting slight errors in exposure to be compensated in development, on the basis of inspection of the print, is of great practical value. It must not, however, be pushed to extremes, i.e. the latitude of the paper must not be exceeded. Excessively short development times are to be avoided because dense blacks are not achieved, image colour is often poor, and the degree of development may not be uniform across the print. At the other extreme, excessively long development is bad because it is accompanied by a risk of fog and staining.

The degree of latitude available varies to some extent with the type

and contrast grade of the emulsion. With bromide papers, development latitude is limited by the fact that contrast varies to an appreciable extent with the degree of development (page 288). Development latitude is greatest with soft papers and least with hard papers. It is generally very small indeed with the hardest grades. For colour print development the processing conditions are fixed and departures from the recommended times and temperatures are likely to lead to inferior results. Most colour print materials require the temperature to be kept within $\pm 0\cdot 3°C$ whilst the Cibachrome process (see page 513) is more tolerant and allows variation of $\pm 1\frac{1}{2}°C$.

Development technique

The exposed print should be immersed in the developer by sliding it face upwards under the solution. Development of papers is a straightforward operation, but prints must be kept on the move and properly covered with solution. Several prints may be developed at one time in the same dish, provided that there is sufficient depth of developer and that the prints are "leafed" repeatedly. The busy printer will find it convenient to develop prints in pairs, back to back, feeding them into the solution at regular intervals, keeping the pairs in sequence and removing them in order when fully developed. The action of "leafing" the prints, i.e. withdrawing pairs sequentially from the bottom of the pile and placing them on the top, will help to dislodge any air-bells which may have formed on the prints.

When making enlargements of very large size, the provision of large dishes or trays sets a problem. Where very big enlargements are made only occasionally, the dishes need only be a few inches larger than the narrow side of the enlargement, because development can be carried out be festooning the paper, or by drawing it up and down through the solution. In exceptional cases, development can be carried out by placing the enlargement face up on a flat surface and rapidly applying the developer all over the print with a large sponge or swab. Previous wetting with water will assist in obtaining rapid and even coverage of the print by developer. Fixing can be done in the same way. Alternatively, makeshift dishes can be made from large pieces of cardboard by turning up the edges, clipping the corners (which should overlap), and coating the insides with paraffin wax or covering them with polythene sheet.

For processing prints, especially colour, many small scale tanks and machines are available and becoming increasingly popular. These may be operated in the light once they have been loaded with the paper in the darkroom. They range from the simple and relatively inexpensive *tube* or *drum* processors to the more costly and somewhat larger *laminar-flow* or *roller processors* (see Figures 21.1 and 21.2). These are all small-scale processing devices used by both amateurs and professionals. The larger-scale, more automatic machines are described in Chapter 17.

The simple drum processor is the print analogy of the daylight film developing tank and is available in a number of sizes ranging from one

Fig. 21.1 – Drum processors
a. Durst Codrum, b. Simmacolor (Besseler), c. Cibachrome (U.S.), d. Kodak Printank, and e. Paterson Color Print Processor

for processing a single sheet of paper 20·3 × 25·4 cm (8 × 10 in) to one large enough to process a single sheet of paper 40·6 × 50·8 cm (16 × 20 in). An appropriate number of smaller sheets can also be accommodated. The exposed paper is loaded into the tank in total darkness with its emulsion surface toward the centre and its other side in contact with the inner surface of the drum. All subsequent processing operations are then carried out in the light. Temperature control is achieved by two

main methods: either by rotating the drum in a bowl of water at the appropriate temperature, or by a pre-rinsing technique in which water is poured into the drum at a temperature above that of the surroundings and the final processing temperature. Details of the required temperature of this pre-rinse are provided by the drum manufacturers in the form of a nomograph or calculator. These simple processing drums use very small quantities of solutions for processing each print but suffer from the disadvantage that they have to be washed thoroughly after each use to prevent contamination. Washing prints is carried out outside the drum.

The *Agnecolor laminar flow* processor (Figure 21.2a) works by a

a.

b.

Fig. 21.2 – Examples of bench top processors
(a) Agnecolor Laminar Flow Processor, (b) Durst Automatic Colour Paper Processor

somewhat different principle. It uses a pump to maintain a thin uniform layer of processing solution constantly flowing across the emulsion surface of the print. To operate this machine the developer is poured into the trough and laminar flow is established by switching on the pump. Once laminar flow has been established the exposed print is placed face downward on the flow and the lid closed.

After each processing step the trough is drained into the solution container and the next solution poured into the trough and processing is continued. The recovered solutions may be replenished and re-used for processing subsequent prints. All processing steps including washing may be carried out in this processing device but once it is loaded with up to four 20·3 × 25·4 cm prints, it cannot be used for processing additional prints until the end of the cycle. Although manual in operation this processor is extremely versatile. It can accommodate virtually any paper process and agitation is very efficiently provided by fresh solution flowing over the emulsion during processing.

An alternative approach to the simplification of print processing is the *Durst automatic roller processor* (Figure 21.2b) in which papers are fed through the processing solutions by rollers and guides. This machine, however, requires washing to be carried out separately, and also stabilisation where appropriate, but prints can be fed into the machine continuously (up to about twenty 20·3 × 25·4 cm prints per hour).

Fixation (see also Chapter 18)

Monochrome prints

Prints are fixed in much the same way as negatives. With prints, an acid fixing bath is very much to be preferred to a plain thiosulphate bath because it reduces the danger of staining — especially objectionable on prints — to a minimum. The thiosulphate concentration of print fixing baths is not usually made to exceed 20 per cent, compared with a concentration of up to 40 per cent for films and plates (page 387).

A fixing time of about 10 minutes is usually recommended, although in a fresh bath 5 minutes is quite adequate and only around 30 seconds is needed for resin-coated papers. To avoid the risk of staining, prints should be moved about in the fixing bath, especially for the first few seconds after immersion. Prolonged immersion of prints in the fixing bath beyond the recommended time should be avoided. It may result in loss of detail, especially in the highlights, as the fixer gradually attacks the image. The action is most marked with chloride and chlorobromide papers, because silver chloride fixes more rapidly than the bromide.

Because the print is the consummation of all the effors of the photographer, everything should be done to ensure its permance, and proper fixation is therefore essential. Improper fixation may not only lead to tarnishing and fading of prints, but also to impure whites on sulphide toning. For the most effective fixation of papers, it is better practice to use a single fairly fresh bath, than to use two fixing baths in succession.

With the latter method, the first bath contains a relatively high silver concentration. Silver salts are taken up by the paper base in this bath, and tend to be retained in the paper even after passing through the second, relatively fresh, bath.

Where processing temperatures are unavoidably high, as in tropical countries, a hardening-fixing bath should be employed. For the hardening of papers, potassium alum is to be preferred to chrome alum because the latter has a tendency to impart a greenish tint to prints. Several proprietary liquid hardeners are available for addition to paper fixing baths. Use of a hardener is often an advantage even in temperate climates if prints are to be hot glazed or dried by heat.

A fixing bath that has been used for negative materials may affect unfavourably the image colour of prints, if these are fixed in the same bath. The trouble is caused by silver iodide from the negative emulsion. The remedy is to use separate fixing baths for negatives and prints.

Bleach-fixing

For colour-print processing the removal of the unwanted silver image and unexposed silver halides is usually carried out in a single bleach-fix solution. We saw earlier (page 387) that such solutions contain an oxidising agent that converts metallic silver to silver ions together with a complexing agent (thiosulphate) that forms soluble silver complexes with the oxidised silver and with any unexposed silver halide remaining in the emulsion.

Bleach-fixing is carried out for the recommended time at the recommended temperature and in small-scale processing is discarded when the specified number of prints has been passed through the solution, or when its storage life has been exceeded. In larger scale processing it is normal practice to recover silver from the solution and re-use the bleach-fix after aeration and replenishment. Either the electrolytic method of silver recovery or the metallic displacement method may be used (see page 395). In the case of the latter method the presence of iron salts in the solution, after silver recovery, is not the disadvantage it is when this method is used to recover silver from fixer solutions because the oxidising agent is iron sequestrene which can be formed by the addition of EDTA (ethylenediaminetetra-acetic acid) to the de-silvered solution. Thus the recovery and replenishment operation forms extra oxidising agent. It is important to bleach-fix the print material for the specified time and temperature because incomplete removal of silver and silver halide results in a degraded print, especially noticeable in the highlight and yellow areas.

Bleach-fixing is a less critical stage than development and a larger amount of temperature variation is permitted (usually $\pm 1°C$).

Washing (see also Chapter 18)

The purpose of washing prints is to remove all the soluble salts (fixer, complex silver salts) carried on and in the print from the fixing bath.

Where only a few prints are being made they may be washed satisfactorily by placing them one by one in a large dish of clean water, letting them soak there for five minutes, removing them singly to a second dish of clean water, and repeating this process six or eight times in all. A method that is equally efficient and much less laborious – though requiring a larger consumption of water – consists of the use of three trays, arranged as in Figure 21.3, through which water flows from the tap. Prints are placed to wash in the bottom tray of this so-called "cascade" washer. When others are ready for washing, the first prints are transferred to the middle tray and their place taken by the new ones. When a further batch is ready, the first prints are put in the upper tray and the second batch in the middle one, leaving the bottom tray for the latest comers. In this way, prints are transferred from tray to tray against the stream of water, receiving cleaner water as they proceed. For washing large quantities of prints, this type of washer is made with fine jets for the delivery of water to each tray. These afford a more active circulation of water and dispense with the occasional attention required with the simpler pattern.

Another efficient arrangement for washing prints is shown in Figure 21.4. It consists of a sink fitted with an adjustable overflow; water is led in by a pipe which is turned at right-angles in the sink and terminates in a fine jet nozzle. The effect of this is to give a circular and also a lifting motion to the water – and equally to the prints – which overcomes the tendency of the prints to bunch together and remain in contact.

When large batches of prints have to be handled, the above arrangement can be duplicated or increased in size as desired, providing a most practical and efficient method of ensuring thorough washing.

Numerous mechanical print washers are sold which are designed to keep prints moving while water passes over them. In purchasing any print washer it is necessary to be satisfied that prints cannot come together in a mass – in which state water cannot get at their surfaces – nor be torn or "kinked" by projections in the washing tank. Generally, commercial print washers are suited only to prints of relatively small size.

Fig. 21.3 – "Cascade" print washer

Fig. 21.4 – Washing sink

Another form of print-washer solves the problem of prints sticking together by holding them in a rocking cradle like a toast-rack. The in-flow of water causes the rack or prints to rock backwards and forewards so ensuring that the prints are in constant motion and that there is an efficient flow of water around them.

Washing in automatic print processors is more efficient than that for manual or batch processing. The reasons for this may be summarised as follows:

(1) Efficient removal of fixer from the print surface by the use of roller squeegees or air-knives.

(2) Control of the temperature of the water.

(3) Uniform time of immersion in the processing solutions.

(4) Control of exhaustion of the fixer by replenishment and possibly by silver recovery.

(5) Efficient separation of the prints so allowing free access of the wash water.

(6) Reduction of carry-over of chemicals from one solution to another by the use of squeegees between the solutions.

All the above features of automatic print processors result in a shorter wash time than is required in manual or batch processing to yield prints of comparable permanence. However some of these features can be incorporated in manual processing. For example tempered wash water can be used, fixers can be replenished and the proper design of wash tanks should give efficient washing.

Stabilisation of colour prints

Following the final wash for colour prints a stabilisation stage is usually carried out, but manufacturers of colour print materials are aiming to omit this step by modifications to the materials and processing solutions to simplify still further colour print processing.

The stabiliser solution usually contains a wetting agent to aid even drying, formaldehyde to help stabilise the dyes against aerial oxidation, to prevent colour couplers reacting with image dyes and converting them to the colourless or leuco form, and to harden the gelatin. An optical whitener may also be included to enhance the appearance of the white areas of the print and to offer some resistance to the fading of the dyes induced by the absorption of U.V. radiation.

Drying (see also Chapter 18)

When thoroughly washed, prints intended to be dried naturally can be placed face upwards in a pile on a piece of thick glass. The excess of water should be squeezed out and the surface of each print wiped gently with a soft linen cloth or chamois leather. The prints should then be laid out on blotters or attached to a line with print clips. Alternatively, an efficient drying apparatus can be made by stretching fine curtain mesh on wooden frames, and placing the prints face downward on the mesh.

Where a large volume of work is being handled, prints are usually dried by heat, using flat-bed or rotary glazing machines (see below), or special rotary driers. For drying on a glazing machine, prints are placed facing the apron instead of towards the glazing sheet or glazing drum. Rotary drying machines are similar in construction to rotary glazing machines, except that the drum is covered with felt. It is usually an advantage when prints are to be dried by heat to use a hardening-fixing bath.

The drying of matt and semi-matt papers by heat gives a higher sheen than natural drying, because raising the temperature of the paper causes bursting of starch grains included in the emulsion to provide matting. With semi-matt papers the higher sheen may in some instance be preferred, but with matt papers it will usually be considered a disadvantage. In the latter event, natural drying should be employed.

When dry, a print will sometimes be more or less curled. If so, it may be straightened by laying it face downwards on a smooth flat surface and drawing a ruler along the back from end to end or from corner to corner, the end or corner being lifted fairly sharply but steadily as the rule is drawn back. Prints dried on heated machines do not usually require straightening.

Resin-coated papers may be dried by hanging up the prints in the air or in a drying cupboard in the same way as films or by the use of one of the many commercially available purpose-made dryers for RC papers. They dry rapidly without curling. They may also be dried on glazing machines provided that the following precautions are observed:

(1) *All* surface moisture is removed.
(2) The *base* is towards the heated "glazing" surface.
(3) The temperature of the "glazing" surface is *below* 90°C.

RC papers are impervious to water so that it is essential that the emulsion is not placed in contact with the heated surface and that surface moisture is thoroughly removed by squeegeeing.

Glazing

The appearance of prints on glossy papers is considerably enhanced by *glazing*, a process which imparts a very high gloss. Glazing is effected by squeegeeing the washed prints on a polished surface; when dry the prints are stripped off with a gloss equal to that of the surface to which they were squeegeed. Glazing is best carried out immediately after washing, before prints are dried. If it is desired to glaze prints that have been dried, they should first be soaked in water, preferably for an hour or more. Glass is usually considered to give the finest gloss, although some other surfaces are also suitable. Chromium-plated metal sheets and drums are widely used — as is polished stainless steel.

Before prints are squeegeed on to the glazing sheet, the surface of the sheet must first be thoroughly cleaned, and then prepared by treating it with a suitable glazing solution to facilitate stripping of the prints.

For the finest glaze, it is probably best to allow prints to dry naturally on glass, e.g. overnight. Where, however, a considerable volume of work is handled it is usual to employ glazing machines, on which prints are dried by heat, to speed up the operation. With these machines — which are of two types, flat-bed and rotary — glazing can be completed in a few minutes. So-called "flat-bed" glazers accommodate flexible chromium-plated sheets on to which prints are squeegeed. The glazing sheet is placed on the heated bed of the glazer and assumes a slightly cylindrical form when held in place by a cloth apron which serves to keep the prints in close contact with the glazing sheet. In rotary machines, prints are carried on a rotary heated chromium-plated (or stainless steel) drum on which they are held in place by an apron.

Detailed directions for glazing are given below.

Hot glazing is carried out using a chromium-plated (or stainless steel) glazing sheet or glazing drum as the glazing surface.

A drum can lose its condition by overheating, by the presence of a lime deposit arising from hard water or by chemical contamination from badly washed prints. The latter can be avoided by thorough washing of the prints to ensure that chemicals are not transferred to the felt and so to the drum. The felt itself should be removed from the machine and washed at regular intervals.

Prints for heat glazing should be processed in the usual way, and thoroughly washed in water as free as possible from air-bells and dirt. Use of a hardening-fixing bath may be an advantage, in particular under summer conditions when the wash water is likely to be warmer than usual.

Operation of a flat-bed glazing machine. The glazer must at first be allowed to warm up to the required temperature. The glazing sheet should then be thoroughly cleaned and a little glazing solution rubbed all over the surface. The wet prints are then placed on the sheet and squeegeed, preferably under a waterproof cloth. The glazing sheet is then placed on the glazer, face uppermost, and the apron tightened down over the prints. As prints dry, they will begin to leave the glazing sheet with a

series of sharp sounds. When this "cracking" ceases, the apron may be lifted back and the glazed dry prints peeled off.

Operation of a rotary glazing machine. The glazer should first be switched on and the drum allowed to warm up to a steady temperature. Prints should be placed face upward on the moving felt, one after the other, the interval between taking prints out of the wash water and putting them on the felt being kept to an absolute minimum. Immediately after placing the prints on the felt they may be lightly swabbed, e.g. with a folded towel, to remove surplus water.

The speed of the machine should be adjusted in relation to the drum temperature so that prints strip off the drum on emerging from the felt. Care should be taken not to allow the drum to overheat and so lose its condition, and under no circumstances should it be so hot as to boil the water on the surface of prints, as indicated by a sizzling sound when prints first touch the drum. The pressure of the squeegee roller should be sufficient to ensure good contact of prints with the drum and to remove much of the superfluous water, but excessive pressure should be avoided. The drum surface should be cleaned as frequently as possible with a fluffless polishing cloth free from grit. As previously mentioned, the felt should be washed periodically to prevent accumulation of dirt and impurities.

Faults in hot glazing

The chief troubles liable to be encountered during hot glazing operations are as follows:

(a) *Oyster-shell markings.* These markings on the surface of the glazed prints are obtained when the rate of drying is too slow, so that prints still partially adhere to the drum when the support of the felt has been withdrawn; the trouble is more likely to occur with double-weight paper than with single-weight. To overcome the defect, the machine should either be run at a slower speed, or a greater degree of heat should be applied, though this must not become excessive.

(b) *Pits.* Any dirt or grit on the surface of prints during glazing will give rise to unglazed pits. These are similar in appearance to fleck-marks (see below), but the offending grit can often be seen in the centre. The contamination may be present in the water, in which case filtration is necessary, or it may arise from the glazing solution, swabs etc.

(c) *Fleck-marks.* These small irregularly-shaped unglazed areas may occur in a variety of ways, some being due to processing technique and some being associated with the material. Serious fleck-marks can be obtained if glazing is carried out at too high a temperature, so that the surplus water boils as prints come into contact with the drum. Highly aerated water such as would be produced from a high-pressure mains supply may be a potential source of trouble, due to fine air-bells, often not visible to the naked eye, being trapped in the film of water adhering

to the print surface. An anti-splash device together with a filter fitted to the tap should help to reduce this problem.

Over- or under-squeegeeing is also a source of fleck-marks. The correct pressure to be applied is a matter of experience; it need only be sufficient to bring the print into good contact with the drum.

Over-hardening of the emulsion film is probably the most frequent cause of fleck-marks, and where it arises to any serious extent a non-hardening fixing bath must be used. Fleck-marking is also associated to some extent with the age of the photographic material, and if the trouble persists it may sometimes be obviated by briefly soaking prints in lukewarm water before glazing. The time of immersion and temperature of the soaking water must be found by experience.

(d) *Patchy glazing.* Areas of poor glaze are likely to occur if the glazing surface is dirty, or if the prints are not properly in contact with the drum, owing to inadequate squeegeeing. Prints that have become partly dry on the surface before placing on the felt are very liable to glaze irregularly. In this event, they must be thoroughly resoaked before glazing.

(e) *Sticking.* Prints rarely stick to the surface of the glazing drum but if they do, there is probably one of two causes: (i) the drum surface is dirty, or scummy owing to lime from hard water; in either case, cleaning is necessary; (ii) the glazer is running at too low a temperature for the print to come off in one cycle.

Clearing and reducing prints

Clearing or reducing of prints by chemical means is rarly required when the technique of printing has been mastered. There are, however, some cases where chemical treatment improves the results, such techniques are described on page 499 and formulae for this purpose are given in the Appendix (page 583).

Toning prints

See Chapter 23.

Stabilisation papers

There are some bromide papers in which a developing agent, usually hydroquinone, is incorporated in the emulsion. They are designed for rapid processing in small machines. The paper passes first through an activator – a strongly alkaline sulphite solution – and then through a stabiliser (page 403). The print emerges from the machine in a semi-dry state, the whole processing operation taking only about 10 seconds. The restrainer required in development may be incorporated in the activator or in the paper, so that not all stabilisation papers and activators are compatible. It is therefore normally wisest to employ the chemicals recommended by the manufacturer of the paper.

Stabilisation papers are available in both contact and projection speeds, and in a range of contrast grades and surfaces.

However with the introduction of polyethylene coated papers (see page 447) and associated processing equipment it is likely that stabilisation papers will become less popular because the prints are not permanent but are subject to yellowing and fading on storage unless subsequently fixed in the orthodox manner. With RC papers permanent, dry prints can be obtained in a reasonably short time (100 seconds for a 10 × 8 in print in the *Kodak Veribrom* processor). Such rapid processors are, however, very many times more expensive than stabilisation processors.

22 Printing and Enlarging

IN the last Chapter we considered the characteristics of the various types of printing paper. In the present Chapter we shall deal with the printing operation itself. There are two main ways of making prints: *contact printing* and *projection printing*, the principal difference between the two being in the method of exposing. In contact printing the sensitised paper is literally in contact with the negative, while in projection printing the paper is placed at a distance from the negative, the negative image being projected on to the paper by optical means.

Contact printing

This form of printing is a more simple operation than projection printing, requiring only the minimum of apparatus and equipment. As the fundamental principles are the same for both methods of printing, experience of contact printing provides a valuable introduction to projection printing.

Papers for contact printing

Contact prints may be made on contact (chloride), bromide or chlorobromide papers (Chapter 21).

Apparatus for contact printing

Contact prints are made using either a *printing frame* or a *printing box*, the latter being essentially a piece of apparatus combining a printing frame with a light source. Printing frames and boxes are intended to ensure as perfect a contact as possible between the negative and the sensitised paper during printing. More commonly, however, contact printing is used to provide proofing sheets from 120 or 35 mm film. Then the paper may be placed on the enlarger baseboard with the negatives on top – emulsion to emulsion. A glass plate holds them in close contact and the enlarger beam is used as a light source. Commercial forms of such a proof printer are available.

A sheet of paper 20·3 × 25·4 cm (8 × 10 in) can accommodate twelve negatives 6 × 6 cm in three strips of four or 36 negatives 24 × 36 mm in six strips of six. Special printing frames are available at modest cost which hold strips of negatives in the manner indicated above. If the negatives are reasonably uniform in density and contrast they can be printed with a single exposure. If not, such a sheet may be used as a guide for selection of a more appropriate paper grade and/or exposure for particular negatives.

Projection printing

Projection printing is the process of making positive prints by optical projection of the negative image on to sensitised paper. The projected image may be enlarged in scale, the same size as the negative or reduced. When the scale of objects in the print is larger than in the negative, the process is termed *enlarging*; when the scale of the print is smaller than the negative, the process is termed *reducing*. As projection printing is usually employed for the production of enlarged prints, projection printers are usually referred to as *enlargers*, and the term "enlarging" is loosely used to cover all forms of projection printing, whether the image is enlarged in scale, is the same size as the negative or is reduced.

Enlarging allows control in various directions to be introduced during printing, by, for example:

(1) *Selection of the main area of interest in the negative*, and enlargement of this area to any suitable size. This enables unwanted and possibly distracting areas around the edges of the picture to be eliminated, thus concentrating interest on the main subject.

(2) *Dodging and shading.* This enables detail in highlights or shadows to be brought out, which would otherwise be lost.

(3) *Local "fogging"* by a small external light can be used where dark areas are required, e.g. around a portrait to concentrate attention on the face.

(4) *Modification of the appearance of the image* by use of diffusers, etc., between lens and paper.

(5) *Correction − or introduction − of perspective distortion* by tilting the enlarger easel.

Apparatus for enlarging

Early enlargers were very similar to lantern-slide projectors, with the optical axis horizontal. To save bench space, some later enlargers were designed with the axis vertical; today, most enlargers are of this type. Not only do vertical enlargers save space, but they are much quicker to use. In some of them, operation is made to be still quicker by means of automatic focusing devices. Horizontal enlargers are, however, still used, particularly for very large prints.

The optical systems of most enlargers are of three main types:

(1) Condenser.
(2) Diffuser.
(3) Condenser-diffuser.

The condenser type, based on the lantern-slide projector, was the earliest form of optical system. Later, diffuse or semi-diffuse illumination tended to displace the straightforward condenser type. Whatever the type of optical system, the illumination is nowadays almost invariably provided by an artifical light source.

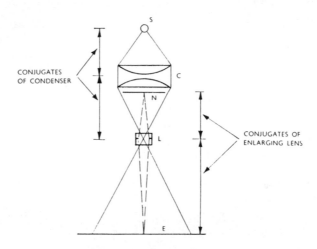

Fig. 22.1 – Optics of condenser enlarger

Condenser enlargers

Figure 22.1 illustrates the arrangement of a condenser enlarger. The purpose of the condenser C is to illuminate the negative evenly and to use the light output of the lamp as efficiently as possible. These are achieved, in practice, if the condenser forms an image of the light source S within the enlarging lens L. The latter is employed to form an image of the negative N in the plane of the easel E. The negative effects some scattering of the light, so that a cone of light spreads out from each image point, as indicated by the broken lines in the figure. This cone fills the lens L, but very unequally, the rays passing through the centre of the lens – and due to the non-scattered rays – being more intense than the rays through the outer zones of the lens. One result of this is that stopping down the lens of a true condenser enlarger does not increase exposure times by as much as might be expected (page 474), but tends to increase contrast.

The required diameter and focal length of an enlarger condenser depend on the size of the largest negative to be used. The diameter must be at least equal to the diagonal of the negative, and the focal length should be about three-quarters of this value.

The choice of focal length for the enlarging lens is restricted by a number of practical considerations. If it is too short in relation to the negative size, it tends not to cover the negative at large degrees of enlargement. If it is too short in relation to the focal length of the condenser, the light source must be a long way from the latter in order to form an image of the source within the lens. This necessitates a big lamphouse. It also means that the area of negative illuminated by the condenser is reduced. If, on the other hand, the focal length of the enlarging lens is too great, the distance from lens to baseboard is inconveniently long when big enlargements are required. The best compromise for most work is usually achieved by choosing a lens whose focal length is at least equal to that of the condenser but does not exceed it by more than one-third. This results in a lens of focal length equal to or slightly longer than that of the "normal" camera lens for the negative size covered.

Setting up a condenser enlarger

To achieve optimum illumination in a condenser enlarger, the various parts of the optical system must be so located that the light beam from the condenser converges to its narrowest cross-section within the enlarging lens. Now, when the degree of enlargement is altered, the distance of the enlarging lens from the negative is altered to obtain sharp focus. As the negative and condenser are fixed in relation to one another, it is obvious that some adjustment of the light source in relation to the condenser must be made if the image of the source formed by the condenser is to be kept within the enlarging lens. This involves "setting up" the enlarger each time the degree of enlargement is changed. The following procedure is recommended:

(1) Insert negative in carrier.
(2) Adjust enlarger to give a sharp image of the desired size.
(3) Stop down to required aperture.
(4) Remove negative (and diffuser, if used).
(5) Examine illumination of easel and adjust the distance of the lamp from the condenser until the illumination is seen to be even. If necessary, adjust the position of the lamp from side to side as well as to and from the condenser.
(6) Replace negative (and diffuser, if used), check the focus and make the exposure.

Diffuser enlargers

Diffuse illumination may be obtained by direct or by indirect lighting of the negative, the two different methods being illustrated in Figure 22.2.

For small negatives, an opal or frosted tungsten lamp with a diffusing screen – opal or ground glass – between lamp and lens is all that is required (Figure 22.2a). This method can be extended to somewhat

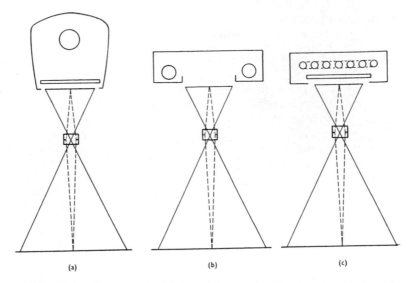

Fig. 22.2 – Optics of three types of diffuser enlargers. (a) Direct illumination through opal diffuser, (b) In direct illumination, (c) Cold-cathode illumination

larger negatives by using a bulb silvered at the tip – or a diffuser specially treated to that the transmission of the central part is reduced – to assist in obtaining uniform illumination of the negative. To illuminate a really large negative directly, an assembly of small bulbs must be employed behind the diffuser.

The indirect method of illumination illustrated in Figure 22.2b is another method of obtaining diffuse illumination; this is very suitable for large negatives. The light source usually consists of a series of tungsten lamps, although the reflected light from carbon arc lamps is sometimes employed.

A method of obtaining diffuse illumination by means of a mercury vapour lamp or cold-cathode lamp is illustrated in Figure 22.2c. Lamps of this type, in the form of a grid or helix, provide a large intense source of uniform illumination. One type of cold-cathode enlarger for amateur use is fitted with a circular fluorescent tube with a saucer-shaped reflector behind it. The illumination of the negative is obtained indirectly in this case.

Practical differences between condenser and diffuser enlargers

Many negatives can be enlarged equally well on a condenser or a diffuser enlarger. For certain types of work, however – especially in professional photography – the choice of enlarger is important.

The following are the main differences in practice between the two types of enlargers:

Condenser enlarger

(1) Gives maximum tone-separation, especially in highlights.

(2) Is unsuitable for negatives that have been retouched — the ridges of the retouching medium printing as dark lines.

(3) Tends to accentuate blemishes, grain, etc.

(4) Is very suitable for work at a high degree of enlargement, because of its high optical efficiency.

(5) Image contrast is higher than when contact printing or using a diffuser enlarger* thus requiring the negatives to be developed to a lower contrast (see Table 22.1) or, alternatively, a lower contrast grade of paper to be used.

(6) Suffers from the inconvenience of requiring readjustment of the lamp position whenever the degree of enlargement is altered appreciably.

Condenser enlargers are therefore often preferred when large prints are required and retouching is usual, e.g. for commercial and industrial photography.

Diffuser enlarger

(1) Is essential where retouching is used. In retouching, matching is done over an opal diffuser, so retouched negatives must be printed under similar conditions for the retouching to yield the desired effect, without being obtrusive.

(2) Subdues scratches, grain, etc.

(3) Is not suitable for work at a high degree of enlargement — unless a high-power cold-cathode or mercury vapour light source is employed — because of the low optical efficiency of the diffuse negative illuminating system.

(4) Image contrast is similar to that obtained when contact printing, i.e. lower than when using a condenser enlarger* and hence requiring negatives to be developed to a higher contrast (see Table 22.1) or a higher contrast grade of paper to be used.

Diffuser enlargers are therefore essential where retouching is a routine. There is no reason why the definition obtained with a diffuser enlarger should be inferior to that obtained with a condenser enlarger.

Because of the variation of the Callier coefficient with density (page 263), the tone distribution in the shadows of a print produced with condenser enlarger may be different from that in a print produced in a dif-

* In one experiment where the same negative was enlarged in different types of enlargers, equivalent results were obtained with papers of which the log exposure ranges were:

Condenser, clear bulb	1·1
Condenser, opal bulb	1·0
Opal diffuser, clear bulb	0·9
Ground glass and mercury vapour lamp	0·8
	(Clerc)

fuser enlarger. The difference is not usually of great practical importance. Table 22.1 relates the required negative contrast to the enlarger type.

	Condenser enlarger	Diffuser enlarger
Contrast index	0·45	0·56
\bar{G}	0·55	0·70

Table 22.1 – Negative contrast and type of enlarger

Notes

(1) Some increase in camera exposure (up to 1 stop) may be required when developing to the lower contrast.

(2) The required contrast refers to average subjects.

(3) The contrasts quoted in the table are those recommended by film manufacturers for printing average negatives on a normal grade of paper.

Condenser-diffuser enlargers

Most popular enlargers of today employ an optical system which includes both condenser and diffuser. For many purposes, especially in amateur work, such a system offers a very practical compromise between condenser and diffuser enlargers. It permits shorter exposure times than a true diffuser enlarger, yet avoids the necessity for adjusting the position of the lamp for each variation in the degree of enlargement as is necessitated in a condenser enlarger. Grain and blemishes on the negatives are subdued to a useful extent – even if not as much as in a diffuser enlarger. In most of these *condenser-diffuser enlargers*, diffusion is achieved simply by using an opal or frosted bulb as light source, instead of the point source required in a true condenser enlarger.

Some condenser enlargers are fitted with a removable diffusing screen – usually a sheet of ground glass – between the condenser and the negative carrier. This avoids the necessity for frequent readjustment of the carrier. This avoids the necessity for frequent readjustment of the position of the lamp, but exposures are longer. The ground glass is uniformly illuminated by the condenser and its scatter is predominately towards the lens. An alternative approach is to use a light integrating box lined with reflective material with a diffuser at the exit face. Such devices are widely used in colour enlargers (see page 487). This action, and the consequent increase in the amount of light passing through the lens (as compared with use of a diffuser without condenser), is the sole advantage of using the condenser in this case. To achieve even illumination to the corners of the negative when a diffusing screen is used in a condenser enlarger, the diameter of the condenser must be somewhat greater than usual, i.e. a little greater than the diagonal of the negative, instead of equal to it (page 464).

Light sources for enlarging

A number of light sources are being used or have been used in enlargers:

 (a) Tungsten lamps,
 (b) Tungsten-halogen lamps,
 (c) Mercury vapour lamps,
 (d) Cold cathode lamps.

A single tungsten lamp provides a very convenient and efficient source of light for enlarging, and most of the smaller enlargers employ such a source. A tungsten lamp may be used in conjunction with a condenser or with a diffusing system. An opal or pearl lamp used with a condenser provides, very conveniently, a condenser-diffuser system. Some tungsten lamps are specially designed for use in enlargers. These are usually slightly over-run, to give high efficiency, and specially treated to provide uniform diffuse illumination with minimum absorption by the envelope of the lamp. Care should be taken in selecting a tungsten lamp for use with a condenser that there is no imprint on the top of the bulb, as this may lead to uneven illumination. (The existence of an imprint is unimportant when several tungsten lamps are used to provide illumination by reflection.)

Tungsten-halogen lamps (page 45), sometimes called quartz-halogen or quartz-iodine lamps are also used in many modern enlargers. Their spectral output differs from conventional incandescent lamps owing to some spectral absorption by iodine vapour and they have a greater output of ultra-violet radiation because the quartz envelope of the lamp transmits this region of the spectrum.

There are a number of types of mercury vapour lamps. The extended source provided by the larger lamps has certain advantages over tungsten lamps when diffuse lighting is required. Its light is intense, it gives out little heat and it is economical in current. On the other hand, the appearance of the image on the easel is deceptive, and a worker inexperienced with this type of light source is very apt to over-expose. Because the mercury vapour spectrum is not continuous, it tends to yield peculiar results with spectrally-sensitised papers. With many of these papers, such as the faster chlorobromides, the results are merely softer than usual, and can be corrected by choice of a harder grade of paper. It should be noted that the mercury vapour lamp does not reach its full intensity until about three minutes after switching on, and it should not, therefore, be used until after that period. It is normal practice for mercury vapour enlargers to be left running while in use, exposures being controlled by means of a shutter. Although most mercury vapour enlargers are of the diffuser type, compact source mercury vapour lamps are sometimes used in condenser enlargers.

The cold cathode type of lamp is a very valuable addition to the range of light sources suitable for use in enlargers. Cold cathode lamps are obtainable in various forms. For use in enlarging they are usually made in the form of a grid or spiral, which provides a large intense source

of uniform illumination. All cold cathode enlargers ar of the diffuser type. Unlike mercury vapour lamps, cold cathode lamps reach their full intensity almost immediately after switching on and do not require to be left on continuously.

Lenses for enlargers

Lenses especially designed for use in enlargers are usually of the symmetrical type. Apertures are often marked not with f-numbers but with figures such as 1 (maximum aperture), ×2, ×4, ×8, etc., to indicate the relative exposure times required. (But see page 122.) For ease in operation in the darkroom, "click" stops are frequently fitted. Because of the danger of overheating, especially if a condenser enlarger is employed, cementing of the elements of an enlarger lens is sometimes avoided.

We have seen that, for a condenser enlarger, the focal length of the enlarging lens should be similar to or slightly longer than that of the "normal" camera lens for the negative size concerned (page 464). This rule holds good for diffuser enlargers too. If the focal length of a lens used with a diffuser enlarger is too short, it is difficult to obtain uniform illumination at the edges of the field; if it is too long, the required throw becomes inconveniently long – just as with a condenser enlarger.

An exception to the general rule for determining the focal length of an enlarger lens applies when working at or near same-size, or when reducing, e.g., when making lantern slides. The angle subtended by the lens at the negative is then much smaller, and it is possible to use a lens of shorter focal length than normal without running into the dangers of uneven illumination or lack of covering power. In fact, use of a lens of shorter focal length is often essential when reducing in an enlarger with limited bellows extension.

In general, camera objectives may be used quite satisfactorily as enlarging lenses, although some which give a flat field with distant objects do not do so when used in the enlarger; this is because the conjugate distances in the two cases differ widely. Generally speaking, however, this defect can be overcome by stopping down.

Incorporation of a heat filter (page 213) in an enlarger fitted with a tungsten lamp is always an advantage in protecting not only the negative but also the lens from overheating.

The use of a mercury vapour light source in an enlarger raises a special problem in connection with the choice of lens. With such a source, focusing is done by means of the visible (predominantly green) image, whereas the effective rays as far as exposure is concerned are in the near ultra-violet region. It is therefore desirable for a lens used in a mercury vapour enlarger to be corrected to bring the green and near ultra-violet foci into coincidence. (An achromat is normally corrected to bring the green and blue-violet foci into coincidence (page 107).) Lenses especially corrected for use in mercury vapour enlargers are therefore

made, although modern enlarging lenses are satisfactory due to their form of colour correction.

Selecting an enlarging lens

When selecting an enlarging lens the following should be considered:

(1) *Focal length.* Is this suitable in relation to the size of negative, focal length of condenser (if employed) and range of extension? The suitability of the focal length of the lens in relation to the negative is a question of covering power. This should be tested when the angle subtended by the lens at the negative is at its greatest. This occurs at large magnifications, when the lens is nearest to the negative. Zoom enlarging lenses are now becoming available.

(2) *Definition.* This should be tested both in the centre and at the edges of the field, at the greatest degree of enlargement likely to be employed in practice, the test being repeated at several apertures. The most useful form of test is to make a series of actual enlargements.

(3) *Range of stops.* Can the markings be read easily or are "click" stops fitted? Is the smallest stop small enough to permit sufficiently long exposures for "dodging" to be done at same-size reproduction.

(4) *If a mercury vapour source is employed*, a check should be made that visual and near ultra-violet foci coincide, for the reason given above. For this check, a suitable test negative should be inserted in the enlarger, the easel should be tilted slightly, and the centre of the image focused as sharply as possible. A print should then be made in the usual way, and examined to see where the image is sharpest. If the sharpest part does not lie in the centre of the print, the chemical and visual foci do not agree. The test may be repeated at various stops. Suitable negatives for the test are: a negative of a printed page, a commercial enlarger test negative or focusing aid, or a ruled fogged negative.

(5) *If an auto-focus enlarger is employed*, a check should be made that the focusing device operates satisfactorily with the lens concerned at all magnifications.

Negative carriers

An important feature of any carrier for film negatives is that it should hold the negative flat. This is often achieved by sandwiching the negative between two pieces of glass of good quality, which must be kept scrupulously clean. With very small negatives, e.g., of the 24×36 mm size, the glass can be dispensed with and the negative held between two open frames, which lessens the chance of dust marks on prints. When such glassless carriers are used, there is, however, a tendency for negatives to "jump" from one plane to another under the influence of heat; if this happens between focusing and exposing, the print may be out of focus. Stopping down to increase depth of field helps to minimise the effect.

Heat filters

To protect negatives from damage due to overheating, some enlargers are fitted with a heat filter, i.e. a filter which passes visible radiation but absorbs heat rays. The provision of a heat filter is particularly important when a tungsten lamp is employed as the illuminant and exposure times are long, e.g. when big enlargements are being made, or when using colour materials. A heat filter will also protect an enlarger lens from possible danger from overheating (page 213).

Easels and paper holders

When using a horizontal enlarger, the sensitive paper is commonly pinned to a vertical easel – which must be parallel to the negative. For enlargements with white borders, it is necessary to fit some form of masking device to the easel. For vertical enlargers, special paper-holding and masking frames for placing on the bench or baseboard under the enlarger head, can be obtained commercially. The easels of some vertical enlargers incorporate built-in masking devices.

Other types of easels are available for borderless prints. One type makes use of a flat board that has a tacky surface that grips the back of the paper to hold it flat but is readily released after exposure. The tacky surface can be reapplied from an aerosol spray when it ceases to be effective. Another method for obtaining borderless prints is by the use of spring loaded magnetic corners that grip the edges of the paper without obscuring the surface and so hold the paper flat on a metal base. More sophisticated easels use a vacuum to hold the paper flat.

For professional enlarging where a large number of prints are required a roll paper holder with motorised transport may be used. This enables many enlargements to be made on a long roll of paper (75 m) and the motorised paper transport mechanism can be coupled to the exposure timer for automatic paper advance after each exposure.

For enlargements with black borders, prints are first made in the usual way – with or without a white border. A sheet of card, measuring, say, 10 mm less each way than the print, is laid centrally on it and the edges, which are not covered by the card, are fogged to white light for one or two seconds.

Determination of exposure times in enlarging

Of the many factors which affect exposure times in enlarging, the following are probably the most important:

(1) Light source and illuminating system.
(2) Aperture of the enlarging lens.
(3) Density of the negative.
(4) Degree of enlargement.
(5) Speed of the sensitised paper (under given working conditions).

The exposure required will also be influenced by the effect desired in the final print.

The most reliable way of determining the exposure is by means of a test strip. A piece of the paper on which the print is to be made is exposed in progressive steps, say 2, 4, 8 and 16 seconds. This is done by exposing the whole strip for 2 seconds, then convering one-quarter of the paper with a piece of opaque card while a further exposure of 2 seconds is made. The card is then moved over to cover half the strip and a further 4 seconds exposure is given. Finally, the card is moved to cover three-quarters of the strip and an exposure of 8 seconds is given (Figure 22.3). If care is taken to move the card quickly and precisely, it may be moved while exposure proceeds, thus avoiding the need for switching the light off and on. The strip is then given standard development, and the correct exposure is assessed on the basis of a visual examination of the four steps in white light.

If the correct exposure appears to lie between two steps, the exposure required can usually be estimated with sufficient accuracy, but if desired a further test strip may be made. If, for example, the correct exposure appears to lie between 8 and 16 seconds, a second strip exposed in steps of 10, 12 and 14 seconds will give a good indication of the exact time required.

Once the exposure time for one negative has been found by trial, other negatives of similar density may be given the same exposure. Further test prints will at first be required for negatives of widely differing density, but with experience it is possible to estimate the exposure required for almost any negative, without resort to test exposures. Such "trial and

CARD MOVED IN THIS DIRECTION
BETWEEN EXPOSURES

Fig. 22.3 – A processed test strip for determining the required exposure in contact printing or enlarging

error'' methods are also used when an electronic assessing device is used as a means of calibrating the instrument using a standard or representative negative (see page 476).

Effect on exposure of variation of aperture

With a diffuser or condenser-diffuser enlarger, the effect of stopping down on exposure is similar to that experienced in the camera, i.e. the exposure time required varies directly with the square of the f-number. In a true condenser enlarger, however, the light reaching the lens from each point on the negative is not distributed evenly in the lens but is concentrated on the axis (page 464). Consequently, stopping down does not reduce the light passed by the lens by as much as might be expected, and exposures do not therefore have to be increased by the anticipated amount. Hence, the customary rule of giving twice the exposure when using the next smaller stop does not apply to the lens of a condenser enlarger. This must especially be borne in mind when using a lens in which the stops are marked with numbers which are intended to indicate the relative exposures required.

Modern enlarging lenses are usually anastigmats giving a flat field and excellent definition at full aperture. Definition may be slightly improved by stopping down one or two stops, but there should not be any necessity to stop down further simply on account of definition. In fact definition in enlarging may sometimes be harmed by excessive stopping down (see page 117). Considerable stopping down is usually required only:

(1) If a glassless negative carrier is employed and there is risk of the film buckling. Stopping down then assists by increasing the depth of field.

(2) If the easel has to be tilted to correct — or introduce — perspective distortion. Stopping down then increase the depth of focus.

(3) If exposure times at larger apertures are too short to enable exposures to be timed accurately or to permit dodging.

Stopping down the lens of a condenser enlarger tends to increase contrast (page 464).

Effect on exposure of variation of degree of enlargement

It might, at first, be expected that the exposure required when enlarging would vary directly with the area of the image, i.e. with m^2, where m is the degree of enlargement (image size/object size). In fact, however, the exposure varies with $(1 + m)^2$ — just as in negative making. When the exposure at one particular degree of enlargement has been ascertained, the exposures for prints at other degrees of enlargement, from the same negative, can conveniently be calculated from the table opposite, which is based on the $(1 + m)^2$ formula. The required exposure is found from Table 22.2 by multiplying the known exposure by the factor lying under the new degree of enlargement on the line corresponding to the old.

Enlarging photometers, exposure meters and timers

Various types of photometer have been devised to assist in the determination of exposures in enlarging. The general procedure when using such an instrument is to read the luminance of the image on the easel at the desired magnification, with the lens stopped down as required. The reading may be made on either the shadow or highlight areas of the image, provided that the instrument is suitably calibrated. A reading of the luminance of the "shadows", i.e. the brightest part of the image, is usually the easiest to take, and is probably the best guide to the exposure required.

Use of an exposure photometer does not completely solve the problem of print exposure. With subjects of unusual luminance range or unusual tone distribution, the exposure indicated by the photometer will not always be the best. In such a case, the exact exposure must be found by trial, although use of a photometer may assist by giving a first approximation to the exposure required.

Some assistance in estimating exposure can be obtained by reading the density of the negative – shadows or highlights – with a densitometer (*off-easel assessment*). The help obtained in this way is not great, however, because allowance must still be made for other variables such as degree of enlargement, aperture, light source, type of optical system employed, etc.

Degree of enlargement for which exposure is known	New degree of enlargement									
	1	2	3	4	5	6	8	10	12	15
1	1	2	4	6	9	12	20	30	40	60
2	1/2	1	2	3	4	5	9	13	20	30
3	1/4	1/2	1	1½	2	3	5	8	10	16
4	1/6	1/3	2/3	1	1½	2	3	5	7	10
5	1/9	1/4	1/2	2/3	1	1⅓	2	3	4	7
6	1/12	1/5	1/3	1/2	3/4	1	1½	2½	3	5
8	1/20	1/9	1/5	1/3	1/2	2/3	1	1½	2	3
10	1/30	1/13	1/8	1/5	1/3	2/5	2/3	1	1⅓	2
12	1/40	1/20	1/10	1/7	1/4	1/3	1/2	3/4	1	1½
15	1/60	1/30	1/16	1/10	1/7	1/5	1/3	1/2	2/3	1

Table 22.2 – Exposure factors and degree of enlargement

Notes. (1) This table holds only approximately for condenser enlargers where the lamp-to-condenser distance is altered to suit new magnification, since this has the effect of altering the illumination on the negative.

(2) At very long exposure times, reciprocity law failure may assume significant proportions. The higher factors in this table should therefore be used as a guide only; the actual exposure time required when a large factor is indicated may be appreciably longer than that derived from the table.

Electronic assessing and timing devices are used extensively in colour printing and are described more fully at the end of this chapter (pages 492 to 494). In order to assess the exposure required for printing a

negative use is made of the fact that the light transmitted by the majority of negatives integrates to a constant density, or spot readings of a small critical area such as a mid-tone (flesh tone or a grey card included in the original scene) are taken with a suitable measuring instrument. Determining exposures by either of these methods with the negative in the enlarger and the probe of the measuring instrument on the baseboard is given the name *on-easel assessment.*

In both cases the meter requires calibration by printing a *master* or *standard* negative (see page 492) by one of the non-instrumental methods described on page 473. Once a satisfactory print has been made the measuring probe is placed on the baseboard and the instrument is "zeroed", employing either a spot or integrated measurement of the light transmitted by the master negative. Any other negative that does not depart markedly from the master should give a satisfactory print after taking a reading with the meter and adjusting the exposure by the amount indicated by the measuring device being used.

Many such assessing devices also have an electronic timer incorporated and lend themselves to automated printing by assessing the exposure during the printing operation and turning the enlarger lamp off after the required time. These automatic assessing devices assess the total or integrated light transmitted by the negative by placing the detector or probe in one of the positions shown in Figure 22.4. The following positions may be used:

(1) Measuring light scattered by the negative before passing through the enlarger lens.

(2) By deflecting a portion of the transmitted light to the detector by means of a beam splitter after it has passed through the enlarger lens.

(3) By measuring light reflected from the paper.

(4) By measuring light incident on the paper after it has been diffused.

(5) By collecting and measuring light after it has been transmitted by the paper.

Methods (1) and (2) are commonly used in automatic printers, while (3) and (4) are used in professional enlargers for both colour and black and white printing. Masking frames complete with photocell or photomultiplier tube on an arm (method 3) are commercially available and are used in the printing of both black and white and colour negatives; some also incorporate a timer. The probe used for method (4) may be either the photomultiplier tube itself, linked to the meter or, to enable a less bulky probe to be used, the detector is placed in the meter and light is transmitted to it by a fibre optic light guide.

It is also possible to use a simple photographic exposure meter for assessing exposures for printing negatives. One such technique involves placing the exposure meter against the enlarger lens to measure the integrated light from the master negative after having first obtained a satisfactory print. Then with the new negative in the enlarger the aperture is adjusted to obtain the same reading as before and a print made

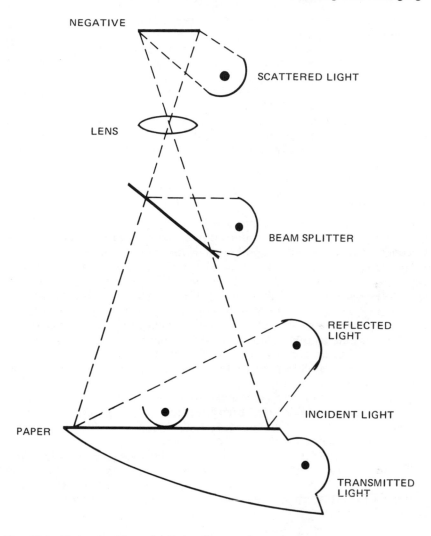

NEGATIVE

SCATTERED LIGHT

LENS

BEAM SPLITTER

REFLECTED LIGHT

INCIDENT LIGHT

PAPER

TRANSMITTED LIGHT

Fig. 22.4 – Various positions of detectors for assessing exposure

using the same exposure time. Although seemingly crude, this technique does appear to work and has even been used in colour printing.

Variation in illuminant in enlarger

The output of a tungsten lamp falls off with age. In determining exposures allowance must be made for this, especially when a new lamp is fitted. If the new lamp is of a different type or make from the previous one – although of the same wattage – its output may differ for this

reason also, since not all lamps of the same wattage have equal efficiencies.

Voltage fluctuations in the mains supply can make it difficult to achieve accurate exposures in enlarging. For example, a 5 per cent reduction in voltage lowers the light output by about 20 per cent and at the same time alters the colour temperature considerably (Chapter 3). Normal supply variations do not usually cause trouble, but, if for any reason the variation is excessive, it may be worth while in critical work to fit some form of voltage regulator to the supply. Both manually controlled and automatically controlled equipment is available for this purpose.

Dodging and shading

We have already stated that one of the advantages of enlarging is that it gives the photographer the opportunity of controlling the picture by intercepting the projected image between the lens and the easel. It is no exaggeration to state that a "straight" enlargement from any negative is seldom the best that can be obtained, and with the great majority of subjects — landscapes, portraits, architecture or technical — a little local shielding of parts which print too deeply, or the printing in of detail in some especially dense part of the negative, will work wonders. Control of this kind may be used to compensate for uneven lighting of the subject or to give added prominence to any given part of the composition.

To bring out detail in a highlight, a card should be used from which has been cut or torn a hole slightly smaller than the part to be treated. After exposing the whole picture in the usual way, the card is employed to shield all parts except that which is to be exposed further. The card is held fairly close to the easel and kept on the move slightly for such additional time as a test or trial enlargement shows to be necessary.

A portrait in which the shadow side of the face becomes too dark before the full details of the other parts are out, can often be improved by using a "dodger". Dodgers may be made from thin card cut to a variety of shapes and sizes, a few of which are illustrated in Figure 22.5, thin stiff

Fig. 22.5 — Dodgers for local control in enlarging

wire being threaded through holes in the card. They are conveniently made to be double-ended as shown, with a twist in the middle of the wire for hanging on a hook in the darkroom. The shape and size of the shadow cast by a dodger can be varied endlessly by tilting it, and by using it at different angles and at different distances from the easel. Professional workers usually find it quickest and simplest to use their hands as dodgers.

Correction – or introduction – of perspective distortion

We saw in Chapter 10 (page 190) that if we tilt a camera upward in order to include the whole of a building in the picture, we shall achieve the unpleasant effect termed "converging verticals". If we are using a camera without movements such results are sometimes inevitable. The distortion can be remedied to some extent by tilting the easel (in the appropriate direction) when the enlargement is made; this will compensate for the convergence in the negative. Usually, however, only a small degree of distortion can be corrected satisfactorily in the enlarger, and there is always a danger of foreshortening or elongating the image.

In some fields, use is made of the control afforded by tilting the easel to *introduce* distortion.

When the easel is tilted – to correct, or introduce, distortion – it is normally necessary to stop down the enlarger lens as far as it will go, to obtain sharp focus over the whole print. Some enlargers have a tilting negative carrier or tilting head to make it possible to focus sharply over the entire print without stopping down.

Minimising graininess

Owing to the fact that all photographic images are made up of fine grains of silver of finite size, enlargements – especially if of considerable magnification – may appear "grainy" (Chapter 25). The graininess of a print is primarily a function of the graininess of the negative and the degree of enlargement. It may, however, be modified to a limited extent at the printing stage, e.g.:

(1) *By choice of a suitable enlarger.* Where graininess is serious, condenser enlargers should be avoided as they accentuate the effect; enlargers of the diffuser type are to be perferred in such a case.

(2) *By using a printing paper with a grained or rough surface.*

(3) *By using a diffuser between enlarger lens and printing paper.* See below under "Soft-focus enlargements".

(4) *By setting the enlarger slightly out of focus.*

The figures in Table 22.3 indicate *very approximately* the degree of magnification permissible with four common types of film, before graininess becomes apparent on prints held in the hand. They assume correct exposure and development.

The graininess permissible in a print depends very much on the conditions of viewing. The graininess permissible for a large print to be hung on

an exhibition wall is much greater than can be tolerated in a small print to be viewed in the hand. Any figures for permissible magnification can, therefore, be only approximate. When preparing "giant" enlargements, critical judgement should not be given until the prints are finally spotted and viewed at the appropriate distance. "Giant" enlargements look extremely coarse and full of imperfections when they are examined prior to mounting and finishing.

Soft-focus enlargements

Subjects of a pictorial nature are often greatly improved by diffusing the image so as to blur its aggressively sharp definition slightly. This may be achieved by breaking up the image by the interposition of a suitable material between the lens and the picture. A piece of black chiffon, bolting silk, fine-mesh wire or crumpled Cellophane may be fitted to a rim which is slipped on to the enlarging lens for part or all of the exposure. Alternatively, an optical "soft-focus attachment" can be employed. The result is to give the image a soft appearance with a slight overlapping of the edges of the shadows on to highlight areas. In addition to giving softer definition, the enlargement also shows slightly weaker contrasts and graininess is minimised. Net-like material or Cellophane stretched over a card cut-out may also be used close to the enlarging paper. The texture effect is then usually more pronounced. Whatever form of diffusing medium is used, at least 50 per cent of the exposure should generally be made without diffuser. The effect produced when diffusion is obtained in the enlarger is not the same as when a soft-focus lens is used on the camera (page 220).

Type of film	Type of developer		
	General-purpose	Fine-grain	Extra-fine-grain
Extreme-speed panchromatic	4×	6×	8×
Fast panchromatic	6×	9×	12×
Medium-speed panchromatic	8×	12×	16×
Extra-fine-grain panchromatic	12×	18×	24×

Table 22.3 — Approximate permissible magnification for four film types

Colour printing

The basic techniques of black-and-white printing are also applicable to colour printing, i.e. contact, projection and machine printing methods are all used, but with some practical restrictions owing to the nature and properties of the colour materials. In addition rather more sophisticated equipment is needed to ensure consistency and predictability of results.

The principles of colour photography are discussed fully in Chapter 14 and the technology of colour reproduction by subtractive synthesis

methods using yellow, magenta and cyan dye images only, is described for both reversal and negative-positive processes in Chapter 24.

Colour printing materials, of which there are a wide variety of general and special purpose types, all utilise such due images although there is a wide diversity of order of layer sensitisation, emulsion contrast, method of dye formation and type of base used, depending on origin and application.

Scope of colour printing

The fundamental technique of colour printing is to produce a colour print of an orginal subject, having correct or acceptable density and colour balance. There are various forms of colour printing, depending on the materials employed, which may be sub-divided into the two classes of *negative-positive* printing and *positive-positive* printing. In the case of the former, a colour negative is printed on to colour print material which is subsequently colour developed to give the final positive result. The latter method uses a colour transparency printed on to colour material which is reversal processed, using either chromogenic development or dye-destruction techniques. These two-stage processes may be further extended if devices such as colour intermediates or masking techniques are employed.

Other forms of printing from colour originals whether negative or reversal, include the making of monochrome prints, colour separation matrices for dye imbibition printing and the production of colour inter-negatives. Figure 22.6 outlines some of the possible printing "routes" to various end products commencing with a colour negative or transparency original.

Colour print materials may have an opaque, white reflecting base of paper, resin coated paper or plastic to give colour prints for viewing by reflected light. Alternatively, a transparent base may be used to give a transparency for viewing by transmitted light.

Variables in colour photography and printing

The accuracy or acceptability of the final colour reproduction, in particular when colour printing by negative-positive techniques, depends on a large number of variables in the reproduction chain. Some are under the direct control of the user, others are not. An abbreviated list of variables include:

(1) The nature of the subject and subjective colour effects.
(2) The properties of the light source used.
(3) The camera and lens used.
(4) Exposure duration.
(5) Film batch characteristics, including latent image stability.
(6) Film processing.
(7) Colour enlarger characteristics.

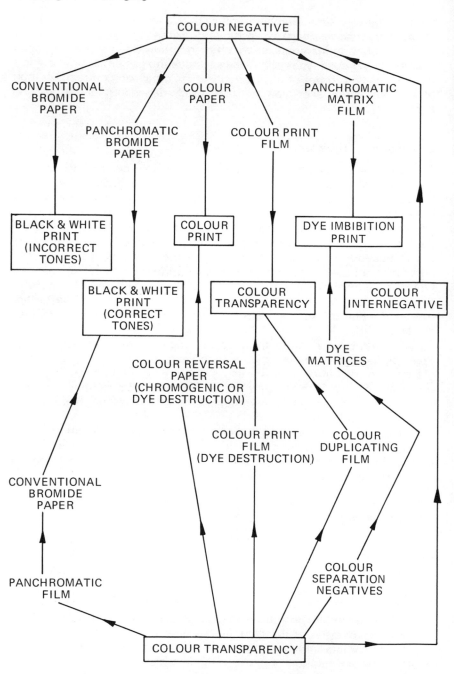

Fig. 22.6 – Some possible printing routes from a colour negative or a colour transparency

(8) Print exposure conditions.
(9) Colour paper batch characteristics.
(10) Colour paper processing.
(11) Viewing conditions for the colour print.

It might seem that colour printing is therefore a formidable task and that the possible sources of error make acceptable colour reproduction a difficult achievement. Fortunately, with some care, foresight and methodical operating techniques, it is possible to control most of the variables concerned with the mechanics of print production so that full attention can be given to the problems of print assessment. Of the greatest importance and assistance to this end is the recording of all useful information where known or available, including negative data, printing data and colour processing control.

Much of the necessary information regarding the use and practice of colour printing is available from the manufacturers of sensitised materials, albeit with the emphasis on their own range of products. There is a certain amount of compatability between one manufacturer's products and those of another so that colour negatives taken on one product may be printed on print material from another source. In addition, paper and chemical substitute formulae from independent manufacturers are also available.

Colour filtration

Some of the errors caused by inconsistencies at the camera stage, such as incorrect colour temperature of the source and reciprocity law failure effects, may be wholly or partially correctable either overall or locally on the print by judicious use of corrective colour filtration of the enlarger light source. Such colour filtration is the prime control of colour reproduction in the print. By altering the relative proportions of exposures to the red, green and blue sensitive layers of the print material, which respectively yield cyan, magenta and yellow dyes in an imagewise relationship to exposure, colour reproduction may be varied at will, as will be described in detail subsequently.

The peak sensitivities of the individual layers of colour print materials are matched to correspond more or less with the peak spectral absorptions of the three subtractive dyes used in colour negative materials – for any one range of products, naturally. However, the individual sensitivities of the three layers of the colour print material vary greatly, to compensate for the particular position of one layer in the coating order and to give adequate separation of spectral sensitivities of the layers without the need for an additional yellow filter layer used in conjunction with the blue sensitive layer. Also compensation for the density of the masking layers in masked colour negative materials may also be given by this means. The difficulties of manufacture mean that each batch of colour print material will have layer sensitivities similar to but not identical with other batches. Finally, the overall response of the colour print material

depends on the spectral energy distribution of the light source in the enlarger and any selective absorption by the optical system.

The major role of colour filtration in colour printing is to compensate for such batch differences of materials. Secondary functions include compensation for differences between enlargers in terms of the quality of light output and the correction of colour casts due to print reciprocity law failure effects. This latter is caused by the unequal response of the three image-forming layers as exposure time is increased either to give a greater magnification or to permit use of a smaller aperture in the enlarger lens.

Colour filtration is, of course, also a creative tool in the hands of the user, permitting mood and effect to be introduced into prints, for "correct" colour reproduction is not always the aim.

The necessity of controlling the relative exposures of the three layers of different spectral sensitivity of colour print materials is a fundamental aspect of the design of equipment for colour printing. Two basic methods are used: sequential selective exposure of each layer (termed *additive* printing), or a filtered single exposure, exposing all three layers simultaneously (termed *subtractive* printing).

Additive or triple-exposure printing

The colour prints material may be exposed to the colour negative (or transparency) by three consecutive exposures using a tricolour red, green and blue separation set of filters. Thereby the blue sensitive layer is exposed only to the yellow dye image carrying blue information about the subject and so on. The exposure level for each layer is adjusted by varying the exposure time given, although it is possible to alter the lens aperture instead and retain a constant exposure time. Because of the filters and method used this printing method is usually referred to erroneously as *additive* colour printing. The term additive is reserved for the method of colour synthesis used in reproduction and is not applicable to this form of subtractive colour reproduction by dyes. The more accurate description of *triple-exposure printing* is preferred.

Overall print density is controlled by the magnitude of the three exposures left in the same ratio. Print colour balance is determined by the ratio of the three exposures, usually as exposure times. From subtractive theory we can derive tables for the effect of corrective adjustments to final colour balance. Table 22.4 refers to conventional negative-positive printing and to positive-positive printing by this method.

The advantages of the triple-exposure method are that initially only three filters are needed, obviating the need for an expensive colour enlarger, provided that basic requirements are fulfilled (page 487) and that it also lends itself to automation, allowing it to be used in colour printers for mass production.

The disadvantages are quite formidable unfortunately. Foremost is that of registration problems, if the enlarger or masking frame should be

Triple-exposure colour printing.

	Negative-positive printing		Positive-positive printing	
	Remedy		Remedy	
	Either	Or	Either	Or
Appearance of test print on assessment	Increase exposure through this filter	Decrease exposure through this filter	Increase exposure through this filter	Decrease exposure through this filter
Too dark	–	All three	All three	–
Too light	All three	–	–	All three
Yellow	Green and red	Blue	Blue	Green and red
Magenta	Blue and red	Green	Green	Blue and red
Cyan	Blue and green	Red	Red	Blue and green
Blue	Blue	Green and red	Green and red	Blue
Green	Green	Blue and red	Blue and red	Green
Red	Red	Blue and green	Blue and green	Red

Table 22.4 – Corrective adjustments when colour printing by triple-exposure methods

moved accidentally between exposures. There is also the possibility of widely differing exposure times for the individual layers.

Some users find difficulty in assessment of colour prints and subsequent corrective action for colour and density changes. Finally, local control of density and colour by selective filtration and exposure is not easy to perform, even for skilled printers. However some colour enlargers use *simultaneous additive printing* in which three light sources can be separately varied (time or intensity) and so avoid registration problems.

Subtractive or white-light printing

The preferred alternative for manual colour printing is to give a single, filtered exposure of white light instead of three exposures of coloured light. Selective exposure of the three layers with a constant exposure time and lens aperture is made by altering the proportions of red, green and blue light from the source by subtracting the excess amounts using weak colour printing filters of cyan, magenta and yellow respectively (see page 310). Hence the alternative names of "subtractive" referring to the filters used or "white-light" referring to the colour of the light used for the exposure.

Once again, from the subtractive theory of colour reproduction, it is possible to derive tables to suggest filtration changes to improve colour reproduction when a test print is assessed. Table 22.5 lists such corrections for negative-positive printing using conventional colour materials. It is worth pointing out that many colour print materials require only the

White-light colour printing.

Appearance of test print on assessment	Negative-positive printing		Positive-positive printing	
	Remedy		Remedy	
	Either	Or	Either	Or
	Add filters of this colour	Remove filters of this colour	Add filters of this colour	Remove filters of this colour
Too dark	Reduce	exposure	Increase	exposure
Too light	Increase	exposure	Decrease	exposure
Yellow	Yellow	Magenta and cyan	Magenta and cyan	Yellow
Magenta	Magenta	Yellow and cyan	Yellow and cyan	Magenta
Cyan	Cyan	Magenta and yellow	Yellow and magenta	Cyan
Blue	Magenta and cyan	Yellow	Yellow	Magenta and cyan
Green	Yellow and cyan	Magenta	Magenta	Yellow and cyan
Red	Yellow and magenta	Cyan	Cyan	Yellow and magenta

Table 22.5 – Corrective adjustments when colour printing by white-light methods

use of yellow and magenta colour printing filters for all corrections. This is because the sensitivities of the blue and green sensitive layers usually exceed that of the red sensitive layer. Also, the use of yellow, magenta and cyan filters in the light path is inefficient as the resultant amounts of neutral density is causing unnecessary loss of light at the image plane.

Table 22.5 also gives the necessary corrective filtration for colour casts when positive-positive printing is being performed. For this technique it should be noted that an increase in exposure gives a less dense print and vice versa, the reverse of the negative-positive case. Also addition of filtration of a particular colour, e.g. yellow, either gives a more yellow result or alternatively, reduces or removes a blue cast from a print.

The advantages of white-light printing are numerous. There are no registration problems or intricate calculations of relative exposures. More efficient use is made of the light output available. Local control of density and colour are possible by the usual shading and burning-in techniques with or without filtration.

The necessary enlarger modifications may be incorporated in an accessory "head".

One disadvantage is the higher initial cost of a large number of colour filters or of a colour head for the enlarger. The filters may fade with use if not of the dichroic variety.

Colour enlarger design

The majority of enlargers used for conventional black-and-white printing may be used for colour printing by the introduction of a few modifications. Alternatively, a different lamp-house may be fitted, complete with colour filtration arrangements, termed a *colour head.* Enlargers constructed specifically for colour printing are also available. Modular design of an enlarger facilitates selection of the necessary mode of operation.

The particular requirements for a colour enlarger may be considered under a number of headings.

Light source

The light source used must have a high light output with a continuous spectrum. Obviously mercury-vapour lamps and cold cathode fluorescent lamps are unsuitable because of their deficiency of red light. The additional requirements of a useful life with constant output and colour temperature as well as compact size make tungsten-halogen lamps an obvious choice for suitability. One or two such lamps of low voltage type which have mechanically robust filaments are used in most colour heads. The lamp envelope may be positioned in an ellipsoidal reflector that reflects visible light but transmits infra-red radiation, called a *cold mirror.* Additional forced cooling using a blower may be needed. Other light sources using tungsten filaments such as conventional enlarger bulbs, photofloods and projector lamps are, or course, also suitable but less convenient.

Optical components

The enlarger lens should be a well-corrected achromat with a flat field. Optical condensers and other glass components such as negative carriers should be of optical quality glass and colourless.

Pure condenser enlargers are seldom used for colour printing; a completely diffused illumination system is preferred. The dye images in the colour negative do not scatter light as do silver images so there is no appreciable difference in contrast in the results given by either a condenser or diffuse illumination system. Indeed, colour paper is available in one contrast grade only for this reason and because of the standard contrast given if processing instructions for the colour negative are obeyed. But scratches and marks on colour negatives do scatter light so diffuse illumination is preferred to minimise or eliminate the need for retouching of colour prints. The loss of efficiency due to this form of illumination is more than offset by the reduction of retouching requirements. The diffuse illumination is usually provided by an *integrating box* above the negative, lined with diffuse reflecting material or mirrors, except for a translucent plastic exit face above the negative. The filtered light from the enlarger light source is admitted through a small entry port into the integrating box.

Electrical supply

To prevent inexplicable colour casts on colour prints it is essential that the light source in a colour enlarger receives a constant voltage supply to a tolerance of less than ±1 per cent, see page 44. Control is possible in a number of ways. The simplest is to use a rheostat and volt meter on the enlarger supply and monitor voltage during use. Alternatively, a voltage regulator in the form of a constant voltage transformer may be used. More elaborate devices offer both voltage and frequency stabilisation.

Low-voltage lamps require also a suitable step-down transformer for conversion from mains voltage. Other light sources in the enlarger, such as scale illumination lamps, only need unstabilised supply.

Control units are available for colour enlargers which incorporate step-down transformers, constant voltage transformers, an electronic timer and various unstabilised outlets for safelights and footswitch control, all in one convenient package.

Timing

It is essential that the enlarger be fitted with a reliable timer to ensure accurate, repeatable exposure times. An electronic timer may be used, incorporating solid state circuitry. An electro-mechanical timer may be preferred as moving hands can indicate elapsed time and permit timing of shading and local control during the main exposure.

Filters

Provision must be made for the various forms of filtration. An *infra-red absorbing filter* or *heat filter* must be incorporated in the light path adjacent to the light source, thereby protecting filters, optical components and the negative. The use of cold mirrors alone is inadequate. The heat filter has another function, absorption of the infra-red radiation to which colour paper is sensitive, thus removing a possible source of variable results.

Similarly, an ultra-violet absorbing filter is located in the light path removing this radiation to which colour paper is sensitive and constituting another source of error. This filter may be glass or acetate.

The colour printing filters may be the tricolour or subtractive varieties. Tricolour filters are of gelatin or glass-mounted. Subtractive filters may be of gelatin, acetate, glass-mounted or of interference (dichroic) types. Location of the filters is discussed below in the evolution of colour enlarger design.

Types of colour enlarger

An enlarger suitable for colour printing has to fulfil the requirements given above. Evolution of design has been fairly rapid (see Figure 22.7). The simplest method is to place individual tricolour filters below the

enlarger lens for each exposure of the triple-exposure method. A simple filter turret may be used for convenience. Subtractive filtration is also possible in the same position, using gelatin colour compensating filters (page 212). A selection of densities in the primary and subtractive colours is necessary to permit a *filter pack* being made up using the minimum number of filters. This necessitates some calculations.

The simplest modification to an enlarger is the provision of a *filter drawer* above the condensers or diffuser. Colour printing filters of low optical quality may then be used.

It is tedious to make up a filter pack from individual filters. Errors are easily made and the process is time consuming when an on-easel colour negative analyser is being used. Consequently, the next stage in colour enlarger design was the provision of continuously-variable filtration set

Fig. 22.7 – Types of colour enlarger

S Light source
C Condensers
N Negative
L Lens

I Integrating box or sphere
D Diffuser
F Filter
R Infa-red absorbing filter

(a) Filters below lens (tricolour or subtractive); (b) Filters above condenser (subtractive); (c) Integrating sphere with subtractive filtration; (d) Dichroic filters (subtractive); (e) Three lamps with tricolour filters and integrating sphere

by calibrated dials. By positioning the filters close to the light source only a small effective filter area was needed and the filtered light was then integrated in a suitable manner.

Typical designs included a fan shaped array of colour printing filters "dialled-in" with two lamps and an integrating-sphere, and another used dyed gelatin on glass filters of a uniform density inserted progressively into the light path to increase their filtration effects. The first type was calibrated in filter density values, the second type in arbitrary numbers.

The next stage in development was the introduction of interference filters (page 202) whose filtration effect was varied by progressive insertion or removal from the light path using calibrated controls reading out in optical density. Yellow, magenta and cyan filters are used. The comparative spectral transmission characteristics of dyed acetate, dyed glass or gelatin on glass and interference filters are given in Figure 22.8. The

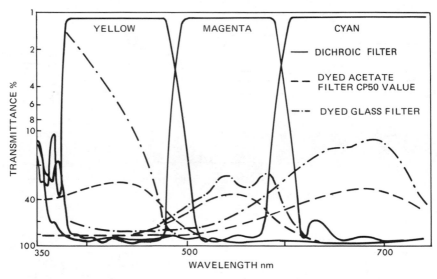

Fig. 22.8 – Spectral transmittance curves for different types of subtractive colour printing filters

advantages of interference filters are the improved spectral transmission properties and that they do not fade progressively with use.

An interesting hybrid form of colour head on an enlarger uses three identical light sources that are filtered red, green and blue respectively to the required amount and the three coloured beams integrated to give a synthesised "white light" of the desired spectral energy distribution for the colour printing conditions.

Further refinements to colour enlargers include the provision of some form of colour negative evaluation to assist selection of the correct filtration to give an acceptable result. This may take the form of filtered photocells inside the enlarger bellows or a unit that is inserted below the lens. They are simplified versions fo the highly automated circuitry of

colour printers. In any event, some form of assessment of the colour negative is desirable.

Methods of evaluating colour negatives for printing

Unlike black and white printing, it is not possible to estimate printing conditions by visual inspection of a colour negative. Consequently, in the absence of any other aid, test prints combined with trial and error methods are necessary to obtain the final result. Colour print materials are expensive and their processing times are significantly longer than those of bromide paper. Consequently, any instrumental methods of evaluation of a colour negative to give a correct or near correct estimate of the colour filtration and exposure requirements for an acceptable result, are of considerable value.

There are a number of possible methods of determining printing conditions, summarised in Figure 22.9.

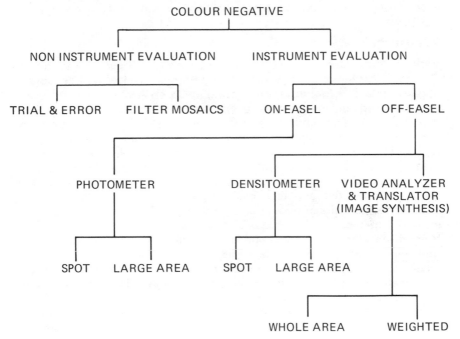

Fig. 22.9 – Methods of evaluating or assessing colour negatives for white light colour printing

Non-instrumental methods

Colour printing by *trial and error* as a routine is not to be recommended but it is the only method when first using new equipment and batches of print material to obtain an excellent quality print. Additionally, even when an instrumental evaluation method is to be used with the enlarger, it is first necessary to produce such a print by trial and error from a *master*

negative. From the printing data obtained, the colour negative evaluation system may be set up for subsequent use. A master negative is one take specially for the purpose, containing a selection of suitable reference areas, colours and a reflectance grey scale. Care is taken over its exposure and processing. A master negative is required for each colour negative material to be used.

The use of a *filter mosaic* may be an improvement over trial and error methods. For white light printing an array of representative filter packs are assembled and put in contact with the negative or print material during exposure. The image area with best colour balance is selected and the corresponding filter values used as a basis for more tests or for a final print. Alternatively, an integrating method may be used with the mosaic on the print material, by putting a piece of diffusing material over the enlarger lens. The image patch closest to neutral grey is then determined and the corresponding filtration used. Exposure determination is a separate problem. Suitably filtered step wedge arrays may be used to determine exposure data for triple-exposure printing.

Instrumental methods

Various instruments are available for use either *off-easel* or *on-easel.* Off-easel evaluation consists of measuring or evaluating the colour negative alone, before insertion into the enlarger. A *colour densitometer* may be used and can service a number of enlargers. The technique depends on setting-up with a master negative. The known filter pack densities for this negative with a particular enlarger are added to the corresponding image dye densities of the chosen *reference area*, as measured by the colour densitometer. A negative to be printed is measured similarly and its densities subtracted from the total densities of the master negative plus filter pack to give the required filter pack. No direct indication of exposure is given and separate on-easel photometry may be required for this purpose although exposure may be determined from off-easel measurements and knowledge of the example required to print the master negative. While this method uses a densitometer and evaluation is done in room light conditions, calculations are necessary and no allowances are made for the fading of colour filters, the ageing of the enlarger lamp or a different magnification.

A most accurate method of off-easel evaluation, when printing conditions such as magnification and paper batch characteristics are accurately known, is by *image synthesis* using a *colour video analyser.* The colour negative is scanned in a closed circuit colour television system and a positive colour image on a monitor screen is manipulated until the required result is given. The calibrated colour balance and density control settings are recorded and related to printing conditions by a translator device during printing.

On-easel evaluation is an application of *image photometry* with measurements of image illuminance made in the image plane on the enlarger baseboard. Such photometers, or *colour negative analysers*

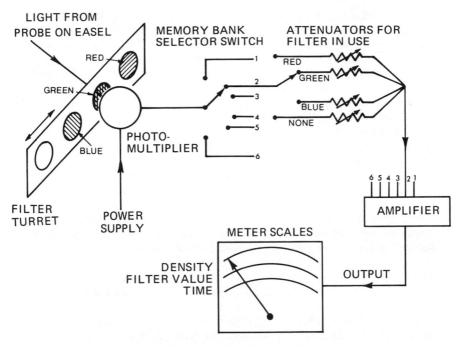

Fig. 22.10 – Simplified schematic diagram of a colour negative analyser

require high sensitivity for this task as measurements are taken through tricolor filters, especially when also coupled with disadvantageous printing conditions such as a dense negative, high value filter pack and high magnification. Cadmium sulphide cells are unsuitable on a number of counts but the availability of photomultiplier tubes and the necessary stable control circuitry has enabled suitable instruments to be made. Latterly, silicon sensors are finding application in this role. On-easel measurements are conveniently made using a small *probe* on the baseboard connected to a fibre optics light pipe to convey the light from the area sampled to the main body of the instrument.

To use an easel photometer, a master negative with known filter pack is inserted into the enlarger and image illuminance measured in the chosen *reference area* through red, green and blue tricolour filters and finally without filters over the photocell. The instrument scale is zeroed or nulled for each condition by means of *attenuators*, small potentiometers (see Figure 22.10). Many instruments have easily resettable attenuators or several sets of four forming a "memory" unit for different batches of paper etc. The new negative to be printed is inserted and for the same photocell filter conditions, the subtractive filtration and lens aperture are altered to null the instrument at each seting. Dial-in filtration is of great advantage for this task. After evaluation, a fixed exposure time at a suitable aperture is given to the colour paper to reduce reciprocity law failure effects.

493

The great advantages of the easel photometer technique are that measurements allow for filter fading, lamp ageing and magnification. Exposure and filtration are given directly. A slight disadvantage is that readings are made in darkroom conditions.

Both on-easel and off-easel methods of evaluation rely for their potential accuracy on the choice of an appropriate *reference area*, as mentioned above. There are two methods available, *small area* or *spot* measurements and *large area* or *integrated* measurements.

Small area measurements coupled with an on-easel technique are the most accurate. The colour negative should contain a suitable reference area such as an 18 per cent reflectance grey card or a skin tone or other preferred colour. This area should receive the same lighting as the significant subject matter but can be positioned in an unimportant region such as the periphery of the negative area.

Unfortunately, it is not always possible to include a small reference area. The subject may be back-lit or inaccessible to the photographer. Also amateur colour negatives are not made with such requirements in mind. Consequently large area measurements are made, usually from the whole negative area, hence the term "integrated" readings. For off-easel densitometers, a large photocell may be used to take such readings. Alternatively, and as for on-easel photometers, the image may be integrated or scrambled by interposition of diffusing material between negative and photocell. The various filter readings may then be taken.

The integration technique must also be set-up on the basis of a master negative but one that is also "typical" in terms of both colour and tonal distribution of the subject matter. The *integration to grey* of such a *typical subject* is the evaluation principle used, as in automatic colour printers. Unfortunately, a small but significant number of negatives contain *atypical* colour or tonal distributions. One consequence is that predominance of one colour in the subject leads to a colour print with a colour cast of the complementary colour. Such a result is incorrectly often termed "subject failure". Corrective measures are possible with automatic printers.

An interesting approach to this problem is a technique of off-easel evaluation whereby a large number of asymmetrically distributed spot readings are taken of the colour negative and average values calculated for determination of printing conditions. This is a form of weighted, large area measurement.

Colour print evaluation

The evaluation or judgement of the colour balance of colour prints for acceptance, rejection and subsequent correction is perhaps the most difficult part of colour printing. To begin with, the printer may have no knowledge of the subject matter or the print colour balance that the client prefers.

It is possible, however, to reduce some of the variables involved in ap-

praisal so that final judgement is subjective and dependent on the printer's experience and opinion.

To begin with it is essential that the viewer has normal colour vision. A variety of clinical tests are available and used to determine the degree of normal or defective vision as some 8 per cent of the male population are deficient in this respect.

Viewing conditions are of the greatest importance. If possible, colour balance should be assessed under the same conditions as those under which the finished colour print will be viewed. The properties of the light souce can influence the apparent colour balance most markedly. In the absence of such knowledge, assessment under standard viewing conditions is advised. The current recommendation is to use a suitable light source, which, if of the fluoresecent type, has a colour rendering index (page 32) close to 100 and a correlated colour temperature of 5000 K. Illumination level should be 220 ± 470 lux for viewing prints or a luminance level of 1400 ± 300 cdm^{-2} for viewing colour transparencies.

The colours of the surrounds of a viewing booth are also suggested. Assessment of a test print under suitable conditions then depends on judgment of density together with colour and amount of any excess colour, giving a *colour cast* to the result.

Assistance as to the necessary corrective change in colour filtration may be given by using either *viewing filters* or a *ring-around set*. Viewing filters are colour printing filters and a "filter pack" is made up by trial and error so that when looking at the print through the pack, an acceptable colour balance is seen. Colour adaptation is a problem. If such a pack is found, the corrective action is to add to the enlarger filter pack, filters of half the density values of the visual pack and of the complementary colour. The method suffers from a number of drawbacks.

A ring-around set of colour prints is a set of prints made from a master negative with each one having a known systematic alteration in colour balance or density. The test print may be matched to one of these prints and the known deviation taken as a basis for correction.

23 After-treatment of the Developed Image

TREATMENT of the image after processing is occasionally useful to correct, at least partially, errors in exposure and/or processing of black-and-white negative materials. The process of lowering the density of a developed image is referred to as *reduction* and that of increasing it as *intensification*.

Sometimes it may be desired to change the colour of a photographic image, be it on film, or on paper. The process of effecting such a change is referred to as *toning*.

Although no similar after-treatment is generally possible for colour materials other than local retouching, colour transparencies may have their densities reduced, either uniformly for all layers, or selectively for a single layer to remove colour casts. For formulae see Appendix page 593.

Reduction

The process of reduction is concerned with the removal of some of the silver from the various parts of the image. Chemically it is not a process of reduction at all, but one of oxidation: the silver is converted into a soluable silver compound or into an insoluble compound which dissolves in some other constituent of the reducer.

Classification of reducers

Many reducers and intensifiers of differing performance have been evolved. They may usefully be classified in general types according to their relative action on the various densities of the image, best displayed by the characteristic curve.

The main classes of reducers according to this system are as follows:

(1) *Proportional*
All the densities of the image are reduced in the same ratio (Figure 23.1a). The action of a proportional reducer may be regarded as "development in reverse".

(2) *Superproportional*
The reduction ratio for the higher densities is greater than that for the lower ones (Figure 23.1b).

(3) *Subproportional*
The reduction ratio for the higher densities is lower than that for the lower ones (Figure 23.1c).

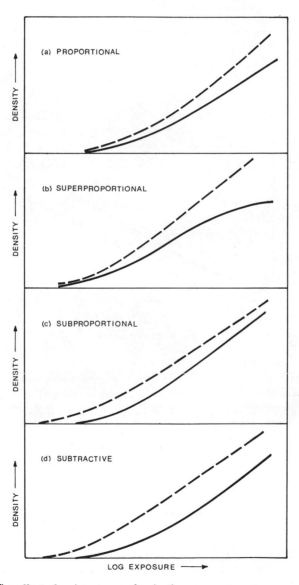

Fig. 23.1 – The effect of various types of reduction

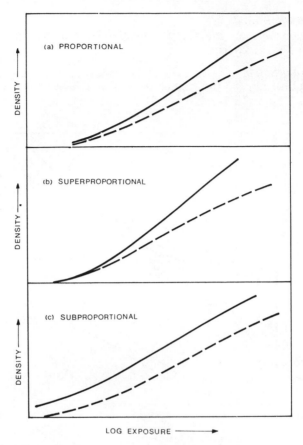

Fig. 23.2 – The effect of various types of intensification

(4) *Subtractive ("cutting")*
A special case of subproportional reduction where all densities of the image are lowered by an approximately equal amount (Figure 23.1d). All practical subproportional reducers tend to approach a subtractive action so that the term "subproportional" is rarely used.

Examples of these classes of reducers are as follows:

Class	Chemical type	Formula
Porportional	Permanganate-persulphate with sulphuric acid	page 584
Superproportional	Ammonium persulphate with dilute sulphuric acid	page 583
Subtractive	Ferricyanide-hypo ("Farmer's") Iodine/thiosulphate	page 583

Table 23.1 – Photographic reducers

Intensification

The increased density produced by intensifiers is achieved in varying ways, e.g.:

(a) by converting the silver image to a form of silver having greater covering power,

(b) by converting the silver into a compound which is more opaque to light,

or

(c) by the addition of silver or other metal atoms to the existing image.

Classification of intensifiers

A convenient classification of intensifiers, in terms of their relative action on the various densities of the silver image is as follows:

(1) *Proportional*
All the densities of the image are increased in the same ratio (Figure 23.2a). The action of a proportional intensifier may be regarded as "increased development".

(2) *Superproportional*
The intensification ratio for the higher densities is greater than that for the lower ones (Figure 23.2b).

(3) *Subproportional*
The intensification ratio for the higher densities is lower than that for the lower ones (Figure 23.2c).

Examples of these classes of intensifiers are as follows:

Class	Chemical type	Formula
Proportional	Chromium	page 584
	Silver	
Superproportional	Copper-silver	
Subproportional	Quinone-thiosulphate	
	Uranium	page 585

Table 23.2 — Photographic intensifiers

After-treatment of prints

The process of overall reduction or intensification of black-and-white prints is rarely carried out because it is usually possible to re-print an unsatisfactory print. However local reduction of large prints is sometimes carried out and a subtractive reducer of the iodine/thiosulphate type is probably the most useful. Intensification of black-and-white prints by almost any process generally produces unacceptable changes in image colour. Simple marks and blemishes on black-and-white prints can be

retouched by the skilful use of a pencil or water colours or retouching dyes applied with a fine-tipped brush. Similarly colour prints can be retouched by the skilful use of special dyes. Black spots or marks in black-and-white prints on conventional baryta paper may be removed by careful scraping with a sharp knife or razor blade followed by retouching by one of the methods described above. However for black-and-white prints on resin-coated paper and for colour prints, black or dense coloured marks are best removed by means of an appropriate chemical reducer (silver bleach or dye bleach) before retouching (see Appendix page 584 for suitable formulae).

Toning

For certain purposes it may be desired to change the colour, or *tone*, of a photographic image, and this can be accomplished by various means of *chemical toning*. Toning is mainly applicable to prints but may also on occasion be desired with films or plates, e.g., for making slides or other forms of transparency.

The main methods in general use may be classified as follows:

(1) *The silver image is converted into silver sulphide (or silver selenide)*
Silver sulphide and silver selenide have brown and purple colours, much warmer than that of the usual silver image, so that these processes are referred to as *sepia toning.*

Sulphide toning is probably the most widely used form of toning, and properly carried out yields images of great permanence. Various formulae for sulphide toning exist: in one the image is first bleached in a ferricyanide-bromide solution and then redeveloped in a solution of sodium sulphide or thiourea. In another, toning takes place in a single operation by immersing the prints in a hypo-alum bath at 50°C. For appropriate formulae see Appendix.

(2) *The silver image is replaced by means of a series of chemical reactions producing a compound of some other metal*
The compounds produced are usually ferrocyanides and the metals used have included:

Metal	Tone	Formula
Copper	Reddish-brown	page 587
Iron	Prussian blue	page 586
Uranium	Orange-brown	
Vanadium	Yellow	

Table 23.3 — Metal toners

(3) *The silver image is replaced by means of colour development producing a dye image*
This process is essentially similar to the production of the dyes in the

three layers of a colour film. Black-and-white prints produced in the normal way are bleached and redeveloped in a colour developer, i.e., a developing solution containing colour couplers (see Chapter 24). A wide range of tones may be produced by such processes of colour development.

24 The Chemistry of Colour
Image Formation

WE SAW in Chapter 14 that the image of a subject may be analysed in terms of blue, green and red light contents. It is usual in colour photography to control these portions of the visible spectrum by means of yellow, magenta and cyan dyes respectively. In this Chapter we shall be concerned with important methods of producing the dye images commonly encountered in colour photography. The methods rely on the generation of dyes, the destruction of dyes, and the migration of dyes respectively. We shall consider each of them in turn.

Chromogenic processes

Generation of dyes

Most commercial colour processes and a number of monochrome processes employ a processing step in which the generation of image dyes takes place. This dye-forming development gives the name *chromogenic* — colour-forming — to such processes. Such a dye-forming solution is called a *colour developer* and in this solution image dyes are generated alongside the development of metallic silver. Two important chemical reactions take place in a colour developer:

(1) Silver halide grains which have been rendered developable by exposure to light, or otherwise, are reduced to metallic silver and the developing agent is correspondingly oxidized:

Developing Agent + Silver Bromide →
 Developer oxidation products + Silver metal + Bromide ion

(2) Developer oxidation products react with chemicals called *colour formers* or *colour couplers* to form dyes. Colour developing agents of the substituted paraphenylenediamine type are used in practice, and the colour of the developed dye depends mainly on the nature of the colour former:

Developer oxidation products + Colour former → Dye

Colour photographic materials

The dye-forming development reaction allows us to generate dyes of the required colours, yellow, magenta, and cyan, to control blue, green and red light respectively. To take advantage of colour development it has been necessary to make special photographic materials of the *integral tripack* variety described in Chapter 14. This means that light-sensitive emulsions are coated in three layers on a suitable support; the construction is shown in Figure 24.1. The records of blue, green and red light are made independently in the three emulsion layers. The resulting layer sensitivities are illustrated in Figure 24.2.

SUPERCOAT

BLUE-SENSITIVE EMULSION

YELLOW FILTER LAYER

GREEN-SENSITIVE EMULSION

INTERLAYER

RED-SENSITIVE EMULSION

FILM BASE

Fig. 24.1 – Cross-section of integral tripack of camera speed

We have examined the method used to obtain separate blue, green and red latent-image records in an integral tripack. Now we shall consider the methods by which the colour-developer oxidation products evolved in an emulsion layer are arranged to react with a colour former to yield the appropriate image dye. As the colour developing agents are mobile in solution and diffuse rapidly through the swollen emulsion we shall be concerned especially with the location of colour formers in chromogenic development.

Location of colour formers

It is required that the records of blue, green and red light shall be composed of yellow, magenta and cyan dyes respectively. This distribution of dyes is achieved by presenting colour formers to developer oxidation products in a selective manner. Thus the oxidation products of development of the blue-recording emulsion are allowed to react only with a yellow-forming coupler. The coupler may be located either in solution in the colour developer, or it may be introduced into the emulsion during manufacture of the film.

Developer-soluble couplers can be used only when a single dye is to be formed in a colour development stage. Three colour developers are needed for a tripack and only one emulsion must be rendered

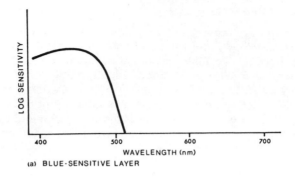

(a) BLUE-SENSITIVE LAYER

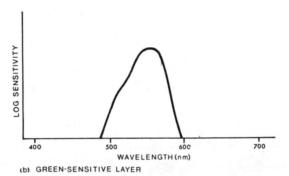

(b) GREEN-SENSITIVE LAYER

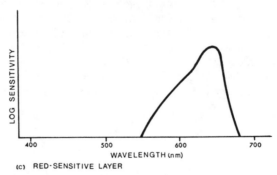

(c) RED-SENSITIVE LAYER

Fig. 24.2 – Effective layer sensitivities of a typical tripack film

developable before each colour development if separation of the colour records is to be achieved. These conditions can be satisfied only in certain reversal processes which we shall consider later.

Couplers incorporated in the emulsions are used to form all three image dyes in one colour development step. In this case only the appropriate dye-forming couplers may be permitted in an emulsion layer if separation of the colour records is to be adequate. The colour formers therefore have to be immobilised to prevent diffusion of the couplers from layer to layer during manufacture or later.

Two main methods of immobilising couplers have been used. The method adopted by Agfa has been to link the otherwise mobile coupler with a long chemically inert chain. This chain interacts with gelatin in such a way that the molecule is effectively anchored in the layer and is described as being *substantive* to gelatin. Processes employing this type of immobilised coupler are referred to as *substantive processes.* Processes employing developer-soluble couplers are often called *non-substantive processes*.

.The second immobilising method is due to Eastman Kodak and employs shorter chemically inert chains linked to the otherwise mobile coupler. The inert chains are selected for oil solubility and render the entire molecule soluble in oily solvents. A solution of such a coupler is made in an oily solvent and the solution dispersed as minute droplets in the emulsion, before coating. The coupler is very insoluble in water and the oily droplets are immobile in gelatin, so that the coupler is unable to diffuse out of the emulsion layer in which it is coated. Processes of the *oil-dispersed coupler* type are also sometimes loosely called substantive processes.

A more recently devised method of locating colour formers is to use a water-insoluble coupler which is capable of reacting in a progressive fashion to build up large *polymeric* molecules. This can be achieved without adversely affecting the colour-forming power of the individual molecules. Molecules capable of polymerisation are called *monomers* and can often react with other monomers forming polymers of mixed composition. A coupler monomer may be mixed with a second suitable non-coupling monomer and the mixture dispersed in water as very small droplets. By allowing polymerisation to take place in each droplet a dispersion is formed of large molecules which are quite immobile in a photographic emulsion but which possess the dye-forming ability of the original coupler monomer. The fine dispersion of the polymer in water is termed a *latex* and such coupler dispersions have received considerable attention in the last decade. An example of such a latex coupler is shown in Figure 24.20(c).

Colour processing

We have already encountered a number of processing steps which are used in colour processing. Before examining the applications of such steps we will summarise the functions of processing solutions commonly encountered in colour processes (Table 24.1).

The major differences between black-and-white and colour processing arise because of the need to generate precisely the required amounts of the image dyes in all three layers. If this is not achieved then objectionable colour effects occur: either largely independent of density level — resulting in a uniform colour cast over most of the tone scale — or, if density-dependent, showing a change in colour balance with density level. The former case corresponds to a speed imbalance of the three

The Chemistry of Colour Image Formation

Solution	Function
Black-and-white developer	Develops a metallic silver image
Fogging bath	Replaces fogging exposure in reversal processes
Colour developer	Develops dye images together with metallic silver
Fix	Dissolves silver halide present after required development has taken place
Stop-fix	Stops development as well as removing silver halide
Bleach bath	Bleaches a metallic silver image, usually by oxidation and rehalogenation to silver halide
Bleach-fix	Bleaches the metallic silver image and fixes the silver salts formed. Leaves only the dye image required
Stabilizer	Improves the stability of dye images, may also contain wetting agent and hardener
Hardener	Hardens the gelatin to resist damage in subsequent processing stages

Table 24.1 — The primary functions of solutions commonly used in colour processes

layers and is illustrated in Figure 24.3b, while the latter corresponds to a contrast mismatch and is illustrated in Figure 24.3c.

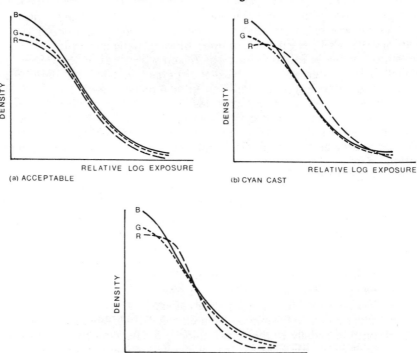

Fig. 24.3 — Characteristic curves of colour reversal films

The processing conditions under which a tripack film will give correct values of speed and contrast for all three layers are very limited and are generally specified very closely by the film manufacturer. The specifications usually include processing times and temperatures, as well as the method and timing of agitation in processing solutions. In addition, such factors as rate of flow of wash water may also be specified. It is important to realise that any departure from the exact processing specifications laid down by the film manufacturer is likely to lead to a lower quality result. Where manufacturers suggest process variations in order to modify a property, speed for instance, there is often a penalty to be paid in terms of some other property, such as graininess.

We will now consider how solutions of the types shown in Table 24.1 are used in colour processes. We shall start by examining colour reversal processing.

Reversal process

As already described, there are two main types of colour reversal process, the developer-soluble coupler type and that with couplers incorporated in the emulsions. The Kodachrome process is of the former (nonsubstantive) type, the couplers being present in the colour developer solutions. It is illustrated schematically in Figure 24.4.

The first step is active black-and-white development in which silver halide grains bearing the latent image are developed to metallic silver — a black-and-white negative image. It is then necessary to form the required dye images by colour development of the residual silver halide grains.

In order to develop cyan dye where red sensitive grains were *not* rendered developable by the camera exposure, all that is needed is to expose the film fully to red light, and to develop the fogged red-sensitive grains in a cyan-forming developer. The exposure is most efficient when unscreened by developed silver and is therefore made through the back of the film to avoid screening by the upper two emulsion layers.

The blue-sensitive layer is then exposed to blue light through the front of the film and developed in a yellow-forming developer. The greensensitive layer may then be fogged by an intense white or green exposure, but in practice it is often preferable to use a chemical fogging agent in the magenta colour developer. In either case the remaining silver halide grains are developed to yield a magenta dye.

At this stage in the process there are three positive dye images together with silver resulting from the complete development of the silver halide emulsions. The developed silver is quite dense and would make viewing of the dye images impractical.

The silver has to be removed by a bleach bath followed by a fix. The bleach bath is usually of the ferricyanide-bromide type and forms silver bromide from the silver metal. The yellow filter layer is also usually discharged during bleaching. The silver bromide may then be removed in a conventional fixing solution leaving only the required dye images present in the gelatin.

The Chemistry of Colour Image Formation

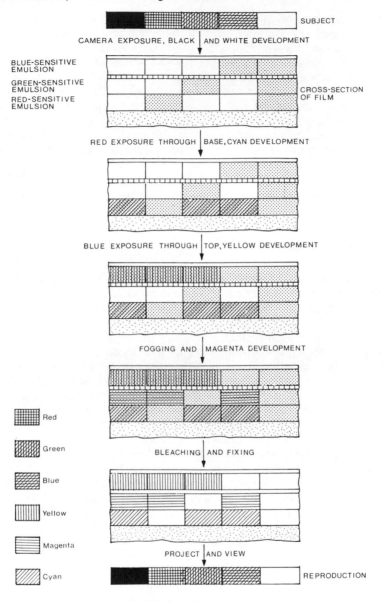

Fig. 24.4 – Non-substantive reversal processing

In addition to the processing steps outlined there are likely to be intermediate rinses and washes and other baths for special purposes. The apparent simplicity of putting soluble couplers in colour developers is thus offset by the complexity of such a non-substantive process which effectively prohibits user processing.

The Chemistry of Colour Image Formation

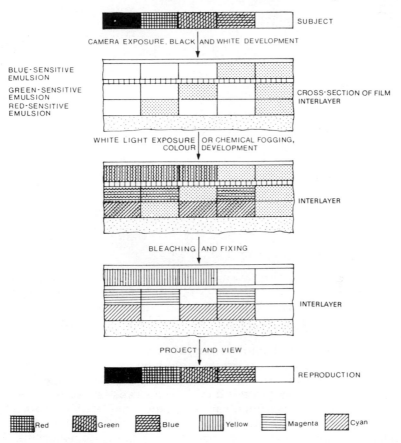

Fig. 24.5 – The substantive reversal process

Reversal films incorporating couplers in the emulsion are simpler to process, and in many cases may be processed by the user. Such a reversal process is shown in Figure 24.5, and commences with black-and-white development. After the first developer the film is fogged with white light before colour development, or chemically in or before the colour developer. The fogged silver halide grains are then colour developed to yield positive dye images together with metallic silver. The appropriate dye colours are ensured by the location of the yellow-forming coupler only within the blue-recording layer, the magenta-forming coupler only within the green-recording layer, and the cyan-forming coupler only within the red-recording layer. Bleaching and fixing are then carried out in order to leave only the image dyes in the gelatin layers.

An example of a Kodak reversal processing procedure, the Ektachrome E6 process, is included as illustration (Table 24.2). The colour couplers are present in oil dispersion or as latex within the emulsions of Ektachrome films.

The Chemistry of Colour Image Formation

Step	Temp. (°C)	Time (min)	Total time (min)
1. Developer	38 ± 0·3	6	6
2. Wash in running water	33–39	2	8
3. Reversal bath	33–39	2	10
4. Colour developer	38 ± 0·6	6	16
5. Conditioner	33–39	2	18
6. Bleach	33–39	6	24
7. Fix	33–39	4	28
8. Wash in running water	33–39	4	32
9. Stabilizer	ambient	30 sec	32·5
10. Dry			

Steps 1 to 3 take place in total darkness, the remaining steps in normal room light. The times recommended vary according to the type of processing employed.

Table 24.2 – Kodak Ektachrome E6 process

Negative-positive process

The negative-positive process is analogous to the conventional black-and-white process in that a negative record is made by camera exposure followed by processing. This record is not intended for viewing but is used to produce a usable positive by a further exposure and processing procedure.

Since information about the blue, green and red light contents of the camera image is to be available at the printing stage it is customary to use the blue-, green-, and red-sensitive layers of the colour negative film to generate yellow, magenta and cyan image dyes respectively. Metallic silver is of course generated at the same time and is removed by bleaching and fixing operations. The remaining dye images form the colour negative record, the colours formed being complementary to those of the subject of the photograph. The production of a colour negative record is illustrated in Figure 24.6a.

If integral masking is employed in the colour negative then low-contrast positive masks may be formed at the development stage if coloured couplers are used. If some other technique of mask production is used, it may take place in the developer, or at some later stage, depending upon the chemistry involved.

The colour negative produced is then the subject of the printing stage. In principle, the negative is printed on to a second integral tripack which is processed in similar fashion to a colour negative. The production of a positive print is shown in Figure 24.6b as the preparation of a reproduction of the subject of the negative exposure. Certain differences of construction are shown in the positive. Printing papers and some print films employ red- and green-sensitive emulsions whose natural sensitivity is low and confined to wavelengths shorter than about 420 nm, a region normally filtered out in colour printing. Consequently no yellow filter layer is required to suppress unwanted blue sensitivity and the layer order can be selected on other criteria. It is found to be advantageous to form the image which is most

critical in determining print sharpness in the top-most layer. In most cases the cyan image is crucial for sharpness and the red-sensitive emulsion is coated uppermost so that the red image is least affected by emulsion turbidity (Chapter 25) at exposure.

Colour printing materials have similar characteristic curves to those of black-and-white print materials, because the tone reproduction requirements are quite similar. Thus, the colour negative film may have characteristic curves similar to those shown in Figure 24.7a, a motion picture release positive film being shown in Figure 24.7b and a typical printing paper in Figure 24.7c. The negative illustrated is masked giving an overall colour cast, and this results in a vertical displacement of the blue and green filter density curves compared with the red curve.

The higher blue and green densities of colour negatives are compensated by manufacturing colour print materials with correspondingly higher blue and green sensitivities than red sensitivity. The printing operation allows manipulation of the overall colour of the reproduction by modification of the quantities of blue, green and red light allowed to reach the print material from the negative (see Chapter 22). This may be achieved by separate additive exposures through blue, green and red filters ("tricolour printing"), or by making one exposure through appropriate dilute subtractive filters — yellow, magenta or cyan ("white-light printing"). This control of colour-balance being easy to achieve, it is not so important that negative and print materials shall possess standard speed-balances as it is that reversal materials shall. No colour correction of a reversal transparency is usually possible after the taking stage whereas in the negative-positive process adjustment of colour balance is a usual procedure at the printing stage.

Typical colour negative and colour paper processes are shown in Tables 24.3 and 24.4.

Step	Temp (°C)	Time (min)	Total time (min)
1. Developer	$37·8 \pm 0·2$	$3\frac{1}{4}$	$3\frac{1}{4}$
2. Bleach	24–40	$6\frac{1}{2}$	$9\frac{3}{4}$
3. Wash in running water	24–40	$3\frac{1}{4}$	13
4. Fixer	24–40	$6\frac{1}{2}$	$19\frac{1}{2}$
5. Wash in running water	24–40	$3\frac{1}{4}$	$22\frac{3}{4}$
6. Stabilizer	24–40	$1\frac{1}{2}$	$24\frac{1}{4}$
7. Dry	24–43		

Steps 1 and 2 take place in the dark, the remainder in the light. Agitation procedures suitable for the process are specified in instructions packed with the processing chemicals.

Table 24.3 — The Kodak C-41 process for colour negative films

Colour paper processes have been simplified and a typical modern process requires only two or three solutions with the necessary washes. The Kodak Ektaprint 2 process is typical of modern trends in colour

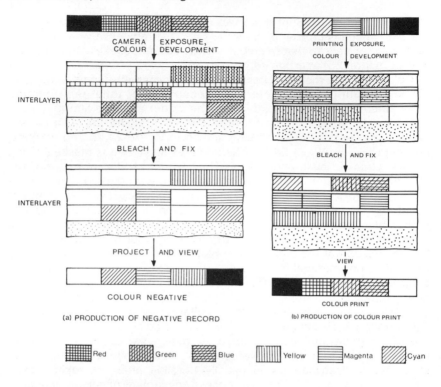

| Red | Green | Blue | Yellow | Magenta | Cyan |

Fig. 24.6 – The colour negative-positive process

processing. It is quick and simple, employing a bleach-fix and operating at quite a high temperature.

Step	Temp (°C)	Time (min)	Total time (min)
1. Developer	33 ± 0.3	$3\frac{1}{2}$	$3\frac{1}{2}$
2. Bleach-fix	32 ± 2.0	$1\frac{1}{2}$	5
3. Wash in running water	32 ± 2.0	$3\frac{1}{2}$	$8\frac{1}{2}$
4. Dry			

Steps 1 and 2 take place in the dark or specified safelighting, the remaining steps in normal room light.

Table 24.4 – The Kodak Ektaprint 2 process for Ektacolor 78 colour papers

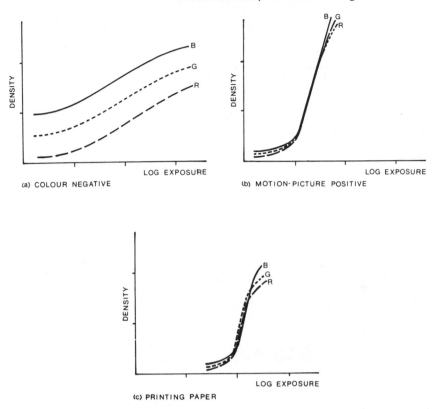

Fig. 24.7 – Characteristics of negative–positive colour materials

Silver-dye-bleach process

The processes so far considered have relied on the formation of image dyes by colour development within the emulsions. There are, however, alternative approaches and one of these has been to destroy suitable dyes introduced into the emulsions at manufacture. In such processes red exposure is arranged to lead to the destruction of a cyan dye, while green exposure causes bleaching of a magenta dye and blue exposure leads to the destruction of a yellow dye.

Commercial processes of this type have used the silver photographic image to bring about the chemical decomposition of dyes present in the emulsion layers. A current process which uses this mechanism is *Cibachrome*, a process for the production of positive prints from positive transparencies. In this system the print material is an integral tripack and is constructed as shown in Figure 24.8. The uppermost, blue-sensitive, emulsion contains a yellow dye. The green-sensitive layer contains a magenta dye, and the red-sensitive layer contains a cyan dye.

513

The Chemistry of Colour Image Formation

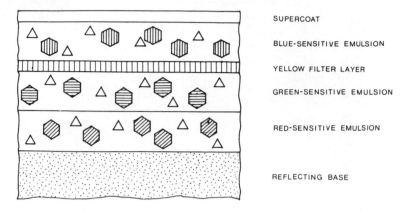

Fig. 24.8 – Cross-section of Cibachrome material

Because of the high optical density of the dyes present in the emulsions, together with emulsion desensitisation by some of the dyes, it is necessary to use quite high speed emulsions in order to achieve printing exposures of a tolerable duration.

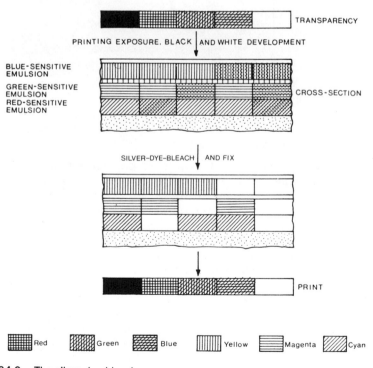

Fig. 24.9 – The silver-dye-bleach process

The processing of modern silver-dye-bleach materials follows the scheme illustrated in Figure 24.9. The initial step is the black-and-white development of emulsion grains rendered developable by the printing exposure. The silver image is then used to reduce the dyes present in the emulsions. This reaction may be summarised:

Dye + Acid + Silver metal→Reduced dye fragments + Silver salts

It is arranged that the fragments resulting from the reduction of the dyes are colourless or soluble or both. Thus in the silver-dye-bleach bath we have imagewise reduction of the dyes by metallic silver and corresponding oxidation of the silver. The reaction is extremely slow and a catalyst is necessary to obtain a satisfactory rate of bleaching. The catalyst is usually incorporated in the silver-dye-bleach, or it may be carried over from solution in the black-and-white developer, within the emulsion layers.

Following the silver-dye-bleach the unwanted silver salts are removed in a fix bath. (In some processes this fixer is preceded by a silver bleach to rehalogenise silver image not oxidised by the dye bleach. In the most recent process, however, listed in Table 24.5, this second bleach has been omitted.) The final result is the positive dye record retained within the gelatin, as shown in Figure 24.9.

Step	Temp (°C)	Time (min)	Total time (min)
1. Developer	30 $\pm \frac{1}{2}$	3	3
2. Wash in standing water	28–32	$\frac{3}{4}$	$3\frac{3}{4}$
3. Bleach	30 \pm 1	3	$6\frac{3}{4}$
4. Wash in running water	28–32	$\frac{3}{4}$	$7\frac{1}{2}$
5. Fixer	30 \pm 1	3	$10\frac{1}{2}$
6. Final wash in running water	28–32	$4\frac{1}{2}$	15
7. Dry			

Steps 1, 2 and 3 take place in darkness, the remainder in normal lighting.

Table 24.5 — A silver-dye-bleach process. Cibachrome P.3

Major advantages claimed for the silver-dye-bleach process follow from the freedom to use compounds classed as azo dyes. These possess better spectral properties than the dyes formed by chromogenic development and are markedly less light-fugitive. The better spectral properties improve the saturation and lightness of image colours, while the improved light-fastness gives a much greater life for displayed prints, compared with those prepared by chromogenic processes.

A further advantage is that the presence of the image dyes at exposure results in a decreased path length of light scattered within the emulsions. This improves the sharpness of the image to such an extent that it is higher than for any chromogenic reflection print material.

The Chemistry of Colour Image Formation

Dye-releasing processes

Polacolor

The modern trend towards instant pictures has led to the development of a number of systems using ingenious chemical processes initiated within the camera. While the chemical reactions yielding the colour images actually progress to completion in a few minutes in the hand of the photographer, such systems are often called *in-camera* processes.

The first instant-picture colour process was the Polacolor system introduced in January 1963. Polacolor prints were obtained by pressing the shutter release and pulling a film and print sandwich from the camera. About one minute later the film and print were separated and the unwanted film discarded. A later development, SX-70 film and its associated special camera, were revealed in May 1972 and in this system no discard was required because the entire process used only a single sheet of material for both exposure and subsequent colour image formation.

Both the Polacolor processes rely on the development of a silver image to modify the mobility of suitable image dyes which are released to diffuse into an image-receiving layer.

In the 1963 Polacolor process a negative film of three light-sensitive assemblies is coated in the conventional order with the red-sensitive emulsion next to the base, and the blue-sensitive emulsion farthest from the support. Each light-sensitive assembly consists of two layers, one of which contains a silver halide emulsion of appropriate sensitivity while the other, nearer the film base, contains a compound of an unusual nature. This compound, called by Polaroid a *dye-developer*, has a molecular structure which comprises a black-and-white developing agent chemically linked by an inert chain to a dye. The construction of a Polacolor light-sensitive assembly is shown in Figure 24.10.

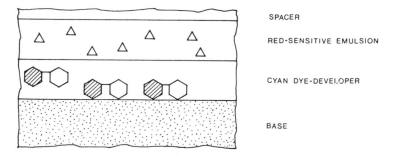

SPACER

RED-SENSITIVE EMULSION

CYAN DYE-DEVELOPER

BASE

Fig. 24.10 – Polacolor emulsion and dye-developer layer combination

After exposure, the Polacolor film is processed to yield a positive colour reflection record. To achieve this, the film is pulled, together with a receiving material, between pressure rollers. The pressure rollers rupture a pod attached to the receiving layer and this releases a viscous

alkali solution which is then spread between the negative film and the positive receiving layer.

The alkali solution penetrates the negative emulsions and activates the dye-developer molecules, rendering them soluble and thus mobile. The mobile dye-developer molecules are very active developing agents in alkaline solution, and on development taking place are once more rendered immobile. Dye-developer molecules which diffuse out of an emulsion-developer layer combination have to pass through a spacer, or timing, layer. They are thus delayed so that by the time they reach another emulsion layer, development of that layer has taken place and they are unlikely to encounter developable silver halide. Under these circumstances the dye-developer molecules are free to diffuse out of the negative material and into the receiving material. The receiving material acts as a sink for dye-developer molecules and this encourages diffusion into the receiving layer. The structure of the receiving layer is shown in Figure 24.11 and the diffusion stage is shown in Figure 24.12.

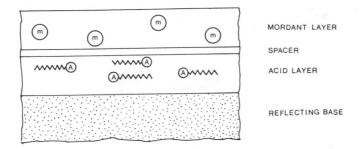

MORDANT LAYER

SPACER

ACID LAYER

REFLECTING BASE

Fig. 24.11 – Polacolor receiving material

Dye-developer molecules entering the receiving layer encounter a mordant which immobilises the dye part of the molecule and therefore anchors the entire molecule. The alkali present in the processing solution diffuses slowly thorugh the spacer layer in the receiving material and reaches the layer which contains large immobile organic acid molecules. The alkali is neutralised by the acid with the evolution of water which swells the spacer layer and assists further penetration by alkali to the acid layer and consequent neutralisation. After about one minute the reactions are completed and the reflection positive is peeled off the residual negative and is suitable for viewing. The positive image is illustrated in Figure 24.13.

The elegance and ingenuity of the process lie in the carrying out of the processing within the material, and in leaving behind in the discarded negative unwanted silver and dye-developer. Note that any emulsion fog results in a lowering of the dye density in the positive; the stain is not increased.

The Chemistry of Colour Image Formation

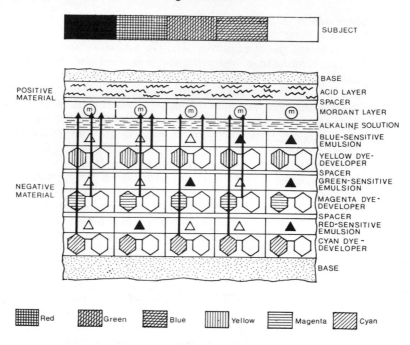

Fig. 24.12 – The original Polacolor – the processing stage

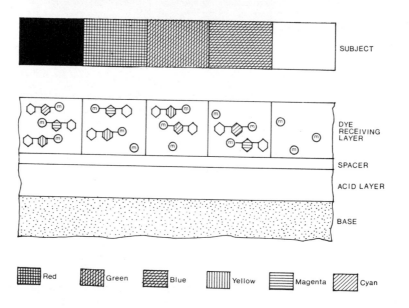

Fig. 24.13 – The Polacolor record

The Polacolor SX-70 process introduced in 1972 uses the mechanisms on which the original process was based. The image-receiving material is, however, part of the same assembly as the light-sensitive emulsions and the associated dye-developer layers. Processing is initiated, as in the earlier material, by the rupture of a pod. The contents of the pod are injected into the composite assembly between the emulsion and image-receiving layers. The structure of the material and the solution injection are shown diagrammatically in Figure 24.14 which is *not* drawn to scale.

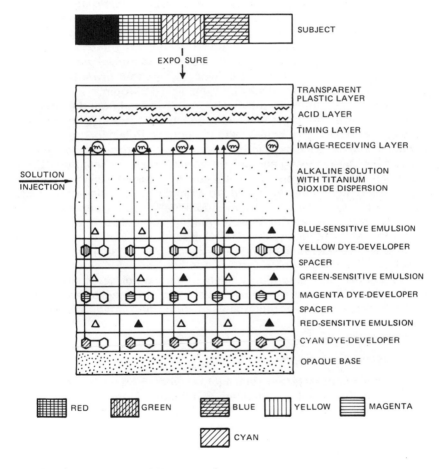

Fig. 24.14 – Poloroid SX-70 film, processing

It will be seen that the material consists of a large number of layers comprising the dye-releasing light-sensitive elements and an image-receiving assembly. These components are not unlike those of the earlier

519

Polacolor materials although certain detail improvements have been made. The major structural difference is that the entire stack of layers is contained between two relatively thick outer layers. One of these is transparent and the exposure is made, and the image viewed, through it. The other is the opaque backing to the material. The processing solution is contained within a wide margin to the picture and is injected into the picture area when the film is expelled from the camera after exposure.

The processing solution consists primarily of a strong alkali containing a dispersion of the white pigment titanium dioxide and certain dyes which are highly coloured in alkaline solutions. The alkali present activates and mobilises the dye-developers in the dye-releasing assembly. The titanium dioxide remains at the site of injection, between the blue-sensitive emulsion and the image-receiving layer, forming a white background to the received image viewed through the transparent plastic front sheet. The protecting dyes present absorb so much light that effectively none penetrates to the emulsion layers; this gives rise to the figurative description of the dyes as a "chemical darkroom".

As the process continues, the dye image is released from the emulsion assembly, diffuses through the white titanium dioxide and is immobilised in the image-receiving layer just as in the original Polacolor process. This continues until the alkaline solution penetrates the spacer or *timing layer* between the dye-receiving and polymeric acid layers present immediately beneath the transparent outer sheet. As in the earlier material, the penetration of the timing layer leads to a rapid neutralisation of the alkali present but this, in the SX-70 film, additionally causes decoloration of the protective dyes present and, ultimately, the colour image is seen against the white titanium dioxide background.

The dye-developers incorporated in the SX-70 material are of an improved type, being complex compounds of dyes with certain metals, notably copper and chromium. Such metal complexes have greater stability than similar uncomplexed dyes and yield images that possess good light-fastness. The complexes used are termed "metalised dyes" by Polaroid.

Kodak instant photography

An alternative approach to instant picture production has been adopted by Eastman Kodak who combined a number of novel features in a process unveiled in the spring of 1976. New immobile compounds were devised which are derivatives of developing agents and which, on oxidation, undergo a reaction that releases a chemically-bound image dye. The image dyes themselves were selected from the class of *azo* dyes, potentially giving better colour reproduction than conventional photographic image dyes. The final major innovation was the use of emulsions which on development yielded *positive* silver images as opposed to the customary *negative* images.

The construction and processing of the Kodak instant picture film is illustrated in Figure 24.15 which shows the situation after exposure and

injection of the activator fluid to initiate image formation. The direct positive emulsions develop in areas unaffected by light and, in so doing, release image dyes that diffuse to the image-receiving layer, where there is a suitable mordant to immobilise them. The dye image is thus located between a white opaque layer and the transparent film through which it is viewed. In the meantime the alkaline activator penetrates a timing layer to reach a polymeric acid which neutralises the alkali and terminates the processing stage.

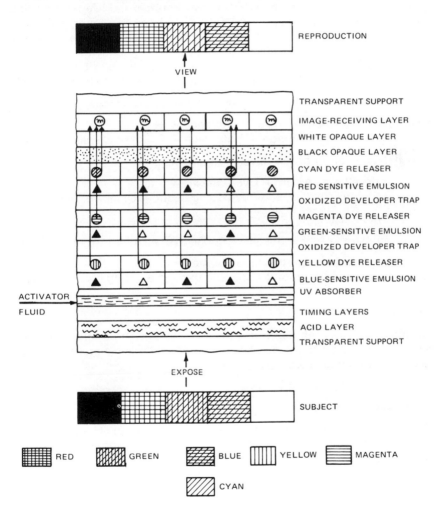

Fig. 24.15 – Kodak Instant Print Film, structure and processing

The dye-releasing species present are immobilised derivates of typical developing agents such as aminophenols. Present in the activator fluid is

a highly mobile developing agent, typically a Phenidone derivative, which reacts with the unexposed silver halide grains to give a silver image and oxidised developing agent. The developing agent is regenerated by reaction with the dye-releasing compounds which are thereby oxidised. The oxidised dye-releaser is unstable in alkaline solution and decomposes yielding the mobile image dye. Thus, in contrast to the Polaroid processes, dyes are released wherever development takes place. The regenerated developing agent is free to react with further silver halide grains. It is evident that it is important to retain oxidised developing agent within the appropriate dye-releaser and emulsion pair, otherwise an inappropriate dye would diffuse to the image-receiving layer. It is thus necessary to trap any oxidised developer leaving a dye-releaser and emulsion pair, suitable interlayers being used for this purpose.

The dye releasing process may be summarised in the following stages:

(1) Silver development of the direct positive emulsions:

Unexposed silver halide + Developing agent→
Silver image + Halide ion + Oxidised developing agent

(2) Regeneration of the developing agent:

Oxidised developing agent + Dye-releaser→
Developing agent + Oxidised dye-releaser

(3) Dye release:

Oxidised dye-releaser + Alkali→ Mobile dye + Unimportant products

As with Polacolor, neutralisation of the alkaline solution is achieved by the eventual penetration of the solution through a timing layer to an acid.

Important chemistry

For those readers with some chemical knowledge there follows a short review of chemical formulae of some compounds and reactions important in colour image formation.

Chromogenic processes

The colour forming reaction takes place between oxidised colour developer and suitable colour formers. Colour developing agents of practical importance possess the general formula shown in Figure 24.16. Such developing agents are usually supplied as salts of acids.

Colour formers usually contain an active methylene or methine group activated by a group or groups adjacent to the active site, or linked by a conjugated chain. Generally, cyclic couplers require one activating group while open chain couplers require two such groups. Examples of colour couplers are shown in Figure 24.17 in which (a) is a yellow-forming coupler, (b) is a magenta-forming coupler, and (c) is cyan-forming; all three are developer soluble.

R_1 ethyl
R_2 ethyl, β-hydroxyethyl or β-methylsulphonamidoethyl
R_3 hydrogen or methyl

Fig. 24.16 – General formula of common colour developing agents

(a) ACETOACET-2,5-DICHLOROANILIDE

(b) 3-METHYL-1-PHENYLPYRAZOL-5-ONE

(c) 2,4-DICHLORO-1-NAPHTHOL

* Indicates the site of coupling.

Fig. 24.17 – Simple developer-soluble colour couplers

The coupling reaction has the stoichiometry:

unless the coupling position is occupied by an electronegative sub-stituent, when a useful change in stoichiometry is observed:

Only two silver ions are then reduced to yield one molecule of developed dye, whereas without the electronegative substituent four silver ions are required.

Substitution at the site of coupling is used in methods of colour masking using coloured couplers. The coloured moiety is linked to the coupling position of the coupler and is discharged on dye formation:

In this case an azo dye moiety is displaced from the 4-position of the colour former on coupling.

A similar use of substitution at the coupling position is a feature of developer-inhibitor-releasing (DIR) couplers which are used to en-courage inter-image effects and improve the micro-image properties of colour photographic materials. The developer inhibitor is released from the point of coupling, typical examples being shown in Figure 24.18.

BENZOTRIAZOLE 1-PHENYL-5-MERCAPTOTETRAZOLE

Fig. 24.18 – Typical developer inhibitors

Cyan-forming DIR couplers may thus have formulae such as those shown in Figure 24.19 and release benzotriazole or 1-phenyl-5-mercaptotetrazole respectively on colour coupling. These couplers are colourless, as are many other DIR couplers, which makes them useful for the colour correction of reversal films. In the case of colour negative film, as we have already seen, coloured couplers are frequently used for masking purposes. The mask density can be substantially reduced if the coloured couplers are arranged to yield a developer inhibitor on dye development. A typical example is shown in which benzotriazole is formed from the displaced masking dye moiety:

COLOURED
COUPLER

OXIDISED DEVELOPING
AGENT

DYE

DEVELOPER INHIBITOR
PRECURSOR

SPONTANEOUS DEVELOPER
CYCLISATION INHIBITOR

Other substituents in colour former molecules are added to influence solubility and mobility in the emulsion. Examples of differently im-mobilised cyan-forming couplers are shown in Figure 24.20. In the case

(a) we have a $-C_{18}H_{37}$ anchoring group which renders the coupler substantive to gelatin, and in order to make the coupler water-soluble for coating purposes the $-SO_3Na$ group is substituted into the 4-position. In (b) the coupler is made suitable for oil dispersion by the $-C_5H_{11}$ group. No water solubilisation is required or desired when oil dispersion is intended. Coupler (c) is immobilised as a latex in the emulsion (see page 505).

Fig. 24.19 – Colourless DIR couplers

* Indicates continuing polymer chain

Fig. 24.20 – Immobilised colour couplers

The silver-dye-bleach process

This process is usually operated with azo dyes and these are characterised by the azo linkage:

$$-N = N-$$

These dyes may be given the general formula:

$$R^1 -N = N-R^2$$

The overall dye-bleach reaction may be represented by the stoichiometric equation:

$$R^1 -N = N-R^2 + 4H^+ + 4Ag \rightarrow R^1NH_2 + R^2NH_2 + 4Ag^+$$

It will be seen that a low pH favours this reaction and consequently the silver-dye-bleach bath is usually strongly acid and operates at a pH between 0 and 1. This pH is conveniently achieved by the use of a halogen acid which will also withdraw silver ions formed by dye bleaching, and hence favour the reaction. More recently sulphamic acid, NH_2SO_3H, also a strong acid, and sulphuric acid, H_2SO_4, have been substituted successfully for the halogen acid previously used. The concentration of *free silver ion* may also be kept to a minimum by the formation of a soluble complex of high stability. A suitable complexing agent is thiourea, and the reaction employing thiourea may be represented:

$$R^1N-NR^2 + 4H^+ + 4Ag + 12 \ S = C\underset{NH_2}{\overset{NH_2}{<}} \longrightarrow$$

$$R^1NH_2 + R^2NH_2 + 4 \left[Ag\left(S = C\underset{NH_2}{\overset{NH_2}{<}}\right)_3 \right]^+$$

The dye-bleach reaction as shown is very slow even at very low pH values and at very low concentrations of free silver ions. It is necessary to employ a catalyst to speed up the reaction, and the useful compounds contain this structural group:

Examples of compounds used as catalysts are shown in Figure 24.21.

Examples (a) and (b) are catalysts which have been used dissolved in the bleach bath, while (c) represents a catalyst which is dissolved in the developer and carried into the bleach in small quantities by the emulsion layers.

At the pH of the bleach bath such catalysts become protonated:

and the protonated catalyst, cat H^+, acts as a redox intermediate:

$$\text{Ag} + \text{cat } H^+ \rightleftharpoons \text{Ag}^+ + \text{cat } H^\ominus$$

oxidising a silver atom and gaining an electron to form a free radical. The

(a)

2,3-DIMETHYLQUINOXALINE

(b)

2-HYDROXY-3-AMINOPHENAZINE

(c)

3-HYDROXY-4-AMINO-NAPHTHAZINE-5-SULPHONIC ACID

Fig. 24.21 — Silver-dye-bleach catalysts

free radicals formed in this way are able to attack the azo linkages of the dyestuff present, and destruction of the dye results from stepwise attack summed up in the equation:

$$4 \text{ cat } H^\ominus + R^1N = NR^2 \rightarrow 4 \text{ cat} + R^1NH_2 + R^2NH_2$$

Examples of azo dyes suitable for the silver-dye-bleach process are shown in Figure 24.22 in which (a) represents a yellow dye, (b) a magenta dye and (c) represents a cyan dye. It should be noted that for dyes to be used in the silver-dye-bleach process they must be substantive to the appropriate emulsion layer, and the amine breakdown products should be soluble enough to wash out of the emulsion in the bleach bath or at a later stage. This latter property is desirable in order to reduce stain, especially on keeping.

Fig. 24.22 – Dyes suitable for the silver-dye-bleach process: (a) yellow (b) magenta (c) cyan

Dye release

The Polacolor process depends for its success on the novel dye-developer compounds incorporated in the negative material. The changes in mobility of these compounds arise from the behaviour of developing agents of the substituted hydroquinone type:

The neutral molecule is insoluble, and hence immobile, in acid conditions and shows *no* developing activity; but in alkali the developing moiety deprotonates to form the soluble and mobile developer anion. This anion is an active developer and readily reduces exposed silver halide to metallic silver with the formation of an uncharged quinone.

The quinone is almost insoluble, and thus immobile, and possesses no photographic activity.

Thus activation of the dye-developer by alkali yields a mobile anionic molecule which remains mobile so long as the solution is sufficiently alkaline and development does not take place.

529

The Chemistry of Colour Image Formation

A variety of dyes is available and selection is made on the basis of colorimetric and photographic properties provided the mobility of the dye-developer species fits the requirements of the process. The dye-developer consists of a dye linked to a developing agent by an inert chain of some kind. Typical, simple, dye developers are shown in Figure 24.23. The developer moiety is, of course, hydroquinone in each case.

The SX-70 process utilising metalised dye-developers leads to compounds of considerable complexity, a consideration of which is beyond the scope of this work. It is sufficient to note that such compounds are essentially dye-developers with added structural features that enable complex compounds to be formed with some metal cations such as Cu^{2+}.

Fig. 24.23 – Simple dye-developers for the Polacolor process: (a) yellow (b) magenta (c) cyan

The Kodak system uses quite different chemicals from those used by Polaroid. The actual development reaction uses a substituted Phenidone (see Chapter 17) which is regenerated by reaction with the dye-releaser – an immobilised developing agent linked to a dye. A typical example of such a compound is

which is immobilised by the —$C_{17}H_{35}$ group. Such a dye-releaser reacts with oxidised developer to reform the developer and is itself oxidised to

an unstable product. This is hydrolysed to yield the immobile quinone and release the mobile dye species.

The more highly automatic and instant that photography becomes, the more complex are the mechanisms used and this is reflected in the processing chemistry. Fortunately, however, the photographer is often scarcely involved in the processing. Its chemistry is of little or no concern to him and can be merely an object of curiosity. For only a few photographers does an interest in chemistry extend beyond black-and-white processing although interesting effects can result from the manipulation of colour processes. For such purposes there is no doubt that an insight into the workings of a particular system can be most useful.

25 Evaluation of the Photographic Image

THE purpose of this chapter is to review some of the properties of photographic emulsions and photographic image structure that have an influence on the quality of the final photographic recording. These all originate in one way or another from the heterogeneous (non-uniform) granular nature of the sensitive layer.

Early on in the chapter we study the photographic image in some depth, using fairly well known methods of evaluation. These are generally easy to understand and have proved valuable in many areas of photography by affording rapid and straightforward measures of image quality.

Later we take a somewhat superficial view of more fundamental approaches to image evaluation based on concepts utilised originally in communications and information theory. These have had an incalculable impact in the field, but because of their mathematical orientation we shall do very little more than mention them in this treatment.

Structural aspects

We have seen that a photographic emulsion consists of fine silver halide crystals, or "grains", distributed randomly in gelatin. When an emulsion is exposed to actinic light and processed, an image of the exposure distribution is formed. This image is made up of grains of metallic silver which, in normal chemical development, are formed by reduction of the grains of silver halide present in the exposed emulsion. The silver grains of the image occupy approximately the same position as the original silver halide grains from which they were formed, but rarely retain the same shape. Silver halide crystals are regular structures whereas silver grains, produced by chemical development, are generally masses of twisted filaments of silver.

Differences in macroscopic (large area) exposure level are rendered as differences in the number of developed silver grains in the emulsion. The greater the exposure level, the greater is the number of silver grains produced (within the limits imposed by the concentration of the original silver halide crystals).

The silver halide grains of an emulsion are not all of the same size; any single emulsion exhibits a range of grain sizes. The extent of this range depends on the method of manufacture and is an important property of the emulsion. The larger grains in any given emulsion are in general more sensitive than the smaller ones. This is probably because the larger grains absorb more light, owing to their greater area and volume. It would therefore be expected that an emulsion with a wide grain size distribution would have a wide range of response to light, i.e. low contrast; and an emulsion with a narrow grain size distribution would be expected to have a restricted range of response to light, i.e., high contrast. In practice this is generally the case.

The production of an emulsion containing large grains, i.e. a fast emulsion, is usually associated with the presence of other grains of a wide range of smaller sizes. For this reason, high emulsion speed is generally associated not only with large grain size but also with relatively low contrast. On the other hand, it is usually possible to obtain a narrow grain size distribution only if all the grains are small. Hence high contrast is usually associated with low speed and fine grain.

Photographic turbidity

Turbidity is the ability of a photographic emulsion to diffuse the exposing light. The diffusion arises as a result of reflection, refraction, diffraction and scattering by the silver halide microcrystals, and depends on such factors as the grain size, silver halide to gelatin ratio and the opacity of the emulsion to actinic light.

Figure 25.1 depicts the formation of the photographic image of a small disc of light. It can be seen that light diffusion and subsequent absorption results in a developed image substantially larger than the true optical image size. Spreading of the image into areas receiving no direct exposure in this manner is referred to as irradiation and generally becomes objectionable with heavily exposed images of points and edges.

However, diffusion of the exposing light is fundamentally of much greater importance than simply reducing the quality of heavily exposed image detail. The diffusion is exposure invariant (i.e. occurs at all exposure levels) and represents one of the major factors influencing the ability of photographic materials to reproduce the detail contained in an object.

Resolving power

Generally speaking, resolving power measures the detail-recording ability of photographic materials. It is determined by photographing a test object containing a sequence of geometrically identical bar arrays of varying size, and the smallest size in the negative recognisable by the eye under suitable magnification is estimated. The spatial frequency of this bar array, in line pairs per millimetre, is called the resolving power. Figure 25.2 shows two typical test objects.

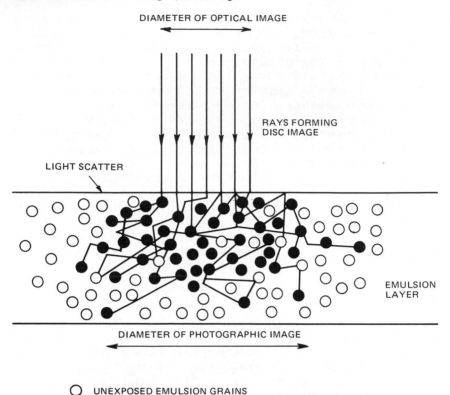

UNEXPOSED EMULSION GRAINS

EXPOSED EMULSION GRAINS

Fig. 25.1 — Image formation showing optical spreading

The appropriate test object is imaged on to the film under test either by accurate contact printing, or more generally by use of optical imaging apparatus containing a lens of very high quality. A microscope is used, in some standardised manner, to examine the developed negative.

Clearly the estimate of resolving power obtained is influenced by each stage of the complete lens/photographic/microscopic/visual system, and involves the problem of detecting particular types of signal in image noise. However, provided the overall system is appropriately designed, the imaging properties of the photographic stage are by far the worst and one is justified in characterising this stage by the measure of resolving power obtained.

Because of the *signal-to-noise** nature of resolving power measurements, its value for a particular film is a function not only of the turbidity of the sensitive layer, but also of the contrast (luminance range) and design of the test object and the gamma and *graininess** of the final negative. It is in-

* These terms are defined and explained later (pages 536 and 548).

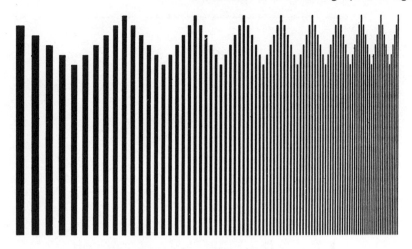

(a) "SAYCE" TYPE CHART

(b) "COBB" TYPE CHART

Fig. 25.2 – Typical resolving power test charts

fluenced by the developer type, degree of development and colour of exposing light and depends particularly on the exposure level. Figure 25.3 shows the influence of test object contrast and exposure level on the resolving power of a typical medium-speed negative material.

The great advantage of resolving power as a criterion of image quality lies in its basic conceptual simplicity while taking account of several more fundamental properties of the system including the *modulation transfer function** of the emulsion and optics, the *gamma* and *granularity** of the emulsion and aspects of the human visual system.

* These terms are defined and explained later (pages 539 and 544).

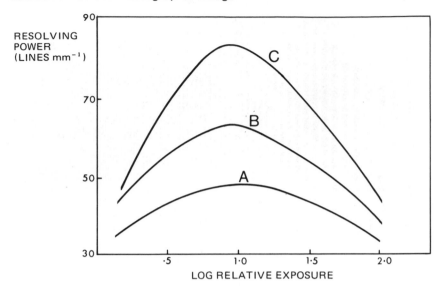

Fig. 25.3 – Variation of resolving power with exposure using test charts of increasing contrast (a) to (c)

Very simple apparatus is required and the necessary readings are straightforward to obtain. Insofar as it is possible to assign a single value to image quality, resolving power has been widely adopted as a useful index of the capabilities of photographic materials in reproducing fine image structure.

Graininess

The individual grains of a photographic emulsion are too small to be seen by the naked eye, even the largest being only about two micrometers in diameter. A magnification of about 50 times is needed to reveal their presence. A grainy pattern can, however, usually be detected in photographic negatives at a much lower magnification, sometimes as low as only three or four diameters. There are two main reasons for this:

(1) Because the grains are distributed at random, in depth as well as over an area, they appear to be clumped. This apparent clumping forms a random irregular pattern on a much larger scale than the individual grain size.

(2) Not only may the grains appear to be clumped because of the way in which they are distributed in the emulsion, but they may actually be clumped together (even in physical contact) as a result either of manufacture or of some processing operation.

The sensation of non-uniformity in the image, produced in the consciousness of the observer when the image is viewed, is termed

graininess. It is clearly a subjective quantity and must be measured fundamentally using an appropriate psycho-physical technique, such as the blending magnification procedure. The sample is viewed at various degrees of magnification and the observer selects the magnification at which the grainy structure just ceases to be visible. The reciprocal of this blending magnification factor is a measure of graininess.

Graininess varies with the mean density of the sample. For constant sample illumination, the relationship has the form illustrated in Figure 25.4. The maximum value, corresponding to a density level of about 0·3,

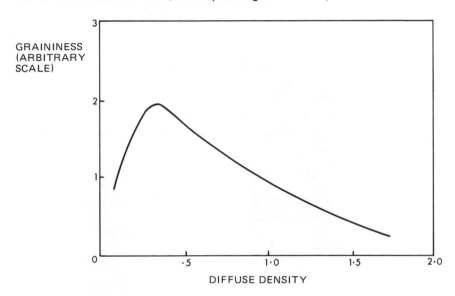

Fig. 25.4 – Graininess-density curve for typical medium speed film

results from the fact that approximately half of the field is occupied by opaque silver grains and half is clear, as is intuitively to be expected. At higher densities, the image area is more and more covered by agglomerations of grains, and, because of the reduced acuity of the eye at the lower values of field luminance produced, graininess decreases.

In the discussion so far we have referred only to the graininess of the negative material. The feature of interest in pictorial photography is however the quality of the positive print. If a moderate degree of enlargement is employed the grainy structure of the negative becomes visible in the print (the graininess of the paper emulsion itself is not visible because it is not enlarged). Prints in which the graininess of the negative is plainly visible are generally objectionable.

Although measures of negative graininess have successfully been used as an index to the behaviour of prints made from the negative materials, print graininess is not simply related to that of the negative because of the reversal of tones involved. Despite the fact that the nor-

mally measured graininess of a negative sample decreases with increasing density beyond a density of about 0·3, the fluctuations of microdensity across the sample in general increase. This follows from a consideration of the behaviour of random distributions. As these fluctuations are responsible for the resulting print graininess, and as the denser parts of the negative correspond to the lighter parts of the print, we can expect relatively high print graininess in areas of light and middle tone (the graininess of the highlight area is minimal because of the low contrast of the print material in this tonal region). This result supplements the response introduced by variation of the observer's visual acuity with print luminance. See Figure 25.5 for the relation between negative and positive samples.

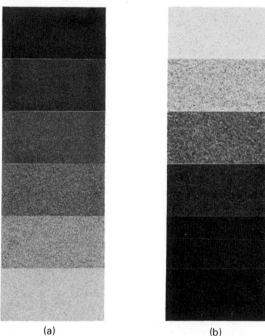

(a) (b)

Fig. 25.5 – Graininess in negative and print. (a) enlargement of negative and (b) corresponding areas of print.

It is now clear that print graininess is primarily a function of the fluctuations of microdensity, or *granularity*, of the negative, the *graininess* of the negative being of little relevance. Hence, when a considerable degree of enlargement is required, it is desirable to keep the granularity of the negative to a minimum.

Factors affecting the graininess of prints

(1) The granularity of the negative. As this increases, the graininess of the print increases. This is the most important single factor and is discussed in detail in the next section.

(2) Degree of enlargement of the negative.

(3) The optical system employed for printing and the contrast grade of paper chosen.

(4) The sharpness of the negative. The sharper the image on the film, the greater the detail in the photograph and the less noticeable the graininess. It can be noted here that graininess is usually most apparent in large and uniform areas of middle tone where the eye tends to search for detail.

(5) The conditions of viewing the print.

Granularity

This is defined as the objective measure of the inhomogeneity of the photographic image and is determined from the spatial variation of density recorded with a microdensitometer (a densitometer with a very small aperture). A typical granularity trace is shown in Figure 25.6. In general,

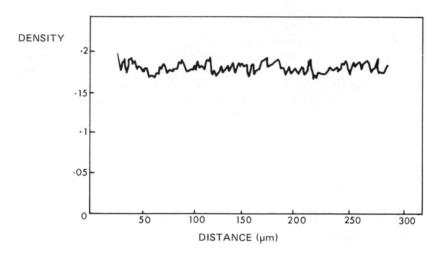

Fig. 25.6 – Granularity trace for a medium speed film, using a scanning aperture of 50 μm diameter

the distribution of a large number of readings from such a trace (taken at intervals greater than the aperture diameter) is approximately normal, so the standard deviation, σ, of the density deviations can be used to describe fully the amplitude characteristics of the granularity. The standard deviation varies with the aperture size (area A) used. For materials exposed to light the relationship $\sigma\sqrt{2A} = G$ (a constant) holds well. This is *Selwyns Law*, and the parameter G can be used as a measure of granularity.

Other measures of granularity have been defined. In particular the Syzygetic density difference should be noted. This is the average density difference between two minute neighbouring areas of the same size, and

evolved as a measure of granularity that would correlate well with visual graininess. However, it can be shown that when measured properly, using uniform, clean samples, Selwyn granularity and the Syzygetic density difference are essentially equivalent, and the former, which is easier to determine, provides a useful index to sample graininess.

Factors affecting negative granularity

The following are the most important factors affecting the granularity of negatives:

(1) *The original emulsion employed*
This is the most important single factor. A large average grain size (i.e. a fast film) is generally associated with high granularity. A small average grain size (i.e. a slow film) yields low granularity.

(2) *The developing solution employed*
By using fine grain developers it is possible to obtain an image in which the variation of density over microscopic areas is somewhat reduced.

Factors (1) and (2) are closely related, for just as use of a fast emulsion is usually accompanied by an increase in granularity, so use of a fine grain developer often leads to some loss of emulsion speed. Consequently, it may be found that use of a fast film with a fine grain developer offers no advantage in effective speed or granularity over a slower, finer grained film developed in a normal developer. In fact, in such a case, the film of finer grain will yield a better modulation transfer function (see page 544) and resolution and in consequence is normally to be preferred.

(3) *The degree of development*
As granularity is the result of variations in density over small areas, its magnitude is greater in an image of high contrast than in a soft one. Nevertheless, although very soft negatives have lower granularity than the equivalent negatives of normal contrast, they require harder papers to print on, and final prints from such negatives usually exhibit similar graininess to prints made from negatives of normal contrast.

(4) *The exposure level, i.e. the density level*
In general, granularity increases with density level. Typical results are shown in Figure 25.7. This result leads to the conclusion that overexposed negatives may yield excessive print graininess.

Sharpness and acutance

The study of the effects of turbidity indicates that the photographic image of an edge does not exhibit an abrupt change from high to low density. Instead, there is a measurable density gradient across the boundary.

The term "sharpness" refers to the subjective impression produced by the edge image on the consciousess of an observer. The term "acutance" is used to designate the objective characteristic of an edge as determined from a microdensitometer trace.

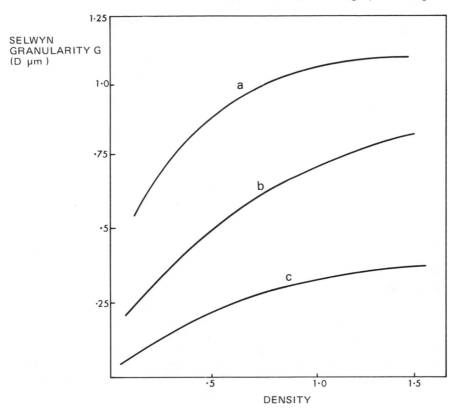

SELWYN
GRANULARITY G
(D μm)

DENSITY

Fig. 25.7 – Granularity as a function or density level for high (a) medium (b) and Slow (c) speed films

The degree of sharpness depends on the shape and extent of the edge profile, but being subjective the relationships are complex and difficult to assess. Acutance can be measured by evaluating the mean square density gradient divided by the density difference across the edge. The number obtained is found to correlate quite well with the visual sensation of sharpness for a number of film/developer combinations.

The density profile of an edge image depends not only on the turbidity of the emulsion, but also on the nature of its development. When development adjacency effects are significant, enhanced sharpness often results. This phenomenon, the so-called edge effect, is used to advantage in many developer formulations and is illustrated in Figure 25.8. The density immediately to the high density side of the edge is increased by the diffusion of active developer from the low density side, while development-inhibiting oxidation products, diffusing from the high density side, reduce the density immediately to the low density side of the edge.

The magnitude of adjacency effects depends on the developer for-

mulation, degree of development, emulsion type and on the exposure level and subject luminance range.

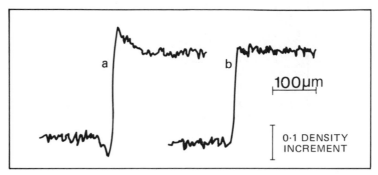

Fig. 25.8 – Edge traces for a typical medium speed film (a) in the presence of and (b) in the absence of edge effects

Quality and definition

Even without defining the terms, the layman interprets "quality" differently from "definition". They are clearly subjective concepts and must be evaluated statistically by having a large number of observers rank appropriate photographs. They both appear to depend on the combined effects of resolving power, sharpness, graininess and tone reproduction. Sharpness and graininess appear equally important when considering the concept of quality, whereas sharpness would seem to be more important than graininess when considering definition.

Modern methods of image evaluation

Techniques developed originally in communications theory have now been established as powerful analytical procedures within the fields of optical and photographic image evaluation. This evolution has occured over the past two or three decades and the methods resulting are now routinely applied to the measurement of all aspects of image quality. Photographic materials can now be quite meaningfully compared in many ways with other imaging systems (e.g. television) although completely different technologies may be involved. Methods of improving the photographic medium have become evident whereas such progress could not have occurred on the basis of simple measures of, say, resolving power alone.

Much of the remainder of this chapter is devoted to a brief outline of the more relevant of these approaches. Before proceeding with these however, it will be instructive at this point to consider what we would expect the performance of an ideal imaging system to be. The significant deviations from this ideal behaviour exhibited by real photographic emulsions can then serve as a useful introduction to the treatment in the rest of this chapter.

Photography as we know it relies on the interaction between the exposing light and the sensitive material in such a manner as ultimately to render visible an image of the incident exposure distribution. To be more precise, the interaction is between individual exposure photons, or quanta of light, and photosensitive elements of the photographic material. The final image is composed of microscopic picture elements corresponding in position to those photosensitive elements that have received adequate exposure.

Intuitively, it would seem that the ultimate photographic process would involve as the sensitive material some form of homogeneous surface over which a one-to-one correspondence existed between exposure photons and resulting picture elements. Every single incoming photon would give rise to an independent picture element and no such element would arise without the interaction of a photon. Furthermore, in such an ideal process, each picture element should occur at the point of intersection of the corresponding incoming photon and the sensitive surface, and should be adequately small so that an accurate reproduction of the original exposure distribution will result. Finally, the elements should contribute equally and sufficiently to the measured output (e.g. density) thus retaining tonal information and providing adequate camera speed.

It is well known that real photographic materials do not behave in such an ideal manner. The following considerations represent a summary of the fundamental shortcomings found in practice:

(1) A significant proportion of photons striking the photographic material during an exposure are not absorbed by any light-sensitive element but are reflected by the front surface of the film or absorbed by the gelatin or backing. Clearly they cannot contribute to image formation and are wasted.

(2) The photosensitive silver halide crystals require far more than one quantum each to render them developable and so produce a metallic image element. It is generally believed that any given emulsion exhibits grains with a wide range of "quantum sensitivities" from a lower figure of about four up to many hundreds. Such a characteristic contributes to the relatively wide range of response to light exhibited in general by photographic materials. Quantum sensitivity is a feature of latent image theory and is covered in more detail elsewhere.

(3) When a grain has absorbed its required number of photons for developability it does not "close its doors" to any further photons for the remainder of the exposure, but continues to absorb them at the same rate as before. The additional photons do not contribute anything further to the image and are thus wasted.

(4) As we saw when discussing photographic turbidity, the non-homogeneous structure of the sensitive layer leads to substantial light scatter during the exposure stage, with the result that fine detail in the image is degraded. The resolving power of the material depends closely on this characteristic although, as we shall see, photographic turbidity is most usefully described using the point spread function and the modulation transfer function.

(5) Because of the grain size and grain sensitivity distributions, and the random nature of the spatial distribution of the grains, the photographic recording is characterised by a level of noise (see Figure 25.11) that is far higher than the noise inherent in the original exposure distribution. In the developed image this noise is recognised as an attribute of the heterogeneous structure of the record and is widely studied as such using a number of techniques. We have already met the terms "graininess" and "granularity" as two appropriate descriptors. A more exhaustive analysis can be performed using autocorrelation and power spectrum methods (see page 547).

Spread function and the modulation transfer function (M.T.F.)

If, in Figure 25.1, the disc of illumination is imagined to become infinitely small while retaining sufficient brightness to produce a photographic response, the image resulting is not a true point. Because of the turbidity of the emulsion layer it comprises a circular distribution, known as the point spread function, some 2–20 μm in diameter, depending on the film type. This is significantly greater than the individual grain size and it is this rather than any one individual grain that represents the building block of all photographic images.

Formation of extended photographic images can be envisaged as the summation of an infinite number of overlapping point spread functions each corresponding to an "elementary" point in the object distribution.

The measurement of point spread functions in practice is difficult owing to their small size. It is more convenient to consider the image of an infinitely thin "line" distribution of intensity – the line spread function. In practice this is considerably easier to measure.

The mathematics of image formation using the spread function as a building block involves the solution of convolution integrals, and the analysis of imaging systems would be a formidable task if this approach were the only one available. Fortunately, methods developed originally for telecommunication and information transfer yield an equivalent method of analysis that is far easier to implement in practice. This is the Fourier approach.

Basically, this depends on the fact that any "scene" exposure distribution can in principle be expressed as a linear combination of sinusoidal exposure distributions of varying spatial frequencies. Because of light diffusion within the sensitive layer, the overall exposure distribution is degraded. In terms of the individual spatial sine waves however, the degradation exists only as a reduction of contrast, or modulation; they retain their sinusoidal form. The degree of modulation reduction, or attenuation, increases with spatial frequency. Thus fine detail is recorded less satisfactorily than coarse detail.

Clearly, a complete specification of the light-diffusing properties of the imaging system is possible using this "sine wave response", or *modulation transfer function* (MTF). This represents the output modulation divided by the input modulation, plotted against spatial frequency.

Examples are shown in Figure 25.9. Mathematically, the MTF is the Fourier transform of the line spread function and includes no information not contained in that function.

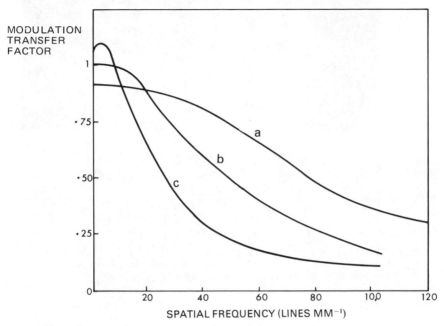

Fig. 25.9 – MTFs for a fine grain film (a), medium speed film (b) and fast panchromatic film (c)

In practice, the MTF can be determined for photographic materials in a number of ways. Photographing a chart containing spatial sine waves of a range of frequencies is perhaps the simplest in terms of the subsequent analysis (see Figure 25.10) although the production of the chart is difficult.

Another common technique involves photographing an edge and analysing the resulting image. In this way the line spread function is readily obtained and with the appropriate Fourier mathematics the complete MTF can be determined.

A third method of measuring the MTF of an emulsion uses a square wave chart of the Sayce type (Figure 25.2a). The photographic image is Fourier analysed to give the true photographic MTF.

Factors affecting the modulation transfer function

(1) *Non-linearities of the photographic process.* Strictly speaking, MTF theory is applicable only if the output chosen for measurement bears a linear relationship with the input. The following are two of the most important sources of non-linearities in photographic materials:

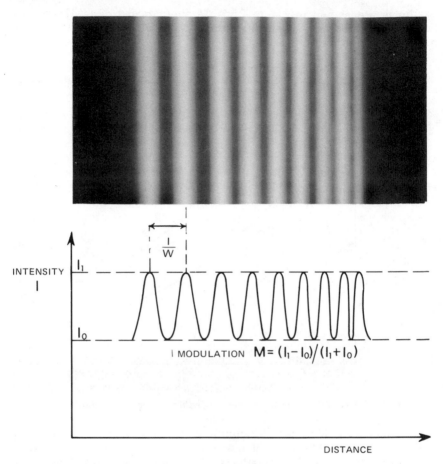

Fig. 25.10 – Section of Sine Wave Test chart showing spatial frequency w increasing to the right

(a) The characteristic, or response curve. The commonly measured output quantities, density and transmittance, are not in general linearly related to the input exposure unless low-contrast images are involved. To overcome this, the output modulation must be measured in terms of the effective exposure distribution inside the emulsion at the exposure stage.

(b) Development edge effects. These are due to exhaustion, diffusion and inhibition processes occuring during development and are an intrinsic feature of the system. Because of their advantageous influence on image sharpness, it is often expedient to promote them. However, in the presence of these effects, MTF's are obtained that are variable with respect to the exposure configuration (edges or sine waves) and also to the mean exposure level, composition of the developer and development time.

546

The presence of edge effects can be recognised by the increase in modulation of the lower frequencies. Curve C of Figure 25.9 illustrates this.

(2) *Colour of the exposing light.* The degree of light diffusion in a photographic emulsion, and hence its MTF, depend on the wavelength of the exposing light. There is however no systematic trend.

(3) *Halation.* This arises when light scattered within the emulsion continues through to the base and its reflected at the base/air interface. The light re-enters the emulsion causing a secondary image. The highest concentration of reflected light appears within a narrow range near the critical angle and gives rise to a characteristic halo around small bright points in the image. Extended bright regions tend to form broad fogged patches with a severe loss of fine detail.

The effect of halation on the photographic MTF is to reduce the level of the function, and this can be seen in the low frequency region of curve a in Figure 25.9.

(4) *Noise.* The image noise, or granularity, makes the measurement of MTF inaccurate. This is particularly the case with edge methods and can introduce a systematic error.

Importance of the MTF

One of the basic advantages of modulation transfer analysis over earlier methods of evaluation lies in its fundamental nature. Although it is not itself a measure of image quality it does allow an analysis of individual components of an imaging system from the point of view of detail reproduction.

The MTF of a combination of components, e.g. a lens and a film, can be determined by multiplying together the MTF's of the individual elements ordinate by ordinate at each abscissa value. Also, the elements of a system can be examined to determine how much each is degrading the image and hence which elements should be improved.

Autocorrelation function and power spectrum

Although the standard deviation of density (i.e. the square root of the mean square density deviation) can be used to describe the amplitude characteristics of photographic noise, a much more informative approach to noise analysis is possible using methods commonplace in electrical communications theory. Instead of evaluating only the mean square density deviation of a noise trace, the mean of the product of density deviations at positions separated by a distance τ is measured for various values of τ. The result, plotted as a function of τ, is known as the autocorrelation function. It includes a measure of the mean square density deviation ($\tau = 0$), but equally important, contains imformation about the spatial structure of the granularity trace.

Evaluation of the Photographic Image

The autocorrelation function is related (mathematically via the Fourier transform) to another function of great importance in noise analysis, the Wiener or Power Spectrum. This function can be obtained from a harmonic analysis of the original granularity trace, and expresses the noise characteristics in terms of spatial frequency components. The power spectrum of granularity is particularly valuable when analysing the transfer of granularity through photo-optical systems. Assuming each stage is characterised by its MTF and contrast such an analysis is relatively straight-forward.

Detective quantum efficiency

Photographic materials are not particularly efficient in utilising exposure photons, which means that for a fixed exposure level the detection quality of the image* is very much poorer than the theoretical maximum. This is probably not significant in normal photography where exposure levels are high enough to ensure images of good detection quality on the output side of the photographic process. In situations involving low light levels however, such as may be encountered in astronomical photography, this characteristic is extremely important and has led to the development of far more efficient image-recording systems to replace or supplement the photographic material. In these situations it is important to appreciate fully the performance capabilities and optimum exposure levels of the image recorders available in order that they may be used most efficiently. Detective Quantum Efficiency (DQE) assesses the performance capability in this context by essentially measuring the efficiency with which the image recorder utilises the incident exposure photons. It is defined:

$$DQE = \left(\frac{\left(\frac{S}{N} \right)_{OUT}}{\left(\frac{S}{N} \right)'_{OUT}} \right)^2 \times 100 \text{ per cent}$$

where

$$\left(\frac{S}{N} \right)_{OUT}$$

denotes the signal-to-noise ratio of the output from the image recording process under consideration, and

$$\left(\frac{S}{N} \right)'_{OUT}$$

denotes the output signal-to noise ratio of an hypothetical "ideal" image recording system registering every single exposure photon.

* We use "detection quality" instead of the more general, highly subjective term "quality", as an objective appraisal of the level of discrimination possible between two density levels or two brightness levels.

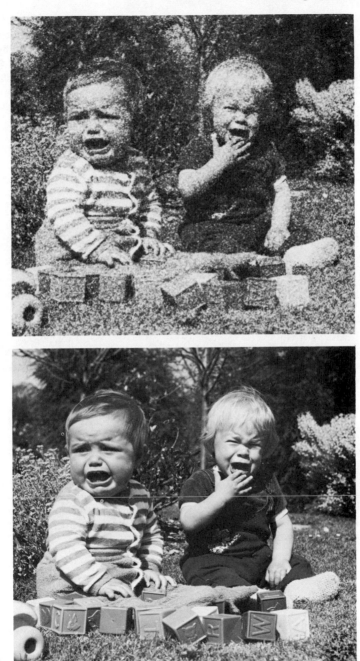

(a)

(b)

Fig. 25.11 – Images of different detection qualities. In (a) the negative has been printed in contact with a noise pattern to simulate excessive graininess. The higher detection quality of (b), printed without the noise pattern, is evident

Evaluation of the Photographic Image

Broadly speaking the signal-to-noise ratio refers to the detection quality of the image and for a photographic material depends on the contrast and granularity of the material. Figure 25.11 depicts a subject recorded with two different detection qualities, while Figure 25.12 shows simulated photographic images for a simple star object and demonstrates the concept of signal-to-noise ratio. In this illustration, (b) represents an image formed by a high speed, coarse-grained material, while (c) represents that formed by a slower, finer-grained film.

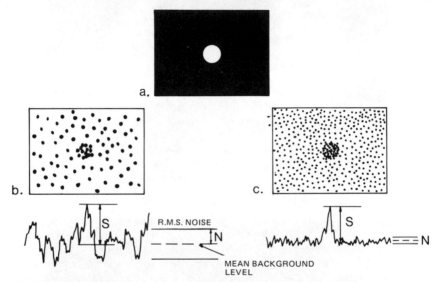

Fig. 25.12 – Simple, low contrast exposure distribution consisting of a star disc on a uniform background
(b) and (c) simulated photographic images. Microdensitometer traces through the star images are also shown. The much higher signal-to-noise ratio ($\frac{S}{N}$) of c is evident

To understand more fully the implications of the above definition of DQE, it is useful to derive two alternative expressions. First, the output signal-to-noise ratio for an ideal image recording process equals, by definition, the input signal-to-noise ratio (i.e. the S/N ratio of the incident exposure distribution). We can therefore write

$$DQE = \left(\frac{\left(\frac{S}{N}\right)_{OUT}}{\left(\frac{S}{N}\right)_{IN}} \right)^2 \times 100 \text{ per cent}$$

Furthermore, it can be shown that the signal-to-noise ratio of an exposure distribution (i.e. the input S/N) is proportional to the square root of the exposure level (because the exposure photons have a random distribution in space and time), i.e.

$$\left(\frac{S}{N} \right)_{IN} = k\sqrt{E}$$

Hence we can imagine comparing the output of our real image-recording process with the output from the "ideal" process while reducing the exposure level of the latter. At some point the two outputs will match, i.e.

$$\left(\frac{S}{N}\right)_{\text{OUT, EXPOSURE LEVEL }E} = \left(\frac{S}{N}\right)^1_{\text{OUT, EXPOSURE LEVEL }E'}$$

where E' is less than E
Hence we can write

$$DQE_E = \left(\frac{\left(\frac{S}{N}\right)_{IN, E'}}{\left(\frac{S}{N}\right)_{IN, E}}\right)^2 \times 100 \text{ per cent} = \left(\frac{k\sqrt{E'}}{k\sqrt{E}}\right)^2 \times 100 \text{ per cent}$$

$$= \frac{E'}{E} \times 100 \text{ per cent}$$

i.e. the DQE of a real image recording process at an exposure level E is given by the ratio E'/E where E' is the (lower) exposure level at which the hypothetical "ideal" process would need to operate in order to produce an output of the same detection quality as that produced by the real process. This idea is demonstrated in Figure 25.13.

Because ideal systems do not exist in reality, this last definition does not help in measuring the DQE for image recorders in practice. Instead it is necessary to use the second definition above and determine an expression for the signal-to-noise ratio of the image in terms of readily measured parameters. When this is done for the photographic process we arrive at a surprisingly simple expression

$$DQE_E = \frac{0 \cdot 43\, \gamma_E^2}{E \cdot G_E} \times 100 \text{ per cent}$$

where γ_E is the slope of the characteristic curve at the exposure level E photons μm^{-2} and G_E is a measure of the image granularity at this point.

Figure 25.14 shows a DQE vs Log Exposure curve for a typical photographic material. It can be seen that the function peaks around the toe of the characteristic curve and has a maximum value of only about 1 per cent at best. The two materials represented in Figure 25.12 would probably have much the same peak DQE values but these would occur at different exposure levels. The curve for the fast, coarse grained material would be at the lower exposure level, corresponding to a lower input signal-to-noise ratio.

This last expression is equivalent to writing

$$DQE = \frac{(\text{contrast})^2 \times \text{speed}}{\text{granularity}}$$

Such a relationship is pleasing as it agrees with conclusions arrived

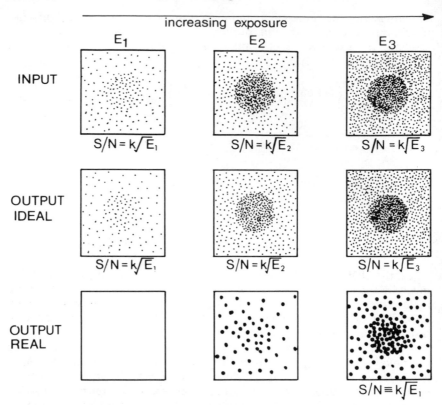

increasing exposure

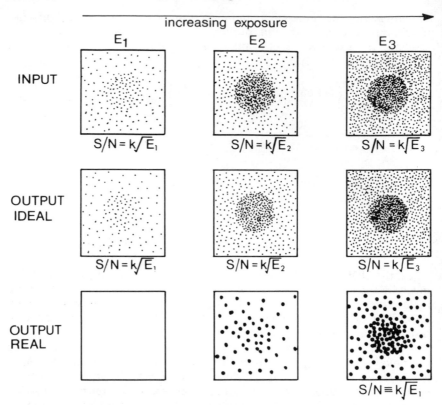

Fig. 25.13 – Input and output for 'ideal' and real image recording process. Top row: Input exposure distribution (photon distribution) at 3 different exposure levels.
Middle row: Output for an ideal detector (identical to the input)
Bottom row: Output for a real detector. Here, exposure E_1 is insufficient for any response and the result for exposure E_3 has been drawn with the same S/N ratio as the input at exposure E_1 i.e. DQE for real detector at exposure level $E_3 = E_1/E_3$

at from a more intuitive, almost common sense approach to the problem of improving the threshold signal-detecting capabilities of photographic images.

Information capacity

The information capacity of a photographic material is a measure of the maximum amount of "information" (in a precisely defined form) that can be stored on the material. It is usually evaluated by determining the number of micro-regions, or cells, per unit area, that can be distinguished as separate. The figure obtained depends on the constraints applied – the greater the number of distinct density levels we wish each cell to be capable of exhibiting, the larger the cells must be. This relationship arises as a result of image granularity.

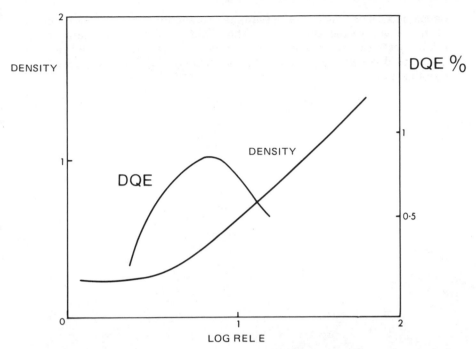

Fig. 25.14 – Detective quartum efficiency (DQE) as a function of exposure for a typical photographic material. The function peaks at an exposure level near the toe of the characteristic curve

Generally only two density levels are adopted and the cell size is found to be of the same order as the point spread function area. It cannot be less. Using such *two-level* recording, each cell is said to possess one *bit* of information and the number of cells per unit area is a measure of the information capacity in bits per unit area.

Values range typically from about 5×10^4 bits cm^{-2} for high speed materials to 2×10^8 bits cm^{-2} for high resolution plates.

Colour images

It is possible to use the techniques of evaluation outlined so far for monochrome (silver) images quite generally for the analysis of colour images. The differences are mainly in interpretation because the fundamental colour image element is a transparent and highly spectrally selective dye cloud. Hence it is necessary to specify the appropriate wavelengths for exposure and measurement in order that the results should be meaningful.

If the M.T.F. is evaluated for each layer of a tripack, it is generally found that the layer closest to the film base yields the poorest result, owing to the greater light scatter involved. As the location and extent of the dye clouds depend on the distribution and size of the original

developed silver grains, the dye-image granularity is generally a function of the silver image granularity. Threshold graininess originates from brightness differences only; colour differences are not involved. Hence magenta dye contributes most to the observed graininess, and yellow dye the least.

26 Faults in Negatives and Prints

NEVER destroy a faulty negative or transparency until the cause of the fault has been ascertained. You will be wiser as the result of your investigation and may save yourself much trouble and annoyance in the course of further work.

It is, of course, impossible to mention *every* fault which may occur, but we propose to deal with as many as possible – usual and unusual. In order to facilitate identification, description of the appearance of the negative is given as a heading, and beneath it are listed the various faults which may be the cause of this appearance.

In arriving at the cause of any particular fault, the first step should be to narrow down the field of investigation by reference to the tables on pages 566–568. By following up the references to text in the tables, it should be possible to classify the fault as one of exposure or of development, and then, from the evidence available, it should be a simple matter to identify the cause. The majority of faults can occur in *all* types of material, but where any faults are peculiar to, or most likely to occur with, one particular type of material or camera this fact is mentioned.

Faults in Black and White negatives

Unsharp negatives

Unsharpness is of several kinds. It may arise from the image being out of focus, due to misjudgement of distance, incorrect setting of the focusing scale or to approaching the subject too closely when using a fixed-focus camera. More rarely the unsharpness may be due to a faulty focusing scale, incorrect register of the film or to the components of the lens being misplaced. In the case of a camera with coupled rangefinder and focusing scale, unsharpness may be due to the coupling being out of adjustment. This is unusual, but it may happen if the camera is dropped or knocked violently.

With reflex cameras and other cameras focused by means of a viewing screen, unsharpness results if the screen is removed and

replaced the wrong way round. Frequently, some part of the subject will be sharp, but not the part which ought to have been in best focus.

Occasionally, when a folding camera has been used, unsharpness may be found to exist more at one edge of the picture than at the other. The fault is due to the front of the camera having been bent slightly forward or backward, or to its having become loose on its runners through wear, with resulting backward sag.

If unsharpness exists more in the centre of the picture than at the sides, then the fault may be due to the camera (if of the folding type) having been opened too quickly, and the film sucked forward out of the plane of focus by the partial vacuum so formed.

Another kind of unsharpness is caused by unsteady holding of the camera during exposure, resulting in several images of the subject being recorded, each shifted slightly from the others. A magnifier usually show these separate outlines, which serve to distinguish this kind of unsharpness from that mentioned above, as does also the fact that camera-shake generally causes unsharpness of everything in the picture. This can be prevented by holding the camera very steady and *pressing* the shutter instead of *jerking* it. A "time" exposure with the camera held in the hand results in unsharpness from this cause.

The beginner who uses a 35 mm or smaller camera, and very often, too, an experienced photographer who has just changed to a small format camera, may have trouble with camera-shake when using long exposures — 1/30th second or longer. This is due to the fact that a degree of camera-shake which would pass unnoticed in a 5 × 4 in negative, is a serious fault in a negative measuring only 24 × 36 mm, which must subsequently be considerably enlarged. Miniature camera photography calls, in fact, for greater care and precision throughout.

Sometimes the blur caused by camera-shake is evident over only a part of the negative. This may be due to one of two causes. In the case of a camera fitted with the focal-plane shutter, the shake may have occurred when the slit in the blind had already travelled across half the width of the film.

The alternative explanation, applicable to any type of camera, is that one hand of the photographer moved while the other remained still, thus one side of the camera moved more than the other — usually it is the hand that presses the shutter release that is the more likely to shake.

Camera-shake can occur when the camera is used on a tripod if there is any vibration due to wind, to a passing vehicle, to carelessness on the part of the photographer, or to "mirror bounce" in an SLR camera. If the tripod legs slip or slide, too, the same effect will be seen in the negative.

There is another kind of unsharpness, which is really diffusion of a sharp image, and may be caused by dirt on the lens, or by the lens becoming clouded when brought from a cold atmosphere into a warm one. This produces a softness over the whole picture.

An unsharpness somewhat similar to camera shake is obtained, in the case of moving objects, if the shutter speed is too low; the image of the moving object on the film has time to move while the shutter is open.

This occurs chiefly with objects crossing the line of sight and, of course, affects the moving parts of the subject only.

This fault can be prevented in three ways:

(1) By giving a shorter exposure and using a wider lens aperture.

(2) By swinging the camera carefully so that the image of the moving subject remains in the same place in the picture area, and the movement is imparted to the background. This technique — termed "panning" — helps to suggest speed and is most effective.

(3) By standing near the line of approach of the subject.

There is no remedy for unsharpness of the negative, but it can sometimes be masked by printing on a grained-surface paper.

Thin negatives

Insufficient density of the negative as whole arises from under-exposure or under-development (or both). Some idea of the cause may be obtained by noticing the occurrence of detail and the density of the highlights (sky) relative to the shadows. If there is detail everywhere, though faint in the shadows, and if the shadows are free from veil (almost clear when the negative is laid face down on white paper), the cause is under-development, i.e. for too short a time, or in a solution that is cold or partly exhausted. The negative is weak (thin, rather than low contrast) and clear. A chromium intensifier may increase the density to give very much the same effect as though development had been continued for the proper time.

If the negative shows detail thoughout, including the shadows, but is veiled all over (so that the picture appears to be buried in fog when the negative is laid face down on paper), the cause is over-exposure followed by under-development. It is not easy to remedy an over-exposed and under-developed negative satisfactorily, but intensification often makes a marked improvement. Unless the negative is excessively thin, it is worth reducing it slightly with ferricyanide-hypo before intensifying. This requires considerable care, but the negative can then be intensified with a better chance of success.

If the negative is thin only in the half-tones and shadows, which are badly lacking in detail, but of fair density in the sky or other highlight, the cause is under-exposure. The negative may look contrasty, owing to the highlight density, but the other parts are flat. It is made worse by usual intensifiers, but is often improved sufficiently to yield passable prints by treatment with a uranium intensifier.

Such after-treatments are rarely practicable on 35 mm or small films. They tend to increase grain size and the extra handling can frequently damage the film physically.

In the case of negatives that are weak or flat from under-development, satisfactory prints can frequently be obtained by using a contrasty paper.

Faults in Negatives and Prints

Dense negatives

Excessive density of negatives results from over-development, but the character of the negative varies very greatly according to whether the exposure has been reasonably correct, too much or too little. The means for improvement likewise differ in the respective cases.

In the case of negatives that have had reasonably correct exposure, over-development results in increased contrast. The heavier deposits grow more in density relative to the faint deposits in the shadows. The negative looks hard and grainy. If this contrast is excessive, the range of densities is too great to be rendered in the print, which then lacks gradation of either the lightest tones or the darkest ones. The remedy is to reduce the negative with a solution which, so to speak, will undo the action of the developer. No reducer does this exactly, but Farmer's reducer is fairly satisfactory if used very weak. The permanganate-persulphate reducer, though nearer the ideal in action, is more troublesome to make up.

In the case of over-exposure, continued development gives a negative that is very dense and black all over, yet may be as perfect as one correctly exposed but similarly developed, except that much longer time is required for printing. This arises from the latitude of the emulsion. But if exposure has been grossly excessive, the negative, though dense, will be low in contrast. In either case it is best to treat with Farmer's reducer until density is reduced to a degree suitable for printing. For negatives judged to be of satisfactory contrast, the reducer should be used weak; if the negative is thought to lack contrast, a stronger solution should be used. (It is a good plan to make certain by making a print before reducing.) Then, if necessary, the negative is brought to satisfactory contrast by intensification. Really extreme over-exposure may result in reversal of the negative to an imperfect positive.

Over-development of a negative that has been much under-exposed results in excessive density, chiefly in the highlight and heavier deposits, which become opaque and almost unprintable. The best reducer is ammonium persulphate, but it is often difficult to remedy a negative of this very hard or "chalky" character.

Fog

Fog — ranging from a thin uniform deposit (called "veil") which causes the negative to print flat, to a heavy one which obliterates the picture — may be due either to general action of light other than that from the lens, or to chemical action.

The condition of the edges of the film, or other portion protected from the action of light in the camera, provides a clue to the probable cause. If these, or parts of them, are practically free from fog, the cause must be sought among things that can possibly happen to the film in the camera, whereas fog that covers every part of the negative is probably due to action of light before or after exposure, or to chemical action.

Fog in the camera arises from gross over-exposure (e.g. use of a

shutter set by accident to "time" instead of "instantaneous"); from the scattering of light caused by a dusty or dirty lens or reflection of light from the camera interior (slight veil); from a scattering of the light which often occurs when the camera is pointed directly against a strong light; or from leakage of light into the camera, in which case the fog often occurs as a band or streak, the position of which gives some indication of the point of leakage, such as a loose-fitting camera back.

Fog or veil over the whole surface may arise from some accidental exposure to white light, or to unsafe darkroom light (handling films too close to the safelight). Fog may even occur from exposure of negatives to white light before they are completely fixed, especially if a plain (not acid) fixing bath is used. Apart from improper action of light, wrongly compounded developer or the contamination of developer with fixer may cause the defect. Materials that show persistent fog should be tried with freshly prepared developing solutions. Fog along the edges of roll film is caused by the spool becoming loose, and light penetrating between the spool paper and the metal flanges of the spool. Such fog extends sometimes right across the width of the film.

Light fogging of 35 mm films while in the camera is unusual, but the possibility of light leakage in the cassette should never be overlooked. If a cassette with a velvet-edged light lock has been used several times and the nap flattened, light is likely to leak in and fog the film at the beginning.

As a rule nothing can be done to remove fog, whatever its cause.

General stain

Yellowish or brownish discoloration of negatives seldom occurs with modern emulsions and developers. When it does, the cause is almost always a stale or oxidised condition of the developer, due to the use of sulphite of poor quality, to a stock solution having been kept too long, to using a developer for too many films or plates, or to "forcing" a negative in the developer. When using hydroquinone developer, a yellow stain is liable to occur if negatives are not well rinsed between development and fixing. An acid fixing bath corrects the tendency to the occurrence of stain.

A very effective method of removing the heaviest developer stain is by use of the following bleaching solution:

Potassium permanganate	6 g
Sodium chloride (common salt)	12·5 g
Acetic acid, glacial	50 ml
Water to make	1000 ml

This solution oxidises the stain to a soluble substance, and at the same time converts the silver image into silver chloride. The negative is immersed in it for ten minutes with constant agitation, rinsed and soaked in a solution of potassium metabisulphite (50 g in 1000 ml water) until

the negative is white when viewed from the back. It is then re-developed fully with any normal M.Q. or P.Q. developer.

Owing to the very acid character of the bleach, it is well to harden the film first by immersion for a few minutes in a solution of chrome alum (10 g in 1000 ml water). Again, such treatment should be used for 35 mm or smaller films only as the very last resort.

Dichroic fog

Dichroic fog is a stain which appears green when looked at and reddish when looked through. It is caused by contamination of developer with fixer, ammonia or other solvent of silver bromide or by keeping films in an impure atmosphere or by the use of alkaline fixer or by one film lying upon another in the fixing bath. It is removed by very weak Farmer's reducer.

Transparent spots

The two chief causes are air-bells clinging to the emulsion surface during development, and particles of dust on the emulsion surface during exposure and/or development. Spots of the two kinds may be distinguished by holding up the negative to the light and examining with a pocket magnifier. Spots from air-bells are all almost circular in shape. They generally arise from air-bubbles in the developer. Water drawn from pressure mains is usually highly aerated, and when used for diluting stock solutions is very liable to cause a crop of bubbles.

Dust spots, under the magnifier, are seen to be all kinds of shapes, much smaller than spots made by air-bells, and of sharp outline. The dust causing this trouble is almost always present in the camera before loading, and occasional cleaning with a "blower" brush is advisable if these blemishes are regularly experienced.

Clear spots on a negative may also be caused by dirty tanks or by impurities in tap water. Clear spots and "smudges" may be caused, too, by the adherence of scum to the surface of the emulsion during development. This scum is found on the surface of large tank developers that have been much used, and should be removed before films are inserted. The formation of scum and oxidising of the developer are greatly reduced if a floating lid is used.

Clear spots arising from causes other than the above are very seldom met with. Developer that has become stale from age or use, or is contaminated with wax or grease, is liable to cause light spots of irregular shape. In tropical countries, similar spots may be formed by bacteria which have found the damp gelatin a suitable culture medium. In temperate climates, cases are occasionally met with in which the gelatin coatings of negatives have been eaten into minute holes by insects.

Light spots of comet shape on a ground of heavy fog are also rare, and may be a puzzle until their cause is found. They arise from leakage of light from some point which causes rays to graze the emulsion surface.

Particles of dust on the latter cast shadows which, in the negative, form the comet-like spots on the ground of fog.

Clear spots on negatives cannot be rectified other than by physical retouching.

Dark spots

Dark spots – caused by undissolved particles of the developing agent (metol, hydroquinone, etc.) in the developing solution; settlement on the emulsion coating of particles of developing agents suspended in the air of the darkroom from previous weighings of the dry chemicals (spots produced by metol dust are very characteristic – they are clear with dark edges); dark, insoluble particles of oxidised developer formed in old or used developing solutions.

Particles of solid matter in tap water may also settle on the gelatin emulsion and cause spots.

Yellow or brownish spots

The cause of spots of this type is air-bells still clinging to the emulsion surface in the fixing bath and thus obstructing the action of the fixer. If noticed soon after fixing, they can usually be removed by returning the negatives to the fixing bath, but as the air-bells will in all probability have been present in the developer the process of fixation will simply fix out the undeveloped silver bromide and leave clear spots.

Light bands and patches

Light bands and patches are usually less easy to diagnose than dark ones. Some of these defects are of very obscure origin. The following may be noted:

A light or clear band across one end of the negative usually means that flash has been used at an unsuitable shutter speed with a focal plane shutter. On larger format cameras it might be due to failure to withdraw the darkslide completely or to an overlong camera baseboard.

A clear patch on a roll film negative, with three straight edges and one irregular edge, may be due to the sealing paper having been torn off and having become lodged in the body of the camera. An irregular shaped patch may be caused by a small, loose fragment of such paper.

Band of lesser density along one side or end of the negative – fixed but unrinsed negative left projecting from the water in the washing tank. Patches of low density may also occur on film negatives left to fix with parts above the surface of the fixing bath.

Areas of lighter density may also be due to uneven flooding of the film with developer, the light areas having remained dry longer than the remainder. This is a common fault when only a very small quantity of developer is used.

Faults in Negatives and Prints

Small, round light patches – finger tip markings – are produced if the emulsion is touched before development with slightly greasy or chemically contaminated finger tips. The finger print pattern usually provides a clue to the cause of this defect. Splashes of fixer on the sensitive material before development will cause clear patches or patches of lighter density.

A light patch surrounded by an edge of greater density is likely to be a drying mark caused by a drop of water remaining on the emulsion after the remainder was dry. Drying marks may also be caused on film negatives by drops of water remaining on the base side. A blank, undefined area at one edge of the negative may be due to part of the picture being cut off by the photographer's finger over part of the lens. Blank areas at the corners of the negative are caused by the lens not covering fully: if only the top corners are affected the fault may be due to the use of excessive rising front. A fault of similar appearance may be caused by a badly fitting or unsuitable lens-hood.

Blank areas or areas of low density on a roll film may be due to two films having been in contact during development, or incorrect loading into a spiral, one film or coil preventing the solution from reaching the other.

Dark bands and patches

Almost always, this type of fog is due to leakage of light into the camera. If the fog has the appearance of a ray originating at one edge of the film, the cause may be sought in a small point of leakage somewhere in the camera back.

In a roll film camera, looseness of the camera back may be responsible while, in the case of a large format camera, a leakage in the film holder, bad fitting of the holder, or worn condition of the velvet surfaced light traps, may cause the trouble.

A round or oval patch may be a "flare spot", more especially if the picture has been taken against the light. Light reflected from bright metal parts inside the camera or in the lens or shutter may cause similar trouble. Lens flare is comparatively rare, but scattering of light and reflection of the shape of the lens diaphragm are seen fairly frequently when pictures have been taken against the light. Because of the greater number of reflecting surfaces that they incorporate, compound lenses are more liable to produce this fault than simple lenses.

Marks of greater density than the image may be caused by water or developer which has been splashed accidentally on to the sensitised material before development. Similar markings of rather less density may be caused by water splashing on to the dry negative.

Dark finger-print patterns occurring on the negative are caused by touching the sensitive material with developer-contaminated finger-tips before development.

Dark or degraded edges of the negative are caused by storage of the

sensitive material in a damp place. The fault is usually accompanied by some degradation over other parts of the negative.

Chemically active substances are also present in some printing inks and for this reason sensitised materials should never be wrapped in printed paper. The ink used to print lettering and numbers on the backing paper of roll films is made from substances that are inactive in this respect.

Yellowish or reddish patches, usually not occurring until some time (days or weeks) after the negative has been finished, are caused by incomplete fixation. In the case of films, they may be due to part of the negative floating above the surface of the fixing bath or to one film pressing on another. If the patch has a straight edge the latter cause is indicated.

Line markings

Fine, clear lines running the length of a band of roll film are caused by friction of the emulsion surface against rough guide rollers or against dust or grit on the latter; they may also be caused by the guide rollers being jammed and failing to revolve as the film is wound across them.

Similar "tram-lines" may occur along the length of a 35 mm film due to the film having been rolled or pulled too tightly, or to the light trap of the cassette picking up grit which causes scratches as the film is drawn through the camera.

Irregular lines may be caused by the film being allowed to touch the working bench – almost any form of friction on the sensitive surface is liable to cause such abrasion marks. A tiny "arrowhead" mark may be caused by the film being allowed to "kink".

A dark line round an outline where (in the subject) dark objects come against a light background sometimes occurs in tank development when the solution is allowed to remain without movement for the whole period of development. Solution in contact with a heavy deposit becomes exhausted, while that on an adjoining light deposit (largely unexhausted) runs over to the former, adding further density all along the edge.

So-called "streamer" lines, i.e. bands of extra density running from the image of a narrow, dark object such as a chimney, flagstaff, etc., result from downward diffusion of largely unexhausted solution in stagnant tank development. The same type of fault can occur when films are developed in spiral tanks, but in this case the streamers run across the *width* of the film and, with perforated films, are likely to be most intense adjacent to the perforations. Streamers occur if the agitation of the developer is insufficient or too intense and regular.

The cause of tangle markings, i.e. a tangle of dark lines, sometimes covering the entire negative, is a pinhole in the body or between-lens shutter of the camera. On carrying the latter about in bright sunlight, the pinhole forms an image of the sun on the emulsion surface, and the position of this image changes continuously as the position of the camera changes. The result is a continuous line, running here and there, accor-

ding to the directions in which the camera was pointed. When lighting is diffused, the indication of a pinhole in the bellows will be small, dark patches on the negative, with heavy centres and undefined edges. A pinhole in the blind of a focal-plane shutter will cause a line of slightly greater density across the negative.

Short "hair-line" marks occurring all over roll film negatives are called "cinch marks", and are caused by winding the spool too tightly after removing it from the camera and before sealing.

Halation

Halation takes the form of a spread of density from the image of bright parts of the subject on to surrounding portions, obliterating detail in the latter. Common examples are the blur of fog round the windows in interiors and from the image of the sky on to that of tree branches. It is largely prevented by the use of anti-halation dyes in the film base or by non-reflective backing of the film.

Irradiation

Irradiation may also occur in such cases. This is due to reflection of the image of a bright part of the subject *within* the sensitive emulsion and, of course, backing is powerless to prevent it.

Positive instead of negative

At times, the image (when finished in the usual way) appears as a positive instead of a negative; usually a greatly fogged positive. Frequently, part only of the subject is positive and the remainder negative. The reversal is generally caused by "forcing" an under-exposed film by protracted development in an unsafe darkroom light (see page 568). The defect is very seldom met with, but cases sometimes occur in which one or two negatives on a spool of film are perfect, while the others are reversed, the exposure to the darkroom light having been greater in the part of the spool affected.

Reticulation

Reticulation takes the form of a fine irregular pattern over the whole negative, but is most pronounced in the heavier densities. It arises from a physical change in the gelatin caused by sudden swelling on transference from a cold to a warm solution, or by sudden contraction when transferred from a warm to a cold solution.

Frilling and blisters

These defects are manifestations of poor adhesion of emulsion to the base. Frilling usually occurs at the edges whereas blisters may be found

at any point on the surface of the negative. Neither trouble is likely to be met with except perhaps when processing is carried out under the worst tropical conditions and when the various solutions are used at widely different temperatures. Frilling may, however, be caused by transference of negatives from a strongly alkaline to a strongly acid bath, and may also result if negatives are held by the edges with warm fingers. Frilling of RC paper may be caused by excessive washing or washing at too high a temperature.

Mottle

This may be caused by age deterioration of the sensitive material, by deterioration caused by chemical fumes or by exposure to the air as in the case of a roll film left in a camera for a period of months. Another form of mottle may be caused by the growth of bacteria or fungus in the gelatin in hot and humid climates. Stagnant developer is the cause of yet another type of mottle.

A mottle that is more or less defined all over the picture arises if a backed film is exposed through the backing – the picture also reversed left to right. Similar mottling occurs if a backed film is left face downward on the bench long enough for the darkroom lamp to fog the emulsion.

Dull image

When the dullness of the image is due to insufficient density of the negative and to a certain amount of veil that extends over the margins, the cause is probably exhausted or contaminated developer. The presence of stain on the negative confirms this. This dullness also may be due to incorrect preparation of the developer. The weakness of the developer is responsible for the weakness of image, and "forcing" or contamination of the solution is liable to produce chemical fog and stain. Such a negative can be improved by *slight* reduction followed by chromium intensification.

Dullness of the image of a negative of good density may be due to inadequate fixation. Undissolved silver salts remain in the negative and obscure the clear parts. Re-fixing and washing is usually successful.

Dullness of the image may also be due to dichroic fog, which is dealt with on page 560, or to veiling of the picture by slight general light fog, to scatter from the lens or to chemical fog.

Do not overlook the possibility of dullness being due simply to under-exposure or to under-development, which are explained on page 557. The subject, too, may have been poorly and flatly lit, when only a dull reproduction can be expected.

Other faults

The reasons for some photographic failures are so obvious that they need hardly be described. For example, the blurring and mingling of the image

that occurs when the emulsion melts in unmistakable and can be attributed only to the use of hot solutions or to drying at too high a temperature.

When pictures overlap on a roll film the fault is in the film transport mechanism.

Torn and/or cockled edges of a roll film are caused by misalignment in the camera. Often this fault is accompanied by edge fog, due to light entering where the spool paper was torn. The misalignment may be due to a bent or broken spool chamber spring, or to one or both of the small guide rollers being bent or moved out of the true position owing to wear of the beating ends.

One must not be dismayed by the foregoing formidable list of the failures that may occur in negative making. The aim has been to put into small compass descriptions of most of the defects that may arise, not excepting many which are of most uncommon occurence and all the more puzzling on that account.

Index to faults in black-and-white negatives

The index of the following pages is included to assist you in the speedy identification of negative faults. It must, however, be used in conjunction with the general evidence in your possession — type of material, type of camera used, etc. It attempts to sum up, very briefly, the information given in the foregoing pages, and reference should be made to these pages.

Appearance of negative	Fault	Information	
		Page	
Unsharpness			
Fuzzy definition	Out of focus	555	
Blurred all over	Movement of camera	556	
Blurred image of part of subject	Movement of subject	556	
Too dense all over			
Flat and much shadow detail	Over-exposure	558	
Contrasty	Over-development	558	
Too thin all over			
Lacking shadow detail	Under-exposure	557	
With shadow detail but lacking contrast	Under-development	557	
Dark markings			
Dark areas with images of lens diaphragm	Light scatter	100	
Black "blobs" with image of lens diaphragm	Lens flare	100	562
Black "splashes"	Light leak in camera	101	562
"Splashes" of greater density	Water or developer splashes before or after development	562	

Table 26.1 — Continued

Appearance of negative	Fault	Information
Black finger marks	Developer-contaminated finger tips	562
Black edges (roll film)	Edge fog	559
Dark or degraded edges	Damp storage	562
Black streaks, usually from edges	Light leaks in film roll, cassette or camera	559
Fine black lines	Abrasion marks	563
Dark streamers from light parts of negative extending on to dark parts	Tank development — insufficient agitation	563
Black spots	Chemical dust	561
Dark ribbon-like tangle	Sun tracks	564
Tink dark ↓-shaped mark, accompanied by dimpling of film negative	Kink mark	563
Very short, rather faint hair lines close together all over roll film negative	Cinch marks	564
Light markings		
Clear areas or areas of lower density	uneven development	561
Sharply defined blank area	Paper in camera	561
Clear finger marks	Greasy or contaminated fingers	562
Sharply defined irregular areas of lesser density	Uneven covering with developer	561
Irregular clear spots	Developer scum	560
Picture fades into transparency at corners	Lens not covering	75
Clear scrape marks — emulsion removed	Abrasion by finger nail or by other negatives	
Emulsion removed or loosened at edges	Frilling	564
Large spot of lighter density with greater density at edges	Drying mark	562
Line of lighter density	Loose thread on blind of focal plane shutter	
Irregular shaped small clear spots	Dust on material during exposure	560
Round spot either clear or of lighter density	Air-bells during development	560
Undefined clear area at one edge of negative	Hand partly covering lens	562
Mottle		
Dappled marking which can be seen also by reflected light	Old material	565
Defined mottle without physical marking of surface	Exposure of fog through backing	565
Defined pattern with physical marking of surface	Reticulation	564

Table 26.1 — Continued

Appearance of negative	Fault	Information
Irregular streaky mottle	Insufficient agitation during development	
Dull image		
Insufficient density with some veil over shadows	Exhausted developer	565
Brownish appearance of back	Inadequate fixation	565
Reddish stain when looked through — greenish stain when looked at	Dichroic fog	560
Obscuration of the picture to a greater or lesser extent	Light fog or chemical fog	558
Distortion		
Converging upright lines	Camera tilt	190
Exaggerated perspective	Short focus lens used too near subject	84
Miscellaneous faults		
Dark halo around highlights	Halation or irradiation	564
Two images on same negative	Double exposure	
Blurring and mixing of the image accompanied by irregularities in emulsion surface	Melting of emulsion	566
Positive or partial positive instead of negative (normal density)	Reversal due to fogging by unsafe darkroom lamp during development	564
Positive or partial positive instead of negative (extreme density)	Reversal caused by extreme over-exposure	564
Two images over part of the negative	Over- or under-winding of film spool	
Torn or cockled edges (roll film)	Misalignment in camera	566

Table 26.1 — Faults in black-and-white negatives

Faults in black-and-white prints

Abrasion or stress marks

These defects, in the form of fine lines, hair-like markings or grey patches, sometimes make their appearance when the sensitive paper has been roughly handled before development. The printing apparatus or processing tongs may have some rough edges. To remove the dark markings, pass the prints through a weak reducer such as ferricyanide and hypo or rub the surface of the dry prints with a soft cloth dipped in a mixture of equal parts of methylated spirit and ammonia.

Blisters

These may be caused by wide variations in temperature of developer, fixing bath and washing water, by too strong a fixing bath or by too long immersion in it. Blisters on sulphide-toned prints may be caused by too strong a sulphide solution. Hypo-alum toned prints may blister if the prints are put straight from the hot toning bath into cold washing water instead of through an intermediate bath of tepid water. Mechanically produced blisters are caused by creasing or folding the paper, or by the strong local action of water in washing.

Colour of image unsatisfactory

Prints on bromide or contact papers that are greenish in colour indicate under-development following over-exposure, too great a proportion of potassium bromide in the developer or too much dilution of the developer. The latter, especially, applies to contact papers.

Contrast excessive or lacking

Excessive contrast generally indicates the use of the wrong grade of paper. Specially soft grades of paper are made for printing from hard or contrasty negatives. Excessive contrast may also be caused by under-exposure and over-development of the print.

When contrast is lacking, the cause may also be the wrong choice of paper. Thin, flat negatives require printing on hard or contrasty papers and will give prints of normal contrast in this way. Another cause of poor contrast is the use of a partially exhausted or improperly compounded developer, or the use of a developer at too low a temperature. Poor contrast may also be caused by over-exposure, followed by short development.

Deposits on dry prints

When caused by the use of hard water the deposit can usually be removed by wiping the surface of the wet print before drying. Prints that have been insufficiently washed after fixing may show a deposit of white powder or crystals. Prints toned in the hypo-alum bath may dry with a bad surface unless well sponged when removed from the toning solution. Sulphide-toned prints will show patchy alkaline deposits if inadequately washed after toning. Deposits can also be removed mechanically by applying to the surface of the dry print a little metal polishing paste on a piece of soft rag, followed by polishing with a clean rag. Beeswax dissolved in petrol, or ordinary wax floor polish, will often improve a bad surface.

Faults in Negatives and Prints

Fading or tarnishing

Incomplete removal of the unused silver salts by the fixing bath or failure to remove all the fixer may cause fading or tarnishing. Impurities in the mount or the use of an acid mountant may also cause fading. Keeping the prints in an impure atmosphere may cause yellowing or tarnishing.

Fog or degraded whites

A grey veil over the surface of a print may be caused by:

(1) Exposure to light or an unsafe darkroom light before or during printing or developing.

(2) Prolonged development beyond the usual time, or with the developer at too high a temperature.

(3) Using an incorrectly made up developer, or one with insufficient potassium bromide.

(4) Storing the sensitive paper in an unsuitable place.

Mottle or patches

Bad storage of the sensitive paper, or failure to keep the print moving in the developer, fixing or other bath, may cause these defects. In the case of prints on contact papers, patches are usually caused by failure to move the developed prints as soon as they are first placed in the fixing bath, especially if the acid content of the fixer is exhausted.

Spots

White spots, other than those caused by defects on the negative, are the result of air-bells forming on the surface of the print during development. Particles of chemicals, either as dust or solution, particularly of fixer, falling on the surface of the paper may cause black or white spots. Dark spots are usually caused by air-bells during fixing.

Stains

The yellow stains that sometimes make their appearance, may be caused by prolonged development, by too long exposure to the air between development and fixation, by imperfect fixing or by insufficient acid in the fixing bath. A mere trace of fixer in the developer or on the fingers when handling the print before development may cause stains.

Faults in colour materials

Because of the complex nature of colour materials and their processing, faults are less easy to assign to single causes. Nevertheless, some of the more general faults listed in Table 26.1 also apply to colour materials. These include: unsharpness, dense negatives, thin negatives, reticulation,

distortion, streaks, partial reversal, air bells, etc. In colour materials line markings, spots, stains, etc., have a particular colour associated with them and this colour is often indicative of the cause but tends to be associated with a particular material and process. A fault with similar appearance in different materials may have a different cause. Thus it may be misleading to give an exhaustive list of faults in colour materials. The tables below list some of the more common general faults which may occur in colour materials but manufacturers generally provide information on possible faults specific to their particular materials and processes.

Unlike black-and-white processing, colour processing is always carried out for a fixed time at a fixed and accurately maintained temperature. Time-temperature nomographs are not used nor are processing conditions varied from those prescribed unless non-standard results are required. This lack of variation in the processing conditions means that some processing faults are less likely to occur, provided that the processing conditions are accurately complied with. Any faults that do occur can be due only to solution contamination, incorrect preparation or use of solutions, faulty materials, or some other extraneous cause such as fogging, abrasion etc. A number of colour materials appear "milky" when wet. This is often mistaken for incomplete fixation but is quite normal and disappears on drying. This apparent fault occurs in those colour materials that have the colour couplers incorporated in the emulsion in the form of a solution in oil droplets (see page 505) and is due to refractive index differences in the wet emulsion layer. Some colour print materials may appear bluish when wet for similar reasons.

Another apparent fault appears in masked colour negatives. These have what looks like an orange/pink stain or fog which is disturbing to those unused to processing colour negatives. This is also quite normal and is the colour of the integral mask used to correct for dye imperfections (see page 333). A knowledge of how due images are formed and the structure of colour materials is helpful in deciding on the likely causes of faults such as colour casts, fogging or staining. For example a red image on a colour reversal film may be due to the use of a red filter over the camera lens, a violet coloration of a masked colour negative film may be due to the exposure of the film to a greenish safelight and so on.

The following tables list some of the more general faults associated with various colour processes but for the reasons given earlier cannot be taken as being exhaustive.

Appearance	Fault
Too dense all over	
Too dark, highlights cloudy	Under-exposure
Almost opaque, overall or patchy	Bleach and/or fixer omitted, too dilute or too exhausted
Too dark and colour cast present	Inadequate first development
Completely black, no image present but edge markings visible	Film unexposed
As above but edge markings not legible	First and colour developers interchanged

Faults in Negatives and Prints

Appearance	Fault
Somewhat dark and colour cast present	Excessive colour development
Too thin all over	
Image flat and "bleached" but edges of film black	Over-exposure
Too light and colour cast present	Excessive first development
Completely clear, no image	Fully fogged before processing
Too light and pronounced colour cast	Contamination of first developer with colour developer or fixer
	Colour developer contaminated with first developer
Colour casts	
Blue/cyan, edges black	Artificial-light-balanced film exposed to daylight
Yellow/red, edges black	Daylight-balanced film exposed to artificial light
Pronounced cast, edges black	Camera filter used (same colour as cast)
Pronounced cast including edges	Use of incorrect safelight, if green may be due to afterglow from fluorescent lamp in darkroom
Markings and spots	
Light streamers from spaces between sprocket holes with 35 mm film	Excessive and regular agitation in colour developer
Light patches with dark outlines	Drying marks
Dark round spots (may be coloured)	Air bubbles in first developer

Table 26.2 – Faults in colour reversal films

Appearance	Fault
Too dense all over	
Too dark with much shadow detail	Over-exposure
Too dark and contrasty	Over-development
Too dark, no image present	Fogging
Heavy fogging and partial reversal	Exposure to light during development
Opaque or cloudy image	Bleach or fixer omitted
Too thin all over	
Image too light and little shadow detail	Under-exposure
Too light and of low contrast	Under-development
Colour casts and stains	
Orange/pink	Normal
Green	Exposure to red safelight
Patches (may be reddish brown)	Solution contamination
Markings and spots	
Streaks and spots in uniformly light areas	Excessive and regular agitation in developer, or parts of film incompletely bleached and fixed
Light spots same colour as mask	Air bubbles in developer or splashes of fixer on film before development

Table 26.3 – Faults in colour negative films

Appearance	Fault
Too dark all over	
Image too dense	Over-exposure or over-development
Too light all over	
Image too light and lacking contrast	Negative and/or print under-exposed, print under-developed
Colour casts and stains	
Colour cast but borders white	Incorrect filtration (see Table 568)
Colour cast including borders	Exposure to incorrect safelight
"Muddy" appearance, especially of yellows	Bleach-fix bath exhausted (incomplete removal of silver)
Pale clearly defined areas	Prints touching in developer
Whites stained, image of low contrast	Exhausted or stale developer
Whites stained image purple	Contamination of developer by bleach fix
Markings and spots	
Red or blue spots	Iron contamination of wash water
Pale bluish irregular spots	Splashes of water before development
Brown spots or patches	Prints in contact in bleach-fix

Table 26.4 – Faults in colour prints

Appendix

Processing Formulae for Black-and-White Materials

THE formulae given below are grouped under the following headings:

 Developers
 Stop baths and fixers
 Reducers
 Intensifiers
 Toners
 Reversal processing of black-and-white films

Making up solutions

All quantities are given in SI (metric) units; conversions between SI units and avoirdupois (Imperial) units are given on page 594.

Dissolve the chemicals in the order given, using about three-quarters of the total volume of water required. This water should be hot, at about 50°C, and then cold water should be added to make up the full amount. In formulae containing metol add a small amount (a "pinch") of sodium sulphite before adding the metol to inhibit aerial oxidation, then add the bulk of sodium sulphite after the metol has dissolved completely.

All solutions and chemicals should be regarded as potentially hazardous and appropriate precautions taken when preparing solutions. More complete details of precautions to be observed when using the chemicals mentioned can be found in *Hazards in the Chemical Laboratory* by G. D. Muir, published by the Royal Institute of Chemistry.

Substitution of chemicals

In formulae containing sodium sulphite, the quantities given are for sodium sulphite, anhydrous. If sodium sulphite, crystalline is used the quantities given must be doubled.

In formulae containing sodium carbonate, the quantities given are for sodium carbonate, anhydrous. If sodium carbonate, crystalline

(decahydrate) is used the quantities given must be multiplied by two and three-quarters. If sodium carbonate, monohydrate is used the quantities given must be multiplied by one and a quarter.

In formulae containing sodium thiosulphate (hypo), the quantities given are for sodium thiosulphate, crystalline. With sodium thiosulphate, anhydrous, use five eighths of the quantities given.

In most P.Q. formulae, Ilford IBT Restrainer solution is specified. An alternative restrainer may be made by dissolving 10 grammes of benzotriazole in 1 litre of 1 per cent sodium carbonate (anhydrous) solution.

DEVELOPERS

Developer formulae for black-and-white materials have been classified into the following groups:

1. Universal
2. Film developers:
 (a) General purpose
 (b) Fine grain
 (c) Acutance
 (d) High contrast
 (e) Extreme contrast (lithographic)
 (f) Tropical
 (g) Monobath
3. Paper developers

1. Universal developers (for roll film, sheet film, contact and enlarging papers

ID-36 Metol-hydroquinone developer
A universal M.Q. developer for films and papers.

STOCK SOLUTION

Metol	3	g
Sodium sulphite, anhyd.	50	g
Hydroquinone	12·5	g
Sodium carbonate, anhyd.	72	g
Potassium bromide	0·75	g
Water to make	1	litre

WORKING STRENGTH

Films
 Dish: Dilute 1 part with 3 parts water.
 Tank: Dilute 1 part with 7 parts water.

Contact paper
 Dilute 1 part with 1 part water.

Enlarging and rollhead papers
 Dilute 1 part with 3 parts water.

Appendix

ID-62 Phenidone-hydroquinone developer
A universal P.Q. formula for films and papers.

STOCK SOLUTION

Sodium sulphite, anhyd.	50	g
Sodium carbonate, anhyd.	60	g
Hydroquinone	12	g
Phenidone	0·5	g
Potassium bromide	2	g
IBT Restrainer, soln.	20	ml
Water to make	1	litre

WORKING STRENGTH

Films
> Dish: Dilute 1 part stock solution with 3 parts water.
> Time: 1¼–3¾ min. 20°C.
> Tank: Dilute 1 part stock solution with 7 parts water.
> Time: 3–7½ min. 20°C.

Contact papers
> Dilute 1 part stock solution with 1 part water.

Enlarging and rollhead papers
> Dilute 1 part stock solution with 3 parts water.
> Time: 1½–2 min. 20°C.

2. Film developers

(*a*) *General purpose*

ID-67 Phenidone-hydroquinone developer
A general-purpose P.Q. formula for roll films and sheet films.

STOCK SOLUTION

Sodium sulphite, anhyd.	75	g
Sodium carbonate, anhyd.	37·5	g
Hydroquinone	8	g
Phenidone	0·25	g
Potassium bromide	2	g
IBT Restrainer, soln.	15	ml
Water to make	1	litre

WORKING STRENGTH
> Dish: Dilute 1 part stock solution with 2 parts water.
> Time: 1¼–4½ min. 20°C.
> Tank: Dilute 1 part stock solution with 5 parts water.
> Time: 2½–10 min. 20°C.

D-61A Metol-hydroquinone developer
A general-purpose M.Q. formula for roll films and sheet films.

STOCK SOLUTION

Metol	3 g
Sodium sulphite, anhyd.	90 g
Sodium metabisulphite	2 g
Hydroquinone	6 g
Sodium carbonate, anhyd.	11 g
Potassium bromide	2 g
Water to make	1 litre

WORKING STRENGTH
 Dish: Dilute 1 part stock solution with 1 part water.
 Time: 7 min. 20°C.
 Tank: Dilute 1 part stock solution with 3 parts water.
 Time: 14 min. 20°C.

(b) Fine-grain developers

D-76, ID-11 Fine-grain developer
An M.Q. borax developer for films and plates. Gives grain fine enough for all normal requirements without loss of emulsion speed.

STOCK SOLUTION

Metol	2 g
Sodium sulphite, anhyd.	100 g
Hydroquinone	5 g
Borax	2 g
Water to make	1 litre

Use without dilution in dish or tank. Time: 6–10 min 20°C.
May also be used diluted 1 + 1 or 1 + 3, with appropriate increase in developing time, and discarded after use.

Replenisher for D-76, ID-11 developer
A replenisher designed to maintain the activity of ID-11 developer, and thus prolong its life.

STOCK SOLUTION

Metol	3	g
Sodium sulphite, anhyd.	100	g
Hydroquinone	7·5	g
Borax	20	g
Water to make	1	litre

Add to the developer tank as required to maintain the level of the solution. Under normal working conditions, where the tank is in regular use, a total quantity of replenisher equal to that of the original developer may be added before discarding the developing solution.

Appendix

ID-68 Fine-grain developer
A P.Q. borax formula for films and plates. Gives grain fine enough for all normal requirements without loss of emulsion speed.

STOCK SOLUTION

Sodium sulphite, anhyd.	85	g
Hydroquinone	5	g
Borax	7	g
Boric acid	2	g
Potassium bromide	1	g
Phenidone	0·13	g
Water to make	1	litre

Use without dilution in dish or tank. Time: 3–12 min. 20°C.

Replenisher for ID-68 developer
A replenisher formula designed to maintain the activity of ID-68 developer, and thus prolong its life.

STOCK SOLUTION

Sodium sulphite, anhyd.	85	g
Hydroquinone	8	g
Borax	10	g
Phenidone	0·22	g
Water to make	1	litre

Add to the developer tank as required to maintain the level of the solution. Under normal working conditions, where the tank is in regular use, a total quantity of replenisher equal to that of the original developer may be added before discarding the developing solution.

(c) Acutance developers

The following formulae have been designed to give enhanced edge effects (acutance).

Beutler developer

STOCK SOLUTION A

Metol	10 g
Sodium sulphite, anhyd.	50 g
Water to make	1 litre

STOCK SOLUTION B

Sodium carbonate, anhyd.	50 g
Water to make	1 litre

WORKING STRENGTH
1 part A, 1 part B and 8 parts water. Time: 8–15 min. 20°C.
Use once only.

FX-1 High acutance developer
A variant of the Beutler developer for which enhanced adjacency effects, better contrast control and a speed increase of $\frac{1}{2}-1$ stop are claimed.

STOCK CONTROL

Metol	0·5 g
Sodium sulphite, anhyd.	5 g
Sodium carbonate, anhyd.	2·5 g
Potassium iodide (0·001% solution)	5 ml
Water to make	1 litre

WORKING STRENGTH

Use without dilution and discard after use. Time: 12–14 min. 20°C.

(d) High-contrast developers

D-19b, ID-19 developer
A high-contrast developer for X-ray film, aerial film, industrial and scientific photography.

STOCK SOLUTION

Metol	2·2 g
Sodium sulphite, ahyd.	72 g
Hydroquinone	8·8 g
Sodium carbonate, anhyd.	48 g
Potassium bromide	4 g
Water to make	1 litre

WORKING STRENGTH

Use without dilution in dish or tank. Time: 5 min.

Replenisher for D-19b developer

STOCK SOLUTION

Metol	4 g
Sodium sulphite, anhyd.	72 g
Hydroquinone	16 g
Sodium carbonate, anhyd.	48 g
Water to make	1 litre

Add to the developer tank as required to maintain the level of the solution.

(e) Extreme-contrast (lithographic or process) developers

ID-13 Hydroquinone-caustic developer
For the dish development of line films when maximum contrast is required. Also recommended for the development of certain special plates used for scientific purposes, when maximum contrast is required.

579

Appendix

STOCK SOLUTION A

Hydroquinone	25 g
Potassium metabisulphite	25 g
Potassium bromide	25 g
Water to make	1 litre

STOCK SOLUTION B

Potassium hydroxide (caustic potash)	50 g
Water to make	1 litre

WORKING STRENGTH

Dish: Mix equal parts of A and B immediately before use.

AN-79b Lithographic developer

For the development of lithographic materials. A two-solution formulation containing paraformaldehyde as a means of keeping the sulphite concentration low with hydroquinone as the developing agent.

STOCK SOLUTION A

Sodium sulphite, anhyd.	1 g
Paraformaldehyde	30 g
Potassium metabisulphite	10·5 g
Water to make	1 litre

STOCK SOLUTION B

Sodium sulphite, anhyd.	120 g
Boric acid, cryst.	30 g
Hydroquinone	90 g
Potassium bromide	6 g
Water to make	3 litres

WORKING STRENGTH

1 part A and 3 parts B. Time: 2 min.

(f) Tropical developers

For processing at high temperatures, up to about 35°C.

DK-15 Tropical developer

STOCK SOLUTION

Metol	5·7 g
Sodium sulphite, anhyd.	90 g
Borax, cryst.	13·5 g
Sodium hydroxide	2·9 g
Potassium bromide	1·9 g
Sodium sulphate, anhyd.	46·5 g
Water to make	1 litre

WORKING STRENGTH

Use without dilution.

D-76, ID-11 plus sodium sulphate

For temperatures 29–32°C add 100 g of sodium sulphate anhydrous per litre of D-76, ID-11 stock solution. For higher temperatures, 32–35°C also decreases developing time by approximately one third.

(g) *Monobath*

MM-1 Monobath

Sodium sulphite, anhyd.	50 g
Phenidone	4 g
Hydroquinone	12 g
Sodium hydroxide	4 g
Sodium thiosulphate, cryst.	110 g
Glutaraldehyde (25% solution)	8 ml
Water to make	1 litre

After the addition of the Phenidone add a pinch of hydroquinone followed by the sodium hydroxide. The Phenidone will then dissolve completely, the small amount of hydroquinone helps prevent the oxidation of the Phenidone. Then add the remainder of the hydroquinone and the other chemicals in the order given.

Process films for 7 min. at 24°C.

Different films respond differently to processing in the monobath, some give speed and contrast increases. To lower contrast add glacial acetic acid (1–5 ml). If increased contrast is required add sodium hydroxide (2·5 g). For certain films some speed loss may occur (½ to ⅔ stop) but the above formula will process Kodak Verichrome Pan film with similar results to those achieved by conventional processing.

3. Paper developers

ID-20 Metol-hydroquinone

STOCK SOLUTION

Metol	3 g
Sodium sulphite, anhyd.	50 g
Hydroquinone	12 g
Sodium carbonate, anhyd.	60 g
Potassium bromide	4 g
Water to make	1 litre

WORKING STRENGTH

For normal use

Dilute 1 part with 3 parts water.

D-163 Metol-hydroquinone

STOCK SOLUTION

Metol	2·2 g
Sodium sulphite, anhyd.	75 g
Hydroquinone	17 g
Sodium carbonate, anhyd.	65 g
Potassium bromide	2·8 g
Water to make	1 litre

WORKING STRENGTH

Dilute 1 part with 3 parts water. Time: 1½–3 min.

STOP BATH AND FIXERS

IS-1 Acetic acid stop bath
For films and papers.

Acetic acid, glacial	17 ml
Water to make	1 litre

Films and papers should be immersed in the bath for about 5 seconds, and should be kept moving.

Note. This stop bath should be replaced when its pH reaches 5·8. This may be determined by using BDH Narrow Range Indicator Paper 5570.

IF-2 Acid-hypo fixer
A non-hardening acid fixing bath for films, plates and papers.

STOCK SOLUTION

Sodium thiosulphate (hypo), cryst.	200 g
Potassium metabisulphite	12·5 g
Water to make	1 litre

WORKING STRENGTH

Films and plates: Use undiluted. Fix for 10 to 20 minutes.

Papers: Dilute with an equal quantity of water. Fix for 5 to 10 minutes.

Note. For more rapid fixing of films and plates the quantities of hypo and metabisulphite in this formula may be doubled.

F-5 Acid hardener-fixer
For films and papers.

WORKING SOLUTION

Sodium thiosulphate (hypo), cryst.	240 g
Sodium sulphite, anhyd.	15 g
Boric acid, cryst.	7·5 g
Acetic acid, glacial	17 ml
Potassium alum, cryst.	15 g
Water to make	1 litre

Dissolve the hypo in 500 ml of hot water and when this solution is cool add the sulphite. Dissolve the boric acid, acetic acid and alum in 150 ml of hot water, allow to cool to below 21°C and slowly pour into the sulphite-hypo solution. Finally, make up to 1 litre with cold water. To obtain full hardening, films remain in the bath for 5 to 10 minutes.

Rapid fixer for films and papers

Ammonium thiosulphate	175 g
Sodium sulphite, anhyd.	25 g
Acetic acid, glacial	10 ml
Boric acid, cryst.	10 g
Water to make	1 litre

Fixing time 30–90 seconds for films and 30–60 seconds for papers.

REDUCERS

IR-1 Ferricyanide-hypo ("Farmer's") reducer
A subtractive reducer, for clearing shadow areas in negatives, and for brightening highlights of prints.

SOLUTION A

Potassium ferricyanide	100 g
Water to make	1 litre

SOLUTION B

Sodium thiosulphate (hypo), cryst.	200 g
Water to make	1 litre

For use, add to Solution B just sufficient of Solution A to colour the mixture pale yellow (e.g. 10 ml of A per 200 ml of B). This should be used immediately after mixing. The process of reduction should be carefully watched and the negative washed thoroughly as soon as it has been reduced sufficiently. The energy of reduction can be controlled by varying the amount of Solution A in the mixture.

IR-2 Persulphate reducer
A super-proportional reducer, for great reduction of negative contrast.

Ammonium persulphate	25 g
Water to make	1 litre

It is important that the water used for making up this bath should be free of dissolved chlorides; distilled water is recommended. One or two drops of sulphuric acid should be added to induce regularity of action. When reduction has gone nearly but not quite far enough, pour off the reducer and flood the negative with a 5 per cent solution of sodium sulphite. Wash the negative thoroughly before drying.

Note. This reducer is ineffective with some modern high-speed emulsions. If it fails, IR-3 should be tried.

IR-3 Permanganate-persulphate reducer
A proportional reducer for lowering negative contrast.

SOLUTION A

Sulphuric acid, conc.	1·5 ml
Potassium permanganate	0·25 g
Water to make	1 litre

SOLUTION B

Ammonium persulphate	25 g
Water to make	1 litre

Caution. When making up solution A, the acid must be added to the water, drop by drop, and not the water to the acid. Adding water to sulphuric acid is highly dangerous. The permanganate should be added last.

It is important that the water used for both solutions should be free of dissolved chlorides; distilled water is recommended.

For use, mix 1 part of A with 3 parts of B. When reduction has gone far enough, pour off the reducer and flood the negative with a 1 per cent solution of sodium bisulphite to clear it. Wash the negative thoroughly before drying.

IR-4 Iodine reducer
For local or general reduction of prints.

STOCK SOLUTION

Potassium iodide	16 g
Iodine	4 g
Water to make	1 litre

WORKING STRENGTH

For use, dilute 1 part stock solution with 19 parts water. After reduction, rinse and re-fix in a 20 per cent plain hypo bath. Wash the print thoroughly before drying.

INTENSIFIERS

IIn-3 Chromium intensifier
For controlled intensification of negatives. This intensifier is not liable to produce stains.

DICHROMATE STOCK SOLUTION

Potassium dichromate	100 g
Water to make	1 litre

This solution keeps indefinitely.

BLEACHING SOLUTION A

Dichromate stock solution (as above)	100 ml
Hydrochloric acid, conc.	2·5 ml
Water to make	1 litre

BLEACHING SOLUTION B

Dichromate stock solution (as above)	100 ml
Hydrochloric acid, conc.	12·5 ml
Water to make	1 litre

Bleaching Solution A gives more intensification than Solution B. Whichever solution is selected should be freshly mixed. Immerse the washed negative in the bleaching solution selected until it is completely bleached, then wash until the yellow stain is removed and re-develop, by white light, or after exposure to light, in an M.Q. or P.Q. developer containing a low concentration of sulphite, e.g. D-163. Wash the negative thoroughly before drying.

IIn-5 Uranium intensifier
For considerable intensification of negatives.

STOCK SOLUTION A

Uranium nitrate	25 g
Water to make	1 litre

STOCK SOLUTION B

Potassium ferricyanide	25 g
Water to make	1 litre

For use, mix 4 parts A, 4 parts B and 1 part acetic acid, glacial. After immersing negative in intensifier, remove the yellow stain remaining by rinsing in water containing a trace of acetic acid. Wash the negative thoroughly before drying.
If required, the intensification can be removed with a weak solution of sodium carbonate.
Intensification by this process is of limited permanence.

TONERS

Sulphide toner
For sepia tones.

STOCK BLEACH SOLUTION

Potassium ferricyanide	50 g
Potassium bromide	50 g
Water to make	1 litre

Use undiluted.

STOCK SULPHIDE SOLUTION

Sodium sulphide	50 g
Water to make	1 litre

For use, dilute 1 part with 9 parts water.
Prints should be fully developed. After the prints have been fixed and

thoroughly washed, immerse them in the ferricyanide solution until the image is bleached. Then wash them for 10 minutes and place them in the sulphide solution, in which they will acquire a rich sepia colour. After darkening, wash prints for half-an-hour. Warmer tones can be produced by reducing the potassium bromide in the stock ferricyanide solution to one-quarter of the figure given. Colder tones can be obtained by immersing the washed black-and-white prints for 5 minutes in the sulphide bath *before* bleaching. Prints are then washed, bleached and darkened in the usual way.

Alternatively the following odourless solution of thiourea can be used in place of the sulphide solution:

THIOUREA SOLUTION

Thiourea	2 g
Sodium carbonate, anhyd.	100 g
Water to make	1 litre

IT-2 Hypo-alum toner
For purplish-sepia tones.

Sodium thiosulphate (hypo), cryst.	150 g
Potassium alum, cryst.	25 g
Water to make	1 litre

First dissolve the hypo in hot water, then add the alum a little at a time.

Until ripened, the bath has a reducing action; ripening is best done by immersing some waste prints or by adding to every 1 litre of the bath 0·14 gram of silver nitrate dissolved in a little water to which is added just sufficient strong ammonia drop by drop, to re-dissolve the precipitate formed. This bath lasts for years and improves on keeping; it should be kept up to bulk by adding freshly-made solution. The prints (which should be developed a little further than for black-and-white) are toned at about 50°C for about 10 minutes. At lower temperatures toning is unduly prolonged; higher temperatures give colder tones. Finally, wash the prints thoroughly and swab with a tuft of cotton wool. This process is suitable for bulk work. For warmer tones, add 1 gram of potassium iodide to every 1 litre of the toning bath.

IT-6 Ferricyanide-iron toner
For blue tones.

STOCK FERRICYANIDE SOLUTION

Potassium ferricyanide	2 g
Sulphuric acid, conc.	4 ml
Water to make	1 litre

First add the acid to the water, slowly; then dissolve the ferricyanide in the diluted acid.

STOCK IRON SOLUTION

Ferric ammonium citrate	2 g
Sulphuric acid, conc.	4 ml
Water to make	1 litre

First add the acid to the water, slowly; then dissolve the ferric ammonium citrate in the diluted acid. For use, mix equal parts of the two solutions just before using.

Caution. When making up both solutions the acid must be added to the water, drop by drop, and not the water to the acid. Adding water to sulphuric acid is highly dangerous.

The prints, which should be a little lighter than they are required to be when finished, must be thoroughly washed before toning. They should be immersed until the desired tone is obtained and then washed until the yellow stain disappears from the whites. Bleaching of the blue image, which may occur on washing, may be prevented by washing in very slightly acid water.

Copper toner
For red tones.

STOCK COPPER SOLUTION

Copper sulphate	25 g
Potassium citrate	110 g
Water to make	1 litre

STOCK FERRICYANIDE SOLUTION

Potassium ferricyanide	20 g
Potassium citrate	110 g
Water to make	1 litre

For use mix equal volumes of the above solutions.

REVERSAL PROCESSING OF BLACK-AND-WHITE FILMS

Reversal processing procedures and formulae for Kodak and Ilford black-and-white negative films are given below.

Procedure and formulae for Kodak films (e.g. Panatomic-X, rated at 80 ASA)

1. Develop in D-19 developer (page 579) containing 2 g/litre of potassium thiocyanate for 6 minutes at 20°C.
2. Wash for 5 minutes.
3. Bleach in formula R-21A for 3–5 minutes.
4. Wash for 5 minutes.
5. Clear in formula R-21B for 2 minutes.
6. Rinse for ½ minute.
7. Expose for 2½ minutes to artificial white light.

8. Develop in D-19 developer (page 579) for 4 minutes at 20°C.
9. Rinse.
10. Fix in an acid-hardening fixer (page 389).
11. Wash for 15–20 minutes.
12. Dry.

Bleach R-21A

Potassium dichromate	50 g
Water to make	1 litre
Sulphuric acid, conc.	50 ml

Caution. Dissolve the dichromate in the water then add the concentrated sulphuric acid slowly with stirring to the *cold* solution.

Clearing solution R-21B

Sodium sulphite, anhyd.	50 g
Sodium hydroxide	1 g
Water to make	1 litre

Procedure and formulae for Ilford films (e.g. FP 4)

1. Develop in ID-36 developer (page 575) diluted 1 + 1 to which 12 g/litre of sodium thiosulphate crystals have been added, for 12 minutes at 20°C.
2. Wash for 3 minutes.
3. Bleach for 3–5 minutes.
4. Wash for 2–5 minutes.
5. Clear for 2 minutes.
6. Wash for 2 minutes.
7. Expose for 1–2 minutes to artificial white light.
8. Develop in the same developer as in 1 above for 6 minutes at 20°C.
9. Rinse.
10. Fix in an acid-hardening fixer (page 389).
11. Wash for 15–30 minutes.
12. Dry.

Bleach

Potassium permanganate	4 g
Water to make	1 litre
Sulphuric acid, conc.	20 ml

Caution. Add the sulphuric acid slowly with stirring to the cold solution.

Clearing solution

Sodium metabisulphite	25 g
Water to make	1 litre

PROCESSING FORMULAE FOR COLOUR MATERIALS

In black-and-white processing there are many universal processing formulae that can be used for processing almost any type of film and most manufacturers of photographic materials have published suitable formulae, some of which were given in the preceding section. In colour processing the situation is somewhat different. Manufacturers of colour photographic materials do not usually publish processing formulae but only market the appropriate pre-packed processing chemicals. Alternatively some independent companies also offer pre-packed chemicals for processing colour films and papers of various manufacturers.

Also colour materials from different manufacturers are so different in their characteristics that universal formulae can only be used to a very limited extent.

However "substitute" formulae for various types of colour materials are published. It should be borne in mind that substitute formulae may give results that are different from those obtained when the material is processed in the manufacturer's pre-packed chemicals and different batches of the same material may respond differently in substitute processing formulae. Accordingly substitute formulae should be treated with caution and some experimentation may be required in order to achieve satisfactory results, although there are many users of substitute formulae who achieve acceptable results.

Some representative examples of substitute formulae devised by Ernst Ch. Gheret are given below but more exhaustive substitute formulae are published in the *British Journal of Photography Annual* and in *Developing* (see Bibliography, page 606).

Colour developers and especially colour developing agents should not be allowed to come into contact with the skin. When preparing and using colour processing chemicals and solutions it is advisable to wear rubber gloves.

Procedure and substitute formulae for the C-41 Process

This process is claimed to be suitable for processing Kodacolor II, Vericolor II, Fujicolor II, GAF Color Print, 3M Color Print, Sakuracolor II, and Turacolor II colour negative films.

1. Colour develop		3 min 15 s at 37·8 \pm 0·15°C.
2. Stop		30 s at 38 \pm 3°C.
3. Rinse		30 s at 38 \pm 3°C.
4. Bleach-fix		4 min at 38 \pm 3°C.
5. Wash		3 min 15 s at 38 \pm 3°C.
6. Stabilise		1 min 5 s at 38 \pm 3°C.
7. Dry		below 43°C.

Notes

1. Agitation and temperature control for colour development are critical

and the following procedure is recommended when developing films in spiral developing tanks. First prepare a water bath at 41°C to act as thermal reservoir. Warm the colour developer to 38°C, pour into the developing tank and agitate continuously for the first 20 seconds. Place the developing tank in the water bath to approximately 2 cm below the lid then remove the tank and agitate by inversion for 5 seconds and replace it in the water bath. Repeat this cycle 6 times each minute until 10 seconds before the end of development. Finally drain the tank for 10 seconds.

2. Agitate continuously when the tank is filled with the stop bath.

Colour developer

Calgon	2 g
Sodium sulphite, anhyd.	2 g
Sodium bicarbonate	8 g
Potassium bromide	1·8 g
Sodium carbonate, anhyd.	30 g
Hydroxylamine sulphate	3 g
6-Nitrobenzimidazole nitrate,* 0·3% solution	10 ml
CD-4	3·2 g
Water to make	1 litre
pH	10·1–10·2
Shelf-life	1 month
Capacity (number of 135/36 exp. films)	5

Stop bath

Glacial acetic acid	10 ml
Water to make	1 litre

Bleach-fix

EDTA NaFe (Merck)	40 g
EDTA acid	4 g
Potassium iodide	1 g
Ammonia, 20% solution	10 ml
Ammonium thiosulphate, cryst.	100 g
Sodium sulphite, anhyd.	2 g
Sodium thiocyanate, 20% solution	50 ml
Water to make	1 litre
pH (adjust by addition of ammonia or acetic acid)	5·8–6·2

Stabiliser

Wetting agent, 10% solution	10 ml
Formaldehyde, 35–37% solution	6 ml
Water to make	1 litre

* Prepared by the addition of 1·5 g 6-nitrobenzimidazole to 500 ml of water acidified by the addition of 0·4 ml of nitric acid.

Procedure and substitute formulae for the Ektaprint 2 process

This is claimed to be suitable for the following colour papers: Ektacolor 78RC, Fujicolor RC, Sakuracolor RC Type QII and 3M Color paper RC.

The table below gives processing times for three temperatures when using a drum processor.

	31 ± 0·3°C	33 ± 0·3°C	38 ± 0·3°C
1. Pre-soak	45 s	45 s	45 s
2. Colour develop	3 min 30 s	3 min	2 min
3. Rinse	45 s	45 s	30 s
4. Bleach-fix	1 min 45 s	1 min 30 s	1 min
5. Wash	2 min	1 min 30 s	1 min
6. Stabilise (optional)	1 min	45 s	30 s
7. Dry		below 107°C	

Notes

1. Agitation should be carried out at the rate of approximately 20–30 cycles per minute according to the drum used.
2. Means of obtaining the correct temperature are usually provided with the drum in the form of a nomogram which takes into account the ambient temperature and a different pre-soak temperature may be required from that given above.
3. For washing in the drum 4 changes of water may be considered equivalent to 1 minute wash.

Colour developer

Calgon	2	g
Hydroxylamine sulphate	2	g
Sodium sulphite, anhyd.	2	g
Potassium carbonate, anhyd.	30	g
Potassium bromide	0·4	g
Benzyl alcohol/ethylene glycol, 1/1 solution	30	ml
6-Nitrobenzimidazole nitrate, 3% solution	7	ml
CD-3	4·4	g
Water to make	1	litre
pH	10·1–10·2	

Bleach-fix

Same formula as that given for the C-41 substitute process but the pH is adjusted to 6·2–6·5.

Stabiliser

Sodium carbonate, anhyd.	2·5 g	
Acetic acid, glacial	12·5 ml	
Citric acid, cryst.	7	g
Water to make	1	litre
pH	3·6 ± 0·1	

Appendix

Procedure and substitute formulae for Agfa colour reversal films (process P-41)

This process is claimed to be appropriate for processing Agfachrome 50S and 50L, Agfacolor CT 18 CT 21 and CK 20 colour reversal films.

1.	Black-and-white develop	13–14 min at 24 ± 0·25°C.
2.	Rinse	30 s at 20–24°C.
3.	Stop	3 min at 22–24°C.
4.	Wash	7 min at 20–24°C.
5.	Re-expose	500 w at 1 metre for 1 min each side.
6.	Colour develop	11 min at 24 ± 0·25°C.
7.	Wash	14 min at 20–24°C.
8.	Bleach	4 min at 22–24°C.
9.	Wash	4 min at 20–24°C.
10.	Fix	4 min at 22–24°C.
11.	Wash	7 min at 20–24°C.
12.	Stabilise	1 min at 20–24°C.
13.	Dry.	

Note

The recommended agitation is 30 seconds continuous agitation initially, followed by two 5 second agitations every minute.

Black-and-white developer

Calgon	2	g
Metol	3	g
Sodium sulphite, anhyd.	40	g
Hydroquinone	6	g
Sodium carbonate, anhyd.	5	g
Sodium thiocyanate	1·8	g
Potassium bromide	2	g
Potassium iodide, 0·1% solution	6	ml
6-Nitrobenzimidazole nitrate, 0·2% solution	20	ml
Water to make	1	litre
pH	10·2±0·1	

Stop bath

Acetic acid, glacial	10 ml
Sodium acetate, cryst.	40 g
Water to make	1 litre

Colour developer

Calgon	2	g
Sodium sulphite, anhyd.	2	g
Potassium carbonate, anhyd.	80	g
Hydroxylamine sulphate	2	g

Ethylenediamine	8	g
Potassium bromide	2	g
Droxychrome (May & Baker)	6·5	g
Water to make	1	litre
pH	11·7±0·1	

Bleach

Potassium ferricyanide	80	g
Potassium bromide	20	g
Disodium hydrogen orthophosphate, cryst.	26·7	g
Sodium hydrogen sulphate	12	g
Water to make	1	litre
pH	5·2±0·2	

Fix

Sodium thiosulphate, cryst.	200 g
Sodium sulphite, ahyd.	10 g
Water to make	1 litre
pH	6·5±0·5

Stabiliser
See formula page 403.

DYE REDUCERS (BLEACHES)

A number of formulae are available for carrying out either overall reduction or selective reduction of cyan, magenta or yellow dyes in colour materials. These formulae are published by the film or paper manufacturer and are usually only applicable to one particular type of material. Two examples of dye reducers for overall reduction are given below.

Dye bleach for Agfachrome 50S and 50L colour transparencies

For overall reduction of Agfachrome films without colour change. A reduction in density of up to one stop may be achieved by immersion in the solution or local reduction in density may be carried out by partial brush retouching.

STOCK SOLUTION

Water	1	litre
Hydrochloric acid, conc.	1·7	ml
Chel DPTA (Ciba-Geigy)	17·5	g
Stannous chloride, Analar	9	g
Perchloric acid, 70%*	36	ml
Formaldehyde, 30%	7	ml

* Caution, oxidising agent, corrosive.

Appendix

After the careful addition of the concentrated hydrochloric acid to the water followed by the Chel DPTA add the stannous chloride with vigorous stirring then filter the cloudy solution. Add the remaining chemicals to the filtrate.

WORKING STRENGTH

Dilute 1 + 1 to 1 + 4 as required. Times of treatment vary from 1 to 5 minutes for these dilutions. Wash in running water for 10 minutes after dye reduction.

The extent of dye reduction cannot be judged visually because of an intense red colouration. If reduction is found to be insufficient the process can be repeated. If reduction is carried out for too long a red cast is obtained which can be removed by treatment in a 2% borax solution. The reducer is super-proportional in its action.

R-19 Non-selective dye bleach (Kodak)

SOLUTION A

Potassium permanganate	60 g
Water to make	1 litre

SOLUTION B

Sulphuric acid concentrated in water, 100 ml dissolved carefully in 800 ml of water and then made up to 1 litre.

When preparing solution A dissolve the permanganate in approximately 800 ml of water at 50°C then make up to 1 litre.

WORKING STRENGTH
5 parts A and 1 part B.

After reduction remove the brown stain with a 5% solution of sodium metabisulphite.

CONVERSION OF UNITS

Mass

British (Imperial) Units to SI Units
1 oz = 28·35 g
1 lb = 0·4536 kg (453·6 g)

SI Units to British (Imperial) Units
1 g = 0·0353 oz
1 kg = 2·2025 lb

Length

British (Imperial) Units to SI Units
1 yd = 0·9144 m
1 ft = 0·3048 m
1 in = 25·4 mm

SI Units to British (Imperial) Units
$$1 \text{ m} = 1.094 \text{ yd} (3.218 \text{ ft})$$
$$1 \text{ mm} = 0.039 \text{ in}$$

Area

British (Imperial) Units to SI Units
$$1 \text{ in}^2 = 645.16 \text{ mm}^2$$
$$1 \text{ ft}^2 = 0.0929 \text{ m}^2$$
$$1 \text{ yd}^2 = 0.8361 \text{ m}^2$$

SI Units to British (Imperial) Units
$$1 \text{ m}^2 = 1.196 \text{ yd}^2 (10.764 \text{ ft}^2)$$

Volume

British (Imperial) and American Units to SI Units
$$1 \text{ UK fl oz} = 28.41 \text{ cm}^3$$
$$1 \text{ US fl oz} = 29.57 \text{ cm}^3$$
$$1 \text{ UK pint} = 0.568 \text{ l}$$
$$1 \text{ US pint} = 0.473 \text{ l}$$
$$1 \text{ UK gal} = 4.546 \text{ l}$$
$$1 \text{ US gal} = 3.785 \text{ l}$$

SI Units to British (Imperial) and American Units
$$1 \text{ cm}^3 = 0.035 \text{ UK fl oz}$$
$$= 0.034 \text{ US fl oz}$$
$$1 \text{ l} = 0.220 \text{ UK gal}$$
$$= 0.264 \text{ US gal}$$

Velocity

British (Imperial) Units to SI Units
$$1 \text{ ft/s} = 0.3048 \text{ m/s}$$
$$1 \text{ mile/h} = 0.44704 \text{ m/s}$$

SI Units to British (Imperial) Units
$$1 \text{ m/s} = 3.281 \text{ ft/s}$$
$$1 \text{ km/h} = 0.621 \text{ mile/h}$$

LOGARITHMS

When a number is multiplied by itself, the result is called the square, or second power of the number. Thus, 4 is called the square of 2, since $2 \times 2 = 4$. The square of 2 is usually written 2^2, the small figure 2 – called an index – indicating how many factors, each equal to the given number, are to be multiplied together. Thus:

$$2^3 = 2 \times 2 \times 2 = 8$$
$$2^4 = 2 \times 2 \times 2 \times 2 = 16$$
$$2^5 = 2 \times 2 \times 2 \times 2 \times 2 = 32 \quad \text{etc.}$$

8 is called the third power of 2, 16 the fourth power, 32 the fifth power etc.

If we add the indices of two powers of the same number we obtain the index of their product. In this way, we can perform multiplication by the usually simpler method of addition. Thus:

$$2^2 \times 2^3 = 2^{2+3} = 2^5$$

Similarly, we can divide any power of a number by another power of the same number by subtracting the index of the latter power from the index of the former. Thus:

$$\frac{2^5}{2^3} = 2^{5-3} = 2^2$$

In these examples we have used only powers of 2, but powers of other numbers can be used to perform multiplication and division in the same way. Thus:

$$5^3 \times 5^2 = 5^{3+2} = 5^5$$

$$\text{and} \quad \frac{10^4}{10^2} = 10^{4-2} = 10^2$$

When indices of powers of 10 are used, as in the last example, they are called *common logarithms*. Every number can be expressed as some power of 10, and tables giving the common logarithms of all numbers have been prepared and their use saves much time in multiplication and division. Common logarithms – usually contracted simply to logarithms – are sometimes distinguished by the prefix "log¹ ".

The logarithms of most numbers are not whole numbers, but fractions. Thus, the logarithm of 2 is 0·3010. It may not be easy to understand the meaning of this (i.e. that $2 = 10^{0.3010}$), but there need be no difficulty in appreciating that fractional indices can be used to perform multiplication and division in the same way as integral ones. Thus:

$$2 \times 2 = 10^{0.3010+} \quad = 10^{0.6020}$$

and 0·6020 is the logarithm of 4. (For certain photographic purposes it is convenient to remember that the logarithm of 2 is almost exactly 0·3).

This example, while illustrating the fact that fractional indices may be added to perform multiplication, does not well illustrate the convenience afforded by logarithms; in this instance they appear, in fact, to complicate the multiplication rather than to simplify it. When, however, we come to a problem such as multiplying 2·863 by 1·586, the value of logarithms is readily apparent. For:

$$\begin{aligned}
\log 2\cdot863 &= 0\cdot4569 \quad \text{(from table of} \\
\log 1\cdot586 &= \underline{0\cdot2004} \quad \text{logarithms)} \\
\text{Sum} &= \overline{0\cdot6573}
\end{aligned}$$

and the number whose logarithm is 0·6573 is 4·542, which is the result required.

Tables of logarithms and detailed instructions for their use will be found in a number of textbooks and mathematical tables, as, for instance, *Logarithmic and Other Tables for Schools*, by Frank Castle (Macmillan). A table of two-figure logarithms is given on the next page.

Logarithmic scales

In photographic sensitometry, a logarithmic (log) exposure scale is almost invariably used, for reasons explained in Chapter 15. The relation between an arithmetical and a logarithmic exposure scale is illustrated by the figure below, where the increased space given to low values of exposure by the logarithmic scale will be noted.

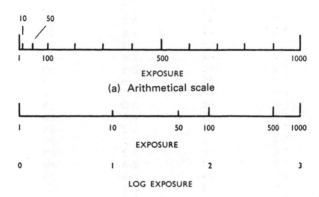

(a) Arithmetical scale

(b) Logarithmic scale covering same range

Appendix

Two-figure logarithms

The following table of logarithms has proved useful in practical problems involving exposure and density. The table is confined to two-figure logarithms, as these give sufficient accuracy for most photographic purposes.

Logarithm	Number	Logarithm	Number	Logarithm	Number
·00	1·0	·35	2·2	·70	5·0
·01	1·0	·36	2·3	·71	5·1
·02	1·0	·37	2·3	·72	5·2
·03	1·1	·38	2·4	·73	5·4
·04	1·1	·39	2·5	·74	5·5
·05	1·1	·40	2·5	·75	5·6
·06	1·1	·41	2·6	·76	5·8
·07	1·2	·42	2·6	·77	5·9
·08	1·2	·43	2·7	·78	6·0
·09	1·2	·44	2·8	·79	6·2
·10	1·3	·45	2·8	·80	6·3
·11	1·3	·46	2·9	·81	6·5
·12	1·3	·47	3·0	·82	6·6
·13	1·3	·48	3·0	·83	6·8
·14	1·4	·49	3·1	·84	6·9
·15	1·4	·50	3·2	·85	7·1
·16	1·4	·51	3·2	·86	7·2
·17	1·5	·52	3·3	·87	7·4
·18	1·5	·53	3·4	·88	7·6
·19	1·5	·54	3·5	·89	7·8
·20	1·6	·55	3·5	·90	7·9
·21	1·6	·56	3·6	·91	8·1
·22	1·7	·57	3·7	·92	8·3
·23	1·7	·58	3·8	·93	8·5
·24	1·7	·59	3·9	·94	8·7
·25	1·8	·60	4·0	·95	8·9
·26	1·8	·61	4·1	·96	9·1
·27	1·9	·62	4·2	·97	9·3
·28	1·9	·63	4·3	·98	9·6
·29	2·0	·64	4·4	·99	9·8
·30	2·0	·65	4·5	1·00	10·0
·31	2·0	·66	4·6	2·00	100·0
·32	2·1	·67	4·7	3·00	1000·0
·33	2·1	·68	4·8		
·34	2·2	·69	4·9		

TRIGONOMETRICAL RATIOS

Sine, cosine, tangent etc.

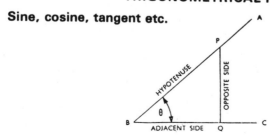

ABC contains an acute angle θ. From a point P on AB, a line PQ is drawn perpendicular to BC. Then, the ratios PQ/BP, BQ/BP and PQ/BQ are called respectively the *sine, cosine* and *tangent* of the angle θ. These terms are usually abbreviated to *sin, cos* and *tan*. Thus:

$$\sin \theta = \frac{PQ}{BP} = \frac{\text{opposite side}}{\text{hypotenuse}}$$

$$\cos \theta = \frac{BQ}{BP} = \frac{\text{adjacent side}}{\text{hypotenuse}}$$

$$\tan \theta = \frac{PQ}{BQ} = \frac{\text{opposite side}}{\text{adjacent side}}$$

Three other less widely used ratios are the *cosecant (cosec), secant (sec)* and *cotangent (cot)* of an angle, where:

$$\operatorname{cosec} \theta = \frac{1}{\sin \theta} = \frac{BP}{PQ} = \frac{\text{hypotenuse}}{\text{opposite side}}$$

$$\sec \theta = \frac{1}{\cos \theta} = \frac{BP}{BQ} = \frac{\text{hypotenuse}}{\text{adjacent side}}$$

$$\cot \theta = \frac{1}{\tan \theta} = \frac{BQ}{PQ} = \frac{\text{adjacent side}}{\text{opposite side}}$$

The values of the trigonometrical ratios (sine, cosine, tangent, cosecant, secant and cotangent) of angles from 0 to 90° are published in mathematical tables, as, for instance, *Logarithmic and Other Tables for Schools*, by Frank Castle (Macmillan).

Radians

If an arc equal in length to the radius be measured along the circumference of a circle (see figure), the angle subtended at the centre by the arc is said to be a *radian*. This angle, which is equal to about 57° 18', is another unit used in trigonometry.

599

THE pH SCALE

Every aqueous solution contains hydrogen and hydroxyl ions (charged atoms or groups of atoms). In a neutral solution, such as pure water, the two types of ions are present in equal concentrations of 10^{-7} g ions per litre. In an acid solution there is an excess of hydrogen ions over hydroxyl ions, and in an alkaline solution an excess of hydroxyl ions over hydrogen ions, but the product of the two concentrations remains at 10^{-14}, as in pure water.

The degree of acidity or alkalinity of a solution is related to the relative concentrations of the two ions, and for this purpose the *pH scale* is used, where:

$$pH = log_{10} \left(\frac{1}{\text{hydrogen ion concentration}} \right)$$

On this scale, pure water — a neutral solution — has a pH of 7. An acid solution has a pH below 7, and an alkaline solution a pH above 7. The greater the amount by which the pH of a solution differs from 7, the greater is its acidity or alkalinity. The limits of the scale are 0 and 14. It will be appreciated that, since the pH scale is logarithmic, quite small changes in pH may indicate significant changes in the activity of a solution.

pH can be determined precisely only by electronic means, using an instrument known as a *pH meter.* For many photographic purposes, however, the pH of a solution may be determined with sufficient accuracy by means of *indicator papers* — strips of paper impregnated with substances which change colour according to the degree of acidity or alkalinity of the solution. There are papers suited to most parts of the pH scale.

SOME OUTSTANDING DATES AND NAMES
IN THE EARLY HISTORY OF PHOTOGRAPHY

1725 J. H. Schulze
Established light sensitivity of silver nitrate. Produced images by allowing sun's rays to fall on flask containing a mixture of chalk, silver and nitric acid, around which stencils of opaque paper were pasted.

1777 C. W. Scheele
Noted that blue and violet light is much more active in darkening silver chloride than red or orange.

1802 T. Wedgwood and (Sir) H. Davy
Printing of silhouettes by contact on paper or leather sensitised with silver nitrate. No fixation. First light-sensitive surface attached to a support. Material found to be too slow to record images produced in camera obscura.

1812 W. H. Wollaston
Meniscus lens ("landscape lens") for camera obscura. (The camera obscura using a pinhole was known at least as early as the eleventh century; with convex lens as early as the sixteenth century.)

1819 (Sir) J. F. W. Herschel
Discovery of thiosulphates (hypo) and their property of dissolving silver halides.

1816 J. N. Niépce
Obtained negative record of camera obscura image on paper sensitised with silver chloride. Partial fixation with nitric acid. Unable to print through negative to obtain a positive.

1822 J. N. Niépce
Permanent copy of engraving by contact printing on to a glass plate sensitised with bitumen of Judæa. The bitumen, normally soluble in lavender oil, became insoluble in this oil on exposure to light. In the following years, Niépce used zinc and pewter plates which, after the image had been perpetuated, were etched in weak acid to form printing plates. Process named "heliography".

1826 J. N. Niépce
First permanent photographs from nature. Bitumen process on pewter plate, giving a direct positive picture.

1828 C. and V. Chevalier
Achromatised landscape lens for use on camera obscura.

1829 L. J. M. Daguerre and J. N. Niépce
Joined articles of partnership. (J. N. Niépce died in 1833; his son Isidore Niépce then took his place as Daguerre's partner.)

1835 W. H. Fox Talbot
Photogenic drawings. Negative prints on print-out paper sensitised with

common salt and silver nitrate, forming silver chloride. Fixation with potassium iodide or by prolonged washing in salt water. Print-out exposure by contact or in the camera obscura. Right-reading positives obtained by contact printing from the negatives.

1837 L. J. M. Daguerre
First successful Daguerrotype. Employed silvered copper plate sensitised with iodine vapour, which formed layer of silver iodide. Development of the latent image by mercury vapour. Fixation with common salt. Image laterally reversed.

1837 J. B. Reade
Photomicrographs with solar microscope. Paper sensitised with solutions of common salt and silver nitrate, producing silver chloride. This was washed over with gallic acid immediately before and during the exposure. Fixation with hypo. (Reade did not realise that he was developing a latent image.)

1839 F. D. Arago
Announced Daguerre's discovery to the Academy of Science, Paris, 7th January.

1839 M. Faraday
Showed Fox Talbot's photogenic drawings and gave the first public description of the process at a meeting of the Royal Institution, London, 25th January.

1839 W. H. Fox Talbot
Disclosed working details of photogenic drawings to the Royal Society, London, 21st February.

1839 F. D. Arago
Made public, on the instructions of the French Government, the working details of the Daguerrotype process, at a joint meeting of Academies of Science and Fine Arts, Paris, 19th August.

1839 (Sir) J. F. W. Herschel
Use of the words "photography", "negative" and "positive". Suggested to Fox Talbot the use of hypo as fixing agent.

1840 J. Petzval
Designed first lens of sufficiently high aperture for portraiture. First lens to be mathematically computed. Manufactured by Voigtländer.

1840 J. W. Goddard
Increased the speed of Daguerrotype plates by fuming the iodized plate with bromine.

1840 H. L. Fizeau
Tones of Daguerrotype images softened and enriched by gold toning.

1840 W. H. Fox Talbot
Discovery of the possibility of the development of the latent image by gallic acid.

1841 W. H. Fox Talbot
Calotype process (later named Talbotype process). Negative prints on silver iodide paper bathed in silver nitrate and gallic acid. Development of the latent image by bathing in the same solution. Fixation with potassium bromide; later with hypo. Positives obtained by contact printing from the negatives on to silver chloride paper.

1847 C. F. A. Niépce de Saint Victor
Negatives on glass. Albumen process. Printed more rapidly than paper negatives and gave clearer prints.

1850 L. D. Blanquart-Evrard
Albumen paper for printing of positives from negatives. Recorded more detail than Fox Talbot's salted paper and became almost universal method of print-making for remainder of century.

1851 F. Scott Archer
Wet collodion process. Glass coated with collodion in which potassium iodide was dissolved, dipped in silver nitrate solution and exposed while wet. Development of latent image with pyrogallic acid or ferrous sulphate. Fixation with hypo or potassium cyanide.

1861 J. Clerk Maxwell
Demonstrated three-colour separation and additive synthesis.

1864 (Sir) J. W. Swan
Introduced carbon tissue commercially and thus first made carbon printing really practicable.

1866 J. H. Dallmeyer and H. A. Steinheil
Introduced, independently, the rapid rectilinear lens.

1868 L. Ducos du Hauron
Proposed various methods of three-colour photography, including subtractive colour synthesis.

1871 R. L. Maddox
Gelatin dry plates. At first, positive-type plates for physical development only.

1873 H. W. Vogel
Discovery of colour sensitisation by dyes.

1880 (Sir) W. de W. Abney
First use of hydroquinone as a developer.

1882 J. Clayton and P. A. Attout
First gelatin colour-sensitive plates (isochromatic).

1883 Howard E. Farmer
"Farmer's" reducer (ferricyanide-hypo).

1887 H. Goodwin
Applied for patent (granted in 1898) for the manufacture of sensitive material on a celluloid base.

1888 G. Eastman
First roll film camera. Employed paper with an emulsion which could be stripped after processing, for printing purposes.

1890 P. Rudolph and E. Abbe
Anastigmatic lenses. Manufactured by Zeiss.

1890 F. Hurter and V. C. Driffield
Scientific study of the behaviour of photographic materials (sensitometry).

1891 A. Bogisch
First use of metol as a developer (introduced by Hauff).

1893 H. D. Taylor
Cooke triplet – an anastigmatic lens with only three elements. Manufactured by Taylor, Taylor and Hobson.

1893 L. Baekeland
Unwashed paper emulsions ("gaslight" paper).

BIBLIOGRAPHY

General photographic theory and practice

Attridge, G. G. and Walls, H. J., *Basic Photo Science,* Focal Press, London (1977).

Arnold, C. R., Rolls, P. J. and Stewart, C. J., *Applied Photography*, Focal Press, London (1971).

Baines, H., *The Science of Photography*, Fountain Press, London (1967).

James, T. H. and Higgins, G. C., *Fundamentals of Photographic Theory*, Morgan and Morgan, New York (1968).

Kowaliski, P., *Applied Photographic Theory*, Wiley, New York (1972).

Langford, M. J., *Advanced Photography*, Focal Press, London, 3rd edition (1974).

Langford, M. J., *Professional Photography*, Focal Press, London (1975).

Mees, C. E. K. and James, T. H. (editors), *The Theory of the Photographic Process*, Macmillan, New York, 3rd edition (1966).

Spencer, D. A. (editor), *L. P. Clerc's Photography: Theory and Practice*, Focal Press, London (1973).

Sturge, J. M. (editor), *Neblette's Handbook of Photography and Reprography Materials and Processes*, Van Nostrand, New York, 7th edition (1977).

Thomas, W. (editor), *SPSE Handbook of Photographic Science and Engineering*, Wiley-Interscience, New York (1973).

Light, optics

Brandt, H. M., *The Photographic Lens*, Focal Press, London (1968).

Cox, A., *Photographic Optics*, Focal Press, London, 15th edition (1974).

Edgerton, H. E., *Electronic flash, Strobe*, McGraw Hill, New York (1970).

Fowles, G. R., *Introduction to Modern Optics*, Holt, London (1968).

Kingslake, R., *Lenses in Photography*, A. S. Barnes, New York (1963).

Levi, L., *Applied Optics: A Guide to Modern Optical System Design*, Wiley, New York (1968).

Neblette, C. B. and Murray, A. E., *Photographic Lenses*, Morgan and Morgan, New York (1973).

Ray, S., *The Lens in Action*, Focal Press, London (1976).

Stimson, A., *Photometry and Radiometry for Engineers*, Wiley-Interscience, New York (1974).

Williams, C. S. and Becklund, O. A., *Optics: A Short Course for Engineers and Scientists*, Wiley, New York (1973).

Exposure, sensitometry, image evaluation

Berg, W. F., *Exposure*, Focal Press, London, 4th edition (1971).

Brock, G. C., *Image Evaluation for Aerial Photography*, Focal Press, London (1970).

Dainty, J. C. and Shaw, R., *Image Science*, Academic Press, London (1974).

Bibliography

Dunn, J. F. and Wakefield, G., *Exposure Manual*, Fountain Press, London (1974).

Lobel, L. and Dubois, M., *Basic Sensitometry*, Focal Press, London (1967).

Todd, H. N., *Photographic Sensitometry, A Self-teaching text*, Wiley-Interscience, New York (1976).

Todd, H. N. and Zakia, R. D., *Photographic Sensitometry*, Morgan and Morgan, New York, 2nd edition (1974).

Colour theory and practice

Coote, J. H., *Colour Prints*, Focal Press, London, 5th edition (1974).

Evans, R. M., *Eye Film and Camera in Colour Photography*, Wiley, New York (1960).

Evans, R. M., Hanson, W. T. and Brewer, W. L., *Principles of Colour Photography*, Wiley, New York (1953).

Eynard, A. E. (editor), *Colour: Theory and Imaging Systems*, SPSE, Washington, D.C. (1973).

Hunt, R. W. G., *The Reproduction of Colour*, Fountain Press, London, 3rd edition (1975).

Kodak, *Printing Colour Negatives*, Kodak Publication E-66 (1975).

Spencer, D. A., *Colour Photography in Practice*, Focal Press, London, revised 3rd edition (1975).

Photographic processing and printing

Coote, J. H., *Photofinishing Techniques and Equipment*, Focal Press, London (1971).

Crawley, G. (editor), *British Journal of Photography Annual, Processing section*, Henry Greenwood, London (1977).

Haist, G., *Monobath Manual*, Morgan and Morgan, New York (1966).

Jacobson, C. I. and Jacobson, R. E., *Developing,* Focal Press, London, 18th revised edition (1976).

Jacobson, C. I. and Mannheim, L. A., *Enlarging*, Focal Press, London, 22nd revised edition (1975).

Photographic standards

Photographic standards for chemicals, equipment, materials and techniques are issued by the following standards organisations:

American National Standards Institute (ANSI)
1430 Broadway, New York 10018.

American Standards Association (ASA)
Former name for ANSI.

Association Francaise de Normalisation (AFNOR)
23 Rue Notre-Dame-des-Victoires, Paris 2c.

British Standards Institution (BSI)
2 Park Street, London W1A 2BS.

Deutscher Normenausschuss (DNA)
1 Berlin 30, Burgrafenstrasse 4–7, West Germany.

Gosudarstvenny j Standart (GOST)
Leninsky J Prospekt 9B, Moscow M 49.

International Organization for Standards (ISO)
1 Rue de Varembe, 1211 Geneva 20 Switzerland.
ISO standards are available for National Standards Organisations.

Japanese Industrial Standards Committee
3–1 Kasumigaseki, Chiyodaku, Tokyo.

INDEX

A

Abbe, 125
Aberrations of a lens, 106, 120, 128
 astigmatism, 106, 114, 115
 chromatic, 106, 107
 coma, 106, 111, 112
 curvature of field, 106, 115
 direct, 106
 distortion, 106, 112–113
 effect on depth of field, 82
 lateral colour, 106, 109, 110
 oblique, 106
 spherical, 106, 110
Abney, 295, 338
Abrasion marks,
 on negatives, 563
 on prints, 568
Absorption curves of filters, 199
Absorption of light, 60
 in colour filters, 199
 in emulsions, 235
 in lenses, 100
Accelerators in developers (see Alkalis in developers)
Acid stop baths, 386
Acutance, 540
Adaptation of the eye,
 chromatic, 312
 dark, 315
Adjacency effects in development, 382–383, 541
Aerial oxidation of developers, 341, 355
Aerial photography, use of infra-red materials, 240
After-treatment of negatives, 496
Agnecolor, laminar flow, 452
Airy disc, 116
Alkalis in developers, 337, 342
 borax, 342
 caustic soda, 342
 potassium carbonate, 342
 potassium hydroxide, 342
 sodium carbonate, 342, 343
 sodium hydroxide, 342
 sodium metaborate, 342
 trisodiumphosphate, 343
Amplitude of light waves, 22
Angle of acceptance of exposure meter, 433
Angle of incidence, 61, 62
Angle of reflection, 61
Angle of refraction, 61, 62
Angle of view, 72, 73, 74
Anti-fogging agents (anti-foggants), 344
 in developers, 344
Aperture of a lens, 89, 90
 actual, 91
 effective, 90
 effective diameter of, 90
 of enlarging lenses, 470
 relative, 90
 systems of marking, 91, 92
Architectural photography
 use of camera movements, 190
Argon, 44
Aspheric surfaces, 111, 154
Astigmatism, 106, 114, 115
Astronomical photography, plates for, 298, 407
Autocorrelation function, 547
Automatic cameras, 150–152, 161–162
 aperture preferred, 152
 shutter preferred, 152
Average gradient (\bar{G}), 275, 410
Axis of a lens, 65

B

Back-focus, 68
Backing layer, anti-halation, 230
Baryta, 229

Index

Base, 227
 film, 227–228
 paper, 228, 229, 447
Base length of rangefinder, 172
Bases, properties of, 228
Battery capacitor (B.C.) flash circuit, 50
Beam splitter, 477
Bellows extension,
 effect on exposure, 100
Between-lens shutters (*see* Shutter, between-lens)
Bisphenol-A polycarbonate, 228
Black-and-white photography, 16
Black-body radiator, 31
Bleaching,
 in fixation, 387, 453
 in reversal processing, 398
 rehalogenising, 398
 to remove developer stain, 559
Bleach fixing, 398, 454
Blisters,
 on negatives, 564
 on prints, 569
Blooming of lens surfaces, 102
Blue-sensitive materials, 238, 317
Boosters for exposure meters, 433
Bracketing exposures, 429
Bromide in development,
 absence of, 343, 367
 in M.Q. and P.Q. formulae, 349
 presence of, 344, 367
Bromide papers, 444
 effect of development, 287
 bromide streamers, 383
Bromine acceptor, 224, 226
Buffering, 343
 of developers, 343
 of hardening-fixing baths, 391
Bunsen, 295

C

Calcium scum on negatives, 345
Calcium sequestering agents, 345
Calcium sludge in developers, 345
Calgon, 345
Callier coefficient (Q factor), 263, 264
 effect on enlargements, 467
Camera angle (*see* Angle of view)
Camera exposure, 422
Camera flare, 100, 293
Camera format, 135–137
Camera movements, 187–197
 cross back, 188
 cross front, 187
 cross movement, 189
 displacement, 187–191
 drop back, 188
 drop baseboard, 197
 drop front, 188
 falling front, 189
 focusing, 187–189, 196
 front focusing, 189
 revolving back, 191
 rising back, 188
 rising front, 188, 189, 190
 rotational, 191–195
 rotating back, 188
 segment tilt, 196
 sliding lens panel, 189
 swing back, 188, 193–195
 swing front, 188
 swinging lens panel, 193
 tilting back, 188, 191, 192, 193–195
 tilting front, 188, 191, 192
 tilting lens panel, 188, 193
Cameras, 135 *ff*
 aerial, 149
 automatic, 150–152
 Contax, 142
 development of, 135 *ff*
 fixed-focus, 139
 folding baseboard, 141, 147, 197
 format of, 135–137
 for self-developing materials, 140, 148
 half-frame, 136
 Hasselblad, 145
 instant picture, 140, 148
 Kine-Exakta, 145
 Leica, 142
 Mamiyaflex, 143
 materials for construction, 137
 monorail, 141, 147, 187
 pinhole, 64
 pocket, 140, 148
 Polaroid land, 148
 press, 149
 rangefinder, 139, 140
 Rolleiflex, 142
 simple, 139, 140
 Sinar, 189, 196
 single-lens reflex, 141, 144
 special purpose, 148
 stereo, 150
 sub-miniature, 148
 "system", 138
 technical, 141, 147, 187 ff
 35mm miniature, 136
 twin-lens reflex, 140, 142
 types of 135 *ff*
 ultra-wide angle, 150
 underwater, 149
 versatility of function, 137
Camera shake, 556
Candela, 36
Candle-power of a light source, 36
 mean spherical, 36

Capacitor flash circuit, 50
Cardinal points of a lens, 68
Cascade washers, 455
Cassettes, 232, 559
Cellulose triacetate, 227, 228
Centre of perspective, 86
Characteristic curves, 266, 299
 bent-leg, 270
 of colour materials, 322, 323, 325, 327,
 328, 334, 506, 513
 of negatives, 266, 299
 of papers, 283, 286–290
 main regions of, 267, 269
 placing subject on, 274–275, 424
 region of solarisation, 267, 269
 shape of, 267
 shoulder of, 267
 slope of, 268
 straight line of, 267
 toe of, 268
 variation with development, 270–271,
 272, 277, 278
 variation with material, 270
Chemical focus, 107, 471
 in mercury vapour enlargers, 471
Chevalier, 122
Chloride papers, 443, 444
Chlorobromide papers, 443, 445
Chromatic aberration, 106, 109, 110
Chromatic adaptation, 312
Chromatic difference of magnification, 109
Cinch marks in negatives, 564, 567
Circle of confusion, 76, 78
 maximum acceptable, 78
Circle of good definition, 75
Circle of illumination, 75
Clearing time in fixation, 392
Click stops on enlarger lenses, 470
Close-up attachments, 66, 221
Close-ups,
 effect of bellows extension on exposure,
 99, 100
 effect of diffraction, 117
Clumping of silver grains, 350
Coating of lens surfaces, 102 ff, 154
 practical value of, 102
Collodion, 225
Colour analysers, 492, 493
Colour charts, 241
Colour couplers, 320, 502, 522–526
 developer-soluble, 503, 504, 523
 DIR, 524, 525
 immobilised, 504
 Latex, 505, 509
 oil-dispersed, 505
Colour developers, 353, 358
Colour enlargers, 487–491
Colour filters (see Filters)
Colour formers, 320, 502, 522–526

Colour, lateral, in a lens (see Lateral colour)
Colour masking, 324, 333
Colour negative, 322–326, 510
Colour negative analysers, 492
Colour papers, 322, 448, 510–513
 bleach, fixing of, 454, 511–512
 stabilisation of, 456
Colour photography, 16, 245 ff
 need for control of light sources, 34
 principles, 245 ff
 reversal processing in, 377, 381,
 507–510
 use of polarising filters, 216–218
 use of u.v. filters, 212
 (see also Colour processes)
Colour printing, 480–486
 additive, 484
 evaluating negatives for, 491–494
 filtration in, 483
 heat filters in enlargers, 488
 negative–positive, 481
 positive–positive, 481
 scope of, 481
 subtractive, 485
 triple exposure, 484
 variables in, 481
 white light, 485
Colour prints, evaluation, 494
Colour processes, 318 ff
 additive, 247–250, 254–256, 329
 chemistry of, 522–531
 chromogenic, 354, 502, 522
 Cibachrome, 513
 Dufaycolor, 255
 dye-releasing, 516–522
 Dye-Transfer, 257
 Ektachrome, 509
 Ektaprint, 511
 imperfections of, 329–331
 instant-print, 516, 520
 Kodachrome, 507
 Kodak instant, 520
 masking in, 324, 334, 510, 524
 negative–positive, 322–326, 510–513
 non-substantive, 505, 507
 Polacolor, 516
 Polavision, 256
 reversal, 326–329, 507
 silver-dye bleach, 513, 527
 substantive, 505, 509
 subtractive, 250–254, 256–257, 330
 Technicolor, 257
Colour processing, 353, 505–531
 drum processor, 365, 366, 450, 451
 inter-image effects in, 324, 327, 332
 524
Colour reproduction, photographic, 1, 16,
 245, 310 ff
Colour sensitising, 238

Index

Colour sensitivity,
 determination of, 241–242
Colour sensitometry, 321–329
Colour, surface, 311
Colour temperature, 31–35
 measurement and control of, 33
 of some common light sources, 29, 33
Colour test charts, 241
Colour vision, trichromatic theory of, 25, 313
Colour blind materials, 238
Colours, 310
 appearance of, effect of light source, 312
 complementary, 249, 250, 314, 315
 of natural objects, 245, 246, 310, 312
 pigmentary, 311
 primary, 25, 33, 247, 250, 314
 pure, 311
 reproduction of, photographic, 16, 245, 310 ff
 response of eye to, 312, 330, 332
 saturated, 311
 secondary, 314
 spectral, 310
 spectrum, 310
 surface, 311
Colour-sensitive materials, 238
 infra-red, 239, 240
 isochromatic, 239
 orthochromatic, 239
 panchromatic, 239, 240
 papers, 322, 442, 448, 510–513
Coma, 106, 111, 112
Compensating effect, 350
Components of a lens, 65
Composition, 14
Condenser enlargers (see Enlargers)
Condensers,
 Fresnel, 40
 in enlargers, 464
 in spotlights, 40
Conjugate distances (conjugates), 72
Contact papers, 444
Contact printing, 462
 apparatus for, 462
 boxes for, 462
 papers for, 444
Contrast,
 average gradient (\bar{G}), 275,
 expressed by gamma, 268
 in condenser enlargers, 467
 in diffuser enlargers, 467
 index, 275–277
 of negatives, influenced by development, 277, 367, 379
 overall of negatives, 277
Contrast grades of papers, 289–291
Control chart, 375

Convergence of horizontal lines, 190
Converging verticals, 190
Converter lenses, 158, 159
 afocal, 158
 teleconverter, 158
Copying,
 lenses for, 126
 materials for, characteristic, 270
 use of polarizing filters, 218
 use of sliding front, 191
Cos^4 law, 97, 98, 127
Covering power of a lens, 75
 effect of stopping down, 75
Criterion of a correctly exposed negative, 275, 423–427
Criterion of film speed (see Speed criteria)
Critical angle, 62
Cross front, 188
Curvature of field, 82, 115
Curvilinear distortion (see Distortion)

D

Daguerre, 18
Dallmeyer, 125
Darkroom safelights (see Safelights)
Daylight, 29, 42
 artifical, 300
 standard, 300
 taken as reference by eye, 316
Defects (see Faults)
Definition,
 causes of poor, 116, 556
 circle of good, 75
 effect of stopping down, 117
 in enlarging, 471
 in photographs, 542
 photographic, 542
 yielded by a lens, 76, 117
Degraded white in prints, 453, 570
Densitometers, 299, 301–308
 automatic plotting, 305
 colour 306–308, 492
 Kodak RT, 302, 303
 micro, 305–306
 photo-electric, 302
 reflection, 301
 single beam – direct reading, 303
 single beam – null reading, 303
 transmission, 301
 twin beam, 304
 visual, 302
Density, 261
 analytical, 307
 and wavelength, 265
 arbitrary, 265
 arbitrary integral, 265
 colorimetric, 265
 diffuse, 262

Density (*contd.*)
diffuse visual, 265
doubly diffuse, 262
fixed, as speed criterion, 407
in practice, 263–266
integral, 307
maximum,
of negatives, 268
of papers, 283–285
minimum, 269
printing, 265
reflection, 262, 283
shoulder, 268, 283
spectral, 265
transmission, 262
visual, 265
specular, 262
Density range,
of negatives, 277
of prints, 287
Depth of field, 80–83
and hyperfocal distance, 82
expressed mathematically, 82
factors affecting, 82
for close-ups, 117
Depth of field scales, 83
Depth of field tables, 83
Depth of focus, 77, 78–80
formulae for, 79
practical value of, 80
Dermatitis from developers, 349
Detail in photographs, 18
Detective quantum efficiency (DQE), 548–552
Developer stain, removal of, 559
Developer streamers, 383, 563
Developers, 336 *ff*
aerial oxidation of, 341, 355
buffered, 343
changes with use, 354–356
colour, 353, 358, 522 *ff*
contaminated, 560
exhaustion of, 355
extra fine grain, 350
fine grain, 346, 349–351
for papers, 448
formulae in general use, 345 *ff*
high-actuance, 352
high-contrast, 346, 352
high-definition, 352
hydroquinone-caustic, 346
heavily restrained, 344
used with high-contrast materials, 338
liquid concentrates, 360
lithographic, 352
making up, 357–361
metol-hydroquinone (M.Q.), 345, 347
for papers, 448
gamma time curve, 273, 274
metol-hydroquinone borax (M.Q. borax), 346, 350
bromide in, 344
gramma time curve, 274
give fine grain, 350
metol-hydroquinone carbonate (M.Q. carbonate), 345, 347
oxidized, 559
parapenylenediamine, 351
Phenidone-hydroquinone (P.Q.), 346, 348, 349, 350
for papers, 448
physical, 351
pre-packed, 359–361
preparation of, 357–361
powdered chemicals, 359
replenishment, 356
shelf life of, 359
soft working, 350
solvent, 351
stale, 559
starters for, 361
stock solutions, 358
warm-tone, 339, 449
working life of, 355
working solutions, 358
(*see also* Developing agents)
Developing agents, 336, 337 *ff*
amidol, 339
catechol, 340
colour, 341, 523
di-aminobenzene, 339
Dimezone, 338
Droxychrome, 341
4-aminoaniline (*see* paraphenylene-diamine)
4-Hydroxyphenylamino acetic acid (*see* glycin)
Genochrome, 341
glycin, 339
hydroquinone, 338
Kodak CD1, CD2, CD3, CD4, 341
metol, 337
metol-hydroquinone (M.Q.), 338
Mydochrome, 341
N-methyl-4-aminophenol sulphate (*see* metol)
1,4 dihydroxy-benzene, 338
1,2 dihydroxy-benzene, 338
1,2,3 triydroxy-benzene, 340
para-hydroxyphenylamino-acetic acid, *see* glycin
paraminophenol, 339
paraphenylenediamine, 339
Phenidone, 338
Phenidone-hydroquinone (P.Q.), 338
1-phenyl-3-pyrazolidone (*see* Pheni-done)

Developing agents (*contd.*)
 pyro, 340
 pyrocatechin, 340
 pyrocatechol, 340
 pyrogallic acid, 340
 pyrogallol, 340
 quinol, 338
 Tolochrome, 341
 2,4-Diaminophenol hydrochloride (*see* amidol)
Developing solutions (*see* Developers)
Developing-out materials, 222
Developing tanks, 362–365
Development, 13, 222, 336 *ff*
 agitation in, 371, 374, 382
 as a rate process, 337
 brush, 374
 chemical, 336
 clumping of grains in, 350, 536
 colour, 354, 502, 522
 compensating, 350
 dish, 361
 dye-forming, 354, 502, 522
 factorial method, 369
 forcing in, 379
 high temperature, 373
 infectious, 353
 in photofinishing, 365
 inspection method, 368, 369, 449
 judging completion, 369, 449
 lithographic, 352
 low temperature, 373
 of flat films, 361
 of 35mm miniature films, 361
 of papers, 448–453
 of roll films, 361
 of sensitometric exposures, 374
 physical, 336, 351
 purpose of, 336
 quality control of, 375
 required degree of, 367
 superadditive, 347–349
 tank, 362–364
 technique of, 361–367
 temperature coefficient of, 370
 time-temperature method of, 368, 369
 two-bath method, 376
 uneven, 561
 uniform, methods of obtaining, 374
 water-bath method, 376
Development centres, 336
Development charts, 372
Development factor, 271
Development latitude of papers, 288
Development technique, 361–364
Development times,
 basis of published, 372
 factors affecting, 370, 371
Development-time factors, 371

Diaphragms, 89, 164–166
 fully-automatic (F.A.D.), 146, 165
 iris, 89, 165
 semi-automatic, 165
 (*see also* Aperture of a lens)
Diapositives, 19
Dichroic fog, 560
Diffraction and the lens, 116
Diffraction of light, 106, 116
 in close-ups, 118
 in enlarging, 117
 in photomacrography, 118
 limits resolving power of a lens, 116
Diffuser enlargers (*see* Enlargers)
Diffusers,
 in enlargers, 465, 467, 489
 in enlarging, 480
 in portraiture, 158
Diffusion discs, 158
Digestion of an emulsion, 227
Dimensional stability of film bases, 228
Diopter, 157
Dirt on lenses, 559
Dispersion of light, 24, 62
Distortion (aberration), 106 *ff*
 absent from pinhole cameras, 65
 associated with telephoto construction 131
 barrel, 112, 113
 curvilinear, 76, 112, 113
 geometric, 75
 pincushion, 112, 113
Distortion,
 of moving objects with focal plane shutter, 163
 perspective, 76
 caused by tilting the camera, 190
 corrected or introduced in enlarger, 479
 in viewing prints from incorrect distance, 87
 with long focus lenses, 87
 with wide-angle lenses, 76
Diverging verticals, 190
D log E curves (*see* Characteristic curves)
Dodging, 463, 478
Dollond, 107, 124
Drawing (perspective) (*see also* Perspective), 83
Driers, print, 457
Driffield (*see* Hurter and Driffield)
Drop baseboard, 197
Drying, 402
 by alcohol, 402
 in the manufacture of photographic materials, 231
 of negatives, 402
 of prints, 457
 rapid, 402

Drying (*contd.*)
 spirit, 402
Drying cabinets, 402
Drying machines, 457
Drying marks, 403, 562
Duplicate negatives, 292
Dust spots on negatives, 560
Dye developer, 516, 529, 530
Dyes, 513
 azo, 520
 metallised, 520
 sensitising, 238
 used in manufacture of filters, 201
Dye sensitising, 238
 to obtain increased speed, 241

E

Easels for enlargers, 472
 tilted, use of, 479
Eberhard effects, 332, 383
Effects,
 adjacency, 382, 383, 541
 Eberhard, 332, 383
 inter-image, 324, 327, 332, 524
 intermittency, 298
 Kostinsky, 383
 Sabattier, 383
Efficiency,
 of a light source, 37
Electrolytic silver recovery, 395
Electromagnetic waves, 21
Electronic flash, 53, 439
 effect of reciprocity failure, 296
Elements of a lens, 65
 floating, 111, 134, 154
Emulsions, 222
 binding agents for, 225
 chemical sensitisation, 227
 coating of, 230–232
 detective quantum efficiency of, 548
 information capacity of, 552
 modulation transfer, 544
 preparation of, 226–227
 Q, 235, 237
 resolving power, 533–536
 restrainers in, 226
 ripening of, 227
 Schumann, 235, 236
 sensitisers in, 226
 speed of (*see* Speed of an emulsion)
 supports for (*see* Base)
 swelling of, in processing, 390
Enlargements, 463
 graininess in, 350, 479
 soft focus, 480
Enlargers, 463–468, 487–491
 auto-focus, 471
 colour, 487–491
 condenser, 464, 489
 condenser-diffuser, 468
 condenser *v* diffuser, 466
 diffuser, 465, 489
 easels for, 472
 horizontal, 463
 lenses for, 470, 487
 light sources for, 469, 487
 negatives carriers for, 471
 paper holders for, 472
 vertical, 463
Enlarging, 463 *ff*
 advantages of, 463
 apparatus for, 463
 dodging in, 463, 478
 effect of diffraction, 117
 effect on graininess, 479, 539
 exposures in, 472
 local fogging in, 463
 papers for, 444, 448
 production of black borders, 472
 production of white borders, 472
 shading in, 463, 478
 (*see also* Enlargers)
Enlarging photometers, 475, 492
Entrance pupil, 90
Equivalent focal length, 69
Ethylenediaminetetracetic acid, 345, 454
Exit pupil, 90
Exposure, 96, 259–260
 and *f*-number, 96
 automatic control of, 151, 161, 164
 camera (*see* Camera exposure)
 correct, 275, 423
 effect of lens extension, 99, 100
 effect of subject distance, 100
 factors affecting, 422
 in sensitometry, 259
 maximum acceptable, 424
 minimum acceptable, 424
 of reversal materials, 426
 over-, 279, 280, 423, 558
 under-, 279, 423
 variation in, effect on negatives, 278
 (*see also* Exposure determination)
Exposure calculators 429, 438
Exposure control, automatic, 181–183
Exposure criteria, 429
 brightest object, 430
 darkest object, 430
 highlights, 430
 incident light, 432
 integrated effect, 431
 key tone, 430
 shadows, 430
Exposure determination, 422 *ff*
 artificial highlight method, 434
 bracketing method, 429
 for flash photography, 437–441

Index

Exposure determination (*contd.*)
 fundamental method, 429
 in enlarging, 472
 incident light methods, 430, 432, 434
 integration method, 430, 431, 434
 key-tone method, 429, 430, 435
 luminance range method, 429
 shadow method, 425, 430
 subsition method, 431
 test-strip method, 427, 473
 through-the-lens (TTL) measurement, 179 *ff*
 using photographic material, 427–429
Exposure factors of filters (*see* Filter factors)
Exposure factors for different scales of reproduction, 99
Exposure guide numbers, 51, 438
Exposure index, 417
Exposure latitude, 280–283, 423
 in printing, 288, 290
Exposure meters, 174–183, 432–435
 accessory, 176
 calibration of, 180
 integral, 177
 operation of, 181
 photo-electric, 175, 432
 angle of acceptance, 433
 boosters for, 433
 cadmium sulphide cell, 146, 175, 433, 434
 incident light, 434
 methods of use, 434–435
 reflected light, 434
 selenium cell, 175, 433
 Weston, 433
 photometers (*see* Exposure photometers)
 sensitivity of, 181
 sensors for, 433
 silicon blue, 175–176, 433, 434
 through-the-lens (TTL), 146, 177
Exposure photometers, 435–437
 electronic, 436
 for enlarging, 475
 S.E.I., 435
Exposure range, 285
 of papers, 285
 useful, of negative materials, 280
Exposure value scales on shutters, 162, 165
Extension tubes and bellows, 157, 159–160
Eye,
 adapts to colour quality of illuminant, 312
 dark-adapted, 315
 photopic, 315
 resolving power of, 77
 response of to changes in stimulus, 261
 response of, to colours, 312–314
 scotopic, 315

F

Fading of prints, 570
Falling front, 189
Faults, 555 *ff*
 in colour materials, 570 *ff*
 in colour negatives, 572
 in colour prints, 573
 in colour reversal film, 572
 in monochrome negatives, 555–568
 (*see also* Index pages 566–568)
 in monochrome prints, 568–570
Festoon drying, 231
Field covered by a lens (*see* Covering power of a lens)
Field curvature, 82, 115
Field curves, astigmatic, 115
Field of view error in viewfinders, 168
Film base, 227
 dimensional, stability of, 228
Film speeds (*see* Speed systems)
Films,
 flat, 232
 notching of, 233
 packing of, 233
 manufacture of, 226–227
 35mm miniature, 232
 roll, 232
 sizes of (*see* Sizes)
 storage of, 233
Filter factors, 200
 affected by reciprocity failure, 297
 determination of, 200, 309
 of polarising filters, 218
Filters, 198–219
 absorption curves, 199, 219
 acetate, 203, 488
 blue, 206
 camera, 156, 201
 care of, 203
 characteristics of, 198–200
 cemented, 201
 colour, 198 *ff*
 colour compensating (CC), 211
 colour conversion, 210–211
 commercial forms of, 200–202
 complementary, 206, 208, 249
 contrast, 205, 206
 correction, 204, 205, 206
 cyan, 206
 Davis–Gibson, 43
 dichroic, 202, 490
 dyed-in-the-mass, 202
 focusing with, 203, 204

Filters (*contd.*)
 for black and white photography, 204–207
 for colour photography, 207–211, 216
 for colour printing (CP), 212, 490
 for darkroom use, 218–219, 220
 for fluorescent lights, 216
 gelatin, 201
 glass, 201
 green, 206
 heat, 213, 472, 488
 haze, 207
 infra-red absorption, 213
 infra-red transmitting, 214
 instrument, 201
 interference, 202, 490
 light, balancing, 209, 210
 magenta, 206
 minus blue, 199, 206
 monochromatic vision (MV), 216
 narrow cut tricolour, 207, 208
 neutral density (ND), 214, 215
 optical flats, 201
 orange, 206
 pale yellow, 206
 polarising, 216–218
 primary colours, 246, 249
 red, 206
 safelight, 218–220
 sizes of, 203
 tricolour, 206, 207, 208, 212
 types of, 198
 ultra-violet absorbing, 212, 213
 ultra-violet transmitting, 213
 viewing, 215, 216
 yellow, 199, 206
 yellow-green, 206
Finders (*see* Viewfinders)
Fine grain, developers, 346, 349–351
Fixation, 385, 453
 agitation in, 392
 clearing time in, 392
 incomplete effects of, 400
 of papers, 453
 rapid, 397
 rate of, 392
 test for completeness, 401
 time required for, 392
 two-bath method, 453
 ultra rapid, 397
Fixing agents
 ammonium thiosulphate, 386, 397
 hypo, 386, 391
 sodium thiosulphate pentahydrate, 386, 391
Fixing baths, 386–389
 acid, 388
 exhaustion of, 393
 changes in use, 393

 for papers, 453
 hardening, 389
 life of, 394
 making up, 391
 plain, 388
 rapid, 397
 replenishment of, 394
 temperature of, 392
Flare, 100, 562
Flare factor, 101
Flare spot, 100, 562
Flash, 49, 53
 automatic, 439
 battery capacitor system, 50
 electronic (*see* Electronic flash)
 high speed (*see* Electronic flash)
Flash bulbs, 29, 49
 characteristics of, 51, 53
 types of, 52
Flash expsoure determination,
 by flashmeter, 437, 440
 by guide numbers, 51, 437, 438
 by modelling lights, 437, 441
 by Polaroid Land film 437, 441
 by variation in flash duration, 437, 439
Flashmeter, 437, 440
Floating elements of a lens, 111, 134, 154
Fluorite optics, 110, 130
Flux, 93
 luminous, 36
 radiant, 25
f-numbers, 91
 and exposure, 91
 and light-passing power of a lens, 91
 effective, 99
 standard, 92
Focal length, 67, 68
 and perspective, 84, 85
 determines ratio of reproduction, 84
 equivalent, 69
 of a compound lens, 68
Focal planes, 67, 68
Focal points, 67, 68
Focal plane shutters (*see* Shutters, focal plane)
Focus, 66
 chemical, 107, 471
 visual, 107, 471
 (*see also* Focal length)
Focusing, 76, 169–174, 187, 203
 by camera back 170, 189
 by camera front, 170, 189
 by front lens cell, 170
 by scale, 173–174
 with infra-red materials, 241
Focusing aids, 171–173
 coincidence rangefinder, 171
 coupled rangefinder, 171, 172
 groundglass screen, 171

Index

Focusing aids (*contd.*)
 microprisms, grids and screens, 173
Focusing, internal, 170
 by movement of entire lens, 170
Focusing mechanism, 169–173
Focusing scales on lens mount, 173–174
Fog, 558
 atmospheric, 207
 chemical, 558
 development, 269, 337
 dichroic, 560
 light, 558, 562
 with papers, 570
Foot-Lambert, 97
Fox Talbot, 18
Frequency of vibration of light waves, 22
Frilling, 564
Front-cell focusing, 170
Full radiator, 31
Fungus in gelatin, 565

G

Galilean telescope, 167
Gamma, 268
 in relation to development time, 271, 272
 variation with wavelength, 274
Gamma infinity (γ_∞), 272
Gamma-rays, 22, 23
Gamma time curves, 272–274
Gauss points, 68
Gaussian optics, 68, 69
Gelatin, 224, 225
 as emulsion binder, 225, 226
 fungus in, 565
 hardening of, 389
 inert, 226
 swelling of, 389
Geometrical optics, 21
Ghost images, 100
Glass, Crown, 107
Glazing, 458
Glazing drums, 458
Glazing machines, 458
Glazing sheets, 458
Glazing solutions, 458
Goerz, 98, 124, 125
Gradation of papers, 289–291, 445–446
Gradient,
 average (\bar{G}), 275, 410
 fractional, 409
 minimum useful, 408
Grain, fine (*see* Fine grain)
Grain size distribution, 533
Graininess, 536–539
 effect of development, 536
 effect of enlarging, 539

factors affecting, 479
Grains, silver, 222, 532
 clumping of, 350, 536
 size of, and image colour, 444
Grains, silver halide, 222
 as unit in photographic process, 532
 frequency distribution, 533
 size distribution of, 533, 544
 size in relation to method of preparation, 227
 size in relation to speed and contrast, 533
Granularity, 539–540
 factors affecting, 540
 Selwyn's law, 539
Graphical construction of images, 69, 70
 using Gaussian optics, 69, 70
Grenz rays, 237
Gurney and Mott, 224

H

H and D curves (*see* Characteristics curves)
Halation, 547, 564
Halogen acceptor, 224
Hardeners, liquid, 454
Hardening, 389
 of emulsion in manufacture, 227
 of negatives, 389
 of prints, 454
 purpose of, 389
Hardening agents, 389
 chrome alum, 389, 390
 formalin, 391
 potassium alum, 389, 390
Hardening baths, 390
Hardening-fixing baths, 389
 for papers, 454
Hauff, 337
Haze,
 in photography, 207
 penetration by infra-red, 207, 240
Helmholtz, 24, 313
Highlights,
 artificial, 434
 defined, 259
 exposing for, 429, 430
Human eye (*see* Eye)
Hurter and Driffield, 266, 291, 292, 293, 408
Huygens, 20
Hyperfocal distance, 80, 81, 82
 in relation to depth of field, 80
Hypo,
 in fixing baths, 386, 391
 in solvent developers, 351
 substitutes for, 397
Hypo eliminators, 400

I

Illumination, 14, 38, 260
 in enlargers, 465, 468
 variation over field of lens, 92, 97
Image, 64
 appearance of, during development,
 349, 369
 photographic, structure of, 532
Image colour of prints, 443, 449
Image evaluation, 532 *ff*
Image formation, 14, 64
 by a pinhole, 64
 by negative lenses, 65
 by positive lenses, 66, 67
 by thick and compound lenses, 68
Image illuminance, 93
Image perpetuation, 14
Image quality, 542
Image size, 72
Images,
 graphical construction of, 69, 70
 real, 66
 sharp, 80
 virtual, 65
Incident-light technique, 430, 432, 434
Indicator papers, 393, 395
Inertia, 269
 regression of, 271
Inertia point, 269
Information capacity, 552
Infra-red filters, 213, 214
Infra-red materials, 240
 focusing with, 241
 wedge spectrogram, 243
Infra-red radiation, 240
Instant print materials, 378, 516
Integral masking, 333–335, 510
Integral tripack, 257, 318, 320, 503
Integration method of using an exposure
 meter, 430, 431, 434
Integration to grey, 494
Intensification, 499
 effect on image, 498
Intensifiers, 499
 action of, 499
 chromium, 499
 copper-silver, 499
 quinone-thiosulphate, 499
 uranium, 499
Intensifying screens, 237
Intensity scale of exposures, 301
Interference of light waves, 102
Inter-image effect, 324, 327, 332, 524
Interiors, photography of (*see* Architectural
 photography)
Intermittency effect, 298
Inverse square law, 38, 39
Iris diaphragms, 89

Irradiation, 564
Isochromatic materials, 239

J

Jones, L. A., 293, 409
Jones point, 410
Joule, 55

K

Kelvin scale of temperature, 32, 36
Key-tone method, 429, 430, 435
Kink marks in negatives, 563
Kostinsky effect, 383

L

Lamps,
 candle-power of, 36
 carbon arc, 29, 46
 enclosed, 46
 high intensity, 29, 47
 low intensity (L.I.), 29, 46
 open, 47
 white-flame, 29, 31, 47
 electronic flash (*see* Electronic flash)
 in enlargers, 469, 487
 flash (*see* Flashbulbs and Electronic
 flash)
 Fluorescent, 29, 31, 32, 47
 cold cathode, 48, 469, 487
 hot cathode, 48
 half-watt, 38
 incandescent, 27, 44
 mercury vapour discharge, 29, 30, 47
 for printing and enlarging, 469
 high pressure, 29
 low pressure, 29
 oil, 27
 sodium vapour discharge, 30, 48
 tungsten filament, 29, 43
 angle of burning, 45
 characteristics, 43
 for printing and enlarging, 469
 gas filled, 44
 general service, 45
 overrun, 44
 Photoflood, 44, 45
 photographic, 45
 Photographic Pearl, 45
 projection, 45
 types of, 45
 types of cap, 45
 vacuum, 33
 tungsten halogen, 29, 45
 quartz iodine, 46
Land, Edwin, 378

Index

Latent image, 223
Lateral colour, 106, 109, 110
 corrected by symmetrical construction, 110
Latitude,
 camera exposure, 280–283
 development of papers, 288
 printing exposure, 288
Lens aberrations (see Aberrations of a lens)
Lens accessories, 220–221
Lens aperture (see Aperture of a lens)
Lens axis, 65
Lens components, 65
Lens elements, 65
Lens equation, 71–72
Lens errors (see Aberration of a lens)
Lens flare, 100
Lens formulae, 71, 72, 73
Lens hoods, 100, 156
Lenses, 65 ff
 absorption of light in, 100
 achromatic (achromats), 107
 afocal converter, 159
 anastigmatic (anastigmats), 114, 122, 125,
 Aplanat, 111, 125
 apochromatic (apochromats), 108, 109, 121
 basic designs of, 123
 bloomed, 102
 Bouwers–Maksutov, 132
 camera, 119 ff, 154–156
 Cassegranian, 131–132
 Catadioptric, 131–132
 Chevalier, 122, 124
 coated, 102, 103
 compound, 65, 68, 119
 Concentric, 125
 condenser, 40, 464
 convergent, 66
 converter, 158, 159
 Cooke, 122, 124, 125
 covering power of (see Covering power of a lens)
 Dagor, 124, 125
 Dallmeyer, 125
 diffraction, 106, 116, 117
 divergent, 66
 Dollond, 107, 124
 Double Gauss, 111, 123, 126
 Double Protar, 125
 effect of dirt, 559
 Elmar, 127
 Elmarit, 127
 enlarging, 470, 487
 field covered by (see Covering power of a lens)
 fish-eye, 123, 129–130
 focal length of (see Focal length)

Fresnel, 158
Goerz, 124, 125
Grubb, 124
Hypergon, 98
importance of cleanliness, 559
inverted telephoto, 129
landscape, 124
light transmission by, 100
light passing power of, 100
long-focus, 74, 130
macro, 155, 159
Mangin, 132
meniscus, 66, 115
mirror, 131, 155
modern, 126
multiple coated, 104, 105
negative, 65, 66
Noctilux, 127
normal focus, 74
Periskop, 122, 124, 125
perspective control, 191
Petzval, 122, 123, 124, 125
photographic, development, of, 121, 122
positive, 65, 66
power of, 157
process, 123
Protar, 122, 124, 125
Rapid Rectilinear (R.R.), 113, 122, 124, 125
reflection of light in, 102
revolving power of, 116
Ross, 122, 125
retrofocus (reversed telephoto), 123, 129
short-focus, 127
simple, 65, 70
soft-focus, 111
standard, 74
Steinheil, 122, 124, 125
summaron, 127
summicron, 127
superachromat, 108, 109
superangular, 127
summilux, 127
supplementary, 66, 139, 156, 157
surface reflections, 102
surface treatment of, 102, 154
symmetrical, 123, 125
Taylor, Taylor and Hobson, 125
teleconverter, 158
tele-elmar, 127
telephoto, 123, 130
Telyt, 127
Tessar, 122, 123, 124, 126
thick, 68
transmittance of, 100
triplet, 122, 123, 124, 125
varifocal (variable focus), 133

Lenses (*contd.*)
 wide-angle, 74, 98, 127–130
 wide-angle converter, 159
 Wollaston, 122, 124
 Zeiss, 122, 124, 125, 126
 zoom, 155
Light, 20 *ff*
 absorption of (*see* Absorption of light)
 artifical,
 methods of production, 27
 cold, 32
 corpuscular theory of, 20
 daylight (*see* Daylight)
 diffraction of (*see* Diffraction of light)
 dispersion of, 24, 62
 Huygens and Young's theory of, 20
 incident, 432, 434
 interference of, 102
 nature of, 20
 Newton's theory of, 20
 Planck's theory of, 20
 plane polarised, 216
 quantum theory of, 20
 reflection of (*see* Reflection of light)
 refraction of, 61, 63
 scattering of (*see* Scattering of light)
 sources, efficiency of, 37
 transmission of (*see* Transmission of light)
 use of the word in photography, 25
 velocity of, 21
 warm, 32
 wavelength of, 21, 22
 wave theory of, 20
 white, 24, 28, 310
Light losses in lenses, 102
Light rays, 21
Light sources, 27 *ff*
 artificial, 27
 characteristics of, 27, 42
 constancy of output, 37
 convenience of, 42
 for printing and enlarging, 469–470, 487
 for sensitometry, 300
 natural, 27
 output of, 36
 photographic standard, 43
 size of, 28
 special quality of, 28
 (*see also* Lamps)
Light waves, 21
 amplitude of, 22
 frequency of, 22
 interference of, 102
 wavelength of, 22
Light passing power of a lens, 100
Light-sensitive materials, 13, 222, *ff*
Line marking on negatives, 563

Linear perspective (*see* Perspective)
Lines per millimetre (unit of resolving power), 533
Log exposure, 266
Log exposure range, 285, 289, 467
Lumen, 36
Luminaire, 40
Luminance, 36, 258
Luminance range of subject, 259, 281, 282
Luminosity curve of eye, 314, 316
Luminous flux, 36
Luminous intensity, 36, 38
Lux, 38

M

Mackie lines, 383
Magnification, 72, 480
 effect on exposure, 99
 formulae for, 72
Manufacture of photographic materials, 226–232
Masking,
 of colour materials, 324, 333, 510
 to control tones in printing, 291
Materials, photographic, 226 *ff*
Maxwell, Clerk, 247, 248, 252
Mean noon sunlight, 43
Melting of negatives, 566
Metameric pairs, 245
Metamers, 245
Meters (*see* Exposure meters)
Microdensitometers, 305–306
Microprism grid, 173
Mired scale, 35
Mired shift values, 35, 209
Mirrors,
 concave, in spotlights, 40
 image formation in, 70
 in reflex cameras, 145, 168
 in viewfinders, 168
 reflection of light in, 60
Mist, 207
Modulation transfer function (MTF), 544
 factors affecting, 545
 importance of, 547
 of colour materials, 553
Monobaths, 353
Monochrome photography, 16
Mottle,
 on negatives, 565
 on prints, 570
Movement in negatives, 556
Movement of cameras, 556
Movements, camera (*see* Camera movements)
Moving objects, photography of
 exposure times in, 556
 panning in, 556

N

Nanometre, 24
Nearest distance of distinct vision, 77
Negative carriers in enlargers, 471
Negative density range, 277
Negative–positive processes, 18, 322–326, 510
Negatives, 18
 after-treatment of, 496 *ff*
 assessment of in enlarging, 475 *ff*, 491–494
 colour, 322–326
 correctly exposed, 275, 423
 defects in, 555 *ff*
 dense, 558
 duplicate, 292
 faults in, 555 *ff*
 master, 476, 491
 on easel assessment of, 476, 491
 paper, 19
 standard, 476
 thin, 557
 unsharp, 555
 variation with development, 277, 278
 variation with exposure, 278–280
Neutral density filters, 214–215
Neutral wedges (*see* Wedges, photographic)
Newton, 20
Nitrogen, 44
Nodal planes, 68
Nodal points, 68, 69
Nodal space, 69
Non-colour sensitive materials, 238
Nonstress supercoat, 231

O

Opacity, 260, 261
Optical attachments, 220–221
 centre focus lens, 221
 graduated filter, 221
 multiple image prism, 221
 soft focus, 220
 split-field close up, 221
 starburst, 221
Optical filters (*see* Filters)
Optical sensitising, 238
Optical spread function, 117
Optical transfer function, 117
Optics, 20
 Gaussian, 68, 69
 geometrical, 21, 64
 physical, 21
 quantum, 21
Ordinary materials, 238
Orthochromatic materials, 239

Ostwald ripening, 227
Overall contrast of negatives, 278
Overall reproduction curve, 293
Oxidation products and development, 342

P

Packing of sensitised materials, 233
Panchromatic materials, 239–240
Panning, 556
Paper base, 229, 447
 tint and thickness of, 447
Papers, 442 *ff*
 baryta, 229
 bleach fixing of, 454
 bromide, 443, 444
 characteristic curves of, 283, 286, 287
 chloride, 443
 chlorobromide, 443, 445
 colour, 442, 448
 colour-sensitised, 443
 contact, 444
 contrast grades of, 289–291, 445–446
 density range of, 287
 development of, 448–453
 and curve shapes, 287
 double weight, 447
 exposure range of, 285
 for contact printing, 444
 for enlarging, 444
 gradations of, 289–291, 445–446
 image colour of, 443, 449
 indicator, 393, 395
 log exposure range of, 285
 manufacture of, 226
 maximum black of, 284
 maximum density of, 284–285
 packing of, 233
 polyethylene (P.E.), 229, 447
 processors for, 450–453
 resin-coated (RC), 229, 447
 sensitometry of, 283 *ff*
 single-weight, 447
 sizes of, 232
 speeds of, 443
 stabilisation, 460
 stabilisation of, 456
 storage of, 233
 thickness of, 447
 tints of, 447
 tone reproduction properties of, 291 *ff*
 types of, 442
 types of silver salt, 443
 types of surface, 446
 variable contrast, 446
 weights, 447
 (*see also* Prints)
Paraxial rays, defined, 64
Particle size and image colour, 443

Permanence of photographic images, tests for, 401
Perspective, 16, 83–88, 194
 apparent, 85
 centre of, 86
 correct, 85, 86
 dependence upon viewpoint, 83, 84
 importance of, 87
 linear, 83
 on taking a photograph, 84
 on viewing a photograph, 85, 87
Perspective distortion (see Distortion perspective)
Petzval, J., 125
Photo-electric cells, 175, 432
Photo-electric exposure meters (see Exposure meters, photo-electric)
Photographic materials, 222 ff
 manufacture of, 226–232
Photographic process, the, 13
 characteristic features of, 15
Photography, 13
Photometers (see Exposure photometers)
Photon, 20
Pinholes, 64
Planck, 20
Plates, 229
 advantages of, 229
Point spread function, 544
Polar distribution curves, 40, 41
Polarised light, 60, 216
Polarising filters, 216
Polaroid, 378, 428, 516
Polyester, 228
Polyethylene terephthalate, 228
Polystyrene, 228
Power of a supplementary lens, 157
Power spectrum, 548
Preservatives in developers, 337, 340
 potassium metabisulphate, 340
 sodium sulphite, 340
Principal focal points, 67, 68, 69
Principal planes, 68
Principal points, 68, 69
Print driers, 457
Printing (see Contact printing and Enlarging)
Printing boxes, 462
Printing frames, 462
Printing out materials, 223
Prints, 462 ff
 clearing of, 460
 contact, 463
 defects in, 568
 development of, 448–453
 drying of, 457
 enlarged, 463
 fading of, 570
 faults in, 568

fixation of, 453
glazing of, 458
hardening of, 454
projection, 463
proof, 462
reduction of, 460
requirements in, 288–289
tarnishing of, 570
toning of, 500
washing of, 454
(see also Papers)
Print washers, 455, 456
Prisms, 62, 63
 deviation of light by, 62
 dispersion of light by, 62, 63
 multiple image, 221
 refraction of light by, 62, 63
Projection printing (see Enlarging)
Processing machines, 365–367
 capacity of, 365
 continuous roller, 366
 drum, 365, 366, 450, 451
 dunking, 366, 368
 Kodak veribrom, 461
 Laminar flow, 450, 452
 self-threading roller, 365, 366, 453
 tube, 365, 366, 450, 451
Purkinje shift, 315, 316

Q

Q emulsions, 235–237
Q factor (Callier coefficient), 263, 264
Quadrant diagrams, 293–295
Quality control, 375
Quantum optics, 21
Quantum sensitivity, 543
Quantum theory of light, 20
Quartz optics, 237

R

Radiation (radiant flux), 25
 electromagnetic, 21
 infra-red (see Infra-red radiation)
 visible, 22, 23
Rangefinders, 171
 built-in, on cameras, 139, 171
 coincidence-type, 171
 split-image, 169, 172
Ratio of reproduction (see Magnification)
Rawling, S. O., 413
Reciprocity law, 295
Reciprocity (law) failure, 295–298
 and filter factors, 297
 and intermittency effect, 298
 in sensitometry, 298
 practical effects of, 296–297

Index

Red-eye effect, 139
Red-sensitive materials, 240
Reducers, 496
 action of, 496
 cutting, 498
 Farmer's, 498
 ferricyanide-hypo, 498
 for prints, 499
 iodine-thiosulphate, 499
 permaganate-persulphate, 498
 persulphate, 498
 proportional, 496, 497
 subproportional, 497
 subtractive, 497, 498
 super-proportional, 497
Reducing agents in developers, 336
Reducing in scale,
 in printing, 463
Reduction, 496
 effect on image, 497
 local, of prints, 499
Reflection factor of papers, 283
Reflection of light, 60
 at lens surfaces, 102
 reduced by lens coating, 103
 by papers, 283
 diffuse, 60
 direct, 60
 from surface of a print, 284
 in a mirror, 61
 mixed, 60
 specular, 60
 total internal, 62, 63
 uniform diffuse, 60
Reflections,
 control of, by polarising filters, 217
Reflector factor, 40, 245
Reflectors, 39, 57
 may affect colour temperature of lamps,
 34
Refraction of light, 61, 63
 Snell's law, 61
Refractive index, 62
Regeneration in developers, 348
Region of sharp focus, 80
Relative log exposure, 269
Replenishment,
 of developers, 356–357
 of fixing baths, 394
Reproduction,
 of colour, 16, 245, 310 ff
 of detail, 18
 of tone, 17, 291–295
Reproduction curve, 293
Resolving power (resolution),
 measurement of, 533
 of a lens, 116
 of an emulsion, 533–536
 of the eye, 77

Resolving power test charts, 535
Restrainers in developers, 337, 343
 benzotriazole, 344
 in Phenidone developers, 344
 inorganic, 343
 organic, 343
 potassium bromide, 343
Reticulation, 392, 564
Reversal,
 from fogging in development, 383
 from over-exposure, 269
Reversal materials, exposure, 426
Reversal process, colour, 381, 507–510
Reversal processing, 376, 381
Reversed Galilean telescope, 167
Rinse bath, 385
Rinsing, 385
Ripening of emulsion grains, 227
 Ostwald, 227
Rising front, 188, 189, 190
Roscoe, 295
Rotating back, 188

S

Sabattier effect, 383
Safelights, 218–220
Scale focusing, 173–174
Scale of reproduction (see Magnification)
Scattering of light,
 in a negative, 262
 in an emulsion, 533
Scheimpflug's condition, 192
Schott, 125
Schumann emulsion, 235
Screens,
 diffusing (see Diffusers)
 intensifying, 237
 safelight (see Safelights)
Scum,
 on negatives, 345, 393
 on surface of developers, 560
Sector wheels, 301
Self-developing materials, 378, 516 ff
Selwyn's law, 539
Sensitising,
 by dyes, 238
 spectral, 238
Sensitive materials, 222 ff
Sensitivity,
 colour, 316, 319, 321
 determination of, 241, 405 ff
 influenced by method of manufacture,
 227
 spectral (see Sensitivity colour)
 (see also Speed of an emulsion)
Sensitometers, 300
 intensity-scale, 301
 time-scale, 301

Sensitometric practice, 298–299
Sensitometry, 258 *ff*
 colour, 321–329
 development in, 374
 elementary, 308
 exposures in, 301
 of papers, 283–288
 wedge method of, 301
Shading,
 in enlarging, 463, 478
Shadows,
 defined, 259
 exposing for, 429
Sharpness, 540
 in negatives, causes for lack of, 555
Shutters, 160
 between-lens, 160–162
 Compur, 161
 Copal, 161
 delayed-action, 162
 electronic, 161–162
 everset, 161
 fully synchronised, 185
 marked speeds of, 161
 preset, 161
 Prontor, 161
 self-setting, 161
 falling-plate, 300
 focal plane, 162–164, 185
 method of releasing, 164
 multi-bladed, 161
 performance curve of, 184
 programmed, 182
 sector wheel, 301
 synchronisation of, 163, 183–186
Signal-to-noise ratio, 548
Silver bromide,
 as a light-sensitive substance, 222
 colour sensitivity of, 236
 in papers, 443, 444
Silver chloride,
 as a light-sensitive substance, 222
 colour sensitivity of, 236
 in papers, 443, 444
Silver chlorobromide,
 as a light-sensitive substance, 222
 in papers, 443, 445
Silver grains (*see* Grains, silver)
Silver halide grains (*see* Grains, silver halide)
Silver halides, 222
 solvents for (*see* Solvents for silver halides)
 spectral sensitivity of, 235 *ff*
Silver iodide, 222
Silver iodobromide, 222
Silver recovery, 395–397
 chemical methods, 396
 electrolytic, 395

metallic replacement, 396
Sine wave test chart, 546
Sizes,
 of films, 232
 of papers, 232
Sky rendering, control of,
 by colour filters, 206
 by polarising filters, 217
Skylight, colour temperature of, 33, 43
Sliding lens panel, 189
Slussarov effect, 98
Smethurst, P. C., 432
Snell's law, 61
Soft-focus attachments, 158, 220
Soft-focus enlargements, 480
Soft-focus lenses, 111
Solarisation
 region of, 268, 269
 term misapplied to Sabattier effect, 384
Solvents for silver halides, 337, 377, 386
 ammonium thiosulphate, 386, 397
 hypo, 386
 in developers, 337, 351
 in fixing baths, 386
 sodium thiosulphate, 386
 thiocyanates, 351, 397
Spatial frequency, 546
Spectral energy distribution curve, 28, 30, 31
Spectral sensitivity, 235 *ff*
Spectrograms, 236, 242
Spectrographs, 242
Spectrography, 237
Spectrum,
 continuous, 30
 discontinuous, 30
 electromagnetic, 22, 23
 equal energy, 314
 line, 30
 power, 547
 visible, 22, 23
 Wiener, 548
Speed criteria, 406
 fixed density, 407
 fractional gradient, 409
 inertia, 408
 minimum useful gradient, 408
 threshold, 406
Speed of an emulsion, 405 *ff*
 and colour of light source, 405
 and intensity level, 405
 expressed by characteristic curve, 270
 in practice, 421
 in tungsten light, 415
 influenced by conditions of exposure, 405
 influenced by development, 378–382
 influenced by restrainer, 343, 344
 methods of expressing, 405–417

Speed ratings,
 aerial film speed, 417
 copying index, 417
 CRT exposure index, 417
 exposure index, 417
 for specialised applications, 417
 of colour negative films, 418
 of colour reversal films, 420
 of commercial films, 416
 photo-recording sensitivity, 417
 printing index, 417
Speed systems, 406, 410
 American Standard (ASA), 410, 411, 412, 413, 416
 ANSI, 411
 APEX, 414
 arithmetical, 415
 British Standard (BS), 410, 411, 412, 414
 conversion between, 415
 DIN, 407, 411
 H and D, 411
 International Organisation of Standards (ISO), 411, 412, 414, 416
 logarithmic, 415
 Scheiner, 407, 411
 Warnerke, 407
Speeds of papers, 443
Spherical aberrations, 106, 110, 111
Spotlights, 40
Spots,
 on negatives, 560
 on prints, 570
Stabilisation of colour prints, 456
Stabilisation papers, 460
Stabilisation processing, 403
Stabilisers in emulsions, 227
Stains,
 on negatives, 559
 on prints, 570
Stereo attachment, 158
Stop baths, 386
Stopping down a lens, effect of,
 on an enlarger lens, 464
 on covering power, 75
 on definition, 117
 on depth of field, 82
 on depth of focus, 79
 on diffraction, 116
 on exposure, 92
 on focus, 111
 on lens aberations, 109, 111, 113, 117
Stops, 89
 click, 89
 Waterhouse, 164
 (see also Aperture of a lens)
Storage of sensitised materials, 233
Streamers, 349, 383, 563
Stress marks on prints, 568
Substratum, 230

Sulphurisation of fixing baths, 386, 388, 391
Sunlight, 30, 43
 mean noon, 43
Superadditivity in developers, 347–349
Supercoat, 231
Supports for emulsions, 227–229
Surface reflections in lenses, 102
Surface treatment of lenses, 102
Swelling of an emulsion, 390
Swing back, 188, 193–195
Swing front, 188
Swinging lens, 193
Synchronisation for flash, 163, 183–18

T

Tall buildings, photography of, use of camera movements, 190
Tarnishing of prints, 570
Taylor, H. Dennis, 125
Taylor, Taylor and Hobson, 125
Technical photography,
 cameras for, 141, 147, 187
Telephoto attachments, 158
Telephotometers, 435
Temperature coefficient of development, 370
Temperature of fixation, 392
Test charts,
 colour, 241
 resolving power, 535
 sine wave, 546
Test strips, 427, 473
Threshold, 268, 269, 406
Tilted easel, used in enlarging, 479
Tilting back, 188, 191, 192, 193–195
Tilting front, 188, 191, 192, 193
Tilting lens panel, 188, 193
Tilting the camera causing converging verticals, 190
Time scale of exposures, 301
Time temperature chart, 371, 372
Time temperature method of development, 368, 369
 charts for, 372
T-numbers, 101
Tone reproduction, 291–295
Tone reproduction, properties of papers, 444
Toners, 500
 copper, 500
 hypo-alum, 500
 iron, 500
 sulphide, 500
 uranium, 500
 vanadium, 500
Tones,
 brown, 500
 orange-brown, 500

Tones (*contd.*)
 Prussian blue, 500
 purple, 500
 reddish-brown, 500
 sepia, 500
 yellow, 500
Toning (*see also* Toners)
Toning agents in papers, 444
Total internal reflection, 62, 63
Transmission factor, 245
Transmission of a lens, 100
Transmission of a negative, 260, 261
Transmission of light, 61
 diffuse, 61
 direct, 61
 mixed, 61
Transparencies, 19
Trichromatic theory of colour vision, 313
Tripack colour films, 257, 318, 320, 503
Tropical photography,
 danger of frilling, 564
 use of hardeners, 389, 454
T-stop system, 101
Turbidity, 533

U

Ultra-rapid processing, fixation in, 397
Ultra-violet absorbing filters, 212
Ultra-violet radiation, 24, 237
 absorption by gelatin, 235
 absorbed by glass, 235
 absorbed by silver halide, grains, 235
 contrast of emulsions in, 237
 near u.v. region, 237
 quartz u.v. region, 236
 scattered by earth's atmosphere, 207
 sensitivity of emulsions in, 235
Ultra-violet transmitting filter, 213
Unsharpness in negatives, causes of, 555, 556

V

Vacuum spectrography, 237
Verticals,
 converging, 190
 correction of; in enlarging, 479
 diverging, 190
Viewfinders, 166–169
 Albada, 167
 brilliant, 166
 direct-vision, 166, 167
 eye-level Galilean, 167
 ground-galass screen, 168
 Newton, 167
 open-frame, 166
 pentaprism, 145, 146, 169
 waist-level, 168

wire frame, 166
Viewing a print
 for correct perspective, 78, 87, 88
 from a comfortable distance, 78, 88
 in practice, 88
Viewpoint determines perspective, 84
Vignetting by a lens, 92, 93
Vignetting by a lens hood, 156
Vignetting by an extension tube, 159
Vision,
 colour, 312
 at low light levels, 315
 trichromatic theory of, 313
 Young–Helmholtiz theory of, 25, 313
 distinct, nearest distance of, 77
 photopic, 315
 scotopic, 315
Visual acuity, 77
Visual focus, 107, 471
Visual luminosity curve, 314, 316
Visual sensitivity
 at low light levels, 315
 photopic, 315
 scotopic, 315
 to colours, 312, 330
 to detail, 77
Vogel, 238, 239
Voltage regulation in enlarging, 488

W

Warm tones, 443, 500
Washers, print, 455, 456
Washing, 399, 454
 in the manufacture of emulsions, 227
 of negatives, 399
 of papers, 454
 purpose of, 399
 tests for completeness, 401
Washing aids, 400
Water
 as solvent for photographic solutions, 344
 hard, 345
Water softening agents, 345
Waterhouse stops, 164
Watkins, Alfred, 369
Watkins factor, 369
Watt-second, 55
Wave theory of light, 20
Wavelength of light, 21, 22
 determines degree of scattering, 207
 variation of gamma with, 274
Waves,
 electromagnetic, 21
 light (*see* Light)
 logitudinal, 21
 transverse, 21

Index

Wedges, photographic, 301
 step, 301
 use in wedge spectographs, 242
Wedge method of sensitometry, 301
Wedge spectograms, 236, 242–244
Wedge spectographs, 242
Wetting agents, 337, 403
Wiener spectrum, 548
Wollaston, 122, 124

X

Xenon, 53

X-rays, 22, 23, 237

Y

Young, 20, 24, 313
Young-Helmholtz theory of colour vision, 25, 313

Z

Zeiss, 122, 124, 125, 126

Notes

Notes

Notes

Notes

Notes

Notes

Notes

Notes

Notes

Notes